A Cubism Reader

Frontispiece: In 1912 Walt Kuhn went to Paris, with introductions to Pablo Picasso and others, to consider works for inclusion in the Armory Show he was organizing for the following year in New York. This is a list, in Picasso's own hand, of artists whom he thought Kuhn should include in the show. As such, this little-known document breaks down the common assertion of an unbridgeable divide between the *bande à Picasso* and "salon" or other cubists. © 2005 Estate of Pablo Picasso / Artists Rights Society. Photograph courtesy of the Walt Kuhn, Kuhn Family Papers, and Armory Show records, 1882–1966, Archives of American Art, Smithsonian Institution, Washington, DC.

A Cubism Reader
Documents and Criticism, 1906–1914

EDITED BY Mark Antliff *and* Patricia Leighten

TRANSLATIONS FROM THE FRENCH BY Jane Marie Todd

ADDITIONAL TRANSLATIONS BY Jason Gaiger
Lydia Cochrane
Lois Parkinson Zamora
Ivana Horacek

THE UNIVERSITY OF CHICAGO PRESS
CHICAGO AND LONDON

Mark Antliff is professor in the Department of Art, Art History & Visual Studies at Duke University. He is author of *Inventing Bergson: Cultural Politics and the Parisian Avant-Garde* (1993) and *Avant-Garde Fascism: The Mobilization of Myth, Art and Culture in France, 1909–1939* (2007), and coeditor, with Matthew Affron, of *Fascist Visions: Art and Ideology in France and Italy* (1997).

Patricia Leighten is professor in and former chair of the Department of Art, Art History & Visual Studies at Duke. She is author of *Re-Ordering the Universe: Picasso and Anarchism, 1897–1914* (1989) and *Art, Anarchism, and Audience in Avant-Guerre Paris* (forthcoming from the University of Chicago Press), and coauthor, with Mark Antliff, of *Cubism and Culture* (2001).

The University of Chicago Press, Chicago 60637
The University of Chicago Press, Ltd., London
© 2008 by The University of Chicago
All rights reserved. Published 2008
Printed in the United States of America

17 16 15 14 13 12 11 10 09 08 1 2 3 4 5

ISBN-13: 978-0-226-02109-6 (cloth)
ISBN-13: 978-0-226-02110-2 (paper)
ISBN-10: 0-226-02109-2 (cloth)
ISBN-10: 0-226-02110-6 (paper)

Library of Congress Cataloging-in-Publication Data

A cubism reader : documents and criticism, 1906–1914 / edited by Mark Antliff
 and Patricia Leighten ; translated by Jane Marie Todd.
 p. cm.
 Includes bibliographical references and index.
 ISBN-13: 978-0-226-02109-6 (hardcover : alk. paper)
 ISBN-10: 0-226-02109-2 (hardcover : alk. paper)
 ISBN-13: 978-0-226-02110-2 (pbk. : alk. paper)
 ISBN-10: 0-226-02110-6 (pbk. : alk. paper)
 1. Cubism—History—Sources. 2. Art, Modern—20th century—
Sources. I. Antliff, Mark, 1957– II. Leighten, Patricia Dee, 1946–
N6494.C8C75 2008
709.04'032--dc22

 2007034619

♾ The paper used in this publication meets the minimum requirements of the
American National Standard for Information Sciences—Permanence of Paper for
Printed Library Materials, ANSI Z39.48-1992.

We dedicate this book to the memory of Daniel Robbins, whose pioneering scholarship helped initiate the larger view of the cubist movement revealed by this book, and to the memory of our friend Vojtěch Jirat-Wasiutyński. But for their untimely deaths, they would have both appreciated the scope and spirit of this project and helped us to complete it.

CONTENTS

Documents

ILLUSTRATIONS

Frontispiece: Pablo Picasso, handwritten list given to Walt Kuhn recommending Parisian modernists for the Armory Show, 1912

ACKNOWLEDGMENTS

This book has taken many years to compile, edit, and write; we owe thanks to many people along the way who helped us with gaining access to and obtaining copies of original documents, and with related information about the many writers and artists represented and discussed here. Thanks also to the excellent translators we were lucky enough to have for this project. Jane Marie Todd brought a sensitivity and flair to the French translations that brought the documents to life. Additionally, we went over each translation in light of the historical questions the documents raise and double-checked for period language and concepts, so any shortcomings are ours.

We communicated with several scholars about various aspects of this project, and we would like to thank them here: William Camfield, Jonathan Fineburg, Adrian Hicken, Lewis Kachur, and Pepe Karmel. Additionally, we want to express our special gratitude to Linda D. Henderson for her generosity in sharing her considerable library of cubist documents; to Genie Robbins for giving us free access to Daniel Robbins's excellent collection of rare cubist-related materials; and to Susan Bielstein, our editor, for her patience and lively faith in the enterprise. To Allan Antliff we owe thanks for his indefatigable, imaginative, and cheerful help. It would be odd to thank each other, but we do, as well as being grateful for friends and family who have been supportive throughout.

For permission to reprint texts, we thank Jacqueline Gojard, executor of the literary estate of André Salmon (documents 22, 23, 26, 27, 32, 50, 51, and 53); Jean-Paul Bosq, representing Fernand Léger's (documents 65 and 75); and Artists Rights Society, representing Albert Gleizes's and Jean Metzinger's (documents 8, 11, 19, 21, 29, 31, 57, and 60). © 2006 Artists Rights Society (ARS), New York / ADAGP, Paris.

Over the past thirty years a new critical discourse on cubism has reshaped our conception of the movement and of early modernism as a whole; this book is the first anthology of primary-source materials that responds to and takes account of that scholarship. In hopes of minimizing the shaping influence of preconceptions that form the editors' understanding (though such preconceptions cannot be altogether avoided, they may be resisted), we have included, in all but three cases, only unabridged documents.[1] All documents have been newly translated—many for the first time—and vetted for the specific language of the period. Each entry includes commentary that frames the text (and, where appropriate, the author) from a historical perspective and engages with the historiography on cubism. And, though the literature is too vast for us to have been encyclopedic in our selection, we have interwoven, in chronological order, (1) substantial writings by the artists themselves; (2) a very broad range of *types* of criticism,[2] including artists' manifestos, correspondence, and exhibition prefaces; government documents; and articles from the popular press, literary magazines, satirical journals, and specialized fine art publications; (3) negative assessments of the movement indicative of the broader public debate over cubism before World War I; and (4) writings that address social, political, scientific, philosophical, and literary issues related to the movement. It was our editorial decision to restrict this already large collection to documents produced during the initial years of the movement's development—1906 to 1914—to minimize the influence of subsequent memoirs and commentary that unavoidably respond to later historical pressures. This choice acknowledges that the First World War itself profoundly changed the terms of discourse relating to art and culture. Such

changes not only set the cubist movement in a new direction, they also resulted in the wholesale reinterpretation of prewar cubism by critics and artists profoundly influenced by the cultural climate and tumultuous events that had transformed wartime Europe.[3]

Culturally encoded assumptions of a related sort played a major editorial role in the only previous book in English to bring together primary source materials on the cubist movement: Edward F. Fry's *Cubism,* a groundbreaking anthology of selected writings that since its appearance in the mid-1960s, through its several reprintings, did much to shape the literature on cubism.[4] Fry was trained at Harvard in the 1960s during the heyday of formalist approaches to a still-unfolding modernism[5]; his concept was to compile and comment on a very significant group of writings by participants in and supporters of the movement, ranging from circa 1905 to circa 1944. His operative assumption was that these *apologiae* would both reveal the aesthetic preoccupations of those surrounding the artists and variously support his own evaluation of the deeper implications of cubism for modernism as a whole. Thus his anthology gave undoubted new focus to the importance of cubism and presented the texts with critical commentary that situated the writers aesthetically, yet judged their value in relation to Fry's own quite brilliant—if ultimately ahistorical—interpretation.

Implicit in Fry's interests, and widely shared with other scholars of modernism, was a traditional hierarchy of value both among the cubist works and among the artists, which encoded the prevailing museum culture's designation of Pablo Picasso as the "leader" and "inventor" of the movement and the others as "followers" whose importance varied widely. This discourse had its roots in the wholesale adoption, by an important constellation of Anglo-American critics, of the dealer Daniel-Henry Kahnweiler's privileging of Picasso and Georges Braque in his wartime book *Der Weg zum Kubismus* (1920; published in English as *The Way of Cubism* in 1949). Written in 1915 while Kahnweiler resided in neutral Switzerland, his championing of Picasso's and Braque's cubism in light of the philosophy of Immanuel Kant was arguably a riposte to xenophobic attacks on Kantian thought in wartime France, and the promotion by his fellow pacifists and exiled German socialists of Kant's call for a "United States of Europe" as a solution to European conflict.[6] In subsequent years Kahnweiler's neo-Kantian terminology—with its reference to the so-called analytical and synthetic phases of Picasso's and Braque's

development—was adopted by key dealers, critics, and historians, including Alfred Barr, Carl Einstein, Clement Greenberg, Douglas Cooper, and John Golding, author of the highly influential *Cubism: A History and an Analysis, 1907–1914* (1959).[7] Fry too followed this group of scholars in declaring Picasso and Braque the "essential" cubists. As was frequent in scholarship of midcentury, he approached the documents he published as a body of material in which he hunted freely for prose nuggets, selecting fragments from the texts that supported his endorsement of the hierarchy between "major" and "minor" cubists, and even occasionally silencing a critic in midflight when the writer passed from discussion of Picasso or Braque to Robert Delaunay or Henri Le Fauconnier, as in the case of Jean Metzinger (document 11 in the present volume). He for the most part ignored the much larger body of negative reception, which seems to a later generation to reveal so much about the values and assumptions that permeated the broader cultural discourse in France. Fry's anthology and introductory text charting the history of the movement was widely used and appreciated for the remainder of the century. Starting in the 1970s and '80s, however, scholars working in the field of cubism studies became critical of the volume and increasingly aware that the operative assumptions behind Fry's selection of extracts, as well as the sometimes overdetermined nature of his translations, were indicative of the formalism of the 1960s and were therefore out of step with methodologies that were reshaping the study of cubism and modernism in general. Yet by bringing these documents into focus, he may have helped initiate the very process of questioning that eventually undercut formalism, in a way that Fry himself—with his wry humor and intellectual open-mindedness—might have thoroughly enjoyed.

It is important to look a little more closely at the introduction to Fry's volume, since his anthology proved to be so highly influential and because the formalist assumptions behind it continue to hold sway in many quarters, especially in the museum world. Fry's book, modeled after the history of cubism developed by John Golding, gathered articles together in such a way as to reinforce Golding's own Kahnweiler-informed, formalist reading of cubism's development: like Golding before him, Fry divided the cubist movement between innovators—Braque and Picasso—and those artists designated as secondary cubists, the artists Metzinger, Albert Gleizes, Juan Gris, Fernand Léger, and their even "lesser" associates who began exhibiting paintings labeled cubist in 1910. Appropriately the first

section of Fry's introduction, "The History of Cubism" (9–35), charts the formal evolution of a cubist vocabulary, beginning with a discussion of the development, by Braque and Picasso, of cubist techniques of *passage* and multiple views, all in response to the dual influences of Paul Cézanne and African as well as Oceanic sculpture, before proceeding to outline the work of those artists Fry designates as their "followers." Having asserted that Braque and Picasso "were without followers" until 1909, he then claims that Léger, "who met Picasso towards the end of 1910" (19), was the first artist to follow Picasso's lead in transforming Cézanne's pictorial innovations into a cubist vocabulary. Léger's *Nudes in a Forest* (1909–10) was said to possess "qualities in common with the contemporary work of Picasso and Braque" but to have still "created a traditional hollowed-out space," a "traditional illusionistic effect" purportedly avoided by Braque and Picasso. Other artists following in the wake of the innovators were also found wanting: for instance Metzinger, "who knew Picasso by 1910 if not before" (25) reportedly "shows a knowledge of Picasso's attempts to abandon closed form" in his *Nue* of 1910 (fig. 11), "but did not apply the idea consistently or with sufficient understanding" (22). Thus Fry concludes that "1911 saw the spread of cubism beyond the circle of Picasso and Braque": "None of these painters, however—Gleizes, Metzinger, Le Fauconnier, [André] Lhote and many others—contributed anything new or essential to the cubism of Picasso and Braque; and few, if any of them, really understood it" (25). Thus the later group were deaf to the neo-Kantianism that supposedly informed the cubism of Picasso and Braque, premises Fry enshrined by adopting Kahnweiler's (and Golding's) categorization of their art into "analytic" and "synthetic" phases.

Fry then closes his introduction with a meditation on cubism's significance, "Cubism as a Stylistic and Historical Phenomenon" (36–41). Here he supplements his neo-Kantian history of cubism's stylistic development from processes of analysis to synthesis by speculating that "the approach to the visual world between Cézanne and 1913–14 cubism has a parallel in the history of philosophy with the differences between the thought of Henri Bergson (1859–1941) and Edmond Husserl (1859–1938)." Whereas Bergson's focus on "the role of duration in experience . . . is analogous to the methods of Cézanne and of the cubists in 1908–10," Husserl's "method of eidetic reduction," "independent of psychological explanations," has "striking similarities" to "the art of Picasso and Braque in 1913–14," although the similarity is rightly deemed "historically coincidental" (38–39). Thus

although Fry recasts Kahnweiler's and Golding's analytic-synthetic pairing in light of Bergson's process philosophy (indicative of the Cézannism of cubism's analytic phase)[8] and Kant's legacy in the field of phenomenology (the synthetic turn),[9] he continued to endorse an ahistorical version of formalism, which had a significant impact on his interpretation of the documents he then reproduced. Speaking of references to Bergson on the part of the "minor" cubists and their literary allies, Fry concludes that Bergson's impact was rather superficial, citing the philosopher's own ignorance of these cubists as proof (63, 67).[10] Similarly, Fry dismisses Gleizes's and Metzinger's claim that their pictorial innovations were indebted to theories of non-Euclidean geometry and the fourth dimension, concluding that references to these terms in their writings "served only to obscure the understanding of cubism with a pseudo-scientific mysticism" (111–12). By contrast, he endorsed the neo-Kantians Jacques Rivière and Maurice Raynal as the only critics to grasp fully the significance of Braque's and Picasso's pictorial innovations (80–81, 93, 96, 100–101).

We counter this set of assertions through our own choice of documents and their related commentaries, but here we want to emphasize that the formalist and hierarchical narrative set forth in his introduction necessarily shaped Fry's approach to the edited documents contained in his volume. From articles referencing the avant-garde's enthusiasm for African and Oceanic sculpture, to excerpts from critics responding to the art of Braque and Picasso, then the writings of Metzinger and others who reportedly emulated the art of the two innovators, his assessment of the writings of the cubists and their critics is made in terms of whether they have understood the formal terminology outlined in his introduction. Thus Fry claims that Metzinger's essay of 1911, "Cubism and Tradition" (document 19), is important solely for codifying "the idea that a cubist painting contains the implication of movement and that in addition to space it expresses time" (67); while the critic Rivière's 1912 essay, "Present Tendencies in Painting" (document 37), is lauded by Fry as an "accurate" description of the cubists' solution to "the problem of space and perspective" (80). Subsequent transformations in the field of cubism studies, inspiring a reevaluation of Fry's 1966 text, have in no small part been due to work of art historians who have rewritten the history of cubism from the standpoint of social history, gender studies, feminism, structuralism, and poststructuralism. The resulting picture of the movement, for most scholars, no longer consists of "leaders" and "followers," but reveals the

differing aims of these artists—including many more artists. Moreover, such documents are no longer read with a singular focus on their relative "accuracy" with regard to cubist praxis, but as expressions of each author's individual intellectual position: not in some cases, but in all cases. In sum, Fry's choice and editing of documents now seems, to a later generation, both limited and overdetermined.

A Cubism Reader begins by acknowledging the cubists' literary roots. We open with essays on the group of writers, artists, and critics who founded the artists' collective known as the Abbaye de Créteil (1906–08; documents 1 and 2), as well as texts acknowledging the impact of symbolism and its heritage on circles associated with the *bande à Picasso* in Montmartre (documents 3–6 and 8). Whereas the former group founded the literary school known as Unanimism, led by the poet Jules Romains, the Montmartre contingent claimed allegiance to the legacy of the symbolist Stéphane Mallarmé; in subsequent years both tendencies, with their shared grounding in contemporary philosophy, would prove highly influential on artists and critics affiliated with the cubist movement. Documents that follow chart the developing discourse on cubism from 1908 onward as it is manifested through artists' statements, shifting critical allegiances, newly formed artists' societies, exhibition prefaces and reviews, political developments and debates, philosophical interpretations, and period surveys assessing cubist aesthetics. While we have reproduced in their entirety documents made familiar through Fry's anthology, there are many more that have never been translated. Fry's collection alerted scholars to Jean Metzinger's importance as a theoretician; our anthology additionally highlights his role as symbolist poet, literary critic, and pedagogue at the first cubist art school, the Académie de la Palette (documents 8, 31, and 66). For the first time we reproduce the complete translation of the critic Marius de Zayas's Spanish-language interview with Picasso in May 1911, as well as Kahnweiler's April 1912 assessment of the cubist movement (documents 16 and 39). We acknowledge the importance of the "theoretician of mathematics," Maurice Princet, by reproducing his only extant piece of art criticism: an exhibition preface on Robert Delaunay (document 35). In addition we have supplemented the list of critical voices on cubism with seminal statements by lesser known critics and artists, including René Blum, Pierre Dumont, Elie Faure, Max Goth, Urbain Gohier, Henri Guilbeaux, André Mare, Jacques Nayral, Marcel Sembat, and Ardengo Soffici.

Taken as a whole, these documents and their related commentaries both complement more recent interpretations of the cubist movement and, in some cases, challenge the historiographical status quo. For instance, it is now common to separate Picasso and Braque from artists such as Robert Delaunay, Albert Gleizes, Henri Le Fauconnier, Fernand Léger, and Jean Metzinger on the basis of their differing marketing and exhibition practices. By categorizing the former as gallery cubists in contrast to the salon cubists, historians have sought to reject the older formalist distinction between "major" and "minor" cubists while maintaining a crisp division between these very same protagonists; yet as our anthology reveals, this distinction does insufficient justice to the complex marketing strategies developed by artists gathered under the salon cubists umbrella (and to the lively intermingling of the two groups; see the frontispiece and its caption). In particular more attention needs to be given to the latter group's exhibition practices *outside* the context of the Salon d'Automne and Salon des Indépendants, both in Paris and beyond the borders of France (see documents 10, 13, 35, 40, 46, 54, 68, and 70).[11] We take account of subgroupings within the so-called salon cubist coterie, most importantly the Société normande de peinture moderne, which evolved independently and then in tandem with the cubist formation that emerged under the auspices of the Parisian salons (documents 7, 30, 34, 38, 42, and 43). To date, historians have charted the merger of these two groups in 1912 and the subsequent fragmentation of the salon cubists in the wake of the major cubist retrospective of October 1912, the Salon de la Section d'Or; but less attention has been given to the rise in prominence or subsequent critical decline of individual artists and literary advocates within this context. To rectify this we have included major aesthetic statements by critics and artists who were instrumental in such developments, including Roger Allard, Guillaume Apollinaire, René Blum, Roger de la Fresnaye, Raymond Duchamp-Villon, Pierre Dumont, Elie Faure, Albert Gleizes, Henri Le Fauconnier, André Mare, Jean Metzinger, Olivier Hourcade, Francis Picabia, Maurice Raynal, Paul Réverdy, and André Salmon. To cite one example, these documents and their related commentaries enable the reader to follow the changing fortunes of Le Fauconnier, who from 1912 onward developed his career in Holland in response to his waning fortunes in France and Germany (documents 10, 15, 29, 41, 54, and 70). Comparable shifts occur in the realm of criticism: for instance Roger Allard, who was an early champion of Delaunay, Gleizes, Le Fau-

connier, Léger, and Metzinger, became disillusioned with these artists after 1912 and subsequently promoted Roger de la Fresnaye, whose allegiance to Cézanne and relative conservatism proved compelling to the later Allard (documents 69 and 71). Our documents and critical analyses also allow the reader to pick up more familiar threads, such as the critical debate over the impact of the symbolist poet Stephane Mallarmé on cubism; the influence of thinkers such as Henri Bergson, Immanuel Kant, Friedrich Nietzsche, and Henri Poincaré on the movement; the rise to prominence of critics Apollinaire, Raynal, and Réverdy over the course of 1912 at the expense of Allard and Olivier Hourcade; and the fragmentation of the salon cubist grouping itself, signified by the sudden explosion of individual manifestos and aesthetic statements as well as shifting critical allegiances following the Salon de la Section d'Or (held in October 1912) and the publication of Gleizes and Metzinger's synthetic statement *Du "Cubisme"* (documents 46, 47, and 57).

An important topic to emerge from this project, worthy of further exploration, concerns the debate among critics on the Left over the merits of cubism. One recent development in the secondary literature has been an overemphasis on negative responses to cubism on the part of self-styled leftists, most notably those of Henri Guilbeaux and the stable of critics affiliated with the journal *Les Hommes du Jour* (1908–23; see documents 14 and 25). To counteract this tendency we have broadened the scope of the debate on the Left to include positive assessments penned by such luminaries as the anarchist and neoimpressionist Paul Signac and the anarchist sympathizer Elie Faure (documents 7, 36, and 42). As is now evident, Signac and Faure both correlated the avant-gardism of the cubists with leftism in the sphere of politics, a discourse also endorsed by Apollinaire, Pierre Dumont (painter and cofounder of the Société normande), and the Socialist deputy Marcel Sembat (documents 25, 38, 55, and 62). It is especially significant that Signac, in response to the public outcry against the salon cubists following the 1911 Salon des Indépendants, declared them the very "raison d'être" of that institution in March of 1912 (document 36). Signac had helped found the Salon des Indépendants in 1884 as an annual jury-free salon and principal forum for those neoimpressionists affiliated with the newly constituted Société des artistes indépendants. As Martha Ward has demonstrated,[12] Signac and fellow anarchist Camille Pissarro established the Salon des Indépendants to combat the

absorption of avant-gardists—most notably the impressionists—into the private gallery system and to provide innovative artists with an anarchist-inspired alternative to the more restrictive, state-sanctioned Salon des Artistes Français (founded 1881) and still later the Salon de la Société Nationale des Beaux-Arts (founded 1890) (for an extended discussion of the various salons, see the commentary for document 58). By declaring themselves neoimpressionists whose new salon protected freedom of expression in the visual arts, Signac's circle took up the mantle of avant-gardism abandoned by the more commercially oriented impressionists. It is significant therefore that Signac lent politically inflected credence to the avant-gardism of the cubists, despite the latter group's stated desire to distance themselves from both impressionism and neoimpressionism. Signac's endorsement of the cubists as "liberators" not only echoed leftist readings of cubist avant-gardism by critics like Apollinaire and Faure, it was a stunning rebuke to Guilbeaux and his circle, who had championed the neoimpressionists while condemning cubism as a mere hoax designed solely to attract attention and assure commercial success for its practitioners.

Signac's spirited defense of cubism challenges yet another historiographical assumption, namely that the anarchist movement was a spent force before the advent of cubism and that "avant-gardism" by this time was itself devoid of leftist connotations for the cubists and their literary allies. In a related argument some historians maintain that, while the new generation of artists and poets embraced Mallarmé's symbolism, they rejected the older poet's own anarchist and liberatory interpretation of "free verse." Allegiance to Mallarmé and neosymbolism on the part of the cubists and their literary supporters, therefore, now signified an aestheticist withdrawal from any leftist engagement into an ivory-tower doctrine of "art for art's sake."[13] Our anthology makes clear, however, that self-styled anarchists associated with the journal *L'Action d'Art* (1913) openly embraced the cubists; moreover their ideological allegiance to Mallarmé, combined with their politicized defense of avant-gardism, won the approval of key members among Picasso's circle, the salon cubists, and the neosymbolist milieu (see document 63 and the related commentary).[14] Such evidence calls into question any clear-cut bifurcation between the rhetoric of avant-gardism and political activism at this historical juncture.

As the project took shape another important issue revealed itself: neoimpressionism—rather than either fauvism or futurism—stood as the dominant rival of modernism for the generation of the cubists. Scholars have focused so often on such "rivalries" as cubism versus futurism or Picasso versus Matisse that we may have missed the forest for the trees. Those rivalries certainly played a role, but throughout these documents, critics and especially cubist theorists framed cubism as primarily over-coming the "limitations" of neoimpressionism *as modernism*. Repeatedly, neoimpressionists are berated for a variety of failures to solve problems that, for these writers, were posed by the conditions of modernism and only solvable through a cubist approach to art making. Understanding this substructure will help future readers interpret the cubist movement in a more historicized way.

Two questionnaires on cubism also highlight the critical responses by a variety of artists and critics outside the movement, including academi-cally trained artists who exhibited at the Salon des Artistes Français and the Salon de la Société Nationale des Beaux-Arts, and critics as various as Camille Mauclair and the doyen of Italian futurism, F. T. Marinetti (documents 36 and 58). Such criticism is remarkable for both its general vitriol and the nature of the accusations deployed against the cubists, which ranged from xenophobic calls for a critical boycott by the press, to claims of charlatanism, mystification, and bluff, to accusations of techni-cal incompetence. The latter assertion followed a telling pattern already established by critics of the impressionists, but whereas earlier critics faulted artists like Claude Monet for making the preparatory method of the academic *esquisse,* or sketch, an end in itself, the cubists were accused of *primitivizing* their art through recourse to preliminary exercises in drawing still in use at the École des Beaux-Arts as well as to children's drawing manuals.[15] In short, when we compare the mainstream critical reactions to impressionism and cubism, we witness a shift from a focus on color to drawing as the principal medium under scrutiny; but the terms of discourse, which made avant-garde art a diacritical subset of academic technique, remained remarkably similar.

Our anthology and related commentaries also address other forms of cubist "cultural politics," most notably critical references to various clas-sicisms; interpretations given to the concept of "Celtic nationalism" by the critics Henri-Martin Barzun, Max Goth, and Olivier Hourcade, and

the artists Gleizes and Léger; the cubists' uniform hostility to the more restrictive cultural agenda of the Action française; and the impact of neo-Catholicism and theories of "Occidentalism" on artists and critics such as Jacques Riviére, André Lhote, and Roger de la Fresnaye. In like fashion, we allow the reader to examine the full ramifications of the Socialist city councillor Pierre Lampué's decision in October 1912 to challenge publicly the right of the cubists to exhibit their art in state-owned buildings such as the Grand Palais (where the Salon d'Automne was held). For the first time historians and students can read translations of Lampué's October 1912 open letter of protest to Undersecretary of Fine Arts Léon Bérard; the December 1912 debate in the Chamber of Deputies between the Socialists Jules-Louis Breton and Marcel Sembat over whether to allow the cubists entrance into publicly owned buildings; and the resulting campaign by the cubists and their critical allies to marshal support for their movement. By including in our survey of the Lampué debate articles culled from a variety of sources—including official government records, daily newspapers, humorist magazines, and more specialized avant-garde revues—we hope to alert readers to the importance of the medium as well as the message in the shaping of public discourse. The heated nature of this cultural exchange, its xenophobic undertones, and the critical responses of the cubist camp to Lampué's campaign lend further credence to scholarly assertions that October 1912 was a watershed moment in the history of cubism.

In closing, because we recognize that we have our own views, with all the contingency attendant upon our own moment in history, we wish both to honor Edward F. Fry for initiating the important project of understanding the cubist movement through its primary sources and to send this book into the hands of a future generation of scholars, who will undoubtedly see things here not apparent to us.

NOTES

1. Document 36 is abridged for reasons outlined in our commentary for that article; documents 50 and 51 are substantial, coherent, and uninterrupted sections excerpted from André Salmon, *La jeune peinture française* (Paris: Société des trente, Albert Messein, 1912).

Citations in the commentary accompanying each document are keyed to the bibliography. All journals were published in Paris unless otherwise noted.

2. In this regard we would encourage readers to consult Malcolm Gee's important essay addressing the role of a broad cross-section of publication venues—from avant-garde

journals, to large-circulation newspapers, to exhibition catalogs—in shaping public discourse on art and the function of art criticism within that discursive frame. See "The Nature of Twentieth-Century Art Criticism," in *Art Criticism since 1900,* ed. Malcolm Gee (Manchester: Manchester University Press, 1993), 3–21.

3. For comprehensive histories of the impact of the war on the Parisian avant-garde, see Christopher Green, *Cubism and Its Enemies: Modern Movements and Reaction in French Art, 1916–1928* (New Haven, CT: Yale University Press, 1987); and Kenneth Silver, *Esprit de Corps: The Art of the Parisian Avant-Garde and the First World War, 1914–1925* (Princeton, NJ: Princeton University Press, 1989). For analyses of retrospective reinterpretation of prewar cubism, especially in light of the impact of neo-Kantianism and formalism on later critics and historians of the movement, see David Cottington, *Cubism and Its Histories* (Manchester: Manchester University Press, 2004), 165–96; Patricia Leighten, "Editor's Statement," in "Revising Cubism," special issue, *Art Journal* (Winter 1988): 269–76; and Daniel Robbins, "An Abbreviated Historiography of Cubism," special issue, *Art Journal* (Winter 1988): 277–83. Leighten's article charts the critical shifts initiated by the trauma of the war decade by decade to the 1980s.

4. Edward F. Fry, *Cubism* (London: Thames & Hudson, 1966); it was last reprinted in 1985 and is still available from Thames & Hudson. Leroy C. Breunig and J.-Cl. Chevalier, in their annotated edition of Guillaume Apollinaire, *Méditations esthétiques: Les peintres cubistes* (Paris: Collection Savoir, Hermann, 1980), reprinted a small but useful French-language collection of contemporary Parisian criticism of cubism from 1908 to 1912, though in often fragmentary form and without commentaries. Their sampling includes Louis Vauxcelles (*Gil Blas,* 20 March 1908, document 5, 25 March 1909, 5 and 19 March 1912, and 14 October 1912); Charles Morice (*Mercure de France,* 16 December 1908, 16 February 1909, 16 April 1909; and 18 March 1910); Henri Ghéon (*Nouvelle Revue Française,* May 1909); André Salmon (*Paris-Journal,* 18 March 1910, 22 December 1910, 30 September 1911, and 19 March 1912); Jean Metzinger (documents 11 and 19); Roger Allard (document 12 and *La Revue de France et des Pays Français,* March 1912); Henri Guilbeaux (document 14 and *Hommes du Jour,* 24 June 1911 and 30 September 1911 and document 25); René Jean (*Gazette des Beaux-Arts,* July 1911 and November 1911); Aloes Duravel (pseud. of J. Granié, *Revue d'Europe et d'Amérique,* June 1911 and 15 November 1911); Gustave Kahn (*Mercure de France,* 16 October 1911, 16 March 1912, 1 April 1912, and 1 November 1912); André Warnod (*Comoedia,* 30 October 1911); Albert Gleizes (document 29); Jacques Rivière (*Nouvelle Revue Française,* January 1912); Olivier Hourcade (documents 33 and 36, *Paris-Journal,* 30 September, 15 and 23 October 1912); Pierre Dumont (document 38); Jacques Nayral (document 40); and Maurice Raynal (document 44).

5. Lucian Krukowski, in his succinct analysis of the conceptual and historical development of formalism, defines the term as follows: "*Form,* as a term in aesthetics, refers to the perceptual elements of an artwork and the relationship holding between them. *Formalism* names the aesthetic doctrine in which these related (formal) elements are said to be the primary locus of aesthetic value, a value that is independent of such characteristics of an artwork as meaning, reference or utility." Formalism's principal philosophical roots have been traced to the philosophy of Immanuel Kant, whose theory of aesthetics and legacy in the development of formalism were foundational to Edward Fry's interpretation of cubism. See Lucian Krukowski, "Formalism," in *Encyclopedia of Aesthetics,* ed. Michael Kelly (Oxford: Oxford University Press, 1998), 213–16. Mark Cheetham, in his exemplary study of Kant's legacy in the field of art history, has noted Fry's enduring debt to Kantian precepts as well as his call, in 1988, for a "new Kantianism." See Cheetham, *Kant, Art, and Art History: Moments of Discipline* (Cambridge: Cambridge University Press,

2001), 78–80; and Edward Fry, "Picasso, Cubism, and Reflexivity," *Art Journal* (Winter 1988), 296–307.

6. On Kahnweiler's wartime cultural politics and cultural debates over Kant in wartime Europe, see Mark Antliff and Patricia Leighten, *Cubism and Culture* (New York: Thames & Hudson, 2001), 199–205.

7. This formalist interpretation of cubism dominated the movement from the 1950s to the late 1980s, when it ceded to structuralist interpretations and those influenced by the social history of art. Authors who embraced Kahnweiler's neo-Kantianism in promoting formalism included John Golding, *Cubism: A History and an Analysis, 1907–1914* (London: Faber & Faber, 1959; reprinted 1972 and 1988); Robert Rosenblum, *Cubism and Twentieth-Century Art* (New York: Abrams, 1960; reprinted 1976 and 2001); Douglas Cooper, *The Cubist Epoch* (London: Phaidon, 1970); Douglas Cooper and Gary Tinterow, *The Essential Cubism: Braque, Picasso and Their Friends* (London: Tate Gallery, 1983); and William Rubin, *Picasso and Braque: Pioneering Cubism* (New York: Museum of Modern Art, 1989), among others. David Cottington and Patricia Leighten have analyzed the genealogy of this formalist discourse (Cottington, *Cubism and Its Histories*, 190–96; and Leighten, "Editor's Statement.").

8. Fry's Bergsonian reading of Cézanne and cubism is indebted to the following sources cited by him: Maurice Merleau-Ponty, "Cézanne," in *Sens et non-sens* (Paris: Nagel, 1948); Maurice Merleau-Ponty, *Phenomenology of Perception* (New York: Humanities Press, 1962); and George H. Hamilton, "Cézanne, Bergson, and the Image of Time," *College Art Journal* (1956): 2–13.

9. Fry cites the following texts in relation to his phenomenological interpretation of "synthetic" cubism: José Ortega y Gasset, *The Dehumanization of Art and Other Writings on Art and Culture* (Garden City, NY: Doubleday, 1956); Guy Habasque, "Cubisme et phénoménologie," *Revue d'Esthétique* (April–June 1949): 151–61; Gaston Berger, *Le cogito dans la philosophie de Husserl* (Paris: Éditions Montaigne, 1941); Edmund Husserl, *Ideas: General Introduction to Pure Phenomenology* (1962); and Edmund Husserl, *Cartesian Meditations* (The Hague: M. Nijhoff, 1960). For evidence of Fry's conflation of "synthetic" cubism and Husserl's phenomenology, see Fry, *Cubism*, 113.

10. For evidence of Bergson's influence and the philosopher's own response to cubism, see documents 11, 12, 18, 19, 28, and 57.

11. For a list of such venues and of works exhibited, see Isabelle Morin, *Analyse raisonnée des catalogues d'exposition des peintres cubistes (1907–1914)* (Paris: Institut d'art et d'archéologie, 1972); and Fry, *Cubism*, 183–85).

12. Martha Ward, *Pissarro, Neo-Impressionism, and the Spaces of the Avant-Garde* (Chicago: University of Chicago Press, 1996), 49–63.

13. This notion of an aestheticist retreat constitutes a metanarrative in David Cottington's interpretation of the evolution of the cubist movement. See Cottington's *Cubism in the Shadow of War: The Avant-Garde and Politics in Paris, 1905–1914* (New Haven, CT: Yale University Press, 1998), 73–80; and *Cubism and Its Histories*, 27–28. Linda Goddard, in "Mallarmé, Picasso and the Aesthetic of the Newspaper," *Word & Image* (October–December 2006): 293–303, argues for a greater similarity between the poet and artist in their engagement with both "aesthetic ideals of truth and beauty" and "conventional modes of communication such as journalism," calling into question the reading of Mallarmé as an aestheticist opposed to popular culture.

14. Mark Antliff has examined the interaction between the *Action d'art* collective and cubists, futurists, and their literary allies. See Antliff's *Inventing Bergson: Cultural Politics and the Parisian Avant-Garde* (Princeton, NJ: Princeton University Press, 1993),

135–56; and "Cubism, Futurism, Anarchism: The 'Aestheticism' of the *Action d'art* Group, 1906–1920," *Oxford Art Journal* 21, no. 1 (1998): 99–120.

15. On impressionist technique and its critical reception, see Richard Shiff, *Cézanne and the End of Impressionism: A Study of the Theory, Technique, and Critical Evaluation of Modern Art* (Chicago: University of Chicago Press, 1984).

"L'Appel de 1906," pamphlet published by the Abbaye de Créteil, 1906

Appeal of 1906

As young writers, poets, and painters, we are passionate about our art and profoundly dedicated to it.

For at least two or three years, each of us, sustained by an altogether youthful confidence in his labor, in his activities, and in the methods proper to his talent, has *attempted to achieve* the beginnings of notoriety that allow the artist to practice his art in complete peace and to make a living at it, however mediocre.

We have now acquired the certainty that, with the exception of extraordinary circumstances in which worth plays only a small role, it takes the writer or artist without a fortune at least half his life to reach a point where he is no longer plagued by material concerns.

We know that many of our elders, in spite of their great talent—and sometimes because of it—can devote to their precious work only the little leisure time left over after they have earned their mercenary living.

Those who wish at all cost, and without a long wait, to live by their pen or paintbrush must stoop to prostitution and take the dangerous road leading downward, from which one never returns and which leads very far below art.

We do not even want to envision that solution. Since we have no fortune, we have up to now adopted the only one possible: to earn a living, we are artisans, or we submit to the least literary of writing jobs.

We are not at all resigned to that fate, however: we are young and not yet emasculated by a mediocre life, not yet cut off from all tangible ideal and all vigor.

The warm feelings of our peers, the hearty reception of our elders and teachers, and the approval of the judges at exhibitions—relative, but valid

in some respect—have given us the joyous certainty that we can do useful work. That is why, in all stubbornness, we want to acquire maximum freedom for the work that is precious to us; and, to do that, we want to bravely undertake a project. Here is the feasible enterprise toward which we are currently working.

Our hearts are set neither on official stamps of approval nor on the insolent noise of parades, which are the monopoly of mediocre people; and we want to remain apart from the struggles, the petty intrigues and bribery, which, along with some other things, constitute literary social climbing.

Although we do not extol the ivory tower, we dream of the dwelling place Nietzsche speaks of, *that dwelling too high and too steep for anyone impure,* and by means of which we will escape from the *gutter.*

And we came up with the following: To found our abbey outside the town, as a sanctuary of art and thought far removed from utilitarianism and economic appetites and struggles, just as the medieval abbey was, for the chroniclers and encyclopedists, a refuge far removed from the feudal wars. In short, to create, for a few people, a free Villa Médicis, whose guests, without the yoke of an official error, would work in complete peace, communing with one another in their enthusiasm, satisfying their needs in common, pooling their resources. Yes, here again, the question of a livelihood is raised; but, after careful study, we have found a way to make it the distraction necessary to any intellectual labor—manual work for four to five hours a day, for which Renan, according to his own account, abandoned his faculty chair.

We now begin a practical explanation of the project.

What manual trade is more likely to captivate literary writers, as most of us are, than printing? And to what other trade would they bring more competence and diligence? It is intimately connected to their work; it is its indispensable corollary, especially since there is more than one way to do printing. There is the laborer-printer and the craftsman-printer; there is the industry catalog and the art publication; there is also the exacting and captivating printing of lithographs and etchings. Aided in that pursuit by the technical knowledge of one of our group and by the experience of an old craftsman, we would thus found a printing office in our abbey; we would edit and publish, in particular, poets, lithographers, etchers, and engravers.

To show what practical interest such an undertaking offers, and for what success it may be destined, we will give only one example:

It is well known within the literary world that poets can no longer find an avenue for publishing that does not cost them anything (with the exception, of course, of the great popular versifiers). A poet goes to a printer, generally a provincial printer; then, once the book is printed, he has to find, at least as a matter of form, a publishing house, *a mark, a firm*. The editors with some renown charge a high price simply for the right to have their name inscribed on the first page of a book; generally, they even impose their own printer, who may not be the least exacting. Poets who do not wish or are unable to pay a firm take on a purely fictitious publisher, a young review or a literary *group*. Let us note that the collection of very important publications by *Plume* and *Mercure de France* came into being in that way, and that the latter has now become one of the most prosperous and useful booksellers. But let us come to our example:

A few years ago, a bibliophile and scholar, Mr. Edmond Girard, who had the dream of making it easier for poets to publish their works, became both their printer and their publisher, and founded La Maison des Poètes.

At the printing office of La Maison des Poètes, there were only two workers: Mr. E. Girard and his wife. And both of them, once they had become skillful in setting the type and in the presswork, undertook, in one of the most artistic formats ever seen, a collection of the best works of poetry from the most recent generation.

There were no fewer than seventy of these works when Mrs. Girard died. That death brought to an abrupt close the thriving Maison des Poètes.

So, then, what Mr. Girard so successfully attempted, we can attempt in our turn; our task will be easier than his, since our printing office will have more than two workers, and since we have, at present, the assurance that the great majority of our fellow writers, in their own interest and out of sympathy for our idea, will come to us.

It goes without saying that we will publish our own works and that our draftsmen, lithographers, and so on, will make prints of their own as well.

A corresponding bookseller in Paris will be in charge of sales.

We would therefore like:

To install our abbey outside the immediate environs of Paris, in a setting picturesque enough to hold the attention of painters, and in a fairly large and simple residence or villa to be rented.

To set up an improvised print shop there, one destined to grow over time.

Periodically to hold, at the abbey and in Paris, exhibitions and sales of paintings, engravings, lithographs, art studies, and, in a general way, to supplement the material resources of our own publications with all those stemming from our respective arts.

And finally, to lead, in the greatest simplicity, the existence of passionate, hardworking, and FREE artists.

For the creation of that abbey, which we desire with all our heart, we are unfortunately lacking the indispensable funds to cover the initial setup costs and the rental of a place of residence. These funds, according to a carefully thought-out appraisal, would come to thirty thousand francs, the detailed allocation of which we are prepared to provide.

For four years, we have considered borrowing these thirty thousand francs. But it is easy to understand that it would be impossible to sign for that loan as a *business* from any financiers or patrons in *commercial* enterprises; they would not see the point of it, and, in addition, would require a large return on their investment and, above all, material guarantees. But the only guarantees we have—and this would be paltry in their eyes—apart from the leased building and the equipment in the print office, which the lender would have at his disposal, are our young talents, the high likelihood of the success of our enterprise, and our proud scruples.

That is why we wanted to turn, not to businessmen, to those who deal in money, but to a heart and mind for whom these guarantees might, all the same, have some value.

Your reputation for kindness, the interest you show toward any undertaking of a useful nature, and your taste for art have led us to knock at your door first of all.

We therefore dare solicit a bit of your attention for our project, putting ourselves completely at your disposal to give you all the information concerning it, and to allow you to get to know our early work and ourselves.

To end this exposition of the generalities, we will only add that we come to you with great hope; that whether our simple dream collapses or becomes a glittering reality is up to you; and that, if this project of a Thélème of artists and poets, destined for the brightest of futures, if this project owes its life to you, our heartfelt and constant gratitude will accompany its birth.

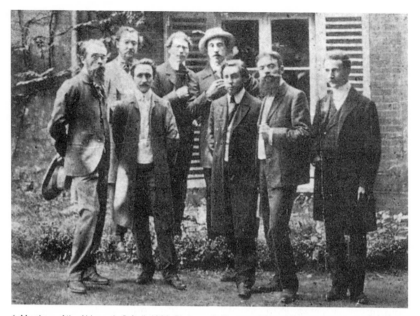

1. Members of the Abbaye de Créteil, 1906. Photograph. First row, left to right: Charles Vildrac, René Arcos, Albert Gleizes, Henri-Martin Barzun, Alexandre Mercereau. Second row: Georges Duhamel, Berthold Mahn, Jacques d'Otémar.

Commentary

Despite its short existence (December 1906 to January 1908), the Abbey of Créteil facilitated interaction between poets and painters who would later become prominent figures in the history of cubism (fig. 1). The origins of the Abbey grew out of the collaboration of the painter-poet René Arcos (1881–1959) and the writers Georges Duhamel (1884–1966), Alexandre Mercereau (pseudonym Eshmer Valdor, 1884–1945), and Charles Vildrac (1882–1972) in the Parisian review *La Vie* (1904). Arcos introduced his collaborators to Albert Gleizes (1881–1953)—an avid reader of the French utopian socialists Henri de Saint-Simon and Charles Fourier—whom he had met while working alongside the painter in a textile design workshop owned by Gleizes's father. Following the demise of *La Vie,* this group founded the Association Ernest Renan in December 1905 with the aim of educating workers and overcoming the "bourgeois" division between manual labor and artistic expression. Modeled after the Université populaire movement (1899–1914), the Association Ernest Renan was resolutely secular, communitarian, and socialist in orientation.

The idea for an artists' commune had first come from Vildrac, who envisioned the creation of a self-supporting artistic community modeled after the vision of an Abbaye of Thélème developed by Rabelais in *Gargantua* (1534), Fourier's concept of a phalanstery (Adams, 33–34) and the self-sufficient agrarian communities championed by the anarchist Peter Kropotkin. In 1906 Vildrac and his friends were able to realize their dream when the poet Henri-Martin Barzun (b. 1881) joined their ranks beginning in December 1906 and provided the funds for renting a decaying house and servant's quarters situated on two and a half acres, southeast of Paris on the banks of the Marne (Brooke, 6). Concurrently the printer Lucien Linard, and the painters Berthold Mahn (1881–1975) and Jacques d'Otémar—all of whom had befriended Gleizes during his military service (1902–5)—joined the collective. In 1907 the composer Albert Doyen also moved to the Abbey and held a number of concerts during his residence there.

As the "Appeal of 1906" makes clear, the group hoped to sustain their community by establishing a small publishing house on the premises and pooling their labor to maximize the amount of time they could spend pursuing their artistic endeavors. In 1907 the Abbey press published Barzun's *La terrestre tragédie,* an epic poem evoking the life of the city, of crowds, and the promethean labor of factory workers; other published texts included Arcos' *La tragédie des espaces,* Duhamel's *Des légendes, des batailles,* and Mercereau's *Gens de là et d'ailleurs.* In 1908 the press printed its most significant volume: Jules Romains' (1885–1972) *La vie unanime,* a poem celebrating the writer's ability to "intuit" a new collective consciousness that he viewed as permeating life in the modern metropolis. This interest in cosmopolitan themes and "epic consciousness" owed a good deal to earlier writers like Walt Whitman (1819–92) and René Ghil (1862–1925) (Robbins, "Sources of Cubism and Futurism"; Brooke, 6–9); scholars have rightly identified Arcos', Barzun's, and Romains' poetry as literary precedents for the grand subjects favored by the cubists Robert Delaunay, Gleizes, Fernand Léger, and Henri Le Fauconnier after 1910 (Fabre; Green, 9–38; Robbins, "From Symbolism to Cubism"; Rousseau et al., 77–91, 118–21; Sund).

The references to Ernest Renan (1823–92) and Friedrich Nietzsche (1844–1900) in the "Appeal of 1906" point to the group's desire to achieve the maximum in individual creative freedom by means of the collective endeavor of book publishing and the common labor involved in main-

taining the buildings and its grounds. In later years Gleizes claimed that individual self-interest gradually undermined the spirit of mutual cooperation, and that this hastened the Abbey's demise (Gleizes); in truth, the inability to meet their fiscal goals was the primary deterrent that resulted in the Abbey's closure in early 1908. In January 1908 the group installed the press at 7, rue de Bainville in Paris, where they continued to meet and to publish books for a brief period. By 1911 a schism had begun to form between the Abbey's former adherents, with Arcos, Barzun, and Gleizes endorsing Barzun's poetic doctrine of "dramatism," while Duhamel, Vildrac, and the poet Jean-Pierre Jouve (1887–1976) joined Jules Romains in propagating "unanimism." Despite the literary divide, figures from both groups continued to publish in the unanimist vehicle *Les Bandeaux d'Or* (1906–14) and in Barzun's *Poème et Drame* (1912–14). After World War I Gleizes, Mercereau, and Duhamel each published widely differing assessments of the Abbey, giving vent to these sectarian disputes (Fabre). Scholars of cubism continue to debate whether the Abbey of Créteil should be regarded as an experiment in anarchist-oriented communitarianism (M. Antliff and Leighten, 91–93; Robbins, "From Symbolism to Cubism") or as an elitist flight from urbanism and contemporary politics (Cottington, 73–74).

Adams, *Rustic Cubism*
M. Antliff and Leighten, *Cubism and Culture*
Brooke, *Albert Gleizes*
Cottington, *Cubism in the Shadow of War*
Fabre, "Albert Gleizes et l'Abbaye de Créteil"
Gleizes, "The Abbaye of Créteil: A Communistic Experiment"
Green, *Léger and the Avant-Garde*
Mercereau, *L'Abbaye et le bolshévisme*
Robbins, "From Symbolism to Cubism: The Abbey of Créteil"
Robbins, "Sources of Cubism and Futurism"
Rousseau et al., *Robert Delaunay*
Sénéchal, *L'Abbaye de Créteil*
Sund, "Fernand Léger and Unanimism"

Martin-Mamy, "Chronique du mois," *Le Feu* (September 1907): 162–65

Monthly Report

Letter from Paris, September 1907

Dear Marie-Louise,

I had an adventure the other day, which I could not conceal from you without doing an injustice; I lived for an hour among sages. . .

To tell the truth, let me say that proverbs, the small change on which the ideology of the common herd feeds itself, are almost always false, and I am happy to be able to write that wisdom *is* of this world, since I was privileged to verify its effects some fifteen kilometers from Paris, next to a Vulci called the Marne, a hundred paces from the church of Créteil, to be precise.

A road that rises a little, then drops suddenly as if it wanted to catch the hiker by surprise, suddenly uncovering to him the green water that runs under the fresh archway of greenery, leads to a portal; and there a plaque is affixed, displaying these simple words: *The Abbey.*

I entered the abbey, I penetrated, under the vault of greenery, the poetic intimacy of its grounds, and I made the acquaintance of the happy little tribe that lives there.

There are about ten of them, poets, painters, sculptors, musicians. Two of them are married. Their wives add grace where there is only beauty, and two babies, shaking little bells with their fresh laughter in the silence, dispense gaiety where there is only happiness.

There are about ten of them there: René Arcos, whose poems have managed to attract the attention of the literary world; Albert Doyen, author of the beautiful "Ode funèbre et triomphante," dedicated to the memory of Émile Zola, and which was recently performed at Le Trocadéro; Georges Duhamel, the author of *Des légendes, des batailles;* the excellent painter

Albert Gleizes; the poet Alexandre Mercereau (E. Valdor), who wrote "Les encens"; Charles Vildrac, who wrote "Poèmes"; Henri Martin, who composed "Feuilles au vent"; and others as well, whose names escape me.

These young people, having remembered that "it is supreme wisdom to subordinate the dream to what is possible," have arranged things so that what is possible does not kill the dream. One day, combining their strengths, compensating for their weaknesses, it occurred to them that, in helping one another, they might, if not completely escape want, then at least make the best of it, and they founded "The Abbey," a kind of improved Thélème, thereby setting in place a sociological, economic, and psychological experiment.

As in Thélème, the motto is: "Do as you like"; like good Rabelais' monks, our secular monks rise when it suits them, but, within the rules and order of their lives, a new factor enters in, one stemming from the economic domain.

A community has expenses. There is the rent, taxes, upkeep, food. The reason they fled frantic Paris, which afflicts the most gifted minds with sterility, is precisely so that they might work in complete tranquility and write the book or paint the picture in a peace and quiet that enhances the creative powers. Thus there was the matter of solving the money problem.

The members of the abbey then became apprentices and turned to manual labor for their income.

From the general fund amassed from the modest contributions of the associates, the necessary money was raised to set up a shop for typographical composition. One of these associates, Lucien Linard, a typographer by trade, taught them how to set up their "take," how to make up pages, how to stitch books. Everyone set to work and, thanks to the general agreement, a rotation was organized to carry out this work plan. Four hours at the least, six hours at the most at the printing office (composition, distribution, proofreading, printing, maintenance of the buildings and gardens, correspondence, office work). Hence, the presses of the abbey have already produced art publications that are true marvels.

Once that is done, everyone is free to work as he likes. One writes verse, another engraves, another sculpts, and another . . . does nothing.

In the evening, in the vast drawing room on the ground floor, people get together to chat or play the piano and organ. A richly furnished library is available to all. Now that it is summertime, the charming feasts

are held on the vast, twenty-thousand-square-meter grounds, beautiful grounds with carefully arranged viewpoints that create the illusion of infinity.

In the company of the colony residents, I visited everything, down the most out-of-the-way nooks, from the drawing room where they chat to the bathroom where they splash about. I saw cells with windows looking out on the chestnut grove, some austere and cold, the refuge of withdrawn sociologists or ideologues, others filled with unexpected touches and originality, the haven of delicate poets or subtle novelists. I saw, finally, the abbey's beach, along a diverted arm of the Marne, where bathers can frolic on August days.

Hence, as a result of a kind of wager, young men have been able to create, thanks to a harmonious association, a true sanctuary of thought close to Paris, a city where the most monstrous battles are being waged for the conquest of gold or glory; and, as I was leaving them, I could not help but secretly admire these happy souls who find their happiness in work, and who heed only the advice of the peaceful river, a green ribbon unwinding in a lilting and contemplative indolence.

Was I not right, my dear Marie-Louise, to write at the start that I had lived for an hour among sages? And would I be any less right to add that neither you nor I is worthy to stay at the Abbey of Créteil?

Martin-Mamy

Commentary

Martin-Mamy's article for *Le Feu* (1905–14) is one of a number of such period accounts attesting to the broader impact of the Abbey of Créteil on literary and artistic circles in Paris. In addition to those in residence, the Abbey was visited by painters and sculptors such as Marcel Lenoir, L. A. Morice, Maurice Robin, and the American fauve Samuel Halpert; writers frequenting the commune included F. T. Marinetti (who would soon launch futurism), Théo Varlet, Ricciotto Canudo (future editor of *Montjoie!*), Valentine de Saint-Point, Jules Romains, and Paul Castiaux (Berghaus, 30–38; Fabre; Robbins). In the summer of 1907 (21 July and 11 August), the abbey organized two *grandes fêtes* consisting of poetry readings, concerts, and art exhibits: Gleizes opened his studio for the occasion, and the exhibitors included Constantin Brancusi, who showed

sculptures titled *Orgeuil* (*Pride*) and *L'Enfant* (*Child*) (Miller, 49–53, 77–78). A third and final "L'Abbaye" exhibition was held in Paris in January 1908: the artists included Gleizes, Henri Doucet, Maurice Robin, Umberto Brunelleschi, M. T. Essaian, E. de Krouglicoff, and the sculptors Brancusi, Drouard, Naoum Aronson, Geo Printemps, and Jean de Sczezpkowski (Fabre). Scholars of futurism have noted the impact of the Abbey writers on the youthful Marinetti, who subsequently developed unanimist themes in his own poetry (Berghaus, Martin).

Berghaus, *The Genesis of Futurism*
Fabre, "Albert Gleizes et l'Abbaye de Créteil"
M. Martin, "Futurism, Unanimism, and Apollinaire"
Miller, *Constantin Brancusi*
Robbins, "Sources of Cubism and Futurism"

Gelett Burgess, "The Wild Men of Paris," *The Architectural Record* ([New York,] May 1910): 400–414

I had scarcely entered the Salon des Indépendants when I heard shrieks of laughter coming from an adjoining wing. I hurried along from room to room under the huge canvas roof, crunching the gravel underfoot as I went, until I came upon a party of well-dressed Parisians in a paroxysm of merriment, gazing, through weeping eyes, at a picture. Even in my haste I had noticed other spectators lurching hysterically in and out of the galleries; I had caught sight of paintings that had made me gasp. But here I stopped in amazement. It was a thing to startle even Paris. I realized for the first time that my views on art needed a radical reconstruction. Suddenly I had entered a new world, a universe of ugliness. And, ever since, I have been mentally standing on my head in the endeavor to get a new point of view on beauty so as to understand and appreciate this new movement in art.

"Une Soirée dans le Désert" [A Soirée in the Desert] was a fearful initiation. It was a painting of a nude female seated on a stretch of sand, devouring her own knee. The gore dripped into a wineglass. A palm tree and two cacti furnished the environment. Two large snakes with target-shaped eyes assisted at the debauch, while two small giraffes hurried away from the scene.

What did it all mean? The drawing was crude past all belief; the color was as atrocious as the subject. Had a new era of art begun? Was ugliness to supersede beauty, technique give way to naïveté, and vibrant, discordant color, a very patchwork of horrid hues, take the place of subtle, studied nuances of tonality? Was nothing sacred, not even beauty?

If this example of the new art was shocking, there were other paintings at the Salon that were almost as dire. If you can imagine what

a particularly sanguinary little girl of eight, half-crazed with gin, would do to a whitewashed wall, if left alone with a box of crayons, then you will come near to fancying what most of this work was like. Or you might take a red-hot poker in your left hand, shut your eyes and etch a landscape upon a door. There were no limits to the audacity and the ugliness of the canvasses [*sic*]. Still-life sketches of round, round apples and yellow, yellow oranges, on square, square tables, seen in impossible perspective; landscapes of squirming trees, with blobs of virgin color gone wrong, fierce greens and coruscating yellows, violent purples, sickening reds and shuddering blues.

But the nudes! They looked like flayed Martians, like pathological charts—hideous old women, patched with gruesome hues, lopsided, with arms like the arms of a Swastika, sprawling on vivid backgrounds, or frozen stiffly upright, glaring through misshapen eyes, with noses or fingers missing. They defied anatomy, physiology, almost geometry itself! They could be likened only to the Lady of the Limerick:

> "There was a young girl of Lahore,
> The same shape behind as before;
> And as no one knew where
> To offer a chair,
> She had to sit down on the floor!"

But it's no use going on; you will, I am sure, refuse to take me seriously. You will merely think I am trying to be funny. Wherefore, I hired a man, a brave one, too, to photograph a few of these miracles. In line and composition the reproductions will bear me out, perhaps; but, unfortunately (or is it fortunately?), the savagery of color escapes the camera. That color is indescribable. You must believe that such artists as paint such pictures will dare any discord. They have robbed sunsets and rainbows, chopped them up into squares and circles, and hurled them, raw and bleeding, upon their canvases.

Surely, one cannot view such an exhibition calmly. One must inevitably take sides for or against such work. The revolt is too virulent, too frenzied to be ignored. Long ago my father said: "When you see a fool, don't laugh at him, but try to find out why he does so. You may learn something." And so I began to investigate these lunatics. Had they attempted to invent a new form of humor? Were they merely practical jokers? Or must we seriously attempt anew to solve the old question: "What is art?"

It was an affording quest, analyzing such madness as this. I had studied the gargoyles of Oxford and Notre Dame, I had mused over the art of the Niger and of Dahomey, I had gazed at Hindu monstrosities, Aztec mysteries and many other primitive grotesques; and it had come over me that there was a rationale of ugliness as there was a rationale of beauty; that, perhaps, one was but the negative of the other, an image reversed, which might have its own value and esoteric meaning. Men had painted and carved grim and obscene things when the world was young. Was this revival a sign of some second childhood of the race, or a true rebirth of art?

And so I sought to trace it back to its meaning and to its authors. I quested for the men who dared such Gargantuan jests. Though the school was new to me, it was already an old story in Paris. It had been a nine-days' wonder. Violent discussions had raged over it; it had taken its place as a revolt and held it, despite the fulmination of critics and the contempt of the academicians. The school was increasing in numbers, in importance. By many it was taken seriously. At first, the beginners had been called "The Invertebrates." In the Salon of 1905 they were named "The Incoherents." But by 1906, when they grew more perfervid, more audacious, more crazed with theories, they received their present appellation of "Les Fauves"—the Wild Beasts. And so, and so, a-hunting I would go!

Who were the beginners of the movement? Monet, Manet and Cézanne, say most, though their influence is now barely traceable. Cézanne, no doubt; Cézanne, the pathetic bourgeois painter, whose greatest ambition was to wear the ribbon of the Legion of Honor, and to have his pictures exhibited in the old Salon, and who, because his maiden sister disapproved of the use of female models, painted nude women from nude men! Truly, he deserved the red ribbon. But Cézanne, though he experimented with pure color, was still concerned with tonalities. He was but the point of departure for these mad explorers. It was Matisse who took the first step into the undiscovered land of the ugly.

Matisse himself, serious, plaintive, a conscientious experimenter, whose works are but studies in expression, who is concerned at present with but the working out of the theory of simplicity, denies all responsibility for the excesses of his unwelcome disciples. Poor, patient Matisse, breaking his way through this jungle of art, sees his followers go whooping off in vagrom paths to right and left. He hears his own speculative words distorted, misinterpreted, inciting innumerable vagaries. He may say, perhaps: "To my mind, the equilateral triangle is a symbol and manifestation of the absolute. If one could get that absolute quality into

2. Georges Braque, 1908. Photograph published in *The Architectural Record* (May 1910).

a painting, it would be a work of art." Whereat, little madcap Picasso, keen as a whip, spirited as a devil, mad as a hatter, runs to his studio and contrives a huge nude woman composed entirely of triangles, and presents it in triumph. What wonder Matisse shakes his head and does not smile! He chats thoughtfully of the "harmony of volume" and "architectural values," and wild Braque [fig. 2] climbs to his attic and builds an architectural monster which he names Woman, with balanced masses and parts, with openings and columnar legs and cornices. Matisse praises the direct appeal to instinct of the African wood images, and even sober Dérian [*sic*] [fig. 3], a co-experimenter, loses his head, moulds a neolithic man into a solid cube, creates a woman of spheres, stretches a cat out into a cylinder, and paints it red and yellow!

Maître Matisse, if I understand him, which, with my imperfect facility with French, and my slighter knowledge of art, I am afraid I didn't, quite, stands primarily for the solid existence of things. He paints weight, volume, roundness, color and all the intrinsic physical attributes of the

3. André Derain, 1908. Photograph published in *The Architectural Record* (May 1910).

thing itself, and then imbues the whole with sentiment. Oh, yes, his paint-
ings do have life! One can't deny that. They are not merely models posed
against a background, like thousands of canvases in the Salons, they are
human beings with souls. You turn from his pictures, which have so
shockingly defied you, and you demand of other artists at least as much
vitality and originality—and you don't find it! He paints with emotion,
and inspires you with it. But, alas! when he paints his wife with a broad
stripe of green down her nose, though it startlingly suggests her, it is his
punishment to have made her appear so to you always. He teaches you to
see her in a strange and terrible aspect. He has taught you her body. But,
fearful as it is, it is alive—awfully alive!

Painting so, in a burst of emotion, he usually comes to an end of his
enthusiasm before he has attained beauty. You point out the fact to him
that his painted woman has but three fingers. "Ah, that is true," he says;

"but I couldn't put in the other two without throwing the whole out of drawing—it would destroy the composition and the unity of my ideal. Perhaps, some day, I may be able to get what I want of sentiment, of emotional appeal, and, at the same time, draw all five fingers. But the subjective idea is what I am after now; the rest can wait."

Matisse, however, should not be classed amongst the Wild Beasts of this Parisian menagerie. But of him I learned something of the status of the movement, which is a revolt against the subtleties of Impressionism. It is a revolt against "mere charm," against accidental aspects of illumination; a return to simplicity, directness, pure color and decorative qualities.

Matisse, being as mild a man as ever tortured the human form or debauched a palette, what of these other Fauves, who had left him out of sight in the runaway from beauty? I picked out seven of the most ferocious and stalked them all over Paris. From Montmartre to Montparnasse I chased, from the stable on the ground floor to the attic on the sixth, through courts, down corridors, up interminable stairs worn to a spoon-like hollowness, in and out of Quartier and Faubourg. And what magnificent chaps I met! All young, all virile, all enthusiastic, all with abundant personality, and all a little mad. But all courteous and cordial, too, patient with my slow-witted attempts to make order out of intellectual chaos. And, after long dialogues on art, on ideals and new orders of beauty, in each studio was a new impossible outrage in color to confute their words. It was amazing in contrast. It was as if some fond mother, after a doting description of her first-born babe, should lift a cloth and show you a diseased, deformed child upon the point of death!

And so, first, to visit Braque [fig. 2], the originator of architectural nudes with square feet, as square as boxes, with right-angled shoulders. Braque's own shoulders were magnificent. He might be a typical American athlete, strong, muscular, handsome, as simple as a child and as modest as a girl of nine. To see him blush when I asked permission to photograph him—and then to turn to the monster on his easel, a female with a balloon-shaped stomach—oh, it was delicious to see big, burly Braque drop his eyes and blush!

It was in a court off the rue D'Orsel, up I don't know how many flights of stairs. No one could have been kinder than was Braque to the impertinent, ignorant foreigner. He gave me a sketch for his painting entitled "Woman" (*Grand Nu,* 1907–8) in the Salon des Indépendants. To portray every physical aspect of such a subject, he said, required three figures,

much as the representation of a house requires a plan, an elevation and a section. His chief preoccupation is the search for violence (he spars, too, does Braque), for a primitive emotion. He looks at Nature in order to possess it emotionally. In his sketch there is a "harmony of volume," which is a step further than any mere flat decorative effect. It is a spiritual sentiment. Now, gentle reader, look at his drawing! I had to keep my face straight.

"I couldn't portray a woman in all her natural loveliness," says Braque. "I haven't the skill. No one has. I must, therefore, create a new sort of beauty, the beauty that appears to me in terms of volume, of line, of mass, of weight, and through that beauty interpret my subjective impression. Nature is a mere pretext for a decorative composition, plus sentiment. It suggests emotion, and I translate that emotion into art. I want to expose the Absolute, and not merely the factitious woman."

Do you get it? It takes a bit of trying. Let's repeat the dose. Follow me, with Braque leading, to visit Dérain [sic], whom all consider the most intelligent and earnest of the Fauves, an experimenter like Matisse, seeking to find the way for the youngsters to travel.

Why, here's Dérain [sic] [fig. 3], now, across the street, with his model, a dead-white girl with black hair, dressed in purple and green, Dérain leaves her pouting, and we walk through a strange, crowded bourgeois neighborhood with Dérain, who is a tall, serious-looking young man, with kind brown eyes and a shrill blue tie. We plunge down a narrow lane-like passage, with casts amidst the shrubbery, into a big open studio, with a gallery at the end.

Look at his biggest picture, first, and have your breath taken away! He has been working two years on it. I could do it in two days. So could you, I'm sure. A group of squirmy bathers, some green and some flamingo pink, all, apparently, modeled out of dough, permeate a smoky, vague background. In front sprawls a burly African, eight feet long. Now notice his African carvings, horrid little black gods and horrid goddesses with conical breasts, deformed, hideous. Then, at Dérain's imitations of them in wood and plaster. Here's the cubical man himself, compressed into geometric proportions, his head between his legs. Beautiful! Dérain's own cat, elongated into a cylinder. Burned and painted wooden cabinets, statues with heads lolling on shoulders, arms anywhere but where they ought to be. A wild place, fit for dreams. But no place for mother.

Dérain, being a quiet man, doesn't care to talk, but he sits obediently for his photograph, holding the cylindrical cat in his arms, as I instruct

him. He shows us portfolios of experiments in pure color, geometrical arrangements such as you did yourself in the second grade of the grammar school, tile patterns, sausage rosettes, and such.

But who am I, to laugh at Dérain? Have I not wondered at the Gobelin designs, at the Tibetan goddess of destruction, and sought for occult meanings in the primitive figures of the Mound Builders? Let Dérain talk, if he will be persuaded. What has he learned from the Africans of the Niger? Why does he so affect ugly women?

"Why, what, after all, *is* a pretty woman?" Dérain answers, kindly. "It's a mere subjective impression—what you yourself think of her. That's what I paint, another kind of beauty of my own. There is often more psychic appeal in a so-called ugly woman than there is in a pretty one; and, in my ideal, I reconstruct her to bring that beauty forth in terms of line or volume. A homely woman may please by her grace, by her motion in dancing, for instance. So she may please me by her harmonies of volume. If I paint a girl in the sunlight, it's the sunlight I'm painting, not the real girl; and even for that I should have the sun itself on my palette. I don't care for an accidental effect of light and shade, a thing of 'mere charm.'

"The Japanese see things that way. They don't paint sunlight, they don't cast shadows that perplex one and falsify the true shape of things. The Egyptian figures have simplicity, dignity, directness, unity; they express emotion almost as if by a conventional formula, like writing itself, so direct it is. So I seek a logical method of rendering my idea. These Africans being primitive, uncomplex, uncultured, can express their thought by a direct appeal to the instinct. Their carvings are informed with emotion. So Nature gives me the material with which to construct a world of my own, governed not by literal limitations, but by instinct and sentiment."

Fine, fine—until one looks again at his paintings to get this appeal to sentiment. Then one is thrown back upon one's reason. Where is that subjective beauty that is his? In the cubical man? In the cylindrical cat? In the doughy bathers? But, as he is only an experimenter, the failure of the experiment does not prove the falsity of the principle involved. So much is already clear, though; these men are not attempting to transcribe the effect Nature makes upon the eye, as do the impressionists. It lies deeper than that.

And now for Picasso, of whom, here and there, one has heard so much. Picasso will not exhibit his paintings. He is too proud, too scornful of the opinions of the *canaille* [riffraff]. But he sells his work, nevertheless.

That's the astonishing thing about all of them. Who buys? God knows! Germans, I suppose.

It is the most picturesque spot in Paris, where the wide Rue de Ravignan drops down the hill of Montmartre, breaks into a cascade of stairs and spreads out into a small open space with trees. Picasso comes rolling out of a café, wiping his mouth, clad in a blue American sweater, a cap on his head, a smile on his face.

Picasso is a devil. I use the term in the most complimentary sense, for he's young, fresh, olive-skinned, black eyes and black hair, a Spanish type, with an exhuberant [sic], superfluous ounce of blood in him. I thought of a Yale sophomore who had been out stealing signs, and was on the point of expulsion. When, to this, I add that he is the only one of the crowd with a sense of humor, you will surely fall in love with him at first sight, as I did.

But his studio! If you turn your eyes away from the incredible jumble of junk and dust—from the bottles, rags, paints, palettes, sketches, clothes and food, from the pile of ashes in front of the stove, from the chairs and tables and couches littered with a pell-mell of rubbish and valuables— they alight upon pictures that raise your hair. Picasso is colossal in his audacity. Picasso is the double distilled ultimate. His canvases fairly reek with the insolence of youth; they outrage nature, tradition, decency. They are abominable. You ask him if he uses models, and he turns to you a dancing eye. "Where would I get them?" grins Picasso, as he winks at his ultramarine ogresses.

The terrible pictures loom through the chaos. Monstrous, monolithic women, creatures like Alaskan totem poles, hacked out of solid, brutal colors, frightful, appalling! How little Picasso, with his sense of humor, with his youth and deviltry, seems to glory in his crimes! How he lights up like a torch when he speaks of his work!

I doubt if Picasso ever finishes his paintings. The nightmares are too barbarous to last; to carry out such profanities would be impossible. So we gaze at his pyramidal women, his sub-African caricatures, figures with eyes askew, with contorted legs, and—things unmentionably worse, and patch together whatever idea we may…

Then Picasso, too, talks of values and volumes, of the subjective and of the sentiment of emotion and instinct. *Et pat-à-tie et-pat-à-ta,* as the French say. But he's too fascinating as a man to make one want to take him only as an artist. Is he mad, or the rarest of *blaguers* [sic] [jokers]?

Let others consider his murderous canvases in earnest—I want only to see Picasso grin! Where has he found his ogrillions? Not even in the waters under the earth…Picasso gets drunk on vermillion and cadmium. Absinthe can't tear hard enough to rouse such phantasmagoria! Only the very joy of life could revel in such brutalities.

But, if Picasso is, in life and art, a devil, he at least has brains, and could at one time draw. Not so, I fear, poor Czobel, a young Hungarian, almost a Hun, that is, what's not Vandal in him. He hasn't yet succeeded in getting himself talked about, but he did his worst to achieve infamy at the Salon des Indépendants this year. He even sacrificed himself in the attempt, painting his own portrait for the enemy to howl at. And Czobel isn't bad-looking, either. He has Picasso's verve and courage tamed into a sort of harmless idiocy. As I waited for him, at the very end of the Cité Falguière, on the bridge that connects a row of studios built like primeval lake dwellings above the level of the gutter, he appeared, bearing a bunch of hyacinths. What a country, where such incarnate fiends on canvas appear, flower-bedecked, to welcome intrusions! I expected at least a vivisectionist, feeding on fried babies.

Czobel's studio was just behind Picasso's in the race for disorder. But, then, Czobel has to work and cook and sleep and hang his clothes and entertain his friends in his one room. Let's scrape the yellow ochre off a chair, wipe it with his shirt, and sit down, while Czobel nervously folds and refolds the black silk handkerchief about his neck, smilingly explaining that he cannot possibly explain. He is painfully inarticulate; he struggles like a dumb beast to express himself, then boils over into German.

In the center of the room is a revolting picture of a woman. Did I say a woman? Let us, in decency, call it a female. Czobel, no doubt, like Braque, would prefer to call it Woman. She is naked and unashamed, if one can judge by her two large eyes. Others of her ilk lie about. As a rule, they are aged 89. They have very purple complexions, enlivened with mustard-colored spots and yolk-yellow throats; they have orange and blue arms. Sometimes, not often, they wear bright green skirts.

Czobel himself has a green throat, but it's only the reflection of his green canvas coat. Back to the plough, poor little Czobel, say I in English, and Czobel sweetly smiles.

But there was one picture I really wanted to buy. It satisfied some shameful, unnamed desire in my breast. It was called *Le Moulin de la Galette,* and is supposed (by Czobel) to represent that lively ball on

a gala night. I had been there myself, but I saw no Aztec children waltzing; I saw no ladies with eyes like gashes cut with a carving knife. All the figures were outlined with a thick line of color. His men were apparently all brothers—to the ape. But let us not take poor Czobel too seriously. Not even Les Fauves do that.

But Friesz is a man we must take seriously, for Friesz is a serious person, and, if he would, could paint. He is a tall, straight blonde, looking like a musician, with clear-cut features, waving hair and an air of gentlemanly prosperity. He is dressed sprucely, except for his rubber overshoes, evidences of the chill, watery Parisian spring. Very gentle, almost winsome. He has huge portfolios of reproductions of Cézanne's pictures, he has many of his own drawings, neatly mounted. He has the work of other painters framed upon his walls. It is evident that he is well-to-do.

His studio is long and wide and high, with ecclesiastical-looking Gothic doors, and out of it another room with many beautiful things. Amongst them, of course, are African-carved gods and devils of sorts. Since Matisse pointed out their "volumes" all the Fauves have been ransacking the curio shops for African art. But Friesz has a quaint taste of his own, for, hung across the window panes, like transparencies, are funny old magic-lantern slides, "hand-painted," made in Germany. They might be examples of Matisse's later manner. Friesz is not only exquisitely courteous, he has a mind. He speaks well. Listen. We must not call it any longer a school of Wild Beasts.

"It is a Neo-Classical movement, tending towards the architectural style of Egyptian art, or paralleling it, rather, in development. The modern French Impressionism is decadent. In its reaction against the frigidity and insipid arrangements of the Renaissance, it has gone itself to an extreme as bad, and contents itself with fugitive impressions and premature expressions. This newer movement is an attempt to return to simplicity, but not necessarily a return to any primitive art. It is the beginning of a new art. There is a growing feeling for decorative values. It seeks to express this with a certain 'style' of line and volume, with pure color, rather than by tones subtly graded; by contrasts, rather than by modulations; by simple lines and shapes, rather than by complex forms."

We're getting nearer, now, though still the theory is apparently inconsistent with the practice. Friesz is the nearest to Cézanne; he's not yet quite clear of tonality. He has only just begun to go wrong. But let's drop in on Herbin, who paints still life and cafés. He's near at hand.

Barely around the corner, it's true, but what a contrast to Friesz's elegance and aristocratic surroundings! Herbin lives in a garret higher than Braque's, smaller than Czobel's, but as sweet and neat and clean as an old maid's bedroom. It is, in fact, bedroom as well as studio. A rose-colored hanging conceals his couch. There's but one small window, a skylight in the roof, but the place is pleasant with pots of flowers. A shelf is filled with bright-colored vases. A Chinese slipper holds a bunch of fresh green leaves. But the mark of the Wild Beast is over all the room, for Herbin's own pictures are hung there, and the wall is gaudy with palette scrapings. I back into them and have a green smooch forever afterwards to remember Herbin by.

Herbin is almost sad. Not that, quite, though; not even quite melancholy, though he is poor and a hermit. He has no friends, and wants none, this small-featured, bright-eyed poet-person, with longish hair and sparse beard, immaculately clean in his dress, scrupulously polite in his hospitality. It seems unfair to describe him, for his aloofness was noble, yet I must draw my picture of life, as he draws his. He sees nobody, never goes to the cafés, is interested in nothing but himself and his work, and a good book or two. There was a completeness about his attitude that forbade pathos.

Nor can Herbin say much of the "movement," if it is a movement. To his mind, it is individualism, and every man works but for himself. He paints for his own satisfaction, at any rate, and the world may go hang. He paints the roundness and heaviness and curliness and plastic qualities of still life; he paints the thing-in-itself. He does not feel the necessity of drawing every twig on a tree, nor yet to present the mere appeal to the eye. Therefore, draw a curved line connecting all the points on the top of a tree, and you have a simple expression of Nature as it appeals to him.

"I don't distort Nature," he says; "I sacrifice it to a higher form of beauty and of decorative unity." And so we leave Herbin, who should be in the green fields, and not cramped under his scant skylight, and go away not quite knowing whether to envy or pity him.

So, finally, to Metzinger's abode. Now, Metzinger himself, like Friesz, has gone through the impressionistic stage; so he should know about this new idea. It is not as if he never were tame. He once painted that "mere charm," of which, it would seem, we are all overfed. Metzinger once did gorgeous mosaics of pure pigment, each little square of color not quite touching the next, so that an effect of vibrant light should

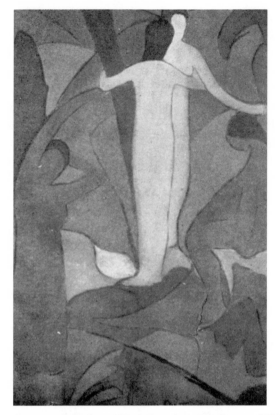

4. Jean Metzinger, *Baigneuses* (*Bathers*), ca. 1908–9. Illustration in Gelett Burgess, "Wild Men of Paris," *The Architectural Record* (May 1910) [document 3]. Location unknown. © Artists Rights Society (ARS), New York / ADAGP, Paris.

result. He painted exquisite compositions of cloud and cliff and sea; he painted women and made them fair, even as the women upon the boulevards are fair. But now, translated into the idiom of subjective beauty, into this strange Neo-Classic language, those same women, redrawn, appear in stiff, crude, nervous lines in patches of fierce color [fig. 4]. Surely, Metzinger should know what such things mean. Picasso never painted a pretty woman, though we have noticed that he likes to associate with them. Czobel sees them through the bars of his cage, and roars out tones of mauve and cinnabar. Dérain sees them as cones and prisms, and Braque as if they had been sawn out of blocks of wood by carpenters' apprentices. But Metzinger is more tender towards the sex. He arranges them as flowers are arranged on tapestry and wall paper; he simplifies

them to mere patterns, and he carries them gently past the frontier of Poster Land to the World of the Ugly so tenderly that they are not much damaged—only more faint, more vegetable, more anaemic.

What's Metzinger? A scrupulously polite, well-dressed gentleman as ever was, in a scrupulously neat chamber, with a scrupulously well-ordered mind. He is as complete as a wax figure, with long brown eye-lashes and a clean-cut face. He affects no idiosyncrasies of manners or dress. One cannot question his earnestness and seriousness or sincerity. He is, perhaps, the most articulate of them all. Let us not call him prim.

"Instead of copying Nature," he says, "we create a *milieu* of our own, wherein our sentiment can work itself out through a juxtaposition of colors. It is hard to explain it, but it may perhaps be illustrated by analogy with literature and music. Your own Edgar Poe (he pronounced it 'Ed Carpoe') did not attempt to reproduce Nature realistically. Some phase of life suggested an emotion, as that of horror in 'The Fall of the House of Ushur [*sic*].' That subjective idea he translated into art. He made a composition of it."

"So, music does not attempt to imitate Nature's sounds, but it does interpret and embody emotions awakened by Nature through a convention of its own, in a way to be aesthetically pleasing. In some such way, we, taking our hint from Nature, construct decoratively pleasing harmonies and symphonies of color expression of our sentiment."

I think that there I got nearest to it. Let's regard their art as we regard Debusy's [*sic*] music, and Les Fauves are not so mad, after all; they are only inexperienced with their method. I had proved, at least, that they were not charlatans. They are in earnest and do stand for a serious revolt. Now, a revolt not only starts an action, but a reaction, and these Wild Beasts may yet influence the more conventional schools. Whether right or wrong, there is, moreover, something so virile, so ecstatic about their work that it justifies Nietzsche's definition of an ascendant or renascent art. For it is the product of an overplus of life and energy, not of the degeneracy of stagnant emotions. It is an attempt at expression, rather than satisfaction; it is alive and kicking, not a dead thing, frozen into a convention. And, as such, it challenges the academicians to show a similar fervor, an equal vitality. It sets one thinking; and anything that does that surely has its place in civilization.

Men must experiment in art and in life. Some may wander east or westward from the beaten track, some reactionaries may even go back

southward along the trail of the past. But a few push north, ahead of the rest, blazing out the way of progress for the race. Perhaps these Wild Beasts are really the precursors of a Renaissance, beating down a way for us through the wilderness.

But there's the contrast between their talk and their work! It doesn't quite convince me yet. But, then, I'm not a painter, and perhaps none but a painter can understand. There's my clue! And so, as a last resort, as the best way, too, I've bought a color box and brushes. I am going to try it out practically on canvas. That's the only test. I'm going to be a Wild Beast myself! For, mind you, they do sell their paintings, and I may sell mine. Who knows!

Gelett Burgess

Commentary

Best remembered as a humorist, Gelett Burgess also maintained an equivocal interest in the European and American avant-garde, as is evident from the tone of his seminal text, "The Wild Men of Paris." Having earned a degree from MIT in 1887, Burgess first became a draftsman and teacher of topological drawing before turning to more literary pursuits around the turn of the century. Aside from coediting a number of "little" magazines, he gained widespread fame as the author of a series of whimsical children's books known as The Goop Books. Arriving in Paris in early 1908, Burgess attended the Salon des indépendants, and it was the shock of this encounter that likely prompted his decision to interview contemporary artists (Fry; Henderson, 183). Over the spring and summer Burgess visited the studios of Matisse, Braque, Derain, Picasso, Bela Czobel, Othon Friez, Auguste Herbin, Auguste Chabaud, and Metzinger, recording some of their thoughts on modernism and commissioning photographs of them and their work, while also remaining complacently contemptuous of their efforts until the journalistic surprise conclusion. The result was an invaluable record of the Parisian avant-garde in 1908, and when Burgess published his findings in May 1910, his article had an immediate impact on American modernists associated with Alfred Stieglitz and his gallery "291." Linda Henderson has documented Burgess's keen interest in theories of the fourth dimension, speculating that the humorist may have provided the Stieglitz circle with "basic information" on the concept—although he seemed unfamiliar with American cubist Max Weber's contemporaneous pronouncements

on the theme and unaware of the impact of such ideas on Metzinger (M. Weber; Henderson, 182–86).

Burgess declares his subjects to be modern-day "Fauves" who hoped to express so-called elemental emotions by studying "the art of Niger and Dahomey," "Hindu monstrosities," "Aztec mysteries and many other primitive grotesques." His text is replete with primitivist tropes (both affirmative and negative), and his views were reinforced by the artists themselves, most notably Derain (M. Antliff and Leighten, 24–30). Despite his satirical tone Burgess was truly impressed by Metzinger's symbolist-oriented pronouncements and quoted the artist at length:

> Instead of copying Nature…we create a *milieu* of our own, wherein our sentiment can work itself out through a juxtaposition of colors…. It may perhaps be illustrated by analogy with literature and music….So, music does not attempt to imitate Nature's sounds, but it does interpret and embody emotions awakened by Nature through a convention of its own….In some such way, we, taking our hint from Nature, construct decoratively pleasing harmonies and symphonies of color expression of our sentiment.

Metzinger's aesthetic views are surprisingly similar to the more well-known statement of Braque, who told Burgess that "Nature is a mere pretext for a decorative composition, plus sentiment." Of the paintings reproduced in the article, Metzinger's is clearly indebted to the Nabis ("Prophets"), especially the early work of Maurice Denis and Paul Elie Ranson, while Braque's registers the impact of African art on his "primitivist" aesthetic; yet both artists employ symbolist tropes to describe their work. In response Burgess instructs us to "regard their art as we regard Debussy's music," concluding that from this perspective "Les Fauves are not so mad, after all; they are only inexperienced with their method." In the article's final paragraph Burgess states that he is now prepared to "try out" such experiments himself, which may have inspired Stieglitz to hold an exhibition of Burgess's "symbolist" watercolors at "291," between 27 November and 8 December 1911 (Burgess; Henderson, 185).

M. Antliff and Leighten, *Cubism and Culture*
Burgess, "Essays in Subjective Symbolism"
Fry, "Cubism 1907–1908"
Henderson, *The Fourth Dimension and Non-Euclidean Geometry in Modern Art*
M. Weber, "The Fourth Dimension from a Plastic Point of View"

DOCUMENT **4.**

Guillaume Apollinaire, "Georges Braque," preface, Exposition Georges Braque, 9–28 November 1908, Galerie Kahnweiler, 28, rue Vignon, Paris

Only a short time ago, the efforts a certain number of artists were engaged in to transform the plastic arts were the object of ridicule not only from the public but also from the critical establishment as a whole. Today, the jokes have stopped; no one would dare ridicule these admirable endeavors any longer, without at the same time disparaging order and harmony, grace and proportion, qualities without which there is no art but only a furious storm of diverse temperaments, more or less noble, trying to express feverishly, hastily, unreasonably, their astonishment in the face of nature. By the latter traits we recognize impressionism. The name was well chosen: here were men truly "impressed" by the sky, the trees, by life, and by light. It was the amazement of night birds at the break of day, the panic of primitive men, of savages terrified by the brightness of a star, by the majesty of an element. Neither savages nor primitive men, however, ever took it upon themselves to see an immediately artistic emotion in their terror. Sensing that such emotion lay above all within the realm of the religious passions, they cultivated it, measured it, applied it, then erected their gigantic monuments, deducing the style of their decorations and, like God himself, creating the expressive images of their conceptions by comparison. In any case, impressionism was only a meagerly and exclusively religious moment of the plastic arts. Apart from a few magnificently gifted and self-assured masters, there were a host of zealots and neophytes, demonstrating through their paintings that they worshiped the light, that they were in direct communication with it, and proving it by not mixing colors, which they had only to spread on the canvas to become a painter, just as one becomes a Christian through baptism, without the consent of the baptized being required. And, to achieve mastery,

they had only to lack taste. I am not referring to those who, at whatever age, have styled themselves painters without prior study, in the pursuit of lucre or because it was easy to impress in an art ruled by chance. Ignorance and frenzy were truly the characteristics of impressionism. And when I say ignorance I mean an absolute lack of culture in most cases; since, as far as science is concerned, they put in a little everywhere, without rhyme or reason. They laid claim to it; Epicurus himself was at the foundation of the system and the theories of the physicists of the time demonstrated the merits of the most wretched improvisations.

But that time is past. Those absurd pictorial experiments have already joined the masterpieces and miserable pieces that are piled up pell-mell in the museums. There is now room for a more noble, more moderate, better ordered, more cultivated art. The future will tell what influence certain magnificent examples had on that evolution: the example of Cézanne, of Picasso's solitary and furious labor, and the unexpected encounter between Matisse and Derain, preceded by that between Derain and de Vlaminck. Success has already rewarded Picasso, Matisse, Derain, de Vlaminck, Friesz, Marquet, and van Dongen. It will also have to honor the labors of Marie Laurencin and Georges Braque, must allow Vallotton's purity to appear, must award a master such as Odilon Redon the place he deserves. And I have no doubt that the task I assign to time will be accomplished by it.

Take Georges Braque. He leads an admirable life. He strives passionately toward beauty and achieves it, as if effortlessly.

His compositions have the expected harmony and fullness. His decorations bear witness to a taste and a culture guaranteed by his instinct [fig. 5].

Drawing from within himself the elements of the synthetic motifs he represents, he has become a creator.

He no longer owes anything to the things around him. His mind deliberately produced the twilight of reality, and now a universal renaissance is working itself out plastically, within himself and outside himself.

He expresses a beauty full of tenderness, and the mother-of-pearl of his paintings turns our understanding iridescent.

A lyricism of color, examples of which are only too rare, fills him with a harmonious enthusiasm, and it is Saint Cecilia herself who makes his instruments sound.

In his glens, the bees of everyone's youth buzz and gather pollen, and the joy of innocence pines on his civilized terraces.

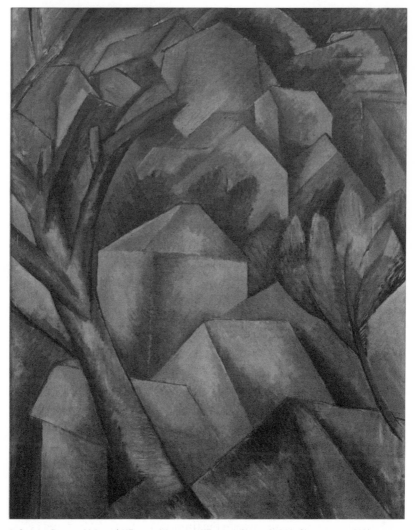

5. Georges Braque, *Maisons à L'Estaque* (*Houses at L'Estaque*), [August] 1908. Oil on canvas, 28¾ × 23½" (73 × 60 cm). Hermann and Margrit Rupf Foundation, Kunstmuseum, Bern. © Artists Rights Society (ARS), New York / ADAGP, Paris. Photograph Bridgeman-Giraudon / Art Resource, NY.

This painter is angelic. Purer than other men, he does not concern himself with anything outside his art that might suddenly make him fall from the paradise he inhabits.

Do not come looking here for the mysticism of the devout, the psychology of writers of literature, or the demonstrative logic of scientists! This painter composes his pictures in accord with his absolute concern for

full novelty, for full truth. And if he relies on human means, on earthly methods, it is only to ensure the reality of his lyricism. His canvases have the unity that makes them necessary.

For the painter, the poet, the artist (this is what differentiates them from other men, and especially from scientists), every work becomes a new universe with its own particular laws.

Georges Braque never rests, and each of his pictures is the monument of an effort that no one before him had attempted.

Guillaume Apollinaire
9–28 NOVEMBER 1908

Commentary

Daniel-Henry Kahnweiler (1884–1979) was a seminal figure in the avant-guerre rise of the private gallery system that would eventually overtake the state-sanctioned salons in importance (Gee). The son of German Jewish parents, Kahnweiler was sent to Paris in 1902; there he nurtured a lifelong interest in leftist politics, participating in a number of Socialist-led demonstrations in 1903–4 related to the infamous Dreyfus Affair. As early as 1903 he began frequenting avant-garde venues, including Lugné-Poë's Théâtre de l'Oeuvre and the Salon d'Automne. In 1907 Kahnweiler announced his intention to become a picture dealer: with familial support he was able to open a tiny gallery (4 × 4 meters) on 22 February 1907 on the rue Vignon near the Madeleine in Paris. His modest stipend allowed him to exhibit and collect the art of the still marginal fauves, including Picasso's neighbor and close friend Kees van Dongen (1877–1968) (Bozo et al., 93–100). Thus Kahnweiler took his place among the newly emerging *dénicheurs,* or "bargain hunters," such as André Level, Wilhelm Uhde, Leo Stein, and Berthe Weill, all of whom purchased emerging artists on a speculative basis (Cottington; FitzGerald; Jensen; Perry, 87–93). In the spring or summer of 1907 fellow art dealer Uhde (who had already purchased Braque's work) suggested Kahnweiler visit the Bateau Lavoir at 13, rue Ravignon, where he saw Picasso's *Les Demoiselles d'Avignon* (1907).

Just when Kahnweiler began collecting Braque's art is still nebulous: he remembered purchasing Braque's work either in the spring or summer of 1907. Between that summer and November 1908, Braque's art had undergone a radical change from neoimpressionist-inspired fauve painting to an austere style indebted to that of Paul Cézanne (whose retrospective

Braque had seen at the Salon d'Automne of 1907) and to the primitivism of Picasso (whom he had first met sometime in March–April, 1907). In an October 1907 article published in *Je Dis Tout,* Guillaume Apollinaire expressed regret that the majority of Braque's work had been refused for the Salon d'Automne of 1907; in late November or early December of the same year the poet-critic accompanied Braque to Picasso's studio, where they saw the *Demoiselles* and Picasso's developing *Three Women* (1907–8). Over the following months the interaction of these three figures intensified, which led Kahnweiler and Braque to enlist Apollinaire to write the preface to Braque's exhibition at Kahnweiler's gallery in November 1908 (Cousins, 340–57).

Braque's l'Estaque paintings provoked artists and critics to employ new terminology in an attempt to describe his latest aesthetic innovations (fig. 5). Matisse had reportedly begun to speak of "cubes" in response to viewing Braque's l'Estaque submissions for that year's Salon d'Automne (Cousins, 355), while the critic Louis Vauxcelles referred to "cubes" in his 14 November 1908 review of Braque's exhibition, but neither spoke of "cubism" (see document 5). The term *cube* had been previously used to describe the neoimpressionist technique of Henri-Edmond Cross and of Jean Metzinger—in 1901 by Jean Béral, with reference to Cross, and in 1906 by Louis Chassevent, comparing Metzinger to Paul Signac (Herbert, 220–27)—but Braque's volumetric forms and muted palette broke with his own previous allegiance to neoimpressionism and fauvism (Herbert, 220–21). Apollinaire's preface clearly acknowledges the by then widespread revolt against what was perceived to be the pedantically "scientific" basis of neoimpressionism, in favor of an art influenced by Cézanne and the primitivism of Henri Matisse, André Derain, and Picasso. Apollinaire describes Braque's l'Estaque paintings as "decorations," expressive of his "absolute concern for full novelty, for full truth." This characterization links Braque's work to the concept of the "decorative landscape" developed by Braque's mentor Matisse (Benjamin), as well as symbolist notions of artistic autonomy, which Braque would elucidate in an interview with Gelett Burgess in April or May of 1908 (M. Antliff and Leighten, 24–63) (see document 3).

M. Antliff and Leighten, *Cubism and Culture*
Benjamin, "The Decorative Landscape, Fauvism, and the Arabesque of Observation"
Bozo et al., *Daniel-Henry Kahnweiler*
Cottington, *Cubism in the Shadow of War*

Cousins, "Documentary Chronology"
FitzGerald, "Skin Games"
Gee, *Dealers, Critics and Collectors of Modern Painting*
Herbert, *Neo-Impressionism*
Jensen, *Marketing Modernism in Fin-de-Siècle Europe*
Perry, *Women Artists and the Parisian Avant-Garde*

Louis Vauxcelles, "Exposition Braque. Chez Kahnweiler, 28 rue Vignon," *Gil Blas,* 14 November 1908

Braque Exhibition. At Kahnweiler's, 28 rue Vignon

Kahnweiler's, 28, rue Vignon. Mr. Braque is a very audacious young man. The disconcerting example of Picasso and Derain has emboldened him. Then too, perhaps the style of Cézanne and the reminiscences of the static art of the Egyptians obsess him unduly. He constructs deformed men of metal, terribly simplified. He has contempt for form, reduces everything— places and figures and houses—to geometrical patterns, to cubes [fig. 5]. Let us not make fun of him, since he is sincere. And let us wait.

Louis Vauxcelles

14 NOVEMBER 1908

Commentary

Having coined the phrase "Donatello among the wild beasts [*les fauves*]" to describe the art of Matisse, Derain, Maurice de Vlaminck, and their colleagues at the 1905 Salon d'Automne (*Gil Blas,* 7 October 1905), the critic Louis Vauxcelles (1870–1943) is commonly credited with inaugurating the cubist movement with his published usage of the word *cubes* to refer to Braque's 1908 pictures of l'Estaque (Fry, 51). In fact recent scholarship has revised this claim by distinguishing between the descriptive function of Vauxcelles' term *cubes* and later uses of pejorative appellations like *cubist* or *cubism* to describe an artistic movement or group (Weiss, 56–59). Vauxcelles describes Braque as a primitivist, whose art recalls "the style of Cézanne," but also "the static art of the Egyptians." Although this hybrid aesthetic leads Braque to reduce nature "to geometrical patterns, to cubes," Vauxcelles admonishes critics "not to make fun of him" but to be patient, for Braque, we are told, "is sincere." One of the earliest references to *cubists* and *cubism* in the pejorative sense occurred on the

front page of the 24 March 1909 issue of *Le Figaro*, where "cubists" figured alongside the "symbolists," "impressionists," and "pointillists" to be seen at the forthcoming Salon des Indépendants. In his review of the Independents exhibition in an issue of *Mercure de France* (16 April 1909), the critic Charles Morice (1861–1919) referred to Braque's "ill-considered" reliance on Cézanne as "cubist," while Vauxcelles first used the term in September 1909 in a sarcastic reference to "a school of peruvian cubists!" at the Salon d'Automne (Martin; Weiss, 56–57; Vauxcelles).

As Jeffrey Weiss notes, the terms *cubist* and *cubism* were in active circulation before any real school or formalized movement existed, and their usage signified "the perceived perpetration of stylistic excess" and the hubristic "folly of merely another school" (Weiss, 56–57). Weiss therefore endorses Gleizes's view that *cubism* only came to signify a self-conscious group effort in the final months of 1910, when artists and poets came together for regular meetings at Le Fauconnier's studio and for Paul Fort's weekly gatherings at the café Closerie des Lilas, in Montparnasse (Gleizes, 12–16; Vauxcelles; Weiss, 57). Braque's and Picasso's perceived role as initiators of the public movement was therefore established retrospectively by critics and artists seeking to overturn the public's identification of *cubism* solely with its practitioners on display at the 1911 Salon des Indépendants: Robert Delaunay, Gleizes, Le Fauconnier, Fernand Léger, and Metzinger. For his part, Apollinaire takes credit for "accepting" the term *cubism* in *Les peintres cubistes*: "The first manifestation of the cubists abroad took place in Brussels the same year [1911] and, in the preface to that exhibit, I agreed, in the names of the exhibitors, to the designations *cubism* and *cubists*" (see document 62).

Fry, *Cubism*
Gleizes, *Cahiers Albert Gleizes*
A. Martin, "Georges Braque and the Origins of the Language of Synthetic Cubism"
Vauxcelles, "Le Salon d'Automne"
Weiss, *The Popular Culture of Modern Art*

Gertrude Stein, "Picasso" (1909), *Camera Work* ([New York,] August 1912): 29–30

One whom some were certainly following was one who was completely charming. One whom some were certainly following was one who was charming. One whom some were following was one who was completely charming. One whom some were following was one who was certainly completely charming.

Some were certainly following and were certain that the one they were then following was one working and was one bringing out of himself then something. Some were certainly following and were certain that the one they were then following was one bringing out of himself then something that was coming to be a heavy thing, a solid thing and a complete thing.

One whom some were certainly following was one working and certainly was one bringing something out of himself then and was one who had been all his living had been one having something coming out of him.

Something had been coming out of him, certainly it had been coming out of him, certainly it was something, certainly it had been coming out of him and it had meaning, a charming meaning, a solid meaning, a struggling meaning, a clear meaning.

One whom some were certainly following and some were certainly following him, one whom some were certainly following was one certainly working.

One whom some were certainly following was one having something coming out of him something having meaning and this one was certainly working then.

This one was working and something was coming then, something was coming out of this one then. This one was one and always there was something coming out of this one and always there had been something

coming out of this one. This one had never been one not having something coming out of this one. This one was one having something coming out of this one. This one had been one whom some were following. This one was one whom some were following. This one was being one whom some were following. This one was one who was working.

This one was one who was working. This one was one being one having something being coming out of him. This one was one going on having something come out of him. This one was one going on working. This one was one whom some were following. This one was one who was working.

This one always had something being coming out of this one. This one was working. This one always had been working. This one was always having something that was coming out of this one that was a solid thing, a charming thing, a lovely thing, a perplexing thing, a disconcerting thing, a simple thing, a clear thing, a complicated thing, an interesting thing, a disturbing thing, a repellent thing, a very pretty thing. This one was one certainly being one having something coming out of him. This one was one whom some were following. This one was one who was working.

This one was one who was working and certainly this one was needing to be working so as to be one being working. This one was one having something coming out of him. This one would be one all his living having something coming out of him. This one was working and then this one was working and this one was needing to be working, not to be one having something coming out of him something having meaning, but was needing to be working so as to be one working.

This one was certainly working and working was something this one was certain this one would be doing and this one was doing that thing, this one was working. This one was not one completely working. This one was not ever completely working. This one certainly was not completely working.

This one was one having always something being coming out of him, something having completely a real meaning. This one was one whom some were following. This one was one who was working. This one was one who was working and he was one needing this thing needing to be working so as to be one having some way of being one having some way of working. This one was one who was working. This one was one having something come out of him something having meaning. This one was one always having something come out of him and this thing the thing

coming out of him always had real meaning. This one was one who was working. This one was one who was almost always working. This one was not one completely working. This one was one not ever completely working. This one was not one working to have anything come out of him. This one did have something having meaning that did come out of him. He always did have something come out of him. He was working, he was not ever completely working. He did have some following. They were always following him. Some were certainly following him. He was one who was working. He was one having something coming out of him something having meaning. He was not ever completely working.

Commentary

The importance of Gertrude Stein (1874–1946; fig. 6) for the development of cubism, and particularly for Picasso's art, remains a matter for debate (Richardson, Lubar, Clark, M. Antliff and Leighten, Bilski and Braun), but no one questions the closeness of Picasso and Stein in this period. We know concretely that Picasso and Braque were exposed to the philosophy of both Henri Bergson and William James through their relations with Stein, who collected Picasso's work and whose portrait he painted in 1906. Gertrude Stein played an enormously important role in the development of modernism in American literature, and the indebtedness of her own writing to the process philosophy of William James is undisputed. Before her arrival in Paris, she had taken courses with James at Radcliffe College in Boston, and in his memoirs her brother Leo recalls that James's theories were the subject of debate at the Steins' Saturday evenings, frequently attended by the two artists. Indeed her own unconventional life and outsider status as a Jewish expatriate living in Paris proved attractive to the marginal coterie of foreign artists and literary bohemians who attended her salon (Bilski and Braun, 113–25). She was later an equally strong supporter of another expatriate, Juan Gris.

James's *Principles of Psychology* posited a dualism within human nature premised on a tendency toward "indiscriminate" absorption of sensory data and the limitation of that sensory intake through "selective attention." This selective attention serves utilitarian ends, leading us to value the fixed and unchanging, since selectivity facilitated our ability to abstract stable concepts and images from the dynamic and unending flux of phenomena entering the "stream of consciousness." Like Bergson, James declared rationalism a mode of utilitarian thinking, which could

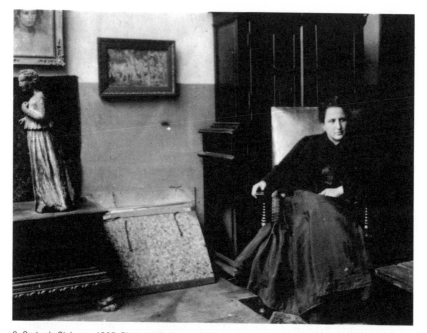

6. Gertrude Stein, ca. 1905. Photograph. Gertrude Stein and Alice B. Toklas Papers, Yale Collection of American Literature, Beinecke Rare Book and Manuscript Library, Yale University Library. Used by permission of the Estate of Gertrude Stein.

lead to overvaluing "extracts from the temporal flux" as superior to the stream from which they were derived. Both James in *Principles of Psychology* (1890) and Bergson in *Time and Free Will* (1889) singled out language as an instance of such abstraction. Bergson drew comparison between words and mathematical symbols. As impersonalized representations of the self, words are convenient counters adapted to social discourse; yet from the standpoint of the personality experiencing an emotion, they are impoverished, generalized symbols. James and Bergson thought intuition potentially allowed one to transcend such fixed concepts and generalized symbols to give form to "durational processes," including the temporal flux of our individual thoughts and feelings in all their freshness and novelty.

Stein aimed to capture this durational experience by turning language against itself in order to immerse the reader in stream of consciousness. As the literary historian Lisa Ruddick has demonstrated, Stein's prewar technique rejected selective attention in favor of a perceptual disinterestedness, or disintegration of focus, needed to grasp the stream

of consciousness (Ruddick, "'Melanctha' and the Psychology of William James" and "William James and the Modernism of Gertrude Stein"). This absence of focus refused narrative structure or dramatic highlights; instead her writings treat objects, events, and personages in a value-neutral, undifferentiated fashion. Stein herself claimed that her literary technique was inspired in part by the art of Cézanne, for he "conceived the idea that in composition one thing was as important as another thing. Each part is as important as the whole, and that impressed me enormously" (cited in Ruddick, "William James and the Modernism of Gertrude Stein," 53).

This lack of focal differentiation was augmented in Stein's prose by a deliberate stress on ambiguity rather than clarity. No sequential train of discrete thoughts appears in Stein's writing; rather she presents a complex intermingling of thoughts and ideas that dissolve into each other to form an unbroken, rhythmic stream. The literary historian Steven Meyer has analyzed Stein's application of this technique in her 1909 prose portrait of Picasso. In this literary portrait her lines appear to be identical, but on close inspection each overlaps or invades the next, conveying both mental continuity and diversity; their permeability and intricate mutation capture processes of thought. The opening lines of her portrait of Picasso perfectly convey this process. The second and third sentences are nearly identical to the first, but for the absence of the adverb *completely* in the second and of *certainly* in the third. Ironically, Stein uses the adverbial forms of *completeness* and *certainty* to suggest partiality and uncertainty. To arrive at a definitive statement, in the Jamesian mode, would be to fix the stream of consciousness by suspending discussion; Stein by contrast wishes to unfold her assessment of Picasso—and to view his art—as a series of unending permutations. In her own modernist approach to language, she both attempts to evoke Picasso's radical art and makes an influential and very one-sided argument about his centrality in the movement. In like fashion Stein's literary method may have proved inspirational for her favorite artist: for instance, Picasso's *Still-Life 'Au Bon Marché'* (1913; fig. 46) may take its title from Stein's prose portrait "Flirting at the Bon Marché" (1908), while the collage's lascivious pun on the French "Trou" echoes Stein's contemporaneous portrait *Americans* (1913), with its punning refrain "B r., brute says. A hole, a hole is a true, a true, a true" (Steiner, 81–82 and 98; Bilski and Braun, 117–23).

M. Antliff and Leighten, *Cubism and Culture*
Bilski and Braun, *Jewish Women and Their Salons*

Clark, *Farewell to an Idea*
Cox, *Cubism*
Four Americans in Paris
Lubar, "Unmasking Pablo's Gertrude"
Meyer, "Writing Psychology Over: Gertrude Stein and William James"
Richardson, *A Life of Picasso,* vol. 2
Ruddick, " 'Melanctha' and the Psychology of William James"
Ruddick, "William James and the Modernism of Gertrude Stein"
L. Stein, *Appreciation*
Steiner, *Exact Resemblance to Exact Resemblance*

Elie Faure, "Préface," Exposition de peinture moderne
(Société de peinture moderne), Salle Boüldieu, Rouen,
20 December 1909–20 January 1910, pp. 1–2

Preface, Exhibition of Modern Painting (Society of Modern Painting)

It would be surprising if the majority of visitors to an exhibition of modern art, especially one organized outside the framework of any coterie and with no official character, did not manifest from the outset feelings of uneasiness, and even of indignation. Up to now, the lessons in art dispensed in childhood have consisted of a perversion of the judgment. And the grown man supposes that it is useless to undertake the education of his eye, convinced that, to appreciate the value of a painting or a statue, he has only to distinguish the white from the black and an automobile from a flower. He ought at least to be warned that the original work of art, for anyone who does not know how to look at it, can only shock at first sight. What we all look for on the walls of a museum is a mirror where we can discover our own image. And, although the originality of the language that a painter, sculptor, musician, or poet speaks does not suffice to make him a great artist, one can at least be sure that, if he expresses himself in a way to be immediately and completely understood by everyone, he is speaking only in platitudes. It is not the artist's task to seek out what the public's state of mind and tastes might be; it is the public's task to wonder what the artist meant to say, to examine whether his tastes and state of mind are likely to expand the heart of those who come to listen to him.

If the public took the trouble to learn the artist's language, if it would simply recognize that there is a language of art that is fairly difficult to understand and impossible to speak for anyone not moved by an imperious command from his own nature, it would see that the artist does not differ from the public as much as each one believes, and one would help

the other to discover hidden resources within itself. That is especially true in the times we are now living in. The irresistible movement toward greater concentration that is coming about in all the orders of human activity anticipates both a new society and a new art. It is precisely when artists seem to be moving as a group away from the mob's habits of seeing and acting that one can be sure that they are expressing the aspirations of that mob with the greatest force. When philosophical adventurers come together at sea to explore unknown islands together, it is certain they have the mission of breaking ground where the men who today misunderstand them will tomorrow plant their vines and wheat.

Elie Faure

7 DECEMBER 1909

Commentary

This exhibition was the first of five initiated by the Société normande de peinture moderne, an organization created by the artist Pierre Dumont (1884–1936; fig. 31) as a vehicle for painters native to Rouen and the surrounding region. Marcel Duchamp, Francis Picabia, and Jacques Villon were among the original members of the society; following Dumont's move to Paris in 1910, the Société normande became increasingly cubist in orientation (documents 30, 42, and 43). In 1911 Dumont settled at the Bateau Lavoir and quickly befriended Juan Gris, Max Jacob, and (through the intermediary of Duchamp) Apollinaire (Coudert, 194–95). In November 1911 the Société normande organized the Exposition d'art contemporain in Paris: the exhibitors included Alexandre Archipenko, Duchamp, Raymond Duchamp-Villon, Gleizes, Léger, Metzinger, Picabia, and Villon (document 30). Such contacts led to lively exchanges between the salon cubists (Gleizes, Léger, Metzinger) and the Normandy group. The sense of camaraderie generated by these meetings culminated in their collaboration in mounting the October 1912 exhibition of avant-garde art known as the Salon de la Section d'Or (see documents 46 and 47) (Spate, 23–25).

The choice of Elie Faure (1873–1937; fig. 7) to write the preface for the group's first exhibition tells us a good deal about the Société normande's political sympathies. Faure was related, through his mother, to the anarchists Elie and Elisée Reclus, both of whom had a lasting impact on their young nephew. Raised in a Protestant household, Faure attended the elite Parisian Lycée Henri IV (1887–91) where he studied philosophy under

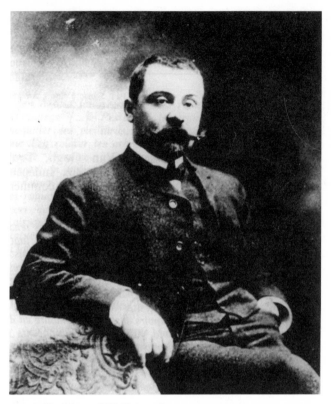

7. Elie Faure as art critic of *Aurore,* 1902. Photograph.

Henri Bergson. Trained as a medical doctor, Faure was an active leftist who moved in anarchist and Socialist circles. A prominent Dreyfusard and antimilitarist, Faure's writings on art first appeared in *L'Aurore* in April 1902, and in 1907 he published his first collection of art criticism under the title *Formes et forces.* In 1904 he helped sponsor a French delegation to the Amsterdam Congrès antimilitariste organized by the Dutch anarchist Domela Nieuwenhuis (the writer and artist Francis Jourdain was a delegate; see document 9). Between 1905 and 1909 he gave a lecture series at the Université populaire "la Fraternelle" at 45, rue de Saintonge: these talks were the genesis of his monumental *History of Art,* the first volume of which appeared in 1910 as *Histoire de l'art: L'Art antique.* A close friend of the symbolist Eugène Carrière, Faure became an honorary member of the Comité du Salon d'Automne in 1904, and was jury member for painting at the 1907 Salon d'Automne. In 1909 Faure was

among those to publicly protest the execution of the Spanish anarchist Francisco Ferrer, and in 1911 he polemicized against the incarceration of Gustave Hervé, editor of the antimilitarist journal *La Guerre Sociale*. Faure's protest against government repression extended to the visual arts, as was evident from his written condemnation, published in *L'Humanité* (16 November 1913), of the state's removal of Kees van Dongen's *Spanish Shawl* (Musée National de l'art moderne, Paris) from the Salon d'Automne of 1913 (Courtois and Morel). Faure's defense of modern art in the name of broader leftist values evidently endeared him to members of the Sociéte normande, for he also contributed a preface to that group's third exhibition in July 1912 (see document 42). His preface for the first show addresses the disjunction between public expectation as to what constitutes art and the jarring effect on that public of avant-garde innovation. Members of the Société normande, we are told, constitute a true vanguard: they are creating a "new art" for a "new society," and "it is not the artist's task to seek out what the public's state of mind and tastes might be; it is the public's task to wonder what the artist meant to say." In his 1912 preface Faure would develop this theme further by drawing on the philosophical and critical vocabulary of the cubists themselves (M. Antliff; M. Antliff and Leighten, 113–15).

M. Antliff, "Organicism against Itself"
M. Antliff and Leighten, *Cubism and Culture*
Coudert, "Pierre Dumont"
Courtois and Morel, *Elie Faure*
Spate, *Orphism*

Jean Metzinger, "La féerie," *Ile Sonnante* (April 1910): 152

La Féerie

Je ne suis ni nue ni vêtue
Et je danse et l'on voit briller
Deux étoiles inattendues
A la pointe de mes souliers.

Quand mon art charmant d'amoureuse
Attire l'oiseau du trépas,
Pour brûler cette aile fâcheuse
Je prends le soleil dans mes bras.

Le soleil, je sais, n'est qu'un piège
Que je tends à mes propres yeux;
L'Ardeur seule est vraie et la neige
N'est qu'un des mille aspects du Feu;

Mais ma chair est si bien l'épouse
Irréprochable de l'Esprit
Que je puis déchiffrer les douze
Hiéroglyphes de la nuit,

Sans me montrer par trop coquette
Envers les Dogmes redoutés
Ni cesser d'être une île en fête
Au centre de l'éternité.

[The Fairy

I am not naked or clothed
And I dance, and two stars

Unexpectedly gleam
On the tips of my shoes.

When my charm as a woman in love
Draws to it the bird of death,
To scorch that troublesome wing
I take the sun in my hands.

The sun, I know, is only a snare
That I set for my own eyes;
Ardor alone is true, and snow
Is but one of the aspects of fire;

But my flesh is the wife of the spirit
So above reproach that I
Can decipher all twelve
Hieroglyphs of the night,

And yet not be coquette
Toward the dogmas I dread
And be ever a festive isle
In the midst of eternity.]

Jean Metzinger
APRIL 1910

Commentary

Born in Nantes, Jean Metzinger (1883–1956) first studied art in his native city under the tutelage of Hippolyte Touront; having sent his paintings to the Paris Salon des Indépendants in 1903, he then moved to that city to reside on the rue du Faubourg Saint-Martin. By 1905 Metzinger was numbered among the neoimpressionists, and he continued to work in this idiom until sometime in 1908 (Herbert, 220–21; Moser, 34–35). Maximilian Luce's March 1904 exhibition at the Galerie Druet, and the large Paul Signac exhibition in December of the same year, combined with the Georges Seurat retrospective at the 1905 Salon des Indépendants, signaled the resurgence of neoimpressionism. Metzinger's aesthetic allegiances were reinforced through his close friendship with another divisionist convert, Robert Delaunay (1885–1941) (J. Metzinger, *Cubisme Etait Né*). Having read the color theory of Ogden Rood and M. E. Chevreul, both artists developed the mosaiclike style found in works like Delaunay's dandyish

Portrait of Jean Metzinger of 1906, with its reference to the two artists' interest in Japanese prints, and Metzinger's bucolic *Landscape (Sunset)* of 1906–7 (Kröller-Müller Museum, Otterlo) (Moser, 34–35; Rousseau, et al., 94–97). The presence of two reclining nudes in the latter picture recalls Matisse's *Luxe, calme et volupté* (1904–5) or the "naturist" landscapes of the neoimpressionist Henri-Edmond Cross (F. Metzinger, 68–81). In 1907 the poet Max Jacob introduced Metzinger to Picasso and Apollinaire, and it was toward the end of that year that his painterly style shifted yet again, this time in the direction of the Nabis painters Maurice Denis and Émile Bernard (Moser, 34–35). In 1908 Metzinger exhibited paintings alongside those of Georges Braque at the Berthe Weill Gallery, and that same year he was interviewed by the American Gellett Burgess (see document 3).

Throughout this period Metzinger developed his literary interests: thus, in 1909, he began publishing what the poet Max Jacob called "Mallarméen" poetry, such as "La féerie" (The Fairy), which appeared in the literary revue *Ile Sonnante* (1907–13) in April 1910 (Cottington, 154–55). Gleizes later underscored the close relation between the cubists and neo-symbolism, noting that by 1912 "cubism refreshed peoples' memories of Mallarmé, and the Symbolists were once again in vogue" (Gleizes, cited by Chevalier). Indeed scholars have noted the integral relation between the cubists and neosymbolists who published in the movement's flagship journal, *Vers et Prose* (1905–14) (M. Antliff, 16–38; Cottington, 73–80; Cornell, 69–77).

Metzinger's own literary ambitions had an enduring impact on his art theory; indeed he published a book of poems in the symbolist idiom in 1947. In a statement of 1907, published in *La Grande Revue* (vol. 124), he drew parallels between painting and poetry, a possible allusion to Seurat's usage of line and color as "musical" devices in his late "Wagnerian" paint-ing (Smith, 141–55). Metzinger claimed that his divisionism produced "a kind of chromatic versification," composed of "strokes" operating as "syllables," which resulted in "the rhythm of a pictorial phraseology." Robert Herbert concludes that, for Metzinger, "each little tile of pigment has two lives: it exists as a plane where mere size and direction are fun-damental to the rhythm of the painting and secondly, it also has color which can vary independently of size and placement" (Herbert, 220–21). In his 1908 interview with Gelett Burgess, Metzinger adapted his literary analogies to a new style of "decorative" painting, reminiscent of the art of the Nabis. In works such as his *Baigneuses* (1908–9; fig. 4), "decoratively

pleasing harmonies and symphonies of color" would now express the painter's "sentiment" (see document 3). Clearly Metzinger was firmly grounded in the language of symbolism; in subsequent years this preoccupation with the "musical" properties of painting and poetry would play a major role in his development of a cubist idiom.

M. Antliff, *Inventing Bergson*
Cornell, *The Post-Symbolist Period*
Cottington, *Cubism in the Shadow of War*
Gleizes, *"Les débuts du cubisme"*
Herbert, *Neo-Impressionism*
F. Metzinger, *Before Cubism*
J. Metzinger, *Cubisme etait né*
J. Metzinger, *Ecluses*
Moser, *Jean Metzinger in Retrospect*
Rousseau et al., *Robert Delaunay, 1906–1914*
Smith, *Seurat and the Avant-Garde*

Léon Werth, "Exposition Picasso," *La Phalange* (20 June 1910): 728–30

Picasso Exhibition

I too could find a few definitive sentences on art, which ought to provide the structure of things and not limit itself to fixing, in a vague tremulousness, the appearance and emotion of the instant, the caprice of the eye. I could also say that decorative nobility is the necessary fruit of that search for structures, manifested on the canvas by the essential planes discovered by the mind. I could also say that, instead of reproducing the photographic or tactile appearances of the motion of masses in a landscape or the play of muscles in a body, it is important to perceive their law, and that only the figures of geometry can provide it free of lies. I could say that the forms created by Mr. Picasso are abstract patterns only for those seeking anecdotes, and that only they have the power and the right to transport onto the plane of the canvas the sensations and reflections that move about in time. I could say that Mr. Picasso's innovative painting is essentially traditional, that it is linked to the great traditions of instinct and to the great traditions of mind. I might invoke the savages of Oceania—no more than necessary—and I might invoke Cézanne, for whom nature was a sphere, a cone, and a cylinder, and who said so.

And who, then, would prevent me, if I had a taste for the "general ideas" revered by provincial lawyers and ladies who offer five o'clock tea, who, then, would prevent me from also arguing the following:

The relationship between the geometrical figures created by the mind and the forms of nature has preoccupied philosophers. And if geometry owes its certainties to the suggestions of our senses, why not—reversing directions—go from geometry to nature or else, why not, starting from nature, proceed to a mathematics of the senses, a mathematics that would be art?

I see no disadvantage in that. But it is all really a matter of indifference to me. I do not believe in theories and I have confined myself to looking at Mr. Picasso's pictures. The fact that he speaks a geometrical language is his business, and we will all like that language if it becomes the means for a revelation. And perhaps, in the same way that Mr. Jourdain spoke in prose, Mr. Picasso, who fancies himself a geometer, will one day, without knowing it, speak a painter's language.

But then, Mr. Picasso knows pictorial language very well. Except that it is other people's language.

The yellow light falling on that woman in a bonnet is that which casts a glow in van Gogh's portraits. That flowerpot, so deeply inspired by van Gogh, suggests this problem to us: how is it possible to borrow van Gogh's aspect and not accomplish any significant and sure drawing?

That scene from antiquity with horses and human figures is at once neoclassical and neo-Gauguin.

Here are two portraits of men, which indicate intelligence and ingenuity, but which, all the same, are a little too "Champs de Mars." Here is a woman in her bath, in front of a wall decorated by Lautrec's May Milton. Is this a new kinship, which Mr. Picasso himself is proclaiming this time?

Here is the dying clown, hands joined, in his death throes on a pallet, and the comrades who contemplate and assist him. This time, Mr. Picasso got scared. He did not completely cover the sketch. His picture was threatening to resemble the hospital scene by Mr. Geoffroy. Mr. Picasso got scared. He thought of the orange that mothers bring to pale children.

These pictures borrow nothing from geometry and, although their inspirations are diverse, Mr. Picasso cannot be criticized for that. Like all artists at the start of their career, while trying to find himself, he has sometimes found other people. From these agreeable and ingenious works, Mr. Picasso arrives at this compote and this glass, which manifest their structure, their hypostructure, and their hyperstructure, and whose simplified harmony is composed of the yellows and greens in certain Cézannes. And he arrives at this landscape of—finally—cubical roofs, cubical chimneys, and trees like chimneys, but nevertheless decorated with palm leaves at the top (fig. 8).

A great painter may use that method tomorrow. But, precisely, he will use it and show us something besides his method. A method is not an end. To perceive the form "turning" or its opposite planes—that is

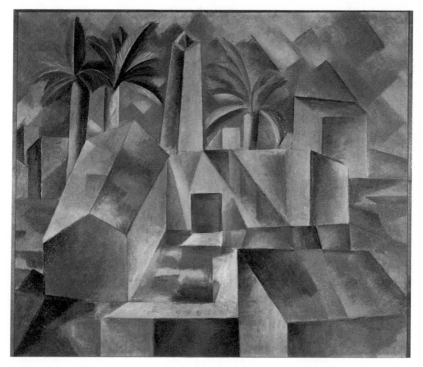

8. Pablo Picasso, *L'Usine à Horta de Ebro* (*Factory at Horta de Ebro*), summer 1909. Oil on canvas, 20⅞ × 23½" (53 × 60 cm). The Hermitage Museum, St. Petersburg. © 2005 Estate of Pablo Picasso/ Artists Rights Society (ARS), New York. Photograph Erich Lessing/Art Resource, NY.

a matter of indifference to me. I am amenable only to the thought of which it becomes the equivalent.

Here and among other painters, I perceive a scholastic confusion between capacities and acts. Painters decide to introduce some quality, some virtue, onto their canvas. One does not paint qualities. One does not paint order, harmony, reason. One paints the things and oneself.

This is an illusion that eternally runs parallel to the labor of creative men, tormented and consoled by reality. The Précieuses rebelled against the idea that one could lie down next to a man who was actually naked.

Léon Werth

JUNE 1910

Commentary

The Léon Werth (1878–1955) review of Picasso's May 1910 exhibition at Wilhelm Udhe's Notre-Dame des Champs Gallery is an important record

of the initial usage of the term *cubic* to describe Picasso's paintings of 1908–9 (works identified as having been exhibited at Udhe's gallery date to this period). Werth's description of a "landscape of . . . cubical roofs, cubical chimneys, and trees like chimneys" likely refers to Picasso's *Factory at Horta de Ebro* (summer 1909; fig. 8) (Cousins, 365), and his claim that Picasso's work invoked both "Cézanne" and "the savages of Oceania" resonates with the widespread identification of Cézanne as a so-called modern primitive whose abstraction in the name of "authenticity" had a non-European counterpart in African and Oceanic sculpture (M. Antliff and Leighten, 46–63; Shiff, 162–74). Werth also associates this abstraction with the "decorative," and his article thus reaffirms Braque and Metzinger's earlier pronouncements recorded in Gelett Burgess's assessment of modernism (document 3).

Concurrently Werth expresses anxiety over what he terms the "scholastic confusion" of Picasso's art, manifest in his desire to develop a cerebral aesthetic dominated by a "geometrical language." This leads Werth (who was a novelist) to compare Picasso to a Mr. Jourdain: "perhaps, in the same way that Mr. Jourdain spoke in prose, Mr. Picasso, who fancies himself a geometer, will one day, without knowing it, speak a painter's language." The allusion here may be to the hapless Monsieur Jourdain in Molière's comedy *Le bourgeois gentilhomme* (1670). In that play Jourdain attempts to aggrandize himself by taking up dancing, fencing, and philosophy, but only succeeds in being the laughingstock of high society. A victim of his own conceit, Jourdain forbids his daughter the right to marry the low-born Cléonte; but the latter deceives Jourdain into sanctioning the union by posing as the Grand Turk, whose nonsensical jargon is taken for Turkish by the witless Jourdain. By declaring Picasso to be a modern-day Jourdain, dabbling in "geometrical language," Werth expresses his caution about the viability of such aesthetic experimentation. He then adds, however, that Picasso might eventually "speak a painter's language," and that "a great painter may use that method tomorrow."

A committed anarchist, Werth combined an interest in avant-garde art with political activism, as is revealed by his presence, with André Salmon (1881–1969), at a May 1910 demonstration and riot protesting the execution of a militant worker, Liabeuf (Leighten, 70–71; Parry, 44–45; Salmon, 278), and by his polemical contributions to *Cahiers d'aujourd'hui* (1912–14), edited by the anarchist sympathizer Georges Besson (Carr, 147–48; Cottington, 80–84). Werth and the writer Francis Jourdain were close

friends of the anarchist art critic Octave Mirbeau, and both were subject to police surveillance at the time Werth wrote his article (Mirbeau Dossier BA/ 1190, Items 105–7, Bureau des Archives et du Musée, Préfecture de Police, Paris, cited in Carr, 146–47). Given Salmon's close links with both Picasso and Werth, it may be that Salmon informed Werth of Picasso's own anarchist genealogy, which surely would have won Werth's approval and respect. Thus Werth's decision to write the review might constitute an act of solidarity, while the review itself is testament to Werth's forthright honesty in both admiring Picasso's ambitions and criticizing the pictorial results.

M. Antliff and Leighten, *Cubism and Culture*
Carr, *Anarchism in France*
Cottington, *Cubism in the Shadow of War*
Cousins, "Documentary Chronology"
Leighten, *Re-Ordering the Universe*
Parry, *The Bonnot Gang*
Salmon, *Souvenirs sans fin*
Shiff, *Cézanne and the End of Impressionism*

Henri Le Fauconnier, "Das Kunstwerk," Neue Kunstlervereinigung München, Moderne Galerie Thannhauser, Munich, September 1910

The Artwork

The work of art is the order that the human mind imposes on the natural elements: it is a relationship composed with these elements in accordance with an arbitrary will. The beautiful is the feeling of that relationship, and number is the most general term for it.

I. The work of art, considered from the constructive point of view.

A numerical work of art must display numerical characteristics of a constructive nature. These characteristics are order and expression in general.

—With regard to order, the number is simple or compound. It is simple when the set of numerical quantities corresponds to the measurement of two- or three-dimensional distances between a sequence of points forming a group. The number is compound when there is a set of primary surfaces that form the basis for the construction, and when there is a set of points that are the result of the different directional effects produced by the primary surfaces.

—In expression in general, as far as values are concerned, the number fictively represents the distances between the various points in relief, extending to an ideal plane running parallel to the picture plane and cutting the space in half, in such a way that it suggests through its properties the other, invisible volumes. As for the expression of tones or colors, numbers constitute a graduated scale corresponding to the light waves (this characteristic is essentially relative and fictive, and belongs to the realm of the senses).

II. The work of art, considered from the qualitative point of view.

Finally, the work of art, conceived numerically, possesses qualitative

characteristics: the utmost succinctness, the realization, and a determinate level of naturalism.

—The utmost succinctness of means for the greatest ends. The artist proceeds by means of abstraction.

—The realization, the sense of the overall formal expression via the application of the most auspicious means.

—The degree of naturalism observed by the artist. Here, naturalism is no longer understood in the sense of the so-called naturalist school (for which it was the sole concern), but stands as a link between mind and matter, leaving only the matter necessary to evoke it in the most economical way.

Henri Le Fauconnier
SEPTEMBER 1910

Commentary

Henri Le Fauconnier (1881–1945) died almost friendless and forgotten, but for the brief period from 1910 to 1912 he was considered a luminary in cubist circles, equal to Picasso in importance (see document 54). The son of a doctor, Le Fauconnier received his baccalaureate from an aristocratic Jesuit college at Boulogne-sur-mer; the nineteen-year-old then began studying law, and moved to 19, rue Visconti (next to the École des Beaux-Arts) in 1900. He quickly abandoned his academic pursuits for training as an artist, joining the Académie Julian in 1905 where he met André de Dunoyer de Segonzac, Luc-Albert Moreau, and Roger de la Fresnaye. In May 1905 Le Fauconnier exhibited neoimpressionist-inspired works alongside those of Georges La Meilleur (1861–1945) at L'Indépendance Artistique, 20, rue Pelletier. The symbolist poet Georges Bonnamour wrote the preface to the 1905 exhibition, a sure indication that Le Fauconnier, like Jean Metzinger, was strongly influenced by neosymbolism (Robbins, 29–30). In the summer of 1906 La Meilleur invited Le Fauconnier to accompany him on a trip to the northern coast of Britanny; during the same period Le Fauconnier met Maroussia Barannikoff, a well-educated daughter of a highly ranked Russian state official who became his lover and the model for many of his cubist paintings, including the female figure in *L'Abondance* (1910–11; fig. 9). Over the course of 1906–8, Le Fauconnier focused his artistic attention on the Ploumanach region, painting Nabis- and fauve-inspired images of young Breton children and of the rocky coast, with its dramatic granite rock formations (M. Antliff and Leighten,

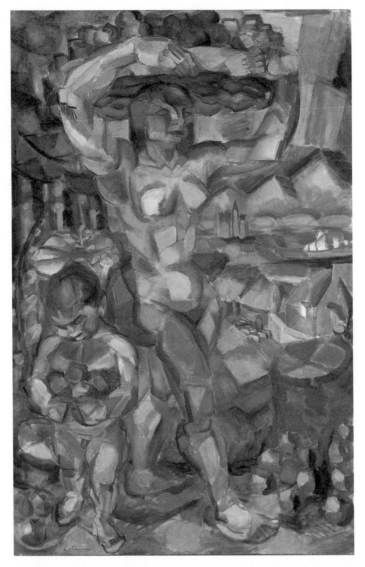

9. Henri Le Fauconnier, *L'Abondance* (*Abundance*), 1910–11. Oil on canvas, 75 × 48" (191 × 123 cm). Gemeentemuseum, The Hague. Photograph Bridgeman Art Library International, NY.

46–48; Cottington, 96–99; Robbins, 30–31). Le Fauconnier was particularly fascinated with the crystalline properties of these rocks and their relation to the *longue durée* of geological time. For Le Fauconnier these coastal formations were the primordial counterpart to the "Celtic" megaliths that dotted Brittany, and like Gauguin before him he associated the

form and content of his images with what he viewed as the "primitive" character of the region (Robbins, 32).

It was this work that attracted the attention of artists and literary figures associated with the Abbaye de Créteil (see document 1). Through Maroussia's contacts with the Russian colony in Paris, Le Fauconnier befriended the poet-critic Alexandre Mercereau, who in turn introduced the painter to Albert Gleizes in 1908 (Fabre, 139; Gleizes, 6). Mercereau became a strong supporter of Le Fauconnier and played a key role in establishing his reputation abroad. When Mercereau helped organize the avant-garde "Golden Fleece" exhibition in Moscow during the spring of 1908, Le Fauconnier's work was exhibited alongside that of Gleizes, Matisse, and Braque; moreover this grouping (minus Gleizes) was repeated in January 1909, for the second "Golden Fleece" exhibition. Concurrently Le Fauconnier began painting portraits of poets associated with the Abbaye de Créteil, most notably Pierre-Jean Jouve (1909) and Paul Castiaux (1910), who coedited *Les Bandeaux d'Or* (1906–14) (see document 1).

In 1910 the Russian-born artists Alexei von Jawlensky and Wassily Kandinsky called for Le Fauconnier's participation in the Neue Künstlervereinigung exhibition, which took place in September at the Thannhauser Gallery in Munich. Jawlensky and Kandinsky had encountered Le Fauconnier in Paris through their involvement in the Groupe d'art des tendances nouvelles (founded in 1904), which included La Meilleur among its members (Fineberg; Robbins, 33). Le Fauconnier's status was such that he was asked to write the preface for the Munich exhibition, which resulted in his first artist's statement, "Das Kunstwerk" (The Artwork). Concurrently the chance hanging of paintings by Delaunay, Gleizes, and Metzinger in close proximity at the 1910 Salon d'Automne made these artists aware of their shared aesthetic concerns. Immediately after the salon, Gleizes, Le Fauconnier, Metzinger, Delaunay, and Léger, the Abbaye de Créteil poets, and critics Apollinaire, Roger Allard, and André Salmon began meeting regularly at the Closerie des Lilas and, most important, at Le Fauconnier's studio on rue Visconti. As Le Fauconnier painted the second version of *L'Abondance* (fig. 9) (the first was finished in the summer of 1910), his allies exchanged ideas and forged the alliance that heralded the public birth of a cubist movement at the 1911 Salon des Indépendants (Gleizes, 6–14; see documents 11 and 18).

The recent discovery of the original French manuscript of "Das Kunstwerk" means we can now interpret its contents with greater precision (Henri Le Fauconnier, 61). Le Fauconnier's difficult and arcane text is divided into two sections, preceded by a short introductory statement. The work of art, we are told, is the expression of "an arbitrary will," but that will imposes human order "on the natural elements" to arrive at a universal notion of the "beautiful," whose abstract elegance resembles that of numbers. In part 1, Le Fauconnier then defines what he means by "a numerical work of art," wherein a complex system of ratios define pictorial space, tones, and colors. Volumetric forms, and the spatial relations between objects, are all subject to this system, as are tonal values: presumably the faceted treatment of bodily elements, muted palette, and tonal gradations in Le Fauconnier's nude portraits of Maroussia conveyed his intentions (Robbins, 34–36). Part 2 considers the painting "from the qualitative point of view," wherein a sense of beauty is achieved by economy of means and the "means of abstraction" generated by Le Fauconnier's numerical system. Art therefore constitutes the "link between mind and matter," and bears a metaphorical relation to the cerebral beauty of numerical order (Murray, "Henri Le Fauconnier's 'Das Kunstwerk'"). The construction of such "universal" systems was common currency among poets, and Le Fauconnier may have been emboldened to write his manifesto by reading texts such as René Ghil's *De la poésie scientifique* (1909).

Le Fauconnier's status as a theoretician was quickly acknowledged by his peers. Shortly after the Salon d'Automne opened in September, Metzinger published his "Note on Painting" (document 11), wherein he drew on Le Fauconnier's manifesto to describe his colleague's art as composed of "a vast harmony of numbers." In November 1910 Allard repeated this maneuver, echoing "Das Kunstwerk" by claiming that "beauty" in Le Fauconnier's painting results from "a harmony of weights and numbers." Murray has convincingly argued that "Das Kunstwerk" had a significant impact on Kandinsky's own aesthetic theorizing, as evidenced by his favorable evaluation of *L'Abondance* (fig. 9) in *Der Blaue Reiter* (1912), co-edited by Kandinsky and Franz Marc. Drawing on Le Fauconnier's text, he described the painting as able to provoke "inner effects" through "relief forms," "distribution of weights," and "an almost tragic overloading of masses" (Ibid.). Over the summer and fall of 1911, Le Fauconnier had been in frequent correspondence with Kandinsky, and was asked to help

procure articles for *Der Blaue Reiter* (Murray, "Henri Le Fauconnier's 'Village in the Mountains,'" 35–36). These non-Parisian contacts would become increasingly important when schisms opened between Le Fauconnier and his cubist friends in the fall of 1912 (document 54).

M. Antliff and Leighten, *Cubism and Culture*
Cottington, *Cubism in the Shadow of War*
Fabre, "Albert Gleizes et l'Abbaye de Créteil"
Fineberg, *Kandinsky in Paris 1906–07*
Gleizes, *Cahiers Albert Gleizes*
Henri Le Fauconnier
Le Fauconnier, "L'Oeuvre d'art"
Murray, "Henri Le Fauconnier's 'Das Kunstwerk'"
Murray, "Henri Le Fauconnier's 'Village in the Mountains'"
Robbins, "Henri Le Fauconnier's *Mountaineers Attacked by Bears*"

Jean Metzinger, "Note sur la peinture," *Pan* (October–
November 1910): 49–52

Note on Painting

Is there any work among the most recent paintings and sculptures that
does not secretly obey the Greek rhythm?

From the primitives to Cézanne, nothing definitively breaks the chain
of variations coiled around the Hellenic theme. I see yesterday's rebels
today mechanically bowing down before the bas-relief of Eleusis. Goth-
ics, Romantics, impressionists: the old measure has prevailed over your
praiseworthy arrhythmia. Yet your labor was not in vain: it gave us the
prescience of a different rhythm.

For us, the Greeks invented the human form; we must reinvent it for
others.

It is therefore not a question of a partial "movement" that takes the
familiar liberties—interpretation, transposition, and other such half-
measures—but of a fundamental emancipation.

Already, a conscious courage is coming to life. Here are some of the
painters: Picasso, Braque, Delaunay, Le Fauconnier. Exclusively paint-
ers, they do not illuminate noumena in the "neoprimitive" manner; they
are highly enlightened, and do not believe in the stability of any system,
even if it were to call itself classical art; and, at the same time, they rec-
ognize in the most novel of their own creations the victory of age-old
desires. Their reason is poised between the pursuit of the fleeting and a
mania for the eternal. Although they condemn the irritating absurdity of
the theorists of "emotion," they refrain from dragging painting toward
decorative speculations. When, to foil the tricks of optics, they master
the external world for a moment, no Hegelian superstition invades their
understanding.

It is useless to paint where it is possible to describe.

Armed with that thought, Pablo Picasso gives us a glimpse of the very face of painting.

Disapproving of all ornamental, anecdotal, or symbolic intention, he brings into being an as-yet unknown pictorial purity. I know of no painted works among the most beautiful of the past that belong to painting as expressly as his do.

Picasso does not deny the object, he illuminates it with his intelligence and his feelings. He combines tactile perceptions with visual perceptions. He experiences, he understands, he organizes: the picture will be neither transposition nor schema, we will contemplate it as the sensorial and living equivalent of an idea, the total image. Thesis, antithesis, synthesis, the old formula is dynamically inverted within the substance of the first two terms: Picasso admits he is a realist. Cézanne showed us forms living in the reality of light; Picasso gives us a material report of their real life in the mind. He establishes a free, mobile perspective, in such a way that the shrewd mathematician Maurice Princet has deduced an entire geometry from it.

Nuances are neutralized around ardent constructions: Picasso despises the often brutal game of the so-called colorists and reduces the seven colors to the primal unity of white.

In abandoning the weighty legacy of dogma, in displacing the poles of habit, in lyrically negating axioms, in skillfully confounding simultaneity and succession, Georges Braque is well aware of the great natural laws that guarantee these liberties.

Whether he paints a face or a piece of fruit, the total image radiates in time [*la durée*]; the painting is no longer a dead portion of space. A principal volume is born physiologically from the rival masses. As fluid accompaniment, a color scheme, faithful to the dual and unimpeachable principle of cold and warm tones, enhances that miraculous dynamic.

Braque, who joyfully fashions new plastic signs, does not commit an error of taste. The new word does not deceive us! I can, without diminishing the innovative daring of that painter, compare him to Chardin and Lancret, can link the bold grace of his art to the genius of his race.

I remember *Manège* [*Carrousel of Pigs*, 1906–7; destroyed by the artist in 1912], which Robert Delaunay produced three years ago. That canvas encapsulated the paroxysms of an explosive and disorderly age. In it

I discerned the elements of an unknown logic. On the basis of that logic, Delaunay has developed his recent notions beyond all artistic prejudices. It has amused him to represent, for example, the Eiffel Tower [fig. 15]: the tower comes dizzyingly alive with a thousand notions he has about it, and on the canvas stands a different tower of unexpected, variable, beautiful proportions. The intuitive Delaunay calls intuition the sudden combustion of thoughts accumulated each day. He paints the way nations [les peuples] build.

His surprising art is not disturbing.

Le Fauconnier excels at distinguishing between the surprising and the disturbing: the surprising connotes the completion of an effort never before completed, and contains the idea of revelation; the disturbing implies a faulty understanding of the past.

Le Fauconnier locates his ideal—inaccessible, especially to those who speak immoderately of order and style—within a vast harmony of numbers. Distributing with impartiality the goods of the intelligence and of the senses, he tolerates "a certain coefficient of naturalism," just that required to satisfy the demands of normal sensuality, and not enough to cloud the mind. He does not allow charm to encroach upon the space reserved for force, or for one of the terms of the vast formula he has adopted to be exalted at the expense of the others. A precise link assembles in irreducible blocks the constituent parts of the picture. Le Fauconnier achieves the height of evocative power; the mode of beauty he adopts is grandeur.

Apart from the ignorant distortions and stiff stylizations, form, considered for too many centuries as the inanimate support of color, finally recaptures its right to life, to instability. It is a tremendous avowal of powerlessness to turn to the Egyptians, the Greeks, and the Chinese for the wherewithal to respond to all modern desires! But, if we leave the ancient world to the archaeologists, the old coins to the numismatists, and do not accept as beautiful anything that may draw its prestige, its doubtful and indirect prestige, solely from its great age, it does not follow, let me repeat, that we are claiming to strike a line through tradition. It is in us, it has been acquired by us unawares, we do not have to pay attention to it. It is necessary to pause for a moment before the masters, listen to them...and then move on. The unique, progressive sparks of the fire come in too quick succession for us to take the time to admire them. Quickly the error of today becomes a truth more complete than the truth

of yesterday, quickly it once more becomes an error, only to give rise to an even richer truth.

Aphrodite, the Venus of the museums, the archetype of formal perfection, does not crystallize the absolute, any more than the figurines of Oceania, the Christian demons, or the landscapes of Hiroshige. Only erotic laziness has made her immortal. The goddess of marble, a sign rising forth from the alphabet of a dead language, has been transformed into an abstract goddess; I am waiting for her to go take her place in some Platonic hierarchy, far away from us.

It used to be said of a woman: why, she's a Velázquez infanta! Now it is said: she's a Renoir blonde! I have no doubt that, in the future, it will be proclaimed: she's as exuberant as a Delaunay, as noble as a Le Fauconnier, as beautiful as a Braque or a Picasso.

Jean Metzinger
SEPTEMBER 1910

Commentary

Published shortly after the Salon d'Automne of 1910, Metzinger's "Note on Painting" was the first to establish theoretical links between the art of Picasso and Braque and that of Delaunay and Le Fauconnier. Recent scholars have underscored Metzinger's crucial role as an intermediary between the Picasso circle in Montmartre and the Abbaye de Créteil group (M. Antliff and Leighten, 20–21; Clark, 205–7; Cottington, 154–58; Robbins, 9–23). Metzinger lived in Montmartre from 1907 to 1912, and from 1907 on he frequented Picasso's studio, often joining the *bande à Picasso* with Georges Braque, André Derain, Max Jacob, André Salmon, and Guillaume Apollinaire, whose Cézannesque portrait he exhibited in the Salon des Indépendants in 1910 (fig. 10). Such associations extended to the commercial realm, for Metzinger exhibited work alongside that of Picasso and Braque at Wilhelm Udhe's gallery in 1908–9 (21 December 1908–15 January 1909).

The dates when Metzinger, Delaunay, Gleizes, and Le Fauconnier first met remain ambiguous: Metzinger in his memoirs claimed to have met Gleizes in 1906, while Gleizes in his *Souvenirs* dated his first encounter with both Delaunay and Metzinger to 1910 (Robbins, 12). Gleizes also recalled meeting Le Fauconnier in 1906 through Alexandre Mercereau, though Le Fauconnier's profound impact on Gleizes's art only occurred in 1909 (Gleizes, *Cahiers Albert Gleizes*, 6–8). Sonia Delaunay in turn

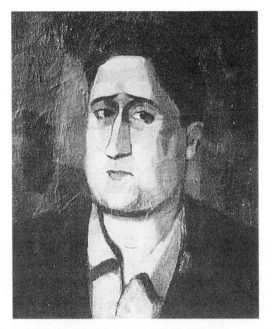

10. Jean Metzinger, *Portrait d'Apollinaire* (*Portrait of Apollinaire*), 1910. Oil on canvas, 51¹/₈ × 38¹/₈" (130 × 97 cm). Private Collection, Germany. © Artists Rights Society (ARS), New York / ADAGP, Paris.

recollected that Robert Delaunay met Gleizes and Le Fauconnier in spring 1910, though Gleizes dated the encounter to the fall of the same year (Rousseau et al., 28). Fernand Léger later stated that he and Delaunay (a close associate of Metzinger's) saw Picasso and Braque's painting at Kahnweiler's in November 1908 on the advice of Jacob and Apollinaire (Ibid., 26). Gleizes dated his encounter with Picasso to October 1911, when he met him at Apollinaire's bequest, and went to Kahnweiler's gallery to see Braque's and Picasso's work for the first time (in the company of Léger, Le Fauconnier, and Metzinger) (Brooke, 21–22). Indeed the paintings exhibited at the 1910 Salon des Indépendants by Delaunay, Gleizes, Léger, Le Fauconnier, and Metzinger bore little relation to Braque's and Picasso's innovations, although the future salon cubists all registered the impact of Paul Cézanne (with the exception of Delaunay). While the *bande à Picasso* and their salon counterparts shared an interest in Cézanne, neo-symbolism, the "durational" philosophy of Henri Bergson and William James, and the "conventionalism" of mathematician Henri Poincaré, the salon painters developed a distinct aesthetic expressive of the "epic" themes championed by poets associated with the Abbaye de Créteil

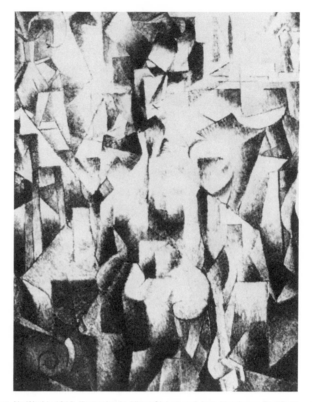

11. Jean Metzinger, *Nu* (*Nude*), 1910. Illustration in Albert Gleizes and Jean Metzinger, *Du "Cubisme"* (1912) and in Guillaume Apollinaire, *Les peintres cubistes: Méditations esthétiques* (Paris: Eugène Figuière, 1913) [documents 57 and 62]. Location unknown. © Artists Rights Society (ARS), New York / ADAGP, Paris.

(M. Antliff and Leighten, 64–110; Cottington, 87–143, 158–65; Henderson, 44–116; Robbins, 9–23). The humble still lifes and intimate portraits favored by Braque and Picasso differed dramatically from the panoramic images of urban and rural society on display at the public salons.

Metzinger stands alone among the artists in 1910 in establishing links between these two groups. Over the period from spring 1910 to September 1910, he was unique in moving from the Cézannism of his *Portrait of Apollinaire* (fig. 10) to his Picasso-inspired *Nue* at the 1910 Salon d'Automne (fig. 11). This stylistic shift, combined with Metzinger's evident familiarity with the art of both circles in his "Note on Painting," suggests his crucial role in defining a new movement, even if the stated

participants remained relatively unfamiliar with one another's work (Cottington, 154–56; Robbins, 10).

Metzinger's text begins with a general definition of modernist praxis before proceeding to individual case studies of Picasso, Braque, Delaunay, and Le Fauconnier. All art—"from the primitives to Cézanne"—had a genealogy in "Hellenic" rhythm, but the younger generation had developed "a different rhythm," thus precipitating "a fundamental emancipation" from past artistic canons, including those of classical Greece. Picasso, Braque, Delaunay, and Le Fauconnier "do not believe in the stability of any system, even if it were to call itself classical art, and, at the same time, they recognize in the most novel of their own creations the victory of age-old desires." Stylistic change, rather than aesthetic stability, is celebrated by Metzinger, and rhythm—the synthesis of the temporal and spatial—is the governing metaphor for the new painting. Metzinger's eulogy to the temporal indicates the pervasive impact of Bergson's durational philosophy on artistic and literary circles at this historical juncture (M. Antliff; Clark, 426n31). Indeed his *Nue* of 1910 (fig. 11) conjured with Bergson's distinction between the normative, quantifiable time (signified by the clock represented in the upper right) and the subjective, qualitative experience of duration nurtured by artists and figured here in the multiple views of the sitter (M. Antliff and Leighten, 83 and 109–10).

Metzinger then turns to the art of his peers to describe the new aesthetic. Picasso is said to combine "tactile perceptions and visual perceptions" to arrive at "the sensorial and living equivalent of an idea, the total image." As Linda Henderson has demonstrated, Metzinger's references to tactile and visual perceptions derive from Poincaré's analysis of tactile, visual, and "motor" spaces in his book *Science and Hypothesis* (1902). Poincaré analyzed the physiological underpinnings of our perception of space before concluding that all forms of geometry, including the Euclidean, were mere "conventions," thus allowing us to freely speculate about other spatial configurations, including the non-Euclidean and the fourth dimension. In Metzinger's estimation such thinking was a catalyst for Picasso's myriad spatial innovations, including multiple perspectives, transparency of planes, and disparities of scale (Henderson, 74–89). Further, Picasso "established free, mobile perspective, in such a way that the shrewd mathematician Maurice Princet has deduced an entire geometry from it." Here Metzinger alludes to the impact the insurance

actuary Maurice Princet had on those artists who gathered at the home of Picasso's patrons, Gertrude and Leo Stein (ibid., 59–72; see document 35). Leo Stein recalled that theories of non-Euclidean geometry, the fourth dimension, and Bergsonian duration were already a topic of conversation as early as 1909. He added that Picasso's interest in these ideas was first stimulated by Princet, a "friend of the Montmartre crowd" familiar with the new geometries (M. Antliff and Leighten, 74; Stein, 74–76). Metzinger, however, speaks of confluence rather than influence, arguing that it was Picasso's paintings that inspired Princet's deductions.

Having identified the philosophical underpinnings behind Picasso's "ardent constructions," Metzinger then turns to Braque, whose paintings combined "simultaneity with succession" to create a "total image" that "radiates in time [la durée]." As a result Braque's art "is no longer a dead portion of space"; instead, "a principal volume is born physiologically from the rival masses," and the "fluid accompaniment" of colors and tone "enhances that miraculous dynamic." Here Metzinger links the rhythmic and volumetric properties of Braque's painting to Bergsonian duration, rather than Poincaré's conventionalism. Referring to the fragmented forms of Delaunay's images of the Eiffel Tower (fig. 15), Metzinger describes Delaunay as having employed "intuition" to capture "thoughts accumulated each day" and the "thousand notions" he had about the tower. Here multiple views are said to express Delaunay's "intuitive" grasp of his own memories of the tower, as well as that of the broader public—a clear allusion to the literary interpretation of Bergson's concept of intuition in the writings of René Arcos and unanimist Jules Romains (M. Antliff, 40–42, 59–61; M. Antliff and Leighten, 93–96; Robbins, 10–11). Finally he draws on Le Fauconnier's "Das Kunstwerk" to describe that artist's ambition to develop a "coefficient of naturalism" by conjoining the "constituent parts of the picture" into "a vast harmony of numbers" that determine volumetric relations (see document 10).

Metzinger's shift in style and his theoretical tract provoked criticism from his close friend, the poet Guillaume Apollinaire. Among the critics, Apollinaire played a role comparable to Metzinger's, since he moved freely between the bande à Picasso and Metzinger's colleagues at the salon. In assessing the paintings of Delaunay, Gleizes, Le Fauconnier, and Metzinger at the 1910 Salon des Indépendants, Apollinaire had argued that the younger generation favored "composition" over color and were developing "many different artistic systems" (L'Intransigeant, 22 March

1910; cited in Breunig, 73–74). However, his response to Metzinger's *Nue* (Fig. 11) at the Salon d'Automne was not nearly as favorable. He now claimed that Metzinger's experimentation "with various methods of contemporary painting" had resulted in "sterile undertakings," and implored the artist to "find his own way and stick to it" (*L'Intransigeant*, 1 October 1910; cited in Breunig, 111). Fully cognizant of Metzinger's own art criticism, Apollinaire repeated the accusation in a later article on the Salon d'Automne: without mentioning Metzinger by name, he asserted that the paintings critics heralded as "cubism" were in fact a "servile imitation" of those "painted by an artist endowed with a strong personality," namely "Pablo Picasso" (*Poésie* [Bordeaux, autumn 1910], cited in Bruenig, 114). This was Apollinaire's first usage of the word *cubism*, and he clearly reserved the appellation for Picasso, rather than those artists at the salons. This statement, and his Nietzschean reference to Picasso's "strong personality," were meant to admonish Metzinger for briefly appropriating the style of his mentor (Nash, 440–43; Leighten, 44–47 and 53–63; Read, 12). Soon, however, Apollinaire would be more magnanimous, as in *The Cubist Painters* (document 62), and Metzinger would indeed move on to find his own way.

M. Antliff, *Inventing Bergson*
M. Antliff and Leighten, *Cubism and Culture*
Breunig, ed., *Apollinaire on Art*
Brooke, *Albert Gleizes*
Clark, *Farewell to an Idea*
Cottington, *Cubism in the Shadow of War*
Gleizes, *Cahiers Albert Gleizes*
Henderson, *The Fourth Dimension and Non-Euclidean Geometry in Modern Art*
Leighten, *Re-Ordering the Universe*
Nash, "The Nature of Cubism"
Read, *Apollinaire and Cubism*
Robbins, "Jean Metzinger"
Rousseau et al., *Robert Delaunay, 1906–1914*
Stein, *Appreciation*

Roger Allard, "Au Salon d'Automne de Paris," *L'Art Libre*
([Lyons,] November 1910): 441–43

At the Autumn Salon of Paris

In no way do I consider desirable the eclectic jumble, the impartiality of the junk room. Certain halls in this exhibition bring to mind the Hôtel Drouot. Another association is more distressing: it looks as if the hand of the installer, on the day the pictures were hung, fell under the occult influence of the commercial galleries. We may well be astonished, for example, at the pompous—and not advantageous—position assigned to the pictures of Othon Friesz. In that rotunda, only Girieud warrants the huge proportions of his canvas. These women bathers evoke Baudelaire's line: Comme un bétail pensif sur le sable couchées.... Lying like pensive livestock on the sand....

I confess that I am responsive to these insidious transpositions when they are manifested in a concert of rich harmonies. Nevertheless, all the pure love and devotion I feel for that art of intelligence and culture are not enough to make me forget the necessary objection: where can the traces of a direction, a starting point, be found here?

It is even less fitting to ask it of Maurice Denis, whose limited skill no longer deceives anyone but "amateurs," or of van Dongen, a rival, and not a happy one, of Humbert and Flameng, or of Matisse, whom the need for lucrative publicity seems to destine for declamatory excesses...it would be better to stop there.

Metzinger, H. Le Fauconnier, and Albert Gleizes—especially Metzinger—were, for the *grand public,* to whom the epithet "grand" has fallen by antiphrasis, a generous goldmine of heartening commentary. It appeared to me, however, that the pink trees and orange meadows of the recent past did more to raise the gawkers' bile, or to open their spleen, depending on their temperament. The distortion of lines, with

the exception of those of the human face, seems to provoke a lesser reaction on the nerve cells of people from every walk of life. The prejudices of form are therefore the least solid ones; that is a good omen for the reformers here.

Metzinger's nude [fig. 11] and landscape are governed by a single desire for fragmentary synthesis. No ordinary cliché from the aesthetic vocabulary is suited to fit the art of this disconcerting painter. Let us consider the elements of his nude: a woman, a clock, an armchair, a pedestal table, a vase with flowers—that, at least, is the result of my personal inventory. The head, which has a very noble expression, is treated formally, and the artist seems to have recoiled before the full application of his law. In reality, a painting by Metzinger has the aim of encapsulating all the plastic material in a single aspect, and nothing more. Hence an art diametrically opposed to impressionism is born, with little interest in copying a chance cosmic episode, and which, in its pictorial plenitude, offers the beholder's intelligence the essential elements of a synthesis located in time [la durée]. The analytic relationships among the objects and their subordination to one another matter little now, since they are suppressed in the execution of the painting. They come to play a role after the fact, subjectively, in every individual act of thought.

I am afraid I will render this commentary obscure by trying to make it too explicit, and I apologize for sometimes using the aesthetic jargon favored by the gentlemen concerned.

Le Fauconnier's art is less distant, but stems from similar formulas. But, in applying these formulas to the particular case of the landscape, he makes accommodations, with some deference to the constraints of our vision. From this gray, rocky setting in Ploumanach [fig. 13] emerges a wise invitation with enough "signs" [affiches], "visions that assert themselves violently," "quivering slices of life," with enough notations and anecdotes.

A beautiful picture is only a proper balance, that is, a harmony of weights and a relation of numbers. Let the painter's eye be sensitive, not his paintbrush.

Great art would thus be the blossoming of an eternal canon within a transitory but imperious modality. Before the time of blind followers and the withering of formulas comes, genius is free to expand traditions in the direction of the classicism of the future.

The noble desire to work toward the restoration of a plastic canon also animates Albert Gleizes, even though, unconsciously, he is sometimes

the dupe of his own appearances and his own play. Gleizes's landscape [*Landscape* or *Sketch for a Landscape near Paris;* Varichon, fig. 350] could profitably be contrasted to Le Fauconnier's. In the latter, the balance is the result of an agreement, rich in harmonious dissonances, between colors integrated into volumes. Albert Gleizes, in contrast, sometimes displays unintentional decorative skills, and I doubt that this constraint is a definitive characteristic in his case. He concedes more, if not to charm, then at least to a certain desire to touch the beholder's memory directly.

I had the very clear impression, in looking at his canvas, of a course of treatment to restore sobriety after the debauchery of impressionism.

A sincere artist may well impose such a cure on himself, provided he does not pursue it for too long. In any case, what I know of Albert Gleizes's work inspires confidence in me.

In fact, I am sure of it, the names of these painters will be part of the authentic history of their art in the near future. With a clumsiness for which probity will be my excuse, I have attempted to say why. In conclusion, I would like to hope that, in full possession of their method and their law, they will reach that glorious stage where the artist of genius can indiscriminately, and with the usual and grandiose gestures of the century, confer style, the invisible dignity of kings, inexpressible royalty.

Roger Allard
NOVEMBER 1910

Commentary

The poet and critic Roger Allard (1885–1961) was an early supporter of the cubists, though he would later express reservations about the mercantilist motives behind Parisian "avant-gardism" (see document 71). Born in Paris, he resided in Lille during his youth and published his first book of poetry in 1902. Allard briefly joined the Abbaye de Créteil, where he met Mercereau and Gleizes (and published a book of poetry, *Les vertes saisons*); concurrently he and his Abbaye colleagues contributed to Léon Bocquet's Lille-based journal *Le Beffroi* (1900–1913). Between 1905 and 1906, *Le Beffroi* press published poems by Abbaye associates Paul Castiaux, Léon Deubel, Théo Varlet, Charles Vildrac, and Allard (his *La divine aventure* in 1905). In 1909–10 Allard solidified his friendship with Gleizes when the two collaborated in producing an illustrated book of Allard's poems, *Le bocage amoureux* (published in 1911; fig. 12) (Varichon, 106–77). Allard's connections with the Abbaye group continued through his involvement

OFFRANDE

U ne tardive encorbeillée
 De nos vendangeuses penchant
Le regret sur l'exil d'un chant
Loin dénoué par la vallée,

Les routes vont au fond du soir
Sous les robes de la dernière
Remuant l'ambre des lisières
Où vous croyez longtemps la voir.

73

12. Albert Gleizes, woodblock illustration for Roger Allard, *Le bocage amoureux, ou le divertissement des amants citadins et champêtres* (Paris: Eugène Figuière, 1911), 73. © Artists Rights Society (ARS), New York / ADAGP, Paris. Used by permission of McCormick Library of Special Collections, Northwestern University Library.

in *Les Bandeaux d'Or* (1912–14), and in Joseph Billiet's *L'Art Libre* (1909–13) (Cornell, 65, 89; Décaudin, 374–77; Sénéchal, 64–65, 101).

Allard's article in *L'Art Libre* (1909–11) was his first attempt to define the new movement (though he does not yet employ the term *cubism*). Having criticized the salon for resembling the Hôtel Drouot auction house, and the role of "commercial galleries" in dictating the privileged hanging of certain artists, including the fauve Othon Friesz, Allard quickly proceeds to the "reformers": Metzinger, Le Fauconnier, and Gleizes. Allard praises Metzinger's *Nue* (fig. 11) for heralding "an art diametrically

13. Henri Le Fauconnier, *Village de Ploumanach* (Ploumanach Village), 1910. Oil on canvas, 73 × 92 cm. Published in Roger Allard, "Sur quelques peintres," *Les Marches du Sud-Ouest* (June 1911): 57 [document 18]. The State Hermitage Museum, St. Petersburg (formerly Shchukin Collection). Used by permission of The State Hermitage Museum, St. Petersburg.

opposed to impressionism" by virtue of the artist's inclusion of the "essential elements of a synthesis located in time [*la durée*]." Contrasting the impressionist copying of "a chance cosmic episode" with Metzinger's grasp of "pictorial plenitude," Allard in effect endorses the durational concept of simultaneity developed in Metzinger's "Note on Painting" (document 11). Drawing on Le Fauconnier's "Das Kunstwerk" (document 10), he describes that artist's painting of Ploumanach (fig. 13) as achieving "a harmony of weights and a relation of numbers," before labeling Gleizes's *Landscape* (Varichon, fig. 350) a "decorative" work, indicative of his "desire to touch the beholder's memory directly." Referring to all three artists, Allard states that their radical innovations mark them as geniuses seeking "to expand traditions in the direction of the classicism of the future."

Allard's identification of aesthetic innovation with a future classicism alludes to Metzinger's own Bergsonian claim, in his "Note on Painting"

(document 11), that adherence to tradition entailed the constant invention of novel forms, rather than the servile imitation of past art (M. Antliff, 16–38; Cottington, *Cubism in the Shadow of War,* 60–67). Allard contextualizes Metzinger's defense of aesthetic novelty in terms of a Bergsonian critique, inaugurated by Metzinger's symbolist allies Joseph Billiet (editor of *L'Art Libre*), and Tancrède de Visan, of a notion of classicism they identified with the cultural views of the ultrareactionary Action française (M. Antliff, 25–37; Cottington, *Cubism and Its Histories,* 56–57). Having accused the royalists of promoting the arid imitation of past art, these writers utilized Bergson—a figure vilified by royalist Charles Maurras—to redefine *classicism.* Thus Allard's text signaled the cubists' intervention in a highly politicized debate over the meaning of the term *classicism* that animated political and literary factions from left to right before 1914 (Décaudin, 271–348; DeLeonibus, *Charles Maurras's Classicizing Aesthetics;* DeLeonibus, "The Quarrel over Classicism").

M. Antliff, *Inventing Bergson*
Cornell, *The Post-Symbolist Period*
Cottington, *Cubism and Its Histories*
Cottington, *Cubism in the Shadow of War*
Décaudin, *La crise des valeurs symbolistes*
DeLeonibus, *Charles Maurras's Classicising Aesthetics*
DeLeonibus, "The Quarrel over Classicism"
Sénéchal, *L'Abbaye de Créteil*
Varichon, *Albert Gleizes*

Jacques Rivière, "Exposition André Lhote.
(Galerie Druet)," *La Nouvelle Revue Française,*
no. 24 (July–December 1910): 806–8

André Lhote Exhibition. (Druet Gallery).

This first exhibition by a young artist is initially disturbing. Does not such a large number of extremely diverse works indicate that their painter lacks the stubborn preoccupation that makes genius? Is there not too much effort expended in not repeating himself, an overly skillful attempt to achieve richness through difference?

That is a legitimate reason to be wary, but it does not survive even the most cursory examination. This is not a calculated diversity, undertaken by an artist who would spend his time distributing a parsimonious originality among his canvases. It is, on the contrary, the diversity of someone who is obliged, by the very continuity of his endeavor, constantly to call everything back into question. His will is so determined, his purpose so clear, that he can never convince himself he has reached his object, and, at every instant, he discovers an entirely new path that will bring him even closer to it. The abundance of his work is no longer disconcerting once we understand that it is the undiscouraged pursuit of an ideal that, in becoming more refined, becomes more inaccessible the closer the assault comes. The disparity of his styles and the unexpectedness of everything he invents stem from the very monotony of his intention and, one might say, of his obstinacy.

But what is Lhote looking for? From Cézanne he inherited the love of construction. Nothing moves him so much as the arrangement of objects; he finds nothing more beautiful to represent than the way things are made, the distribution of their planes, the different and adjoining visages they offer to the unquantifiable rush of air. In him I rediscover the

delicious passion that made Cézanne, standing in front of a house, suddenly turn religious. Respect for the ridges—the divisions—of architecture, the regular angles and curves.

In Lhote's first canvases, the interest in construction leads only to poses that mutually support one another as it were. They are gently set one on top of the other, such as, in *Autour de la chanteuse* [*Around the Singer*], the man on the shoulders of a young girl, nodding his head. They fold into the center; they are balanced like crossed branches. They draw strength from the combination of their oblique angles (*Suite de gestes*) [*Suite of Gestures*]. But, gradually, they right themselves. They find the courage to stand apart. Lhote now sets out to construct every part of the painting: he shapes each body, each face, each object; he gives each its own volume and its own base. At the same time, the composition opens like a fan: the correspondences cease to be marked simply by the slant of the angles. A heavy, material equilibrium replaces the very ideal equilibrium of the arabesque. The beautiful bodies of *Jeux au printemps* [*Games in Spring*] can break loose with their free dance without fear of shattering their union; for they carry it with them. Lhote is not content to construct solids. He suddenly perceives an entirely new world, whose mobility he undertakes to fix. With a light hand, in the shadows, he will shape leaves, accentuate their subtle angles, draw out their fine backward slopes, and fashion their light, airy dwellings. The air itself is open to construction. The shapes of the objects, bathing in the air, trace subtle wakes in it. A few branches are entangled against the sky: immediately, it is as if the spaces between them fall into regular shapes. Lhote attempts to represent even the concave surfaces and swirls of air, even the smooth architecture of the atmosphere. Finally, the air, in becoming tangible, requires that the objects be constructed in a new way. It slides over their different faces and communicates its limpid uniformity to them. It makes the unnecessary protrusions and hollows disappear, obliterates the too-easy opposition between shadow and light. Hence the modeling is no longer achieved through variations in hue: the lines drawn mark fine ridges in the thick patches where the color is divided up, only to stream everywhere in great sheets, like a smooth wave. Hence the forms appear as robust as objects that, inundated by invisible waters, would be fashioned by the simplicity of their currents. The figure in *Femme en deuil* [*Woman in Mourning*], with the long vertical fold of the veil that divides

her face and body in two, stands firm and sleek, like the silent advancing of a ship's bow.

Jacques Rivière

1910

Commentary

In his review of the first one-man show of André Lhote (1885–1962), critic and essayist Jacques Rivière (1886–1925) developed the interpretation of Cézannism that would later inform his important critique of cubism, published in 1912 (document 37). Born in Bordeaux, Lhote studied decorative sculpture at the local École des Beaux-Arts and at a local atelier from 1898 to 1904; the following year he turned to painting, seeking to combine an abiding interest in the old masters with a newfound enthusiasm for Paul Gauguin, and later, Paul Cézanne. In 1906 Lhote met Rivière, and the two developed a friendship based on their mutual admiration for the Roman Catholic playwright Paul Claudel. In subsequent years Lhote gave pictorial expression to his conservative values: for instance his painting *La grappe* (*The Bunch of Grapes*; 1908) was inspired by a reading of Claudel's religious play *Tête d'or*. Lhote later recalled that the geometricity of this "vaguely gothic" painting signaled his allegiance to Cézannesque principles of solidity and compositional order that made his art a harbinger of cubism (Lhote). This synthesis of religiosity, traditional aesthetics, and modernism was found in other paintings of the period, such as Lhote's *Colloque des muses* (*Meeting of the Muses*; 1909) and his *Suite des gestes* (*Suite of Gestures*; 1909), a work praised by Rivière in his preface. By 1911 Lhote numbered himself among the cubists, and the following year he participated in the Salon de la Section d'Or, the first major cubist retrospective in Paris (Briend; Lucbert).

Rivière, in turn, played a major role in promoting Lhote's career. In 1908 André Gide and Eugène Montfort had founded *La Nouvelle revue française* (1908–43), and soon enlisted Rivière, the Catholic symbolist Maurice Denis, and Claudel as contributors. Historians have noted the close ties between the *NRF* and Adrien Mithouard's conservative journal *L'Occident* (1901–14); indeed Rivière, Denis, and Claudel had all contributed to that journal before the appearance of the *NRF* (Cornell, 86–89; Décaudin, 348–51). As Cottington has noted, Rivière's aesthetic preferences were informed by his alliance with right-wing, traditionalist factions in the *NRF* grouping, and it was this conservatism the led him to

celebrate Lhote's Cézannism (Cottington, " Cubism, Law and Order";
Cottington, *Cubism and Its Histories, 70–73*). "From Cézanne," Rivière
declares in his 1910 text, Lhote had "inherited the love of construction,"
and from Lhote himself one can "rediscover the delicious passion that
made Cézanne, standing in front of a house, suddenly turn religious."
By 1910 Lhote numbered Denis, Gide, and Rivière among his patrons,
and Claudel too was reportedly won over after encountering Lhote's *Suite
des gestes* (1909) at Rivière's residence (Lhote). Claudel's neo-Catholicism
also had a profound impact on André Derain, whose painting after 1910
was indebted to the religious art of the Italian Renaissance, and whom
Rivière would later praise, along with Lhote, in his 1912 critique of cubism
(Lee, 35–45; document 37).

Briend, "Lhote, 'l'imagier' du cubisme"
Cornell, *The Post-Symbolist Period*
Cottington, *Cubism and Its Histories*
Cottington, "Cubism, Law and Order"
Décaudin, *La crise des valeurs symbolistes*
Lee, *Derain*
Lhote, *André Lhote*
Lucbert, "Lhote aux expositions de la Section d'or (1912–1925)"

Henri Guilbeaux, "Exposition Pablo Picasso (Vollard, rue Laffitte)," *Les Hommes du Jour* (7 January 1911): n.p.

Pablo Picasso Exhibition (Vollard, rue Laffitte)

I am told that Mr. Picasso is prepared to abandon the path of error he has been following for some time. That would be for the best, since he is a very gifted painter. And then the only cubists and subcubists remaining would be those whom Mr. Charles Morice could unite into a gang and conduct to the dinner of the Fourteen (alias the Arena dinner, or even the dinner of *Human Celebration*).

Mr. Picasso, having done more than show promise, began one day totally to abdicate his personality. He imitated the Spanish masters and others, and he fancied himself the humble successor to the primitives.

What he offers us today accentuates the intentional distortions, which sometimes reach the level of the grotesque, the ugly. Careful studies of nudes; gestures, postures taken from notorious painters and sculptors; anatomies, visible by design under the folds of fabric; an excessive disproportion of certain bodily members, which sometimes produces a fairly intense effect.

The young, nude ephebe holding a youngster on his shoulder is quite nice; his members are fully formed and his phallus already vigorous.

The old musician and the woman doing her ironing are making the identical gesture—head thrown back, shoulder lifted; quite simply, they smack of the study.

And there are women with unappetizing flesh, who, thanks to the painter's whim, are monstrous or grotesque.

Henri Guilbeaux

7 JANUARY 1911

Commentary

As this review makes clear, cubism met with opposition among cultural arbiters on the political left as well as the right. Henri Guilbeaux (1884–1938), a self-declared anarchist with ties to syndicalism, is exemplary of those among leftists who were skeptical of the movement. He regarded cubist aesthetics and theoretical pronouncements as no more than a publicity stunt designed to baffle critics and public alike, create a well-publicized scandal, and, in the last analysis, nurture sales (Weiss, 85–87). No catalog exists for the Ambroise Vollard exhibition, though we know—not least from Guilbeaux's comments—that a cross-section of Picasso's art from the Blue and Rose periods was on display, including *Family of Saltimbanques* (1905) and *Woman Ironing* (1904) (Breunig, 124–25, 486). Guilbeaux numbers Picasso among the "primitives" by virtue of his "intentional distortions, which sometimes reach the level of the grotesque, the ugly." To his mind such primitivist distortions culminated in cubism, a position he shared with critics such as Guillaume Apollinaire and Louis Vauxcelles (M. Antliff and Leighten, 46–63; Leighten). Guilbeaux, who disliked cubist primitivism, holds out the hope that Picasso is now "prepared to abandon the path of error" developed by "cubists and subcubists."

Guilbeaux's position on cubism contrasted dramatically with leftists associated with the journal *Action d'Art* (1913), who endorsed the very cubist avant-gardism condemned by Guilbeaux in the name of anarcho-individualism (M. Antliff, *Inventing Bergson*, 135–55; M. Antliff, "Cubism, Futurism, Anarchism"). Although Guilbeaux rejected cubism in the anti-militarist weekly *Les Hommes du Jour* (1908–23), he did not dismiss modernism as such; indeed he championed the aesthetic of Paul Signac and the neoimpressionists as a more legible art able to galvanize the masses and inspire political ideals close to Guilbeaux's own (M. Antliff, "Their Country," 75–76; Cottington, 146–47).

Ironically Guilbeaux himself was a poet who, in 1910, founded his own avant-garde movement, known as dynamism. Born in Belgium of French parents, Guilbeaux was a Germanophile who sought to promote the spirit of working-class solidarity and internationalism through his poetry and criticism. Thus dynamism celebrated the beauty and energy of the people, in particular the "heroism" of modern agrarian and industrial workers. Guilbeaux found precedents for his doctrine in the poetry of the American Walt Whitman, the Belgian Émile Verhaeren, and the

Germans Richard Delmel and Johannes Schalf. During World War I, Guilbeaux sided with the pacifist movement, but went even further by endorsing the revolutionary Marxist position on the war advocated by Lenin. Having settled in Switzerland, Guilbeaux propagated his views through the journal *Demain: Organe du Groupe Communiste Français de Moscou* (1916–18); in 1918 he was arrested twice, and in 1919 was deported to the Soviet Union. Condemned to death in absentia by a French military court, Guilbeaux remained in Moscow until 1922, then settled in Germany before returning to France in 1932, where he was acquitted of treason after a brief period in jail (Goldberg, *En l'honneur de la juste parole,* 211–30). Before his death in 1938, Guilbeaux underwent a political evolution from communism to a version of Italian fascism, based in part on the "collectivism" that underlay his poetry (Goldberg, "From Whitman to Mussolini," 153–73).

M. Antliff, *Inventing Bergson*
M. Antliff, "Cubism, Futurism, Anarchism"
M. Antliff, "*Their Country*"
M. Antliff and Leighten, *Cubism and Culture*
Breunig, ed., *Apollinaire on Art*
Cottington, *Cubism in the Shadow of War*
Goldberg, *En l'honneur de la juste parole*
Goldberg, "From Whitman to Mussolini"
Leighten, "The White Peril and *l'Art nègre*"
Weiss, *The Popular Culture of Modern Art*

J. C. Holl, "Une enquête sur l'orientation da la peinture moderne. Part 2: Le Fauconnier," *La Revue du Temps Present* (2 May 1911): 466–67

An Inquiry into the Orientation of Modern Painting.
Part 2: Le Fauconnier

A theorist, categorized as a member of the "fauves" group, allowed himself to be taken in by such formulas as cubism, for which Mr. Metzinger, of hilarious memory, is the dedicated promoter . . . until something better comes along.—J. C. Holl

I admit I do not share your pessimism about the latest phases of modern French painting. The evidence of efforts by artists to outdo one another seems unconvincing but inevitable to me, and so inevitable that there have always been Henners and Ziems, to mention only the most recent ones.

If there is uncertainty, contradiction, or weariness, I see these states of mind much more in the public than in the true artists, and without the artists being in any way responsible for them. And, if it were necessary to give the cause, I would be likely to point to a misunderstanding of the true meaning of the plastic arts.

The public is more inclined to be amused in the presence of works of art than to seek to penetrate their profound essence and, as a result, to enjoy them at a deeper level.

Yesterday's public was like that, which accounts for their very belated discovery of Cézanne, whose lofty artistic consciousness chose not to lend itself to such passing amusements. Cézanne had, among other things, the great merit of not dwelling on the temporary fluctuations of taste (by which I mean even the best taste) and of going back to the fundamental principles of the pictorial tradition, adapting them to his own means of expression.

The day art lovers rediscover Poussin's *Enlèvement des Sabines* [*Rape of the Sabines*], Ingres's *Apothéose d'Homère* [*Apotheosis of Homer*], and David's admirable *Sacre* [*Coronation*], they may realize that there are painters of their own time who, far removed from any exoticism, symbolism, or neoclassicism, are serenely working within the most profound French tradition.

<div style="text-align: right">

Henri Le Fauconnier

2 MAY 1911

</div>

Commentary

J. C. Holl's satirical presentation of Le Fauconnier as a former fauve, now "taken in by such formulas as cubism," was in keeping with that critic's hostility toward the avant-garde, as manifest in his criticism for *Les Hommes du Jour* (Weiss, 87). Nevertheless, Le Fauconnier's response to Holl's "Inquiry" is testament to the ongoing debate over matters of "tradition" in cubist circles. In this brief statement Le Fauconnier makes clear his own study of his artistic forebears, albeit filtered through the lens of Cézanne. Le Fauconnier praises Cézanne for having ignored the proclivities of contemporary taste in order to return to "the fundamental principles of the pictorial tradition." Cézanne then adapted these principles "to his own means of expression," thus avoiding any slavish imitation of past art. For this reason Cézanne, like "[Nicolas] Poussin," "[Jean-August-Dominique] Ingres," and "[Jacques-Louis] David," was a painter of his own time who nevertheless worked "within the most profound French tradition." As David Cottington has pointed out, Le Fauconnier had embarked on a kind of Cézannesque "apprenticeship" the previous year by adapting the latter's "classicizing geometry" in paintings like *L'Ile Bréhat* (1910) (Cottington, 91–93). In 1911, Le Fauconnier copied a Poussin in the Louvre before traveling to Italy to study Raphael—a sure indication of his avid interest in the old masters (André Salmon, "La Palette," *Paris-Journal*, 5 July 1911, p. 4; cited in Cottington, 99).

By proclaiming self-expression, tempered by "fundamental principles," adherence to the French tradition, Le Fauconnier endorsed the Bergsonian notion of a "future classicism" advocated by his peers, Jean Metzinger and Roger Allard (M. Antliff, 16–38; Cottington, 60–67; 93–95; documents 11 and 12). Moreover, unlike André Lhote, Maurice Denis, and Jacques Rivière—who also wedded Cézanne to the French tradition—Le Fauconnier's interpretation was devoid of what Cottington

refers to as the "explicit political and religious allegiances" that animated artists and critics affiliated with Adrian Mithouard's journal *L'Occident* (1901–14) (see document 13). Cottington nevertheless concludes that Le Fauconnier's reference to Poussin, Ingres, and David indicated his qualified endorsement of "the exclusive latinist and rationalist classicism promulgated by Maurras" (Cottington, 91). In fact, as Neil McWilliam has recently demonstrated, the Action française condemned David's and Ingres's classicism as anathema to their version of the French tradition; thus Le Fauconnier's enthusiasm for these two artists is testimony to his rejection of, rather than allegiance to, the cultural politics of Charles Maurras and his allies (McWilliam).

M. Antliff, *Inventing Bergson*
Cottington, *Cubism in the Shadow of War*
McWilliam, "Action française, Classicism, and the Dilemmas of Traditionalism in France, 1900–1914"
Weiss, *The Popular Culture of Modern Art*

Marius de Zayas, "Pablo Picasso," *América, Revista Mensual Illustrada* ([New York,] May 1911): 363–65

Pablo Picasso

I don't believe in art criticism, especially when it deals with painting.

Everyone has the right to express his opinions on art, to applaud or censure, based on his personal way of seeing and feeling, but not on his authority or his pretension to possess absolute truth, or even relative truth, and only if he doesn't judge according to established rules on the pretext that they are consecrated by use and by the verdict of higher authority.

Between a civil or criminal judge and a critic, there is a big difference. A judge judges according to the law; he doesn't judge the law itself. He has to submit to the letter and spirit of the law, even if he disagrees with it, because the law is an indispensable rule of conduct, dictated by society, and we all must submit to it. On the contrary, art is free. It has not had, nor will it ever have a legislator, in spite of the academies, and each artist is within his rights to interpret nature as he likes, or as he can, and the public is free to applaud or reject the work.

All critics are priests of a dogma, of a system, and they implacably condemn what is outside their faith—a faith not based upon reason but blindly imposed. They never stop to consider the personality of the artist whose work they judge, or inquire by what tendency, or purpose, or effort the artist reaches his object or, indeed, whether he has reached it.

I have dedicated my life to the study of the arts, principally painting and sculpture. I believe that I have seen with deliberation what is worth seeing, what should be seen, but I have never presumed to judge whether the work is good, even if it is signed by the most famous artist, nor have I declared a work bad, even if it is by someone completely unknown. The

Translated from the Spanish by Lois Parkinson Zamora.

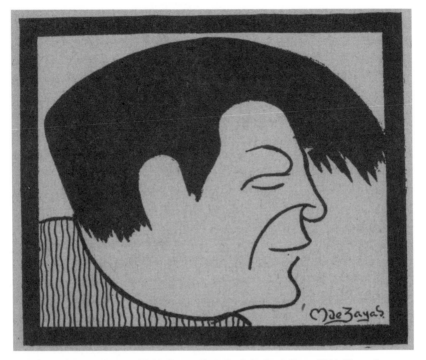

14. Marius de Zayas, caricature of Pablo Picasso. Illustration in Marius de Zayas, "Pablo Picasso," *América, Revista Mensual Ilustrada* ([New York,] May 1911): 365 [document 16]. Used by permission of Harvard College Library / Harvard University.

most that I venture to say is whether I like the work or not, and explain the *personal* motives for my *impression*. Sometimes when I look at a painting or a statue, my sense of humor prompts me to joke, as I joke with a pencil when I draw a caricature [fig. 14]. But I realized that when I draw a caricature, I don't say to the public that "so-and-so looks like this" but rather that "this is how I see so-and-so through my caricaturist's lens."

I will go even further. Academic critics benefit no one. On the contrary, they weigh down the wings of the creative spirit; they discourage, humiliate, and kill those who are weak enough to listen to them.

Nothing is more absurd than to think that because Phidias sculpted in a certain way, that this is how one should sculpt now and forever, to the end of time. Or because Rafael painted in a certain way; or because Horace wrote poetry in a certain way, that this is how all poets should write. If this narrow view had prevailed, our museums would be filled with Jupiters, sacred families and madonnas, and our libraries with *bea-*

tus ille. . . . Michelangelo would not have sculpted his Moses, Rembrandt and Franz Hals would not have left their beautiful canvases, or Shakespeare his *Hamlet;* nor would Victor Hugo have filled the entire nineteenth century with the magnificent sound of his lyre.

Every period has its artists, and must have its own art, as each also has its scientists and its science, and anyone who tries to oppose this—like a dike against the rising sea of human genius—is either perverse or foolish.

To put it bluntly, this passion for artistic dogma, this tendency of the academy to constrain, suffocate, and degrade, causes great damage in the countries where it exists. It has been an obstacle to the progress of art in Spain, where artists who are original and possessed of a restless spirit—which is how the true artist must be—either perish or emigrate to Paris. They seek more propitious surroundings, and though there is an academic sect here, too, that suffocates artists and proclaims that it holds the key to salvation, art has nonetheless managed to achieve an independence that allows all kinds of daring and experimentation. Here, art fights openly, no holds barred, against scholasticism, and pays no attention to its pompous proclamations and inoffensive epithets.

Say what you will, art isn't dead in Spain, or anyway, not among Spaniards. Tradition, or rather intransigent traditionalism, is slowly disappearing, the proof of which is the notable number of Spanish painters who live in Paris and who prosper, achieve enviable fame, and will end up among the glories of France instead of adding their illustrious names to the long list of distinguished Spanish artists.

I intend to make these artists known in America, to describe the work of each one of them, not as I see or feel or understand it, but as each of them conceives it. This undertaking is not anti-Spanish; I love Spain too much to mount an adversarial crusade. On the contrary, I judge it to be eminently Spanish, to claim for our people the place that belongs to them, to which they have legitimate right: to claim the spirit of genius of their sons, who today carry the artistic banner of Spain to the world with as much glory as the Castilian regiments carried it to the battlefield in earlier times.

Today I want to speak of PABLO PICASSO, from Málaga, who is foremost among innovators, a man who knows what he wants and who wants what he knows, who has broken with every scholastic preconcep-

tion, who has opened an ample path and gained the notoriety that is the first step to glory.

Is he known in Spain? Yes. Are his efforts appreciated and his work studied? I don't know. The only thing I do know is that he is a Parisian personality, which is already a stamp of glory.

I have studied Picasso's art and I have studied the artist, which isn't difficult since he is a sincere and spontaneous man who makes no mystery of his ideals or the procedures he follows in order to paint them.

Picasso aims to produce in his works an impression, less by means of the subject matter than by his way of interpreting it. He receives an impression directly from external nature, he analyzes it, develops it, translates it, so to speak, and then he executes it in his particular style, with the aim that the painting present the pictorial equivalent of the emotion that nature produced in him—take note: *the emotion.* He presents his work so that the spectator may seek and find in it not the spectacle, but the emotion engendered by it.

It is a short step to the psychology of form, and the painter has taken that step resolutely and deliberately by devising a psychology of form (not of physical objects) that inspires in him geometric sensations by virtue of his special temperament.

When he paints, he doesn't limit himself to those planes of a body that the eye perceives, but offers all of the planes he believes to constitute the individuality of the form, and in his peculiar fantasy he develops and transforms them to suggest new impressions, which he reveals with new forms such that the presentation of one being gives birth to another represented form distinct from the first.

Each of his paintings is the coefficient of the impressions that the form has created in the spirit of the artist, and in each painting the public should see the embodiment of an artistic ideal, and should judge it by the abstract sensation it conveys, without endeavoring to find the factors that entered into the composition of the whole.

Since the aim is not to perpetuate on canvas an aspect of external nature nor to fix the memory of a present sensation, but rather to represent by means of the paintbrush the impression that the artist receives directly from nature and synthesizes by means of his fantasy.

Perhaps my explanations seem overly subtle, but not so. Instead, I err on the side of clarity, trying to make the intangible tangible.

Picasso has a very different conception of perspective from that current among traditionalists. To his way of thinking and painting, a form should be represented according to its intrinsic worth and not in relation to other figures. It seems wrong to him that a child should appear larger than a man, just because the child is in the foreground and the man is in the background. This perspective of *distance,* to which academic art subordinates everything, seems to our artist useful for a topographic or geographical map but completely false and useless to a work of art.

In Picasso's paintings, there is no perspective but rather harmonies suggested by the forms and successive planes that fill the rectangle of the canvas.

Following the same philosophical system with respect to light, which he uses to paint form, there are no colors but rather the effects of light. This produces in his bodies certain vibrations, and these in turn produce certain impressions. His paintings thus depict the evolution of form and light in his brain, an evolution that produces the idea, and in turn, the composition, which is the expressive synthesis of his emotions.

Those of my readers who have studied Egyptian art carefully and without Greco-Roman prejudices know that the sons of the Nile and the desert wanted their art to express an ideal, conceived through meditation and solitary ecstasy beside the mysterious river. Thus they converted the ideal into substance, which in turn reflected essence. Something like this happens in Picasso's work, where an artistic representation of the psychology of form attempts to grasp the essence of what seems to exist, at most, in substance.

When we contemplate part of a Gothic cathedral, we feel ourselves possessed by an abstract sensation, the result of a complex of geometrical figures whose significance we don't perceive and whose real form we don't understand. Picasso's paintings tend to produce an analogous effect, impelling selves and objects toward abstraction. Their representation is the highest point to which his imagination can take us by means of geometric morphology.

According to Picasso, all peoples in their artistic beginnings have represented form through a fantastic lens, modifying it in order to adapt it to the ideas they want to express. In short, all peoples have pursued essentially the same artistic ideal with similar techniques, the sum of which constitutes their intellectual "I."

Of what value is this theory? The same as any other. It is not my concern or my purpose to evaluate it. It is enough to draw it to the attention of those who are interested in the current artistic movement, to show them the most visible part of its evolution, and make clear the tendencies affirmed by sincere observers. There is not, nor has there ever been, an art critic capable of considering and assessing the value of contemporary art. They are inside the movement without realizing it; like people on a speeding train, they don't realize the distance they're traveling; they think that the train is standing still and it is the landscape that recedes before their eyes.

I repeat, I am not an art critic; rather, I describe the artistic movement that I observe. I present facts, allowing everyone to draw the conclusions he wishes.

Picasso doesn't give a fig about public opinion. Like all true artists, he thinks and paints for himself, responding to his intimate desires, working to satisfy the insatiable need of his spirit. If the majority of the public doesn't understand his paintings, it may be because they see in art only what they have been taught to see, and they can only enjoy art when they find what they expect to find beforehand—elements that correspond to the usual molds. Another part of the public, precisely those who consider themselves enlightened, refuse to see what this artist feels and wants to express. They seek only what those who influence them are accustomed to feeling and expressing in their preconceived ways, according to what they have been taught.

Both groups, recognizing the challenge to their habitual ways of seeing, feel themselves defrauded, but instead of blaming their own lack of artistic intelligence and analytic sense, they condemn the artist because he commits the unpardonable sin of seeing with his own eyes, of feeling with his own soul, of thinking with his own brain, of being one with himself, of pursuing a new ideal, of opening new paths, of loving his own style and expressing his love in rhymes, rhythms and special vibrations, emanations of a daring soul who needs something of infinity to create his own space, and something of eternity to create his own time.

Commentary

Marius de Zayas (1880–1961) was an important figure in the American avant-garde (fig. 14). A bilingual Mexican artist, caricaturist (some were

published in *Les Soirées de Paris* in summer 1914), and writer, he was close to Alfred Stieglitz and his circle and published in *Camera Work* (Camfield). He played a key role in facilitating the exhibition of Picasso's work at Stieglitz's Little Galleries of the Photo-Secession ("291") in April 1911, the occasion of this text (a shorter and more well-known translation appeared in pamphlet form during the exhibition). He wrote two books in the prewar period: *A Study of the Modern Evolution of Plastic Expression* (New York: "291," 1913) and *African Negro Art* (New York: Modern Gallery, ca. 1916). De Zayas spent the summer of 1914 in Guillaume Apollinaire's company in Paris, when the poet was publishing his first calligrams (documents 76 and 77). From March 1915 to February 1916, de Zayas served as director of the short-lived but influential review *291*, during which period he introduced visual poetry to the United States (Bohn, "The Abstract Vision of Marius de Zayas") and became director of the Modern Gallery in New York.

De Zayas published a well-known interview with Picasso in 1923 ("Picasso Speaks," *The Arts* [May 1923]: 315–26), but this Spanish-language article by de Zayas published during the cubist period has been overlooked.[1] Like many of the documents in this anthology, its themes would not have made sense in any strictly formalist interpretation of Picasso's work, but de Zayas's sympathetic understanding of and personal commitment to avant-gardism—combined with the fact that they were able to speak their native language—give this document considerable interest. De Zayas begins by positioning himself against art criticism, which is of necessity always behind the times, and in favor of letting artists do what they want: "art is free." He echoes Apollinaire, whose writings on art were ubiquitous in his Parisian circles, by supporting the free expression of any period in opposition to academic rules of art: "Every period has its artists, and must have its own art, as each also has its scientists and its science." Like Picasso a highly intellectual anti-intellectual (Leighten), he laments the state of tradition-bound art in Spain and proposes to convey to Americans what Spanish artistic exiles in Paris are doing, beginning with Pablo Picasso.

Both the primitivist underpinnings of cubism and the perceptual relativism of the cubists come through in de Zayas's article. Picasso is "sincere and spontaneous." According to de Zayas, Picasso asserted that "all peoples in their artistic beginnings have represented form through a fantastic lens, modifying it in order to adapt it to the ideas they want to express.

In short, all peoples have pursued essentially the same artistic ideal with similar techniques, the sum of which constitutes their intellectual 'I.' " This concept levels cave art and Raphael, and ends on a Nietzschean note, an important aspect of Picasso's work from his Barcelona period through the prewar period (Leighten). (This contrasts strikingly with Picasso's surrealist-influenced comments of 1937 to André Malraux—conjuring with "exorcism," "disgust," "magic," and the "unconscious"—frequently yet inappropriately referenced for his attitude toward the "primitive" in the period of *Les Demoiselles d'Avignon* [1907] [Malraux; Rubin]). At the same time, Picasso follows a new "philosophical system" in approaching perspective and light, rejecting tradition in favor of "the synthetic expression of his emotions": "He presents his work so that the spectator may seek and find in it not the spectacle, but the emotion engendered by it," and de Zayas concludes, "It is a short step to the psychology of form, and the painter has taken that step resolutely and deliberately." This wedding of expressionism to a new "philosophical system" and "the psychology of form" indicates de Zayas's—and by implication Picasso's—allegiance to the wider cubist circle, from Georges Braque's statement to Gellett Burgess in 1908, to the discussions of Henri Bergson, William James, and the "new geometries" at Gertrude Stein's soirées, to Jean Metzinger's and Albert Gleizes's early writings (documents 3 and 11; commentary for document 6). Themes equally germane to Parisian and New York avant-gardism (A. Antliff)—including fierce individualism and antiacademicism—thread through de Zayas's presentation of Picasso's art, presenting cross-cultural challenges to its interpretation.

EDITOR'S NOTE
 1. My sincere thanks to William I. Homer for sharing this document with me in the early 1980s.—PL

A. Antliff, *Anarchist Modernism*
M. Antliff and Leighten, *Cubism and Culture*
Bohn, "The Abstract Vision of Marius de Zayas"
Bohn, *The Aesthetics of Visual Poetry,* 1914–1928
Camfield, *Francis Picabia*
Leighten, *Re-Ordering the Universe*
Malraux, *La tête d'obsidienne*
Rubin, "Picasso"

Cyril Berger, "Chez Metzi," *Paris-Journal*, 29 May 1911, p. 3

At Home with Metzi

Again this year, Room 41 of the Salon des Indépendants, the sanctuary of cubism, is dispensing an incomparable emotion to its visitors.

One work above all commands attention. On a frameless canvas stands an Eiffel Tower [fig. 15] of an alarming beauty; cut up into irregularly reassembled pieces, it is melting, buckling, coming to dizzy life, falling to pieces, shouting, between two piles of houses that encircle and clutch it tight, to the point of suffocation.

I felt I had before me the most complete manifestation of art in our modern times and, no doubt, in all times. An aspiring cubist, with whom I shared all my confusion, told me: "If you want to understand completely, go see Metzi. He is both a great artist and the official theorist of the group."

I went to see him at once.

"A school's raison d'être," said the master, a very young man with limpid eyes, "lies in the search for a standard of unprecedented beauty. What we need is to try to express reality by never-before-used signs. And the artist must not only create that standard of beauty, he must also impose it. Believe me, the day will come when the only women declared beautiful are those of a type that reminds people of the cubist ideal fashioned by us."

"And what is cubism?" I asked, my voice choking on emotion. "What is its essential significance?"

"Our formula is to set aside all the accidental, complex forms and to retain only the fundamental and purely geometrical forms. That is why, to paint, we juxtapose cubes, squares, triangles, diamonds, parallelograms, trapezoids, pyramids, cylinders."

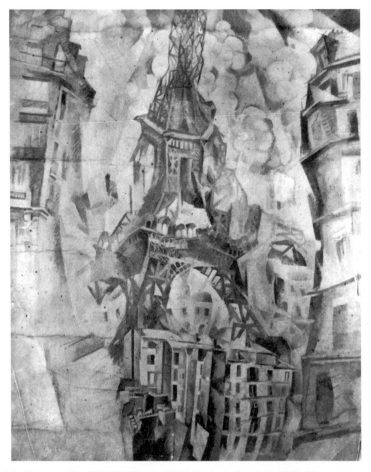

15. Robert Delaunay, *Tour Eiffel* (*Eiffel Tower*), 1910 (Salon des Indépendants, 1911). Oil on canvas. Illustration in Roger Allard, "Sur quelques peintres," *Les Marches du Sud-Ouest* (June 1911): 63 [document 18]. Destroyed in 1945. © L&M Services B.V. Amsterdam 20050801. Used by permission of L&M Services.

"Sir," I ventured timidly, "your school has magnificently displayed its contempt for the major laws governing drawing. I cannot formalize them in any way—nevertheless . . ."

"Do not be too surprised," he responded, "to see in our works the contours of certain forms bristling with edges, which are the tips of cones or of triangles, or to see entire members distorted by certain rotundities of surface . . . That, basically, is not of great importance. The need to create

a rhythm subordinates the concern for pointless resemblances. Without doubt, one needn't exaggerate. Even as one must not put three arms on a woman, even if that would emphasize her expression. There are situations when you have to know how to resist your own genius."

I then steered the conversation to the canvas that had made such a strong impression on me.

"Yes," he told me, the Eiffel Tower by Nouveauney [Robert Delaunay].... Yes . . . it is a work of magnificent intuition."

"On that canvas," I observed, "Nouveauney has, so to speak, appended two enormous cubes of houses to the monument, and the houses are so tall they almost come up to the last platform. How do you explain that?"

"It's very simple. In bringing the houses closer together, the painter has eliminated the awkward empty spaces; by adding height to them, he has suggested a softer, more harmonious curve between the top of the houses and the tower's summit. And then, in reality, dimensions, relationships, have only a relative value. Since, given the infinite divisibility of the line, no one can prove the absolute equality of two lengths, no one can sustain that the houses next to the Eiffel Tower are not as tall as it is."

"What about the distortion inflicted on the monument?"

"That's an old prejudice you have to shed. Objects are not immutable. Everything moves, everything in nature is crawling with life, the Eiffel Tower like everything else. Run around it and you'll see that it runs. So to want to represent it motionless and all in one piece, as on postcards, is quite nonsensical. In truth, what did Nouveauney do? He cut it into four parts; after which, he reassembled the pieces, being very careful not to juxtapose them and to leave large gaps between them. He could have even intervened and put the summit at the base and the pillars at the top. In that way, he might have produced a disconcerting monument."

"Disconcerting but sublime!"

"Our major preoccupation, you understand, is to arrive at a total image that is the subjective representation of the object. Take a portrait. If it is from the front that the character of the figure is most apparent, but there is in the structure of the nose, for example, an important characteristic element that can be seen only in profile, the painter has the right to place his nose in profile on the figure viewed frontally . . . Now, to extenuate that little infraction of the rules of anatomy, he has only to paint the nose black or red. In that way, he replaces the anatomical equilibrium he destroyed with a plastic equilibrium of a new kind."

"Admirable!" I exclaimed.

"Until now," he continued, "we have been condemned to paint only empty things, corners of studios, little bits of landscapes: what I would like is to tackle great official paintings . . . I dream of capturing through our procedures grand ceremonies, unveilings with the President of the Republic, assemblies, the Tsar in the middle of his Court . . . or then again, military revues, battle squadrons . . . It is to us that this returns by right. Because, you see, the art of the official salons is the vastest, the most monstrous hoax, the crudest farce that has ever been committed."

He gave me a deep, penetrating look and added: "On the whole, all those people are madmen."

Then he resumed in a more ardent voice: "We cubists have only done our duty by creating a new rhythm for the benefit of humanity. Others will come after us who will do the same. What will they find? That is the tremendous secret of the future. Who knows if some day, a great painter, looking with scorn on the often brutal game of the supposed colorists and taking the seven colors back to the primordial white unity that encompasses them all, will not exhibit completely white canvases, with nothing, absolutely nothing on them."

I retreated at that point, distraught.

Cyril Berger

29 MAY 1911

Commentary

In the wake of the *succès de scandale* of the 1911 Salon des Indépendants, cubism attracted the interest of a broader public, as evidenced by Cyril Berger's interview with Metzinger. Berger's decision to consult Metzinger, whom "an aspiring cubist" designated "the official theorist of the group," stemmed from the disorienting impact of cubism on Berger, exemplified by his tongue-in-cheek reaction to the "frameless" *Tour Eiffel* (1910–11; fig. 15) by "Nouveauney" (Robert Delaunay). Berger, like many other critics, took the cubists' rejection of verisimilitude as indicative of the rising tide of "theory" and conceptual "formulas" in modern art. This view of modernism probably had its origins in critical reactions to the "scientific" underpinnings endorsed by the neoimpressionists, and later claims that Henri Matisse's fauvism constituted yet another example of "theory" overwhelming traditional "praxis" (Benjamin, 1987). As Jeffrey Weiss has demonstrated, the very "geometricity" of cubism lent itself to

this interpretation: indeed Weiss cites an explosion of such criticism after the Salon d'Automne of 1910, beginning with Paul Reboux's claim, in November, that none other than Metzinger was the chief "theoretician" among the fauves (Reboux; Weiss, 73–82).

Responding to Berger's queries, Metzinger reiterated precepts first outlined in his "Note on Painting" of October 1910 (see document 11). Once again Metzinger highlights modernism's vanguard role in establishing new canons of beauty by means of "never-before-used-signs"; the function of these signs in creating a new plastic "rhythm," attuned to an artist's subjective reaction to a motif; and the role of "intuition" in Delaunay's own exploration of such aesthetic issues in his *Tour Eiffel*. Metzinger concludes the interview with the (then) audacious claim that some future generation might take abstraction to its logical conclusion by abandoning representation altogether and returning the colored spectrum to its "primordial" condition by exhibiting "completely white canvases." Two years later Metzinger's vision was realized in the satirical manifesto "Amorphism," possibly written by Francis Picabia (published in *Les Hommes du Jour,* 3 May 1913; see document 64). The latter text has been identified as a send-up of Apollinaire's 1912 doctrine of "pure painting" (Apollinaire in Breunig, 197–98; cited in Weiss, 87; document 59), but its author could just as well have had Metzinger in mind when he justified amorphism's blank canvases by claiming "light is enough for us."

Apolliniare, "Du sujet dans la peinture moderne"
R. Benjamin, *Matisse's "Notes of a Painter"*
Reboux, "Revue des revues"
Weiss, *The Popular Culture of Modern Art*

Roger Allard, "Sur quelques peintres," *Les Marches du Sud-Ouest* (June 1911): 57–64

On Several Painters

For any curious and impartial observer, there can be no doubt that painting, of all the arts, currently occupies the most advanced point on the ideal evolutionary curve. In fact, if one concedes that the loftiest assertions of the plastic arts were built within logic and consciousness— and how can one fail to do so?—one thing is clear: the masters, authentic inventors of canons, ephemeral but age-old in their genius, have almost everywhere outpaced the meditations of philosophers and the words of poets, thanks to the prestige of a few colored strokes.

Without pointless scholarly retrospection, let us take in the seventeenth-century French garden at a glance. Next to Racine's noble and pure portico *Bérénice* stands the *Triomphe de Flore* [*Triumph of Flora*]. On the one hand, the end point, the synthesis, the maximum tension of an adult art. On the other, the same irreproachable maturity, a no less perfect objectivity, but swelling with the possibility of flight.

Some forms of beauty tolerate the ornaments of a charm born of fashion. In the vicinity of their accessible perfection, they excite the taste, intelligence, and secondary gifts that nature has always lavished on pasticheurs.

A few of them—but oh, so few—look so unlike *our* lives, make gestures so different from those we *believe* to be alive, that we are likely to look upon them as dead beauties.

But they are false ruins, and, as soon as the procession of skillful imitators has vanished, the architect of genius comes along and continues the still-unfinished arch, like that of a sublime bridge connecting one age to the next.

Next to that exemplary lesson, what is the worth of the puerile sophisms that the exploiters of fashion raise as objections to every renaissance?

And yet, have not these exploiters, with the naive complicity of a nation of sheeplike art lovers, attempted to cover over the tracks and to create such a confusion that it has become almost impossible to find, in the current chaos, *the directions of painting*?

This study, in fact, is dedicated to a determination of them. I have chosen to make it schematic: it may be incomplete. Upon reflection, my excuse lies in the difficulty of synthesizing sometimes contradictory movements.

Some may be astonished, others will feign astonishment, in the presence of the names they read here. I do not even dare hope that everyone will grant me the benefit of the doubt. But the impartial reader of these preliminaries will no doubt perceive, and this is the essential thing, the spirit of objective determinism that presides over the critical essays that follow.

At the 1910 Salon d'Automne, a landscape by Le Fauconnier [fig. 13], another by Albert Gleizes, and a third by Metzinger expressed in diverse ways a common postulation of an artistic renaissance, a notion surely inaccessible to the tendencies of the contemporary painters who are called avant-garde, in a childishly bellicose metaphor.

The influence of Cézanne on these artists, and on others to be discussed later, is manifest. But once this observation has been made, it is important to prevent any ambiguity. Cézanne rediscovered a certain number of pictorial truths, or rather, a single truth with multiple aspects. Amid the sickly exhaustion of secondary formulas, he stood tall like a tree coming back to life, renewed by the true tradition, to which we are indebted for Poussin, Lorraine, Ingres, and Corot. . . . But painters attentive to the suggestions of a vulgar or prettified sensualism have perceived in him only an original collection of minor variants, which they have assimilated and used with equal unawareness. It would be an easy trick to illustrate this assertion with many examples, but pointless for the present study. The artists to whom this study is dedicated have been able, contrary to so many others, and because they were seeking only a subjective benefit, to find in Cézanne's work a lesson and an encouragement.

In terms of influence, I would not be doing an injustice if I omitted Pablo Picasso and Braque.* The violent personality of the former lies

* I would have if Metzinger, by nature delicately literary and very impressionable, had not avowed, long ago, having seen the work of these artists [Braque and Picasso]—who remain formidable—with eyes other than those of the objective critic.

resolutely outside the French tradition, and the painters with whom I am concerned have felt that instinctively. In addition, some sort of composite Mallarmism could not deceive for very long, and pursuits in that direction are limited by the most narrow horizon. It was all the more important, in this case, to make a note of my feeling at once, since I believe I can discern the portents of an auspicious inversion of aesthetic values somewhere else.

The advent of a new canon is therefore an eventuality that it is fitting to envision with the most sympathetic attention.

The belated defenders of individualism will be greatly shocked—necessarily so—to see a strong *group* forming under the auspices of an attraction to the same ideal: *react violently against the instantaneous notation, the insidious anecdote, and all the substitutes for impressionism. In that regard, do not be satisfied with skillfully varying modish appearances, but reappraise the arsenal of painting and exclude from it the bric-a-brac of false literature and pseudoclassicism.*

The ambition of these artists is to express themselves with the painter's means. Between their sensibility and that of the beholders, they claim to tolerate only plastic intermediaries. Courageously, they wish to destroy the rigged screens indispensable to all practitioners of *the most limited skill.*

There is no concern to be soothing to the eye, to finesse the transition between the logical aspect of a balance of colors or that of an equivalent set of measures, and the incurable inertia of the retinas equipped with immutable stencil plates.

Hence, the cosmic incident, reduced to its legitimate importance, stripped of the excess weight of tinsel imposed by seductive fashion, by that very fact regains its primordial value.

One should not conclude from that harsh tactic that this is an oppressive discipline of one's essential instinct. On the contrary, the artistic gift is all the more indispensable to the artist in that he does not allow himself the auxiliary procedures that some people have abused to such advantage.

Le Fauconnier, whether he is constructing the image of rocky Brittany [fig. 13], or arranging the postures of his noble and familiar heroines, subordinates everything to composition. Hence grandeur is the dominant characteristic of his art. Sometimes, too conscious of his mastery, he does not even refrain sufficiently from an inclination to communicate

a premature museum look to his canvas. But one must pay tribute to the desire for construction that governs each of his pictures. When one looks at them, one never has the impression of embellishment and ornamental veneer. On the contrary, every detail of form or color turns out to have come into being via a fully intelligent genesis. The portrait of the poet P.-J. Jouve, *Femme à l'éventail* [*Woman with Fan*], the landscapes of the last Salon d'Automne, the portrait of P. Castiaux, and *Abondance* [fig. 9], which can be seen at the Salon des Indépendants, mark the stages of a productive journey of conquest, whose end is not in sight. Since I have decided not to resign myself to a form of descriptive criticism whose vanity is abundantly—and daily—demonstrated, I will note in all the artists concerned the most salient traits, and moreover, I invite the hurried reader, perchance worried about theoretical generalities, to read the beginning of this study.

In a commendable spirit of reflection, Albert Gleizes continues his evolution. As he emerged from the impressionist crisis full of aversion for the verbalism of color, he wanted, with exceptional awareness, to impose upon himself a true cure, if I may say so, of sincere and accurate simplicity. He was able to understand that, in accelerating the development of his personality, in rushing forward, he had nothing to gain but pernicious flattery. Hence he devotes the greatest attention to form. His most recent landscapes and the very beautiful study of a nude reproduced here are evidence of that [Varichon, figs. 345, 352].

In the latter canvas, I perceive intentions far removed from the preparation of an academic study or a rapid neoimpressionist sketch. The effort at composition manifests itself not through an organization of gestures but through concerted alternations, in which all elements of the spectacle participate.

How can one fail to admire the effort of an artist in perpetual struggle against the very abundance of his gifts, and whose goal is to discipline them to the point of leaving nothing of the decorative impulses that once made me hesitate to embrace him.

In addition, I cannot make up my mind to ignore the criticisms directed at Albert Gleizes regarding the compositions with which he illustrated a recently published book of poetry [fig. 12]. Some people wanted to see these drawings as a commentary on the text, and they questioned whether there was a perfect concordance between the character of the drawings and that of the poems. One thing mattered, however: to create

a balance, on every page and throughout the book, between lines of print and concerted arabesques. It did not seem to me that the artist fell short of that essential task. The very beautiful images with which he decorated Mr. Alexandre Mercereau's next book confirm me in that feeling.

Delaunay appears very different. Gifted with a phenomenally keen eye, he instantly resituates the materials of his decorative constructions within the ambiance of the prism. In my view, it is there, rather than in risky pursuits, that his true originality lies.

The dissociation of the objects constituting an aspect—to the point of producing a mobile interpenetration among them—brings to mind, in particular, a certain futurist manifesto that provoked a great deal of laughter, I don't really know why. At bottom, it was only an adaptation of the impressionist method, applied to larger surfaces and volumes, but which would culminate in disintegration and chaos, not order and harmony.

When Delaunay fragments and dismembers the Eiffel Tower [fig. 15] to give substance to the plastic forces diverging around it, I think he is making too explicit what ought to be an indirect suggestion.

Also, inevitably, the result of that emphasis will be to make us rapidly blasé, and to raise the possibility of a dangerous banality. But Delaunay is the master of his color. He knows the art of capturing light suspended in the atmosphere, divided in four by a central axis. In general, in that artist's pictures, centrifugal currents dominate. Those of Le Fauconnier, in contrast, are more deliberately focused, and always seem animated by converging wills.

One would not want such artists to have the naïveté of Henri Rousseau, and yet, that painter's memory is oddly evoked by certain of Fernand Léger's intentions. Léger will be criticized for the monstrosity of the figures he creates. As for me, I sense how painful this transitional stage in his evolution is to the painter himself. The need for it is not in doubt, and *Hommes nus dans un paysage* [*Nudes in a Forest* (1909–10), Kröller-Müller Museum, Otterlo, The Netherlands] bears witness to a considerable and probably fertile effort. One cannot deny the exactitude or the audacity of the measurements, and, in certain portions, the perfect organization of the horizontal planes. There is an innate sense of composition in it.

What excites Léger is less the architecture of inert volumes than the intermittent and multivalent life of human or cosmic gestures. It seems that

he is intent on measuring the most insignificant trajectories, in analyzing their most extensive torsion.

Whereas Delaunay frequently displaces the beholder's point of view, and sometimes puts it at the center of the plastically represented event, a futurist and, in my view, very risky conception, Fernand Léger is fond of dragging along an entire entourage of atmospheres, accessories, and complements—intentionally confused, in fact, in the neutrality of a rather unpleasant, and, I am convinced, transitory color—as he displaces a volume.

Last year, Jean Metzinger caused an excessive degree of alarm. In carefully considering the canvas of his that caused the scandal, I found that the most daring possibilities were only barely indicated, and that one ought to be grateful to this poet for a certain reserve in applying Mallarmism to painting.

In any case, the poetic, and hence instructive, feature of his art has since become sharper. I confess I am very sensitive to the precious charm that surrounds his two figures of nude women [fig. 16]. This canvas exudes a real intimacy, thanks to the integration of the setting into the principal volumes, and not through the facile flittering or reshuffling of arbitrary strokes, common in Vuillard, for example.

I was less appreciative of his landscapes, where composite elements are introduced here and there. The tones are, in fact, very appealing, and exempt from all extremist grandiloquence. But it is very clear that this study is above all a quest for possibilities, which leads me to a natural conclusion. All the tendencies I have just indicated all too briefly attest, in short, to a unanimous desire: to paint *pictures,* by which one must understand composed, constructed, organized works, and not notations and rapid sketches where the ruse of false spontaneity masks a fundamental void.

The sterility of any effort in the direction of impressionism need no longer be demonstrated. There would be more danger in certain little formulas, based on tiny retrospective discoveries, and destined to create an illusion were they not shortly to become outdated. That is the inevitable fate of works of art produced under the influence of fashion or superficial literary excitation.

It would be pointless to conceal how dangerous that return to great painting appears to the commercial interest groups currently setting the standards.

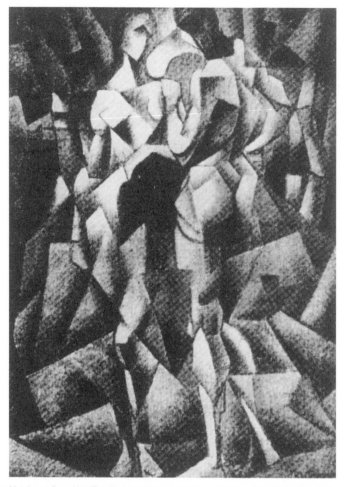

16. Jean Metzinger, *Deux Nus* (*Two Nudes*), 1910–11. Location unknown. © Artists Rights Society (ARS), New York / ADAGP, Paris.

Should these tendencies come to prevail, the result will be the collapse of minuscule and fragmentary art, and the total rout of those who scandalously profit from its sham popularity.

Anyone who wishes to see the end of the period of anarchy and confusion that painting has just gone through must encourage these truly liberating efforts, and delight in the spectacle of them.

Roger Allard

JUNE 1911

Commentary

Roger Allard's third article on cubism and his second on the 1911 Salon des Indépendants celebrates Henri Le Fauconnier, Albert Gleizes, Robert Delaunay, Fernand Léger, and Metzinger for inaugurating an artistic "renaissance" prefigured in the art of Paul Cézanne. Following the 1910 Salon d'Automne, where works by Gleizes, Le Fauconnier, and Metzinger were grouped together by chance, the artists and the critics associated with these artists conspired to orchestrate a similar grouping at the April 1911 Salon des Indépendants. The group, which included the painters Delaunay, Gleizes, Léger, Le Fauconnier, and Metzinger, and the critics Allard, Guillaume Apollinaire, Alexandre Mercereau, and André Salmon, began meeting regularly at the Closerie des Lilas and Le Fauconnier's studio on rue Visconti; as of early 1911, they gathered at Gleizes's atelier in Courbevoie. In his memoirs, Gleizes recounted their carefully laid plan to usurp the existing hanging committee and establish a new one that would hang artists in a more coherent manner, following artistic tendencies. Previously the hanging committee had been dominated by Paul Signac and the neoimpressionists, who would routinely form a panel that received automatic approval at the annual General Assembly of the Société des artistes indépendants. To rebuke the status quo, the cubists circulated at the 1911 General Assembly a petition protesting the chaotic appearance of previous salons and proposing an alternative slate of artists to serve on the hanging committee. Le Fauconnier and Metzinger were numbered among the list of candidates, along with artists sympathetic to cubism, including André Lhote, Jean Marchand, Roger de la Fresnaye, André Dunoyer de Segonzac, and Gleizes's Abbaye de Créteil associate, Berthold Mahn (Gleizes, 14–19; Brooke, 16–17; Golding, 6–8).

When the maneuver proved successful, the cubists were able to divide the salon into two sections. One headed by the neoimpressionists Paul Signac and Maximilian Luce took up the center rooms, while artists of the younger generation—all of whom had rejected impressionism and neoimpressionism—inhabited the side rooms. Delaunay, Gleizes, Le Fauconnier, Léger, and Metzinger reserved Salle 41 for themselves, and accepted the inclusion of Marie Laurencin at Apollinaire's request. Room 43 contained artists whose work shared the cubists' general orientation, most notably La Fresnaye, Lhote, André Mare, and Segonzac. In Room 42 the young artists conspired to present a retrospective exhibition of forty-seven paintings by Henri "Le Douanier" Rousseau (1844–1910), who

had died the previous year (Adriani, 275). Esteemed as a true "primitive" by Delaunay and Léger, Rousseau was considered a precursor by the salon cubists, on a par with Cézanne, another modernist primitive (M. Antliff and Leighten, 46–51; Adriani, 133; Morris and Green; Rousseau, 156–61).

Allard's article gave cubism a historical genealogy that reached back to the Renaissance. In an opening gambit, he numbers these painters among the "authentic inventors of canons" whose art bears comparison to Jean Racine's tragedy *Bérénice* (1670), Nicholas Poussin's *Le triomphe de Flore* (*Triumph of Flora*; 1630) in the Louvre, as well as the art of "Lorrain, Ingres and Corot." Unlike fashionable "pasticheurs," "skillful imitators," or the impressionists, Allard's artists reject an aesthetic of "instantaneous notation," "pseudoclassicism," or "modish appearances," thereby signaling "the advent of a new canon." Allard summarizes views expressed in his article on the 1910 Salon d'Automne (document 12), but he also addresses newly emerging aesthetic debates concerning the poet Stéphane Mallarmé's impact on cubism (Cottington, 132–33 and 149–50). Acknowledging Metzinger's familiarity with the painting of Picasso and Georges Braque, he claims that Metzinger and his peers recognized Picasso's "violent personality" as foreign to "the French tradition" and, therefore, to their aesthetic aims. Moreover it is not only Picasso's national temperament, but his "composite Mallarmism" that makes his art suspect. In this regard Allard differed from his friend Joseph Billiet, who, in a December 1910 article published in *L'Art Libre,* described the cubism of Gleizes and Metzinger as "quasi-Mallarméan" (Billiet, cited in Antliff, *Inventing Bergson,* 30). Still later Allard approvingly cites Metzinger's *Deux Nues* (fig. 16) as evidence of that poet-painter's "reserve in applying Mallarmism to painting," thus acknowledging Metzinger's close ties to painters and poets affiliated with the neosymbolist *Vers et Prose* while seeking to distance Metzinger from Picasso and his ally Apollinaire (see document 11 commentary). By asserting Metzinger's aesthetic independence, Allard was no doubt responding to Apollinaire's earlier claim that Metzinger's *Nue* (Fig. 11) was a slavish imitation of Picasso's cubism (Apollinaire, "Salon d'Automne," *Poésie* [(Bordeaux,) Autumn 1910], cited in Breunig, 113–14).

Concurrently, Allard makes clear that his own poetic allegiances are to the unanimist-oriented aesthetics of the Abbaye de Créteil, rather than the "Mallarmism" promoted by Metzinger and writers associated with *Vers et Prose.* This stance accounts for Allard's unqualified admira-

tion of Le Fauconnier, Léger (whom he identifies as a follower of Henri Rousseau), and Gleizes. Having praised these artists for emphasizing "construction," "composition," and "form" in their art, he then defends Gleizes's illustrations for Allard's book *La bocage amoureaux* (1911) (fig. 12) and for Alexandre Mercereau's *Conque miraculeuse* (written at the Abbaye in 1907, and published in 1922) on comparable grounds. Both texts were inspired in part by the "collectivist" and "unanimist" version of poetry promoted at the Abbaye, rather than by Mallarmé's precepts.

Allard's comments on Delaunay's *Eiffel Tower* (fig. 15) in turn signal the early impact of Italian futurism, founded by the poet F. T. Marinetti in 1909, on the Parisian avant-garde (Buckberrough, 56–65; Cox, 162–64; Spate, 172–76). Futurism's relevance for the visual arts was fully outlined in the "Technical Manifesto of Futurist Painters" in April 1910, which appeared shortly before Delaunay embarked on his Eiffel Tower series. In that text the futurists Umberto Boccioni, Carlo Carrà, Luigi Russolo, Giacomo Balla, and Gino Severini proclaimed their allegiance to divisionism and their desire to put the spectator in the center of their canvases so that he or she could experience the "universal dynamism" of modern life (Apollonio, 27–31). Allard acknowledges that Delaunay's emphasis on color and the "centrifugal" fragmentation of form brings to mind "a certain futurist manifesto," but he distances Delaunay's method from the "disintegration and chaos" resulting from the futurists' "impressionist method." Delaunay, we are told, situates his "decorative construction within the ambiance of the prism" and therefore aspires to effect the "order and harmony" of his cubist colleagues.

Adriani, *Henri Rousseau*
M. Antliff, *Inventing Bergson*
M. Antliff and Leighten, *Cubism and Culture*
Apollonio, ed., *Futurist Manifestos*
Breunig, ed., *Apollinaire on Art*
Brooke, *Albert Gleizes*
Buckberrough, *Robert Delaunay*
Cottington, *Cubism in the Shadow of War*
Cox, *Cubism*
Gleizes, *Cahiers Albert Gleizes*
Golding, *Cubism*
Morris and Green, *Henri Rousseau*
Rousseau et al., *Robert Delaunay*
Spate, *Orphism*
Varichon, *Albert Gleizes*

Jean Metzinger, "Cubisme et tradition," *Paris-Journal,*
18 August 1911, p. 5

Cubism and Tradition

Today, thanks to a few painters, painting appears naked and pure.

United by an exemplary discipline, these painters obey no watchword, are slaves to no formula. Their discipline is the common concern never to violate the fundamental laws of art.

Because they use the most simple, the most complete, and the most logical forms, they have been made out to be "cubists." Because they extract new plastic signs from these forms, they are accused of not measuring up to tradition. How could they fail to measure up to tradition, which is an uninterrupted series of innovations, when they, through innovation, do no more than continue it? Don't people know that the artist's essential mission is to impress his own notions on the minds of others? The glory of the masters is precisely to have impressed their spirits into prototypes so perfect that we can say, centuries later, that the beautiful is that which approximates them, and the ugly that which differs from them. Those who are called cubists attempt to imitate the masters, applying themselves to the fashioning of new prototypes (to the word *new* I attach the idea of *difference,* and set aside the ideas of superiority and progress). Already, they have uprooted the prejudice that directed the painter to stand motionless, at a determined distance from the object, and to capture on the canvas only the retina's photograph of it, more or less modified by "personal feeling." They have allowed themselves to move around the object to give a concrete representation of several aspects of it in succession, under the control of the intelligence. The picture used to occupy space, now it reigns in time [*la durée*] as well. In painting, every audacious feat is legitimate if it tends to accentuate pictorial force. To draw the eyes of a portrait full-face, the nose in three-quarters profile, and to divide the mouth into sections in such

a way as to reveal its profile, that might very well intensify the resemblance in amazing ways, provided the worker has some tact, and, at the same time, it might point out the right path at a crossroads of artistic history.

The technique of the "cubists," clear and rational, excludes the tricks of the trade, the facile grace, and the stylization promoted today. Painters, conscious of the miracle that is accomplished when the surface of the canvas elicits three-dimensional space, shatter the line as soon as it threatens to take on a descriptive, decorative importance. Quantities of light and shadow, distributed in such a way that one of them gives rise to the others, justifies, on the plastic level, the breaking of the line, and the orientation of these breaks creates the pattern.

Le Fauconnier's admirable levelheadedness asserts itself through the indispensable mix of certain conventional signs with new signs. In his picture *L'Abondance* [fig. 9], human figures and landscapes materially burn with the same love, magnificently develop what men of our race are accustomed to admire in natural scenes; and the power that, through fruit and leaves, allows us to perceive flesh, figures with the far-away whiteness of boats, and inexpressible cosmic sympathies contain enough unknown elements to impress several generations.

As for Robert Delaunay, he substitutes personal discoveries for the laws of general optics. Out of a repugnance for chance events, vague recollections, and ambiguities, he intentionally uses mechanical techniques, as Seurat did for different ends. His will breaks down surfaces and volumes into impossible fractions, to better become their master.

The dramatic reality of his *Ville* and his *Tour Eiffel* [fig. 15] has such a strong effect on the mind that it sometimes becomes impossible to evaluate it.

Le Fauconnier and Delaunay mark two limits, which could not be crossed without falling into academicism on the one hand and esotericism on the other.

Albert Gleizes, Marie Laurencin, and Fernand Léger are on guard against such falls. Albert Gleizes reconciles the solidity of construction, the richness of matter, and a watercolorlike fluidity. Logical, sensual, human, and Latin, Gleizes interests us to an infinite degree in the struggle his prudence maintains against his audacity—a fruitful struggle! Marie Laurencin, the only woman of whom it could be said, "She's a painter!" has found the hermetic cipher for grace. Anyone who rejects her *Portrait* or her *Jeunes filles* [fig. 17] assaults French taste.

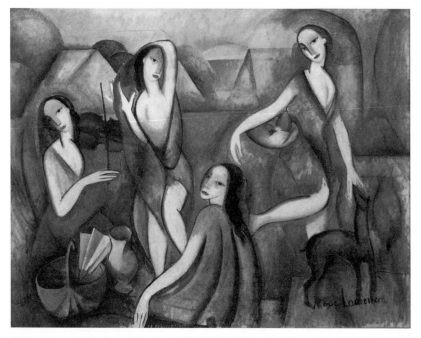

17. Marie Laurencin, *Les jeunes filles* (*Young Girls*), 1910–11 (Salon des Indépendants, 1911). Oil on canvas, 115 × 146 cm. Moderna Museet, Stockholm. © Artists Rights Society (ARS), New York / ADAGP, Paris. Used by permission of Moderna Museet, Stockholm.

Fernand Léger measures the day and the night, weighs blocks, calculates resistance. His composition *Nus dans un paysage* [*Nudes in a Forest* (1909–10), Kröller-Müller Museum, Otterlo, The Netherlands] is a living body, with trees and human figures as its organs. Fernand Léger, an austere painter, is passionate about the profound side of painting that borders on the biological sciences, and which Michelangelo and Leonardo sensed.

We who wish to build the monument of our age, will we not find the materials there above all?

<div align="right">

Jean Metzinger

16 AUGUST 1911

</div>

Commentary

In this essay Metzinger develops themes he and Allard had expounded in earlier texts (documents 11 and 18), and provides us with additional comments on the art of Le Fauconnier, Delaunay, Gleizes, Léger, and, for the first time, the *bande à Picasso* artist Marie Laurencin (1885–1945) (see

document 51). Once again the cubists are said to emulate the old masters through "innovation," and Metzinger's reference to cubism's "Hellenic" rhythms in his "Note on Painting" (1910) is paralleled here by an allusion to Gleizes's "Latin" temperament. Metzinger also analyzes the pictorial methods utilized to achieve innovation, making plain cubism's metaphysical underpinnings. The "motionlessness" and "pure opticality" induced by single-vanishing-point perspective is contrasted with the cubists' aim of infusing "durée" into their canvases by moving around an object to portray "several aspects of it in succession." Thus he reiterates the synthesis of Henri Poincaré's conventionalism and Bergsonian metaphysics outlined in his "Note on Painting" of 1910 (see document 11) (M. Antliff, 43–48; Henderson, 57–99). However, Metzinger goes further by clarifying the difference between cubist space and "descriptive" or "decorative" space; that is, between cubist space, single-vanishing-point perspective, and an emphasis on the canvas's two-dimensional surface. The cubists attempt to maintain a sensation of volumetric space while undercutting the verisimilitude associated with academic perspective or the abstract planarity of decorative surfaces; to achieve this they fragment the lines delineating objects and distribute "quantities of light and shadow," thereby creating a rhythmic "pattern" suggestive of other "plastic" forms. Here Metzinger outlines the Bergsonian concept of "extensity" that would reemerge in Gleizes and Metzinger's seminal text Du "Cubisme" (1912; document 57) (M. Antliff, 39–66; M. Antliff and Leighten, 72–93). This description, in conjunction with references to the use of multiple perspectives when portraying human physiognomy, brings to mind Metzinger's painting Le goûter (1911; Philadelphia Museum of Art), soon to be exhibited at the Salon d'Automne.

In commenting on his colleagues Metzinger further refines his aesthetic views. His reference to Le Fauconnier's mixture of "conventional and new signs" in L'Abondance (fig. 9) points to the tension between imagery based on art-historical precedents (the allegorical theme of abundance) and that artist's "novel" (cubist) technique. In subsequent years Metzinger and his colleagues would develop a comparable mixture of "conventional and new signs" in works such as Metzinger's Femme à fenêtre, maternité (1911–12), with its allusion to Vigée-Lebrun's Self-Portrait with Daughter of 1789, housed in the Louvre; or Raymond Duchamp-Villon's variation on the Capitoline Aphrodite in his Seated Woman of 1914 (M. Antliff and Leighten, 111–19). Next in his comments, Metzinger refers to Delaunay's

substitution of "personal discoveries" for the "general law of optics" in his paintings *Ville* (1911) and *Tour Eiffel* (fig. 15) to stress the distance from Delaunay's neoimpressionist roots, and, by inference, Italian futurism. In describing Léger's "composition" *Nudes in a Forest* (1910–11) as a "living body," Metzinger alludes to the Bergsonian notion of organic form subsequently developed in *Du "Cubisme"* (M. Antliff, 35); finally his characterization of Laurencin's cubist painting as typified by "grace" in contrast to the robust "solidity of construction" of Gleizes's work indicates his endorsement of the gender stereotypes that pervaded cubist art criticism (M. Antliff and Leighten, 136–58; Perry).

M. Antliff, *Inventing Bergson*
M. Antliff and Leighten, *Cubism and Culture*
Henderson, *The Fourth Dimension and Non-Euclidean Geometry in Modern Art*
Perry, *Women Artists and the Parisian Avant-Garde*

Ardengo Soffici, "Picasso e Braque," *La Voce* ([Florence,] 24 August 1911): 635–37

Picasso and Braque

To talk in some depth about two young painters, one of them (Pablo Picasso) Spanish and the other (Georges Braque) French, and about their art—a complex, difficult, and bewildering art if ever there was one—it is absolutely necessary that we first recall, even just in passing, what was impressionism: what was its essence, and for what reasons it provoked the reaction of which our two artists are, to this day, the ultimate champions.

For anyone who considers it in its pure state—that is, as it was launched by Jongkind, who was Dutch, and was understood and put into practice by such Frenchmen as Pissarro, Sisley, and, in particular, Claude Monet, its true, its greatest, and its most logical representative and popularizer—impressionism was above all the result of sensibility and a spirit of analysis prevailing over the imaginative, the will to synthesize, and the other faculties that in the past were held to make up grandeur and style. If we examine its substance more in depth, we see that impressionism was not only that, but also (and perhaps more) the product of a genuine spiritual revolution that began in philosophy and passed simultaneously into the fields of the sciences and the arts. What I mean by this is that impressionism, as an artistic phenomenon, corresponded to an activation in the realm of thought that rejected the concept of a reality external to or superior to the human spirit, and that considered the universe to be a creation of that spirit, hence without intrinsic aesthetic categories, but only with the categories inherent to the intuitive profundities of the individual—that is, of the artist, the genius.

Translated from the Italian by Lydia Cochrane.

In fact, all we need to do is to examine the work of an impressionist painter with a degree of perspicacity to realize immediately that its principal characteristic is not a hierarchization of beings and things according to a given set of idealistic, intellectual, or even ethical principles in view of achieving a grander effect, but rather the placement on the same level of all natural phenomena that manifest themselves by means of forms and colors; the legitimation and the poeticization of all vital manifestations; the equalization of the diverse values of the visible universe. Before, the general run of artists, who remained faithful to old academic prejudices or, in the best of cases (when they were not creators of genius, who one might say have always been impressionists), were inclined to an objective evaluation of things, habitually subordinated one thing to another according to a rigorous classical-scholastic criterion and interpreted the world as an aggregate of figures and spectacles, all of greater or lesser meaning and interest, that required choice or modification in the process of organizing and creating the world of art. Then the impressionist painters came along and, ignoring all extra-artistic considerations and trusting their powers of fantasy and lyricism alone, proved that everything can provide material for beauty and poetry if contemplated with a creative eye; that any being, any place, any thing, or any part of that thing, was capable of reflecting and suggesting the divine idea of the beautiful, hence was just as worthy as any other of being studied, loved, and depicted. It was by means of this freer concept, this more generous and more deeply poetic idea of reality, that the human figure, the animal, the most insignificant corner of nature, even an inanimate thing—a utensil, an empty glass, a ragged piece of cloth—could have equal value as pure artistic elements, differentiated only by their color and their form, could be placed together without sacrificing one to the other, or could stand alone as the subject and theme of a work of art.

The problem is that although impressionism, to speak spiritually, claimed the "panpoeticality" (if I may be permitted the strange term) of the world and demanded that the artist of the future enjoy an absolute freedom of inspiration, henceforth and forever, as a school of painting it was not immune to the scourge of false theories and a unilateral vision that proved fatal to it in the long run, leading it to insipidity and death.

I have spoken about impressionist theory in these pages too often to repeat myself here. I shall only say, in summary, that because impressionism was founded on a principle of preferring sensibility over the

imagination and the spirit of analysis over that of synthesis, impression-
ism demanded that the painter not only render the impression he receives
of the things standing before him in their full freshness and spontaneity,
but that he also do so on the spot, at the very moment of the felt emotion,
in the least possible time, and that he strive to depict, with the highest
degree of fidelity and precision, the particular nuance, the unique, fleet-
ing, momentary aspect of the person, place, or thing that had excited
his fantasy. It is easy to argue from this that while the immediacy of the
representation conferred a totally new quality and vivacity to the painted
work, it nonetheless prevented the figuration of the reality depicted from
rising to the breadth and universality of expression that are the fruit of
a happy coupling of sensibility and will—the two components of style—
becoming instead immersed in the transitory, the anecdotal, and at
times even the absolutely illustrative. It is not enough for the impres-
sionist painter to liberate himself from traditionalism and rehabilitate a
neglected faculty, if he has not first assimilated the healthy part of that
traditionalism and has not learned to make use of the opposite faculty to
the extent that pure necessity demands. Nor was not having understood
that truth—a bit convoluted, perhaps, but clear to anyone who has re-
flected deeply on the problems of art—the only defect of the impression-
ist school. Another and perhaps a more serious drawback was its mode
of conceiving the physical universe. Jules Laforgue, whom I have cited on
other occasions and who was and remains the most penetrating of the
followers of that school, has a passage in his *Mélanges posthumes* that ac-
curately reflects that conception. "The Impressionist," he says, "sees and
renders nature as it is, that is, wholly the vibration of color. No line, light,
relief, perspective, nor chiaroscuro . . . All these are in reality converted
into the vibration of color, and must be obtained on canvas solely by the
vibration of color."[1] It is of course both natural and legitimate for the
impressionist painters, with the backing of science, to revolt against the
academic school and its bitumen and see nature exclusively as a radiant
and shimmering spectacle, made up of a tremulous and elusive seething,
and that in order to translate that spectacle they should have recourse to
that manner of theirs of painting everything in touches and flickers of
pure and vivid colors. But it is no less true that such a vision and such
a system, developed to the utter limit, as they indeed were by Claude
Monet, gradually neglected every other quality of the things depicted in
order to render only their luminous vibration, ineluctably leading to an

inconsistent sort of overly tenuous and vaporous painting in which forms and bodies disintegrate, fade, melt, and dissolve in the fluidity of the air, to the point that everything vanishes and drowns in a dazzle of white light. This is what impressionist painting tended to become, if it was not completely so already. If at first sight it might titillate and caress the eye of the observer, it cannot in any way satisfy the desire for corporeality, for variety, and for concreteness that the other senses require as they work with the eye in the perception of a work of art.

It is precisely for these reasons that impressionism, although it enlarged the confines of pictorial art and produced works of great beauty, could not and did not last. Some painters, who were more profound and whose aspirations were more vast, after assimilating what was good in the discoveries and the reforms of impressionism, did not take long to realize the dangers that the school was running into and detached themselves from it. One of them (and not the least), Paul Cézanne, even turned his back on them and, by grasping things once more, reconstructing them artistically in their solidity, and reasserting volume, chiaroscuro, drawing, and everything that the others had denied, set off a reaction that has lasted for a number of years now and in which all the forces of artistic youth in France are engaged today.

So as to arrive at a contrary excess? We shall see. In the meantime, let us turn to our two artists, both of whom are in the first ranks of art in France.

Picasso first. Pablo Picasso has not always been the disturbing artist, confounder of critics, disconcerter of colleagues, and scarecrow of the philistines that he has been for some time in these parts. When I met him a dozen years ago in Paris as a twenty-year-old freshly arrived from Málaga, in Andalusia, he was painting landscapes, portraits, and simple scenes of Parisian life that were no different from the exercises that the good youths of independent means of the time indulged in, except perhaps for their greater audacity in drawing and a greater and almost savage exaltation of color. It is true that from that time on, or at least until 1902 or 1903—that is, until those first forays were followed by more lively and more virile experimentations—you could already see something in his painting that resembled a preoccupation with order and with style. What I mean to say is that whether he followed Toulouse-Lautrec, studying the noctambulant and alcoholized world of the Parisian cocotte, or turned to a modern, gro-

tesque or tragic interpretation of vice, misery, and pain that drew inspiration from Goya, El Greco, or Signorelli (since Picasso is endowed with a highly sensitive temperament, he has understood, loved, and taken nourishment from utterly diverse forms of beauty, always adapting them to his personality), his art always and increasingly has distanced itself, both in spirit and in technique, from the extemporaneousness and disintegration of impressionist art. Investigating nature ever more deeply, he was already translating it with more complexity, more solidity, and more drama. Anyone who knows and remembers the sweet gravity of some of his works of that period—a woman lovingly embracing a raven, two thoughtful young women seated nude on the ground, a beggar with his sack full of sad, faded flowers, a heap of miserable bodies on the sidewalk—cannot but see in them signs of a decisive rebellion against what would be the dominant school. Even color, with black returning among his whites and blues, signified protest. The cycle of works that came immediately after, which we might call picaresque, signified protest as well. Melancholy itinerant tumblers, emaciated players traveling from fair to fair, a distillation of humiliation and fiasco as they rest by the roadside in a bare, sunbaked village just as poor and sallow as they, with no shelter for miles and miles; scrawny harlequins and clowns roving the outskirts of the cities or seated at the door of a hovel, their eyes avidly following a Columbine in sandals and a skimpy checkered skirt with a child in her arms as she comes and goes between the tent and the cook pot while a slightly older child plays with a drum or with the father's belled hat or snores beside a circus dog among the frippery and the trumpets; athletes in purple or blue jerseys showing off their monstrous biceps and their enormous waxed handlebar moustache or else shameful of their thinness*; resigned vagabonds and beggars who have seen it all, dragging their tired bones through the harsh ways of the earth under a grey and lonely sky.

It was in reference to these works that Guillaume Apollinaire, writing in that period about Picasso, noted the sobriety that underlay his work and remarked on his return to a more general understanding of things

* One of these works was shown some years ago in Venice. Zuloaga, at the time commissioner for Spain, had asked Picasso for it, and Picasso sent it. It was hanging for only a few days, however, when Fradeletto (or someone acting in his name) returned it to the artist with the excuse that its novelty scandalized the public. [The work in question has been identified as *Acrobat et jeune arlequin* (*Acrobat and Young Harlequin;* gouache, 1905); see Daix, *Dictionnaire Picasso,* 9, 916.]

seen in their corporeality, no longer dissolved into the accidental quali-
ties of light and reflection. "Color has the flat quality of frescoes, and the
lines are firm. . . . Picasso's penchant for the fleeting trait transforms and
penetrates and produces almost unique examples of linear drypoints, in
which the general aspect of the world is not altered by the light that modi-
fies forms by altering colors." [2]

Still, the decisive step, the one that led Picasso into a realm of much
more advanced experimentation, came only a few years later when, after
gradually moving farther away from the impressionists' ways of look-
ing, he found a firmer basis for his later investigations in an art totally
opposed to theirs. This art was the painting and sculpture of the ancient
Egyptians and the related—and perhaps even more innately synthetic—
art of the savage peoples of southern Africa. Another artist before him,
Gauguin, fleeing the particularism and the "photolatry" of pure impres-
sionism, had taken refuge in the study of similar primordial artistic
worlds, but with his intellectualism and—whatever his admirers may
say—with his affection for false symbolic displays, he had been unable
to draw from those worlds anything more than a certain composure and
breadth that some have taken to be sublime or religious, but were in fact
only decorative and literary. Perhaps it was thanks to his almost Moorish
origin that once Picasso had come to comprehend and love an art that
was both ingenuous and great, simple and expressive, rough and refined,
he immediately appropriated its essential virtues. And given that those
virtues consist in interpreting nature realistically, distorting certain of
its aspects according to an occult lyrical necessity in order to intensify
its suggestiveness, from that time on he applied himself to translating
the true into his works, transforming it and distorting it, not in the same
way as his masters but—as they had taught him, each with a particular
example—following the innate movements of his own modern soul.

Here I should perhaps explain what I mean by an artistic distortion of
things according to a lyrical law, given that this notion is the foundation
for an entirely new comprehension of line and of the forms of the work
of art. In spite of the fact that I have already discussed the question on
another occasion,[3] I shall attempt to give, if not a comprehensive defini-
tion, at least some idea of it (I am writing in the land of such phenomena
as Ettore Tito, Gemito, Bistolfi, Mancini, Sartorio, and others). For the
moment let it suffice to say that for certain artists, the planes, masses, and
outlines of things can have proportions, relations, and movements that

differ enormously from those perceived by common mortals. In short, independent of their concatenation as coefficients of a scientifically or practically conceived reality, those elements can be considered simply pictorial: they are transformable, movable, and can be distorted for the purposes of a purely artistic harmony in which the true is reborn liberated from all experimental logic and operates simply as a pretext, as a hieroglyphic that the artist uses to communicate a suggestion to the observer. A head too small, an arm too big, a contorted shoulder, a leg badly joined to the rest of the body, a flattened tree trunk, a twisted house, and other things that the people commonly take to be obvious and laughable errors, are simply the necessary modes of a deeper beauty, in the same way that the forced image or the discordant adjective of a poet are legitimate means for enlarging the vision he is trying to suggest, and for breaking open its confines and making it continue, in infinite vibrations, in the reader's imagination. We need only recall the "giace dispettoso e *torto*" (lies sullen and twisted) with which Dante makes Campaneus into a granitic figure out of Aeschylus; Carducci's "Danton, pallido, *enorme*" [Danton, pallid, enormous]; or Leopardi's violent use of colors in "le vie dorate e gli orti" [the gilded paths and orchards]—not to mention non-Italian examples, among the moderns in particular.

But to get back to the point.

After beginning with something rather like impressionism, we see Pablo Picasso moving away from it step by step until he arrives at the antipodes of that school. Like many others, after first being content to grasp a fleeting moment of nature and fix it in all its splendor, he used meditation and experimentation to arrive at the conclusion that true art is synthetic and that one cannot synthesize without sobriety, generality, and concreteness. If he were easily satisfied (but he was not), he could have been content to focus his subsequent studies on that truth. If he had done so, he would simply have repeated the curve that every artistic intelligence traces when, moving off from a new affirmation, it goes back imperceptibly and fixes onto a very old and contrary affirmation. Picasso, a superbly lively and restless spirit, was never satisfied with that sort of result of his studies; quite to the contrary, he had hardly arrived at that new way of understanding art when he immediately set himself the task of confronting it squarely and trying to resolve the various problems inherent in it.

The first of these was the problem of volumes. Anyone who has followed my discourse this far will have understood (also because I have insisted on the point, perhaps too much) that one of the strong motivations of the reaction to theoretical impressionism lay in the latter's inability to render the corporeality of things. Picasso, one of the most courageous partisans of the rebellion against impressionism, was simply pushing protest to the extreme by returning to the primitive and barbarous arts, which draw all of their power of observation from what an American aesthete, Berenson, calls "tactile values." With a difference, however: after pursuing his study of those arts for a time, Picasso realized that a painter refined by culture, with modern sensibilities, could go much farther in the investigation and expression of those values.

In fact, it is not enough to criticize impressionism by stating that the sense of touch, working through recall of previous experiences, has just as great a part as vision in the visual perception of reality, hence it is just as important to render the volume of the objects and beings represented as their color. We also must ask whether we do not need some pictorial mode totally unknown to antiquity in order to make our awareness of volumes manifest. To offer an example, while we are looking at an object, we obviously can see only the sides and the planes exposed in perspective to the lens of our eye; but it is equally true, either thanks to previous experience or by deduction founded on analogy, that we know and can say that we feel the sides of that object that are hidden from our view. Let us imagine that we have before us some sort of object—say, a violin, to choose an object that Picasso has depicted many times. It lies on a table, and we see only the top surface on a diagonal, one side rib, and the profile of the neck and the scroll. An artist who wanted to depict the instrument according to the criteria of all preceding painting would have to be content with those planes and those lines. Still, is it not true that if we did so we would sacrifice part of the reality that we know, because on other occasions our own eyes have shown us that the violin is not wholly contained in those lines and those planes, but also consists in the underside of the sound box and the other half of the side rib and the neck, that the central hole is not oval, as it appears to our gaze, but almost round, and that the inward curves of the sides have a harmonious line that is lost in our current view. Moreover, if the thing that we have before us is more purely geometrical in form—say, a house, a tree trunk, a washbasin, a glass—that observation seems even more obvious. It was on the basis of

just that sort of consideration that Pablo Picasso devised a new pictorial manner for expressing beings and natural spectacles in their totality. But what is that manner? It is not easy to define and still avoid awakening false suspicions of theoretics or even a mechanistic approach to his investigations, which were, to the contrary, uniquely pictorial and artistic. Nonetheless, I shall try to explain what I mean.

Above all, it is clear that such an integral projection of reality onto a flat surface cannot be carried out by following a rigorous system; to the contrary, it operates independent of all preestablished rules, according to strictly poetic criteria, and only in cases in which beauty requires it. Indeed, although Picasso is interested in translating a person, a thing, or a landscape in the totality of its volumes, he will not imitate the geometrician by de-composing the object into so many figures to be lined up side by side, a procedure that would be absurd and ridiculous. Rather, he will combine an internal awareness and partial sensation and lay out, next to the image as it presents itself, the hidden surfaces (felt, however, as if they really appeared), the hidden faces, and the fleeting profiles in their variety and harmony of proportions, the whole interpreted and organized so as to achieve a lively and perfect unity. Thus, to return to the example of the violin, the unseen parts will appear, in Picasso's figuration of that instrument, opened up and de-composed in their volumes, beside the visible ones. The hidden side of the sound box will be spread out on the table, the bays at its edges forming their soft curves; the other profile of the neck and the central hole will be given their forms in a lateral flutter of lights and shadows. In other words, he will dissolve all those things into their emotive elements—lines, foreshortening, tonal nuances—to provide something like the sum total of the emotions that he received from them; he will create a reconstruction of a reality that is a strictly pictorial, purely lyrical summary of the violin.

Similarly, he will anatomize all facets of the human figure by means of a sort of measurement that emphasizes its cubic volume (and this is the origin of the term *cubism*); he will lay it open before our eyes as if in a circular refraction, thus giving the viewer an entire, definitive, and immutable vision of reality. This does not occur—it is worth stating—as some (for example, the horrible Beuron school) have suggested, by stylizing and schematizing masses and lines. The art of Picasso, rather than leading forms to a fixed, invariable, and impersonal type, takes them apart in

the infinite variety of their aspects, rummages within them, scrutinizes them, and displays their multiple characters and appearances.

These de-constructions, these shifts of perspective, this effort to understand the various appearances of the true all at one time and to display them on the same plane would be completely in vain if the resulting work lost even a minimal part of its power of suggestion. That would inevitably happen if Picasso were primarily preoccupied by the pictorial analysis of volumes, but for him that analysis is only a melodious interweaving of lines and tints, a music of delicate tones, of light and dark, warm and cold, the mystery of which increases the joy of the observer. In fact, along with his solution to the problem of volumes, Picasso has resolved the problems of line and of light. We already know that for some time Picasso has not considered it the task of drawing to restrict bodies and model them into precise contours, fitting member into member with the logic that is inherent in each being and each thing represented. First the healthy sort of impressionism, then his barbarian masters taught him to consider drawing as an instrument of free and bold distortion. Its value for him now is rather as a hieroglyph for writing down (for those capable of reading it) a lyrically intuited truth. Thus, armed with this pliable tool capable of a thousand nuances, beginning with the subtlest and most fleeting understatement (and in this Picasso's method somewhat resembles the elliptical syntax and grammatical transpositions of Stéphane Mallarmé), rather than twisting the aspects of the things he depicts with the aim of giving an integral description of them, Picasso walks around those things, considering them poetically from all angles, receiving and then rendering successive impressions of them. In short, he shows them in their totality and their emotive perpetuity, and he does so with the same intensity and liberty with which impressionism rendered one aspect of them at one fleeting instant.

As for light, from the moment that Picasso no longer cared to depict nature in its appearances in his paintings, choosing instead to show in them a tissue of pure pictorial values aimed at occultly suggesting (I might say mathematically suggesting, since mathematics can be the foundation of painting as it is of music) a sense of concreteness—as for light, to repeat, and reflections, it is natural that they be considered simple chromatic spots among objects' other spots, even that they take form and a defined body and in a sense themselves become objects. Impressionism

had dissolved the densest masses into luminous vibrations: what wonder is there if an art that is the exact negation of impressionism should decide to consider light as something that can be measured or encircled, at least when it settles peacefully on any ordinary spot on things?

In any event, it is with such means that Picasso's painting manages to communicate grandiose and severe sensations that we would look for in vain from the majority of the best painters, modern and ancient. With colors that increase in sobriety with every passing day, he is able to create images of a beauty that is both powerful and delicate. Figures of a living intensity that derives from the fixity of an expression obtained—precisely— through a rigorous highlighting of the volume of each member; still lifes like crystalline and metallic treasures wrapped in occult and disquieting poetry, in which the solidity of each thing awakens ideas of eternity; granitic landscapes that, were it not for their color, recall the

terrible paysage,

Que jamais oeil mortel ne vit

of Baudelaire,[4] where the rooftops stand straight, redoubling their peaks, where the earth seems to suffocate its seeds in its frozen breast to give all of its sap to a thriving palm tree, and where a unique note of color sings like a solitary sparrow on a deserted shore. Works whose obscurity and mystery augment their enchantment and their poetic terribleness.

At times, it is true, the obscurity of the arabesque becomes nearly total, and perhaps the danger of Picasso's art is to become so profound that it degenerates into a sort of pictorial metaphysics. Certainly its only defect, especially in the representation of the human figure, is a certain antique air, a taint of archaism that modern "elect spirits" abhor.

I speak of elect spirits because, although the art of Picasso is, as I have said, of singular importance and a very great originality, and although it is destined for a great future, as things are today it can be understood and loved exclusively by the few; only much later and possibly not ever will it please the multitude. But, as the philosopher Bion of Borysthenes was fond of saying, you cannot please the multitude except with a pastiche [*pasticcio:* pastiche; sugar cake] and sweet wine.

Which brings us to Georges Braque. Since I have spoken at such length about Picasso, I will not retrace the course and development of Braque's art, since these were, if not completely like Picasso's, at least closely parallel, leading the two colleagues to an almost identical way of

seeing and of expressing themselves. Indeed, Georges Braque, who started off (like Picasso) by exploring impressionism, soon moved (again, like Picasso) toward a form of art less unilateral than the art in vogue at the time and aimed at reconstituting reality in all of its sober and stable calm. His broader interpretation, rather than capturing a fleeting, shimmering, flashing reality, focuses instead on what intelligence, combined with sensibility, perceives that is permanent, immutable, and concrete under the incessant flow of attitudes and illuminations. I cannot say precisely how early in his career this change of direction took place, but we can already discern in some landscapes painted in southern France around 1907 or 1908 his volumetric vision of things and his preoccupation with synthesis. These paintings are simple views of gigantic aqueducts thrown over a gully, with solid, sharp-edged arches that rise above the tops of the trees and cut into the sky; of white roads flanked by walls clinging to the edge of a rocky precipice; of villages perched on a bare rock that emerges from a thick wood. But Braque, by bringing his new eye to bear on these poor, spare combinations of nature and human works, penetrates them, develops their lines, and pares down their nuances in ways that immediately give his work an admirable vastness and boldness. The arches, the rocks, the walls, the trees, and the houses, their structure analyzed and eviscerated, are immobilized, as if in a stupor of imperishable things, in a homogeneity and a unity of spiritual conceptions. Later he would depict solitary doors at the foot of high crags where boats rock, moored before miserable houses with large black doors yawning before the sea; he would paint people and still lifes, his style becoming ever more rigorous, more logical (one might say) in the way he leads transitory things to an extratemporal, absolute existence. Clearly, Braque lacks the versatility that makes Picasso a prodigious living compendium of ten years of pictorial investigations; in compensation, however, how much love, acuity, and delicacy he brings to his works, especially the more recent ones! Still lifes that group household objects on a table; musical instruments, an apple, a piece of cloth, and pots and pans; fruit-filled bowls—objects in which crystal facets, reflections of wood surfaces and inlaid work, and folded fabrics create a prismatic magic that recalls the solitary magic of alpine glaciers. It is precisely that love and that delicacy that differentiate the Frenchman and the Spaniard. Picasso, his spirit filled with an almost barbaric fire, encloses within the dull tonalities and the apparently algebraic line of his paintings the mute violence of drama; Braque, with only

very slightly less rigorous technique, obtains a sort of musical calm filled with both lightness and severity. Together, the two of them—without betraying their respective origins, but to the contrary, reconnecting with the most profound tradition of their race—inaugurate a school of art that is admittedly not easily understood at the present, but is worthy of and capable of a glorious future.

I hasten to add (in parentheses and to end my remarks) that their new school has nothing to do with a certain much trumpeted and arriviste band of jugglers known as "les fauves" that for a few years has been scandalizing and frightening the simple bourgeois who visit the Salon des Indépendants with their indecent and repellent doodles. Metzinger, Le Fauconnier, Léger, Delaunay? So many blind and empty fantasticators infatuated with originality and success (a critic who is a supporter of theirs, Roger Allard, compares them to our futurists). Without understanding even one of the profound aesthetic reasons that guide the investigations of Picasso and Braque, they have nonetheless taken to distorting, geometrizing, and "cubing" aimlessly and haphazardly, perhaps in the hope of hiding behind triangles and other figures their innate, ineradicable, and fatal banality and academism.

There are some very different artists who can be compared with Picasso and Braque, at least for their sincerity, the seriousness of their intentions, and their results: Marie Laurencin, Derain, Dufy . . .

EDITORS' NOTES
1. Quoted from *Selected Writings of Jules Laforgue,* ed. and trans. William Jay Smith (New York: Grove, 1956), 192.
2. *La Plume,* 15 May 1907; trans. in Leroy C. Breunig, ed., *Apollinaire on Art: Essays and Reviews 1902–1918,* trans. Susan Suleiman (New York: Viking, 1972), 16.
3. See Ardengo Soffici, "Divagazioni artistiche," II/41, *La Voce.*
4. Soffici somewhat misremembers the opening lines of Charles Baudelaire's poem "Rêve parisien" (Parisian Dream) from *Les fleurs du mal* (1857): "De ce terrible paysage, Tel que jamais mortel n'en vit" (Of that awe-inspiring landscape, such as no mortal ever saw; trans. William Aggeler in *The Flowers of Evil* [Fresno, CA: Academy Library Guild, 1954]).

Commentary

The Italian artist, writer, and critic Ardengo Soffici (1879–1964) played a key role in introducing French art to an Italian audience before 1914, and his article "Picasso e Braque" was the first critical analysis of cubism to appear in Italy (for monographic studies of Soffici, see Cavallo and Richter).

Born the son of a farm manager in a small village just east of Florence, Soffici moved to Paris in 1900; he met Picasso and Max Jacob there in 1902 and, in 1903, joined the symbolist circle associated with the journal *La Plume* (1889–1905, 1911–14). From 1903 onward Soffici spent his summers in Florence where he cultivated his Italian literary connections and joined Guiseppe Prezzolini and Giovanni Papini in producing the avant-garde journal *Leonardo* (1903–7). Concurrently he developed an identity as a self-styled regionalist, increasingly wary of the cosmopolitanism of the French capitol. Following his decision in 1907 to leave Paris and return to his native Tuscany, Soffici, together with Prezzolini and Papini, collaborated on the Florentine journal *La Voce* (1908–16). In 1909 Soffici entered into a lengthy correspondence with Picasso, and following the emergence of F. T. Marinetti's futurist movement in 1909, he repeatedly ridiculed the futurists in his articles, which led Umberto Boccioni and his colleagues to embark on the infamous "punitive" expedition to Florence in July 1911, where they assaulted Soffici in the Giubbe Rosse Café. After the futurists' February 1912 exhibition at the Bernheim-Jeune Gallery in Paris, Soffici developed a more conciliatory attitude toward the futurist painters, which culminated in Soffici and Papini's short-lived alliance with Marinetti's Milanese futurists while the former pair produced the Florentine journal *Lacerba* (January 1913–May 1915). Following the outbreak of World War I, Soffici joined Marinetti in calling for the Italian government to abandon its neutrality and side with Britain and France. Italy entered the war in May 1915, and in December of the same year Soffici enlisted in the infantry as a second lieutenant. Following the war he became an ardent fascist, contributing essays on art and culture to the Florentine fascist journal *Sassaiola Fiorentina* and the regionalist fascist organ *Il Selvaggio* (1924–43).

Like many among the Italian avant-garde, Soffici identified culture as a form of secular religion able to inspire the moral and political regeneration of Italian society (Adamson, *Avant-Garde Florence;* Adamson, "Ardengo Soffici and the Religion of Art"). His prewar endorsement of modernist aesthetics was filtered through his own fierce embrace of the nationalist doctrine of *toscanità,* which was also central to his later fascism. Tuscany and its local peasantry were to be the artistic stimulus for the creation of a new national culture, which would reconcile avant-gardism with an indigenous populism. Thus Soffici came to view himself as the Florentine equivalent of Paul Cézanne: like his French mentor, he

embraced both modernist aesthetics and a regional identity, substituting Tuscany's landscape and culture for Cézanne's Provence. Soffici admired Arthur Rimbaud for similar reasons, and in 1910 he wrote a book on the poet claiming that Rimbaud's provincial upbringing in the Ardennes accounted for the moral and religious inflection of his anarchism and the so-called mystical paganism of his literary production. Soffici's treatment of Picasso and Braque in his August 1911 article for *La Voce* also sought to reconcile avant-gardism with regional identity, but in this instance it was Picasso's status as an outsider who bridged the gap between modern Paris and his native Spain that reportedly accounted for his special role in founding cubism. Soffici's closeness to Picasso, combined with his pivotal role as an intermediary linking the Italian and French avant-gardes has been noted by numerous scholars who have analyzed the influence of Stéphane Mallarmé and Guillaume Apollinaire on Soffici as well as the continued relevance of symbolism for Soffici and for Picasso's evolving aesthetics (Adamson, "Ardengo Soffici and the Religion of Art"; Braun; Poggi, *In Defiance of Painting*; Poggi, "*Lacerba*"; Rubin; Vinall).

Despite his own sympathy for Soffici's cultural agenda, Prezzolini, who edited *La Voce,* insisted that no illustrations accompany the article for fear that the journal's readership would be scandalized (Del Puppo; Braun). As a result readers of *La Voce* had to wait until the December issue to see reproductions of Picasso's *The Old Mill* (1909), his *Mademoiselle Léonie* (1910), and Braque's *Glass, Plate, and Knife* (1910). In the earlier article of August 1911, Soffici followed other critics in interpreting cubism from the standpoint of anti-impressionism and Bergsonism, but unlike Roger Allard, he identified Picasso and Braque as the only true cubists, and drew on the art criticism of Bernard Berenson as well as writings by Jules Laforgue, Charles-Pierre Baudelaire, and Mallarmé to define cubist aesthetics. In the process he recast Picasso's move from his Africanizing phase to the full-blown cubism of 1911 in terms of Picasso's racial status as a Spaniard whose "almost Moorish origin" enabled him to grasp the "essential virtues" latent in the art of non-European "primitives," especially that of "the savage peoples of southern Africa." But as a European "refined by culture" and imbued with a "modern" sensibility, Picasso was able to further investigate and develop plastic values intrinsic to African art, but inscrutable to the Africans themselves.

Soffici informs us that Picasso seized on the volumetric quality and "artistic distortion" of African sculpture not only to transcend the

limitations of impressionist technique, but to distance his art from a scientific or logical experience of reality. Soffici makes his Bergsonian assumptions clear by drawing on his earlier essay "Divagazioni sull'arte: Le due prospettive" (*La Voce* [22 September 1910]) to justify his claims, citing premises laid out in that earlier article. In that essay Soffici utilized Henri Bergson's distinction between rational and intuitive modes of thinking to draw a sharp contrast between those artists who followed "rigid rules of scientific perspective" in constructing pictorial space, and "pure" artists like Giotto who created proportional relations in response to the emotive and spiritual power of their subject matter (Adamson, "Ardengo Soffici and the Religion of Art," 55–56). Writing in August 1911, Soffici argues that Picasso continued Giotto's spiritual quest, which ultimately led him to focus on "what an American aesthete, Berenson, calls 'tactile values.'" Here Soffici alludes to Berenson's claim, in his book *Florentine Painters of the Renaissance* (1896), that Giotto's primary achievement was to have stimulated our tactile sense of touch through volumetric form, thereby reinforcing the "life enhancing" quality of art. Lest we regard Picasso as yet another Pre-Raphaelite, Soffici pointedly distances Picasso's primitivism from that of "the horrible Beuron school"—a reference to the medievalizing aesthetics of the Benedictine monks Peter Lenz (1832–1928), Jacob Wüger (1829–92), Fridolin Steiner (1849–1906), and former Nabis Jan Verkade, who maintained ties with the Paris-based artists Maurice Denis and Paul Sérusier. Picasso's Spanishness positioned him as uniquely able to bridge the cultural gap separating the art of Europe from that of sub-Saharan Africa. Cubism therefore synthesized European and African culture to arrive at a new art, whose emphasis on the "tactile values" produced by volumetric form, recourse to simultaneity, and synesthetic (and symbolist) "melodious interweaving of lines and tints" was the product of a poetic imagination, "lyrically intuited." Since Picasso followed "strictly poetic criteria" and operated "independent of all preestablished rules," critics were wrong to associate his cubism with "theoretics or even a mechanistic approach" to art.

Soffici has comparable praise for Braque, whose art was "closely parallel" to Picasso's. However, it was the "love" and "delicacy" signified by the "musical calm" of Braque's *Maisons à l'Estaque* of 1908 (fig. 5) and his *Harbor in Normandy* (1909; Art Institute of Chicago) that served to "differentiate the Frenchman and the Spaniard." Moreover their cubism bore no relation to the work of Jean Metzinger, Henri Le Fauconnier,

Fernand Léger, and Robert Delaunay, whom Soffici dubs an "arriviste band of jugglers known as 'les fauves' that for a few years has been scandalizing the simple bourgeois who visit the Salon des Indépendants." According to Soffici, Metzinger and his cohort crudely imitated the outward appearance of Picasso and Braque's cubism without understanding the latters' aesthetic aims. Soffici then underscores the insult by adding that "a critic who is a supporter of theirs, Roger Allard, compares them to our futurists."

Adamson, "Ardengo Soffici and the Religion of Art"
Adamson, *Avant-Garde Florence*
Braun, "Vulgarians at the Gate"
Cavallo, ed., *Ardengo Soffici*
Del Puppo, "*Lacerba*" 1913–1915
Poggi, "*Lacerba*"
Poggi, *In Defiance of Painting*
Richter, *La formazione francese di Ardengo Soffici, 1900–1914*
Rubin, *Picasso and Braque*
Vinall, "French Symbolism and Italian Poetry, 1880–1920"

Albert Gleizes, "Art et ses représentants," *La Revue Indépendante* (September 1911): 161–72

Art and Its Representatives

Jean Metzinger

Amid the current overproduction, amid the excess of talents manifesting themselves today, it is nevertheless relatively easy, whatever one may say, to deduce a possible direction for painting. After the efforts of Picasso, Braque, and Derain—questionable, no doubt, but undeniably coming at the right time—let us point out, among the group that asserted itself this year in Room 41 of the Salon des Indépendants, Jean Metzinger, not as an exceptional case, but because this study is devoted to him.

He is a painter first, gifted with a rare sensibility, sustained by a will and a logical mind in the service of a subtle intelligence. Some day, the influence his research has had on the evolution of the plastic method, on the renaissance of twentieth-century painting, will have to be recognized.

And since I have written the word *Renaissance,* I will take the opportunity to explain myself regarding the meaning I give it. It seems to me, in fact, that the many recent surveys on this matter have shown, above all, a desire to return to the heroic age of the sixteenth century. And yet, there is a clear line leading from Giotto to Raphael that is just as profound as that extending from Watteau to David, and that is no less a Renaissance than that which took place between Poussin and Cézanne. Since the Renaissance of art must naturally follow the progress of Humanity itself, whatever responded to the needs of yesterday must obviously be reshaped to meet those of today. Opposition to progress would mean death by boredom, and an artist's duty is, in the first place, not to evade the era into which he is born. His birth will be a rebirth, a renaissance, of the ideal arc of Beauty, and to him falls the honor of discovering signs that will add new links to the chain of previous efforts. He must know that Past

well enough to distinguish the main road of tradition from the insidious paths where the mediocre are content to remain. As I said earlier, the masters—Giotto, Raphael, Poussin, David, and Cézanne—who paved the illustrious way for us, allow us to recognize the lesser talents, who were sometimes ingenious but who abused their talent and misled followers who were on the lookout for a formula to exploit.

During the time of impressionism—for I do not intend to review all the ages of painting here—Cézanne alone understood the danger of that fragile search, solely directed toward the external and inconsequential. One had to particularly distrust that pleasant art, which, all in all, offered only a secondary charm through a rejuvenation of color: it led ultimately to the advent of social art, within the reach of masses of people, whose education was based too much on the law of the least effort. Yet Cézanne, the most significant painter of this time, in terms of his starting point if not in what he actually accomplished, tried to recapture the true spirit of the French tradition. His works, born of restlessness, stand superbly opposed to the throng of disparate tendencies born of impressionism, pointillism, divisionism, and the "neos." His research on forms and density were to serve the generation to follow, which, through him, would become conscious of the road to take, or rather, to rediscover. The works of David, Ingres, and Delacroix could now really be understood. Instead of the ridiculous banalities imposed by the adroit followers of the "Grand Old Men"—banalities that, having become official, do not for that reason acquire a new vitality—instead of the epileptic smears of the overly high-spirited naturalists, we were going to return, as Guillaume Apollinaire very rightly said, "to a simple and noble art, expressive and measured, ardent in its search for Beauty . . . returning to the principles governing color and composition, drawing and inspiration." And it was truly Cézanne who was the link between them and these latter tendencies. As for the great principles—color and composition—the fauves had already given an inkling of them. With the painters called "cubists" (?), we rediscover and transform Writing and Inspiration.

This digression has been useful in that it has allowed me to show the efforts of Jean Metzinger, whom we will place under the cubist label. Metzinger, who arrived when impressionism was triumphant, when Matisse was beginning to come forward and to matter, perceived early on—with his intelligence more than with his painter's sensibility—that, in its subversive research, painting was struggling merely with the superstructure,

and that the very valuable suggestions of Picasso and Braque did not, in spite of everything, emerge from an impressionism of form, which they nevertheless distinguished from the impressionism of color. Did he not write that we are exclusively under the sway of principles invented by the Greeks, and that the research of a modern artist ought, on the contrary, to imagine the creation of plastic signs that might enrich our realm of perception? To extend our perception through new insights: everything depends on that. And such will be the direction of Metzinger's art.

The twenty centuries of Greco-Roman traditions, and the forms canonized by those times, have become so familiar to us that it seems impossible to imagine any others: for our Western cultures, the plastic signs of the Hindus, the Chinese, the Egyptians, or the Africans are merely a matter of curiosity and exoticism. It is dangerous and useless to consider them capable of adding something to the tendencies of our own race. In fact, do we not regard our own ancestors, the early masters, with more complacency than admiration? Greece imposed its art and its canons on us, and that makes possible our rapid comprehension by means of a too facile comparison.

The idea we construct of *form* under such conditions can be explained only by the standard "type," which forms the basis of our education, as a mold into which we pour all our sensations. When the type coincides perfectly, the result is perfect beauty: that's all we need.

Nevertheless, the child who is born with eyes and ears sees and hears in the exact sense of those words, but it is obvious that his idea of images and sounds is not the same as it is for more fully developed individuals, and that he cannot sense the subtleties that allow us to say, "That face is ugly" or "That song is beautiful." The upbringing he receives will thus be a first measurement, a unit of judgment for establishing relationships; and, in accordance with the direction of his education, he will form ideas about beauty and ugliness. Hence, nothing is more indeterminable than the meaning of these words, and the artist alone can and must give them a true significance. There is nothing less immutable than the establishment of these relationships, which, however, form an entire system of balances. It will therefore be Metzinger's duty to discover new relationships in order not to end up destroying the known system of balances. Hence he will bring his own personal effort to the established tradition. I cannot always accept Metzinger's findings, but I greatly admire the audacious logic behind them, and I will therefore try to explain them here.

Metzinger cannot force himself to assume the fixed position of the painter who places himself before the object and thus submits to the laws of an earlier and unchanging perspective. Obsessed by the desire to inscribe the *total Image,* he will give a considerable dynamism to the plastic artwork by making the artist move around the object to be represented; then, with a tact that will be in proportion to and in harmony with the painting, he will inscribe the greatest p ossible number of its planes. He wants to add, to the purely objective truth, a new truth coming to life from what his intelligence has allowed him to know. As he himself says, he will add *duration* to *space.*

One example: in the plastic representation of a human figure, a portrait, Metzinger is convinced that, by inscribing the face frontally and then in profile on the same canvas, these two planes, brought together by the entire sensibility that informs the picture and can increase the resemblance to an extraordinary degree. It is obvious that this will be done with moderation, which will be the point in common between the tradition of the old masters and present-day endeavors. In short, he wishes to develop the visual field by multiplying it, in order to inscribe it within the space of the canvas itself. It is at that point that the cube will play a role, and it is there that Metzinger will use that means to reestablish a balance that has been momentarily interrupted by these audacious inscriptions.

At the last Salon d'Automne [1910], we were able to get an idea of that technique, inscribed and set out in simple terms.

His *Femme nu* [fig. 11], depicted from various angles and in integral relationship with the setting, the shapes very subtly nested one into another, was more like a masterful demonstration of the total image than an exclusively pictorial creation.

Certain discriminating critics (oh, so discriminating!) who judge artworks only by the extraneous elements they include—literature, anecdotes, character, and so on—considered it a metaphysical discovery more than a manifestation of art. Alembics, laboratory tubing, intellectual masturbation—people have called his works all those things, with the greatest seriousness in the world. Well, my God, you have to explain even what you can't understand, don't you? And, among imbeciles, are not irony and jokes the arguments in favor? Where there was only the honest explanation of an artist struggling with his temperament and his will, they wanted to see a completed work, a definitive monument. It is clear that, in this instance, great ignorance was coupled with an obvious lack of sincerity.

The unease, which undoubtedly led to these incoherent judgments, and produced outrage among the regular visitors to our salons, was attributable above all merely to the weak coefficient of naturalism, excluded voluntarily as I understand it. But it was Jean Metzinger's duty to show us scientifically, that is, deliberately, the result of his research, and winning over the few literate beholders was enough for him. Did not Degas say that a work of art was made for only three or four art lovers? One should not ask for more.

Since then, in the notorious Room 41 of the Salon des Indépendants [1911], which, in the opinion of real artists supporting that movement—Guillaume Apollinaire and Roger Allard, for example—was the most significant pictorial demonstration of recent times, we have been able to follow Metzinger over the course of his evolution. There, "the Emperor of cubism"—as one of the neurotic critics incapable of sensing artistic potential has so wittily baptized him, having perhaps captured the ear of a public reluctant to expend any intellectual effort and satisfied with the commonplaces in their memories—there, "the Emperor of cubism" has shown us new achievements in the plastic realization of his art. In *Paysage* [*Landscape*], perfectly balanced and purified of any needless chatter, where the forms of houses and trees converged with those of the terrain and the sky in a whole that was classical in the full sense of the word, where the transposition of objects, soberly depicted, made it easy to read, one could assess the considerable contribution his will has given us. In *Portrait de femme,* which rightly led deputy public prosecutor [Joseph] Granié, a subtle and knowledgeable critic, to say: "Very eighteenth century, that woman's head by J. Metzinger," one again found, and perhaps there more than anywhere else, the broken thread of tradition. Through the subtlety of the drawing highlighted with a completely internal, delicate color, and with a very rare sensibility, through forms diametrically opposed in appearance, the face and profile drawn and juxtaposed with perfect tact, and the picture as a whole marked by a certain preciosity, which moreover added a certain charm to the canvas, it was possible to accept it, even admire it, in good faith.

The small *Nature morte* [*Still Life*] was the only thing in his exhibition that could make the jackals of criticism, the robbers of corpses, bark. But even these gentlemen, without having to fear for the delicacy of their brain structure, could have easily comprehended the total image conceived by Metzinger through that schema. They could have understood his entire method without great effort, since it is very lucidly set forth.

I say "method" because it would be pointless to try to extend our already rich patrimony by replacing the results of yesterday with just any system. It must not be seen as a mathematical application of a questionable scheme, but, on the contrary, as a new and broader expansion of our means. It is a plus and not a minus.

We add to our cultural legacy by supplementing our creative and perceptive faculties, and we cannot agree to see all the efforts and creations of the past conjured away in favor of a fashion, an illusion to be exploited for modern neurasthenia.

For my part, I am firmly convinced that there is, in all this, a normal return to the great eras. This research may at present appear somewhat disconcerting: such a discipline cannot hope to draw a mob of followers into its order; the outcry it is provoking was anticipated, since how could we assume for an instant that the people nosing about, on the lookout for a formula they can easily plagiarize, could cheerfully leave behind the disorder and the license where they have found their easy success, in favor of a rigid and deliberate method, entirely internal, constructive, synthetic, and merciless toward hasty creations?

Later, once the origins have been recovered and the modes of labor established, it will be easy to give an account of the road traveled. Not everyone is gifted with foresight; Metzinger and his friends, therefore, know they should not be surprised by the struggles they face, Metzinger more than the others perhaps, since it seems to me that he is the one who wants to be the most daring, but always in a logical way, with all the force of his intelligence, his will, his education. He is tilling a field both modern and traditional, from which the harvests will come forth, for our joy and the joy of those able to anticipate them.

Finally, I will end this study with a historical account that may help readers follow step by step the research of an enthusiastic and honest artist, from his often misty beginnings to the luminous creations of tomorrow.

A long period has already elapsed since Metzinger began his craft as a painter. Arriving from Nantes, where he had found an "award-winning artist" to oversee his first steps, he was immediately won over in Paris by Seurat's work; he conducted his research in that direction, and exhibited a series of canvases at the Indépendants. For the record, let me mention *Ile [Island]* (1906), *La bacchante* (1908) [*Bacchante* (ca. 1906), Kröller-Müller Museum, Otterlo, The Netherlands], *Le paon [Peacock]* (1906), *Les*

flamands [*The Flemish*] (1907), and *Les paysages du midi* [*Landscapes of the Midi*] (1907 and 1908). Then, weary of that somewhat artificial orientation, and feeling the need to return to tradition, he abandoned the point—no longer seeing anything but surfaces and volumes—and color, which he distinguished from nuance. It was the time of *Portrait de G. Apollinaire* [fig. 10] and *La femme à genoux* [*Kneeling Woman*] (1911). Finally, with admirable consistency, we arrive at the logical development of his ideas and the conclusive, absolute moment of his art: the Salon d'Automne (1910) and the Indépendants (1911).

We must pay tribute to Metzinger, recognizing that, just when he was about to be able to easily exploit the formula of pointillism (since it has formulas and procedures) with a little more sense of form and intention than the creators of the system (with the exception of Seurat, however), he had enough willpower to avoid the temptations, the glory, and the sales, which weaker constitutions can never resist, and to attempt to contribute his fair share of audacities and foresight to the return to the French tradition, the pillars of which are grandeur, clarity, equilibrium, and intelligence.

I have refrained, in this study of an artist whose efforts are dear to me, from trying to write literature. I wanted to speak simply as a painter about a painter, and I took little care in shaping my sentences. Let those who make it a religion do so, but, as for me, I was solely intent on expressing myself as clearly as it was possible for me to do on a subject familiar to me.

In spite of that, I will apologize, and will conclude with a quotation I culled from Nietzsche's *Thus Spake Zarathustra,* and which I find admirably suited for the situation:

"But this is the truth: the Righteous must be Pharisees, they have no choice.

"The Righteous must crucify the man who invents his own virtue for himself, this is the truth.

"It is the creator they hate the most, the man who breaks the tablets and the old values, the breaker, it is him they call 'criminal.'

"For the Righteous cannot create; they are always the beginning of the end.

"They crucify the man who writes new values, they sacrifice the future for themselves.

"They crucify the entire future of men.

"The Righteous were always the beginning of the end."

And is that not why Metzinger, who brings us so many new values— and not just him, but also those having similar aspirations—must expect only a relentless opposition on the part of the Righteous, critics and artists who, powerless to create, keep the men they ought to lead toward the future in a state of sweet drowsiness and satisfied beatitude?

Albert Gleizes

SEPTEMBER 1911

Commentary

In this, the first full-length article devoted to Jean Metzinger, Albert Gleizes provides us with an apologia for Metzinger's cubist innovations. Written shortly after his first viewing of Georges Braque's and Pablo Picasso's painting, Gleizes's essay contextualizes Metzinger's own writings on art in terms of broader debates over whether an artistic "Renaissance" was in the making (Brooke, 23–24; see documents 11 and 19). Gleizes asserts that cubism inaugurated a contemporary Renaissance with cultural roots in the Italian-French tradition, but not one restricted to the sixteenth century. His reference to the "many recent surveys" on the subject no doubt alludes to the explosion of such *enquêtes* in literary journals from 1905 onward (Décaudin, 307–30). In Gleizes's estimation, "the road to tradition" for Metzinger and the cubists was forged by Paul Cézanne, and he bolsters his reading by quoting from Apollinaire's defense of cubism in his preface for the Annual Salon of the Cercle d'art "Les Indépendants" held in Brussels in June–July 1911 (Breunig, 172–73). He likewise distinguishes cubism from an art inspired by cultures not "of our race," most notably "the plastic signs of the Hindus, the Chinese, the Egyptians, or the Africans." Here he reinforces Metzinger's own dismissal of "neoprimitives" in his "Note on Painting" (document 11). Gleizes then marshals Metzinger's theoretical pronouncements on "duration," the "total image," and volumetric space in an analysis of such cubist paintings as his *Nue* (1910; fig. 11) and lost works, including a landscape, a portrait of a woman, and a small still-life, all of 1911.

Gleizes concludes his article with a brief survey of Metzinger's production before quoting Friedrich Nietzsche's *Thus Spake Zarathustra* (1885) to the effect that Metzinger's creative powers had instigated a transvaluation of values, indicative of the cubists' elitist role in society. As art historians have noted, this Nietzschean conception of the artistic *surhomme*

had already been reiterated by Apollinaire in a published review of the Salon d'Automne of 1910 (Apollinaire, "Salon d'Automne," *Poésie;* cited in Breunig, 113–14). In that article, Apollinaire referred to Metzinger's *Nue* of 1910 (fig. 11) as "a listless and servile imitation" of "an artist who is endowed with a strong personality," namely "Pablo Picasso." By the Salon des Indépendants of 1911 Apollinaire had revised his assessment: while he still identified Picasso as the Nietzschean font of cubism, he now expressed admiration for Metzinger as the only salon artist whose work could "properly be called cubist" (Apollinaire, cited in Breunig, 151). By championing Picasso in the name of Nietzschean paradigms, Apollinaire echoed Picasso's own politicized enthusiasm for the philosopher; beginning in 1911 Gleizes and Metzinger numbered themselves among this Nietzschean elite, a position codified in *Du "Cubisme"* (1912) (M. Antliff; Leighten; Nash; see document 57).

M. Antliff, *Inventing Bergson*
Breunig, ed., *Apollinaire on Art*
Brooke, *Albert Gleizes*
Décaudin, *La crise des valeurs symbolistes*
Leighten, *Re-Ordering the Universe*
F. Metzinger, *A Forgotten Painter in the Rijksmuseum Kröller-Müller*
Nash, "The Nature of Cubism"

La Palette [pseud. of André Salmon], "Pablo Picasso," *Paris-Journal*, 21 September 1911

Pablo Picasso

He has left his fur trapper's house perched on the Butte for a more academic studio located not far from the Cirque Médrano. The decor is picturesque and unexpected. On every piece of furniture, curious wood figures grimace, the best selected pieces of African and Polynesian statuary. Picasso, long before showing you his own works, will have you admire these primitive wonders. Welcoming and mocking, he is dressed like an aviator. As indifferent to praise as to criticism, he finally shows the canvases the collectors are after, and which he has the coquetry not to exhibit at any salon. Here are gaudy rogues, already twelve years old: the influence of Toulouse-Lautrec is obvious. Here are the beggars, the cripples, the suppliants, all painted blue and white, sorrowful, tragic, and who make you think of El Greco; here are the Harlequins, the acrobats, the mystical wandering players who revealed Picasso's true personality. Here, finally, are the recent works, which many people find less directly appealing. The astonishment of a few art lovers gives Picasso a great deal of joy, and he does not contradict them. At the very most, he denies being the father of cubism, which he simply suggested. To a younger painter, who asked him whether one ought to draw human feet round or square, Picasso replied with great authority: "There are no feet found in nature!" The other fellow is still running, to the great joy of the one who pulled his leg.

La Palette [pseud. of André Salmon]

21 SEPTEMBER 1911

Commentary

The poet, critic, and novelist André Salmon (1881–1969) was an important witness to the development of cubism. Having met Picasso in 1904

he quickly became a close associate of the artist and his literary allies, Apollinaire and Max Jacob (1876–1944) (Leighten, *Re-Ordering the Universe*, chap. 2; Gersh-Nesič). Salmon lived alongside Picasso and Juan Gris in the Bateau Lavoir (referred to here as "the fur trapper's cabin") until 1909, when he married and took up residence in Montparnasse. During the prewar period Salmon not only published journalistic reports in *Paris-Journal* on the avant-garde under the pseudonym "La Palette" (from 1909 to 1914), he also wrote an important assessment of modern art, *La jeune peinture française* (1912) (documents 50 and 51) as well as numerous novels and works of art criticism. This sympathetic and tongue-in-cheek account of Picasso's studio reveals the deep respect they all had for African and Oceanic art, while Picasso's playful and mocking side gets central play (Leighten, "The Dreams and Lies of Picasso"). The final quip of Picasso's playfully distorts Monet's famous impressionist dictum: "There is no black found in nature."

Salmon's role as art critic for *Paris-Journal* had broader implications within the context of debates over the status of the avant-garde in French society. As Fay Brauer has demonstrated, *Paris-Journal*, along with *Gil Blas* and *L'Intransigeant*, was a self-styled "independent" newspaper, which claimed no overt political allegiance, yet positioned itself in opposition to cultural institutions and political parties that promoted French nationalism or the conservative status quo in the realm of culture. *Paris-Journal* was founded in 1908 by Gérault-Richard, whom Salmon described as a Socialist with anarchist leanings (Salmon, *Souvenirs;* cited in Brauer, chap. 1). Salmon, along with art critics writing in *Gil Blas* and *L'Intransigeant*, promoted the association of avant-gardism with the doctrine of *l'art révolutionnaire*, broadly defined as freedom in the arts. Writers espousing this agenda included Apollinaire and Jacob; a comparable discourse emerged independently under the auspices of the anarchist art criticism of Paul Signac and Elie Faure (see documents 36 and 42). This discourse was considered anathema by academic painters gathered under the auspices of the Société des artistes français and Société nationale des Beaux-Arts. In the press, academic artists won the approval of pronationalist papers such as *L'Eclair, Le Matin,* and *Le Figaro,* as well as royalist organs like *Le Gaulois* (Brauer). The culture wars between these factions reached a head when *Le Matin* first publicized Socialist Pierre Lampué's virulent attack against the cubists on 5 October 1912 (see documents 45, 49, and 55). The resulting debate made plain the increasingly xenophobic nature of the attack on

cubism, manifest not only in Lampué's overblown claim that the cubists represented a threat to French civilization, but in the vitriolic assessments of cubism penned by academic artists associated with the Société des artistes français and Société nationale des Beaux-Arts (see document 58).

Brauer, "L'Art révolutionnaire"
Gersh-Nesič, *The Early Criticism of André Salmon*
Leighten, "The Dreams and Lies of Picasso"
Leighten, *Re-Ordering the Universe*
Salmon, *Souvenirs sans fin*

La Palette [pseud. of André Salmon], "Jean Metzinger," *Paris-Journal*, 3 October 1911

Jean Metzinger

He is blond and pink, like Maurice Rostand, but his poetry is more mysterious; yes, the acknowledged leader of cubism is also a poet inspired by Mallarmé. He is blond and pink, with blue eyes protected by long lashes; he seems fragile, but one can discern that he is nevertheless full of energy. Jean Metzinger does not look the artistic type. His dark morning coat becomes him, and his black pants are made of silk. As the supreme refinement, this perfect dandy smokes a clay pipe, even in the street; it is true he is a "Narcissus," to which the poets attribute certain esoteric virtues. Jean Metzinger has struggled hard for cubism; let us acknowledge that, this year, he is prevailing over a fairly keen opposition. It is owing to his unflagging propaganda that the cubists occupy Room 8 at the Salon d'Automne. Jean Metzinger has written: "Tomorrow it will be said of a woman: she is beautiful as a Braque; she is pure as a Le Fauconnier."

His 1911 submission, *Goûter* [Philadelphia Museum of Art], the portrait of a young woman, is a metaphysical puzzle, and ought truly to be considered the cubist *Mona Lisa;* let Mr. Frantz Jourdain keep watch over it! Jean Metzinger was born in Nantes, as he admitted recently: but, in the past, the catalog read: "Metzinger (Jean), born in Leipzig." Now there are so many foreigners at the Salon d'Automne that there is no longer anything original about this exoticism. That is why the young prince of cubism acknowledges he is Breton, counseled by his compatriot Max Jacob, a painter and teacher of the Kabbalah, who initiated Jean Metzinger into the Great Mysteries.

La Palette [pseud. of André Salmon]

3 OCTOBER 1911

Commentary

In this colorful description of Metzinger, Salmon makes plain his own affinity with the poet-painter and the latter's enthusiasm for the symbolist poet Stéphane Mallarmé (Salmon edited the neosymbolist and Mallarméan journal *Vers et Prose* between 1905 and 1910) (Cornell, 69). Salmon also references Metzinger's close ties to the poet Max Jacob (1876–1944), who had reportedly introduced Metzinger to the "Great Mysteries" of the Kabbalah. Like Metzinger, Jacob was friends with Picasso, having met the artist in 1901 and shared a studio with him in 1902. Metzinger later recalled that it was Jacob who introduced him to Guillaume Apollinaire in 1907 (J. Metzinger, 41–47). Jacob apparently had a serious interest in the occult, and like many of his generation found proof for his beliefs in modern science and theories of the fourth dimension. Thus Jacob, along with Maurice Princet, was likely instrumental in nurturing such interests among the denizens of the Bateau Lavoir (Henderson, 65 and 71–72; Hicken, 8–18; Richardson, 203–7).

Salmon characterizes Metzinger as a dandy whose appearance resembled the then popular playwright Maurice Rostand (1891–1968). He then underscores Metzinger's importance among his peers by highlighting his supposed role in orchestrating the cubists' placement in Room 8 of the 1911 Salon d'Automne. Albert Gleizes would later contradict Salmon, noting that the hanging "had not been arranged by us," and was instead the responsibility of two new converts to cubism, Raymond Duchamp-Villon (1876–1918) and Roger de la Fresnaye (1885–1925) (Gleizes, 26–28). In the spring of 1911 Gleizes, Metzinger, and Henri Le Fauconnier had successfully conspired in Le Fauconnier's election as president of the hanging committee for the annual Salon des Indépendants (21 April–13 June), thus assuring that paintings by Delaunay, Gleizes, Le Fauconnier, Léger, and Metzinger were hung together in Room 41. A group of the "satellite" artists, including André Lhote, André Dunoyer de Segonzac (1884–1974), and la Fresnaye were hung in the adjacent Room 43. Gleizes then claimed that Room 8 "lacked the homogeneity of Room 41" by placing the "representatives of orthodox cubism, Le Fauconnier, Léger, Metzinger and myself" alongside artists "who resembled us only remotely" (Gleizes, 28). Historians now concur that Gleizes's version of events, in contrast to Salmon's, is the truer one, and that Gleizes's retrospective distinction between orthodox and nonorthodox cubists signaled schisms in the movement that first emerged in the autumn of 1911 (Cox, 148–75).

Cornell, *The Post-Symbolist Period*

Cox, *Cubism*

Gleizes, *Cahiers Albert Gleizes*

Henderson, *The Fourth Dimension and Non-Euclidean Geometry in Modern Art*

Hicken, *Apollinaire, Cubism and Orphism*

J. Metzinger, *Cubisme était né*

Richardson, *A Life of Picasso*

Urbain Gohier, "Notre peinture," *Le Journal,* 10 October 1911

Our Painting

Painting in cubes has barely produced its effect at the Salon d'Automne when it is threatened by painting in cylinders: the tubists are going to succeed the cubists, just as the cubists succeeded the pointillists and the confettists.

What was first ventured as a good joke at the exhibitions of the Incohérents, then as a revolutionary manifestation among the Indépendants, will be normal tomorrow, and official day after tomorrow. Joyous daubers, backed by deceptive critics and by dealers full of craftiness, had wanted to fathom the public's naïveté, but they found it unfathomable.

At the village school, the little brats crush a fly's head or press a drop of ink into the fold of a sheet of paper, which produces, in red or black, diverse maculated sheets. In the studios, you must press colors into a folded canvas. You open it: nothing more to do than frame it. It is a fantastic flower or the interior of a factory, unless it is a row of Hindu dancing girls or a flight of airplanes. There will always be buyers, provided an increase in the product's value can be predicted.

A blue-chip investment! In ten years, what you pay five hundred dollars for will be worth ten, twenty thousand francs if it's worth a cent. You have only to launch the brand and support the currency. M. Prudhomme no longer intends to be called a Philistine. Henceforth, he does not judge a canvas; what does it matter if the drawing resembles the efforts of a caveman and the colors sear the retina? He is not patronizing the arts: he is engaging in speculation.

The good people still become alarmed; the members of the public who visit the salons and are not "insiders" stand flabbergasted before these burlesque scenes, these subjects that seem to have been taken from the morgue or a museum of horrors. When they go outside, it takes them

a good moment to reconcile themselves to the blue sky, the golden clouds, the green of the lawns; their crazed eyes no longer recognize the familiar silhouettes, the logical perspectives, the balanced movements. They are astonished at the houses, which are vertical, and the women, who are not dropsical, boneless, or in convulsions.

Isn't there enough ugliness in the world? Why do they manufacture it for pleasure? We would so much like to escape painful, discouraging, agonizing impressions! Why do they inflict them on us? Our heredity, our climate, our noble and sweet horizons gave us delicate tastes: why deliberately spoil them?

Combined with avant-garde prose, symbolist poetry, and futurist music, that mode of painting puts our nerves on edge.

"Oh! But excuse me!" the painters who practice it reply. "We are expressing our age, just as our predecessors expressed theirs."

The conception of beauty varies across time, just as it varies in space; the Venus of the Hottentots does not resemble the Venus of the Greeks because the beautiful Hottentot girls do not have the same charms as the beautiful Greek girls.

Rubens and Van Dyck, Philippe de Champaigne and Vélazquez, Watteau and Greuze painted men, women, a society, characters, mores, passions, and heroes as they saw them; and we paint madmen, invalids, vices, perversions, and puppets as we see them. It is not our fault if, at that time, life was magnificent, elegant, if humanity feasted on good meat and generous wine, if there was power and grandeur even in the physiognomy of scoundrels, and nobility even in the physiognomy of fools, whereas life today is mean, narrow, seedy, whereas our contemporaries feed on chemical products and mineral water, whereas the rogues are dull rogues, and the imbeciles do not redeem themselves by their appearance!

The scenes and characters on our canvases did not come from our imagination, but were taken from life, from a neurasthenic, hysterical, epileptic, alcoholic, ether-addicted, opium-addicted, morphine-addicted humanity, fed on poisons, suckled on poisons, injected with poisons, given over to all the causes of breakdowns, and without the strength to resist them.

Thus, these bizarre anatomies, these deformations, these contortions, these drab or frantic faces are your own. Our painting is faithful. We have an exact idea of what men, society, the lives of previous ages were like when we contemplate the canvases of those times; our descendants

will have an exact idea of what men, society, and life today are like by looking at our canvases.

Even more than reproducing reality, painting expresses an aspiration. The bodies of women, the sumptuous fabrics, the jewels, the fêtes, the battles, the heroic carnage, the sublime deaths that the paintbrushes of the old masters described to us teach us above all what they dreamed, what men of their time dreamed of. Similarly, today, if artists delight in representing macabre episodes, gamy flesh, dismembered carcasses, dazed or frenetic faces of the mentally ill, greenish skin, eyes glazed over by debauchery or gleaming with sadism, it is because they dream, because we dream, because the entire human race, in these times, dreams of unhealthy joys and unprecedented extravagances.

Claude Gelée tells us what spectacles enchanted his contemporaries; the pointillists and confettists interpret our vision of nature. Just as Charles Lebrun was Louis XIV's painter, the cubists, the tubists, the Enragés, the Incohérents, the catastrophists, are truly our painters.

Urbain Gohier

LE JOURNAL, 10 OCTOBER 1911

[See commentary following document 25.]

Henri Guilbeaux, "Le cubisme et MM. Urbain Gohier et Apollinaire," *Les Hommes du Jour* (11 November 1911), n.p. [8]

Cubism with MM. Urbain Gohier and Apollinaire

Cubism is glorified by Mr. Apollinaire in *L'Intransigeant* (10 October 1911) and made fun of by Mr. Urbain Gohier in *Le Journal* on the same day. Cubism inspires intelligent reflections in Mr. Gohier, but makes him say erroneous things. One cannot indict cubism and the neoimpressionists at the same time. The neoimpressionists, whose methods may be open to criticism, have created works and have proved to be great decorators and luminists; the cubists conceal their lack of personality behind an annoying and depressing technique. But Mr. Urbain Gohier is trustworthy, and it is clear that it is owing to these stupendous hoaxes that the "bourgeois" is losing interest in questions of art, and admires the art of Mr. J.-Émile Blanche or Mr. Charles Cottet. A quarter of a century ago, the bourgeois feared and despised the audacities of the impressionist painters; then he saw that the imbecilic critics had deceived him by snickering in front of Monet's and Cézanne's canvases. The cubists imagine that they are currently playing the same role as the impressionists. They say: "Now we are disavowed, ridiculed; tomorrow we will be acknowledged, we will be glorified." It does not occur to these shrewd people that, just because the work of an innovator is at first frightening or disconcerting, it does not mean that every canvas or book with a strange appearance is necessarily a work of genius. Suppose I want to commit some crude act in the street. I know that people will look at me and shrug their shoulders. Have I demonstrated genius? Yes, asserts Mr. Metzinger.

What Mr. Apollinaire writes is a much more serious matter. To several people, and to myself in particular, Mr. Apollinaire has had very harsh things to say about cubism. I met him before the opening of the exhibit in Room 8. He was accompanied by the likable and dryly ironic Pablo

Picasso, whose talent as a painter, a true painter, is undeniable. Both poked fun at the canvases that displayed cubes, cones, and tubes, and expressed a rather unfavorable opinion. And yet, in the newspaper where he publishes his notes on art, Mr. Apollinaire writes: "Without mistaking the talents of all kinds that are on display at the Salon d'Automne, I am quite sure that cubism is the most noble thing in French art today." I do not wish to criticize Mr. Apollinaire's irony, but I believe he might warn the readers of *L'Intransigeant* with a headline indicating that his only goal is to be a humorist.

There are some who admire the talent of a practical joker that Mr. Apollinaire possesses: I am not one of them. I recognize the culture and work of Mr. Guillaume Apollinaire, but I question his right to contribute toward the skewing of values. In contemporary art, the joke is erected into a principle, and hence we see a publisher bringing out a volume on Cézanne, one on Van Gogh, and one on—Le Douanier Henri Rousseau. People have been too benevolent in their acceptance of practical jokers in recent times; these jokers must at present be tracked down and prevented from carrying out their harmful mission.

Henri Guilbeaux

11 NOVEMBER 1911

Commentary

These two articles reveal telling social and political tension in the aesthetic debates of the avant-guerre, with a variety of positions taken. Urbain Gohier (Urbain Degoulet-Gohier) (1862–1951), adopted by his namesake, was the natural son of Gustave Hervé, antimilitarist leader and editor of *La Guerre Sociale* (1906–15). Gohier was a very well-known journalist and editor, writing for and serving as editor on a range of journals throughout his long career, including *Le Soleil* (1884–97), *L'Aurore* (1897–98, the leading Dreyfusard journal), *Cri de Paris* (1903–4), *Le Matin* (1906), *L'Intransigeant* (1907), and, finally, *La Libre Parole* (1909), Edmond Drumont's virulently anti-Semitic journal affiliated with the extreme right wing. During the Dreyfus affair, while editor-in-chief of *L'Aurore* (which published the famous Zola letter "J'Accuse"), he was an ardent Dreyfusard and criticized the government, the army, the church, and monied interests. The latter theme became one of his obsessions, leading to his outspoken anticapitalist anti-Semitism (defended by Victor Méric in *Les Hommes du Jour* in 1909) (Datta). Having studied law in his earlier days, in 1909 he was

called to the bar in Paris; this inside knowledge may have helped his being acquitted numerous times of antimilitarist-propaganda charges in a series of a dozen trials, some sensational; but in 1905 he served a year in the Santé prison for his antimilitarist polemic. By 1911—despite Méric's defense—Gohier seemed to leftists a right-wing maverick rather than the socialist revolutionary he once was, but he continued to publish in a great variety of venues, including the centrist *Le Figaro, Le Gaulois,* and the anarchist *Le Libertaire.*

The occasion of Urbain Gohier's article was the Salon d'Automne of 1911, with its famous "Cubist Room" 8, and the numerous supporting comments made in the press by Guillaume Apollinaire (and others) about this new art. Paintings on view included Jean Metzinger's *Le goûter* (Philadelphia Museum of Art), Henri Le Fauconnier's *Landscape, Lake Annecy* (Hermitage, St. Petersburg), Fernand Léger's *Essais pour trois portraits* (fig. 21), Albert Gleizes's *The Hunt* (private collection, Paris), and André Dunoyer de Segonzac's *Les boxeurs* (fig. 22). Gohier's article actually appeared the same day that Apollinaire threw down the glove in *L'Intransigeant* (10 October 1911): "Cubism is the highest undertaking in French art today." Apollinaire asserted in this article, "In the monumental appearance of compositions that surpass contemporary frivolity, people have refused to see what is really there: a noble and measured art ready to undertake the vast subjects for which impressionism had prepared not a single painter. Cubism is a necessary reaction, which, whether one likes it or not, will give rise to great works" [authors' trans.]. The very title of Apollinaire's article makes one of his favorite arguments: "The Exceptional Attention Accorded by the Press to Cubism Proves Its Importance," and in numerous places he had claimed that cubism was the "sign of the times, the modern style that people pretend to wish for, that they seek without wanting to recognize where it is located" (*L'Intransigeant,* 21 April 1911) (Apollinaire, 253–57).

Gohier blasts Apollinaire's position by agreeing with it. He finds cubism—along with "tubism" (Léger's new work), the "Incoherents," and the neoimpressionists—perfectly expressive of a decadent society, rising to eloquent heights of loathing and contempt for contemporary art and society alike. In the name of logic, balance, and "our heredity, our climate, our noble and sweet horizons"—all essentialized aspects of the French race and tradition he is defending—he rejects the primitivist basis of cubist paintings, which look like "the efforts of a caveman," concluding

that modernism is indeed a realist reflection of present-day degeneracy in art and in society.

Henri Guilbeaux (see document 14), who took over from Maurice Robin as art critic of *Les Hommes du Jour* in January 1911, takes issue in his response, not with the "trustworthy" Gohier's rejection of cubism—which prompted "intelligent reflections"—but with his lumping of the neoimpressionists in with the younger artists. Guilbeaux, a staunch supporter of the neoimpressionists, admired Paul Signac's anarchist aesthetic. Signac viewed modernist art as the free expression of the individual artist, whose radical vision may at first challenge viewers but which will eventually help shape a freer society (Herbert and Herbert; Ferretti-Bocquillon et al.). Yet Guilbeaux hardly agrees with Apollinaire that therefore every public rejection "proves" the presence of genius; indeed, the newest manifestations of radical individualism clearly challenge his own defense of modernism. In an article reviewing the Independents in *Les Hommes du Jour* the previous spring, Guilbeaux perceptively noted the influence of Le Douanier Rousseau, but which, "added to that of Gauguin and more recently to that of Picasso, has produced grotesque results, ridiculous, made it seems in order to shock the middle-class [*épater les bourgeois*]," citing the work of Léger, Francis Picabia, and Metzinger (Guilbeaux). Now he views cubist paintings as "stupendous hoaxes," purporting to reveal that Apollinaire and an admirable young painter named Pablo Picasso agree with him and calling for the poet to reveal the truth to the readers of *L'Intransigeant.* Failing to perceive that Apollinaire and Picasso could criticize particular works while sincerely defending this newest manifestation of modernism, Guilbeaux believes that both the art critic and the cubists are jokesters, purposely risking the skewing of values—beauty over ugliness, recognizable themes over abstraction—that he cannot imagine they do not share.

Apollinaire pays back both critics in *Le Passant* (Brussels, 25 November 1911) with a real—and very politicized—joke: a mocking "Letter from Paris" (to Guilbeaux's home country) in which he parodies a "Committee for the Freedom of Art," naming Urbain Gohier among other so-called reactionaries who purport to stand in principle for freedom. The fictive meeting begins with a call from one member who requests "that Jews, foreigners, Protestants, and freethinkers not be allowed to invoke this freedom in order to spread their abominable ideas." Others speak up in favor of *la liberté de l'Art,* but each in turn wants to suppress that freedom for

his own pet peeve, including the theater, cubism, and sex, among others. The committee expressly decides that freedom of art has no relation to other freedoms, such as freedom of the press, and concludes "that we are here for the Freedom of Art, and that we will not leave without having undertaken proceedings against all those who compromise it by making use of it" [Apollinaire, 262–65, authors' trans.]. Apollinaire, early immersed in anarchist thought, remained throughout his career devoted to defending all forms of innovation in the arts, and saw such freedom of expression as inextricably tied to other forms of social freedom, including most particularly freedom of the press and sexual liberation (Leighten).

Apollinaire, *Chroniques d'art, 1902–1918*
Birnbaum, *Anti-Semitism in France;* see especially part 2, "Drumont's Legacy: Jewish Money, Perversion and Nomadism"
Datta, *Birth of a National Icon*
Ferretti-Bocquillon et al., *Paul Signac, 1863–1935*
"Gohier," s.v. *Dictionnaire de biographie française*, 500–501
Guilbeaux, "Paul Signac et les indépendants"
R. and E. Herbert, "Artists and Anarchism"
Leighten, *Re-Ordering the Universe;* see especially chapter 2, "Earthly Salvation: Anarchism and the French Avant-Garde, 1900–1914"
Méric [Flax], "Urbain Gohier"

La Palette [pseud. of André Salmon], "Georges Braque," *Paris-Journal,* 13 October 1911

Georges Braque

Is he not an African king (a gigantic king) who has come to get himself bleached at the École des Beaux-Arts? Inadequate laundering! Georges Braque went to other steam rooms to wash himself clean of tradition. It is he who, if he did not invent cubism, at least popularized it, after Picasso but before Metzinger. I believe there is no painter who loves painting with such a violent love as that good colossus, hiding a Boschean head of hair under a Tyrolean hat of the Ernest La Jeunesse style.

In his mind, Georges Braque, lying on the roof at nap time, piles up the cubes that, in a moment, will form *Homme au violon* [*Man with a Violin*] or *Torse de vierge* [*Torso of a Virgin;* fig. 18]. This painter willingly practices wrestling, skating, and the trapeze; and, every morning, before beginning to paint, he gets a hand in at the punching bag. A dandy in his own manner, he buys Roubaix suits returned from America by the dozens, claiming that the long stay down in the hold improves their cut and gives an incomparable suppleness to the fabric.

<div style="text-align: right">

La Palette [pseud. of André Salmon]

13 OCTOBER 1911

</div>

Commentary

In this playful portrait of Georges Braque, the artist becomes the so-called primitive, an African king who has shed himself of tradition and who stands for a healthy physicality in his life and an utter lack of social pretense. Salmon admires Braque as second only to Picasso in the "invention" of cubism; beginning with such seemingly innocent portraits, Salmon will follow up in *La jeune peinture française* (document 50) with a historical construction favoring Picasso over the other cubists in the history of the movement.

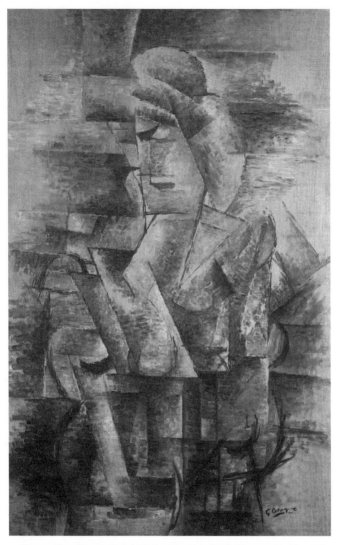

18. Georges Braque, *Figure* (*Female Figure*), L'Estaque, autumn 1910. Oil on canvas, 36 × 24"
(91 × 61 cm). Location unknown. © Artists Rights Society (ARS), New York / ADAGP, Paris. Photograph
Bridgeman Art Library International, NY.

La Palette [pseud. of André Salmon], "André Derain," *Paris-Journal,* 25 October 1911

André Derain

He is the third collector of African statues. But he adds a little imagination to his passion for the exotic knickknack, and each of his grimacing figures is baptized. I will not give the names of the painter or poet friends chosen by André Derain. He stopped exhibiting several years ago, and, no doubt, will not exhibit again for a long time, judging that the most famous salons are now merely art fairs.

André Derain, one of the best and most robust artists of the younger generation, is a painter to the core; he frequented Matisse without suffering for it and brought back only joyful memories from his journey to the kingdom of cubism. Having participated in the preliminary palaver, he knows all the weakness of its constitution. André Derain works patiently [fig. 19]. He had almost been persuaded to send a large picture of obvious beauty, *Le déjeuner* [*Luncheon*], to the Salon des Indépendants. But Derain blotted out the canvas; the still life, he said, had taken on too much importance. The human figures, far from consuming the meal, had been devoured by the luncheon! To relax, Derain composes woodcuts for poets' books, plays the ocarina or the clarinet like the late Rousseau and, when evening comes, treats himself to comedy at a minuscule theater built in his studio, a vast romantic poet's garret.

La Palette [pseud. of André Salmon]

25 OCTOBER 1911

Commentary

This admiring portrait of André Derain honors his independent route through fauvism and cubism to his own version of modernist painting. A major fauve artist from 1905 through 1908, Derain experimented for

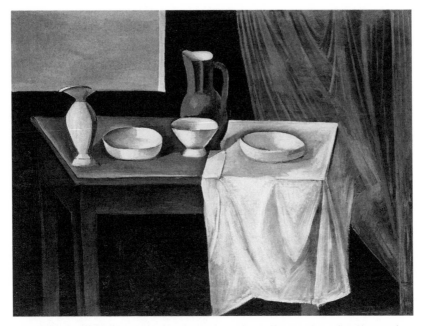

19. André Derain, *La Table* (*The Table*), 1911. Oil on canvas, 96.5 × 131.1 cm. Metropolitan Museum of Art, New York. © Artists Rights Society (ARS), New York / ADAGP, Paris. Used by permission of the Metropolitan Museum of Art, New York.

a short period with a personalized response to cubism—especially that of Picasso and Braque—producing some greatly admired Cézannist works around 1908–10 (fig. 19). From the period of La Palette's portrait to the Great War, Derain developed a traditionalist style of modernism that led to his more conservative celebration of French values between the wars (Munck and Simon). His return to tradition and its religious underpinnings in this so-called Gothic or Byzantine period (1911–14) is discussed by Lee. Here Salmon recognizes both Derain's earlier achievements and his stature as a major modernist finding his own way, a position supported by Guillaume Apollinaire in *The Cubist Painters* (document 62).

Lee, *Derain*
Lee, "Les écrits inédits de Derain"
Munck and Simon, "1911–1914, les années singulières"
Pagé et al., *André Derain*

Maurice Verne, "Un jour de pluie chez M. Bergson,"
L'Intransigeant (26 November 1911)

A Rainy Day with Mr. Bergson

The rain is falling slowly in front of the parlor windows. We could count the heavy drops, the way one counts, on days of boredom, the captive beads on the door curtains in Tokyo.

Mr. Bergson [fig. 20] has gone over to the window. The gray day gently washes over his face. The philosopher has leaned over to read the manifesto "Cubism," which an admirer had cut out for him from a morning paper.

Out there, the large lawn is spread out, soaked with water. There are heaps of dead leaves slowly decomposing, the flowing brown matter already in fermentation, since Life never interrupts its Rhythm.

Mr. Bergson shifts positions to see better; at present, having stepped completely into the window recess, he conceals from us the long black garden sobbing in the downpour. His silhouette is lean in his black clothes; his stature is small; his delicate head rests on a fragile neck barely contained by the detachable collar.

The philosopher has begun to reread aloud the young painters' manifesto: "The cubist painters have allowed themselves to move around the object to give, under the control of the intelligence, a concrete representation of it composed of several aspects in succession. The painting used to possess space, now it reigns in time [*la durée*] ... To draw a nose frontally, the eyes of a portrait in three-quarters profile, and to divide the mouth into sections in such a way as to reveal the profile, that might very well intensify the likeness to an extraordinary degree, provided the worker has some tact."

"That's very interesting as a theory, don't you think?" comments Mr. Bergson. "I am sorry not to have seen the works of these painters, I am sorry about that."

20. Henri Manuel, Henri Bergson at fifty, 1909. Photograph. Bibliothèque nationale de France, Paris. Used by permission of Bibliothèque nationale de France.

The philosopher has returned to the darkness of the provincial parlor. He wedges his armchair next to the fireplace, where a little gas radiator is wheezing.

"What is remarkable today is that theory precedes creation. . . . Yes, in everything: in the arts and in the sciences. . . . Once it was the reverse. . . . For the arts, I'd prefer genius, how about you? . . . But we have lost ingenuousness, it's true we have to replace it with something."

Nearby us on the wall hangs a photographic reproduction of Rembrandt's *The Philosopher Reading* (163; National Museum, Stockholm). Mr. Bergson has lifted his hand:

"Oh, that one knew how to extract Life, extirpate it from the general movement and set it down, quivering and captive, on a little canvas or copperplate. . . . Rembrandt knew how to capture Movement, Movement. What a miracle!"

Coming from Mr. Bergson's mouth, that statement of approval is a touching thing. Did he not personally confess to us the difficulties he encounters in externalizing and placing in the poor mold of language what he feels within him: inaccessible, fleeting, elusive, slipping away and exceeding his understanding on every side?

Rodin told us in his last book how he too manages to seize a bit of the great quivering of Life. "I sacrifice, for a vibrant line," he said in substance, "the other parts of my work." For a single vibrant line, just one!

At what cost in pain and suffering does a philosopher like Mr. Bergson, who does not build vast systems on abstractions, manage to encompass life as a whole?

In their snobbery, the society ladies who would like to see Bergson succeed the innocent Mr. Caro,[1] are perhaps wrong to believe that philosophy is solely something distinguished. In fact, I will always remember the cry of terror by the very distinguished individual who was reading Kant, when I told her that the sisters of her philosopher had been servants. The lady has since ceased to struggle with the *Logical Table of Judgments*!

Hence Mr. Bergson, who is perhaps Kant's true successor, is always indignant when someone speaks to him of the society women who are after him.

Now Mr. Bergson speaks of Death. The rain may be coming down harder in the garden: we can barely see each other in the parlor. We are, as it were, snuggled up in our armchairs like frightened children.

"Yes, one thinks of Death only in a theoretical way. One says, I will die, but one does not seem to believe it. . . . However, one must not be afraid of death. The animal does not *sense* death. He knows nothing of it: hence his instinct awaits it, accepts it. . . . But I am confident . . . One day, a new Galileo will voice the cry of deliverance. . . . Finally, man *will know*! You see, one must listen to what rises from the depths of our lives: there are forces within us, formidable forces! Man has infinite prolongations, but he does not yet know his power. The day he wrests from himself the great dormant, vegetating forces, when he knows how to channel the course of his intuitions into the precision of philosophical teachings, perhaps he will finally achieve superhumanity."

The radiator wheezes suddenly in the silence. It has the short, tragic groans of a wounded beast. We also hear the moaning of the denuded

trees contorted by the harsh wind from the north. In the corners of the rooms, shadows are continuing to grow.

It is not until the maid appears on the lawn in the storm that we are reminded it is noon, time to eat! Noon: it is dark as night in the large home. Outside, has day stopped struggling in the close mesh of the heavy winter rain?

Maurice Verne

26 NOVEMBER 1911

EDITORS' NOTE

1. Maurice Verne's allusion to "Mr Caro" probably refers to the French philosopher Elme Marie Caro (1826–87). Like Bergson, Caro was celebrated for his philosophical defense of religious faith, but unlike Bergson, Caro was appointed first to the Sorbonne (1867) and then to the Académie Française (1876). In 1911 Bergson was a controversial figure whose own appointment to the Sorbonne had been blocked and whose possible election to the Académie Française was hotly debated in the Press (Bergson was elected to the French Academy on 12 February 1914). Maurice Verne was not the last to compare Bergson to Caro, as evidenced by an article titled "Le nouveau Caro," in *La vie parisienne* (No. 56, 1914, 145) (Grogin, 175–96).

Commentary

At the time of this interview the philosopher Henri Bergson (1859–1941; fig. 20) was arguably the most famous intellectual of his day. Bergson had become an international celebrity following the 1907 publication of *Creative Evolution,* which argued that a creative impulse or *élan vital* permeated all processes in the universe, both material and biological. Previously Bergson had published two books on the metaphysical import of the creative nature of time, and the role of empathetic intuition, rather than rationalism, in discerning inner duration (his term for *temporality*). *Time and Free Will* (1889) described the temporal dimension of human consciousness as synonymous with creative freedom, while *Matter and Memory* (1896) applied his previous findings to a philosophical analysis of the relation of mind to body. After 1900 Bergson disseminated his ideas through public lectures at the Collège de France and numerous lecture tours that took him to Italy (1911), England (1911), and America (1913).

Bergson's lectures attracted prominent intellectuals with ties to the cubist movement, most notably the symbolist poet and critic Trancrède de Visan and the art historian and critic Elie Faure (document 7) (M. Antliff, 23–31 and 42). Bergson's concepts of time (*durée*) and intuition had become influential in cubist circles well before 1911. His writings were a frequent

topic of conversation at the Abbaye de Créteil (document 1), and had a lasting impact on Albert Gleizes's and Jean Metzinger's close friends, Roger Allard (document 12), Réne Arcos, and Alexandre Mercereau (Bidal, 79–91). Metzinger's "Note on Painting" (October–November 1910; document 11) referred to *durée* in discussing cubist techniques, as did his "Cubism and Tradition" (16 August 1911; document 19)—the text read by Bergson during Maurice Verne's interview. Shortly after the interview's publication, the critic André Salmon wrote an article titled "Bergson et les Cubistes," which declared that de Visan, "who encounters these men [Metzinger, Gleizes, Henri Le Fauconnier, and Fernand Léger] at the *Vers et Prose* soirées, seems absolutely committed to present them to the illustrious metaphysician" (*Paris-Journal*, 29 November 1911). The attempt to rally Bergson to the cubist cause continued in 1912. Mercereau, in his book *La littérature et les idées nouvelles* (1912), noted that cubism had won Bergson's approval, while Salmon could publicly record Bergson's tentative agreement to write a preface to the Section d'or exhibition of 1912 "if he was definitely won over by their ideals" ("La section d'or," *Gil Blas*, 22 June 1912; M. Antliff, 39–40). Although this preface never materialized, Bergson's philosophy had a profound impact on such cubists as Marcel Duchamp, Gleizes, Le Fauconnier, Léger, and Metzinger, among others (Adams, M. Antliff, M. Antliff and Leighten, Henderson).

Maurice Verne's interview reveals a paradox fundamental to Bergson's assessment of Metzinger's text, namely, how can one utilize tools of analysis to arrive at an intuition of *durée*, when analysis itself ran counter to intuition and its object, an inner duration that remained ineffable and eluded most forms of representation? Bergson himself points to this conundrum by claiming that Metzinger's essay was interesting "as theory," but that his analyses (both written and pictorial) were de facto not the product of intuition (M. Antliff, 3). Since theory preceded "creation" in contemporary arts and sciences, both were now devoid of true "genius," the creative spark resulting from an intuitive grasp of inner *durée*. To bolter this claim Bergson, in various texts, cited figures such as Rembrandt, Leonardo da Vinci, and Camille Corot as among those rare artists able to capture the rhythmic pulse of life through the medium of their art (ibid., 39, 50–52, and 58–59). Maurice Verne in turn adds Auguste Rodin to Bergson's list by citing that sculptor's own recently published writings (*L'Art, entretriens réunis par Paul Gsell* [Paris: B. Grasset, 1911]). And Verne is quick to remind us that Bergson himself "does not build vast

systems of abstractions" but attempts to "mold" his language to "what he feels within him," lest we accuse the philosopher of losing sight of his own intuitions through the act of verbal translation.

Adams, *Rustic Cubism*
M. Antliff, *Inventing Bergson*
M. Antliff and Leighten, *Cubism and Culture*
Bidal, *Les ecrivains de l'Abbaye*
Henderson, *Duchamp in Context*

Albert Gleizes, "A propos du Salon d'Automne,"
Les Bandeaux d'Or ([Arras,] November 1911): 42–51

Concerning the Autumn Salon

It may seem difficult at first for a painter to speak of a salon, given his overly personal observations and his obvious and necessary bias: but it appears to me that, whereas newspaper criticism, obliged solely to inform the public and to guide it among the rooms of an exhibition, can attest to a no less obvious impartiality, magazine criticism, in contrast, which addresses itself to an elite, can and must clearly display an orientation and declare itself for or against. That will therefore be my approach.

The dailies have all provided a complete guide to the salon, room by room; their sparkling critiques, with all their insight—somewhat exhausted by the struggles of the past, which is understandable—have again expressed the stale jokes and commonplaces that they often offered us, with the exception of a few writers of great faith. We can say of them, paraphrasing a cliché, that "they were all excellent . . . under the Empire, and were then able to understand and sustain the rising art movement."

The primary goal of my stroll through the Salon d'Automne will be to deduce the dispersed tendencies, to collect into a bundle the new and avant-garde efforts, to accentuate the results and to say nothing of the inferior so-and-sos who, unfortunately, form its rear guard.

This year's Salon d'Automne definitely affirms its vitality. I am convinced that no other annual salon could be of so much interest. It is the most original and the most significant manifestation of art today. It is an admirable response to our age, and the intelligent visitor can find great joys there, provided his education protects him from the chaff inevitable in such exhibitions.

The dominant note seems to be a tribute to impressionism, but it is a tribute without fervor, almost without respect, a sort of lax complacency cynically manifested in the plagiarism of the glorious techniques. The early analytical form has been replaced, out of laziness more than awareness, by superficial syntheses, displayed on the dadoes in the hasty sketches and never-ending drips that loudly proclaim their sensibility and emotion. A great weariness emanates from the distressing emptiness of these creations, which ought to assert the intelligence of a long-mature art, stripped of anecdotal foolishness, which were only pretexts in Courbet, Manet, Monet, Sisley, and other early realists.

A few men of character, however, are making an honorable place for themselves within that anarchy, and their discipline sustains them, though insufficiently. Of them, Charles Guérin [1875–1939] has shown all the delicacy of his sensibility in some of his old canvases; the big machine that was given the honor of the first room highlights the poverty of his plastic means and adds nothing to his works, which are as beautiful as a fairy tale. Pierre Girieud [1876–1948], in the more massive *Portrait de jeune fille* [*Portrait of a Young Girl*], makes us regret the archaism that prevents him from fully realizing his unquestionable gifts. I contrast the timeless work, as conceived by Girieud, to the work of an era with its roots in the past and moving clearly toward the future. That is a more human conception, and one more in harmony with the evolution of the races. Bonnard holds his own through the real charm of his three decorative panels, more than through the will, the starting point for a pictorial work. Matisse is indulging himself with obvious satisfaction in the tinkling echoes of a glory that was justified in the past; he shows it to us in the two selections representing him. I find Dongen almost likable in his *Andalucia*. Rouault is an admirable artist who is related to the impressionists only through a certain notational side, which is secondary in the study of his work, but appears here in several pictures. The solidity of his lines and the tragedy of his color make me think of Daumier. Georges Desvallières, in a bookcase panel, shows a concern for composition, balance, and logic, and I am happy, despite the great differences that separate us, to be able to recognize and admire his truly plastic coefficient, which is very significant. I mention in passing Puy, Flandrin, Vallotton, Francis Jourdain, Lombard, Diriks, Marinot, Ottmann, Chabaud, Manguin, Valtat, and Marquet because it would be an injustice not to do so, but my personal orientation leads me to find only moderate enjoyment in them.

Vlaminck, after the well-composed and firmly drawn landscapes, which we respect, ought to understand that it is now time to attempt the definitive works we have a right to expect from him.

Finally, let me be permitted to express regret to add to those names the ones who abstained this year, and whom we miss: Grantzow, Dufy, and B. Mahn. Their absence reminds me as well of the very significant absence of Picasso, Braque, Derain, and Delaunay, which leads me quite naturally to Room 8, where the truly original movement of this salon is located. Having just now given it a quick glance, let me say that I am happy, finally, to find myself standing before the effort of a generation conscious of the direction to take. Here, apart from a few stragglers without importance, everything impressionist that I have encountered is clearly banished. The general look of the room creates a rapid-fire succession of colors glimpsed from another place: it is the shimmering of quintessentially French colored grays, the grave sumptuousness of a harmony both new and entirely traditional.

In Room 41 of the Salon des Indépendants, the painters in that discipline had already put their orientation on display, and that is why, in this study, I would like to point out the very clear nuances that separate them here.

First and foremost, there are those who have been named *cubists* (to what end?): Jean Metzinger, Le Fauconnier, and Fernand Léger.

Next, there are La Fresnaye, Dunoyer de Segonzac, and Luc-Albert Moreau, who originally had similar concerns.

And finally, thanks to certain affinities of race, there is André Lhote.

Wishing to determine as accurately as possible the boundaries of these efforts, I shall seek out the artists, dispersed throughout the other rooms, who should have appeared here—Marie Laurencin, Marchand, Othon Friesz—and who were sacrificed to mysterious considerations.

The radical lack of understanding of a mocking press, panic-stricken by the suddenness of a trend that threatens to dash the supreme impressionist hopes, has given a considerable vitality to this group. In the combative pamphlets against cubism, one may typically observe that no truly direct attack was formulated: it was a question of many things, from the happy-go-lucky nature of these painters to the cut of their suits and the way they wore their hair, but nothing having to do with their art in itself. The broadest and easiest jokes were not spared; but, as for trying to demonstrate their error logically, as for honestly refuting their conception, as

respectable all in all as that of the impressionists and pointillists, for example, in the face of the undeniable effort emanating from their canvases, much greater than the swarms of slapdash sketches next to them, one set of critics displayed ignorance, another a corresponding bad faith.

I mentioned previously that, in all conscience, the scrupulous beholder, facing Léger's and Metzinger's more or less hermetic canvases, could not fail to be surprised by the mere quality of the painting. Contrasting with the debauchery of the sketches and notations was a quite considerable polish and craft. With the coefficient of realism willfully excluded and the usual stereotypes not applying at first, superficial minds in quest of immediate gratification were truly put off.

Consider Fernand Léger's *Essai pour trois portraits* [fig. 21]. Although the composition is much less barbaric than in his *Nus dans un paysage* [*Nudes in a Forest,* Kröller-Müller Museum, Otterlo, The Netherlands] at the Salon des Indépendants, its absolute will to exist only in plastic terms gives it an aspect that is somewhat disturbing at first glance. But, the more one considers the canvas, the more one penetrates it, the more the motif comes across, takes root, and takes on an intense life, animated by a strange and real dynamism; the human figures and the surrounding objects, in constant relationships with one another, on a scale that seems a little small to me, have an admirable volume and a painstaking suppleness. Léger's color is extremely personal, the hues of the landscapes are patiently obtained by halftones; the quality of the blacks and the variety of the whites give a very captivating velvety look to his subject. The same generalities apply to Jean Metzinger's pictures. *Goûter* [Philadelphia Museum of Art], which I prefer to *Paysage* because it seems more fully realized to me, is sufficiently intelligible that the foolish comparisons with puzzles can be dismissed. It might very well be that his guiding technique cannot be shared, but one cannot deny the importance that his new inscriptions may have on the evolution of modern painting. And there is always the same propriety, the same bearing, the same impression of grandeur and repose. Through the complete elimination of the stroke, he easily arrives at our French tradition, which gave value only to the composition, the organization of the picture, the balance of forms, and the inscription of shapes. It is the intelligence of that painting that appears first, at the expense of its sensibility, of which our ears and eyes have had their fill for nearly half a century, particularly by way of contrast; it appears very spare, compared to the flabbiness of recent pictorial

21. Fernand Léger, *Essais pour trois portraits* (*Study for Three Portraits*), 1911. Oil on canvas, 77 × 45¾". Milwaukee Art Museum, Anonymous Gift, MX.5. © Artists Rights Society (ARS), New York / ADAGP, Paris. Used by permission of the Milwaukee Art Museum.

creations, which betray a complete lack of assertiveness! The muffled stammering of those with nothing to say is being replaced by the willful and headstrong eloquence of that sort of reaction. Henri Le Fauconnier's exhibit, more human and less remote, ought to meet with fewer detractors. His *Paysage lacustre* [*Lake Annecy,* Hermitage Collection] and *Le village au bord du lac* [*Village in the Mountains,* Private Collection] are entirely safe works. He is very good at pretending not to shatter in a single stroke the carelessness of the past, and at bringing an appreciable share of it to the concerns of the present. I will once more reproach Le Fauconnier for the somewhat slipshod aspect of his three pictures. That fine artist seems to be considerably bothered by material: he thinks more than he paints, and I am certain that his constructions could only improve if he supported them with the materials that constitute the very foundation of a painter.

In their experiments with form, their constructive intentions, and the sobriety of their color, the following artists are related to the cubists:

In the case of la Fresnaye, although the works we have before us here appear less complete, because more restless, than his *Cuirassier* (Musée National d'art moderne, Paris), they are nevertheless much closer to completion, with a definite direction. They speak more violently, with a less decorative but more practical concern, especially the still life of the dining room pier glass, which can be admired in the Decorative Arts section devoted to André Mare.

I will criticize Dunoyer de Segonzac for the somewhat caricaturally drawn boxers [fig. 22], which bother me because of certain exaggerations, for purposes more decorative than plastic. The gray color, very appealing in fact, lacks variety because it was distributed much too quickly in large flat planes. I confess that I miss the greatly superior nudes of the Salon des Indépendants. Isadora Duncan's drawings show us the full quality of observation he possesses: he ought to be wary of the great aptitude he has, it serves him well in his very curious, small-scale notations, which, however, would not hold up if they were enlarged into a picture. That may be the error in the exaggeratedly realist canvas exhibited here. As for Luc-Albert Moreau, the severity of his almost repugnant color connects him much more to the movement I am discussing than do his formal discoveries. His nude woman, sad and profane, is nevertheless superior to his landscape, though the latter is solidly grounded, but does not have the proper balance.

22. André Dunoyer de Segonzac, *Les Boxeurs* (*The Boxers*), 1911. Published in Huntley Carter, *The New Spirit in Drama and Art* (New York: Mitchell Kennerly, 1913), 218. Location unknown; presumed destroyed.

Marie Laurencin, represented at the Salon d'Automne by a still life that adorns a desk's pier glass in André Mare's Decorative Arts section, realizes all the delicacy confined within the female soul with rare intelligence and a plastic restlessness that no other woman possesses. The basket, the flowers, and the fan of that composition, dominated by vibrant drawing, ought to appeal even to those who, miserly in the expenditure of effort, seek charm above all else. The elegant fireplace on which that delicate and willful panel sits is one of the purest things in that section [fig. 23].

André Lhote, who has been linked to Friesz and Dufy, because of the sources common to these three artists, wastes a very fine temperament on retrospective pursuits. Epinal imagery cannot interest us anymore,

except by virtue of the delicious naïveté of the artists who engraved the plates; but what is the point of now redoing with paint what was only an accident in the wood engraving? Parts of his *Port de Bordeaux* show that Lhote can compose and balance his pictures otherwise than by tearing them to shreds and splitting them apart.

Marchand reveals real qualities in his *Suzanne au bain;* I will make the same reproach of it as I made to Lhote's canvas, and of Othon Friesz's *La calanque* [*Rocky Inlet*]: much talent is expended for original reconstitutions, on which it is urgent not to linger, despite their great intelligence.

23. Roger de La Fresnaye, fireplace in André Mare's study; with Marie Laurencin, *Still Life with Fan,* Salon d'Automne, 1911. Illustration in *L'Art Décoratif* (October 1911): 271.

Such are the new tendencies, indicated as swiftly as possible, that the Salon d'Automne offers this year. Georges Desvallières was conscientious enough to see that the hospitality of the Grand Palais be granted to them, since, in spite of the opposition of a hostile jury, his word was able to prevail over the contested votes.

Alongside these new efforts, the Salon d'Automne offers a few retrospectives every year: recently, there have been those of Gauguin, Cézanne, El Greco, Courbet, and so on; this time, it is the engravings of Pissarro and the exhibition of the living artist Henry de Groux.

Pissarro's engravings, which Durand-Ruel already offered us a few years ago, add nothing to the great impressionist's glory. Granted, these vigorous drypoint sketches highlight the suppleness of his talent, but I would have especially liked to see some of his beautiful canvases there, which would have assured the top ranking to which he has a right, and which seems to be disputed in favor of Claude Monet.

Henry de Groux is heroically witnessing the pinnacle of his career: his work, though lasting, is somewhat too cerebral and, above all, literary, for me to want to study it in detail. The plastic side, which ought to dominate, manifestly gives way to his need for evocation. Wagner, Caesar, Napoleon, and Jesus have particularly obsessed him, at the expense of the more exclusively pictorial qualities he possessed.

I find his sculptural works more appealing because less verbal. His Tolstoys, Napoleons, Dantes, and a few others are truly sculptures first.

His ponderous compositions, where character has been elaborated to the utmost, where the verbiage of a highly educated mind has, as I said, killed off the fine qualities of a painter, are prototypical examples when the cubists are criticized for being too exclusively intelligent.

Intelligence, yes, literature, no. Intelligence can organize the dominant values of a temperament, orient them toward what is proper to painting in this case, and make it possible to avoid the dangerous peregrinations into the nearby realms of philosophy, literature, and so forth.

In conclusion, this year's displays at the Salon d'Automne will matter for the history of painting. Rarely has such an opposition been organized against artistic creations; rarely has the press been seen to rise up en masse against an intellectual movement. That is a good omen for the innovators I mention, and the howlers of today will be the bootlickers of tomorrow.

Albert Gleizes

NOVEMBER 1911

Commentary

Gleizes's evaluation of the Salon d'Automne of 1911 registers his attempt both to address public criticism of the cubists, and to win further support from his peers in literary circles. In contrast to the Salon des Indépendants of the previous spring (see document 18), the hanging for Salon d'Automne of that year had not been organized by Gleizes's immediate cohort; instead the religious painter Georges Desvaillières (1851–1950) had managed to persuade a hostile jury to approve the cubist canvases for inclusion, and only then were hanging committee members Raymond Duchamp-Villon and Roger de la Fresnaye able to establish a cubist room (Salle 8) (Gleizes, 26–31; Golding, 12; Salmon in document 50). Gleizes in his memoirs noted that Room 8 met with the same *succès de scandale* provoked by the Salon des Indépendants Room 41, but that the degree of enmity was even greater. He recalled that newspaper vendors sold vindictive articles at the salon entrances declaring the cubists unworthy of public display, and accusing them of "all the sins of Israel" (*tous les péchés d'Israël*) (Gleizes, 28–29).

Gleizes's review in the November edition of *Les Bandeaux d'Or* (1906–14) defends the movement against this journalistic onslaught. Edited by Paul Castiaux, *Les Bandeaux d'Or* was dominated by the Abbaye de Créteil group; regular contributors included Allard, Arcos, Georges Duhamel, Pierre-Jean Jouve, and Jules Romains (M. Antliff, 59–60; Cornell, 88–89). Thus Gleizes's review was directed at writers and critics potentially sympathetic to cubism, a fact underscored by his distinction between the "impartiality" of criticism written for newspapers and *engagé* "magazine criticism" addressed to "an elite" (see Gee on the function of criticism). In a clever move, Gleizes associates the hostile reaction to cubism in the dailies with the retrograde aesthetics of impressionism. The press that mocked cubism was reportedly "panic-stricken by the suddenness of a trend that threatens to dash the supreme impressionist hopes." In Gleizes's estimation, the quality of the impressionist-inspired paintings at the salon signaled the death knell of that movement: its practitioners were plagiarists who substituted "superficial syntheses" for the rigor of the original technique, and evidenced a "weariness," "laziness," and "distressing emptiness." By contrast, vanguard artists at the salon had "banished" the impressionist palette for "quintessentially French colored grays" that made cubism "both new and entirely traditional." Whereas the press dubbed the cubists guilty of the "sins of Israel," Gleizes

declares their art of the French "race," although he no longer claimed a Greco-Latin genealogy for such art (see document 21 and M. Antliff, 126). Likewise he defends the cubists for the "considerable polish and craft" of their canvases, when compared to "the debauchery of sketches and notations" that typified the impressionist-inspired canvases on display at the salon. Since xenophobic critics frequently derided cubism as a movement dominated by foreigners whose style was an assault on French *métier* (Leighten, 98–101), Gleizes's defense of the cubists as "quintessentially French" in their attention to "craft" was carefully calculated. In sum, Gleizes drew on Allard's and Metzinger's previous critiques of impressionism, but he took their defense of cubism out of the realm of specialized aesthetic discourse and into the arena of public debate (See documents 11, 12, 18, and 19).

M. Antliff, *Inventing Bergson*
Cornell, *The Post-Symbolist Period*
Gee, "The Nature of Twentieth-Century Art Criticism"
Gleizes, *Cahiers Albert Gleizes*
Golding, *Cubism*
Leighten, *Re-Ordering the Universe*

René Blum, "Préface," Exposition d'art contemporain
(Société normande de peinture moderne), Galerie
d'Art Ancien et d'Art Contemporain, Paris,
20 November–16 December 1911, p. 1

Preface, Exhibition of Contemporary Art (Norman Society of Modern Painting)

It is fitting to praise the initiative, let us even say the audacity, of the organizers of this exhibition, who have managed, within the narrow framework of a private gallery, to give us a striking microcosm of the efforts of an entire generation of artists. These efforts, concentrated in such a way, assume a significance they would not have on the walls of salons, where the original work of art is, precisely, lost amidst the surrounding mediocrity. Here, on the contrary, the works open to the examination of art lovers are grouped according to well-defined tendencies, and, while they display the most contradictory personalities, there is not a single one that is of no interest, or that does not reveal a temperament or a sensibility. Even the visitor who feels the most shocked by the unexpectedness of certain juxtapositions, the violence of certain contrasts, will not fail to discern, in the muddle of these initiatives, a common characteristic, a common will.

There is no doubt that our plastic arts are going through a period of transition. Losing ground to the invasion of mechanical procedures, they can no longer restrict themselves to being only the faithful interpretation of nature. It is no longer on the canvas, but on the photo negative, that we will henceforth have to seek the expression or reflection of our social life and the precarious or immutable settings where it manifests itself. Art, finally liberated from all discipline, claims strictly to capture the moments of our sensibility. The artist, less attentive to the spectacle of nature, broadens his vision, frees himself from slavish rules, and, heedless

of an overly rigorous technique, seeks within himself the resources of his inspiration and lets himself be guided by his "imagination."

It seems indisputable to me that this imagination sometimes flourishes to an exasperating degree, that the intensity of colors or the originality of forms somewhat outstrips the capacities of our understanding, and that the traditional technique is replaced by another technique that is just as traditional but more abstruse. But we must ask ourselves, in all sincerity, if it is not our critical senses that are lacking in vivacity, if the education of our eye is not a bit slow to develop, and if, in that general evolution, it is not ourselves, in the end, whom we find behind the times.

But, whatever our preferences, and despite the fact that not all these endeavors seem equally successful, we must acknowledge that, among the canvases exhibited, there is not one where a search for the new, an effort in its direction, cannot be discerned. I do not know any ambition more praiseworthy on the part of an artist or any that I find more worthy of applause. Although success and honors belong to the pasticheurs, to the plagiarists, to all those who favor and exploit the public's lazy taste for the mediocre—and often for the worst—it is our duty to encourage, always with true sincerity, the naive ambition of those who seek to triumph solely through the prestige of their personality.

René Blum

20 NOVEMBER TO 16 DECEMBER 1911

Commentary

In this, their Paris exhibition, the Société normande de peinture moderne brought together the fullest range to date of cubist painters (Camfield), including Gleizes (*Study, Portrait of Jacques Nayral*), Metzinger, Henri Le Fauconnier, Fernand Léger, Marcel Duchamp (*Sonata* [1911]), Roger de la Fresnaye, André Lhote, Marie Laurencin, Francis Picabia, and Jacques Villon (who exhibited a *Service de café* [1911]), and sculptors Alexander Archipenko and Raymond Duchamp-Villon (*Chanson* [1908]) (Ajac and Pessiot, 144; Golding, 13–15; Pétry, 156; Robbins, 51; Varichon, 132). In September (1911) the links between the Société normande group and the so-called salon cubists became formalized with the establishment of regular meetings held at Villon's studio at 7, rue Lemaitre in Puteaux. Participants included the Duchamp brothers, Gleizes, Czech modernist František Kupka, de la Fresnaye, Léger, Metzinger, and Picabia; critics in attendance included Roger Allard, Guillaume Apollinaire, André Salmon, Olivier

Hourcade, and Maurice Raynal. The exhibition was held at a gallery located on the rue Tronchet, directed by a Monsieur Hedelbert.

To help publicize the show the Société normande chose the prominent critic René Blum (1878–1942) to pen the preface. Blum—brother of the literary critic and future Socialist politician, Léon Blum—was coeditor and art critic for the literary daily *Gil Blas* (1879–1914, intermittent until 1940) from 1910 to 1914. Following World War I, Blum joined the editorial board of the Riciotto Canudo's journal *Gazette des Sept Arts* (founded 1923), and in 1924 he became director of plays and operettas at Monte Carlo. Cofounder, in 1932, of the Ballets russes de Monte Carlo, Blum was among those deported from Drancy, France, to Auschwitz, where he died in 1942 (Desbiolles, 293; Logue, 26, 172–24; Walker, 3–4).

In his preface Blum takes up issues first broached by Elie Faure in his remarks for the Société normande's first exhibition in 1909–10 (see document 7). Asserting the modernist trope that the birth of photography had freed contemporary artists from the need to imitate appearances, Blum acknowledges that their subsequent turn to pure "imagination" for sources of inspiration had produced works whose "originality of forms somewhat outstrips the capacities of our understanding." Such work is "exasperating," we are told, because our "critical senses" are "lacking in vivacity" and the "education of our eye" is "slow to develop." In short, Blum reiterates the avant-gardist precepts underlying Faure's earlier preface, which asserted that the artists of the Société normande had far exceeded "the mob's habits of seeing" in the pursuit of their "imperious" imaginations. In his preface for the Société normande's third exhibition (June–July 1912) (document 42), Faure would add a philosophical veneer to this avant-gardism, as would Gleizes and Metzinger in their text *Du "Cubisme"* (1912) (document 57).

Ajac and Pessiot, eds., *Duchamp-Villon*
Camfield, *Francis Picabia*
Desbiolles, *Les revues d'art à Paris, 1905–1940*
Golding, *Cubism*
Logue, *Léon Blum*
Pétry, "*L'École de Rouen*"
Robbins, ed., *Jacques Villon*
Varichon, *Albert Gleizes*
Walker, *De Basil's Ballets Russes*

Jean Metzinger, "Alexandre Mercereau," *Vers et Prose* (October–December 1911): 122–29

Alexandre Mercereau

Alexandre Mercereau [fig. 24], quick to spotlight the merit of others, so fastidious about honor that he indicates the provenance of any idea he did not find within himself, possessor of an intelligence where the most antinomic philosophies are elaborated, has very quickly passed through the phases of contemporary literature, with the cheerful self-assurance of someone who has never been affected by the herd instinct.

If life is activity, no one is so alive as he. A look at his past may edify us.

In 1901, he made his debut in letters, submitting poetry and criticism to the Oeuvre d'art internationale, and signing them "Eshmer Valdor."

In 1904, he founded a magazine with a few friends: *La Vie,* where he assumed the role of assistant editor, drama critic, and columnist.

In 1905, he published a book of verse, *Les thuribulums affaissés,* which abruptly drew attention to him, and we find him among the founders of the "Association Ernest-Renan."

In 1906, taken to Russia by Nicholas Riabuchinsky, a Russian artist and patron, he directed the French part of a Slavic review: *The Golden Fleece,* the most amazing review that ever was, and contributed to *The Scales,* a Muscovite review.

In 1907, he published *Gens de là et d'ailleurs,* and, with his friends at *La Vie,* created an art cooperative: the Abbey of Créteil, where each artist had to engage in manual work at the printing office for several hours every day. It managed to last for fifteen months, and ended only for lack of money.

In 1909, he organized the literary section of the Salon d'Automne, which he now runs.

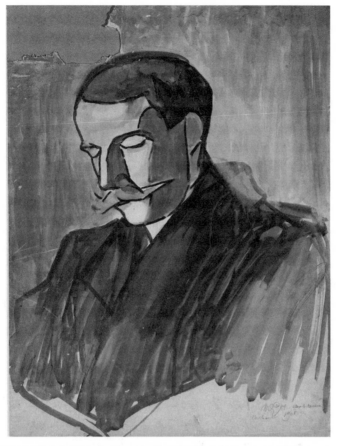

24. Albert Gleizes, *Portrait d'Alexandre Mercereau (Portrait of Alexandre Mercereau)*, 1908. Ink and wash on card, 64.3 × 49.2 cm. Musée national d'art moderne, Centre Georges Pompidou, Paris. © Artists Rights Society (ARS), New York / ADAGP, Paris. Photograph CNAC/MNAM/Dist. Réunion des Musées Nationaux / Art Resource, NY.

In 1910, he published *Les contes des Ténèbres*.

In 1911, he published *La littérature et ses idées nouvelles,* in which his brilliant columns from the *Revue Indépendante* are collected, and edited *La conque miraculeuse,* a deluxe book illustrated with wood engravings by the painter Albert Gleizes.

He was chosen to be secretary for the Oeuvre du jardin de Jenny and for the Société internationale de recherches psychiques.

He is a member of the Comité d'initiative théâtrale de l'Odéon.

He brought together the most luminous names in modern painting and sculpture, modern-day romanticism, in exhibitions in Moscow,

Petersburg, Kiev, and Odessa, and lent them his support in very serious articles in Russia and Bohemia.

At this time, he is completing a book of lyrical and moral essays: *Paroles devant la vie,* which he will publish in 1912.

Finally, the pure poet Paul Fort hired him to direct *Vers et Prose,* a literary periodical and an honor to our letters. And I leave aside many secondary organizations where he selflessly exerted himself for everyone, without asking anything of anyone.

It is difficult to follow a torrent. At the risk of saying nothing about many a flurry and downpour—isolated marvels—I will linger on what seems to have been the most significant, in terms of the progress and orientation of his work and ideas. I make no claim to reduce *Les thuribulums affaissés, Gens de là et d'ailleurs,* and *Contes des ténèbres* to a few pages of study, and will confine myself to noting what my faculties allow me to immediately seize from them. Tomorrow I will without a doubt be astonished at my blindness of today, but I will not be sorry for it: the joy of knowing that there are still books whose substance is not exhausted by several readings seems adequate compensation to me.

Les thuribulums affaissés is the monument of a crisis. A gust of wind that announces imminent arrivals hastens the setting of the symbolist sun. One last time, the poet manipulates the pieces of the old poetic arsenal, to see if there is any way to adapt them to new conceptions. The result is an art that is murky and charming, barbarous and precious; and, if one is to appreciate it, one must be through fighting it.

Reason embraces fantasy, metaphysical angst combines with human clamor. Swans drift toward heroines, who gather stars on the water at dusk. The moon engages in grammatical phantasmagoria. Barrel organs wail in Valkyrian nights. The sheet metal of smokestacks vibrates with chivalrous echoes, wind and death howl under the doors.

Alexandre Mercereau glorifies the androgyne, establishes ingenuous relationships between sacred vessels and instruments for the boudoir, and remains expressly a poet.

Sometimes the elaborate flash of a rocket stirs the solemnity of spiritual perspectives, and a sorrow, whose depth can be measured by the duration of the conceptual world, swallows up the magical isles.

The great lyric poet reveals himself, and a robust song soars from the instrument he received from the hands of Laforgue and Verlaine:

Le Sonneur des ages

Dans le beffroi du malheur,
sur la montagne de roche,
d'arain, de cuivre et de fer,
dans le beffroi d'enfer,
au long, tout au long des heures,
carillonne et sonne, sonne
le lourd tocsin de sa cloche,
le vieux sonneur
des Temps Impairs.

De pieux encens grisent
sa pauvre âme grise.

Le sonneur est visionnaire
et possédé;
En son beffroi solitaire
se sont juchés
les hiboux et les chouettes,
maints oiseaux et maintes bêtes
de son idéalité.
Le sonneur, branlant sur ses jambes folles,
ses deux bras au ciel comme un Janséniste,
a damné son âme, sa belle âme noble
à quelque projet de grandeur sublime.

Depuis que la terre est en tournoiement,
son vieux corps de possédé,
son vieux corps qui cloche,
agite la cloche
des inanités
indiscontinuement.

Il a sonné
quand est née
la douleur humanitaire,
pensant ébranler la terre
du souffle de la pitié.

Il a sonné des épithalames
aux noces des lois iniques,
(n'entendez-vous point un glas?)
et fait d'étranges musiques
lorsque trépassaient les âmes
pour vivre dans l'au-delà . . .
(n'entendez-vous point son glas?)

Depuis longtemps, depuis toujours,
le view sonneur a vu l'amour
mis en beau cercueil d'Utopie,
là-bas dans la mer de lait,
en Thulé
l'inconnue,
(Las!
n'entendez-vous point un glas
dans les nues?)

Il a jeté, par volées
le vol de la vérité
en triangularité,
mait tout a passé
par les méchants effacé.

Sa voix large de tocsin
d'airain,
sa voix de vieux solitaire
a bramé l'appel austère;
AFrères!"
Et les échos ont roulé
des silences acharnés!

Folle, la cloche a hurlé
à détourner les étoiles
de l'orbite accoutumé . . .
Nul vaisseau n'a mis la voile
Vers le vieillard possédé!

A l'ors
il a coulé des sanglots

par larges quartiers de pourpre
dans la cloche grosse et lourde
et tortionné ses os
à secouer l'alme gourde . . .
Des rires ont répondu
de tous les côtés venus.

Ces rires ont tournoyé
comme des oiseaux de proie
autour du beffroi
et la cloche a ricané . . .

Le vieux sonneur solitaire
a quitté le lieu d'enfer
où la cloche ricanait
des glas morts qui sanglotaient.

Bons braves gens, voici tout blanc,
de candeur et de temps
le vieux sonneur des âges
venu du lointain pays des mirages.

Bons braves gens, laissez passer
le sonneur des temps passés,
car le sonneur est un fou
il a toujours été fou
et sa cloche est bien fêlée
depuis mille et mille années . . .
il a toujours sonné ses glas
avec sa cervelle et son crâne!

[Bell Ringer of the Ages

In the belfry of misfortune,
on the mountain made of rock,
of bronze, of copper, and of iron,
in the belfry of hell,
every single hour,
the old bell ringer

of Times Uneven
chimes and rings, rings
the heavy tocsin of his bell.

Holy incense dulls and soddens
his poor dull soul.

The bell ringer is a visionary
and a man possessed;
In his lonely belfry,
barn and screech owls
have made their perch,
many birds and many beasts
of his ideality.
The bell ringer, rickety on his lunatic's legs,
raising his arms like a Jansenist to heaven,
has condemned his soul, his fine, noble soul
to some plan of grand sublimity.

Since the earth was set to spinning
his body of a man possessed
his old body, wobbling like a bell,
has agitated his bell
of inanity
without letting up.

He rang
when humanitarian sorrow
was born
thinking to set the earth moving
with a waft of pity.
He rang epithalamia
at the wedding of iniquitous laws
(don't you hear a knell?)
and made strange music
when souls passed on
to live in the beyond . . .
(don't you hear his knell?)

For a long time, for all time,
the old bell ringer saw love
placed in a beautiful coffin of Utopia,
there in the sea of milk
in Thule
the unknown quantity
(Alas!
don't you hear a knell
in the clouds?)

He cast into midair
the flight of truth
into triangularity,
but everything has passed,
by the wicked obliterated.

His deep tocsin voice
of bronze
his voice of a lonely old man
has wailed the austere call;
"Brothers!"
And the echoes rumbled
from the desperate silence!

Madly the bell howled
to divert the stars
from their accustomed orbit . . .
No vessel set sail
Toward the possessed old man!

And then,
he poured tears
in wide patches of purple
into the great and heavy bell,
and his bones were twisted
from his shaking the nourishing gourd . . .
Laughter from all sides
was the reply.

That laughter circled
like birds of prey
around the belfry
and the bell snickered . . .

The lonely old bell ringer
left that place of hell
where the bell was snickering
at the sobbing death knells.

Dear brave souls, he is all white,
with innocence and with time,
the old bell ringer of the ages
from the distant land of mirage.

Dear brave souls, let him pass,
the bell ringer of past times,
for the bell ringer is a madman,
has always been mad,
and his bell has been cracked
for a thousand years and more . . .
he has always rung his knells
with his brain and skull!]

I do not know what convinced Mercereau, already trained in the play of assonance and meter, to give up verse. In any case, he does not abjure poetry and if, in stripping it of its silky fictions and its traditional purple, he exposes it to the harshest blows, it is only to fortify and enrich it.

Leaving the palaces and museums, he enters the peasant's house, passes through the bigot's living room, visits Parisian slums.

Gens de là et d'ailleurs is a book of psychological observation; but the author attempts to capture human mechanics inasmuch as they are linked to universal dynamics, and he is not interested in advancing a certain school with narrow views.

The beings he presents to us have nothing in common with the marionettes of the naturalists. They have a true life because they are schematic. In art, the conditions for life are not the same as they are in nature.

Rural brutes, stupid workers, women unhinged by lust or piety, they incarnate the servitude that a writer, called upon to speak of rebellion and triumph, was obliged to expose to us from the beginning.

Alexandre Mercereau works hard at writing: concise without being obscure, simple without mouthing platitudes, precise without being dry. His language attests to a vast culture and, at the same time, to an innate self-assurance. He has already achieved the essential quality, the *sustained intensity of expression.* He sometimes hazards an impressive brevity:

Once they had a girl. Another time they had a boy. Then, having accomplished their task, they grew old.

Mercereau was unable to linger on observations, however penetrating they might be. A huge dream expands his personality. He feels vested with higher powers. Having studied human mechanics, he applies himself to perfecting them. He creates a human prototype, the hero of *Contes des ténèbres.*

La troïka d'Enfer, Esotérisme, Elfride, Aëllo, Le printemps, Le brouillard, Mon frère, Le bataillon fantôme, La main de gloire: all these tales pour forth from the darkness, from the unfathomable and bleeding darkness where wisdom grows.

La troïka d'Enfer drags the monsters of the intelligence through a Russia as true as it is artificial.

L'Homme caoutchouc [*The Rubber Man*]: here is man realized at last. It celebrates the victory of mind over body. The inorganic enslaves the organic. The army of muscles and viscera, subject to putrefaction, moves at the mercy of a desire that now transgresses all natural law.

Esotérisme initiates us into everyday magic. Before aspiring to free ourselves, let us learn to know the oppressor. What do we know of matter?

"From Zoroaster to Mr. Bergson," Mercereau appeals to everyone who has had a brush with the unknowable.

A neutral region lies between ruins and possibilities, and there he finds his bearings:

"I do not yet believe in something, and I already no longer believe in anything."

Since nothing is more impossible than everything, and the afterlife is just as unbelievable as life, why shouldn't we take into consideration the strangeness that the most familiar objects sometimes exude?

Let us not be hasty to conclude, from the fact that a phenomenon alters the knowledge we have acquired, that there is a confusion of the senses. That would make it all too easy for us, if we so pleased, to demonstrate that the external world does not exist. Mercereau refrains from concluding, he baldly sets out facts.

Le printemps. Nothing surpasses the lyricism of these pages. It is absolute. It encompasses its own definition.

Everything proclaims the vertigo of being weightless:

"The law of gravity did not govern anyone and the passersby, airborne, were transported far away merely on their own wishes."

Men, beasts, trees, and houses are now only a single effusion, limited, all the same, by the sadness of the Creator, from whom the created object inevitably separates itself.

Le brouillard. The horde comes to terms with the hostile universe and resists it with its inertia.

"To defeat the scourge, which, not finding any obstacle, would forsake a land without space, a municipal order declared that day a day of suspension. Hence the murmur of progress was halted in the clocks, and the march of time stopped in its tracks. Since a law had been spoken, light no longer separated itself from darkness; the line was thereby abolished. Tangibility and motion, substance and its attributes were conscripted for underground labor and disappeared from the surface of the body."

But the individual struggles desperately. For once, he is defeated.

The universe conquers him cell by cell, penetrates the arteries and veins, mingles with the marrow of his bones, invades every cavity and becomes the sticky lump of crimson that the heart cannot send up to the brain.

Le bataillon fantôme. The ghost battalion marches through the centuries. The road it traveled—we will verify by the bones—is called history. The road it ought to take sinks deep into the undefined darkness where the constellations fall silent, where there is no longer north or south, nothing but the order—given by no one—to march toward the enemy who does not exist and who kills.

Mon frère. Did metaphysical angst ever inspire such a harrowing drama?

Two roads lead to the absolute: inertia and activity. Two kinds of bliss offer refuge: that of the stones lying under the earth's crust, and that of pure thought, an essential activity. It is necessary to choose.

Since the earliest days, humanity has wavered. Since the earliest days, magi and philosophers have expended all their energy seeking the argument that would put an end to tragic uncertainty.

Alexandre Mercereau joins in. He does not solve the problem; he poses it in a new form, with a wrenching lucidity.

A man has dedicated himself to inertia and greatly enjoys the advantages it confers on him. Certain that he is determined, he meticulously obeys the law that determines him.

He has let other men curse and flee him, so that nothing in their dealings with him will incite him to transgress that law. The slightest infraction could lead to catastrophe; he does not make a move unless he knows it necessary for the fulfillment of his destiny. Careful of the firebrands whose heat makes one sluggish, and the copious food that wards off vicissitudes of the mind, he defies the external storms and calmly awaits death.

A knock on the door of his wealthy home shatters his deep peace.

Someone is asking for help. He recognizes his brother, who has long been driven by adventure and hunger.

Now, he knows that modifying anything whatsoever would be violating the law.

"*Do we have the authority to rectify the judgments of Providence? At the crossroads of depravity, the quadrangular cippus indicates the four cardinal points: it does not say which way to turn. Since, in the whole sensible universe, the predominant power is that which we call the power of evil, we have reason to believe that human suffering is what pleases the gods.*"

He turns away the unfortunate brother.

Hyena on the prowl, I snarled, will you never leave me in peace? Why come and disturb my solitude? Your fate is not in my hands! Did an adder cover your mother? Is your father a female? Did you suck on the wine of leprosy? Do your veins attract the darkness of the invocations of evil spirits? If, for a hundred thousand years, death has taken precedence over life, it is because therein lies an ill-fated will of heaven. If it were otherwise, the howling of the desperate would long ago have shattered the universe. Are you not weary of the tocsins rung in pure futility? Haven't you howled enough, prayed enough, implored enough, threatened enough, blessed enough, cursed enough! Have you burned enough incense, however, made burnt offerings, split open your entrails, tormented your heart, flayed your flesh! Has anyone seen the stars flicker or the azure lose its luster because of it? Did the globe tremble as a result? Did it refuse, for even one day, its fodder of atrocities? No, at every minute it has demanded its share. *Gorged* to the point of death, the fat, wretched, dried-up old lady wallows in space, smiling like a respectable matron, and adorns herself with flowers like a young fiancée . . . Don't you see, evil is the will of the Sage. Is it not better

to submit? Woe to the presumptuous madman who grants himself rights! For myself, I do not feel I am the master of the laws that govern me. A fortiori, I will not become entangled in a destiny whose logic and purpose I do not know. I am not a hero who engages in struggle with the powers of the occult, and who assumes responsibilities. I for one do not want to precipitate anything. Man may be a sacred thing, he may be an accursed thing. To save him may be to damn him. Perhaps one ought not to act. We might be angering the one we believe we are appeasing.

Once he has chased him away, he realizes that, in not acting, he has indubitably acted:

My brother, I believed you had understood and had left without asking for anything; that I had touched nothing, and that everything had been done without me. Now I have acted upon external forces, and I do not know them! I ruled your night, and I may have plunged myself into darkness! May the dictating will be my witness, however! I did not think I was usurping anyone's power. I desire nothing and am prepared to fall into nothingness if a glimmer of light orders me to do so. This is the house of the man who awaits the light of death, to know if he ought to be or not to be.

After a time, the poor soul returns. Suffering has transfigured him. He possesses energy and will. He, having the power to know, wanted to act so that he would know. He is an intelligent effect who revolts against his impenetrable cause: he commits patricide.

"An exemplary deed as well, suited to terrify those who stole from heaven the celestial fire of generation. Because of them, ugh! we feel our bellies churning. Thanks to them, even those of us who are heroes will always be the sons of man."

He drags the man who had chased him away to the scene of the crime. The two brothers examine the corpse; but the father who, when alive, propagated life without elucidating its secret, gives forth only shadow now that he is dead.

The murderer deeply regrets the senseless act. The man who set the consequences in motion becomes alarmed imagining universal annihilation. Time passes. One evening, after his luxurious home has been transformed into a cramped garret, he discovers in his bed his brother's emaciated body, discovers a dead thing within himself—the part of him-

self he had cast out into the storm—and he thinks that the principle of action has no doubt finally deserted his mind.

La main de gloire. This tale contrasts with the previous one and continues it. The man has achieved bliss, not by inertia, but by activity: pure thought. Thanks to the power of mind over matter, he has made himself independent of the universe:

"Having managed to refine his matter, he had gotten it to the simple state of essential vibration: to feed it, he needed neither blood vessels nor overly demanding lungs."

His lodgings do not participate in the rotation of the earth and are absolutely motionless, by which it is understood that they have a speed equal to that of the revolving planet. With such a gift, he might have easily prevailed on one of the four esoteric planes, but:

"An entity forever created for one sphere, where all are the same, leaves it and will never leave it again. *To escape* the captivating effect of the limit, *he claims himself as his only domain,* the only one over which each person ought to rule."

As he appears to us, not living outside life, but living in the place where life escapes us, he assures us that, so long as humanity has not substituted an ideal of wisdom for its ideal of pleasure, has not subjectified science, has not directed onto the dark depths of being the rays with which it illuminates external realities—producing useless comforts as the only benefit—it will tremble before the forces it channels, and will be unable to create.

Some have tried to link the Shakespearean *Contes des ténèbres,* in which all the characters are entities, to the nightmares of hashish-inspired literature, full of booby traps; others declared it was inspired by Edgar Allan Poe. And yet, every page exudes health, and, if we pay the slightest attention, we learn that, although the author hangs an old man on the peg of an antechamber, he does not do so to amuse or horrify us.

As for the monstrosity of the anecdote, it is fully justified by the intensity of the internal anxiety. There is no ambiguity possible. In addition, any reader who maintains that *Mon frère* is a poorly composed tale, chopped into three pieces, gives irrefutable proof of the weakness of his faculties. It is clear that the shifts in plot correspond exactly to the fluctuations of the subject's mental tension. And the transformation of the mansion into a garret marks the spiritual catastrophe so clearly that it

would be unseemly to insist. This is not symbolism, but the mind acting on literary matter in accord with the same law that makes our brow crease or the muscles of our arms contract when worry or anger takes hold of us. And never mind those who laugh at the grimace, make fun of the arm gesture, or condemn the audacity, never mind the "shortsighted."

In fact, with *Paroles devant la vie,* all anecdotal appearance vanishes. The writer borrows the indispensable reality from the word itself. And the words, releasing their claws, deliver unsuspected riches to anyone who knows how to take hold of them. But nothing, whether star, flower, or god, interrupts the magnificent flow of thought. The matter of art no longer has to twist in the wind of mental squalls. It is identical to the mind. The absolute calm of absolute motion! Head-spinning bliss! The vision broadens so much that a thousand new ideas collide, without us ever doubting for an instant the indestructible unity they set in place. We walk beside the waves, flashes of salt enliven the restful geometry of the horizon!

Alexandre Mercereau develops the ideas fully, historically, to the point of sophistry!

In *Paroles devant la mort du juste,* he addresses the corpse:

"And now I wonder if you are truly the one who vanished with your passing. Are we not rather the ones who have disappeared in you? Are we not the consciousness of your current state? It is we who bear your death, while you persist in us and, by that very fact, remain indubitably alive."

A brilliant writer extracted a novel from a similar idea. Mercereau never advances an idea that could not give rise to several volumes; but he practices the difficult art of capturing the most expansive development in the smallest number of lines. He intuitively synthesizes dimensions and transforms quantities into qualities.

His creative power is such that he creates beauty with elements that are apparently contrary to the fundamental facts of life. He tells the pregnant woman:

Pardon me, woman, but, seeing you graceful and weak, your shape soft and flabby, or, quiet and slender, occupied with indoor work, I have often thought that you could never bear a noble and strong race.

I have wished that the child would clutch the hard, rough flank of a bronze-skinned man. Woman, I said, ought perhaps to fall under the charge of woman, but let man be entrusted to man, whose hull advances through space, narrow, but powerful and fearless.

How much energy he would have, the man who had been cradled by waves on the sea, or by the invariable sauntering of the farmer on his land. O body soothed by the cadence of the smith striking his anvil! Would not the seed that grew in the midst of humming forests, or on the untamed slope of the mountain, have a hundred unexpected qualities? Might one not expect deep thoughts from someone who had been conceived by the quarryman breaking stone, or the warrior in the heat of battle?

It is you, mountain man, brother of the man of the plain, brother of the builder in the city, brother of the man on the ocean, you I would have liked to give birth to me.

Lyricism has substituted its own logic for Logic. Just as we are about to sense its emptiness, the corrective is put forward:

"But, woman, I just caught sight of you sustaining the ripeness of your fruit, and I understood that you alone were needed for the task of creation."

That technique conforms in every detail to the French genius, capable of expanding the metaphorical field without pushing the limits beyond the range of the perceptible.

Mercereau invents a rhetoric in which every moment of time comes back to life or blazes up. He embraces the origin and the end. Were it not for the particular modernity of tone, he might bring to mind the lofty poems, the work of generations, where human desire unfolds in primitive and supreme sublimity.

Paroles devant la vie—I rely on the previously quoted excerpts and on a few as-yet unpublished ones—marks a degree of execution that the most gifted rarely achieve.

The impartiality of the system of thought, the grandeur of the conceptions, the authority of the language do not rule out a sense for the moment. Witness *La littérature et les idées nouvelles*, where Mercereau, supported by a colossal erudition, washes clean the contemporary mind.

The book begins with a brilliant definition of criticism. And the author immediately demonstrates that he is resolved meticulously to follow the precepts he sets out.

No subjective pettiness, but formidable confrontations. Woe to the plagiarist who, trusting in the ignorance of those around him, would proclaim himself the originator: Mercereau ransacks his memory and throws the key piece of evidence onto the courtroom table. But his gen-

erosity leads him to attack books above all, and the ideas to which the books give rise in preference to those contained within them.

The pages devoted to *La question du Latin,* to *L'Occultisme,* and to *L'Incohérence* are the result of a perfect method. As he accumulates the documents and fathoms the most unfathomable abysses of the past, he works to establish the genealogy of the notions under study. It is only on the basis of the most extreme, the most expansive certainty that he takes sides. The scruples of a scholar, to be sure. Criticism is a science. To judge either men or books requires hard work in preparation. It was high time that someone declared as much. The incompetence of most of the people who make judgments in the name of art is such that many courageous artists fear their praise above all else. It was high time that someone correct criticism's "little hands," give spankings to certain pretentious men, and dispel the ponderous prejudices that are polluting the air of our time.

From *Gens de là et d'ailleurs* to the recent lines, Alexandre Mercereau's prose continues to transform itself. In the former, independent of all that remains unrealized within it, that prose approaches classical perfection; in the latter, it surpasses it.

Like Mallarmé, Claudel, Paul Fort, and René Ghil, Mercereau creates a syntax and chooses a language of his own. That, today, is a sign. Is it not commonly alleged that "everybody's way of writing" is adequate to express the most noble ideas, as if the writing were not a reflex of the idea? Anyone who thinks in an ordinary way conceives in an ordinary way, and it took centuries and thousands of imitators for the style of a few great minds to draw the mob.

When a man who holds style in contempt, one of those who "reacts against symbolism," produces a remarkable idea, we can be certain of some deception.

I said that Mercereau works hard at writing. It does not follow from that that he tires himself polishing sentences and freezing them in a tedious and monotonous harmony. He is by turns smooth and harsh, irregular and symmetrical, melodious and dissonant, strident and grave. When there is the need for evocation, he utters the same word a hundred times: in *Paroles devant la mort du juste,* the word *dead* is repeated so frequently, and intensified by so many scholarly allusions, that we feel we are being invaded by billions of funereal insects to the depths of our most secret cells. He knows how to knock vocables together and make them

crash like waves around the solid block being eaten away. He knows how to make long sentences march in step in the sun, knows how to make the pages undulate to the rhythm of great and gentle breezes, and he is not someone who insults jewels and flowers with his fundamental arrogance. He is not familiar with a certain "insatiable" purism, unhealthy and foolhardy. He never steals a single term from those nationless languages that too many good thinkers cultivate.

When he describes an operation of consciousness, he will have nothing to do with the jargon of professional psychologists, and touches us as directly as when he chooses to paint a wall, a tree, or an outdoor scene for us. The closer he comes to the indefinite and the imponderable, the denser he becomes, the more carefully he weighs concrete words.

His writing is truly the body of his thought, a tangible mode of his thought. That thought is not for the feeble. It does not resemble those long, rectilinear corridors called systems that lead to nothingness, but where one has only to spread one's arms to feel the support of the walls. It is by turns the cell and the plain, the rubble-strewn path and the smooth road, the precipice of negation and the bulwark of truths.

The sum total of these alternations points in a clear direction.

What is the point of ingeniously evoking internal battles and following mysterious developments stage by stage, if not to draw some productive principle from it?

Of course, we hate tendentious art and despise equally the naive people who spread it and the industrialists who exploit it. Apart from the needs of politics, the desire "to enlighten the masses" seems like a sign of dementia to us. When an esteemed writer decides to rebuke the mob, we think it is a joke. Nevertheless, we cannot deny the artist the right to intervene *as a creator* in the various scientific and moral domains.

To maintain that what enriches the intellect impoverishes the sensibility, that a restless mind clouds the poetic faculty, amounts to negating all great artists, all great poets; it amounts to reducing literature to the state of an inarticulate cry. That at least would spare us the disappointments.

Intelligence and sensibility are in no way incompatible. The truth is, there are no fewer mediocre minds among reasoning types than among hypersensitive types, and mediocre minds are banished from the region where all the ascending forms of thought lend one another a hand!

Mercereau wants to take us there. He knows all sciences, all philosophies, all religions, and has observed their ineffectualness. Neither the priests

who have inebriated humanity, nor the magi who have dazzled it, nor the sages to whom it sometimes listens with respect, have opened its eyes. It has not yet understood; it is still a slave where it ought to have reigned. Yet truly there is a cord linking all minds to one another; and somewhere there are dormant mines, the combustion of which would illuminate eternity. It is a matter of touching the cord; it is a matter of causing a spark.

Caligula wanted the Roman people to have a single head, so that he could cut it off; Mercereau would like humanity to have a single brain, so that he can infuse supreme wisdom into that brain. Hence his concept of the absolute man.

Some people criticize him for depicting the absolute man sometimes as absolutely inert, at other times as absolutely active. Let us repeat that Mercereau does not barricade himself behind a superficial unity and that, when he gets hold of a concept, he runs from the point where he seized it to the point farthest from it. Since these points have been called *contraries,* and since a tendency to mutually annihilate each other has been attributed to them, it is not surprising that Mercereau contradicts himself, and that he is criticized for it.

Nothing neutralizes anything. To destroy is to free energies. Black combined with white makes gray, which is a value. Even negation and affirmation do not annihilate each other, and anyone who negates what he has just affirmed increases his power to make affirmations.

In expanding, deepening, the notion of inertia until it intersects that of activity—or the reverse—Mercereau makes a leap.

The effects of this will be, in the moral realm, all the virtues that belong to the most complete idea man can form of Man, that is, courage, loyalty, magnanimity, and a kindness one must be able to manifest energetically. Although Mercereau does not sound Nietzsche's harsh bugle in our heads, he also refrains from hinting that it be renounced.

He affirms that he is an individualist, despite the fact that, in *Passer,* he admirably developed a philosophy similar to that of the interpsychologists. There is no dispersion, no dilution. It is in seizing hold of all spatial virtuality, in binding together the thousand components of scattered power in the minute coming to pass, in condensing universal life, that man reaches plenitude and exerts control over contingencies.

Having thus been realized, he will have the mission of restoring the universal to the universe, which, in provoking the sudden shattering of earlier equilibriums, will constitute the act of creation.

Alexandre Mercereau's morality arises from art reverberating against consciousness.

Jean Metzinger

OCTOBER–DECEMBER 1911

Commentary

Jean Metzinger's lengthy essay on Alexandre Mercereau (fig. 24) amply testifies to that writer-critic's crucial role in the cubist movement (for a concise biography on Mercereau, see Fabre). Mercereau first gained prominence on the literary scene when he joined René Arcos, Georges Duhamel, and Charles Vildrac in founding the journal *La Vie* (1904). In 1905 the poet René Ghil recommended Mercereau to Nicholas Riabuchinsky, director of the celebrated avant-garde magazine *Le Toison d'Or*: as a result Mercereau was invited to Moscow to direct the French-language section of this Russian journal. While in Moscow Mercereau signed his publications under the pseudonym Eshmer Valdor (a practice dating to 1901) and contributed articles on French literature to the Moscow journal *Viessy* (The Scales). Metzinger's text documents Mercereau's feverish rate of production up to 1912, his role as cofounder of the Abbaye de Créteil, his codirectorship, as of 1910, of the neosymbolist journal *Vers et Prose* (1905–14), and his contributions to literary criticism in the *Revue Indépendante* (published in the volume *La littérature et ses idées nouvelles* in 1911). Metzinger also highlights Mercereau's role as secretary of the Société internationale de reserches psychiques; indeed, through his writings for the symbolist journal *La Vie Mystérieuse* (1909–14) Mercereau nurtured an interest in the occult among the salon cubists (Henderson). His importance as a writer and editor was matched by his seminal role as the principal cultural intermediary who facilitated the spread of modernism throughout Europe. Between 1908 and 1914, Mercereau organized cubist-related exhibitions in Moscow, Saint Petersburg, Kiev, Odessa, Riga, and Prague. As a cultural buffer against the rising tide of nationalism in Europe, he became secretary, in 1912, for the League "Pour mieux se connaître, oeuvre de rapprochement intellectuel franco-allemand." Mercereau maintained his belief in international cooperation throughout World War I. During the war he served as a paramedic in the ambulance service, and Albert Gleizes later recalled that Mercereau shared Gleizes's abhorrence of the jingoism and carnage caused by the war (Brooke, 50). In the postwar period Mercereau (like Gleizes) moved in leftist and pacifist

circles in his new role as editorial assistant to the gallery owner and publisher Jacques Pavolovsky. Pavolovsky published texts by dissident Russian Marxists disillusioned with Leninism, and under Mercereau's guidance he edited a series devoted to the poetry of all nations. Titled *Les grandes anthologies,* the series included Mercereau's *La conque miraculeuse* (1922), with illustrations by Gleizes datable to 1908, and Henri-Martin Barzun's *La fondation d'Europe, 1916–1920* (1921), which argued—as had socialists in wartime Switzerland—for the creation of a United States of Europe as an antidote to the threat of European conflict (M. Antliff and Leighten, 204–5; Brooke, 73–83). After 1928 Mercereau retreated from the literary scene in part due to the demise of the Caméléon, a cultural center he founded in Montparnasse in the early 1920s. Nicknamed the "Sorbonne Montparnassian," Mercereau had created the Caméléon in the hope of promoting his pacifist ideals among the interwar avant-garde (Fabre).

In his evaluation of Mercereau the poet-painter Metzinger reveals his own high level of literary sophistication as he charts Mercereau's evolution from a symbolist poet to a prose writer with a philosophical interest in Henri Bergson and the occult. Metzinger first notes the postsymbolist tone of Mercereau's book of verse *Les thuribulums affaissés* (1905), then charts his interest in human psychology, manifest in his 1907 book of prose, *Gens de là et d'ailleurs,* and concludes by considering the mystical and Bergsonian underpinnings of *Les contes des Ténèbres* (1910) and the "lyrical and moral essays" that were to be collected in *Paroles devant la vie* (1912). Mercereau had begun publishing sections of the latter text in 1911: Christopher Green has argued that one such excerpt likely inspired the generative theme of Henri Le Fauconnier's *L'Abondance* (*Abundance,* 1910–11; fig. 9) (Green, 32–33), while Metzinger claimed that an excerpt titled "Paroles devant la mort du Juste" may have stimulated Jules Romains in the writing of his famous book *Mort de quelqu'un* (Death of a Nobody; 1911). The following year a thirty-two-page version of Metzinger's essay on Mercereau was published by Eugène Figuière under the title *Alexandre Mercereau, essai critique* (Paris: Figiuère, 1912).

M. Antliff and Leighten, *Cubism and Culture*
Brooke, *Albert Gleizes*
Fabre, "Alexandre Mercereau"
Green, *Léger and the Avant-Garde*
Henderson, "Mysticism, Romanticism, and the Fourth Dimension"

La Palette [pseud. of André Salmon], "Courrier des ateliers: Exposition probable," *Paris-Journal*, 21 January 1912, pp. 4–5

Art News: A Likely Exhibition [Juan Gris]

The draftsman Juan Gris, who has made a name for himself with his elegant and witty drawings published in illustrated newspapers, has, as we already announced, made his debut as a painter. About fifteen of his canvases and numerous drawings are currently on display at the Galerie Sagot. It is likely that art lovers will soon be invited to a major exhibition of the works of this disciple of Picasso.

<div align="right">

La Palette [pseud. of André Salmon]

21 JANUARY 1912

</div>

Commentary

André Salmon's favorable notice of Juan Gris (1887–1927) links his name with his reputation as a published caricaturist for the popular and political press without dismissing that aspect of his work, as have many scholars (Leighten). His characterization of Gris as a "disciple of Picasso" was, in this case, openly embraced by Gris himself, who studied his compatriot's cubism, as well as that of all the cubists, quite carefully; his results, however, were not so much "Picasso-esque" as unique forays into visual equivalents for ideas shared widely among both the Puteaux group and the Picasso circle (Green). The major exhibition Salmon heralds does not seem to have taken place, unless Salmon was referring to Gris' planned inclusion of thirteen works in the Salon de la Section d'Or (Galerie de la Boétie, 10–30 October 1912) (Debray and Lucbert).

Gris was trained at the Escuela de Artes e Industrias in Madrid 1902–4, where he probably studied mathematics, natural sciences, and engineering before deciding in 1904 to become an artist (Green, 301–2). Moving to Paris in 1906, he published hundreds of satirical drawings and

caricatures in the French and Spanish press from 1905 to 1914 (Tinterow). He met Pablo Picasso soon after his arrival through a Spanish friend, Vázquez Diaz, and became Picasso's neighbor in the Bateau Lavoir around 1908. In 1910 he turned seriously to painting, slowly developing his work up to this first exhibition at Clovis Sagot's in January/February 1912. Gris first appeared in the Salon des Indépendants in March 1912, making a splash with his *Homage to Pablo Picasso* (Art Institute of Chicago). This painting was noticed by Guillaume Apollinaire in his review of that salon in *L'Intransigeant* as an instance of "Integral cubism," one of Apollinaire's rather spontaneous neologisms (see Breunig, 214). Salmon also responded to this painting, writing in *Paris-Journal* (19 March 1912, pp. 4–5): "This evidence of good faith will not deny him his personality. Certainly, it is not yet with reference to Juan Gris that the question of Cubism should be re-opened; the work of those who have made researches for five years will be the pretext for discussion. But one must recognize immediately the taste and the clear sense of direction of this new painter, in whom one must have confidence" (Green, 14). Gris followed Picasso and Georges Braque again in exploring *collage* beginning in 1912 and *papier collé* in 1913, developing some of his most extraordinary works within the terms of collage aesthetic.

Breunig, ed., *Apollinaire on Art*
Debray and Lucbert, eds., *La Section d'or*
Green, *Juan Gris*
Leighten, "*Réveil anarchiste*"
Tinterow, ed., *Juan Gris (1887–1927)*

Olivier Hourcade [pseud. of Olivier Bag], "La tendance de la peinture contemporaine," *La Revue de France et des Pays Français* (February 1912): 35–41

The Tendency of Contemporary Painting

Ladies and Gentlemen,*

I do not have the foolhardy intention to tell you new and transcendental things. But, since art, already proscribed by the official salons, is not yet banned by law in France, I shall take advantage of this brief bright spot to chat with you about a theme that is dear to me: contemporary painting. And the goal I set for myself today is to try to rally the scattered ideas all of you possess within yourselves about the principal *tendency* of contemporary painting—by which I mean avant-garde painting—around to my way of thinking on this subject.

Eminent critics choose to consider the innovators eccentrics. They remind me of the part-time botanists who do not admit a plant is beautiful unless it was cataloged and awarded a prize at the last exhibition of the Petit Palais. Most of these critics have never seen the pictures they laugh at, and do not wish to go see them. Hence their reports are frequently stylish, mordant, but vacuous. I would like to demonstrate to you that these "eccentric painters" are, above all, serious workers and researchers, or rather that *the tendency that guides the labor of each one of them is to try to render the essential TRUTH of what they want to represent* and not simply *the external and transitory aspect* of that truth.

To develop that proposition, I will take the example of the three Gascon painters whose work is familiar to me and who are exhibiting in this gallery: Tobeen, who will represent the fauves, Gleizes, who will represent the cubists, and Lhote, who will represent the curious group—Véra,

*Notes for a talk on Contemporary Art.

Marchand, Dufils [Raoul Dufy], la Fresnaye, and Duchamp are the other examples—that seems to be in between the *cubists* and those one might call the *linearists,* namely, Tobeen, Girieud, and the other painters I like, but whom I am prevented from naming and praising according to their merits because of my obligation to be brief.

I will not argue about whether the works I will discuss with you are beautiful or grotesque. In the *Critique of Judgment,* Kant wrote, quite rightly: "The principle of the judgment of taste that we call aesthetic can only be subjective"; it changes a hundred times with a hundred individuals, a thousand times with a thousand. Therefore, to argue about the beauty of a picture (or of a symphony) is futile. But beauty imposes itself on the experienced man. It must be admitted that our bourgeois are too accustomed to the official mediocrity of the nests of daubers in the government of the Republic not to be initially surprised in front of an avant-garde painting, a contemporary work of art. How many times has it been said that art is a kind of revolt (or reaction, if you like). All the great artists—Rembrandt, Delacroix—were great rebels against the ordinary principles of their age. In recent years, we have tended to lose sight of the fact that it was harmful to follow the whims of fashion and of the mob. As Schopenhauer taught, "The mob is made to obey the laws and not to dictate them." It is up to each artist to dictate the laws of aesthetics through his works.

Let no one set down rules to be followed! And let no one say: "Apart from the aesthetics of Cormon, there is no salvation!" Art existed before aesthetics, whose role is not to create painters but to explain their art.

In this exhibition (which has gathered together the best elements of the new painting), a different aesthetic can be drawn from each artist. Each is as logical as the next.

All of them ought to bear this line—written by Remy de Gourmont— as an epigraph: "Everything I think is real. Thought is the only reality. The external world is relative. Everything is transitory but thought."

Yes, that is the point in common in the dream of art of these fervent creators, that is the tendency that guides them:

"The external appearance of things is transitory, fleeting, and RELA-TIVE. One must therefore search for THE TRUTH and no longer sacrifice to the pretty effects of perspective or graduated shading in the manner of Carrière. One must seek the *truth* and no longer sacrifice to the ordinary illusions of optics."

II

Thus art is free, provided that it renders the truth in a more plastic manner.

And, perhaps, there has been too much wailing in the news that we are living in an age of anarchy. The current efforts are far from anarchical in their diversity. It appears they are rather a return to sound traditions.

Fauves and cubists are not revolutionaries, they are reactionaries. "They are classics," as public prosecutor [Joseph] Granié has declared with me.

Our thirteenth-century painters wanted to render their thoughts and faith, and their intuition, their fervor, produced more beautiful frescoes than those that might be produced by the practiced eye and hand of our Prix de Rome winners and their masters. In times past, in fact, the painter required of his paintbrush that it express his belief; then books came along and reduced the painter's domain. The invention of siccatives for oil and the popularization of the methods of drawing and painting led straight to decadence. I base my statements on the opinion of a man for whom I have a personal respect, and who is not always kind toward the innovators, Mr. Camille Mauclair. He says that, in fact,

> since the fifteenth century . . . the domain of painting has been markedly reduced in size. Before the invention of printing, it was, alongside architecture, which it invigorated, the art best suited to present the mob with great syntheses of general ideas. *The fresco was a book of colors, just as the cathedral was a book of stone.* The poem, the tale, or the treatise, handwritten, had an infinitely more limited diffusion. The printing press abruptly made literature a vehicle of much handier, more accessible, and more rapid ideas; and, just as the book was coming into being, the picture, equally portable, was also created. It separated itself from the fresco and became an object of ornamentation. Later, painting lost another important monopoly over ideas and emotions, when choral music, then orchestral music, made their appearance and became a sort of abstract fresco.
>
> Hence, little by little, all the great thoughts and lofty emotions that, for several centuries, had been expressed exclusively by the painters, were now spoken by the book and by music. Having lost its mystical mission, painting also lost its ideological mission: it became a pleasure for the eyes and a luxury for the wealthy, *it left the idea behind and condescended to the anecdote, it adorned where it had once inspired meditation, its methods*

became more ingenious as its purpose became less proud and as the great intellectual currents turned away from it.

That is why every present-day painter, if he is bold enough to "think," is afraid to become a "literary" type. And yet, deprived of the heroic fresco and reduced to the picture, painting can enclose, within a panel the size of a book, as many suggestions as that book itself. Once a vast public revelation, it has dwindled to the point of no longer being anything but a familiar counsel; where once it proclaimed its lyric hymns across enormous walls and before heaven, now it speaks in hushed tones in private spaces. As a result, the task may fall to it to say what music and the book cannot say, to touch people on the periphery of the emotion of the latter media, and thus to refashion for itself a utility and a beauty, while being at the same time an object of ornamentation, between the curio and the wall hanging.

But does anyone even imagine that painting can have an architectural purpose? The principle of the line, of the linear armature of a painting, was obliterated from people's minds along with the principle of the fresco. The line is negated and concealed under color. And so it has gone, following a law of progression, from Domenico Veneziano to Carrière and the impressionists.

A reaction took root, the most steadfast representative of which I consider to be Tobeen.

The old Italian painters, Fra Angelico himself, used paint (mixed with glue or egg) on panels of dry wood or *a bueno fresco,* on still-wet whitewashed walls.

The difficulty of such a technique is the speed with which you must paint, since fresco paintings dry quickly, and, in executing them, you cannot know the definitive tones you are setting down.

The struggle with matter is also the appeal of that technique, which Tobeen has adopted.

It requires an extraordinary keenness of vision. In the mind of the artist who is going to paint, the picture must appear in its completed form.

Every object, and the landscape itself, must also be greatly simplified. Hence the technique itself leads Tobeen to seek the essential character, *the essential truth,* of the place he wants to paint.

Tobeen is Basque in the same way that Dumont is from Rouen and Verdihan from the Midi. With the fervor of a primitive, he wants to convey

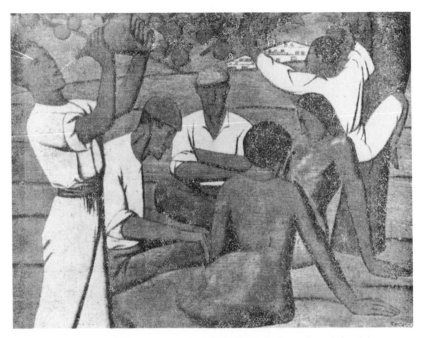

25. Tobeen, *Le repos* (*The Rest*), 1912. Illustration in Olivier Hourcade, "La tendance de la peinture contemporaine," *La Revue de France et des Pays Français* (February 1912) [document 33]. Used by permission of Princeton University Library.

his homeland. You will see these paintings in a moment: *Les fauches* [*The Reapers*] and *Repos* [fig. 25]. They sing tunes in patois and in Basque. That pink soil is made of the union, in the painter's soul, of the thousand lights that illuminate the Basque region, and maintains within itself the dominant hue of the pink sand of Ciboure. Let me recount one anecdote in this regard, to show this painter's meticulous artistic consciousness. He brought back from what we call "le Pays" a little bit of dirt; when he prepared his pink, he put a little of that dirt in a bowl, added water, and compared and reworked his pink until the colors in the two bowls were the same. And it is not unusual (is not this gesture worthy of our great primitives?) to find, on the canvas, a corner of pink fresco painted with the dirt of his home region.

In these frescoes, the line plays a very large role, a reaction against the impressionist fog, its indecisiveness. The shapes of the human figures are firmly drawn. The grace or rusticity of the hands is rendered with an extremely sober outline. The physiognomies of the men are composed

with only a few essential strokes. And this is not a sign of sterility or powerlessness, since the peasants depicted do not have the look of nondescript models hired at five francs the pose: they are true Basques. And therein lies the very interest of that work of art: we do not have before us some nondescript peasants of 1911, we have the race, the peasant who has always been, and whose dialect will not give way to the French language. Even the body of the reaper drinking from the izard horn is not ordinary-looking.

Anyone slightly versed in anatomy would discover the character of the Basque race there.

To sum up: the principal tendency that seems to emanate from Tobeen's works is the search for profound truth. Despising the banal decor for tourists and postcard collectors, he captures the essential and plastic aspect of the land of Saint-Jean de Luz and Ciboure.

It is for that reason that I believe Tobeen's still very early work will last. No truly human work has ever died. The painters preoccupied with painting only ephemeral impressions—official reports on nature, in the words of Zola, who was not always a fool—will pass away for the most part. The rubbish left over from the impressionist era will be tremendous, since the impressionists did not seek truth, but only a fragment, an aspect, of truth.

What I like about the cubists is their similar interest in being true: in the early ones, in Le Fauconnier, who gives me a sense of the force of Michelangelo, and whom I would like to see take on large compositions, "The Mob" or "Hunger." (See the *extraordinary power* of the sketch he displays here, in the room reserved for the cubists [Le Fauconnier, *The Hunter*, 1911–12, Gemeentemuseum, The Hague].) What I like about the cubists, I said, is their similar interest in being TRUE, in the deepest sense of the word—both the early cubists such as Le Fauconnier, Gleizes, Metzinger, and Léger, and the new converts.

Excuse me for saying the words *truth* and *true* at every turn, words that shock those who are still deluded by a tradition that grew up around the decadence of painting, to such a point that they believe that the painter's role is to faithfully reproduce a corner of nature: faithfully, which is to say, like a camera. They certainly sense that truth has multiple aspects, and it is their wish to compare various reproductions of these aspects to one another. They want the pleasure they get from a picture to be the same as what they get looking at a natural landscape. And they are astonished

to sense a difference. That is because nature is life, and one cannot render that life except by distorting it.

Let us take a canvas by Lhote (I am speaking of the recent Lhote), and let us compare that picture to a photograph of the place he chose to represent. The distortion is glaringly obvious, and yet (I can vouch for it because of a personal memory I will share with you), the essential character of the model is preserved.

I ran into Lhote several times last month in Bordeaux, and he showed me landscape studies he had just made and sketches of the Bordeaux harbor, which he wants to attempt again with greater sincerity. Now, about ten days before coming to Paris, I took a little trip to Lot-et-Garonne and Dordogne, and was struck by the odd relationship that existed between Lhote's landscapes and that natural setting in Gascony. After returning to Bordeaux, I was at the painter's home, and, in the course of our conversation, I told him: "I saw the models for your landscapes." "Where was that?" "Between Eymet and Bergerac." I was right, and yet, I am no Oedipus.

Hence, when Mr. René Blum, an art critic of great talent, writes that "our plastic arts, giving way to the invasion of mechanical procedures, can no longer confine themselves to being merely the faithful interpretation of nature," I do not at all share his view, if he means that the artist must be simply an eccentric. Nothing is less eccentric than a fresco by Tobeen, a landscape by Lhote, a still life by Gleizes, or Le Fauconnier's *Abondance* [fig. 9].

The plastic arts tend toward *true interpretation,* toward the *sensuous interpretation* of nature.

And Mr. René Blum falls into a common error when he says that photography will now give expression to our social life.

It is not photography that will be the latest improvement at the École des Beaux-Arts, nor the canvases of Mr. Cormon, ingeniously accurate in their thousand details. That is not what will provide a reflection of social life. It is color cinematography.

But cinematography has not been, is not yet, even officially, a plastic art.

Our *plastic* arts must be a condensation of what we see, a stylization; in that, *they can be the best and the most faithful interpreters of nature.* They must be to *pompier* painting and to cinema what the statuary of the early Greeks, of [François] Rudé, or of the great Rodin is to cinema and official sculpture: a capturing of life, undoubtedly distorted somewhat,

but a capturing of the truth of life through that very distortion. *More than a commonplace snapshot or an impressionist canvas, Tobeen's frescoes and Lhote's and Gleizes's canvases convey their models, because they display, not their fleeting aspect, but their immutable character.*

And now, I do not want to appear to present another discussion of *cubism,* after the brilliant lecture by Guillaume Apollinaire.

You are all undoubtedly familiar with Schopenhauer's line summing up Kant's idealism: "The greatest service Kant rendered was to distinguish between the phenomenon and the thing in itself, between what appears and what is; and he showed that, between us and the thing, there is always the intelligence."

Hence the painter, when he has to draw a round cup, knows very well that the opening of the cup is a circle. When he draws an ellipse, then, he is not being sincere, he makes a concession to the lies of optics and perspective, he tells an intentional lie. Conversely, Gleizes will try to show things in their sensuous truth.

How's that? What's that you say? That that procedure is as old as the world. I am well aware of it.

If Gleizes—and I could say the same of Lhote—had to render a book displayed horizontally, he would show its back. But, to be TRUE, he would also show the cover and the top of the book. He would represent it for us in its three dimensions, length, height, and width, the same way that Bibles are represented on the pediments of Protestant churches, or that the Ten Commandments, Moses's tablets, are represented in Catholic churches.

And that, at bottom, overly simplified, is cubism, which wishes to express the truth of things.

All in all, the interest of the cubist canvases does not lie solely in the presentation of the principal objects but in the dynamism that emanates from the composition of the canvases, a bizarre, disturbing *dynamism,* but strictly accurate. I will even propose that the misleading term *cubism* given to this school of painters be replaced by the more accurate *dynamism.* The interest in these works, in fact, lies in the materialization of the forces that combine things and beings, it is the realization of life in its truth.

━━━━━━

But we must come to an end.

The shortest discussions are the best.

You see, I kept my promise, I did not teach you anything transcendental or new, and confined myself to saying, in brief, relying on a few examples, that the *principal tendency of contemporary painting* (setting aside the image makers such as Dumont, Picabia, and [Alcide] Le Beau) is a desire to recapture the sincerity and truth of the primitives. Since the stamping out of the Gothics, painting has been in the process of gradual decline. There were exceptions, Rembrandt, for example. But the Rembrandts were immediately followed by the Bouchers. We are currently witnessing a period of renaissance in the plastic arts, the precursors of which were Delacroix and Rodin. I have faith in that renaissance of an art that, leaving behind superficiality and pastiche, tries to show in an original way the profound truths of a race, a country, or, more generally, of matter.

Fauves or cubists have the right to our respect and to our desire to better know them and to help them, because they are returning French art to sincerity and truth.

Olivier Hourcade [Olivier Bag, pseud.]

FEBRUARY 1912

Commentary

Auguste-Victor-Marie Hourcade (also known as Olivier Bag) (1892–1914) was a prominent poet, regionalist, and supporter of cubism. A native of Bordeaux in southern France, Hourcade first emerged on the literary scene in 1910 when he created the Société des poètes girondins et du Sud-Ouest along with his close friend, the poet Francis Jammes (1868–1938). A regionalist and ardent Catholic, Jammes lived near Othez (Basses-Pyrénées) and wrote poetic odes to his native region of Gascony and its peasantry (Griffiths, 18). Hourcade's hometown is the cultural center of that region (Gers, Lot-et-Garonne, Gironde), whose native language was quite distinct from that of neighboring Languedoc (E. Weber, 41–49). In March 1911 Hourcade founded the regionalist journal *Les Marches du Sud-Ouest. Revue Régionaliste d'Action d'Art,* which was soon absorbed into the short-lived *La Revue de France et des Pays Français* (February–August 1912). Whereas *Les Marches du Sud-Ouest* trumpeted the culture of Hourcade's native Gascony, *La Revue de France* promoted regionalist movements throughout French-speaking Europe and North America.

By the same period, Hourcade had established contacts with symbolist and cubist circles: for instance, contributors to *Les Marches du Sud-Ouest* included the neosymbolist and Bergsonist Trancrède de Visan and

a cubist ally, Roger Allard (see documents 12 and 18). As of September 1911, Hourcade participated in regular meetings of the salon cubists and Société normande group held at Jacques Villon's studio in Puteaux (see commentary for document 30). An art critic for *Paris-Journal, Paris-Midi, Le Siècle,* and *Revue de France,* Hourcade published two books of poems, *Des ombres tremblantes* (Bordeaux, 1909) and *Petits poèmes* (Bordeaux, 1911), as well as a small book of art criticism, *La tendance de la peinture contemporaine* (1912). After his death in 1914, a posthumous book, *Chansons du pays de Gascogne et de Béarn* (1924), was published, which included two dedicatory poems by Francis Jammes and Paul Fort, and a drawing by Félix Tobeen (pseudonym of Félix Elie Bonnet [1880–1938]), a Gascognard artist championed by Hourcade.

Hourcade's essay—his first on cubism—was originally given as a talk to coincide with the second Société normande exhibition of 20 November–16 December 1911 (see document 30). It has received attention primarily due to his use of the thought of the German philosopher Immanuel Kant, filtered through Schopenhauer, to justify the cubist departure from conventional perspective in the representation of objects (M. Antliff; Crowther; Golding, 17–18; Nash. For a lucid summation of the literature on Kant and cubism, see Cheetham, 78–87). Citing Kant, Hourcade claims that the salon cubists abandoned a so-called optical representation of an object through linear perspective in favor of a conceptual representation, in which multiple views allow both artist and viewer to synthesize the object into a single image of the thing as it is rather than as it appears. Hourcade also casts Albert Gleizes, André Lhote, and Tobeen in a regionalist vein, claiming that their painting revealed "the profound truths of a race [and] a locality." Thus their return to "sound traditions" marked them, in a positive sense, as "reactionaries," not "revolutionaries," whose figurative and landscape painting captured a racial essence (see Cottington, 151, on Hourcade's regionalism). Hourcade's analyses of Tobeen's paintings of local Basque peasants further confirms the traditionalist inflection of his regionalism (fig. 25). He lauds the "Basque" Tobeen not only for adopting the Italian "primitive" Fra Angelico's use of fresco, but also for using a hue reminiscent of "the pink sand of Ciboure" (a seaside village near Saint-Jean de Luz in the French Basque region) to ground his peasant subjects in the local landscape. This regionalist agenda also informs Hourcade's critical evaluation of René Blum's preface for the Société normande exhibition (document

30). In his text, he critiques Blum's claim that the cubists no longer sought to interpret nature. To Hourcade's mind, cubists' technique constituted a "sensual interpretation of nature" indicative of a "truer" understanding of the "immutable character" of the landscape. To arrive at this "understanding," the cubists of the Société normande had rejected impressionist and academic methods to "recapture the sincerity and truth of the [Italian] primitives" and artists of the Gothic era. For Hourcade, the cubists' fundamental aim in using "primitivist" techniques to grasp an essential, Kantian "truth" was to capture the still deeper "truth" of their own regional identity. What made cubism unique was the quality of "dynamism that emanates from the composition of the canvases," a dynamism that marked the cubists as "the best and most faithful interpreters of nature." In short, Hourcade regarded the Société normande cubists as yet another regionalist entity, in sympathetic dialogue with his own modernist circle in Gascony. To quote Hourcade himself, "Tobeen is Basque in the same way that [Pierre] Dumont is from Rouen."

M. Antliff, "Bergson and Cubism"
Cheetham, *Kant, Art, and Art History*
Cottington, *Cubism in the Shadow of War*
Crowther, "Cubism, Kant, and Ideology"
Golding, *Cubism*
Griffiths, *The Reactionary Revolution*
Nash, "The Nature of Cubism"
E. Weber, *Peasants into Frenchmen*

"Lettre d'André Mare à Maurice Marinot," 20 February 1912 (collection Mme. Mare-Vène, Paris)

Letter from André Mare to Maurice Marinot

6, rue Brochant

20 February 1912

My dear Marinot,

I am happy to see that you are wholly entertaining ideas that are dear to me and that are shared by my friends.

There will be about ten of us, then, including you, who are almost of the same age, and in any case of the same generation, and with ideas in common. That is the way to get things done, and it is urgent, if a movement is to take—and to give something back—that there be absolute unity and perfect cohesion in the collaborations. We are thus resolved to remain close by one another so as to achieve a perfect totality, and, for that reason, we meet regularly every week. Unfortunately, you are too far away for that, but you have seen our efforts of the last year, and, however imperfect they may have been, they must give you an idea of our present research. Knowing what you are doing, I therefore believe we might very well do something together. If you were to come to Paris, we would show you, at our various homes, our current research and our works in progress, and I believe that would also be very worthwhile.

I thus begin by succinctly bringing you up-to-date on our projects and collaborators.

It is agreed, first, that each of us will be responsible for the costs of the objects exhibited (by which I mean the cost of production).

In addition, for a group exhibit, one must count on relatively significant general costs.

For that, we have found a sponsor who will *give* us a sum that should cover the costs. As a result, you have only to provide your glasswork, without worrying about any installation costs.

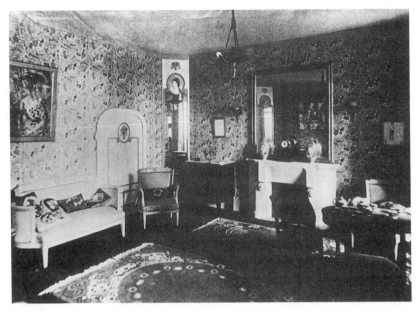

26. Le Salon Bourgeois, La Maison Cubiste, 1912. Photograph. Mare-Vène Collection, Paris.

So much for the material side.

From the artistic point of view, the project is fairly extensive. We will display the façade of the house, with entry door, windows, and so on; a vestibule with the beginnings of a staircase, a parlor [fig. 26], and a bedroom; plus a storefront, where various objects will be displayed.

Duchamp-Villon [fig. 27] is in charge of the façade.

I am doing the furnishings.

Gambert is making the wallpapers, the curtains, and the embroidery.

Desvallières, the handrails for the staircase, the balconies, and a chandelier.

La Fresnaye took on the interior architecture.

Favre, bronzes.

Vera and Fontenay, tapestries. And you the glasswork.

As for the spirit of what we want to do, it stems directly from what you saw last year.

First and foremost, to do something very *French*, to remain within the tradition—to let ourselves be guided by our instinct, which forces us to react against the errors of 1900, and that reaction may consist in this:

1. To return to simple, pure, logical, and even somewhat cold lines, whereas the period preceding us was horribly overwrought.

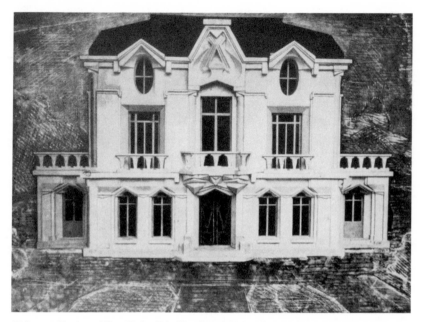

27. Raymond Duchamp-Villon, "Projet d'hôtel/façade de la Maison Cubiste" (façade of the "Cubist House" project), Salon d'Automne, 1912. Illustration in Guillaume Apollinaire, *Les peintres cubistes: Méditations esthétiques* (Paris: Eugène Figuière, 1913) [document 62].

2. To return to very clean, very pure, very bold colors, whereas, again, that same preceding period reveled in washed-out, faded, anemic tones.

To have a vigorous and naive design—to render the detail amusing without being imposing; to be more rough than skillful.

For the decoration, to adopt the motifs that did not change from the Renaissance to Louis-Philippe. To give them a new life, to adapt them to the forms. To treat them in accord with our way of feeling (the bouquet of flowers, the basket of flowers—or of fruit—the garland, the rose, the pink, the tulip, and, as ornaments, primarily the helix). In short, to make things with rather severe lines, whose coldness will be corrected by a pleasant, boldly colored decoration, all in a very French tradition.

To make novelty reside in the sensibility rather than in the inventiveness. Of course, to leave nothing to chance, "to do things always quite intentionally," but without it being perceptible.

As for the rooms, the parlor [fig. 26] will measure five by five-and-a-half meters. In each corner will be a niche occupied by a mirror surmounted by a painting—two windows—and a large door. The background wall

hanging will be on a gray ground with a large floral design, blue dominating, but which will include a fairly significant coefficient of different colors. The curtains will be embroidered. The wooden seats, painted blue and gray, will be covered with cobalt blue silk. There will be a desk covered with a red lac close to the color of sealing wax, with green and yellow motifs. The other furnishings will be of natural, inlaid wood.

The vestibule will be very sober in its decoration.

The bedroom will be very bright. Wallpaper with a white background, or an inconspicuous design. White curtains embroidered with color. Seats in natural wood, upholstered with tapestry. Furniture in natural wood. A bedspread with bright colors, but on a white background.

[A set of glassware] (tray, carafe, drinking glass, sugar bowl, and some sort of little oil pitcher).

Small perfume jars on the fireplace, for example (which will be the same one that was in the office last year). Jars in the parlor as well.

Simple things, without excessive decoration.

Try to get hold of the issues of *L'Art Décoratif* for 5 January 1912 and 20 November 1911, one on the Nouveau style, the other on the furnishings at the Salon d'Automne [fig. 23]. You will find interesting suggestions there. To be sent to London.

Very cordially yours,

A. Mare

Commentary

In this letter written to fellow collaborator and friend, Maurice Marinot (1882–1960), the interior designer André Mare (1887–1932) outlines the preparations that led to the creation of the infamous Maison Cubiste in the Decorative Arts section of the Salon d'Automne of 1912. Arriving in Paris from Normandy with his close friend Fernand Léger in 1903, Mare was initially intent on becoming a painter, but in 1910 turned to designing furniture and interior ensembles (Troy, *Modernism and the Decorative Arts in France*, 67 and 96). In 1911 Mare exhibited two of his own ensembles at the Salon d'Automne: one a dining room, the other a study. Through his contacts with the Société normande circle, he was able to recruit Roger de la Fresnaye, Marie Laurencin, Léger, Jacques Villon, and Raymond Duchamp-Villon as contributors to the 1911 interiors (Ajac, 133–34; Apollinaire, in Breunig, 184). On Mare's initiative, these artists then began planning a more ambitious ensemble for the next Autumn Salon—the result was the

Maison Cubiste. Behind a plaster building façade designed by Duchamp-Villon (fig. 27) were three rooms, including a principal interior known as the *salon bourgeois* (fig. 26). While Mare was responsible for designing the furniture, a host of female and male modernists collaborated on other objects in the salon bourgeois. The cubist de la Fresnaye designed the woodwork, fireplace, and chandelier, Jean-Louis Gampert the wallpaper, Sabine Desvallières the fire screen, and Maurice Marinot the enameled glassware. Marie-Thérèse Lanoa was responsible for the rugs, and the cubist Marie Laurencin executed the oval paintings of women's heads inserted above mirrors in the four corners of the room. Although both men and women created the decorative elements integral to the interior, it was men alone who contributed the fine-art objects hung separately on the walls of the salon bourgeois. Among the cubist works were easel paintings by Marcel Duchamp, Gleizes, Léger, Jean Metzinger, and de la Fresnaye as well as sculptures by Duchamp-Villon (Agee and Hamilton, 64–69; Amano; Pradel).

As Nancy Troy has demonstrated, Mare's turn to the decorative arts was in part a response to a broader national "crisis" over the poor quality of French design when compared to that of Germany (Troy, *Modernism and the Decorative Arts in France,* 79–102). To help reassert the cultural hegemony and commercial viability of French decorative art, Mare consciously rejected such international styles as art nouveau in favor of those tied exclusively to the French tradition. Thus in his letter Mare instructs Marinot to consult two articles from the journal *L'Art Décoratif* as a key to his intentions: his friend André Vera's attack on art nouveau, and Louis Vauxcelles's perceptive evaluation of Mare's interiors at the 1911 Autumn Salon (Vauxcelles; Vera; both cited in Cottington, 22–27). Vera called on his generation to reject art nouveau for a courtly French tradition of design whose chronological scope ran from the classicizing taste of the seventeenth century to the historicizing style promoted by Louis-Philippe in the early nineteenth (Auslander, 40–175; Vera). Vauxcelles in turn lauded Mare's 1911 ensembles for adding a Norman "folk" style to this eclectic mix (Vauxcelles). As David Cottington has demonstrated, Mare's allusion to the rural art of Normandy indicated his endorsement of the Socialist and republican celebration of folk art as the indigenous cultural "glue" that could aid in uniting all classes in France (Cottington, 23–27). Thus Mare's eclectic ensembles, whose jarring hues earned him the label of *colorist,* referenced both aristocratic and rural styles in an attempt to create a uniquely French style, untainted by foreign influences.

At the same time, Mare's ensembles poised theoretical problems for Gleizes and Metzinger, who, in *Du "Cubisme"* (1912), had reputed the subordination of painting to any decorative ensemble, and proclaimed the absolute autonomy of painting from its surrounding environment (see document 57; M. Antliff; 380–84; Troy, *Modernism and the Decorative Arts in France*, 83–88 and 94–95). As Troy notes, Mare alleviated such concerns by pointedly rejecting the subordination of an interior's constituent parts to any overriding style. Thus the eclecticism of his interiors allowed each object to maintain its individual integrity, and its potential value for any consumer unable to purchase the whole ensemble. In cubist circles another discourse divided the "low" commercialized field of the decorative from the "high" metaphysical aims of easel painting along gender lines, declaring the former to be a "feminine" sphere and the latter a "masculine" pursuit. Thus the merger of "high" and "low" art forms in the Maison Cubiste brought a range of related issues to the fore, including the perceived status of female cubists in the movement, the role of art criticism in maintaining a gender divide, and the relation of easel painting to the marketplace, whether in guise of commercial galleries, public salons, or even department store installations (M. Antliff and Leighten, 136–58; Kahn, 61–69; Troy, "Domesticity, Decoration, and Consumer Culture," 113–29).

Agee and Hamilton, *Raymond Duchamp-Villon 1876–1918*
Ajac, "Repères biographiques"
Amano, "Cubisme, décor et tradition vers 1912"
M. Antliff, "Organicism against Itself"
M. Antliff and Leighten, *Cubism and Culture*
Auslander, *Taste and Power*
Breunig, ed., *Apollinaire on Art*
Cottington, "The Maison cubiste and the Meaning of Modernism in Pre-1914 France"
Kahn, *Marie Laurencin*
Malone, "André Mare and the 1912 Maison Cubiste" (reprints the above letter)
Pradel, "La Maison Cubiste en 1912"
Troy, "Domesticity, Decoration, and Consumer Culture"
Troy, *Modernism and the Decorative Arts in France*
Vauxcelles, "Au Salon d'Automne (II)"
Vera, "Le nouveau style"

Maurice Princet, "Preface: Robert Delaunay," Les Peintres R. Delaunay, Marie Laurencin, Galerie Barbazanges, Fauburg Saint-Honoré, Paris, 28 February–13 March 1912

All artists have talent, few are unaware of it, and many revel in that obvious fact. It is from that perpetual self-satisfaction that so many charming and worthless works come into being. It is important for the mind to be the master of talent and use it as a docile instrument. However delicious nonchalance may be, when it is produced in order to please, it rapidly leads to a poverty of means and the uniformity of results.

Robert Delaunay has understood from the start that need to condense in a complete equation the gifts nature has bestowed on him. He pleases and charms first, but that initial success does not yet satisfy him. He wants to tame his grace, offer it to true lovers of art in solid and reasonable appearances.

He combines a vibrant temperament, the truly French qualities of vividness and exuberance, with the most rigorous discipline in his search for the means of his art. Craft, so neglected by both representatives of the tradition and by revolutionary independents, seems to him to be the true labor of the artist. Our sensations take on life in spite of us, and neither the environment nor the climate develops them; they are almost consequences of our personality. It is a fruitless preoccupation to seek to produce them artificially. They must be systematized in our brains, divested of the fog enveloping them, so that their clear logic can show through to anyone who comes to admire them.

But, some will say, he is a rationalist painter, one of the too numerous painters who forget their art to lose themselves in systems, waste their energies in learned theories while the canvas stands abandoned on the easel.

No, if Delaunay debates, argues, compares, and deduces, it is always with palette in hand. His arguments are not a delicious acrobatics of ingenious paradoxes; his reflections lead him neither to mathematical formulas nor to the mystic symbols of the Kabbalah. They simply and naturally steer him toward pictorial realities, colors, and lines. He expresses himself with masses, values; he defends his old works with new ones that explain their predecessors.

We like the calm continuity of his effort, palpable at every moment. His first attempts already show the undeniable quality of a painter who will assert himself later; the same natural gifts are there, in some landscape or portrait from the past. We can sense in them a love of life that owes nothing to book education, but which is vibrant and spontaneous within him. He abandons himself, gives himself over completely to the joy of painting, to the victorious effort that takes hold of the present sensation to capture and display it.

But, gradually, the effort becomes tauter, the role granted to the unconscious increasingly limited.

One of the first artists in the youthful school that so astonished fools and elicited so much sarcasm and anger, he was able to extract artistic results from conceptions that were purely theoretical and, for the most part, alien to painting. His clear good sense prevents him from pushing too far the logical, overly logical, consequences of minds more delighted to astonish than eager to produce. No more a writer of literature than a mathematician, he intends to remain a painter.

His recent sketches and his landscapes offer us eloquent proof of that. His sensibility has not been destroyed by his research in the technical field, as some might fear. On the contrary, it has been purified, sharpened, expanded, without losing any of its initial freshness.

For a long time, passionately in love with modernity, but without professing the futurists' subversive opinions regarding the Louvre and other museums, he has chosen the Eiffel Tower as the subject of his studies [fig. 15]. His instinct alerted him, before any logical argument, that he would find in it the explication of our architectural future.

That mass of iron at first appeared formless and ridiculous to us, coming to life by chance, out of the childish fantasy of an engineer who knew nothing about the harmony of things. Only a few years ago, in Montmartre one night, a young poet pointed it out to us with the gesture of a street vendor, exclaiming: "My last toy, the last invention of the year."

Despite appearances, the Eiffel Tower is not such a childish and ridiculous plaything. We concede it is planted there without any justification, and that, at first glance, that lack of harmony disappoints us. But we must look more closely. The grace of its curves, the strange slenderness of its lines, give it a true beauty.

That beauty is only the necessary result of algebraic formulas, of abstract calculations regarding the resistance of materials. It is to these abstractions that we also owe that miracle of grace, supple and solid, the pont Alexandre.

This cannot astonish anyone except those who know nothing about architecture, which has always been the material realization of the mathematical research of an age.

Without knowing anything about these things, Delaunay has guessed them from what he is able to read in the lines, forms, and colors. It was a lucky intuition that dictated that choice to him.

It is not our role to seek what people ought to admire in him. Every eye and every look modifies the quality of the sensations they receive. We simply wanted to note the effort he has made. It is up to sincere souls to pronounce whether that effort has been helpful.

Maurice Princet
28 FEBRUARY–13 MARCH 1912

Commentary

Maurice Joseph Princet (1875–1971) was an insurance actuary who lived two doors from the Bateau Lavoir and was probably the source of the cubists' interest in the fourth dimension and non-Euclidean geometries, based on his reading of Henri Poincaré's *Science and Hypothesis* (1902) and other mathematicians' works (Salmon, *Souvenirs sans fin, deux-ième époque [1908–1920];* Henderson, 64–72). Before 1909 he conveyed his enthusiasm for the new mathematics to André Salmon, Guillaume Apollinaire, and Pablo Picasso and in turn became interested in the new painting, even selling some of Picasso's works from his home (Daix). Leo Stein remembered that

> Picasso began to have ideas. Bergson's creative evolution was in the air with its seductive slogan of the *élan vital* or life force. There was a friend of the Montmartre crowd, interested in mathematics, who talked about infinities and fourth dimensions, Picasso began to have opinions on what was and what was not real. (L. Stein, 75–76)

In his column of 10 May 1910 Salmon claimed that Princet, "a mathematician inspired with curious reflections by the efforts of modern painters," was engaged in writing "a curious work of aesthetics" (M. Antliff and Leighten, 74; Henderson, 64). Metzinger later recollected that Princet tutored Juan Gris and himself in the new geometries around the same time (Metzinger, 43–44 and 62–63). By 1912 Princet had befriended the salon cubists, especially Robert Delaunay, and was a regular at Gleizes's weekly meeting in his studio at Courbevoie, on the outskirts of Paris.

Despite Salmon's claim, this is the only published writing of Princet's, so it has special interest as an indicator of his ideas. Reviewing Delaunay's work in this exhibition preface, Princet admires the artist's experimentalism as well as his dedication to craft. Lauding the artist's talent, he notes that in Delaunay his sensations are—as they must be—systematized; the result is clear logic, leading to "pictorial realities," not "mathematical formulas." A "vibrant and spontaneous" "love of life" animates his work, yet his sensibility has been "purified, sharpened, expanded, without losing any of its initial freshness." He applauds Delaunay's "intuition," which led him to embrace modernity in the form of the Eiffel Tower, whose "beauty is only the necessary result of algebraic formulas, of abstract calculations regarding the resistance of materials." "Architecture," he concludes, "has always been the material realization of the mathematical research of an age." According to Princet, then, Delaunay's art, in basing itself on the mathematics of architecture, constitutes a vanguard of the painting of modernity. Princet's views, combined with the influence of Leonardo, are thought to have inspired Delaunay to experiment with the golden section in his painting *City of Paris* (1912) (Buckberrough, 90–91, 102–4, and 109–10; Rousseau, 156–61) (see commentary for document 59). Concurrently Princet was studying Georges Seurat's neoimpressionism, preparing an essay that unfortunately never appeared, and actively encouraging Delaunay to embark on his own fresh revision of the laws of simultaneous contrast (Buckberrough, 99–104). This piece of Princet's writing—his only art criticism—does not reveal his larger thoughts on the relation of painting and non-Euclidean geometry, but it provides some tantalizing clues to his views on the importance of mathematics in modern art.

M. Antliff and Leighten, *Cubism and Culture*
Buckberrough, *Robert Delaunay*
"Daix, Pierre," s.v. *Dictionnaire Picasso*

Henderson, *The Fourth Dimension and Non-Euclidean Geometry in Modern Art*
J. Metzinger, *Cubisme etait né*
Rousseau et al., *Robert Delaunay, 1906–1914*
Salmon, "Courrier des artistes"
Salmon, *Souvenirs sans fin, deuxième époque (1908–1920)*
L. Stein, *Appreciation*

Olivier Hourcade [pseud. of Olivier Bag],
"Enquête sur le cubisme," *L'Action* (25 February,
[10 March?], 17 March, and 24 March 1912)

Survey on Cubism

Part 1

The "La Palette" Academy has just entrusted the directorship of the former Jacques Blanche studio to Mr. Le Fauconnier. Mr. Jean Metzinger will teach at the same academy. The event is making the rounds of the Landerneau of painters: "A cubist academy! A cubist academy!"

"They did not need to rail against the École des Beaux-Arts," a person of distinction from the Salon d'Hiver told us. "They too are academics, those cubists."

The futurists themselves, rather than eclipsing our avant-garde painters, are contributing toward placing them in the forefront of the current scene. The futurists, in effect, are their disciples, even while owing a great deal to Signac, and even to Detaille. Picasso's influence on Séverini and Metzinger's influence on Boccioni are indisputable.

It was therefore interesting to collect a few authoritative opinions on "cubism" for our readers today.

<div align="center">Mr. Camille Mauclair</div>

issues a harsh condemnation of cubism and of the cubists:

> I have read their declarations and the commentaries that have accompanied them. I am terribly sorry to be forced to disavow young men, and I question their sincerity only after having exhausted the resources of courteousness and good faith, and after having credited the strangest intentions, to the point of appearing naive. It is therefore because I cannot do otherwise that I give you the following opinion: these paintings and these

theories are the paltriest, the most unintelligent, the ugliest, and the most puerile imaginable. One cannot find any reference to them in the history of the arts or any justification for them in the evolution of human sensibility and logic.

The "fauves" were ignoramuses, bluffers, or neurotics. The cubists are something close to madmen, and their creations belong to the province of mental illness. Let the public find amusement in them: I do not want to laugh, I regard that crisis with astonishment and sadness. I hope it will affect the moral health of only a very small number of young people. I hope it will be only one of the fleeting manifestations of psychopathology that is ravaging and degrading an enervated era, absolutely driven to distraction by the excess of theories and the awful mania for originality, and destined for an implacable reaction. No, there is truly nothing there that can be justified, either in the intellectual order or in the plastic order, nothing but an absolute nullity of conception and of its result. I say this as an artist and as a critic who has always considered it the greatest joy and the finest reward to have something to discover, to love, to feel for, to propagate. I would love with all my heart to be able to say otherwise, to hail an effort, to praise a tendency, to invoke a need, to hope for a transition: the view of these compositions leaves me no means. They are neither developed nor to develop: they are zero.

In front of a Flemish bock beer, we ran into the painter
Henry de Groux,
who, we were told, was the enemy of the cubists. The author of *Christ aux outrages* replied:

Before the throng of bad paintings of our time, I can only have respect for those who dare attempt a new art.

Their theories are defensible and seem serious. I am waiting for the lasting works that will prove their value.

Part 2[1]

Marinetti:

We are separated by a profound gulf. I admire them because they are heroes . . . in their way. But our growing need for truth can no longer be con-

tent with form and color as they have been understood until now. In order to paint a human figure, it is necessary to include the entire enveloping atmosphere.

—But this isn't far from cubism, we respond [*interviewer*].

—I think of cubism as Boccioni, Carra, Russolo, Balla and Severini think of it. The cubists persist in painting the immobile, the frozen and all the static states of nature; they adore the traditionalism of Ingres, of Corot, aging and petrifying their art with a retrograde [*passéiste*] obstinacy that remains absolutely incomprehensible to our eyes.

With points of view absolutely futurist, on the contrary, we search for a style of movement, which has never been attempted before us. Far from relying on the example of the Greeks and the ancients, we ceaselessly exalt individual intuition. All the truths learned in schools and in studios are abolished for us. Our hands are free enough and virgin enough to begin everything anew.

It is indisputable that several aesthetic affirmations of our French comrades reveal a kind of masked academicism.

Is it not, in fact, to return to academicism to declare that the subject of painting has an insignificant value?

We declare, on the contrary, that one cannot have modern painting without an absolutely modern sensation as the point of departure, and no one can contradict us when we affirm that *painting* and *sensation* are two inseparable words.

To paint a model who poses is an absurdity and mental cowardice, even if the model is translated on the canvas in linear, spherical or cubic forms.

To give allegorical value to some nude or other by deriving the signification of the picture from the object that the model holds in her hand or from that which is disposed around the artist is for us the manifestation of a traditional and academic mentality.

This method, like enough to that of the Greeks, of Raphael, of Titian, of Veronese, is well designed to displease us.

We repudiate impressionism, but we believe that the cubists deceive themselves in combating it with the laws of the past. We disapprove of the present reaction which, in order to kill impressionism, returns painting to the old academic forms.

Part 3

An indiscreet glance around the Salon des Indépendants, which is going to open on the 20th, makes it possible for us to assert that, more than ever, the cubist school will be represented there.

There were four or five cubists at the Salon d'Automne, there will be about twenty at the Indépendants.

The battle to be waged in a few days at the salon on quai d'Orsay gives a new relevance to our survey, which we are pursuing impartially.

Mr. Plumet, painter:

> The only direction art has is given it by nature. The painter must seek his truth. But perhaps truth is relative for every person, since the cubists' truth is not mine. They are pursuing an interesting art, but have they attained it? I do not believe so. In fact, cubism does not exist as a school. All these painters are extremely diverse, and the only thing connecting them may be the distance they take from nature.

Mr. Maurice Robin,
who has just written the pamphlet *Cubistes et conistes n'ont rien compris à mon K* [Cubists and Conists Have Understood Nothing about My K] is an opponent of the new currents in painting.

> Our concern for impartiality obliges us to render the opinion of the pamphleteer painter in all its severity:
> Those cubists are eaters of bird droppings, they are failures; a kube is a product of zeroes.

Mr. Benoni-Auran,
so kind to his comrades that he was elected with the most votes to the classification committee at the Salon des Indépendants, gives us the finest welcome to his studio, cluttered with old knickknacks. He tells us:

> The cubists? They invented nothing. They draw in accordance with the first principles taught in school. No doubt it is difficult to put a subject in place, but it is more difficult to press on with it. A rough draft does not satisfy me. I want pictures.
> "Do you believe that the cubists' canvases are only rough drafts?"

No, certainly not. They want to simplify drawing. That is a fine desire. But to simplify excessively is to return to principles, and I find that that is insufficient. But I would not think of denying that the cubists have talent. They are artists, true artists, and that makes me think. Their works interest me a great deal. But I do not understand painting as they do. I believe that these artists, whom I respect, are making a mistake.

<div style="text-align:center">Mr. Jacques Nayral</div>

sends us the following few lines:

My opinion of the cubists? I think of the evocative power of Le Fauconnier, of the violent gentleness of Léger's figures, of the elegant and so very personal mathematization of the philosopher Metzinger. And then I look at Albert Gleizes's portrait of me, the light of my humble work office, and I say to myself: "There are painters in France."

<div style="text-align:center">Mr. Signac,</div>

whom we encounter among the canvases being hung, declares:

What shocks me in cubism is the use of ridges. In fact, not all the cubists use that procedure. La Fresnaye, for example, paints flat. Each of these young people has his personal technique. In that way, each contributes to our acquisition of freedom. Long live independence! Long live the liberators!

The cubists are our salon's raison d'être. I am very happy, as chairman, to welcome them into our midst.

Part 4

<div style="text-align:center">Mr. Gustave Kahn,</div>

who holds the post of modern art critic at the *Mercure de France*, writes us:

You ask my opinion of the cubists.

Let me tell you, first of all, how strange I find the fits of anger with which they are bombarded! It is bad form to welcome with insults artists seeking something new. If we had not proceeded, since the early masters, by successive evolutions, by contributions of new ways of seeing and interpreting, the adversaries of cubism would not have a very supple tech-

nique against which to compare them. Art lives on movement and not on stagnation.

If we think of the many diverse and unvarying injustices of which the public and the critics have been guilty toward all seekers, we will hesitate to display aggression toward the young painters. At least, it would be prudent to temper the invective against the new presentations, because, whereas painting remains, criticism leaves traces, and some aggressive acts turn against their authors. It was not so long ago that connoisseurs and dilettantes blamed Puvis for making wooden figures, Fantin-Latour for painting with strands of hair, and they roared with laughter when they stood before the first impressionists, who were accused of seeing everything in violet. And again, just recently, how many times did people speak ironically of those who were called "fauves"! And all that anger falls away, criticism puts away its knuckle-rapping ruler, and art lovers, once indignant, hang the canvases in a prominent place.

Apart from the theories and their systematization, I believe that the cubist painters have talent. Let me add that more people would be of that opinion if the cubist painters would provide a bridge or two between them and the public, that is, if, on the favorable occasion of a joint exhibition, they would show their starting point. There are paintings, pastels, and drawings done by them, conceived before their current research, that would demonstrate, to impartial people, their talent and the logic of their evolution.

No doubt it is a more swaggering gesture to go head to head with the public, but that juxtaposition of old works would win them followers.

It does seem that the art of Rodin, with his research into volumes, is not alien to the art of the cubists. But, obviously, sculpture is one thing and painting another, and the procedures for each are different. Every new action is also a reaction against some system in force. Cubism is a reaction against impressionism and its colored harmonies. Merely as a result of the fact that impressionism has, for fifty years, produced so many masterpieces and beautiful works, and especially, because it has reached the culminating point of its research, a reaction was inevitable. That reaction has offered various aspects. Some of them, in the direction of academic painting, are misguided.

In the direction of free art, or, to put it better, of pure art, cubism is the most logical of these latter forms of reaction. There is even a link to the chain of tradition: it is the work of Cézanne, whose research on solid con-

struction impressed the cubists as much as it did the fauves. It is among the cubists that that influence was accepted in the most analytical manner.

The cubists have sought the solidity of planes and the sobriety of color. Without wanting them to remain exclusively within temperate harmonies, we cannot deny that, in their room at the Salon d'Automne and in their exhibition at the Galerie Moderne, their color schemes as a whole produced an agreeable impression.

The ridges in their drawings are perhaps too sharp. We are a long way from the old axiom: "There are no straight lines in nature," but there are volumes: the cubists see them and accentuate them.

It seems there is a fervor there characteristic of the early stages, and a prejudice in favor of earnestness, which will mellow. Not to mention the fact that the eye will grow used to that conception of the layout of pictorial elements.

That, in fact, is how aesthetic movements come about. Mastery softens the sharp edges and the works are then better understood.

I do not mean to say that the cubists' theories render the other formulas null and void. There is room for various modes of interpreting nature, and the variety of aesthetic means makes it possible for everyone to assert his temperament. The cubists do not erase what has preceded them: they add to it.

Let us make note of that point. One of the difficulties—the greatest one—for the new formulas is to adapt themselves to a true transcription of the human face. The cubists have succeeded. The example is the very vibrant portrait of Jacques Nayral exhibited by Albert Gleizes [fig. 33]. One can criticize them, one can say they are not in focus, but one cannot deny the painterly gifts of artists such as Gleizes, Metzinger, Léger, Le Fauconnier, André Lhote, Delaunay, Chabaud, Tobeen, Duchamp, and so on.

Mr. Maurice Robin,
whose opinion we summarized on the basis of a recent pamphlet, sends us the following response:

Cubism is one of the most recent and the most lusterless manifestations of inopportuneness, which occur in every era.

In order to give pleasure to the distinguished art lovers who at present hold the trademark, the label, in order to give them illustrious ancestors,

I consent to call cubist the man who cut the tail off his dog and the man who threw himself into the Mount Etna volcano.

Today, the cubists are those who, in all branches of human activity, outdo themselves playing the fool (not to be confused with being original, audacious, and courageous).

A little "futurism"?

Cubists are people who would set fire to the Louvre so that people would talk about them.

And to conclude: if genius is made of copper, talent is of made of gold.

Olivier Hourcade [pseud. of Olivier Bag]

25 FEBRUARY, 10 MARCH [FRAGMENTARY], 17 MARCH, AND 24 MARCH 1912

EDITORS' NOTE

1. We have been unable to locate the correct edition (morning or evening) of the 10 March issue of *L'Action,* as part 2 does not appear in the microfilm copy of *L'Action* at the Bibliothèque Nationale, Paris. We nonetheless include here Marinetti's response from part 2, reproduced in Guillaume Apollinaire, *Les peintres cubistes: Méditations esthétiques,* ed. L. C. Breunig and J.-Cl. Chevalier, 206–8 (Paris: Collection Savoir, Hermann, 1965, 1980), for its exceptional importance, and regret the omission of the other respondents published in this issue (including Apollinaire, Michel Puy, Jacques Rivière, and P.-N. Roinard). These latter texts are reproduced as excerpts in Breunig and Chevalier's edition of *Les peintres cubistes.* Michel Puy's assessment outlines pictorial innovations frequently associated with the cubists; Rivière's response is reprised and developed in document 37; and Apollinaire's brief response reiterates his idea that the negative press proves the lasting importance of cubism, "the most noble artistic manifestation of our time" [trans. in Breunig, ed., *Apollinaire on Art*]).

Commentary

Hourcade's survey on cubism, whose publication roughly coincided with the opening of the 1912 Salon des Indépendants (20 March–16 May), is an extremely rich document, testifying to the lively critical and artistic debate that surrounded the salon cubists at this juncture. Hourcade solicited critics and painters from widely diverse backgrounds for their thoughts on the movement. The first published response is that of writer Camille Mauclair (1872–1945), a former leftist and defender of impressionism and symbolism, who, with the publication of *Trois crises de l'art actuel* in 1906, became a virulent critic of all forms of modern art from Cézanne onward (Golan, 156–73). While Hourcade had made use of Mauclair's thought in his earlier "primitivist" defense of cubism (see document 33), Mauclair himself clearly did not share Hourcade's enthusiasm for these modernists. Hourcade's second respondent is the Belgian painter Henry de Groux

(1866–1930), an artist closely associated with the symbolist group "Les XX." Part 2 of Hourcade's survey includes responses from Michel Puy, art critic for *Les Marges* (1903–37); F. T. Marinetti (1876–1944), who founded Italian futurism in 1909; Guillaume Apollinaire; and critics Jacques Rivière and P. N. Roinard. Of these five, we have reproduced Marinetti's assessment in recognition of its importance as the first recorded rebuttal of cubism by the futurist chief following the February Bernheim-Jeune exhibition of futurist painting in Paris. Next in order of appearance comes the painter Jean Plumet (born 1871) and the artist-critic Maurice Robin. Plumet was a landscape painter who in June–July 1911 had participated alongside the cubists in an exhibition in Brussels organized by the Belgian Société des artistes indépendants (Golding, 9). Robin wrote art criticism for the leftist journal *Les Hommes du Jour* up to 1910: like *Les Hommes du Jour* contributors Henri Guilbeaux and J. C. Holl, he was unflinching in his hostility to the cubists, although he approved of a full range of leftist artists, from the neoimpressionists Paul Signac and Maximilian Luce to the fauvist Kees van Dongen (see documents 14, 15, and 25). Hourcade then includes an assessment by the painter Benoît Bénoni-Auran (1859–1933), a former student of Alexandre Cabanel (1823–89), who exhibited regularly at the Paris-based Salon d'Automne and Salon des Indépendants. Finally, he closes his *enquête* with responses by three prominent defenders of cubism: the poet Jacques Nayral (document 40); the neoimpressionist and founder of the Salon des Indépendants, Signac (1863–1935); and the symbolist writer, theorist, and critic Gustave Kahn (1859–1936).

In his opening gambit Hourcade sets out to bolster his earlier claim that the cubists were "traditionalists" by noting with approval the recent appointment of Henri Le Fauconnier as director of the artists' Academy "La Palette," and Jean Metzinger's role as a teacher at the same establishment, located at 18, rue du Val de Grâce (La Palette also hired André Dunoyer de Segonzac as a teacher; see document 66). As the sole "academics" of the avant-garde, the cubists reportedly had servile "disciples" in the Italian futurists, although Hourcade acknowledges the futurists' debt to Signac, and, on a satirical note, to the painter of French military battles, Édouard Detaille (1848–1912) (on the cubist response to futurism see Cox, 162–66 and 195–99). Hourcade then publishes a range of responses to cubism, which in many ways were exemplary of current arguments for and against the movement. On the negative side, critics like Mauclair and Robin questioned the sincerity of the cubists, identifying them as mere "bluff-

ers" (Mauclair) who are adept at "playing the fool" (Robin). Such thinking coincided with the widespread accusation that the cubists were talentless "mystifiers," whose complex statements and obfuscating paintings were a mere publicity stunt, designed to win public attention and, presumably, sales (Weiss, 89–105). Bénoni-Auran in turn reiterated a frequent complaint voiced by artists, namely that the cubist technique was little more than a public school exercise in the most basic aspects of artistic training, in this case drawing (for instance, see C. Léandre's statement in document 58). This claim was later advanced by such major adversaries of cubism as Louis Vauxcelles, who, in an article in *Gil Blas* (3 December 1912), asserted that the cubists' geometricizing of form was in rank imitation of basic drawing exercises taught at the École des Beaux-Arts (Vauxcelles, referenced in Weiss, 78). However, Mauclair struck a darker chord by declaring the cubists "madmen" whose art was indicative of "mental illness" and constituted a threat to the "moral health" of all who came in contact with it (he had already deployed such terminology against Paul Cézanne and the fauves; see Golan, 160–61). This pathologizing of cubism would become common currency in the fall of 1912, when the Socialist city councillor Pierre Lampué publicly challenged the right of the cubists to exhibit their art in state-owned buildings (see documents 45 and 49; Leighten; and Brauer, chaps. 4 and 5). Marinetti in turn summarized the futurist challenge to the cubists' self-proclaimed status as an avantgarde group. The futurist leader condemned cubist technique for producing "immobility" rather than dynamism, and he mocked the cubists' devotion to "traditionalism," citing as proof their admiration for Camille Corot and Jean-Auguste-Dominique Ingres. The cubist dismissal of modern subject matter, combined with their recourse to allegory, amounted to a "masked academicism." Futurism, by contrast, "searches for a style of movement" by embracing "modern sensation," relying on "individual intuition," and rejecting the cubists' retrograde emulation of the "Greeks and the ancients." Clearly Marinetti was well aware of references to the French tradition and classicism in the writings of Roger Allard, Albert Gleizes, and Metzinger (documents 11, 18, 19, and 21); moreover he challenged the cubists' allegiance to Henri Bergson by claiming the mantle of Bergsonian "intuition" for the futurists. His appropriation of Bergson, to the detriment of cubism, was part of a concerted campaign that colored the cubist and futurist debate over simultaneity in 1913, and culminated in Umberto Boccioni's Bergsonian critique of cubism in his book *Pittura*

scultura futuriste: Dinamismo plastico (1914) (on relations between cubism and futurism, see M. Antliff, *Inventing Bergson;* M. Antliff, "The Fourth Dimension and Futurism"; Bergman; Braun; Cottington, 102–4).

These negative appraisals are counterbalanced in the survey by those of the painters de Groux and Signac, and the critic Kahn. Groux judged cubist theory both "defensible" and "serious," and Signac lauded the cubists as exemplary of the libertarian ideals that motivated him and his fellow neoimpressionists to found the Salon des Indépendants in the first place (see Ward, 49–63; and Distel, 40–50). As the only juryless salon, this venue allowed for the maximum amount of artistic "freedom" and "independence"; since the cubists were considered the most outlandish artists of the moment, they were, de facto, the salon's "raison d'être." The political implications of Signac's cry—"Long live independence! Long live the liberators!"—underscored his own anarchist agenda, and the implicit threat of the Salon des Indépendants to the established institutional order. Kahn (an early supporter of neoimpressionism) also upheld the principle of freedom of expression, claiming that "art lives on movement and not stagnation" before describing the cubist reaction against impressionism as yet another stage in art's "successive evolutions." In Kahn's estimation, however, that so-called evolution needed bolstering; the cubists, we are told, would do well to exhibit their past work alongside "their current research" to reassure the public of "their talent and the logic of their evolution." "No doubt it is a more swaggering gesture to go head to head with the public, but the juxtaposition of old works would win them followers." Speaking of modern art generally, Kahn mapped out two recent reactions against impressionism: one "in the direction of academic painting," the other "in the direction of free art." Cubism reportedly stood for the latter orientation, and even here "tradition" existed in the guise of Cézanne's impact on the fauvists and cubists. Thus Kahn and Signac allied cubism to their defense of avant-gardism and libertarian freedom, a maneuver frequently utilized by those defenders of cubism who inhabited the political spectrum from socialism to anarchism (see documents 7 and 42, and M. Antliff; Leighten; and Brauer, chap. 1).

M. Antliff, "Cubism, Futurism, Anarchism"
M. Antliff, "The Fourth Dimension and Futurism"
M. Antliff, *Inventing Bergson*
Bergman, *"Modernolatrià" et "Simultaneità"*
Brauer, "L'Art révolutionnaire"

Braun, "Vulgarians at the Gate"

Cottington, *Cubism and Its Histories*

Cox, *Cubism*

Distel, "Portrait of Paul Signac"

Golan, "From Fin-de-Siècle to Vichy"

Golding, *Cubism*

Leighten, *Re-Ordering the Universe*

Ward, *Pissarro, Neo-Impressionism, and the Spaces of the Avant-Garde*

Weiss, *The Popular Culture of Modern Art*

Jacques Rivière, "Sur la tendance actuelle de la peinture,"
Revue d'Europe et d'Amérique (1 March 1912): 384–406

On the Current Tendencies in Painting

*Today, as we announced and promised after the odd article in which our
contributor [Jules] Granié, in the issue of 15 November 1911, defended the
cubist painters in reference to the last Salon d'Automne, we publish an
article on the same subject, which in some sense constitutes a reply to
Granié.*

*Written by the eminent art critic Jacques Rivière, it assumes particular
importance given the imminent publication of a volume on "cubism" by
MM. Gleizes and Metzinger. The stir these discussions of art have caused
is well known. We are certain to interest our readers in bringing them the
ingenious and brilliant offering they are about to read.*

There is "in *cubism*" an extremely interesting idea of considerable impor-
tance. But surely no one is more anxious than the cubists to learn what
that idea is.

The cubists are not joyful daubers who have fun with their invention
and enjoy the confusion it produces. They are not amusing themselves.
On the contrary, they are morose. From the day they launched their
system and ventured their first canvases, not without an expansive thirst
for adventure, they lost all tranquility: "How can we work things out?"
they wonder. "What have we embarked on?" They listen here and there
to what people are saying. Sometimes there's hope: a little argument pre-
sents itself; they timidly propose it to their critics; they test it, not too sure
themselves of what it is worth. (But it is an argument! If only, by some
chance, it would do the trick!) "One might say," one of them suggested
in front of his own canvases, which he was haltingly trying to defend,

"one might say that it is a synthesis of small analyses."* And, if someone declares he is not satisfied with that justification, they fall back into new perplexities.

I do not think we should misinterpret that anxiety and hesitant conviction on the part of the cubists. I do not see them as signs of an arbitrary inclination; I do not conclude from them that their efforts are in vain and gratuitous. On the contrary, their perplexity leads me to believe that, in this matter, there is something that transcends them, an all-powerful necessity in the evolution of painting, more truth than it is possible for them to perceive at first glance. They are the precursors—and, like all precursors, clumsy—of a new art, which is henceforth inevitable. If they are unsure of themselves, it is because the power that directs them disdains to discuss things with them and uses them as unskilled labor, without giving them reasons, leaving them to invent any they like, since they are also unable to see the true ones. But, because this power does not justify them, its orders are slavishly—which means, very poorly—executed. The cubists have their nose to their work; since they possess only the letter, not the spirit, of the innovation they are advancing, they painfully translate word for word what is dictated to them. Hence the amateurish and breathless aspect of their works; each bit of them was written by turns, and painfully, by someone who, far from planning it, was always waiting for what was to follow.

It is my intention to give the cubists a little more freedom and self-assurance by providing them with the profound reasons for what they are doing. True, I will not be able to do so without showing them how badly they have done it until now.

Part 1: The Current Needs of Painting

1. The Origin and Meaning of Painting

First, let us go back to the flood.

What was primitive man looking for when he drew, on the wall of his cave, the object he had just seen? He wanted to prevent it from being absent. Soon, perhaps, he would encounter it again. But, in the meantime,

*Another, in reply to the questions of a friend with whom he had lost contact for a certain time, provided this response: "Oh! I have launched into a vague cubism!" For anyone who guesses whom I mean, that line is not lacking in a certain spice.

he wanted to keep it before him in a certain way, he wanted to hold on to it across time, he wanted to establish continuity between its apparitions, to fill the intervals between them, to remedy their intermittence. He wanted not to need a new stroke of luck to know what the object was like.

The scientists teach us that, in tracing the shapes of the animals, primitive man had the precise plan of "bewitching" them. He had just lost them, he no longer had them at hand; thus he cast a spell over them and, however far away they might go, they would not cease to belong to him. He would be their secret master. He contrived the cipher that gave him complete power over their disappearance. They could move about at their ease and believe themselves free in the immense forest; he, the clever sorcerer, governed them unbeknownst to themselves with the thing he had made and which did not move. It was there on the wall, it yielded to the distant initiatives of the beings it depicted. It let them do as they pleased, but only because it was the magic circle from which they could not escape. It is well known that, in the eyes of every barbarian, an effigy is a means to possess the original, to hold it long distance, and that he has only to put a spike through it to kill what it represents.

We must therefore admit that the original usefulness of the drawing was to create a sort of substitute for the object and, by that means, to reduce to slavery everything that escaped man's actual and direct domination. To draw is to seize hold of a prey, despite the fact that it has fled.

We must conclude that the primitive artisan sought to trace a figure that was the exact equivalent of its model, which replaced it, took its place. It could not change or be subject to the variations of the object. Thus he applied himself to making it such that, without moving, it could represent all these variations. It would always be the same; and nevertheless, since the eyes of an immobile man continue to be the match of the things they watch passing by, it would follow the object through the entire cycle of appearances it went through in a day. It would never tire of suiting it, of being equal to it; it would overtake it with its infallible truth everywhere caprice might lead the object. The fixity of the figure would be faithful as the moving shadow. At every instant, it would be possible to substitute it for its model, like an image that could not be denied. Is it not the nature of a magic cipher to hold within its secret simplicity the whole complex revolution of beings it has captured and to remain imperturbably and

mysteriously adapted to the most unexpected movements of its illusory independence?

But it is obvious that, to thus satisfy all the successive aspects of an object, the figure traced must not reproduce any single one of them. It cannot resemble all of them unless it is different from each of them. It can replace the object without warning and perfectly, not by imitating its face of the moment to the point of being mistaken for it, but rather by being it more than it itself is at that moment. The figure must constantly be truer than the object appears. Thus, it will have no characteristics by virtue of which it belongs to one instant or another; it will be carefully stripped bare of any accidental mark. And, above all, it will not represent its model as it showed itself to the artist. If the savage seeks to fix the image of an animal he saw bolting away, why—unless it is some beast whose essence is to flee—would he depict it in the act of fleeing? He wants to preserve it, hold on to it: therefore, in his drawing, he is not going to give it the attitude of one escaping. He is going to set it down in its entirety, as if he had surrounded it during a hunt with his dogs, as if he had discovered it standing in a clearing. He will try to return to it its integrity, the only thing that interests him, and which, since he was unable to see it in reality, he wants to show at least in effigy. He will struggle to render a horse, not a half-glimpsed leaping rump. He draws to complete what was fragmentary, awkward, and mutilated in his perception, to complete the rough sketch his eyes had begun and left incomplete. Hence, far from attaching himself to the particularities of his vision, which are always imperfect, he will attempt merely to set them aside, and to restore the object itself, pure, alone, intact, and true. Since he proposes to ensure its presence between the intervals of its apparitions, how could he imagine retaining the traits it bore when it appeared?

We now understand the true meaning of painting, by virtue of its origin. It represents objects as they are, that is, otherwise than how we see them. It always tends to give us their sensible *essence,* their presence: that is why the image it forms does not resemble their *appearance.* The painter must consider each thing at its center, direct a pertinent gaze toward each, encounter none by happenstance, but struggle to take each in turn to the pinnacle of its reality. He will not forget his naive ancestor's intention: he will have in the face of nature that desire for possession, that secret and sly greediness that seeks to seize hold of the object while turning it completely around; he will set it, with its complete existence,

in front of him. But, in order to do that, he will have to show it as he has never seen it.

Those who think that the goal of painting is to give us a faithful copy of things are correct, as are those who claim that painting must transform things. Indeed, to copy them properly, it must transform them. A great painter such as Cézanne has only one idea while he is working: to create an exact image of what he sees; but, in the end, his canvas is entirely different from the spectacle; and he is the only one who does not perceive it. That is because, unbeknownst to himself and in spite of himself, he has changed the *aspect* of the things he was contemplating in order to express their *being;* he has relieved them of that forced and arbitrary attitude in which they presented themselves. Completing what he perceived of them, he has spontaneously returned them to their reality.

2. Practical Consequences

Let us now try to determine more precisely what sort of transformations the painter must make to the objects such that he sees them in order to express them as they are. These transformations are both positive and negative: he must disregard lighting and perspective; and he must put other, truly plastic values, in the place of these two values.

WHY LIGHTING MUST BE ABOLISHED. The lighting of an object, that is, the direction from which it is encountered by light, must not be represented. In effect, it is the sign of a certain instant and varies with the sun's position in the sky. Even though lighting appears motionless, it has no more stability than the hands of a watch, and it indicates, with a mathematical exactitude, the hour on the form. It is the way an object participates, not in the continuity of time, but in every minute. If one fixes the lighting, one prevents the object from enduring, arrests it at a certain point in its existence. It is captured, but the way something is captured in a snapshot, with the look of being about to go away. Therefore, if the plastic image serves to reveal the essence and permanence of beings, it must be stripped of all lighting.

Lighting is not merely an accidental mark; it has the effect of profoundly altering forms. If one lets light do as it will, it distributes itself over objects in accordance with an entirely mechanical law devoid of intelligence; it falls on them, inevitable, inert, rigid, like gravity; it obeys physics. It does not know the thing it touches, does not guess its secret.

Nor does it arrange itself following the object's profound predispositions, but adds to it brutally, accentuating and dissimulating its parts without concern for their real importance. Hence the most essential parts are often swallowed up by shadow, while the least interesting are exaggerated in full brilliance. It is therefore possible to say that lighting prevents things *from appearing as they are.* In reality, these alterations have no serious disadvantage, because we can always come back to see the object an hour later, to complete the knowledge we want to have of it. The sun has shifted; other parts now benefit from its rays. Contrary to what one might think, sight is a successive sense; we have to combine many of its perceptions to arrive at a good knowledge of a single object. But the painted object is fixed; it cannot count on time to remedy its inadequacies; it must not hope to ever say more than what it says immediately; it is forbidden to move away from what it is to complete itself. Thus, since its mission is to fully express things, it must do so from the first glance and reject lighting.

WHAT LIGHTING MUST BE REPLACED WITH. The immediate consequence of abolishing lighting is the equality of all the parts of the object; they all claim the same right to the attention. The painter applies himself to maintaining a certain subdued equivalence among them. He shows them next to one another, without preference or favor.

But it seems that, in this way, he renounces communicating the sense of their distinction and the internal articulation of the object; it seems he makes himself vulnerable, out of too much respect, to introducing confusion and disorder. Lighting, in fact, was a means of analysis: the contrast between shadow and light, in accentuating all the protuberances of the object, in effacing all the valleys, separated and distributed its elements with clarity. It may be dangerous to deprive oneself of such important services.

One can try to obtain the benefit of them by other means; when one abolishes lighting, one can and ought to replace it. That replacement is possible because lighting is not the only or the best means to analyze the object; it does not represent the difference between the parts in any real way, but only in a completely ideal and abstract manner; it simply suggests it, proposes it, indicates it. It lets the various faces succeed one another *flat* on the canvas, and, through the clash between light and shadow, it leads us to think they are separated; but we manage to see that separation only through the imagination.

It is possible to depict it in a more effective and more plastic manner. Even while conserving the luminous equality of the faces of the object, the painter will distinguish them from one another by slight ridges. He will make these faces proceed from the ridges like the opposing slopes of a roof; he will solidly articulate them as they are articulated in nature. He will retain their reciprocal obliqueness and their angular arrangement.

Nevertheless, that obliqueness will appear, those division lines will be ridges, only if the painter still consents to make use of highlights and shadows. Fortunately, that use is not forbidden him. He has given up lighting, that is, the direction of light, but not light itself. He rejected lighting because it sacrificed entire parts of the object by casting them into darkness, whereas others were pointlessly displayed over their entire expanse. For him, then, it is simply a matter of remedying that disadvantage; and he can do so without completely depriving himself of the services of lightness and dark. He has only to replace the brutal and unfair distribution of light and shadow with a more subtle and more equitable distribution; he has only to distribute impartially, among all the faces, the shadow that was piled on certain of them. He will use the small share of light conferred on each one, setting it against the closest edge of another lit face, to mark the slope and respective divergences of the parts of the object.

Hence he will be able to shape the object without resorting to contrasts, simply with peaks and inclines. That procedure will have the advantage of marking not only the division, but also the juncture of the planes; instead of a succession of bright protrusions and dark holes, we will see slopes leaning against one another and subtly interdependent. Since they will be both separated and connected, the requirements of both multiplicity and unity will be satisfied.

In short, the painter, instead of showing the object *as he sees it,* that is, disarticulated between light and dark, will construct it *as it is,* that is, in the form of a geometrical volume, free of lighting. In the place of its relief, he will put its volume.

WHY PERSPECTIVE MUST BE ABOLISHED. To express the things he sees as they are, the painter must transform them in another way. They appear to him in perspective, that is, with some behind the others and diminishing in size and sharpness as they grow more distant. But perspective is as accidental a thing as lighting. This time, it is not the sign of a certain

moment in time, but rather of a certain position in space. It indicates not the situation of the objects but the situation of a certain beholder. It designates the chair, the bench, or the stone on which the painter sat to work. It points to something that is absolutely external and indifferent to the objects represented by the canvas, namely, the way these objects receive the gaze of someone who, in a moment, will no longer be there. For man is by essence someone who changes places. That is why, in the last analysis, perspective is also the sign of an instant, of the instant when some man found himself at some point. It is clear how unrepresentative it is of the permanence of objects.

In addition, like lighting, it alters them, dissimulates their true form. In fact, it is a law of optics, that is, a physical law. It is directed like a beacon onto things, it passes over them but without stopping at any, without *informing itself* about any; it shows and dissimulates without preference the parts that their situation displays to or conceals from its revelation. A book, seen in perspective, can look like a thin rectangular ribbon, even though it is in reality a regular hexahedron. And that deformation of the objects placed in the foreground is benign compared to the mutilations the others endure: partially masked, cut up arbitrarily by those that preceded them in the order of depth, they appear misshapen, ridiculous, unrecognizable. When perspective installs a tree in front of a house, that house may change into two white triangles separated from each other. A river, seen through a curtain of poplars, can look like a string of brilliant little diamonds. And yet, is it not the essence of a house to be a cube, and the essence of a river to flow all at once, deep and continuous? No doubt, reality shows us these objects mutilated in that way. But we can move around in reality: one step to the right and one step to the left complete our vision. The knowledge we have of an object is, as we said, a complex sum of perceptions. The plastic image, for its part, does not move: it must be complete from the first glance. Hence, it renounces perspective. I claim that if certain real spectacles were reproduced by a painter with an absolutely rigorous respect for perspective, it would be impossible for anyone to recognize them, because the objects would appear so different from what they are.

WHAT MUST REPLACE PERSPECTIVE. It is at this point that the most serious problems arise. To simplify, let us distinguish between the representation of the object and the objects themselves.

On the first point, the difficulty is not great. The abolition of perspective quite naturally leads to this simple rule: one must always present the object from the most revealing angle. It must advance to meet our gaze in the attitude in which it best reveals itself, as we see it when we see it well. It must disregard the constraint that the canvas as a whole would like to impose on it and, disengaging itself from the imperfect position to which the universal point of view would reduce it, it must deliver to us enough faces of itself for us to know it well. It has the right to demand, against the mechanical pressure of perspective, a certain freedom that allows it to comfortably set out its volume and to offer the multiplicity of its planes. In other words, each object will ask us to place ourselves in relation to it at a particular viewpoint, which will be that of its most solid apparition.

Sometimes, it will even be able to supply several points of view; it will sometimes show itself in a way that would be impossible for us to ever see, with one more face than we could discover in it with our feet firmly planted. As a matter of fact, there are objects whose true nature reveals itself only after several sightings. And, as we said, every view is a synthesis: a bridge is something under which water passes and over which vehicles drive; it has an above and a below, which contribute equally to making it what it is. It is therefore important to represent both at once, the interior of the arch and the pavement or, at the very least, the two parapets. Only then will the object take on its reality, its shape, and become something other than a fantastic cutout. This is merely a deformation of volume, which has the same meaning and the same aim as the deformations of the surface made by the stroke: that is, to create a figure that contains in its motionless eternity the complex integrity of the object, which appears only in time, to imprison movement all at once, without stopping it, whether that movement belongs to the object or to us in relation to the object.

But, at this point, the abolition of perspective produces the trickiest consequences and requires the most inspiration and intelligence from the painter. If not only every subject, but objects as well, are no longer hierarchized by perspective, what is the result? Obviously, they all fall on the same picture plane; they rise in tiers, one on top of the other, and occupy the canvas from bottom to top, without becoming deformed as they climb higher. This consists of setting the spectacle upright in a certain way. The sky is no longer at the far end of the receding landscape, but sits on it like a lid, and the clouds are added to all the rest, objects

one must not forget to express before finishing. A picture is thus the inventory, the scrupulous enumeration, of all the elements of a spectacle. Its magnificence is that of a very exact, very complete, and very impartial memory.

That impartiality, however, does not seem to be without danger. Will not that equivalence among all the objects, that way of gathering them together and on a single plane, culminate in the very jumble that the abolition of lighting and the equivalence of the parts had already made us fear regarding the object? Perspective, like lighting, analyzes, distinguishes objects from one another, and does so in several ways.

First, it prevents them from encroaching on one another and mixing their elements together; through it, each renounces what it must leave behind to be able to enter into the composition with the others without becoming indistinguishable from them. It obtains from them all the mutual concessions indispensable for their proximity not to be a confusion.

In addition, it suggests the intervals by which they are separated in the order of depth.

In abolishing perspective, the painter must seek to obtain by other means the dual analysis it brings about. He rejects it only to replace it. And first, he must slip between the objects, grouped together on a single plane, gaps, slight intervals, by virtue of which they appear isolated from one another. He cannot achieve this except by mutilating them in turn, by omitting to depict certain of their parts. We have said that his job was to express things *essentially*; but that does not mean from beginning to end, *entirely*, without cutting anything out. An object can be represented in a profound and perfect manner by a single of its parts, *provided that part is the nodal point of all the others*, that it holds them within itself, that is, provided it is the angle joining all the planes, the solid angle formed by their union. A house, perceived at the point where two planes of the roof and two walls meet, is more completely known than if its façade were seen in its entirety, but by itself. All the other parts only repeat that one; they restart it, multiply it, but add nothing to it. They are like the replicas of a painting; it is pointless to go see them to know what their subject is. They form an entirely geometrical enlargement around the original, but without any expressive meaning. Hence the painter can overlook them, cut them out, reject them; he can make as many sacrifices as perspective might have demanded, provided that he presents what is most essential

and most significant about each object. Or rather: the sum of sacrifices that perspective imposes on objects is very arbitrarily and very unequally distributed among them; those in the foreground usually find all their elements represented, even the most pointless, the most monotonous; the others are attacked in their very substance, in what is most eminent, important, about them. The painter, by contrast, distributes the sacrifices impartially; since he has brought all the objects onto the same plane, none has the capacity to develop more than the others; he arrests the figure of each one the moment it expresses the object essentially and before it prevents the other from in turn appearing as it is. He guides the omissions, so to speak, and makes them fall where they ought. He uses the gaps determined by these omissions to delimit and isolate the objects; he makes sly absences circulate among them, which give a striking clarity and force to the apparitions of the objects. Now they advance, each offering its prow, like a powerful and succinct fleet whose depth and lightness are embraced in a single glance.

In conclusion, the painter must find an equivalent to the intervals that perspective makes us imagine between the objects in the order of distance; by some ruse, he must steal from perspective the secret of the new sort of distinction it slips between them. Before examining how he will go about it, let us note that the undertaking is not a priori impossible. To abolish perspective is not necessarily to abolish depth, any more than to abolish lighting is to abolish light. The objects are in perspective only in relation to someone. Set aside their relationship to someone and perspective disappears, but they remain in depth. They do not cease to be in space; there is still distance between them; their intervals are attached to them and endure with them. It is therefore possible, at the very least, to *imagine* objects that are separated by depth without being in perspective.

But is it possible to *represent* them in that way without the aid of perspective? Perspective is not the only, or even perhaps the best, means to translate depth. In fact, it does not express depth in itself, directly, by name; it can only suggest it by carving out profiles. The figures by which it evokes depth are not arranged as recesses; they do not in any way participate in the third dimension; they are not turned obliquely in relation to the picture plane; they make no sign toward the distance, but all of them face the beholder; they are parallel, like the uprights of a stage set. It is without imitating what is proper to distance, but simply by taking a

counterfeit attitude toward it then and there, that they suggest that there are intervals between them, *about which, in fact, they say nothing.*[†]

Fortunately, depth is not a pure vacuum; it can be presumed to have a certain consistency, since it is also occupied by air. The painter will thus be able to express it in a manner other than perspective, by communicating a shape to it, not by evoking it, but by painting it as if it were a material thing. To that end, from each of the ridges of the object he will draw out slight planes of shadow, which will recede toward the more distant objects. The forward position of one object in relation to the others will thus be marked by the fringe with which its contour will be bordered. Its form will stand out from the others not as a simple profile on a screen, but because the strokes that delimit it will be edges, and shadows will flow from it toward the ground, the way the waters of a river fall regularly from a dam. Depth will appear as a subtle but visible recession accompanying the objects. In vain will they stand on the same plane: between them, that positive distance and separation produced by the small dark slopes will insinuate themselves. They will distinguish themselves from one another, without needing to change their real face, solely by the sensible presence between the images of the intervals that separated them in nature. Space, in being embodied as shadows, will respect their discretion even in the picture.

And that procedure will have an advantage over perspective, in marking both the division and the connection between objects. Indeed, the planes that separate them will also form a transition between one and the next; they will both repel and go seeking the distant objects.

That back-and-forth movement, that receding and returning, in fashioning depressions and protrusions, will, in the end, give a certain volume to the picture as a whole, nearly independent of perspective. The whole spectacle, like the object, will take on a geometrical relief; it will display itself with its true solidity, which is entirely different from the dry and fictive depth of a stage set. We will no longer have before our eyes the fragile and artificial vision of an instant, but rather a dense image, full and firm like reality.

[†]Nothing is more hypocritical than perspective. On the one hand, it pretends to ignore the fact that the picture is a plane surface and, on the other, it imitates depth solely through a system of profiles, all established on the same plane, the picture plane to be precise. To represent depth with sincerity, the painter ought first to admit that he is working on a plane surface: that is what he will do in placing all the objects next to one another. Then, he will have to try to imitate depth with something that is more its nature than is a play of flat profiles.

You may ask what sort of emotion we can expect from such paintings. The reply must be: the only emotion a plastic work has ever had the right to give us, that of seeing beings perfectly captured, and without any violence having been done to them. What is the expression of a painted face, if not the fixing of its life, that is, the replacement, by a single image, of all the appearances it can assume? In requiring from the painter that his pictures completely encompass their objects, become their supreme masters, we have at the same time required that he give them their maximum expressiveness.

Part 2: The Cubists' Errors

From the principles we have just set out the justification for cubism quite naturally follows; but not, alas, the justification of those who have applied it up to now. We must now see to what extent the cubists have misunderstood cubism.

But, before attacking them, and to increase our regrets in advance, let us see how important the work is that they are carrying out so poorly; let us complete our understanding of what consolation that undertaking, at the precise moment of history in which we find ourselves, might bring to painting. Despite appearances, painting did not emerge from impressionism. Impressionism is any art that proposes to represent, rather than the things themselves, the sensation we have of them; rather than reality, the image by which we apprehend it; rather than the object, the intermediary that places us in relation to it. That intermediary, which certain ancient philosophers believed to be a subtle pellicle [membrane] emanating from real beings and drifting toward our eyes, is changing, floating, trembling like an overly thin veil subject to the most imperceptible air waves. That is why an impressionist painting gives such indecisiveness, such hesitant limits to forms: it does not copy them where they are, that is, in things, but in us, in the quivering *idol* that brings them to us.

Impressionism is an essentially subjective art, since, all things considered, its object is the subject, or rather, the way the subject perceives external things. That is what is most profoundly characteristic of it, not the procedure of dividing up tones. On the contrary, that procedure—so long as it was applied—in imposing a certain discipline on the painters and communicating similarities and relative uniformity to their works, only moderated impressionism. The true impressionist frenzy dates from

the moment that procedure was abandoned. Each artist then began to represent what was most personal, most private, most desperately lonely about his sensations. He insisted immoderately on their difference from all the others, which is to say, at the same time, on their difference from their object. And we witnessed the incredible explosion of hasty works, constructed solely to accentuate some extreme rarity of vision, some monstrosity of the eye, of which the one afflicted with it declared himself altogether proud. Did not the growing sadness we absorbed at exhibitions of paintings come from the exasperating personality of the canvases we saw there? Yes, the public was right to become indignant. What arrogance on all those walls! How firmly each one who exhibited there clung to his little discovery! With that cult of difference, art worked to make itself impossible! It was thanks to the cubists that a future was again offered to art, and a new health, and a very simple and joyous task: the representation of things themselves in their permanence, in their internal *acquiescence,* in their solidity. Undoubtedly Cézanne already undertook that task, and was the first to do so. It is in that respect that he towers over Gauguin and even van Gogh,‡ who were more artistic and more sensitive than he. But he was not yet followed; or, at least, only a part of his lesson, the most obvious and the least important, was understood, that which he professed to share with Gauguin and van Gogh. Under his influence, the painters renounced pure color and returned to tones, but they continued to paint with tones what they had painted with pure color: their sensations. The cubists would take up the most serious part of Cézanne's lesson; they would return to painting its true aim, which is to reproduce severely and respectfully objects as they are.

At least I would like to hope so.

But if I turn to look at their works, what courage I need to continue to entertain that hope! In the end, I must truly admit to myself that the cubists understand nothing of the principles they are charged with making prevail.

‡In the joy van Gogh gives us, is there not also a little dread? That is precisely because, with gifts and a passion that no impressionist has known, he, like the impressionists, continues to paint his vision rather than things. It is magnificent and more flamboyant than reality. But his canvases remain internal; they shine like an image blazing in the brain. The proof is that, in the end, van Gogh's vision became hallucinatory, taking the place of the external world within him: that was his madness.

I would like to point out methodically the errors and confusions where, in my view, they fall.

The Cubists' First Error

From the fact that the painter must always show enough faces of an object to suggest its volume, they conclude that he must show all its faces. From the fact that one must sometimes add, to the visible faces, a face that can be seen only by moving a little, they conclude that one must add all those that can be seen by moving around the object and by contemplating from above and below.

There is no need to establish at length the absurdity of such inferences. Let us note simply that the procedure, as it is understood by the cubists, culminates in a result that is the direct opposite of that for which it is done. If the painter sometimes shows more faces of an object than can be seen at once in reality, he does so to give its volume. But every volume is closed and implies that the planes return to themselves; volume consists in a certain relationship between all the faces and a center. By placing all the faces next to one another, the cubists give the object the appearance of an unfolded map and destroy its volume.

To tell the truth, that first error is so crude that it is not too disturbing: it seems as though the cubists cannot fail to perceive it in short order and to correct its effects. But there is a second, more serious one, because it is more subtle and more difficult to sort out.

The Cubists' Second Error

From the fact that lighting and perspective—which bring about the subordination, respectively, of the parts of the object and of the objects in the picture—must be abolished, they conclude that all subordination must be given up.

Let me explain that confusion in more detail: lighting, by concealing certain parts of the object from us and accentuating the others, mechanically establishes a hierarchy among them. In the same way, perspective, by diminishing and dismembering the distant objects and, conversely, by enlarging those in the foreground, establishes a hierarchy between them. But we have seen that perspective and lighting obtained that result only through arbitrary mutilations, and practiced cuts in things without rhyme or reason. The cubists rightly think that these sacrifices, which

destroy the plenitude of forms, must be avoided at all cost; as a result, they set aside perspective and lighting. Now herein lies their error: they understand the *abolition of perspective and lighting* as a synonym for the *renunciation of all sacrifice;* they hold these two ideas to be equivalent, interchangeable. Consequently, they condemn themselves to no longer dare cut anything from reality and, since there is no subordination without sacrifice, the elements of their pictures engage in anarchy and form the mad cacophony that we find so laughable.

But their assimilation of these two ideas is a confusion; it is illegitimate; logic prohibits it.[§] Because sacrifices other than those required by perspective and lighting are possible, subordinations other than the one they bring about are also possible. Nowhere have we claimed that the integrity of objects had to be respected in such an absolute and servile manner; we have simply said that it was necessary to replace the blind and mechanical sacrifices by intelligent sacrifices, that the artist had to substitute himself for the physical laws, put his discernment in the place of their stupidity, and carry out, in their stead, the indispensable eliminations. We have asked that, acquiring a long and faithful knowledge of each object, he rough out and trim it only by obeying its profound nature, the predispositions of its essence. Consequently, we have ceased to concede that he must introduce preferences and a hierarchy into his picture; we have only required that that hierarchy, instead of being established on the basis of the situation of objects in relation to a beholder, be founded on their intrinsic importance, on their value proper, on their degree of individual perfection. In addition, instead of an arbitrary subordination, like that of perspective, which, for example, may place a three-masted ship under the orders of a small rowboat, we ought to have a subordination which is that of the objects themselves in nature, which would make them depend on one another as a function of their merit. The cubists take modesty too far. Their refusal to intervene in any way is unacceptable; in the end, their respect for things makes them render the latter unrecognizable. It was not to deform or misshape them that they renounced per-

[§]Here is their reasoning in the form of a syllogism: 1. Lighting and perspective constitute subordination. 2. Lighting and perspective must be abolished. Therefore, all subordination must be abolished. And here is the sophism it contains: the major premise is a universal assertion. Now, everyone knows that, in a proposition of that sort, the attribute is taken only in part of its extension; in this case, *subordination* designates only a part of all the subordinations possible. It is therefore forbidden to take it in all its extension in the conclusion.

spective and lighting; but they reach the point of blurring and confusing them with one another, giving them an incoherent look, because they did not dare touch them.

We have only to point out one last error on the part of the cubists, which, though not the most serious, nevertheless contributes a great deal toward feeding the ridiculous appearance of their canvases.

The Cubists' Third and, Perhaps, Last Error

From the fact that one must express depth in truly plastic terms, that is, by presuming it has a consistency, they conclude that one must represent it with as much solidity as the objects themselves and by the same means.

To each object they add the distance that separates it from the neighboring objects in the form of planes as resistant as the object's own; they show it thus prolonged in all directions and armed with incomprehensible fins. The intervals between the forms, all the empty spaces in the picture, all the places occupied only by air, become filled by a system of walls and fortifications. These are new objects, entirely imaginary, that come to be placed between the first ones, as if to prop them up.

Here again, the procedure becomes pointless and automatically abolishes the effects it seeks to produce. The painter applies himself to expressing depth only to distinguish objects from one another by that means, only to mark their independence in the third dimension. But if he gives the same appearance to what separates them as he does to each of them, he ceases to represent their separation and tends on the contrary to confuse them, to weld them together in an inexplicable continuity.

In short, the cubists seem to be parodying themselves. They push to the point of absurdity all the principles they perceived and thereby destroy their import, take all meaning away from them. They abolish the volume of the object out of a wish to omit none of its elements. They abolish the respective integrity of the objects in the picture out of a wish to keep them intact. They abolish depth, which serves to distinguish them, out of a wish to represent them solidly.

We could sum up all their errors, in a slightly different manner, by saying that they have a remarkably poor understanding of the principle of addition. To represent objects as they are, we need to add to what

we see, to complete our perceptions. The cubists feel that need, but, understanding it only vaguely, they add everything they *know* is lacking from their perception, without making choices. An element of the things perceived need only be invisible and they immediately go seeking it and triumphantly set it up in apposition. But, precisely, because they add too many things, they can only place them next to one another, can only pile them up without combining them. They set up the equation, but they do not manage to come up with the sum. They place parts next to parts, objects next to objects, and next to the objects, depth; but they form no object and no spectacle. Since they have no gaps, no space between their materials, they do not find centers around which to assemble them; they are incapable of constituting units and , as a result, of giving a unity to their picture. Everything remains scattered. These supposed constructors know only how to accumulate; their work is not an edifice but a construction yard.

In the face of so many blunders, confusions, and absurdities, let us nevertheless avoid bearing any malice toward them, for they know not what they do. To be sure, we were right, at the beginning of this article, to consider them unconscious laborers employed in the advent of a new art. Do not all their errors have one thing in common, that they are a literal and not an intelligent use of certain principles? The cubists act like insects, with a perfect, indefatigable, and never discouraged logic, but without knowing toward what aim their gestures are moving. If their work is ugly, whereas that of insects is admirable, it is because man is not born to work under the influence of instinct. He has to know what he is doing in order to do it well. A work of art is beautiful only if the artist masters the principles that drive him adequately enough to stop applying them as soon as their application would make them deviate from their meaning. But the cubists continue to apply them indefinitely and blindly, like the crab that persists in covering his shell with algae, even when, transplanted into an aquarium, it no longer needs their cover to conceal itself from its enemies.

It is nonetheless better that it should be so than if we were to see them refine with understanding and perspicacity already worn-out and decadent procedures. Our hope must be measured by their ignorance; our confidence in the future must be encouraged by everything that remains for them to learn.

As a matter of fact, it is impossible not to discern already, among certain young arti sts, a more skillful and more penetrating comprehension of cubism. In this article, I took issue primarily with Picasso, Braque, and the group formed by Metzinger, Gleizes, Delaunay, Léger, Herbin, and Marcel Duchamp. Le Fauconnier, who has been part of that group until now, seems to be in the process of liberating himself. He will perhaps be a fine painter. But it is especially toward Derain and Dufy, on the one hand, and la Fresnaye, de Segonzac, and Fontenay on the other, that my greatest hopes are directed, ever since Picasso, who for a moment proved to be close to possessing genius, wandered off into occult pursuits, where it is impossible to follow him. Finally, I shall single out André Lhote, whose recent works, in my view, mark, with an admirable simplicity, the decisive advent of the new painting.

Jacques Rivière

REVUE D'EUROPE ET D'AMÉRIQUE

1 MARCH 1912

Commentary

In his response to Jules Granié's (pseud. of Aloës Duravel) defense of cubism in *Revue d'Europe et d'Amérique* (15 November 1911), the critic Jacques Rivière wrote a perceptive, if critical, response to cubism, informed in part by his own conservative values (see document 13). Rivière divided the article into two sections: the first, devoted to current tendencies in painting, justifies the avant-garde rejection of academic techniques of lighting and perspective construction in terms of a neo-Kantian distinction between things "as they appear" and an object's "essence," independent of our perceptual faculties (Crowther). In Rivière's opinion Paul Cézanne had initiated this avant-garde transformation by utilizing light and volumetric depth to capture an objects' essence in hieratically "ordered" canvases. In the second section Rivière asserts that these Cézannesque principles were a "justification for cubism" but not for the aesthetic of its erstwhile practitioners, "Picasso, Braque, and the group formed by Metzinger, Gleizes, Delaunay, Léger, [Auguste] Herbin, and Marcel Duchamp." While he commends this group for following Cézanne in rejecting impressionism, he admonishes them for retaining the impressionist emphasis on subjective "sensations" to the detriment of the object itself. As a result, these cubists had created a travesty of cubism's "true" principles

by destroying volume, doing away with pictorial hierarchy and order, and creating totally abstract (and meaningless) planes, with no coherent relation to the objects portrayed. These artists, therefore, are not in control of their medium: Rivière describes their painting as sheer "anarchy," a "mad cacophony" he deems "laughable" and "ugly." However, he sees hope for a "more penetrating comprehension of cubism" in the work of Le Fauconnier, André Derain, Raoul Dufy, Roger de la Fresnaye, de Segonzac, and Charles de Fontenay. Above all, it is André Lhote who marks "the decisive advent of the new painting."

David Cottington has argued that Rivière's aesthetic precepts expressed conservative values he had developed along with his neo-Catholic colleagues associated with *La Nouvelle Revue Française,* most notably the writer André Gide and the artist Maurice Denis (Cottington, "Cubism, Law and Order"; see document 13). The latter, along with Cézanne and Lhote, were the standard-bearers for a form of modernism that, in Rivière's opinion, had roots in Nicolas Poussin's classicism, and the work of Jacques-Louis David and Ingres (Cottington, "Cubism, Law and Order," 748). T. J. Clark in turn has reconsidered Rivière's article to take into account those aspects of Rivière's "principles" that could have some bearing on Pablo Picasso's praxis, manifest in the "materialism" of his paintings of 1909–10 (Clark, 204–6). Thus the intrinsic value of Jacques Rivière's text as an index of cubist intentions is still open to debate, as evidenced by Cottington's response to Clark's reading in his more recent analysis of the reactionary drift of Rivière's art criticism (Cottington, *Cubism and Its Histories,* 68–73).

Clark, *Farewell to an Idea*
Cottington, *Cubism and Its Histories*
Cottington, "Cubism, Law and Order"
Crowther, "Cubism, Kant, and Ideology"

Pierre Dumont, "Les arts: Les Indépendants," *Les Hommes du Jour* (part 1: 6 April 1912, n.p.; part 2: 13 April 1912, n.p.; part 3: 20 April 1912, n.p.)

The Arts: The Independents

Part 1

Despite the obvious ill will of the government, the Salon des Indépendants has once again opened its doors. There was some question of giving the Grand Palais to the Indépendants, but, unfortunately, the Grand Palais was not free: it had been promised to the fine arts (!) of aviation, pisciculture, the automobile, and cuisine, to the obviously industrial fine arts. But then, the courageous Indépendants are not official!

Here is an organization, whose only law is the principle of equality, a principle our democratic government claims to embrace, which is obliged to pitch its tent on the banks of the Seine, even though there is a palace dedicated by the Republic to the fine arts.

And yet, are not these seekers worthy of all our interest? Have they not proved themselves? Have not most of our young stars come out of that group? What salon would have exhibited van Gogh and Toulouse-Lautrec, to mention only those two glorious names? Why do they have no right to the Grand Palais, into which the other salons are freely admitted? Do they not have an even greater right to it than others, since they are younger, poorer, more passionate, since they represent French art in all its truth, still so full of errors, but also of promise, even though the other salons are willing to show us only a part, and always the same part, of art. We ought to have an obligation, in a state claiming to be liberal, to give a significant place to all innovators, equal at least in the ardor they have felt: desperate sometimes, but always rising up again, and often triumphant.

It would be a fine thing to encourage all efforts, whatever they might be, and particularly the boldest of them. I am not unaware of the danger of overproduction that that attentive liberalism might yield. In exchange for a certain number of unfortunate souls, spurred to be productive by vanity alone, and whose regrettable weakness is quickly recognized, one might then keep alive the fond hope and the perhaps impertinent satisfaction of not having smothered a pure genius in the dark. A single yes would have spared us the stupid nausea of going to look for it in the room reserved for aborted fetuses!

The public is finally beginning to grow weary of our debt to the sentimental imbecility of certain painters. And the profiteers of impressionism, the pasticheurs who popularize ad nauseam the latest pointillist recipes or whatever else, now attract little or no interest, to judge by the empty rooms to which they are relegated.

I will therefore speak at once of the painters who, in my opinion, are the very reason for this salon's existence, because they are attempting the boldest, the most necessary revivals we have had in the last thirty years of painting. At issue are MM. Jean Metzinger, Le Fauconnier, A. Gleizes, Fernand Léger, and Marcel Duchamp.

We are no longer dealing with painters preoccupied with rendering the external aspect, the fleeting side of nature, the "official report," as Zola said, but with artists who are trying to render the essential truth of what they wanted to represent. We cannot yet say that they are showing us definitive results, but we can easily anticipate that success is imminent. Perhaps they have sometimes gone astray as a result of overintellectualizing. But their errors—if errors they be—are respectable because they were committed in the passion of the task pursued amidst almost absolute indifference, if not hatred in some cases. And then, can painters be criticized for being overly intellectual?

At any rate, they have the right to our respect—I was going to say, to our admiration—because they had the courage to leave behind the superficial and facile side of sensibility and to construct with their means an admirable artistic architecture, while abandoning the old materials.

Part 2

[*Editor's Note: Obeying an old habit of long date, that of letting the contributors to* Hommes du Jour *express themselves freely, we will publish the*

series of articles in which our friend Pierre Dumont attempts a justifica-
tion of cubism. The arguments set forth by Pierre Dumont did not convince
us, but they compelled our attention.

He asks us to give credence to cubism and to not revive the protests that
welcomed impressionism and pointillism, movements that now prevail.
The argument is skillful. Let us therefore allow Pierre Dumont to proceed
with his defense; the future will set things right.]

I would not have anyone believe that I attempted an exclusive and exag-
gerated defense of cubism in this forum. And I am intent on explaining
myself on this point, since, in my view, to do criticism is, above all, to
discuss in good faith.

If we truly want to understand one another, we must assign an identi-
cal value to the same words. And we are, in point of fact, facing a new
form of art, whose results we do not know, but which demands a consci-
entious examination.

First and foremost in a work of art, I want to see the artist's personality,
setting aside for a moment what it owes to the schools of yesterday and to-
day in terms of skill or successful execution . . . For these reasons, I accord
no interest to the well-executed works whose objective is to flatter the naive
tastes of an often ignorant and lazy public, or one preoccupied with other
things. It seems to me that every artist must, in the end, add some new par-
ticularity to the already-established field and make us experience, through
some unfamiliar interpretation, the passion of his sensibility or his spe-
cial vision. Anyone who comes along and says nothing, who is content to
gather together the scattered features of beauty from the past, and to con-
struct from it a successful work, is only a loving pupil, a servant, who will
not sit at the masters' table. And I will feel a sincere gratitude toward him,
no doubt, but no admiration. Indeed, it must truly be said that the artist is
someone who does not abdicate his vision, and I would like him to walk
alone and free toward his unknown goal, propelled by the august and blind
force of his temperament, without getting mixed up in risky formulas.

And that is why cubism, which is finding a following in its turn, does
not satisfy me completely, in that it is already erecting itself into a tactic,
a system, and soon, for many, a conventional method. For many inferior
painters, it has too much of a tendency to become "cubism, or the last
resort." One must concede, however, that, in our own time, it is the last
stop on the uninterrupted journey, just as impressionism with Monet and

pointillism with Signac—once so decried, but whose contribution everyone is happy to praise today—were in their time.

═══════════

Mr. Jean Metzinger is the one who did the most for the new architecture of that art. I admit that, for a long time, I was disturbed by the too exclusively intellectual and "scientistic" experiments that marked his early works. But he now seems to have regained his self-control: his *Port* will elicit your admiration, despite the fact that our eyes are still unaccustomed to the new discoveries. His recently exhibited *La femme et le cheval* [*Woman and Horse*, Statens Museum for Kunst, Copenhagen] certainly did a better job of realizing his way of thinking. One cannot deny that Mr. Metzinger's drawing is highly developed, and, moreover, does not in any way depend on the subject of the picture itself. Let us regret the fact that he has momentarily (let us hope!) abandoned the force of color that he captured in *Goûter* [Philadelphia Museum of Art] at the Salon d'Automne. Certainly, his painstaking effort to definitively surround his composition with decorative accessories clearly shows his orientation toward pictures. And, although I do not absolutely applaud, I am obliged to recognize the presence of a powerful will.

Mr. Fernand Léger gives evidence of an expansive personality in his composition, but I find less creativity in it than in Mr. Metzinger's. He adds to that a great deal of delicacy in his colors, and a surprising, but at times somewhat facile, variety of measure. One senses that that artist experienced a real joy in painting his canvas, and that it is truly the proper expression of his will.

Le chasseur [*The Hunter* (1911–12), Gemeentemuseum, The Hague] is, of course, the most accomplished canvas that Mr. Le Fauconnier has shown us up to now; it seems to be a further development of *Abondance* [fig. 9], with, in addition, a force and a meticulous use of unaccustomed colors—which, however, do not seem sufficiently personal to me. In his drawing, he is inspired too much by Michelangelo; in his color, by Cézanne. The female figure, for example, is painted with a sureness and a grandeur that denote a master.

Mr. Albert Gleizes has made a considerable effort, abandoning rigorous *discipline* for a time and putting his all into a composition whose difficulty he has almost overcome, perhaps by returning to the quality of his earlier color scheme, but surely through the effort in the construc-

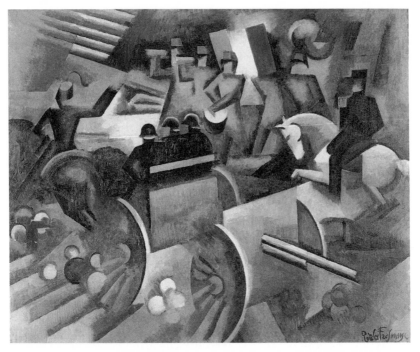

28. Roger de la Fresnaye, *L'Artillerie* (*Artillery*), 1911. Oil on canvas, 51¼ × 62¾" (130.2 × 159.4 cm). Metropolitan Museum of Art, New York, Gift of Florene M. Schoenborn. Used by permission of the Metropolitan Museum of Art, New York.

tion of his human figures and landscapes; only the clouds in the shape of a question mark sound a discordant note [*Les baigneuses* (*The Bathers*), Musée d'Art Moderne de la Ville de Paris].

Mr. Marcel Duchamp is exhibiting only one drawing. That is regrettable, since it does not allow us to appreciate sufficiently the rare qualities of that pure artist.

To find Mr. Robert Delaunay's large composition, I have to go all the way back to the next-to-last room [*La Ville de Paris* (*City of Paris*), Centre Georges Pompidou]. I am not very clear about the artist's intention in the piece, which brings together already familiar studies on a large surface; the whole thing is rather poorly balanced. There are a few excellent bits remaining, however: the left corner, for example.

But let us go back and enjoy the somewhat mannered artlessness of Miss Marie Laurencin [*Women with Fans*]. Her drawing, to be sure, is of an indisputable grace, which, unfortunately, the sometimes overly subtle color scheme does not adequately support.

Mr. Dunoyer de Segonzac, very calm this time, primarily shows us his qualities as a distinguished colorist, in a still life, *Vénus de plâtre* [*Plaster Venus*]; his drawings, as usual, have a refined elegance.

The very propitious evolution of Mr. Tobeen displays a very real sense of rhythm in *La pelote basque* [*Basque Pelota*]; but why this study in gaudy greens that accompanies his submission?

Mr. de La Fresnaye exhibits two canvases, one of which, *Les artilleurs* [*The Artillerymen;* fig. 28], charms us with the perfect balance (too perfect even) of the volumes and with the muted and delicate harmony of the colors; but what a grave error is his portrait, whose face could have been painted by one of Mr. Cormon's weaker students.

Mr. Lhote, who is haunted by the futurists, may be reining in his gifts too much.

Part 3

One of the felicitous peculiarities of the Salon des Indépendants is the fine diversity of the works exhibited. They are grouped intelligently and, in accordance with the rising curve, spaced harmoniously. It is an enormous advantage for our eyes and mind not to be obliged to engage in tiring gymnastics to move from one canvas to the next. The tendencies are grouped by room, and anyone willing to do a little searching has no trouble following a natural evolution, even though it seems abnormal to some people.

Mr. Francis Picabia, like the cubists, wishes to communicate a new artistic emotion to us while expressing himself with harmonies of colors and the search for orderly forms, a sensation closely associated in some sense to what we feel at a musical recital. For almost two years we have observed his research toward this goal; and, if he has not yet arrived at a complete realization, it is certain that, with the three canvases exhibited here, he has taken a big step in that direction [fig. 29]. He will achieve his ideal, I am sure of it, and in a very short time, because he knows where he is going; he possesses within himself the imperious force that pushes him to achieve his desire and allows him to fight, out of contempt, a veiled and mocking hostility.

Mr. Marchand, who seems obsessed with the "futurists," is perhaps reining in his gifts too much.

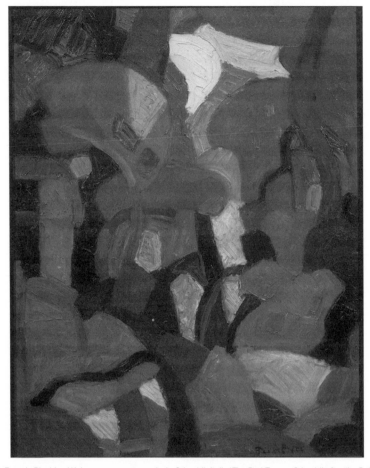

29. Francis Picabia, *L'Arbre rouge ou souvenir de Grimaldi, Italie* (*The Red Tree or Grimaldi after the Rain*), ca. 1912. Oil on canvas, 36¼ × 28¾" (92 × 73 cm). Illustration in Guillaume Apollinaire, *Les peintres cubistes: Méditations esthétiques* (Paris: Eugène Figuière, 1913) [document 62]. Musée national d'art moderne, Centre Georges Pompidou, Paris. © 2005 Artists Rights Society (ARS), New York / ADAGP, Paris. Photograph CNAC/MNAM/Dist. Réunion des Musées Nationaux / Art Resource, NY.

I understand less well Mr. Lhote's contribution, whose geometric lines do not always fall just right.

Mr. Albert Moreau remains very conventional. His *Repos* [*Rest*] is too inspired by the Julian academy, but one senses a strong will and a beautiful frankness in his nude.

Mr. de Vlaminck, a former "fauve," is still trying. His seascapes, with more sharply constructed lines, are gaining in clarity.

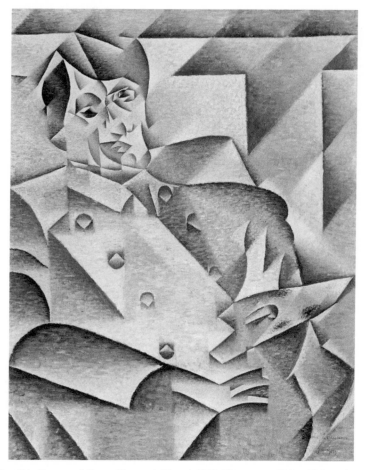

30. Juan Gris, *Hommage à Picasso* (*Homage to Picasso*), 1912. Oil on canvas, 93.3 × 74.3 cm. Art Institute of Chicago, Gift of Leigh B. Block, 1958.525. © Artists Rights Society (ARS), New York / ADAGP, Paris. Photography © The Art Institute of Chicago. Used by permission of The Art Institute of Chicago.

I could not conclude this list—incomplete to be sure—of those who are bringing a fresh note to this salon, without adding the names of MM. Juan Gris, who seems to have a clearly defined goal [fig. 30], as well as Kanchalowsky [*sic*], Kandinsky, Lotiron, and Miss Alix Peer-Kroog.

We must pay tribute to the valiant fighters of yesterday, Paul Signac and Maximilian Luce. Even though they offer us nothing very unexpected today, they no longer need to defend themselves, so to speak, and could, to be sure, exhibit elsewhere, but they stand fast at their posts to

the end, so that the ship they have been steering up till now does not go off course and remains within the securest shelter of free art.

We are sorry not to see, not far from them, Matisse, van Dongen, Girieud, Othon Friesz, Vuillard, Bonnard, and Vallotton.

Come along, austere critics and ironic young people, stop blaspheming. Tomorrow you'll be receiving lessons from those you laugh at today. Your reluctance stems from your lack of clear-sightedness. These forms, which you find shocking, were made by bold men, the valiant sowers of an art you find disconcerting, just as the innovators from the past, whom you nevertheless accept, disconcerted their contemporaries. They rise slowly but surely, the first ones on the adventurous road leading them toward the unknown.

Before spitefully condemning them, remember that only mediocrity produces an immediate effect on the mediocre. And patiently give credit to the hardworking young people, who justify all hopes inasmuch as they hold the future.

Like every year, the first rooms are not of the slightest interest. It is only in Room 16 that we will pause in front of the canvases of Mr. M.-L. Verdejorak. That artist, both violent and sentimental, will undoubtedly soon gain complete mastery of his gifts and will provide us with works of art.

Lucien Laforge is, to be sure, a better draftsman than a painter.

Tribout uses too much pink.

In Room 18, let us mention the vigorous decorations by Miss Rice; *Lecture,* by Mr. Verttoeven; Mr. Guilmont, a follower of Rousseau; the two frescoes by Mr. Dubouchet; Mr. Serton, who pays tribute to Cézanne; and Miss Suzanne Valadon.

In Room 19, we do not very much like Miss Alix's cathedral, which was inspired by Chabaud, Othon Friesz, and Delaunay; or Hatvany, who vulgarizes Vallotton; or Louis Audibert.

In Rooms 21 to 26, Mr. Henri Hayden is fairly personal in *L'Âge d'or* [*The Golden Age*]. Mr. Pirola. Mr. Chabaud's *Les trois grâces* adds nothing to his obvious talent.

The other compositions by Mr. Hayden are too reminiscent of those by Othon Friesz.

In Room 28, Mr. Féron, a sincere and committed artist, but who is evolving slowly. Mr. Person, a poor imitator of Signac.

In Room 31, Y. Da Silvo Bruhus plagiarizes Ribemont-Dessaigne.

In Room 33, a portrait by Van Hassett, which is inspired by both Vallotton and Manet. A snow scene by René Juste.

In Room 37, Germaine Magnus pays tribute to the talent of Mrs. Hassenberg; Mr. Facke to Mathis; Mr. A.-M. Le Petit to Lebourg. Mr. Picard Le Doux exhibits a portrait of a little girl that is strangely reminiscent of Mare's *Fillette aux violettes* [*Young Girl with Violets*] exhibited at the Salon d'Automne two years ago.

In Room 38, Mr. G. Ribemont-Dessaigne is still excessively decorative.

In Room 39, Mr. Zac exhibits a painting that marks a felicitous evolution; but how impersonal and disagreeable his drawings are! Mr. Tristan Klingsor miscorrects Cézanne.

In Room 40, let us admire the art of MM. Manguin, Puy, Laprade, Charles Guérin, Lebasque, Marquet, Charmy, A. Challié, who seem to have nothing more to teach us.

In Rooms 41 and 42, the art of Mr. Tarkoffa has increased in force. Let us mention as well MM. Asselin and A. Bacqué, who are still trying to find themselves, and the young Butler, already too erudite.

In Rooms 43 and 44, Mr. Blanchet, one of the best decorators of our time. Mr. Ottmann, a voluptuous artist, is in love with color and form; he exhibits two canvases that do honor to his talent. And, in conclusion, let us mention Mrs. Agutte, and let us regret the fact that Mr. Francis Jourdain exhibited only one canvas, fairly well developed but of little importance.

Pierre Dumont

6 APRIL, 13 APRIL, AND 20 APRIL 1912

Commentary

The artist Pierre Dumont's (fig. 31) defense of cubism, cast in terms of a revue of the 1912 Salon des Indépendants, gives us insight into the means by which cubism's allies hoped to win support among those positioned on the extreme left (on Dumont, see our commentary for document 7). Dumont—who founded the cubist-oriented Société normande—published his apologia in the leftist journal *Les Hommes du Jour* (1908–23), edited by the self-described antimilitarist and anarchist sympathizer Victor Méric (pseudonym Flax) (see the biographical sketch "Victor Méric" in *Les Hommes du Jour*, 3 October 1908; and references to Méric and this venue in Maitron). David Cottington describes *Les Hommes du Jour* as "radical

31. Pierre Dumont. Undated photograph.

socialist" (Cottington, 83), but the journal should more properly be called dissident leftist, since its editor lent support to individuals and causes that encompassed the political spectrum from socialism to anarchism. As Cottington and Weiss note, the journal's art critics Henri Guilbeaux and J. C. Holl were unsympathetic toward cubism (see documents 14, 15, and 25), a position underscored by the editorial disclaimer accompanying Dumont's article (Cottington, 146–47; Weiss, 87, 92). Dumont defends the cubists by asserting that the perceived radicalism of their art would win broad approbation with time, just as impressionism and neoimpressionism had done previously. Responding to the widespread claim that the cubists were "mystificateurs" (see Weiss's discussion, 91–105), Dumont asserts that they are in fact sincere innovators, although he acknowledges that cubism had recently fallen prey to "pasticheurs" who converted the aesthetic to a "conventional method." Just as importantly Dumont casts the cubists as practitioners of the very freedom of expression that Paul Signac and his fellow neoimpressionists had sought to protect by founding the jury-free Salon des Indépendants in 1884 (Distel, 37–50; Herbert, 54, 128–29; see document 36). Dumont's plaintive protest against the "ill will of the government," which forced the salon's organizers to set up

shop at the Baraquement du quai d'Orsay, Pont de l'Alma (March 20–May 16) (Galitz, 312), alludes to the Independents' status as unsanctioned by the state, and thus unable to secure entrance into public buildings made available to the Salon d'Automne (founded 1903). Thus Dumont praises the Salon des Indépendants as "the securest shelter of free art" where "the principle of equality, a principle our democratic government claims to embrace," would continue to be upheld, despite "the danger of overproduction that that attentive liberalism might yield." In the coming months cubism would be the lightning rod for a broader debate over issues of freedom of expression, as witnessed by protests in the Chamber of Deputies over the admission of the cubists into the Grand Palais under the auspices of the 1912 Salon d'Automne (see documents 45, 49, and 55).

Dumont's expression of regret over Marcel Duchamp's meager entry of a single drawing alludes to another rift, this one internal to the cubist movement itself. Duchamp had originally intended to exhibit his *Nude Descending a Staircase, No. 2*, but withdrew it when Gleizes—who chaired the hanging committee—expressed a worry that this painting was "too futurist," and campaigned against its inclusion despite the official policy of the jury-free Independents. That summer Duchamp traveled to Munich, where he studied the writings of the German philosopher Max Stirner (A. Antliff); the following fall he produced a series of controversial works, culminating in his first "readymades" (1914) and *The Bride Stripped Bare By Her Bachelors, Even (The Large Glass)* (1915–23). As Linda Henderson has demonstrated, these works were premised, in part, on a satirical refutation of the Bergsonian precepts of Gleizes and Metzinger, codified in *Du "Cubisme"* (1912) (document 57) (Henderson). The inclusion of Duchamp's *Nude* in the Cubist Exhibition at the Galerie J. Dalmau in Barcelona in April 1912 may have been an attempt to placate him after the disappointment of the Independents (see document 40).

A. Antliff, *Anarchist Modernism*
Cottington, *Cubism in the Shadow of War*
Distel, "Portrait of Paul Signac"
Galitz, "Chronology"
Henderson, *Duchamp in Context*
Herbert, *Neo-Impressionism*
Maitron, *Le mouvement anarchiste en France*
"Victor Méric," *Les Hommes du Jour*, 3 October 1908
Weiss, *The Popular Culture of Modern Art*

Jacques de Gachons, "La Peinture d'après-demain (?),"
Je Sais Tout! (15 April 1912)

Painting of the Future?

Recently, Paris has seen several pictorial manifestations—futurists, cubists, Picassoists—and *Je Sàis Tout* could not fail to take an interest in them [fig. 32].

"Sir," I said, entering an art dealer's sober little shop close to La Madeleine. "Sir, I have been told that the best 'cubists' show their works here with you."

The young dealer drew himself up to his full height and raised his eyebrows, as he blinked his eyes rapidly in succession. I had offended him. I had probably gotten the wrong door. And yet, on the walls were canvases that cried out to me in their hieroglyphic language that I ought to be insistent.

"Sir," the owner finally replied, "I know there are 'cubists,' or rather, people who like to be called that for the sake of publicity. My painters are not cubists."

"Oh! . . . Nevertheless . . . I find them extraordinary enough to notify our readers about them . . . I have been asked to do so for *Je Sais Tout . . .*"

"For *Je Sais Tout*! Well then, Sir, don't go on, I beg you. I prefer that your magazine not speak of my painters. I don't want anyone to try to ridicule them. My painters, who are also my friends, are sincere, dedicated seekers—artists, in a word. They are not acrobats who spend their time stirring up the crowd."

"But you are wrong, I assure you. We have no intention of making fun of these gentlemen. Any conviction is worthy of respect. We wish to show what has become of the people who were booed and hissed in the past, the Gauguins, the Signacs, the Cézannes, the van Goghs, perhaps going back as far as Manet, who was rejected by the salon and is now in

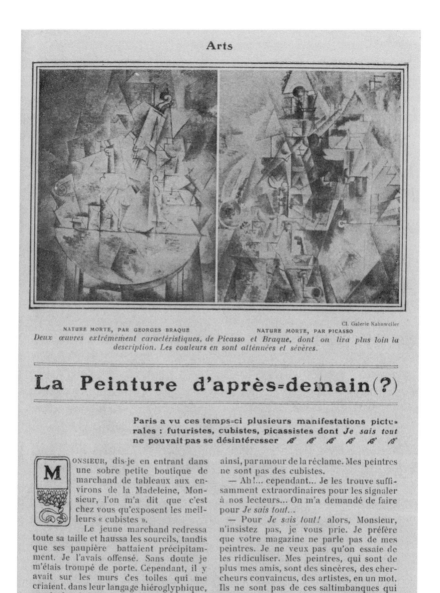

Cl. Galerie Kahnweiler

NATURE MORTE, PAR GEORGES BRAQUE NATURE MORTE, PAR PICASSO

Deux œuvres extrêmement caractéristiques, de Picasso et Braque, dont on lira plus loin la description. Les couleurs en sont atténuées et sévères.

La Peinture d'après=demain (?)

Paris a vu ces temps=ci plusieurs manifestations pictu=rales : futuristes, cubistes, picassistes dont *Je sais tout* ne pouvait pas se désintéresser *𝄞 𝄞 𝄞 𝄞 𝄞 𝄞*

MONSIEUR, dis-je en entrant dans une sobre petite boutique de marchand de tableaux aux en-virons de la Madeleine, Mon-sieur, l'on m'a dit que c'est chez vous qu'exposent les meil-leurs « cubistes ».

Le jeune marchand redressa toute sa taille et haussa les sourcils, tandis que ses paupière battaient précipitam-ment. Je l'avais offensé. Sans doute je m'étais trompé de porte. Cependant, il y avait sur les murs ces toiles qui me criaient, dans leur langage hiéroglyphique, que je devais insister.

— Monsieur, me répondit enfin le maitre du logis, je sais qu'il existe des « cubistes » ou plutôt des gens qui se font nommer

ainsi, par amour de la réclame. Mes peintres ne sont pas des cubistes.

— Ah!... cependant... Je les trouve suffi-samment extraordinaires pour les signaler à nos lecteurs... On m'a demandé de faire pour *Je sais tout...*

— Pour *Je sais tout!* alors, Monsieur, n'insistez pas, je vous prie. Je préfère que votre magazine ne parle pas de mes peintres. Je ne veux pas qu'on essaie de les ridiculiser. Mes peintres, qui sont de plus mes amis, sont des sincères, des cher-cheurs convaincus, des artistes, en un mot. Ils ne sont pas de ces saltimbanques qui passent leur temps à ameuter la foule...

— Mais, vous vous trompez, je vous assure. Nous n'avons pas du tout l'inten-tion de nous moquer de ces messieurs.

32. Illustration in Jacques de Gachons, "Painting of the Future?," *Je Sais Tout!* (15 April 1912), 1, with Georges Braque, *Nature morte* (*Pedestal Table*), Céret, autumn 1911; and Pablo Picasso, *Nature morte* (*Clarinet*), Céret, August 1911 [document 39]. Used by permission of the General Research Division, The New York Public Library, Astor, Lenox and Tilden Foundations.

the Louvre. Then we will tell our readership, which likes to be informed about everything: 'And now, here is the extreme avant-garde of today.'"

The irascible young dealer had returned to his normal size, his eyebrows had lowered, and his eyes were smiling.

"Under those conditions, Sir, I can procure all the documents you may need . . . Here is the album of Picassos, there is the work of Georges Braque, here are the Vlamincks, the Turels [Derains]."

The photographs of these painters' canvases, arranged chronologically, truly marked an effort worthy of attention. The first Picassos, for example, look quite a bit like a Maurice Denis or a Gauguin. Then, the subjects become more conspicuous, the lines break, the angles become sharper, the bodies take on unexpected reliefs. Finally, in 1911–12, the painter seems to have achieved mastery over his style. The uninitiated person of goodwill is a bit like the turkey in the fable, he sees something, all right, but he cannot make it out very well.

The kind young dealer comes to my aid: "Oh! I know that deciphering the recent Picassos and Braques is rather difficult. For myself, I am an initiate. I witnessed the birth of those pictures. I know everything the artist wanted to put into them. So this, Sir, this represents 'the poet.'"

"Oh!" (Simple courtesy demanded that I not elaborate further on my extreme astonishment. I had thought I was looking at a landscape and it was a poet!)

"Yes, he is seated. That's his forehead. That's his left arm . . . his leg."

"And this line that falls obliquely?"

"It corresponds to nothing real, but observe how significant it is. It immediately struck you . . . His hands."

"Where are the poet's hands, please?"

"Here's one."

"It's very odd."

"Don't you think so?"

"And this?" I said, turning a page of the album.

"A still life. It's one of Picasso's most perfect inventions. There's a violin, a fan, glasses, a manuscript from which pages are slipping out, a pipe."

The eloquent young man's conviction was touching: I felt he truly saw everything he designated with a slight gesture, somewhat resembling a great fashion designer's flick of the finger or a rose grower's caress in the direction of their creations.

Therefore, let us not make fun, for fear of upsetting that gracious young dealer.

I am sorry I did not run into the painters themselves. Nevertheless, I wanted to know something about them.

"Mr. Picasso is a Spaniard no doubt."

"Yes, Sir, he was born in Málaga."

"He is young."

"About thirty."

"What about Georges Braque?"

"Thirty years old."

"A Frenchman?"

"Yes, he was born in Argenteuil."

"What about Maurice de Vlaminck? A Belgian probably?"

"He was born in Rueil. And Turel [Derain] was born in Châtou."

"All over the outskirts of Paris, then! It's very peculiar. Do they know one another?"

"They hardly leave each other's sight."

"I thank you, Sir, for your obligingness. I'll show photographs of a few works characteristic of these gentlemen and let the public judge. I do not guarantee that I will compose a dithyramb in their honor. I admit I prefer Chardin, Latour, and even Mr. Ingres, but I promise I will not be unfair."

I hope I have kept my promise.

Jacques de Gachons
JE SAIS TOUT! 15 APRIL 1912

Commentary

In this important document we have a record of Daniel-Henry Kahnweiler's strategy for distancing his stable of artists from those cubists then on display at the 1912 Salon des Indépendants. The public controversy concerning the so-called salon cubists led the journalist Jacques de Gachons to seek out Kahnweiler's gallery, since he had been told that "the best 'cubists'" exhibited there. De Gachons gave his readers a visual record of his findings by including two illustrations in his article: Georges Braque's *Pedestal Table* (autumn 1911) and Pablo Picasso's *Clarinet* (August 1911; fig. 32). By the end of 1912 Kahnweiler had in fact signed exclusive contracts with Braque and Picasso (Monod-Fontaine in Bozo, 133), but even before this date he monitored the exhibiting practices of both artists, whom he

actively discouraged from exhibiting in the Paris-based public salons (Gee). By contrast Robert Delaunay, Albert Gleizes, Juan Gris, Henri Le Fauconnier, Fernand Léger, André Lhote, and Jean Metzinger enjoyed no such arrangement; they nurtured their careers by exhibiting at the public salons, and in group shows at commercial galleries (Gris and Léger signed exclusive contracts with Kahnweiler in 1913; Monod-Fontaine in Bozo, 113 and 119). Fully aware that many among the broad public and press viewed "salon" cubism as little more than a publicity stunt, Kahnweiler staved off such criticism for the artists he represented by downplaying the commercial aspect of his dealership. Thus the Galerie Kahnweiler was situated in a small shop on the rue Vignon, away from the high-profile galleries located on the rue Lafitte and rue Le Pelletier. Rather than mount well-publicized and carefully orchestrated exhibitions, after 1908 he merely exhibited works as he acquired them (Kahnweiler, 40–41); moreover the paintings themselves were displayed on plain sackcloth walls in a room devoid of furnishing, in marked contrast to the opulence that typified commercial gallery interiors in that era (Troy, "Domesticity, Decoration, and Consumer Culture"; Troy, *Couture Culture*, 57–67). This austere setting, combined with Braque's and Picasso's retreat from the public salons, allowed Kahnweiler to claim higher, noncommercial motives for the artists he represented, as distinct from the publicity seekers at the public salons (Gee; Troy, *Couture Culture*, 63–67). Thus Kahnweiler, while acknowledging to de Gachons that "there are 'cubists,' or rather, people who like to be called that for the sake of publicity," quickly adds that "my painters are not cubists," noting that his artists are "sincere" and not "acrobats who spend their time stirring up the crowd." However, while Kahnweiler actively discouraged Picasso and Braque from exhibiting at the Parisian salons, he was eager to publicize their art abroad: for instance in 1912 and 1913, he shipped their work to exhibitions held in every major city in Europe (Gordon, cited in Troy, *Couture Culture*, 59). As a result, in 1912 the public in Amsterdam, Moscow, Berlin, and London could see paintings by Braque and Picasso hung alongside works by "salon cubists" Delaunay, Lhote, Gleizes, Le Fauconnier, and Metzinger (Morin; Gruetzner-Robins, 64–77). By shoring up the elite status of his artists at home and maximizing their exposure abroad, Kahnweiler was able to identify Picasso and Braque (and later, Gris and Léger) as superior to their salon counterparts, all the while taking full advantage of the public attention the latter had won for cubism in the press (Troy, *Couture Culture*, 63). In his wartime

publication *Der Weg zum Kubismus (The Way of Cubism)*, Kahnweiler repudiated Picasso's interest in the work or theories of the salon cubists (Kahnweiler, *Der Weg zum Kubismus;* M. Antliff and Leighten, 203–5). Despite this claim, we have direct evidence of Picasso's engagement with their writings; in a letter of June 12, 1912, Picasso requested of Kahnweiler himself: "And do tell me if the book on painting by Metzinger and Gleizes has come out yet" (Cousins, 394–95). Picasso doubtless anticipated that the authors of *Du "Cubisme"* (document 57) would celebrate his work as emblematic of the art resulting from their dynamic new theories; Metzinger had written in 1910: "Cézanne showed us forms living in the reality of light; Picasso gives us a material report of their real life in the mind. He establishes a free, mobile perspective, in such a way that the shrewd mathematician Maurice Princet has deduced a whole geometry from it" (document 11).

M. Antliff and Leighten, *Cubism and Culture*
Bozo et al., *Daniel-Henry Kahnweiler*
Cousins, "Documentary Chronology"
Gee, *Dealers, Critics and Collectors of Modern Painting*
Gruetzner-Robins, *Modern Art in Britain, 1910–14*
Kahnweiler, with Francis Crémieux, *My Galleries and Painters*
Kahnweiler, *Der Weg zum Kubismus*
Morin, *Analyse raisonnée des catalogues d'exposition des peintres cubistes (1907–1914)*
Troy, *Couture Culture*
Troy, "Domesticity, Decoration, and Consumer Culture"

Jacques Nayral [pseud. of Jacques Huot], "Préface,"
Exposició d'art cubista, Galeries J. Dalmau, Barcelona,
20 April–10 May 1912, pp. 1–7

Preface, Exhibition of Cubist Art

Preface

To properly praise the work of art, we would need a loftier and more passionate tone than that of ordinary, dryly analytical prose. Only a great poet, in possession of the word and of magnificent rhythms, ought to be allowed to celebrate the sacred object, to express the emotion it suggests, to glorify the images the artist invented and the new relations he discovered, to piously pull away the succession of veils that envelop the multiple and living enigma that is a picture.

Enigma is the word I use, and it will not seem too strong to all who—and there are many today—admit that the artist must no longer cling to servile imitations, that artistic joy is not produced by the observance of an exact reproduction of appearances, but that it is born of the interaction of our sensibility and our intelligence, that the deeper the artist leads us into the unknown, the more talent he has. A multiple enigma, which does not reveal itself in its integrity and in a single stroke, but gradually and step by step—just as we read a book page by page. The better the work of art, the more time it will take us to understand it fully, and the more often we will have the joy of discovering new reasons to admire it. The absolutely perfect work of art—if such a thing is imaginable—would be the one that could never be completely possessed by us, since it would contain the infinite, for which we desperately yearn without ever being able to embrace it.

Take a portrait in a landscape. Is it simply the reproduction of the few lines that allow our eye to recognize a head, clothing, trees? For that,

photography would suffice. The work of the painter is to situate a physiognomy, a human thought, within the harmony of the surroundings, reconcile it with the environment, reveal the concert of all forms of life—man's thoughts, the perfume of that flower, the brilliance of that plant, the vibration of that light.

Why do those boats about to leave the harbor have such enormous sails, which seem to multiply ad infinitum? Why do they seem to huddle together? Because it is not only the wind filling their sails but also enthusiasm and faith and the spirit of adventure; they caress one another, embrace one another, because they are brothers, they rush off together toward a common danger, they share the same hope mixed with fear; they hesitate, and the lapping of the waves is troubling, and the water is full of mystery, because the future is evoked, full of mystery and worry, because the soul of the boats is joined to the shore by a thousand signs, by a thousand acts of tenderness.

And don't go looking for a narrow-minded critic to judge the work of art; above all, don't be surprised if your neighbor finds something different in it than you do. You may discover tomorrow what he has discovered today, whereas he will grasp the relations you have just grasped, will take in the images you have just taken in. A good picture, a beautiful sculpture, holds within itself many thousands of reasons to be admired. It is the task of talent to elicit the greatest number of correspondences possible in the minds of the most diverse people. The man of genius is someone whose powers of harmony are such that he makes the souls of all men, from the most unpolished to the most cultivated, vibrate in unison with science.

In addition, is not the conception of the work of art as something that continues endlessly to be discovered not infinitely more noble than that of a work of art as something immediately intelligible? In the latter, there is never any new joy to be hoped for. The former, which reveals itself gradually, constantly holds in reserve reasons for my sensibility and intelligence to exert itself and find satisfaction. Through these faculties, I gradually get to the bottom of things, and the things are imbued with my sensibility and intelligence; my field of knowledge is broadened, and that is why I bless the artists who, peering into "profound reality," wrest from it the secret of unknown truths.

I would be contradicting myself if I now tried to define and categorize the talents of the artists whom I have assumed the glorious but per-

ilous mission of introducing. The lines that follow should therefore be seen only as the expression, very inadequate moreover, of my particular sensibility, and, above all, should not be viewed as making judgments of the type formulated, with such ridiculous dogmatism, by critics who are behind the times.

Metzinger puts an inflexible logic and a marvelous willfulness in the service of an extremely penetrating and subtle intelligence. Struck by the false idea we have of *form* and the incomplete interpretation given of it until now, he struggles to realize the "total image"; he achieves it by drawing the greatest number possible of planes of the object to be represented. Gifted with a rare sensibility and a lucidity that allows him constantly to discover new relations and new cause for emotion, preoccupied with giving, in a felicitous formulation, "a plastic consciousness to our instinct," he adds to purely objective truth a more profound, more real truth, the truth that only the intelligence grasps. His qualities as a delicate colorist, his clarity, his precision, communicate a charm to his canvases that is at once original and traditional; a picture by Metzinger is an admirably composed book, but so complete and diverse that we believe we can always find another page that has not been read.

Albert Gleizes, a painter in the strongest and most admirable sense of the word, brings about an absolute fusion of the intelligence and of the sense of concrete matter. He is a logician as well, and his logic is spontaneous, full of candor and freshness. Consider this landscape of Ile-de-France [*Landscape at Meudon*]: it joins grandeur and lightness, finesse and force. Even in its haughty discipline, its technique remains free and easy. The balance of the groups of trees, the fluidity of the air and water, the solidity of the initial planes link that work to the great tradition of Claude Gellée and Corot. The portrait of the author of the present lines [fig. 33], a sketch of which is seen here, attests to a profound sense of expression that has nothing in common with facile characterizations. In other words, it is both a portrait and a painting, with the likeness and the pictorial qualities in perfect balance: that is *style*.

Marie Laurencin has all the sweetness, all the fragile emotionalism of the female soul. How easily one discerns the soul of a girl from "la douce France" in that art so full of charm and grace! Marie Laurencin, though not rejecting on principle the tendency toward decoration, knows how to reconcile the harmonious suppleness of lines with the more plastic requirements of volumes and densities. And I like her human figures,

33. Albert Gleizes, *Portrait de Jacques Nayral* (*Portrait of Jacques Nayral*), 1911. Oil on canvas, 180 ×
130 cm. Illustration in Nayral's preface, Galerie Dalmau, Exposició d'art cubista, Barcelona, 20 April–10
May 1912 [document 40]. Tate Gallery, London. © Artists Rights Society (ARS), New York / ADAGP, Paris.
© Tate, London. Used by permission of Tate Gallery.

sometimes vague in their intention, for their very ambiguity: bodies of nude women, of whom one cannot say whether they are more chaste or more passionately desirable.

In Juan Gris, the keen sense of form, the strident color, reveal an excessive intelligence, which, however, does not exclude the most delicate sensibility. It appears above all in his very new understanding of light, which Juan Gris makes the principle of everything. That light, so original, with a true personality, is one of the most unusual appeals of that curious and penetrating painter.

In Marcel Duchamp, the mathematical mind seems to dominate. Some of his pictures are pure schemata, as if he were working toward demonstrations and syntheses. Marcel Duchamp is, in fact, distinguished for his extreme, speculative audacity. He endeavors to configure a dual dynamism, both subjective and objective: hence *Nu descendant un escalier* [*Nude Descending a Staircase;* Philadelphia Museum of Art]. That abstract side is muted, however, under the influence of an entirely Verlainean delicacy, as it appears in *Sonate* [Philadelphia Museum of Art; fig. 34].

The sculptor Agero realizes "cubist" works of great beauty in marble and wood [fig. 35]. His art, extremely supple and profound, adapts admirably to the demands of a strict technique. The genius of his race bursts forth in the perfection of the figures exhibited here. Rhythm, voluptuousness, and sensibility are contrasted and counterbalanced by will, discipline, and intelligence.

There, hastily and somewhat poorly explained, are a few of the reasons that lead me to like the artists of whom I have just spoken. I say a few of the reasons, since there are others, of course, but so subtle and so personal, no doubt, that I have not yet been able to get at them, and would not know how to formulate them within the banality of common words and the stammering of an inadequate prose. It is in lyric poetry, as I said at the beginning, that one would have to express those profound feelings. No, not even that: in exchange for a supreme and marvelously selfish joy, it would be better not to try to analyze that divine sensation of mystery, that communion with the great unknown, which the contemplation of pure beauty elicits in the depths of our souls.

Jacques Nayral [pseud. of Jacques Huot]

20 APRIL–10 MAY 1912

34. Marcel Duchamp, *Sonata*, 1911. Oil on canvas, 145 × 113 cm. Illustration in Jacques Nayral, preface, Galerie Dalmau, Exposició d'art cubista, Barcelona, 20 April–10 May 1912 [document 40]. Philadelphia Museum of Art, The Louise and Walter Arensberg Collection, 1950. © Artists Rights Society (ARS), New York / ADAGP, Paris / Succession Marcel Duchamp. Used by permission of the Philadelphia Museum of Art.

35. August Agero, *Jeune fille à la rose* (*Young Girl with a Rose*), ca. 1912. Wood; dimensions unknown. Illustration in Jacques Nayral, preface, Galerie Dalmau, Exposició d'art cubista, Barcelona, 20 April–10 May 1912 [document 40]. Location unknown.

Commentary

Jacques Nayral's importance in the history of cubism stems primarily from his role as editor, but on this occasion, he took on the task of critic to write a preface for the first self-declared group exhibition of cubist painters, held at the Galeries J. Dalmau in Barcelona (20 April–10 May 1912). Jacques Nayral (1879–1914), pseudonym for Jacques Huot, was a poet and novelist who married Gleizes's sister, and whose untimely death was commemorated by the artist in a somber wartime portrait dated to 1917 (Varichon, 204). In 1911, Nayral was to have joined Alexandre Mercereau and cubists Gleizes, Le Fauconnier, and Metzinger in founding a journal devoted to the plastic arts (*Paris-Journal*, 17–30 October 1911; cited in Golding, 12). By 1912, Nayral had published two novels, one vaudeville play, and two books of poetry; in addition he was a founding member, along with Mercereau and the publisher Eugène Figuière, of the Société internationale de recherches psychiques (Mercereau, 65 and 276–78; Henderson, 7–9 and 240n52). In his role as Figuière's editor-in-chief, Nayral launched a series entitled Tous les arts, which published two seminal books on cubism:

Gleizes and Metzinger's *Du "Cubisme"* (1912) and Guillaume Apollinaire's *Les peintres cubistes: Méditations esthétiques* (1913) (see documents 57 and 62). A year previously Gleizes had exhibited an important portrait of the writer at the 1911 Salon d'Automne (Varichon, 132–33; fig. 33). The work proved so successful that Gleizes exhibited another smaller portrait of Nayral at the Société normande exhibition of 20 November–16 December 1911 (see document 30), and at the Galeries Dalmau exhibition in April– May 1912 (Varichon, 132). Critics also acknowledged Nayral's status as an insider, as evidenced by critic Olivier Hourcade's inclusion of Nayral in his February–March 1912 "survey" on cubism (see document 36).

Robert Lubar, building on the scholarship of Jaume Vallcorba Plana, has given us a concise history of the exhibition (Lubar, 309–21). Josep Dalmau, who was in Paris from 23 March to 11 April 1912 to organize the show, had originally wanted the poet Max Jacob to write the catalog preface; given Jacob's close relations with Picasso, it is likely that Braque and Picasso were also slated to exhibit (ibid., 310). The absence of both of these artists from the exhibition and the inclusion of all the major salon cubists probably accounts for the decision to commission Nayral, rather than Jacob, to write the preface. The exhibition itself comprised fifty-two drawings, paintings, and sculptures by August Agero, Marcel Duchamp, Gleizes, Gris, Marie Laurencin, Le Fauconnier, Léger, and Metzinger (ibid., 309–10). The inclusion of the now obscure Agero among the exhibitors stemmed from his close ties to Picasso (he had a studio at the Bateau Lavoir), his Catalan origins, and his cubist aesthetic, which combined the influence of African sculpture with cubist angularity (Debray and Lucbert, 123–25).

In his evaluation of the Dalmau exhibition, Lubar argues that the art criticism of polemicist Eugeni d'Ors—who interpreted the exhibition in light of his own anti-Bergsonian, Cartesian concept of classicism—bears an essential "affinity" to the artistic intentions of the salon cubists, as evidenced by references to classicism, Latin culture, and anti-impressionism in the writings of Roger Allard, Gleizes, and Metzinger (Lubar, 311–19; this thesis is reiterated by Rousseau, 160–79; see documents 11, 12, 18, 19, and 21 and their commentaries). However, methodological reliance on the concept of "affinity" has itself come under criticism (Clifford, 191–96), and d'Ors' hostility to Bergson, combined with his Cartesian definition of classicism, is hard to reconcile with the Bergsonian concept of classicism propagated by Allard, Gleizes, and Metzinger (M. Antliff,

16–38; Cottington, 60–67, 94, and 156). This suggests rather that d'Ors' writings provide us with valuable information concerning the critical reception of cubism among figures associated with the Catalan Noucentisme movement rather than any fundamental insight into the cultural politics of the French cubists and their allies.

This point can be reinforced through careful study of Nayral's preface (which is not analyzed in Lubar's article). In summarizing cubist aesthetics, Nayral claims that cubism is born "of the interaction of our sensibility and our intelligence" before citing Metzinger's assertion that the cubist sensibility gives "a plastic consciousness to our instinct" (this formulation would reappear in Gleizes and Metzinger, Du "Cubisme" [1912]; see document 57). Such statements bear close resemblance to Henri Bergson's conception of artistic intuition, which he defined as a kind of empathetic intelligence, or form of "instinct that has become disinterested" (Bergson, 193–95; M. Antliff, 44–51). Nayral, who corresponded with Bergson (Robbins, "The Formation and Maturity of Albert Gleizes," 102), likely shared the philosopher's view that the rhythmic cadence of poetry was the medium best able to convey an artist's intuition to others—hence Nayral's assertion in the preface that only "lyric poetry," governed by "magnificent rhythms," could properly "express those profound feelings" that give birth to art (on Bergson's theory of rhythm and poetry, see M. Antliff, 65–66). Nayral's contrast between the aims of photography and those of the portraitist find an echo in Gleizes's retrospective description of his own painterly procedures while working on his 1911 portrait of Nayral (fig. 33) (Gleizes, 25–26, cited in Robbins, "Jean Metzinger," 20; M. Antliff and Leighten, 87–93). Gleizes's and Nayral's descriptions of the role of empathy, memory, and poetic association in the artistic process are arguably closer to Bergsonian theory than the "rational" methods promoted by d'Ors. This conjecture is reinforced when one takes into account the pervasive impact of Bergson among the poets associated with the salon cubists (M. Antliff and Leighten, 93–96; Green, 24–25, 32–33).

M. Antliff, *Inventing Bergson*
M. Antliff and Leighten, *Cubism and Culture*
Bergson, *Creative Evolution*
Clifford, *The Predicament of Culture*
Cottington, *Cubism in the Shadow of War*
Debray and Lucbert, "Dictionnaire de la Section d'or"
Golding, *Cubism*
Green, *Léger and the Avant-Garde*

Henderson, *Duchamp in Context*
Lubar, "Cubism, Classicism, and Ideology"
Mercereau, *La littérature et les idées nouvelles*
Robbins, "The Formation and Maturity of Albert Gleizes"
Robbins, "Jean Metzinger"
Rousseau, " 'L'Âge des synthèses' "
Varichon, *Albert Gleizes*

Olivier Hourcade [pseud. of Olivier Bag], "Le mouvement pictoral: Vers une école française de peinture," *La Revue de France et des Pays Français* (June 1912): 254–58

The Pictorial Movement: Toward a French School of Painting

I just ran into my friend Jean Copieur [John Copier][1]: his features were drawn, his complexion yellow like some picture by Verdilhan, his back stooped, and he smelled of death.

"I can't believe it," he told me, "I've just come from the Salon des Indépendants. A great many of us painters were there. It's not even funny anymore, that Indépendants. Bénoni-Auran was meditating in front of Léger's submission [titled *Composition avec personnages,* since identified as *The Wedding,* Centre Georges Pompidou (fig. 36)]; and Signac, the master of neoimpressionism, loudly proclaimed that the cubists were the salon's raison d'être. Many from 'l'Automne' did not send any canvases. But this only proves that, since they have reliable customers with Bernheim or Druet, they don't want to expose themselves to the risk of losing them by bringing them to the troublemakers, who are not without talent or charm."

To be obliged to recognize talent in people who scandalized him with their new technique, that went beyond Jean Copieur's routine common sense. Roughly quoting a line from Gustave Kahn, he added:

"Our artisans are working, they're progressing. It seems that the public's taste is encouraging them, that French art lovers are becoming educated, are abandoning the picture mills for the artists, the copies of masterpieces for beautiful modern works. It's abominable. The conditions of development for the fine arts are twofold: you need creative artists, but they must have a public of buyers who will allow these artists to get their projects off the ground. And they are beginning to have it!"

36. Fernand Léger, *Study for "La Noce"* (*The Wedding*), 1911. 32 × 26". Illustration in Roger Allard, "Salon des Indépendants," *Revue de France* (1912): 71. Private Collection, France. © Artists Rights Society (ARS), New York / ADAGP, Paris.

Poor Jean Copieur, who earned his bread slavishly reproducing the traditional masters for "châteaux" that want to possess historical galleries! So one of your aims is out of reach, since the art lover now understands contemporary painting and has contempt for the fake Rembrandts, the fake Corots, even the fake *Tintoretto Painting His Dead Daughter,* rightly preferring the canvases of van Gogh, Cézanne, Puvis, or even Le Fauconnier (Shchukin collection), Lhote (Frizeau collection), and the other cubists. But perhaps the art lover is right to prefer our creative painters, our French painters, to our copiers of Dutch or Sienese painters, to prefer our provincial furniture or that of André Mare to the Henri II or Louis XV white elephants of the Faubourg Saint-Antoine. Might the art lover, in so doing, be the principal architect in the creation of a new national style?

Let us consider the renewal of chauvinism in France. Our entire country's reaction against the 1870 defeats is still taking place, it seems to me. And any country's reaction has a greater influence on the contemporary arts than people seem to realize.

I no longer remember who reminded us that England owed its school to the feeling of antagonism that, under William III, stirred up the nation against France and Louis XIV. Kent created an anti-French art that would soon assume its individual character, with Hogarth in the *Marriage à la Mode*. To develop that proposition regarding the influence of the social milieu, we would have to use the further example of Holland. As soon as it had shaken off Spain's yoke, a new Dutch school emerged in which the enormous church paintings were abandoned for small easel canvases, representing landscapes or the interiors of Dutch Protestant family homes, and treated in a different manner.

Hence, the growing national unrest of our times has contributed toward leading the artist toward a "French school." But that does not come about in a single year. And it takes a courageous continuity of effort.

Just as the symbolists did not wish to owe anything to anyone and thought there was no graver insult than to be called Anglo-Saxon, American, or Teutonic, the cubists and their precursors—which must include Charles Lacoste, whom Jammes likes so much and for such good reasons—the cubists make it a point of honor to appear absolutely original.

No reissues of Michelangelo, Raphael, or the Sienese painters: they want theirs to be a French epoch.

And that would be new and truly remarkable.

The paintings of our compatriots were, in almost every era, the paintings of students from Italy.

In seeing the cubists' first experiments, I believed in them with the friendliest enthusiasm; I believed they were finally offering the "French formula" that was going to justify our chauvinistic pride; a number of them made the effort by wandering through Gothic-style cathedrals, others by leafing through our painters, still others by absorbing, with all the power of their gaze, the dynamism of nature in Brittany or Gascony.

Today, Metzinger's *Port* [fig. 37], Delaunay's *Paris* [*La Ville de Paris* (1912)], Gleizes's *Baigneuses* [*Bathers*], Tobeen's *Pelotaris* [*Pelota Players*],

37. Jean Metzinger, *Port,* 1912. Illustration in Albert Gleizes and Jean Metzinger, Du *"Cubisme,"* (1912) [document 57]. © 2005 Artists Rights Society (ARS), New York / ADAGP, Paris.

Miss Marie Laurencin's young ladies, and the works of two or three other painters are approaching that real and magnificent result, that victory delivered in the last few centuries: the creation of a "French" and absolutely independent school of painting.

But, in contrast, look how the two Marchands—not to mention André Lhote—are wasting their fine qualities on already slightly obsolete Epinal-style images, which now have only the relative interest of not very fresh patterns for industrial wallpaper! And, above all, how Le Fauconnier (who could not imagine my respect for him) has disappointed me! His *Abondance* [fig. 9] and his *Paysages* [*Landscapes*] showed the promise of an admirable creator, and now he's losing his way in some kind of Italianization, for it is indisputable that Le Fauconnier's very recent pilgrimage—pious and very laudable—to the museums in the large Italian cities had a pernicious influence on his noble and fine talent. He will break free of it.

The painters also need to be a little less concerned with means and more with the aim.

I do not deny that canvases with no subject can be of great interest. But that is, properly speaking, Oriental art—if we do not call Chinese or Hindu art Oriental art. In any case, it is no longer French art.

It was, in fact, characteristic of Oriental art to delight in zigzags, concentric rectangles, triangles, zones of dots. With the Minoan influence, that art was confined to Turkey. It no longer exists today in its absolute form. For about fifty years, Turks-turned-Parisians—for the most part, students of Gérôme—have been painting the human figure.

The characteristic of Western art, both in the Christian era and in the Quaternary period, has always been the importance of the subject. Drawings representing animals from the prehistoric era, to which we have alluded, which were found either in the French Pyrenees or in the Garonne basin in France, are no doubt remarkable for their sense of rhythm, but often as well their interest lies in the subject (not only for the scientist but also for the artist). The painter today must be more concerned with his aim.

This is especially so for Fernand Léger, who has acquired such mastery that he performed the miracle of giving us, at the Indépendants, a beautiful "composition" without a subject [fig. 36].

The characteristic of Western art, as I said, is "the subject," and we have seen that it is, in effect, the characteristic of the reindeer hunters from the Garonne basin. In terms of Oriental art, we have concerned ourselves only with Turkish art, originating in the purest Asian civilizations. We have chosen not to speak of Chinese or Hindu art. In fact, as Mr. Salomon Reinach declares in his very incomplete but very curious and remarkable *Apollo:*[2] "If I say nothing here about the art of India or China, it is because the great antiquity attributed to them is an illusion. India had no art before the age of Alexander the Great, and, as for Chinese art, it began to produce its masterpieces only in the European Middle Ages. The oldest Chinese sculptures that it is possible to date are from the year a.d. 130; *they are works influenced by a degenerate form of Greek art,* which had gradually spread from the banks of the Black Sea toward Siberia and Central Asia."

But is not Greek art (and Minoan art in particular), which expressed so well the life and dynamism of animals, a successor to the art of the reindeer hunters? Following Mr. Reinach's appealing hypothesis, I believe

that "the art of the reindeer hunters, which disappeared from France several thousand years before the splendor of Knossos and Mycenae, continued in some still poorly explored area of Europe and, in the end, was introduced into Greece by one of the numerous invasions of the peoples from the north, who continually descended from central Europe toward the Mediterranean."

It seems indisputable to those of us who think in that way that our current mentality, which takes an interest in the art of the Greeks, in the Italian or Spanish Primitives, and in Chinese art, is rediscovering in them the Western genius within us.

―――――――

It would be regrettable if the admirable effort we have witnessed in the last several years should not bear fruit.

As a critic who is a friend of the cubists, I must tell them: Watch out on your right, do not veer too much toward the enchanting appeal of the old image makers; it is good to know them, but it is an anachronism to redo them, to come close to plagiarizing them. You must create their counterpart.

And watch out on your left! Do not veer into the error of an intellectual who denies that the picture has any function. You paint to paint, granted. But there is painting and then there is painting. You paint to paint something. Tobeen creating "the game of pelota," Delaunay interpreting Carpeaux's *Danse* in his own manner, are more original than Le Fauconnier painting an incoherent hunter [*The Hunter* (1911–12), Gemeente Museum, The Hague]. Our deep tradition desires a subject, and the originality of the cubist school can only lie in rejecting "the anecdote" to rediscover "the subject."

The current period is very dangerous. Cubism (in the broadest sense of the term—it is acknowledged that this title, created by Matisse and reporters, is absurd; there have never been so few cubes as on a cubist canvas), cubism can be the so-long-awaited French school. Will it be? We cannot yet make that assertion, but we are nevertheless permitted to hope so.

Olivier Hourcade [pseud. of Olivier Bag]

JUNE 1912

EDITORS' NOTES

1. Jean Copieur is a fictitious name for those artists who slavishly copy the work of past artists.

2. Hourcade refers here to Salomon Reinach (1874–1922), a prominent art historian who had recently published *Apollo, histoire générale des arts plastiques professée en 1902–1903 à l'École du Louvre* (Paris: Hachette, 1904).

Commentary

In this article Olivier Hourcade staked out his position in the volatile debate over cubism's relation to the French tradition. He asserts that all national schools are the result of antagonisms between nations: England's unique style was a cultural reaction to French imperial dominance in the seventeenth century, the Dutch school first emerged after Holland "had shaken off Spain's yoke," while in contemporary France, cultural chauvinism was a direct "reaction against the 1870 defeats." One would expect this declaration to be a preamble for an attack on Germany, but curiously Hourcade instead turns his attention to Italy. Ever the regionalist, he claims that the cubists likely had a precursor in the Nabis-inspired aesthetic of a "native son" of Gascony, Charles Lacoste (1870–1959), but above all he celebrates their desire to "shake off the yoke" of Italian culture (see Thomson, 116–19; Jammes). "No reissues of Michelangelo, Raphael, or the Sienese painters: they [the cubists] want theirs to be a French epoch." "That," adds Hourcade, "would be truly new and remarkable," since French painting "of almost every era" was the art of "students of Italy." In rejecting Italian art, the cubists had arrived at a "French formula," derived from meditative strolls through "Gothic-style cathedrals" and responses to "the dynamism of nature in Brittany [Henri Le Fauconnier] or Gascony [Félix Tobeen]" (here Hourcade alludes to his previous aesthetic formulations concerning "dynamism" and regionalism in document 33). Evidence for this autarchic "French formula" was found in the cubist paintings recently on view at the 1912 Salon des Indépendants, but Hourcade now chides Le Fauconnier for having succumbed to Italian art. Thus Le Fauconnier's recent "pilgrimage" to Italy had "had pernicious influence on his noble and fine talent," and Hourcade could only hope that he would "break free of it" (Le Fauconnier's trip to Italy occurred in the summer of 1911; see document 15).

Such statements are in stark contrast to those made by Hourcade in February 1912, when he praised Le Fauconnier's art for possessing "the

force of Michelangelo" and counseled the cubists to emulate Italian "Primitives" like Fra Angelico (see document 33). Hourcade's hostility toward Italian culture is the result of two events: the impact of futurism on French art following their exhibition in Paris in February 1912, and his endorsement that same year of a political organization known as the Ligue celtique française (on reactions to futurism in cubist circles, see Cox). In the March–April edition of *La Revue de France,* and in his February 1912 enquête on cubism (document 36), Hourcade had described the futurists as "pupils" of the cubists and Paul Signac, thus refuting the futurists' brazen claim to have usurped the avant-garde status of the cubists (Hourcade, "Beaux-Arts: Les Futuristes," cited in Golding, 28). However, Hourcade's wholesale dismissal of the Italian tradition (including the so-called Primitives) stemmed from his allegiance to the cultural politics of the French Celtic League (M. Antliff, 106–34). Founded by polemicist Robert Pelletier in the spring of 1911, the Celtic League asserted that the French were "Celtic," that France's indigenous culture was "Gothic" rather than derived from the Latin "classical" tradition, and that every regional dialect in France had its roots in a native "Gallic" tongue. Pelletier's argument was bolstered by the linguist and Celtic League member Charles Callet, whose father, Auguste Callet, had traced the origins of all forms of "patois" to a singular "Celtic" source. Over the course of 1912, such prominent supporters of cubism as Hourcade, Figuière, Mercereau, Paul Fort, and Tancrède de Visan all joined the league. In the June 1911 edition of *Les Marches du Sud-Ouest,* Hourcade published an article praising the work of the linguist Auguste Callet ("Les Revues," 132), and endorsed the writings of both Auguste and Charles Callet in the February, May, and June editions of *Revue de France* (see references to Callet and Hourcade in M. Antliff, 107–8). In the February 1912 edition of *Revue de France* Hourcade seconded Callet's proclamation that "France is not Latin, France is not Germanic: it is and it remains Gallic"; and in a later article, "The Wisdom of the Druids" (May 1912, 148–55), he stated that Callet's ideas should be used "to combat the Latinist epidemic." In the June edition of *Revue de France,* Hourcade's polemic "Toward a French School of Painting" was preceded by an article on the Celtic origins of "patois" written by Auguste Callet (217–21). Thus Hourcade's claim that the cubists nurtured their aesthetic by studying "Gothic-style cathedrals" was indebted to the anti-Latin agenda of the Celtic League, an agenda that received its fullest

endorsement in cubist Albert Gleizes's important essay of 1913, "Tradition and Cubism" (see document 60).

Hourcade concludes his article by counseling the cubists to reject the "Oriental" tendency toward pure abstraction, and instead to embrace representation, "the characteristic of Western art." In a creative interpretation of Salomon Reinach's book *Apollo* (Paris, 1904), he argues that all of Western art, including that of classical Greece, ultimately had its origins in the prehistoric cave painting of his own native region of French Gascony. Thus prehistoric artists "from the French Pyrenees or in the Garonne basin in France" were the true wellspring of European art, and the art of Greece only emerged following "the invasions of peoples from the north." In effect Hourcade turns the tables on those who would claim a "Latin" genealogy for French culture, by asserting that France, in fact, had given birth to the whole of Western art.

M. Antliff, *Inventing Bergson*
Cox, *Cubism*
Golding, *Cubism*
Hourcade, "Beaux-Arts"
Jammes, "Un Peintre girondin"
Thomson, *Monet to Matisse*

Elie Faure, "Préface," Troisième exposition de la Société normande de peinture moderne, Rouen, 15 June–15 July 1912, pp. 2–4

Preface, Third Exhibition of the Norman Society of Modern Painting

We do not know any of the languages we speak. They are constantly creating themselves. They flee and slip away, impelled by the growth of the mind. But no language requires more effort to be heard than painting; it is in painting that our peaceful habits would like to rediscover the appearance of the external objects we see. Painting is not that. It seeks the unstable point where that appearance is in harmony with the heroic feeling an exceptional man gets from it. It transports the universe to the loftier region of life, where the intelligence takes possession of the elements that form it.

It is not for us to impose the inertia of our vision on the artist. It is up to the artist to impose on us a view of the world acquired solely through sensuality and meditation on the common education he received in spite of himself. When someone is among those who collect the voices we do not hear, the eternal voices that sing only for the one whose senses and heart submit with terror to the daily lessons of admiration and to the desire to learn, it is against us that that person is correct and for us that he works. He is the translator of the power of growth that we bear unbeknownst to us; he sees the secret images that dwell within us and that are the expanding shadow of our muddled desires, on the road where we hesitate. An artist is a great witness. He comes to say that, deep within our unrecognized innocence, there is an uplifting power we did not suspect and whose gradual revelation we must await from him, with that feeling of recognition in which men of the past sensed the presence of a god.

I beg those who come to see paintings to look at them with respect. Never will our need for them take root with such inevitable force. Present-day France is the theater for a great intellectual drama, where the peoples of the West acknowledge their uneasiness and in which the evolution of painting is the central episode. Most people, and almost all French people, do not know it, and that has always been so. What a silent tragedy! Here, in the confused melee of ideas and feelings, is an exploding point, but one that no one perceives, a radiant and veiled form rising from the shadows of the past to tell us what we are, where we are going; it is the hope that keeps us on our feet in the general oscillation of the world, allowing us to seize from it the strength to come to a decision. Something unknown advances and, from every side, like a symphonic din for which French art is today the rallying cry, a moment of history as decisive as that when the ancient world overturned all values in the throng of Alexandria, to clear the new paths that were necessary for us, and which we are going to leave behind. Everything is going to change: science, ethics, the great unanimous notions on which social organizations have rested for a few centuries, the invisible and grandiose rhythm that soothes our adventure and that, from millennium to millennium, rises from the depths of need to give us a new reason to act. We do not see it, we do not know it, we do not believe it! Those who have an inkling of it cannot convince anyone. They feel it, they shout it, their voice falls in the face of universal indifference. And that is good. It cannot be otherwise. The most vibrant actors in the drama do not even suspect it. We must go wrest them from their solitary power to tell them of our love.

In a circumstance as solemn as this, when we come to ask an illustrious city to listen to us, it would be beneath me to try to define the tendencies and the meaning of the paintings of today. The person who could show, in one page, that the individual, as a result of being liberated, goes astray and seeks the individual, that we are seeing the growth of seeds of a new and ardent and immoral religion in the midst of the tatters of the old beliefs, that a general upward movement toward something that is to be in the future is becoming more pronounced in a reconstitution of the organization of labor, in the rehabilitation by philosophers of constructive and lyrical intuition, and, above all, in the decorative aspect—reeling with joy, astonished, and, to sum it all up, primitive—of young painting—the person who could do that would himself be one of those mystic heroes in whose heart the unknown world to come is elaborated. After Rodin's

prophetic pessimism, Cézanne's sentimental indifference and desire for architecture, and the victorious optimism of doubt recaptured by Renoir, the young painters do not know any better than we do, but they feel, they want to construct, a passion has a hold on them and stirs them up, makes them go toward the intuitive life once again, with the trembling and joyous desire to obey its will. Here they are. We are floating, desperate, between the most inaccessible peaks of knowledge ever glimpsed and the eternal sources of an instinct that has remained exactly as it was in the most remote depths of our animal roots. How could we not go forward confidently to meet those who, even while stammering, dare admit their defeats in order to impose their victories, gravely unveil their certainty and their anguish, and seize on every flickering gleam to shake it at us? They bring with them the power and confusion of the mind. Let us look with deference, let us try to understand, and especially, let us not judge.

Incomprehension commands men to silence. Those who modestly and proudly keep silent in the face of a new form whose meaning they do not immediately grasp are soon rewarded for it. A feeble murmur takes root there; it grows day by day to become a hymn that fills them and lifts them above their mechanical gestures and leads them into a loftier light whose growing intensity will allow them to read more and more clearly into themselves. Painting is the moving image of the invisible symphonies that poetry, music, love, and the pride of being alive awaken in our senses, in contact with the immortal appearances of space. One must not simply look at painting, one must hear it, touch it, live it, gather around you its scattered soul, which the artist fixes for us in a provisional form, where we will be able to recognize the changing aura [?] of desires and torments that make us what we are. The person who passionately loves the faces of life penetrates its hidden depths by the surest paths and recognizes, in the art of shaping the spirit of the world, the most powerful means for reaching that world.

Elie Faure
15 JUNE–15 JULY 1912

Commentary

In this, his second preface written for the Société normande group, Elie Faure presents a case for the social and philosophical significance of avant-garde art that had a direct relation to his politics. Repeating an argument first broached in his preface for the 1910 exhibition of the

Société normande (document 7), he attributes the public's disdain for the new art to the "inertia" of their perceptual and aesthetic faculties. Whereas artists understood that the essence of life and society resided in its eternal dynamism, the general public—overly enamored of the fixed and familiar—actively resisted all signs of change, including vanguard art. The artist, we are told, perceives the element of change both within us and in our world and, as "a great witness" to that change, seeks to communicate this prophetic vision through the medium of art. Faure describes his own era as subject to a change "as decisive as that when the ancient world overturned all values in the throng of Alexandria." "Everything is going to change," including "science," "ethics," the "unanimous notions" behind "social organizations," and even the "grandiose rhythm" that governs our everyday actions. Artists were not alone in grasping change, for among those fully "liberated" were the creators of a "new and ardent and immoral religion in the midst of the tatters of the old beliefs." Faure sees further evidence of societal change "in a reconstitution of the organization of labor"—an allusion to revolutionary syndicalism—and on a Bergsonian note, "in a rehabilitation by philosophers of constructive and lyrical intuition." The "young painters" in turn are "primitives" who aid in these developments through their passionate turn "toward the intuitive life." It is up to us to patiently allow the synesthetic impact of their "decorative" art to penetrate our consciousness, in order that we might transcend our "mechanical gestures" and glimpse the "hidden depths" of life itself.

Faure's vitalist celebration of vanguardism is indebted to Henri Bergson's philosophy of intuition and creativity (M. Antliff, 371–73). Bergson argued that intuition alone enables artists and philosophers to grasp the intrinsic dynamism of life in the process of creative evolution; Faure claimed that humanity is subject to similar dynamic forces, and that artists, by virtue of their intuition, are at the shaping edge of societal change. That this change is cataclysmic is clearly indicated by Faure, a fact underscored a year previously in an article titled "Sur une guerre" (*Les Hommes du Jour,* 7 October 1911 and 21 October 1911). In that earlier polemic Faure argued that change itself is both intrinsically violent and creative, and that militants among the working class should realize that "creative violence" is integral to any true revolution. "I do not defend war as an instrument of death but as an instrument of life," Faure proclaimed (21 October 1911). He bolstered this argument by citing the example of art: "Art always

flows out of warlike energy [*énergie guerrière*]. Never, during the great moments of creative power, have artists searched the cloisters and cemeteries. They lived there where the action was, for it is action that gives them birth" (7 October 1911). Faure then called upon all "revolutionaries" to follow the example of artists, and instill a comparable "creative enthusiasm" in the masses (7 October 1911). In short, art (in imitation of life) could be a potential catalyst for radical change and in Faure's opinion the militants of *Les Hommes du Jour* could find allies among those "intuitive" artists who made up the avant-garde of their era. Faure's public endorsement of the Société normande cubists thus constituted a challenge to the aesthetic preferences of leftists like Urbain Gohier, Henri Guilbeaux, and Maurice Robin, who continued to dismiss cubism as a sham (see documents 14, 24, 25, and 36).

The Third Société normande exhibition anticipated the Section d'Or exhibition in its scope. Participants included August Agero, Marcel Duchamp, Pierre Dumont, Gleizes, Roger de la Fresnaye, Juan Gris, Marie Laurencin, Fernand Léger, André Lhote, Francis Picabia, Félix Tobeen, and Jacques Villon. Paintings on view by artists affiliated with the cubist movement included the following:

Marcel Duchamp: no. 113, *Portraits (Sonate)*; no. 114, *Portraits de jouers d'échecs (Portraits of Chess Players)*.

Pierre Dumont: no. 120, *Nature morte (Still Life)*; no. 121, *Étude pour portrait (Study for a Portrait)*.

Roger de la Fresnaye: no. 11, *Étude (Study)*; no. 112, *Dessin (Drawing)*.

Albert Gleizes: no. 89, *La chasse (The Hunt)*; no. 90, *Les arbres (The Trees)*; no. 91, *Passy*; no. 92, *Baigneuses (Bathers)*; No. 93, *Cathédrale*.

Juan Gris: no. 95, *Paysage (Landscape)*; no. 96, *Nature morte (Still Life)*; no. 97, *Dessin (Drawing)*.

Marie Laurencin: no. 94, *La musique (Music)*.

Fernand Léger: no. 87, *Étude (Study)*; no. 88, *Esquisse (Sketch)*.

André Lhote: no. 84, *Nue (Nude)*; no. 85, *Paysage (Landscape)*; no. 86, *Nature morte (Fleurs) (Still Life—Flowers)*.

Francis Picabia: no. 107, *Tarantelle*; no. 108, *Port de Naples*; no. 109, *Paysage (petite toile) (Landscape—Small Canvas)*; no. 110, *Paysage (grande toile) (Landscape—Large Canvas)*.

Félix Tobeen: no. 104, *Pelotaris (Pelota Players)*; no. 105, *Pays basque (Basque Country)*; no. 106, *Étude (Study)*.

Jacques Villon: no. 98, *Gravure de bois: Repos sur l'herbe* (*Woodblock Print: Resting on the Grass*); no. 99, *Portrait eau forte* (*Portrait—Etching*); no. 100, *Portrait*; no. 101, *Laide, gracieuse*; no. 102, *Femme de Thrace* (*Thracian Woman*); no. 103, *Gravure portrait (pointe sèche)* (*Engraved Portrait—Drypoint*).

M. Antliff, "Organicism against Itself"
Faure, "Sur une guerre"

Maurice Raynal, "Préface," Troisième exposition
de la Société normande de peinture moderne,
Rouen, 15 June–15 July 1912, pp. 9–11

Preface, Third Exhibition of the Norman Society of Modern Painting

Along with a great number of intrepid scientists who have devoted themselves to extraordinary scientific research, whose very data will turn the common understanding and ordinary sensibilities upside down, the twentieth century has witnessed the birth of a generation of artists who, provided with an extraordinary erudition, have wished to transform, with the help of their knowledge and their affinities with the modern movement, the pictorial conceptions and manners of the ancients.

The superiority of a man is unquestionably to be measured by the delicacy of his sensibility, and that delicacy can be acquired only with the aid of knowledge. It is in that way that modern painting has transformed itself. The unsettled periods, when the lack of popularized scientific methods left room for creations of the imagination, of chance, of inspiration, of superficial observation, or of reverie that were often lovely, but inadequately considered, have given way to a more positivistic age in which people have resolved to study the essence of things before attempting to discourse about them.

The elite of today rightly think that the artist must not just see but must also conceive of the object he intends to represent. In fact, the goal of art is not the slavish imitation of nature; what interest would there be in it if it were only that? Rather, it must be its translation, its interpretation in accordance with the artist's intellectual capacities. Imitation in itself may be an art, if you like, but an art that photography will easily bring to perfection.

To be sure, painters ancient and modern have also claimed that they have interpreted nature in accordance with their sensibility, and that is very true. But, unfortunately, the extremely reactionary artists have never wanted to modify their ways of conceiving to accord with the modifications in life resulting from progress and time. They have always wanted to understand their art only in terms of what they learned at school. Hence the torpor in which art has so long been stagnating.

The painters and sculptors in our group have attempted to free Painting and Sculpture from the slump into which the obstinacy of often eminent artists has plunged them. Even though it is rash to set out such theories in so few lines, we shall try to give a brief view of their conceptions.

The "cubists," since that is the label—somewhat erroneous, however—they must be given, have sought before all else to learn on their own what their schooling was unable to teach them. That is why they called upon the law of synthesis, for which they have been so criticized, but which nevertheless governs all conscientious speculation in our time. They have thus sought in the reflections preceding their labors and in the work itself to move judiciously from principles to consequences and from causes to effects, for the purpose of leading the two arts to their common and essential principle and to their ideal simplification, namely, the line.

Above all, they separate out the principal elements of the bodies they intend to render, following their own analytical methods and the characteristics of the object. They then study these elements in accordance with the most elementary pictorial laws, then reconstruct the objects with the help of their elements, now well known and rigorously determined.

In that way, the cubist painters have created the algebra of Painting. They know that all bodies have a particular form only as the consequence of the mathematical conception that the artisan who constructed it has—more or less knowingly—made of it. Thus objects must no longer be considered solely representations of some kind, but rather agglomerations of forces and aggregates of distinct parts constructed in accord with mathematical laws. These objects will henceforth be volumes, and volumes now considered in the pure sense of the word, that is, spaces filled and occupied by aggregates of bodies.

In addition, objects can be considered from two other points of view, in terms of their natural equilibrium and in their different movements, that is, from the static and from the dynamic point of view. From the

start, the cubist painters and sculptors took into consideration the fact that motion magnified forms and that being at rest diminished them. Next, following the principles of statics and dynamics, bodies can undergo perceptible modifications; the dynamics of one body can influence the statics of another, or vice versa. Regardless of what has been said about them, objects cannot be independent one from the other; they have relationships with one another that will be determined by their sphere of influence, which are similar to the attractions or repulsions existing among certain elements joined or separated by their chemical affinities. And since static and dynamic elements can be found in every object, even inanimate ones, these objects will be rendered on the canvas by diverging lines occasioned by their intimate, rational, or influence-derived forces.

It is at this point that the sensibility intervenes. Every artist, in accordance with his temperament and his personal pictorial conceptions, will give lines the directions that he, of his own free will, judges necessary. It is in this part of the work that the artist's personality will best assert itself; it is there he will most allow himself to be dominated by the arbitrary; in a word, it is at this culminating point that we believe we must seek and find the full manifestation of the arts of Sculpture and Painting.

Unfortunately, we cannot expand on this exposition of the remarkable speculations by the painters in our group. We have tried to indicate the principal ones, and we would be happy if, after reading this, people are able to grasp the others, and to understand, admire, and like the works we are presenting. These few works of art attest beyond all question to the most concerted effort ever made to free art from the matter-of-fact and nauseating aspects of its routine, and that is why, by virtue of the admiration we feel for its results and successes, we ask readers to be kind enough to forgive us for the inadequacy of this presentation.

Maurice Raynal
15 JUNE–15 JULY 1912

Commentary

Maurice Raynal (1884–1954; fig. 38) was one of the leading art critics to defend the cubists before the war, playing a leading role in explicating their work in Kantian terms. He knew all the artists and critics associated with the movement by 1910, and was especially enamored of the work of Pablo Picasso, Georges Braque, and Gris, of whom the last became a close friend. Pierre Dumont, who moved to the Bateau Lavoir in 1910 and

38. Juan Gris, *Portrait of Maurice Raynal,* 1912. 55 × 46 cm. Private Collection. © Artists Rights Society (ARS), New York / ADAGP, Paris. Photograph courtesy of Blondeau & Associés, Paris.

shared Raynal's Kantianism, was likely to have facilitated his contact with the Société normande. He took over Guillaume Apollinaire's column in *L'Intransigeant* in 1912 and was hired by Louis Vauxcelles (documents 5 and 52) to write for *Gil Blas* in the same period. Raynal served in the French army during World War I and played a major role in the 1920s and '30s in developing the dominant formalist discourse on modernism through his many writings, including *Modern French Painters* (New York, 1927) (Gee). Despite his closeness to the cubists, however, the importance of the Kantian basis of his explication of the motives behind the movement is debatable, having been specifically rejected by Albert Gleizes and Jean Metzinger in 1912 (document 57), though reinvigorated in the hands

of Daniel-Henry Kahnweiler in his wartime text, *Der Weg zum Kubismus (The Way of Cubism).*

In this, his first writing on cubism, Raynal represents the artistic avant-garde as not merely parallel to scientists whose "very data will turn the common understanding and ordinary sensibilities upside down," but as a generation of artists fully informed by the new science and "who, provided with an extraordinary erudition, have wished to transform, with the help of their knowledge and their affinities with the modern movement, the pictorial conceptions and manners of the ancients." Thus science and the visual arts progress hand in hand to "a more positivistic age," and viewers may look to them for an understanding of the "essence of things" and for the art of the future. Raynal views cubism as an intellectual pursuit of truth, with the artist's conception of objects triumphing over his visual perception of them, based on mere sensation no matter how informed by knowledge. Positioning himself as a member of a small elite of cognoscenti who understand this vanguard and its importance, he assures us that

> the elite of today rightly think that the artist must not just see but must also conceive of the object he intends to represent. In fact, the goal of art is not the slavish imitation of nature. . . . Rather, it must be its translation, its interpretation in accordance with the artist's intellectual capacities.

He claims that these artists understand a "law of synthesis" that will lead painting and sculpture "to their common and essential principle and to their ideal simplification, namely, the line." Having discovered this basic element of art-making, these artists proceed, according to Raynal, in a highly formulaic and scientific manner:

> They separate out the principal elements of the bodies they intend to render, following their own analytical methods and the characteristics of the object. They then study these elements in accordance with the most elementary pictorial laws, then reconstruct the objects with the help of their elements, now well known and rigorously determined.

Raynal's scientistic language assures us of these artists' objectivity in "a positivistic age." He comes close to the teachings of Maurice Princet (document 35) when he adds that "objects must no longer be considered solely representations of some kind, but rather agglomerations of forces and aggregates of distinct parts constructed in accord with mathematical

laws," hence following a form will reveal an underlying mathematical truth. Raynal's "scientifically" based explanation borders dangerously on sounding like the formula ridiculed in other reaches of the press, and he hastens to add a modernist truism as a reminder to his readers that "every artist, in accordance with his temperament and his personal pictorial conceptions, will give lines the directions that he, of his own free will, judges necessary. It is in this part of the work that the artist's personality will best assert itself."

Raynal's dry prose contrasts sharply with the poetic drama of Elie Faure's politicized interpretation of vanguard art written for the same catalog. This contrast could be indicative of the plurality of opinions and voices within the Société normande itself, which included a virtual cross-section of the cubist avant-garde.

Gee, "Raynal, Maurice"

Maurice Raynal, "Conception et vision," *Gil Blas,* 29 August 1912

Conception and Vision

There is, in our suburban gardens and in many inexpensive bouquets, a fairly insignificant but extraordinarily dainty plant, whose little white flowers tremble with the slightest breeze, and which has the pleasant name "the painters' despair." And, if you question the first gardener you come across about that strange designation, he will reply quite innocently: "It is because it moves so much that the painters cannot paint it."

That is charming, no doubt, but when you consider that the act of painting what one sees has produced such a consequence, such painting seems fairly difficult to accept without comment.

The need to paint what one sees is an instinct and, as a result, the opposite of a superior aspiration of the mind's faculties. In the animal kingdom, many specimens can be found in which this need is very highly developed, and the ape offers very curious examples of it.

Cavemen carved figures of the animals they had seen into the walls of their "home." Children, as soon as they are old enough, execute portraits, act like Daddy, or savage an old dowager like Mother and Father. Even the common people have a craving to paint what they see; their so-called imagistic language is strewn with vulgar comparisons, and it is not only poets who sprinkle their works with metaphors of so-called imitative harmonies.

Sometimes, the need to imitate what one sees still has unfortunate consequences in scientific research. The examples are many, but one of them turns out to be pertinent today: Icarus, when he wanted to fly, sought to imitate the birds. This was an error, but he had the excuse of not being a scientist. But many researchers, excited by the problem of flight, tried methodically to solve it by this same technique, and our modern Ader

continued the error, also recommending the system of flapping wings. Since, to succeed at flying like a bird, one needed not a bird's wings but merely a spinning piece of wood, to attempt to reach truth one must not simply seek to imitate nature but rather look elsewhere.

Yet, although the search for truth must not be undertaken solely with the support of the things we see, but also with the help of those we conceive, painters, since before the Renaissance, have in their works rendered what they saw rather than what they conceived; and they did so, having completely forgotten that nothing was less legitimate than external perception, that nothing was [more] in contradiction with the laws of reason than visual sensation.

Painters render on the canvas the apparent plastic forms of objects, rather than the forms their minds conceive. We will not go so far as to accept Berkeley's idealism without restriction; but there can be no denying that the judgments and arguments based on perception alone are, for the most part, erroneous. To find an example of this, let us call on the futurist painters. In their canvases, several of them wanted to render the real motion of several objects. Yet the perception of real motion presupposes that we are cognizant of a fixed point in space that can serve as a control point for every other motion. But that point does not exist. The motion that the futurists perceived is thus only relative to our senses and not at all absolute. Here, then, is an error in reasoning attributable to our senses.

Paintings based solely on external perception thus seem inadequate. Now, if art must be not merely a means to flatter the mind and the senses, but much rather a means to increase knowledge, the act of painting the conception of forms will furnish the means to do the latter, which the Primitives understood so well. In effect, when Giotto painted the picture where a fortified city can be seen in the background behind men in the foreground, he did so in such a way that one perceives it from a bird's-eye view. He thus depicted it as he had conceived it, that is, as a whole, in all its parts at once. In that, he respected neither the perspective nor the visual perception; he painted the city as he had conceived it, and not as the figures in the foreground would have seen it.

In fact, we never see an object in all its dimensions at once. Hence, in our view, there is a gap which it is important to fill. Conception gives us the means to do it, allowing us to perceive the object in all its forms, and even to perceive objects we cannot see. "I do not see a Chiligone," said Bossuet, "but I conceive of it very well." When I conceive of a book, I do

not perceive one particular dimension of it, but rather all dimensions at once. If, therefore, the painter manages to render the object in all its dimensions, he creates a work with a method superior to that of a work painted only in its visual dimensions.

In addition, the Primitives conceived not only the forms of objects, but also the formal qualities of these objects. When a Primitive had to paint soldiers crossing a bridge, the first thing that struck his mind was the idea of the soldier, which is, in fact, more important than the idea of a bridge. Thus, just as in discourse the expression *soldier* comes before *bridge,* the artist made the soldiers much larger than the bridge, which may be contrary to the laws of visual perception, but not to those of reason.

That is why it is so regrettable that the artists who succeeded the Primitives felt that they ought to abolish the principle of conception and substitute that of vision. The latter is, beyond any dispute, infinitely inferior in the intellectual or even the practical order. It replaced the idea of art for art's sake, inherent in the principle of conception, with an idea of practical execution, which led painting into many errors, and, above all, to the complete loss of a broader view of things, culminating in the creation of commercial painting.

In addition, if the artist's goal is admittedly to get as close as possible to truth by means of his art, the conceptionist method will lead him there. The mathematical sciences are exact, that is, absolutely certain, because they apply to abstract notions. Now, in painting, anyone who wishes to approach the truth must record only conceptions of the object, the only things created without the aid of the senses, which are the source of inexhaustible errors.

Hence, since the perfection of an art lies in its being simplified as much as possible, the painting of the visual appearance of objects, considerably purified by their conception, will be the source of works of art with a much loftier tone.

The beautiful must be, in Kant's excellent expression, a "purposiveness without purpose"; that is, it must require an internal harmony without an external goal. It must be distinguished from seemliness, which is only the arrangement with a goal in mind; and it is not necessary to have the definition of a beautiful form for it to be pleasing.

Maurice Raynal
29 AUGUST 1912

Commentary

In this article, Raynal moves beyond the "scientific" tone of his preface for the Société normande exhibition of June–July 1912 by explicating a full-blown history of art and visual perception, rooted in a version of neo-Kantian aesthetics. The diacritical pair "vision" and "conception" are here contrasted on the basis of humanity's recourse to "instinct" or "intellect." In Raynal's estimation, forms of representation that sought to imitate visual perceptions were the regressive product of instinctual urges. Raynal underscores this point through primitivist tropes: those governed by an instinct for mimesis include prehistoric cavemen, small children, and "the common people," as evidenced though their "vulgar" recourse to "imagistic language" (on primitivism, see M. Antliff and Leighten). All are deemed inferior when compared to the "conceptual" thinking of the scientist or of the cubist painters, who correctly identified "visual sensation" to be antithetical to "the laws of reason." Raynal locates a historical precedent for such thinking in the art of the trecento artist Giotto (1266–1337). In an effort to paint an urban landscape as he "conceived it," Giotto reportedly had imagined "a bird's-eye view" and depicted it "as a whole, in all its parts at once." This early recourse to simultaneity was matched by another pictorial device, an attempt to capture the "formal qualities" of objects by following laws of reason rather than the laws of visual perception. Reason, for instance, might have led an early master to depict soldiers crossing a bridge as larger than the bridge itself: this was because "the idea of the soldier" may have struck an artist as "more important than the idea of the bridge." In like fashion, the cubists too had decided to "distort" the scale of objects in a "reasoned" response to the motif. Ultimately Raynal equates such techniques with a purely cerebral and therefore (in the Kantian sense) "disinterested" form of perception, whose aesthetic corollary was "the idea of art for art's sake." Thus the art of Giotto and the cubists represented an advancement in human history, whereas the mimeticism signaled by the development of Renaissance perspective heralded a regression. As Paul Crowther has argued, Raynal's creative misunderstanding of Kant, along with that of Olivier Hourcade and Daniel-Henry Kahnweiler, has enabled subsequent historians to conceptualize cubist painting as a formalist teleology. In this regard Raynal's early defense of cubism as a cerebral form of art focused on the "internal harmony" of the canvas provided

powerful justification for later critics who claimed that cubism's raison d'être resided in the self-reflexive contemplation of its own medium (Crowther;, 78–87).

In Raynal's estimation single-vanishing-point perspective was synonymous with the "visual dimensions," but with the advent of the conceptual art of cubism, artists were able to transcend mere vision "to render the object in all its dimensions," even those "we cannot see." Raynal lends historical weight to his argument by referring us to the famous theologian Jacques Bossuet (1627–1704), who had conducted a long correspondence with the philosopher and mathematician Gottfried Leibnitz (1646–1716). Just as Bossuet could "conceive" of a thousand-sided figure like a "Chiligone," so too the cubists could imagine unseen dimensions, a clear allusion on Raynal's part to the fourth dimension (for an analysis of this aspect of Raynal's thought, see Henderson, 77–78 and 311–12). Although Raynal's Kantian interpretation of cubism met with dismissal by the Bergsonists Gleizes and Metzinger in *Du "Cubisme"* (document 57), his model of cubism was not without influence: thus the cubist and Société normande adherent Dumont appropriated Raynal's analysis of Giotto and his reference to Bossuet in his own rendition of the conception-versus-vision thesis, published in 19 April 1913 (Dumont's aesthetic statement is published in Sheon).

Like Roger Allard and Hourcade before him, Raynal also critiques the futurists, but his basis for doing so was radically different (see documents 18 and 36). Rather than condemning futurism as a form of impressionism (Allard) or on the basis of a national aesthetic (Hourcade), Raynal chastises the Italian futurists for their slavish devotion to the "erroneous" data of their senses. Although the futurists claimed to grasp the "real" or "absolute" motion of objects, quite distinct from the relativity of perception, Raynal, through "scientific" analysis, asserts that "the motion the futurists perceived" was only "relative to our senses" and therefore "not at all absolute." Thus Raynal seems to have misunderstood the Bergsonian basis for futurist concepts of relative and absolute motion (M. Antliff), relying instead on mathematician Henri Poincaré's discussion on the subject in his influential book *La science et l'hypothèse* (1902) (on Poincaré's profound influence on the salon cubists, see Henderson).

M. Antliff, "The Fourth Dimension and Futurism"
M. Antliff and Leighten, "Primitive"
Cheetham, *Kant, Art, and Art History*
Crowther, "Cubism, Kant and Ideology"
Henderson, *The Fourth Dimension and Non-Euclidean Geometry in Modern Art*
Sheon, "1913"

"M. Lampué s'indigne contre le Salon d'Automne," *Le Journal*, 5 October 1912, p. 1

Mr. Lampué Indignant about the Autumn Salon

Our distinguished contributor Mr. Gabriel Mourey, in his criticism of the Salon d'Automne, said rather harsh truths to the innovators at that exhibition. Now city hall, in the person of Mr. Lampué, the most senior member of the Municipal Council, is indignant in turn, and protests against such a deformation of art. Mr. Lampué, in fact, has just sent the following open letter to Mr. Bérard, Undersecretary of the Fine Arts, a letter that cannot fail to have repercussions.

Sir,

If the voice of a municipal councillor were able to reach you, I would beg you to go take a tour of the Salon d'Automne [fig. 39].

Go there, sir, and, even though you are a minister, I hope you will come away from it as incensed as many people I know. I even hope you will whisper to yourself: do I really have the right to lease a public monument to a band of wrongdoers who act in the art world the way Apaches do in ordinary life?

You will wonder, Mr. Minister, as you come away from it, whether nature and the human form have ever been subjected to such an outrage; you will observe with sadness that, in this salon, they display, they accentuate, the most trivial ugliness and vulgarity imaginable, and you will also wonder, Mr. Minister, if the dignity of the government of which you are part is not being attacked, since it appears to be taking such a scandal under its protection, by housing such horrors in a national monument.

It seems to me that the government of the Republic ought to be more concerned with, and more respectful of, the artistic dignity of France.

39. Installation photograph, Salon d'Automne, 1912. Illustration in *L'Illustration* (1–7 October 1912): 268.

A year ago, and for a different reason, I wrote to your predecessor, who did not take any account of my letter, but, astonishingly, he then let everyone believe he was from the south, even though he was born in Montmartre.

Mr. Minister, a friend has told me privately that you are from Orthez, we are thus fellow countrymen, it is almost as if you were from Montréjeau; so then, *Diou bibant!* It will not be long now.

Respectfully yours,

Lampué

5 OCTOBER 1912

EDITORS' NOTE

1. Entries to the so-called Cubist Room no. 11 at the October 1912 Salon d'Automne included František Kupka, *Amorpha, Fugue in Two Colors* (National Gallery, Prague); Francis Picabia, *The Spring (La source)* and *Dances at the Spring II* (Museum of Modern Art, New York); Jean Metzinger, *Dancer in a Café* (Albright-Knox Gallery, Buffalo); Albert Gleizes, *Man on a Balcony* (Philadelphia Museum of Art); Fernand Léger, *Woman in Blue* (Kunstmuseum, Basel); and Henri Le Fauconnier, *Mountaineers Attacked by Bears* (Museum of Art, Rhode Island School of Design); sculpture on view included works by Amedeo Modigliani and Elie Nadelman.

Commentary

Among responses in the press to the Maison Cubiste and cubist paintings on view at the Salon d'Automne (fig. 39),[1] the art critic for *Le Journal,* Gabriel Mourey, thought the cubists "the most deplorable, the most reprehensible, the most dangerous" and, above all, mostly foreigners; he concluded: "We are pursuing at this very moment the syndicates of

40. Pierre Lampué, *Frontispice d'architecture byzantine,* undated. Agence Giraudon. Private Collection; formerly owned by Auguste Rodin. Photograph courtesy of Musée Rodin, Paris.

teachers, who propagate in youth the hatred of patriotism; what a pity that there exists no law permitting a judiciary action against the painters who propagate in the public the hatred of beauty!" (Mourey). Amidst such heated debate, the Socialist Pierre Lampué (1836–1924)—the ranking senior municipal councillor of the City of Paris and its former president—published an open letter in *Le Matin*—excerpted in *Le Journal* and many other papers—to the Undersecretary of the Fine Arts that surpassed such scorn with the accusation that this art actually represents an attack on "the dignity of the government . . . since it appears to be taking such a scandal under its protection, by housing such horrors in a national

monument." The cubists "act in the art world the way Apaches do in ordinary life," a term frequently used in the press to denote anarchists and street riffraff (Sonn). Lampué himself was also a successful photographer—exhibiting for many years in the photographic salons and specializing in documenting architecture—whose photographs could be purchased at the Giraudon Bibliothèque Photographique, 15, rue Bonaparte, across the street from the École des Beaux-Arts. Adolphe and his son Georges Giraudon—comparable to the Alinari in Italy—commissioned and sold photographs of works of art, architecture, and archaeological monuments to artists (Voignier, 148; Le Pelly Fonteny) (fig. 40). Lampué's participation in their project seems to have manifested an idealistic and ideological mission—preserving and promoting tradition and the classical and Christian past—as well as a commercial motive; hence the cubist "attack on tradition" violated the nationalist sentiments encoded in his aesthetic position.

Lampué's accusations must be understood in the environment of patriotism and xenophobia mounting during the buildup to World War I, with particular animus against the Germans (Leighten, "Picasso's Collages and the Threat of War, 1912–14" and *Re-Ordering the Universe*, 98–101; for an expanded treatment of this question and of Lampué himself, see Brauer, "L'Art révolutionnaire," chap. 4). More recently scholars have studied the ways this debate reflects nationalist discourses (Cottington) and the related fear that the French were being subjected to a foreign invasion on commercial and cultural fronts in advance of the military (Brauer, "Commercial Spies and Cultural Invaders"). The editors of *Le Journal* were not wrong in stating that the letter "could not fail to have repercussions": far from a merely rhetorical gesture, Lampué's letter raised serious political issues, taken up in the Chamber of Deputies two months later for debate at the level of the state (document 55), with numerous responses among the movement's defenders (for Guillaume Apollinaire's see document 47).

Brauer, "L'Art révolutionnaire"
Brauer, "Commercial Spies and Cultural Invaders"
Cottington, *Cubism in the Shadow of War*
Leighten, "Picasso's Collages and the Threat of War, 1912–14"
Leighten, *Re-Ordering the Universe*
Le Pelly Fonteny, *Adolphe et Georges Giraudon*
Mourey, "Au Salon d'Automne," *Le Journal*, 30 September 1912, p. 2 (authors' trans.)
Sonn, *Anarchism and Cultural Politics in Fin-de-Siècle France*
Voignier, *Répertoire des photographes de France au dix-neuvième siècle Français*

René Blum, "Préface, Salon de 'la Section d'or,'"
Galerie de la Boétie, 64 bis, Paris, rue de La Boétie,
10–30 October 1912, pp. 1–2

Preface, Salon of "the Golden Section"

The few artists whose works will be found collected here exhibited last year, in a gallery where the limited space was prejudicial to their works. Today, displayed in a more favorable setting, sufficiently isolated, these works assume, separately or as a whole, all their significance.

Whatever the impression that visit may leave with you, you will find it difficult not to laud the tenacious effort of young artists pursuing the path they have set out for themselves, with no concern for the obstacles, no preoccupation with the objections or snickering of some among the public. They do not have tendencies in common or deep affinities among them, but a single thought guides them: to disengage art from its tradition, from its outdated connections, to liberate it, in a word, since to subjugate it strictly to the artist's personality is to liberate it.

Stand in front of these canvases with bright colors, look at these busts with their bold forms, and try to find an influence. The exhibitors, escaping all constraint, rejecting all guides, owe nothing to anyone but themselves. It is from their sensibility that they receive lessons and inspiration.

It is not the variations of a school you will find here. You will observe only differences in sensibility. And it must be admitted that, with our artists, sensibility has been combined with a new element: imagination, which allows every variety, which validates every power of art, and which favors the most audacious combinations, the most unexpected collisions, creates a harmony almost always composed of contrasts.

That collaboration makes it possible to go beyond the limits of impressionism. Monet's formula is no longer adequate, the painter is no longer concerned with a moment or a color; his mind can offer him countless

visions of nuances and forms. Nature is now only a suggestive element of his art.

Some of these innovators were seduced by the same technique, but this is not the place to discuss it. That discipline, in fact, is not the element that impels us the most; it should not be seen as the principal appeal of an art that is valuable particularly for its affirmation of the personality.

That conception is still new and the experiments of our artists, though they are making constant progress, still find the public resistant and sometimes hostile. If they do not have the good luck to convince or if they do not directly reap the fruit of their initiative, at least they will have the merit of having shown the way, and it is to them that the honor of innovation may fall.

René Blum
OCTOBER 1912

Commentary

The Salon de la Section d'Or was planned by its principal organizers—Jacques Villon, Gleizes, Metzinger, Picabia, and Pierre Dumont—to be a major event, with 31 avant-garde artists exhibiting over 185 works, an ongoing lecture series in the gallery, and the publication of a journal, *La Section d'Or,* of which only the first issue appeared (Camfield; Debray; document 47). The salon—opening in October 1912, the same month Gleizes and Metzinger's *Du "Cubisme"* appeared—has been considered the most important independent self-organized group exhibition since the first impressionist exhibition (1874) in presenting a coherent movement and underlying philosophy to the public (Robbins). The artists exhibited their work in a vast space on the rue de la Boétie, which had previously served as a furniture store (Debray, 25). Two groups of modernists came together in this exhibition: the cubists of Room 41 at the Salon des Indépendants in 1911 (Gleizes, Metzinger, Léger, Robert Delaunay, and Le Fauconnier) and the Société normande de peinture moderne (Villon, Raymond Duchamp-Villon, Marcel Duchamp, and Picabia). Of the former group, Delaunay and Le Fauconnier refused to participate, and both also refused to be included in Metzinger and Gleizes's *Du "Cubisme,"* signaling their departure from this group effort in order to advance their independent careers (Spate). An earlier private group exhibition, Exposition d'art contemporain (Galerie d'Art Ancien et d'Art Contemporain, Paris, November–December 1911), brought most of these artists together

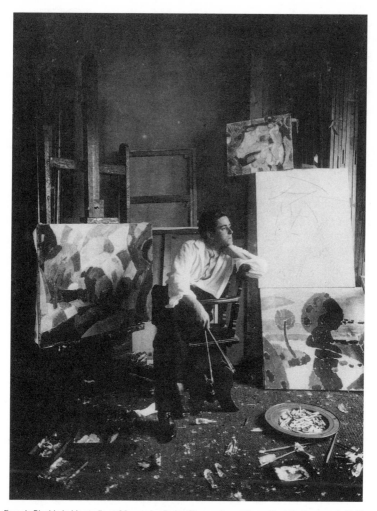

41. Francis Picabia in his studio at 82, rue des Petits-Champs (now 26, rue Danielle Casanova), 1912. Photograph. Archives Comité Picabia. Used by permission of William A. Camfield.

preceding the Salon de la Section d'Or; Picabia (fig. 41) played a crucial role by arranging for this exhibition, which anticipated the Salon de la Section d'Or in its scope (document 30; Camfield; Debray, 25). Daniel Robbins persuasively argues that, while the title alludes to the mathematical "golden section" (document 46), it also references the name of the earlier Bandeaux d'or group, with which Gleizes and other past members of the Abbey de Créteil were deeply involved (Robbins; document 29).

René Blum was coeditor and art critic for *Gil Blas* from 1910 to 1914 (document 30) and gave one of the afternoon lectures at this exhibition. His preface for La Section d'or consists of a defense of innovation, *tout court*. Asserting more firmly and clearly the ideas bruited in his preface for the Exposition d'art contemporain (Société normande de peinture moderne) in November–December 1911, he praises the cubists for their rejection of all schooling and tradition: "a single thought guides them: to disengage art from its tradition, from its outdated connections, to liberate it, in a word, since to subjugate it strictly to the artist's personality is to liberate it." According to Blum, their new art utterly rejects study, rules, and schooling of any sort; the cubists, "escaping all constraint, rejecting all guides, owe nothing to anyone but themselves. It is from their sensibility that they receive lessons and inspiration." Thus art springs from within the artist and is not merely a response to the outside world. "With our artists, sensibility has been combined with a new element: imagination, which allows every variety, which validates every power of art, and which favors the most audacious combinations, the most unexpected collisions, creates a harmony almost always composed of contrasts." These artists have gone beyond impressionism and beyond nature; their art is assured of individuality because it emerges from the uniqueness of their "personalities." This antitraditionalism, and the concept of "liberating" art from all discipline and history, evidently needs no defense in Blum's view—though his defense of cubism in these highly politicized terms would in itself have been as controversial for most viewers as the paintings themselves.

Camfield, "La Section d'or"
Debray, "La Section d'or"
L'École de Rouen de l'impressionnisme à Marcel Duchamp, 1878–1914
Robbins, "The Genealogy of the Section d'Or"
Spate, *Orphism*

La Section d'Or. Numéro Spécial consacré à l'Exposition de la "Section d'Or," vol. 1, no. 1 (9 October 1912). Rédacteur: M. Pierre Dumont. Secrétaire de la Rédaction: Pierre Reverdy. Guillaume Apollinaire, "Jeunes peintres ne vous frappez pas!," 1–2; Maurice Raynal, "L'Exposition de la 'Section d'Or,'" 2–5; G. Buffet, "Impressionisme musical," 5; Pierre Reverdy, "A un pauvre écoeuré," 6; Marc Brésil, "La revue de la presse et des livres," 6–7

Young Painters, Do Not Come to Blows!

A few young people—art writers, painters, and poets—are gathering to defend their plastic ideal, which is *the* ideal itself.

The title they have given their publication, *La Section d'Or* [The Golden Section], indicates well enough that they do not believe themselves isolated in art, and that they are linked to the great tradition. It happens that the tradition in question is not that of most pop ular art writers of our time. Too bad for these art writers.

A few of them, to give gravity to their flightiness, have not hesitated to demand that their opinions carry penal sanctions against the artists whose works they do not like.

Passion is blinding these poor people. Let us forgive them, for they know not what they are saying. It is in the name of nature that they are attempting to crush the new painters.

We wonder what nature can have in common with the products of degenerate art defended by the citadel of rue Bonaparte, or with the paintings of the wretched heirs to the impressionist masters.

It is much more likely that the severe investigations of the young masters who, with admirable courage, have accepted the burlesque name people used to ridicule them, will lead back to the study of nature.

The cubists, whichever current they belong to, appear to everyone concerned about the future of art to be the most serious and the most interesting artists of our time.

And to those who would like to deny such an obvious truth, we reply that, if these painters do not have any talent, if their art is unworthy of being admired, those who make it their profession to guide the public's taste have no reason to concern themselves with it.

Why so much anger, distinguished censors?

The cubists don't interest you? Then don't take any interest in them. But look at the shouting, the gnashing of teeth, the appeals to the government.

When so much venom enters the hearts of art critics, such violence, such lamentations prove the vitality of the new style of painting, and the works it produces will earn admiration for centuries to come, whereas the poor detractors of contemporary French art will soon be forgotten.

It must not be forgotten that they took shots at Victor Hugo. His glory was not diminished. On the contrary.

Guillaume APOLLINAIRE

The "Section d'Or" Exhibition

The chief characteristic of the Section d'or exhibition may be that it entails the first complete grouping of all the artists who ushered in the twentieth century, with works clearly representative of the tastes, trends, and ideas that characterize it overall. Until 19 10 P. Picasso, J. Metzinger, and G. Braque were the only pioneers of the movement (in various ways, which we will study moreover) and it was they who originated the term *cubism.* Since then, however, a growing number of artists have followed them and have made significant contributions to the search for truth; have displayed great courage in the face of critics' inevitable attacks; and have just caused a complete panic among the judges. These judges would readily call the outdated views of their ancestors drivel, even though, essentially, the poor things think just like them. In any case, the number of artists was so great and so valorous that it now seems very difficult to place all those represented under a single label. The difference between Metzinger and Picasso is as clear as that which separates Renoir from Cézanne, to whom they are comparable, by the way, in their temperaments and in certain gifts. In addition, there is such a difference between men such as Fernand Léger and Marcel Duchamp, between Picabia and

de la Fresnaye, and between A. Gleizes and Juan Gris, that, just as it no longer occurs to anyone to call Cézanne and Renoir impressionists, the term *cubists* is losing meaning day by day, assuming it ever had a well-defined one. "There were ten of them a year ago, there are fifty this year," a champagne broker declared the other day in a major daily. In his classic sample case he lines up venerable wine bottles that are much more commendable than he, of course, all the while composing little diatribes against every art venture that he thought, or at least that he was told, was resolutely free from any filthy commercial idea. Well, for once, that fellow was right, so much so that the development this art movement has undergone for some time has been so great that its proponents felt they ought to combine their efforts in this exhibition, despite brokers of any camp whatsoever, people who love the new provided it looks like the old, and the very people La Rochefoucauld spoke of, who, though fools endowed with some wit, nonetheless have no reasonable judgment.

This exhibition, furthermore, seems complete to me because it offers a set of infinitely varied temperaments. There are realists and sensualists, idealists and intellectuals, impulsives and ponderers, sages who, following the directive of the Greek philosopher, "combine an ounce of madness with their wisdom," and also madmen who temper their madness with some wisdom.

In a word, there is a rich flowering of diverse personalities such as can be seen in any artistic period of some value.

I will not mention here the principles of the only painting worthy of that name, which these brilliant minds have codified. What idea could be more beautiful than that conception of a *pure* painting which, as a result, is neither descriptive nor anecdotal nor psychological nor moral nor sentimental nor pedagogical nor, finally, decorative? I am not saying that such ways of understanding painting are to be overlooked, but there is no disputing that they are irremediably inferior. Painting must be exclusively an art derived from the study of forms with a disinterested aim, that is, with none of the aims I have just cited.

What more noble loftiness of thought could there be, what more frank refusal to please the ignorant gawkers at these big painting fairs held annually in covered markets on sinister avenues, whether Alexander III or Antin?

What is there to say of that rich flowering of new ideas, still very solidly founded on the best and the purest precepts of the ancients, on their

love of learning, which is a criterion for our ever-so-refined modern sensibility, on that tendency to weigh and measure everything properly, to leave nothing to vague and ever-so-ridiculous inspiration, on that absolute desire to make a painting otherwise than by holding the little nude model in one hand and by thinking, on the other, how you will sell the painting, which, all in all, must not be so easy as that? What is there to say, finally, about these noble efforts, except to note the enthusiasm they inspire?

Who would not be surprised by that marvelous idea borrowed from the Primitives, which the hackneyed artists of the Renaissance had forgotten, the idea of a painting of conception in place of a painting of vision? Only someone who was loved but meagerly by the gods and cherished but slightly by his mother could fail to glimpse the brilliant results that may be occasioned by that principle, curious and pure, of painting things as one conceives them and not as the myopic broker in whatever-it-might-be, introduced above, believes he sees them?

How can we not praise that categorical rejection of such antiquated childishness as horizontal composition, respect for perspective, trompe l'oeil, foreshortening, and other little tricks worthy of some Lépine competition or a theater in Le Châtelet?

And above all, that unvarying love of dogged research. One senses that the painters of these canvases, almost never satisfied with themselves and unhappy with their works as soon as they're done, do not wait to finish one painting before addressing new problems and let go of a resolved issue only to turn to the elucidation of a new one.

For them, any new thing immediately becomes an opportunity to know, to discuss, to draw profitable lessons, with the aim of refining their sensibility even further. Of course, they are not among those who think that no art is possible in our time; on the contrary, they live intimately with it and, as it were, set up guard to protect it.

Puvis de Chavannes, who was brought to the famous Galerie des Machines one day—since he never would have set foot there on his own—exclaimed: "Oh! My children, *there is no more art to be done!* How could a painter, a poet, fight such social influence, such power over the imagination? Let's get out of here! What will become of us artists in the face of that invasion of engineers and mechanics?" A man who proposes such outrageousness is capable of anything, but fortunately nobody reads him.

By contrast, the modern artist must live with his era and know how to extract the beautiful, the curious, and the sensitive from everything

that happens, to extract the pretexts for diversions of the mind and of the imagination. But obviously, the ignorant have no right to conduct similar investigations, it's quite enough already if they never think about them.

For the most part, the artists whose works we have seen appear remarkably well educated. No branch of intellectual activity fails to interest them and they are also hard workers, which means that the most difficult problems are very familiar to them.

At this point, it is fitting to recall the masterful quality predominating in all these works.

Overall, the artists are gifted with a very keen intelligence. Nevertheless, I feel obliged to say that they may have misused it slightly, though that misuse seems excusable. In point of fact, since nearly all of them are in a period of research, they have emphasized the intellectual element over the purely human. But that cannot be a reproach in this case, since as far as theories go, research is never too intensive and, in any case, the artists may humanize themselves only too quickly.

We have just considered a few of their opinions; let us now examine the works in particular.

The broker in I-remember-what-now, since he sells wine to Rodin, but whom I swear not to talk about this time, readily called the "cubists" blind and hunchbacked, and suggested they do not know how to paint. But, in our time, the man who may best know how to paint is a cubist. This is surely J. Metzinger.

He displays a marvelous skill and knowledge and, had he only those qualities, he could be considered one of the best painters of our time. Yet he displays others as well. The nobility and delicacy of the *Portrait of Woman* he is exhibiting will be particularly appreciated. That portrait, severe and academic in its manner, is appealing for its finesse and especially for the self-assurance in its execution. The compelling charm it exudes attests to J. Metzinger's refined sensibility. No one will be surprised that the artist is being compared to Renoir and that he has the latter's grace, vivaciousness, and several of his best qualities.

Francis Picabia's work was viciously attacked recently, especially, of course, by those who did not believe they needed to make an effort to understand it. For many critics, it's shameful to ask the artist to explain his conception of art. That shows a paucity of human respect. How much better it is to appear lacking in insight than to risk foolishness you may later regret. M. Nozière expressed it very well recently: it is imprudent to say,

while looking at a painting, "It's foul or idiotic!" Yes, alas, and how many people now regret treating the works of the great Mallarmé that way.

It is nevertheless true that Picabia's conception is beautifully bold and vast in scope. I cannot expound on it in the limited space I have here, but I will do so at more length some other time. It is very obvious that one must get to know it, since it is excessively personal, but there is no denying that, even in considering his submission only superficially, his painting already seems to have a rare power and an extreme appeal. But, I repeat, it is still necessary to take great care in learning about it and, given the rigorously personal pursuit, it is good not to judge it without due consideration. We have never understood Mallarmé at the first reading, and those who make fun of Picabia's work would similarly mock Racine's *Iphigenia* if they had not already been taught what it was about.

Alongside that fiery portrait of a woman, which—and this is very rare—is both very powerful and very restrained, Fernand Léger exhibits several landscapes that are extremely worthy of interest. Léger, who once said, "Let's not forget the impressionists," has wisely combined the precepts of these masters and modern imperatives. In these landscapes, it will be apparent that the slightly depraved charm of sensual vision has been tempered by the rigor of the school's principles. In addition, Léger seems to be one of the most deserving artists in the group, given that, endowed with a tumultuous imagination and a violent temperament, he is forced to restrain them as much as possible, counterbalancing them with precision and reason. Like J. Metzinger, he possesses a rare skill and his art has a distinction that will be very appealing.

Albert Gleizes exhibits several canvases, the largest of which will attract special attention. For some time, A. Gleizes has been making surprising progress. Very gifted from a pictorial perspective, he used to be somewhat careless. Today he has to a great extent pulled himself together. His large painting demonstrates a very clear tendency toward classicism, it may even be a bit "museum," but the vigorous lines and rich color, as well as the originality of his ideas, mitigate the apparent coldness. In addition, this painting shows how wrong it is to claim that cubism does not please the eye, since, though it is not altogether pure painting, it is deliciously charming to look at.

Juan Gris has made a considerable effort. He is certainly the most unshakable purist in the group. To indicate clearly that the exclusive study of forms is his only preoccupation, he numbers his paintings rather than

giving them titles. The painting that depicts a vanity table equipped with its implements will be an attention-getter. To make it clear that, in his view of pure painting, there are absolutely antipictorial objects, he has not hesitated to affix several real objects to the canvas. In fact, flat surfaces cannot be painted, since they are not bodies; if we paint them, we fall back into imitation or pursue the skills characteristic of sign painters. If I imagine a bottle and want to transpose it as it is, the label covering it seems like only an insignificant accessory that I may omit, since it is only an image. Nevertheless, if I am intent on depicting it, I could copy it exactly, but that is pointless labor; therefore, I fix the real label to the canvas, but only after cutting it to fit the shape I have given the bottle, which constitutes the truly tricky part of the idea and determines its charm. Juan Gris applied the same principle to the mirror he placed on his canvas. That act has led to many discussions, but it is possible to say that it does not harm the work in any way and indicates the odd originality of Juan Gris's imagination.

Marcel Duchamp is also one of the artists in the group who will be accused of not knowing how to paint, for the express reason that he is one of those who acquits himself best. *The King and Queen,* a work he is exhibiting this year and which seems much more comprehensible and less convoluted than *Nude Descending the Staircase,* is particularly rich in felicitous new discoveries. Marcel Duchamp combines Metzinger's delicacy and Picabia's refined sensibility. He is remarkably skillful and, if one still discerns a little incoherence in his submission, it is because he is extremely young and may somewhat indulge his temperament, which is charming to be sure, but needs a little strengthening. He will no doubt achieve that as he simplifies and condenses the contents of his sensibility.

One of the revelations of this exhibition is certainly Louis Marcoussis's submission. Curiously adept and with a charming sensibility, Marcoussis has composed several watercolors that include a few personal and already very distinct discoveries. His etchings are striking for their skill and craft, and his portrait of Guillaume Apollinaire is charming in its delicacy and ingenuity. When he has sufficiently freed himself from Juan Gris's influence, he will no doubt show us subtle impressions.

Pierre Dumont is an ardent colorist who has not yet adequately rid himself of the impressionist influence. He trusts in his gifts, which are considerable, but may not apportion them adequately. The serious labor

he is engaged in will certainly ensure a more perfect equilibrium in his works, and when he "reasons out" his intentions somewhat more and proves to be somewhat less of a "painter," they will acquire a simplicity and a unity, which his large still life, though very interesting, may still be somewhat lacking.

Marchand, who could submit only a few things, exhibits a slightly tortured and feverish imagination. Well-versed in the craft of painting, he may misuse it somewhat at the expense of his conception of art, which does not appear sharply, and of his method, which still seems rather unclear. He too has not yet liberated himself from the impressionist influence, but he can hardly be reproached for that, since it will disappear.

Henry Valensi completes that important group in a curious manner. Here is an example of an artist who, disconcerted by the inadequacy of the old formulas, is resolutely seeking a new direction. He may still attach somewhat too much importance to the subject, and, it seems, even falls somewhat into the superficial observation dear to the futurists, but, given the qualities found in his paintings, one senses it will not take him long to find the specific manner that suits his own conception, which is still somewhat ill-defined.

The sculptor A. Agero submitted a wooden bas-relief depicting a boxing session, among other works. It is probably his best. In it he displays a power and, above all, a self-assurance he had not previously achieved. Some may find the repetition of the same shapes in the figures of the spectators somewhat monotonous, and the conception of the boxers' gestures is not altogether pure and immaculate, as he says, but the work is striking in its novelty and will be found very pleasing. Finally, among several very gracious works, there is a male bust that is much more delicate and powerful than the living model used for it.

Such are the exhibitors who seem best suited to be included among the artists tormented by the search for novelty. Let those who do not understand or do not wish to understand refrain from looking at their works, let them worship the paintings of the ancients; we will not prevent them and we will do as they do. But allow us to think, like the common people, that one does not live with the dead; that new times bring new mores; that our modern sensibility is different from the old one; and that we therefore cannot commune with or fully appreciate the works of the ancients or even those of the previous century. And then, since France has always been the country of the most productive daring, even if you

cannot understand that of the artists we are presenting, it is rather petty not to take an interest in them, and above all, profoundly ridiculous to laugh at them with imbecilic irony and cowardly skepticism.

Maurice RAYNAL

Musical Impressionism

Right now, music is going through a period fairly similar to what impressionism was for painting a century ago.

In the name of the natural laws of sound vibration, it is getting away from scholastics and musical rhetoric and is reacting against the arbitrariness of the harmonic codes and the laws of composition.

In the same way, in painting the laws of light vibration were the starting point for impressionist theories; and in both cases those theories culminate more in a search for objective reality than in an effort to be creative.

The impressionists and neoimpressionists have attempted to give the illusion of atmosphere, of vibrant light, on the canvas by using complementary colors and by distributing tones.

This system is very similar to the way one adds harmonics far removed from the fundamental to the common chord, to produce a chord found abundantly in all modern works and which gives the illusion of sounds moving about the atmosphere. Tonality comes forth no longer through the simple relationships between thirds and fifths, but through a subtle amalgam of all subdivisions of its fundamental sound, whose tonal logic our ears barely follow.

The musical idea is no longer an abstract, measured discourse interrupted by well-defined periods, a line whose precise pattern can be followed, but a series of embryonic lines dependent on the harmonic work, which can hardly be discerned in the subtle combinations and dissonances as a whole. The aesthetic impression we have of it is less the result of the consistent logic of the idea than of the entirely sensorial pleasure of that overlapping of sound vibrations: less an "arrangement" than the search for rare harmonies whose value of expression depends not at all on a controlling melodic idea but rather on their reciprocal relationships, their relativity.

In short, we observe a prodigious enrichment of the musical "material," the flowering of all the natural resources of music—but has music itself benefited from these new riches?

We appeal to the works to form our own opinion on this subject and are led to observe, with a few exceptions, the general weakness of what has been produced from these tendencies, their inconsistency and their lack of depth, which also seems clear to us in the impressionist project in painting.

The proof also lies in the impossibility of today's music to survive on its own without a literary groundwork of some kind. Unlike present-day painting, which is moving toward an increasing freedom of expression, music, despite the new riches of its "material," is no longer sufficient unto itself, and, to exist, the works must prop themselves up on a program they claim to be accurately describing.

Music is thus becoming a sort of sound imagery.

How can we fail to understand how puerile that project is, and that overlaying such new harmonies, however subtle they may be, on a literary framework, with no architecture proper, is not making music?

How can we not conclude (emboldened as well by the example provided us by impressionism in painting) that a great fluorescence in today's music is impossible?

What does it matter to us, therefore, that we have left behind the harmonic codes, the formulas, the ancient molds, if it is only to arrive at a greater enslavement of music itself to other procedures that run the risk of impeding its development even further?

G. BUFFET

To a Poor Disheartened Man

So, once more, M. Lampué is indignant. Indignation is the artistic function of that worthy municipal councillor.

At fixed intervals he feels the need to treat himself to a little nausea. To provide himself with that cheap amusement, he waits for a painting exhibition to open. He takes a look around—and boom, the little disgust hits him.

And, on a regular basis, coming out of that exhibition where he's choking on his indignation, he rushes home, takes up his loveliest pen, and writes to the minister!!

No one replies, but who cares!

He starts up again at the next opportunity.

And this time, M. Lampué is counting on a sense of regionalist solidarity to bring his request to fruition.

And he's quite right, isn't he, to demand the most severe penalties against the artistic wrongdoers.

What, if you please, do they mean, these works about which one understands nothing and that no longer have anything in common with the artistic emotion a photograph can give us?

And what will become of photography if that goes on? *Diou Bibant!* It's time to stop such vandalism, Mr. Minister!

It seems, dear M. Lampué, that you cherish photography. Well, we do not want to encroach on its domain, we leave room for it, we even give it more room, since some of us recognize that it will replace to advantage certain pictorial works that once occupied a place of honor.

Of course, we know very well that cubist works do not yet have the appeal of that famous photography, even when it manifests itself in pornographic subjects. But we are not working toward the same goal. And if you cherish *photography,* we will let you enjoy it in peace.

But you in turn must stop going to painting exhibitions whose atmosphere is deleterious for you. That will spare you the terrible fits of anger that can play such nasty tricks on the people subjected to them. You see, when you're angry, you don't do any good. And then, you must beware of heavily breathing friends. Either they're asthmatics, which is unfortunate for them, or they're mischief makers who whisper tall tales, like the obliging pal in high school who takes it upon himself to whisper the lesson to you.

You're furious, upset, you lose your head, and, in all good faith, you say or write what is whispered to you—and there it is, you've said something stupid.

And after that, you know, M. Lampué, there's no advantage to being from the Midi, the result is the same as if you "had only been born in Montmartre!!!"

Finally, let's hope your epistle will have a positive effect on its recipient. If he's clinically depressed, it will cheer him up for a moment.

Pierre REVERDY

Book and Press Reviews

I will not resist the pleasure of citing, at the beginning of this article, these few lines on the cubists that appeared in *Paris-Midi* and in *Action,* signed by our colleague André Tudesq. After explaining what MM. Metzinger, Gleizes, Léger, Le Fauconnier, Marcoussis, Picabia, and

Juan Gris were before they gave themselves heart and soul to cubism, M. Tudesq writes:

"They sold their canvases and drawings without difficulty;——as the popular expression has it, they were on their way. Yet, having concluded that the artist's high destiny is neither to follow nor to be satisfied with vain kudos and immediate advantage, they broke with their past. They have secretly stored away in cardboard boxes—not without sadness, believe me—what had been their momentary dream. And with resolute heart they went out to meet anger and sarcasm head on. The oldest of them is not yet thirty-five. With only one exception *they are all poor;* and they live only by their art.

"Now, if you can still muster the courage, laugh."

I would be annoyed with myself if I toned down these final lines of an article with commentary.

In general, if the cubists complain about what the press writes about them, it's because they're difficult. Yes, I know, there's M. Metzinger; but people lend money only to the rich, the mob assures us. M. Metzinger will forgive M. Vauxcelles for having lent him a great deal of money, just as some day M. Vauxcelles will regret the unfair lines he wrote about "X . . . the lad I don't wish to promote."

Finally, MM. Metzinger, Gleizes, and Picabia will undoubtedly smile to learn how casually the Napoleon of cubism is treated in a news item. He is called "Picasho," and that may not be a misprint.

Before the Salon d'Automne of 1912, the cubists—we must allow them that grotesque designation, since they accepted it so as not to seem frightened by it—have generally been considered by the press to be hilarious eccentrics, people who delight in bamboozling the mob with incomprehensible flights of fancy. Our colleagues laughed, expecting someone would put an end to these burlesque peregrinations in the field of art.

Now M. Ernest la Jeunesse merely tells Guillaume Apollinaire that "he doesn't like it"; others hesitate, and some, like M. Gabriel Mourey and M. Vauxcelles, snicker or storm; finally, dear M. Lampué who, along with a name well suited for ridicule, is saddled with a municipal post, officially calls for the plunderers to do their job. I forgot our grave colleague, M. Georges Lecomte, who resigned as honorary member of the Salon d'Automne. Decidedly, the cubists are no longer happy to be "those goddamned little cubist practical jokers," as the condescending

and colloquial M. Vauxcelles wrote. "Goddamned little . . . !"—isn't that somewhat sympathetic already?

While awaiting better days, when they will see M. Vauxcelles's smile shine on their future exhibitions, the cubists take consolation in knowing that, in M. Vauxcelles's own home, friendly fingers are skillfully weaving a discreet garland for cubism. Let us hope we shall often read again the sympathetic items by MM. Salmon and Raynal and that *Gil Blas* will once more open its columns to articles such as M. Raynal's *Conception and Vision* [document 44], which we have not forgotten.

But there is not only the exquisite *Gil Blas* and the prudish *Journal* [documents 24 and 45]; there is *Paris-Journal* [documents 17, 19, 22, 23, 26, 27, and 32], in which many items appeared, even an article by M. Kahn on Gleizes. It is in *Paris-Journal* that M. Olivier Hourcade published a shrewd study of the Salon d'Automne. M. Olivier Hourcade concluded: "Of course, if you want to judge these painters not by their own theories but by your own, I will never presume to get you to like them."

Along with *Paris-Journal*, we must cite *Comeodia* and rich articles by André Warnod; and *Le Temps,* the grave and sententious *Temps,* which offered its readers auspiciously conciliatory words after a level-headed article by M. Thiébaud-Sisson [*sic*]. We must not forget *Paris-Midi,* where, thanks to M. Tudesq, we now find news items and information on cubism. It is there that M. René Dupuy discussed logarithmic painting with great wit.

In *La Cote,* M. Roger Allard wrote a powerful and scathing essay that was also an excellent defense of M. Le Fauconnier. But we have to regret his harshness—I would even say his injustice—toward a painter who has much more value than what M. Roger Allard wrote about him. We have to hope that at the Section d'or, M. Roger Allard will reconcile himself with the undeniable art of that artist, whose canvases at the Section d'or, we are assured, will be very beautiful.

Finally, we cannot forget the anticipated articles in the *Intransigeant* and other journals, written by Guillaume Apollinaire, which have attracted a great deal of attention. In them the valiant critic fights the good fight.

Several works on cubism or the cubists, written by our charming colleagues—MM. Guillaume Apollinaire, André Salmon, Olivier Hourcade, Jean Metzinger, and Gleizes—are constantly being announced

as forthcoming. M. Maurice Raynal will also collect his lectures and articles in a volume.

On this subject, permit me to express my regret that no publisher has had the idea of bringing out a book on cubism on the occasion of the opening of the Salon d'Automne and the Section d'or. That publication would have satisfied a great number of requests. It is not only a commercial blunder to have failed to do it, it is a deplorable act of artistic oversight.

<div align="right">Marc BRÉSIL</div>

Commentary

The journal La Section d'Or was founded at the moment of the exhibition of the same name, though only one issue appeared (translated here in full). The five essays, by Guillaume Apollinaire, Maurice Raynal, Gabrielle Buffet, Pierre Reverdy, and Marc Brésil, range from spirited defenses of the beleaguered cubists to theoretical treatments of modernism in painting and music. Planned future contributors included Roger Allard, Adolphe Basler, René Blum, Max Goth, Olivier Hourcade, Max Jacob, Pierre Muller, Jacques Nayral, Maurice Princet, P. N. Roinard, André Salmon, Paul Villes, André Warnod, and Francis Yard. Pierre Dumont was the managing or business editor and Pierre Reverdy the editor. Evidently, they felt that an editorial statement of intention was sufficiently evoked by Apollinaire's passionate opening article, with its battle-cry title, in defense of the cubists (Lucbert).

Responding to Pierre Lampué's letter and articles like those by Gabriel Mourey, Urbain Gohier, and Henri Guilbeaux (see documents 24, 25, and 45), Apollinaire makes it more the occasion to counter hostility in wide reaches of the press than to undertake an explanation of cubism. He reasserts that the cubists "appear to everyone concerned about the future of art to be the most serious and the most interesting artists of our time," pointing out that these critics need not concern themselves with an art that they find unworthy of interest. "But look at the shouting, the gnashing of teeth, the appeals to the government." "Why so much anger, distinguished censors?" he asks, concluding that "when so much venom enters the hearts of art critics, such violence, such lamentations prove the vitality of the new style of painting." Again, Apollinaire takes the libertarian high ground, pointing to these critics—many of them socialists and libertarians themselves—as falling back on the state to prop up their

taste. But it is the very intensity of their reaction that, for Apollinaire, proves the importance of this art, challenging them in its intense push toward a new future. Thus two themes thread themselves through his short piece: the freedom of artists to pursue their own vision and the important role art plays in presaging the future (Leighten; see also commentary in document 62). The very title of the exhibition—"The Golden Section"—Apollinaire rightly cites as an allusion to a glorious past, a mathematical proportion dating back to Egyptian art, "the great tradition," referred to in ancient literature and cited by Jacques Villon, as referenced in his readings of Leonardo (Camfield, "Juan Gris and the Golden Section"; Henderson, 66–67; Hicken, 187–89). The notion of an underlying proportion in great art may have sufficed to evoke for the cubists their excitement about the new non-Euclidean mathematics. Thus the cubists are by no means divorced from the past, merely from a puerile, immediate academic past, "the products of degenerate art defended by the citadel of rue Bonaparte [the École des Beaux-Arts], or . . . the paintings of the wretched heirs to the impressionist masters." Apollinaire's article and the Section d'Or exhibition itself became a catalyst for a polarized debate between cubism's defenders and its adversaries, which pitted the contributors to the *Section d'Or* against such well-known critics as Louis Dimier, of the royalist movement Action française, and Louis Vauxcelles, former champion of the fauves (Lucbert; Weiss, chap. 2).

Maurice Raynal's article, "The 'Section d'Or' Exhibition," opens with the grandiose claim for the show "that it entails the first complete grouping of all the artists who ushered in the twentieth century." He defends the cubists in similar terms to Apollinaire, praising their "significant contributions to the search for truth" and their "great courage in the face of critics' inevitable attacks." He calls cubism "the only painting worthy of that name" and asks, rejecting all the terms of both academic and symbolist art: "What idea could be more beautiful than that conception of a *pure* painting which, as a result, is neither descriptive nor anecdotal nor psychological nor moral nor sentimental nor pedagogical nor, finally, decorative?" Not surprisingly he concludes—echoing his essay "Conception and Vision" in the August issue of *Gil Blas*—that "painting must be exclusively an art derived from the study of forms with a disinterested aim, that is, with none of the aims I have just cited," reasserting his Kantian position that cubism is a "painting of conception in place of a painting of vision" (see document 44 and commentary). Only briefly

explaining this idea here, he goes on to praise individual cubists, especially defending Francis Picabia's right to his "rigorously personal pursuit." His discussion of Juan Gris—"the most unshakable purist in the group"—is of special interest, since it is one of the few discussions of collage in the prewar period:

> To make it clear that, in his view of pure painting, there are absolutely antipictorial objects, he has not hesitated to affix several real objects to the canvas. In fact, flat surfaces cannot be painted, since they are not bodies; if we paint them, we fall back into imitation or pursue the skills characteristic of sign painters. If I imagine a bottle and want to transpose it as it is, the label covering it seems like only an insignificant accessory that I may omit, since it is only an image. Nevertheless, if I am intent on depicting it, I could copy it exactly, but that is pointless labor; therefore, I fix the real label to the canvas, but only after cutting it to fit the shape I have given the bottle, which constitutes the truly tricky part of the idea and determines its charm.

Gabrielle Buffet met Picabia (1879–1953) in 1908, while studying music in Berlin; they married the following year. Buffet was a serious student of music and musicology, having studied with both Gabriel Fauré and Vincent d'Indy (Camfield, *Francis Picabia*, 15). D'Indy, a devotee of Wagner, impressed his knowledge of symbolist aesthetic theories upon his students at the Schola Cantorum; he was especially close to the Roman Catholic symbolist Maurice Denis and shared Denis' anti-Semitic and reactionary values (Vaughan, 38–48; Marlais), though Buffet seems to have been uninfluenced by this. There is clear evidence that Picabia was intellectually engaged with the anarchist movement at this juncture, an orientation that continued into his Dada years, constituting for him one level of a commitment—which he shared with Buffet—to the avant-garde (Papanikolas). When Buffet and Picabia met, the artist was restless with his somewhat conventional painting, and the two excitedly shared a dialogue about the equivalence of art and music and the importance of "liberating" both (see commentaries for documents 67 and 68). Buffet's ideas were based on the radical ideas of composer and theorist Ferruccio Busoni, especially his *Sketch of a New Esthetic of Music* (trans. T. Baker, New York: G. Schirmer, 1911). According to Rothman, "At stake here was the attempt to draw music as close as possible to 'nature herself.' Not to represent nature, but to be nature. In this, Busoni imagined a kind of

musical composition that would live and grow as any natural organism—music as a body of sorts, self-organizing and self-contained, a music guided by 'natural necessity,' following 'its own proper mode of growth.'" (Rothman, n.p.). In his book, Busoni lamented,

> We have divided the octave into twelve equidistant degrees because we had to manage somehow, and have constructed our instruments in such a way that we can never get in above or below or between them. Keyboard instruments, in particular, have so thoroughly schooled our ears that we are no longer capable of hearing anything else—incapable of hearing except through this impure medium. Yet Nature created an *infinite gradation—infinite!* Who still knows it nowadays? (cited in Hugill)

Buffet and her fellow student, future composer Edgar Varèse (1883–1965), shared an enthusiasm for Busoni's ideas and even built several instruments he had proposed as escapes from traditional tonality (Rothman; Hugill). Such ideas were profoundly influential on both Picabia's cubist abstractions and his later mechanomorphic works (Rothman).

In her essay, "Musical Impressionism," Buffet rejects recent modernist music, comparing it to impressionist painting of "a century ago." Seemingly moving forward, "in the name of the natural laws of sound vibration, it is getting away from scholastics and musical rhetoric and is reacting against the arbitrariness of the harmonic codes and the laws of composition." But, according to Buffet, such music remains mired in the past: "In the same way, in painting the laws of light vibration were the starting point for impressionist theories; and in both cases those theories culminate more in a search for objective reality than in an effort to be creative." Though she does not define what "creative" music would be, she ends by rejecting both impressionist music and impressionist painting: "How can we not conclude (emboldened as well by the example provided us by impressionism in painting) that a great fluorescence in today's music is impossible?" Thus she clears the way for the cubist abstractions in the Section d'Or exhibition as well as for a future music, whose development will displace notions of modernism still based on mistaken literary and imagistic attachments.

Among other important aspects of this single issue of *La Section d'Or,* Pierre Reverdy (1889–1960)—poet, art critic, and future editor of *Nord-Sud*—makes his debut as a defender of cubism. Having arrived in Paris in October 1910, Reverdy found his way quickly to the center of the

cubist controversy. In his first theoretical article on cubism—which appeared in *Nord-Sud* in March 1917 ("Sur le cubisme," *Nord-Sud* 1, no. 1 [15 March 1917]: 5–7)—he claimed that the painters were the first to learn from Stéphane Mallarmé and Arthur Rimbaud, praising Apollinaire and other neosymbolist poets as transitional to modernity: "To create the work of art which may have its independent life, its [own] reality which is its proper end, appears to us more elevated than any fanciful interpretation of real life" (cited in Stone-Richards, 99–100 and 112). In the present essay, however, he mounts a critique of Pierre Lampué, the architectural photographer (fig. 40) and municipal councillor whose open letter in *Le Journal* on 5 October initiated this round of debate in the press over cubism (document 45; see also documents 49 and 55). Reminding readers of Lampué's career as a photographer, Reverdy mockingly asks, "What, if you please, do they mean, these works about which one understands nothing and that no longer have anything in common with the artistic emotion a photograph can give us?" Answering this Lampuéiste question, he positions photography and cubism at opposite ends of the creative scale: "It seems, dear M. Lampué, that you cherish photography. Well, we do not want to encroach on its domain, we leave room for it, we even give it more room, since some of us recognize that it will replace to advantage certain pictorial works that once occupied a place of honor." With this left-handed slight to academic painting, he concludes: "Of course, we know very well that cubist works do not yet have the appeal of that famous photography, even when it manifests itself in pornographic subjects. But we are not working toward the same goal." This argument, which began with the impressionist movement, is repeated by Buffet in *Camera Work* in June 1913: "Thanks to photography and to the cinematograph this kind of [naturalist] painting has ceased to live" (document 67).

The writer Marc Brésil, in the last essay in the issue, reviews the press's reaction to the cubists, in what had become an extremely polarized debate, as a way of defending cubism and ridiculing its detractors. He cites, as Lucbert notes, the unconditional defense of the partisans—Apollinaire, Raynal, Allard, Salmon, Hourcade, Warnod, and others—and the invectives of its adversaries: Vauxcelles and a legion of *passéistes* (those devoted to the past) writing in the mass-circulation papers: Georges Lecomte at *Le Matin,* Gabriel Mourey and Camille Mauclair at *Le Journal,* Laurent Tailhade at *Comoedia,* André Nède at *Le Figaro,* Louis Dimier at *L'Action Française,* Louis Paillard at *Le Petit Journal,* and Paul Ginistry at *Le Petit*

Parisien. Between these extremes, writing more nuanced if not enthusi-astic criticism, are Robert Kemp at *L'Aurore* and Gustave Kahn at *Le Mercure de France* (Lucbert, 46–47). Brésil also praises the favorable articles on cubism by André Tudesq in *Paris-Midi* and in *L'Action* (where Tudesq discusses Metzinger, Gleizes, Léger, Le Fauconnier, Louis Marcoussis, Picabia, and Gris), M. Thiébault-Sisson in *Le Temps,* and Apollinaire in *L'Intransigeant.* Finally, Brésil promotes various forthcoming books by supporters of the movement, including proposed works by Apollinaire, Salmon, Hourcade, Metzinger, and Gleizes, doubtless including *Les peintres cubistes, La jeune peinture française,* and *Du "Cubisme"* (documents 50, 51, 57, and 62), all of which appeared shortly after the Section d'Or exhibition.

Camfield, *Francis Picabia*
Camfield, "Juan Gris and the Golden Section"
Henderson, *The Fourth Dimension and Non-Euclidean Geometry in Modern Art*
Hicken, *Apollinaire, Cubism and Orphism*
Hugill, "Imaginary Music Technologies"
Leighten, *Re-Ordering the Universe*
Lucbert, "Du succès de scandale au désenchantement"
Marlais, *Conservative Echoes in Fin-de-Siècle Parisian Art Criticism*
Papanikolas, "The Cultural Politics of Paris Dada, 1916–1922"
Rothman, "Between Music and the Machine"
Stone-Richards, "Nominalism and Emotion in Reverdy's Account of Cubism, 1917–27"
Vaughan, "Maurice Denis and the Sense of Music"
Weiss, *The Popular Culture of Modern Art*

Lan-Pu-Hé, "Cubist Bar," *Fantasio,* 15 October 1912, p. 195

Cubist contains . . . "bist."—Victor Hugo

On rue de Ravignan, up on the Butte, the bartender has a debonair look. There is nothing of the Yankee or the Anglo-Saxon about him; he seems more like a sentimental Auverpin. He must have coal merchants in his family; perhaps he is a former coal merchant himself. Not all of them end up as managers of furnished rooms on the outskirts of the city or as senators, as is generally imagined.

A modest bistro counter is enough for this unmysterious alchemist, on which he pours out to the "workers" and housewives from the neighborhood—as to des Grieux[1] homesick for the parish of the Moulin de la Galette—absinthe, spiked coffee, or export cassis, "with much more export than cassis." You would never suspect that this modest tavern keeper holds the fate of contemporary art in his broad hands with their spatula fingers.

The rumblings of the revolution that must sweep everything away emanate from the back room. It is there that the general meetings of cubism are held. It is there that these Leatherstockings of line and color shout their war cry and shake their tomahawks over piles of saucers, waiting to scalp their intransigent elders.

In fact, they are fine boys for the most part, to whom "our friend Paul," the bartender of the place, ought simply to serve, as an evening drink, some very clear infusion of hellebore, if hellebore possessed the prepran-dial virtues of absinthe, which I doubt.

It would be wrong to believe them terribly dangerous. There is no need for iron gates to separate them from the public. A feature article in *Le Figaro* would be enough to subdue them. They would become conservative in turn and would end up at the Institut—with rheumatism, a subscription to the

Revue des Deux Mondes, and principles. Mr. Paul Bourget would celebrate their art as the equal of that of the Pre-Raphaelites, and Mr. Arthur Meyer would open the imposing columns of *Le Gaulois* to exegeses of their work.

First, and this deserves to be noted, they generally find alcohol repugnant. Let us illustrate that observation with an anecdote. Recently, a young dramatic actress, alongside an exquisite poetess, and whose auspicious beginnings in a dark melodrama the Left Bank applauded not long ago, climbed that holy mountain in the company of one of her friends, an impenitent Baudelairean. She hoped to see cubists *up close.* Wanting to pay lip service to local color, when she found herself installed under a disconcertingly geometrical fresco at the Academy of the Cube, she thought it advisable to order "a stiff Pernod" from "our friend Paul."

Our friend Paul, stunned, made her repeat the order twice.

"A Pernod. Don't you understand?"

"Oh yes, ma'am, it's just that these gentlemen, the cubists, do not usually drink Pernod."

"What do they drink then?"

"*Milk.*"

It was about six thirty when they began to arrive one by one: Juan Gris, Markous—"Markousi" in the cubist religion—and Picasso, whose notoriety has extended beyond the Montmartre neighborhood. These are the three pillars of the place. If "our friend Paul" were not to see them, he would lose his bread and butter. Sometimes the theorist of cubism, Guillaume Apollinaire, who resembles Saint Gregory Nazianzus only more eccentric, comes in to join them. They shake up doctrines. They quote Bergson and Leonardo da Vinci.

But a car roars up, it's Picabia, the only cubist whom fate granted a private income from his cradle. He arrives in his fifty-horsepower automobile. The chauffeur swears: "That SOB of a hill!" "Our friend Paul" rushes up: "How have things been going since we saw you last? You can imagine, we thought you were dead."

No. Picabia was not dead. If he had been, everyone would have known—his pictures would be selling. But he's just come directly from Céret. Céret in the Pyrénées-Orientales, the Mecca of cubism. It is there that the sculptor Manuel Héret [Hugué], known as "Manolo," and the painter Haviland, son of the famous Limoges porcelain dealer, live. The poet and astrologer Max Jacob, whom we recently had the privilege of running into at six o'clock in the morning, painting a cubist landscape at

the Bois de Boulogne, went along. They found common cause in the cube, it was charming.

Picabia proclaims, with the air of a dark torero killing the bull: "In 1844, the mob booed Courbet; in 1880, it was slashing Renard's canvases; in 1912 . . ."

Then the theories begin. No one understands a word. But everyone talks. In the meantime, the room is invaded by everybody and anybody associated with cubism. Léger, Derain, Le Fauconnier arrive one by one. "Our friend Paul" is sent for groceries since food is not served here, but "you can bring in your own meal," the proprietor explains to me.

Then, while the bartender sees to the groceries, a voice rises up, solemn, addressed to the proprietress of the place.

"Madame Paul!"

Lord, what is about to happen? What oracle is going to emerge from that carefully shaven mouth? We are all ears, ready to note down for future generations the word that is to save French art from its current decadence: "Madame Paul!" repeats the voice. "Please tell the Municipal Council of Paris on our behalf that it's a pain in the ass."

"Very good, sir, and what else?"

"Then, bring us . . . bring us . . . *the dominos.*"

Lord, admit it, your right hand is no longer terrible. The cubists play dominos.

Lan-Pu-Hé

15 OCTOBER 1912

EDITORS' NOTE

1. Allusion to des Grieux, the lover of Manon Lescaut in the novel of the same name by Abbé Prévost and in the opera *Manon* by Jules Massenet, suggesting the presence of slumming aristocrats at this "Cubist Bar."

Commentary

This parodic evocation of a cubist hangout up on the Butte in Montmartre purports to be an 'anthropological' exploration deep into the heart of the revolutionary art movement on the part of an intrepid Asian outsider, Lan-Pu-Hé, whose name sounds suspiciously like a certain Parisian municipal councillor (documents 45 and 49). Obviously written by a somewhat sympathetic insider, it paints a picture of animated domesticity at a local bar mingling figures that scholars have long cordoned off from each other: Pablo Picasso, Henri Le Fauconnier, Francis Picabia, Louis

Marcoussis, Juan Gris, André Derain, Max Jacob, Fernand Léger, and Guillaume Apollinaire. Gino Severini chronicled just such a location or two in Montmartre where the cubists and their friends (including him) gathered beginning in 1906: Père Azon's bistro, where the proprietor sometimes accepted paintings in lieu of payment for meals, and the cabaret Lapin Agile, at the corner of the rue des Saules and the rue Cortot, where Père Frédé provided music and drinks late into the night (Severini, 31, 34, and 40). The author uses argot, slang, to suggest the comradely lack of pretension of the group and how much these artists aspire to be "of the people." It is safe to point out that, in France, only children drink milk, and its mention here would likely draw guffaws from its French readers. But intermingled with this humorous picture is mention of some of the serious issues that preoccupied many or all of the cubists, including Henri Bergson's philosophy and Leonardo's involvement with the golden section. This suggests not only an important exchange of ideas between the Montmartre group surrounding Picasso and those cubists residing in Montparnasse or Puteaux, but also their shared aesthetic interests, all of which contributed to the many cubist styles and meanings (M. Antliff and Leighten).

M. Antliff and Leighten, *Cubism and Culture*
Severini, *The Life of a Painter*

Pierre Lampué, "Lettre ouverte à M. Bérard, sous-secretaire d'Etat aux Beaux-Arts," *Mercure de France* (16 October 1912): 894–95

(The Editors:) An incomplete version of this letter was published in the press; we publish the text in extenso, solely for purposes of documentation.

Open Letter to Mr. Bérard, Undersecretary for the Fine Arts

If the voice of a municipal councillor were able to reach you, I would beg you to go take a tour of the Salon d'Automne.

Go there, Sir, and, even though you are a minister, I hope you will come away from it as incensed as many people I know. I even hope you will whisper to yourself: do I really have the right to lease a public monument to a band of wrongdoers who act in the art world the way Apaches do in ordinary life?

You will wonder, Mr. Minister, as you come away from it, whether nature and the human form have ever been subjected to such an outrage; you will observe with sadness that, in this salon, they display, they accentuate, the most trivial ugliness and vulgarity imaginable, and you will also wonder, Mr. Minister, if the dignity of the government of which you are part is not being attacked, since it appears to be taking such a scandal under its protection, by housing such horrors in a national monument.

It seems to me that the government of the Republic ought to be more concerned with, and more respectful of, the artistic dignity of France.

A year ago, and for a different reason, I wrote to your predecessor, who did not take any account of my letter, but, astonishingly, he then let everyone believe he was from the south, even though he was born in Montmartre.

Mr. Minister, a friend has told me privately that you are from Orthez, we are thus fellow countrymen, it is almost as if you were from Montréjeau;

so then, Diou bibant! It will not be long now. You will tell the Belgian Frantz Jourdain, who has very modestly given himself the mission of reforming French art and, who, to demonstrate fully his competence, has deposited, I won't say garbage, but the Samaritaine store almost directly across from the Louvre, which adequately proves the superiority of his hardware shop over the beautiful architecture of the Renaissance; therefore, let that architect know that, in the future, he can house his reforms and his reformers wherever he likes, but not in a public monument, and everyone who has a taste and a love for beautiful things will applaud you.

Respectfully yours,

Lampué

Pierre Lampué
16 OCTOBER 1912

Commentary

The editors of *La Mercure de France* have brought back Lampué's open letter to the Undersecretary of the Fine Arts eleven days after its appearance in *Le Matin,* with its longer concluding paragraph than appeared in *Le Journal.* In this section, Lampué casts Franz Jourdain, the president of the Salon d'Automne and architect of the department store La Samaritaine, as a foreigner "who has very modestly given himself the mission of reforming French art" and whose reprehensible taste is reflected both in the Salon d'Automne and in his building, "almost directly across from the Louvre, which adequately proves the superiority of his hardware shop over the beautiful architecture of the Renaissance." Lampué repeats his request for the "reformers" of art to be housed "not in a public monument, and everyone who has a taste and a love for beautiful things will applaud you" (see commentary, document 45).

André Salmon, "Histoire anecdotique du cubisme,"
in *La jeune peinture française* (Paris: Société des
Trente, Albert Messein, 1912), 41–61

An Anecdotal History of Cubism
(Manuscript finished April, 1912; published October 1912)

1

Picasso [fig. 42] was leading an admirable life at the time. Never had the
blossoming of his free genius been so dazzling.

He had consulted the masters worthy of reigning over troubled souls
that were earnestly in love, from El Greco to Toulouse-Lautrec. Now he
was truly himself, and, self-assured, allowed himself to be driven by a
quivering imagination that was both Shakespearean and Neoplatonic.

During that period, Picasso was driven only by his mind. One example
will enlighten us on his working methods.

After a beautiful series of metaphysician acrobats, of ballerina slaves to
Diana, of bewitching clowns, and of "Harlequins Trismegistus," Picasso
had painted, without a model, the very pure and simple image of a young
Parisian worker, beardless and dressed in a blue work shirt. Close to the
appearance of the artist himself during his working hours.

One night, Picasso deserted the company of some friends who were
killing time in endless intellectual discussions. He went back to his stu-
dio and, returning to the canvas abandoned a month before, put a crown
of roses on the effigy of the craftsman. Through a sublime whim, he had
made that work a masterpiece.

Picasso was able to live and work that way, happy, satisfied with him-
self, and rightly so. Nothing led him to hope that further exertion would
bring more plaudits or a quicker fortune—for his canvases were begin-
ning to be fought over.

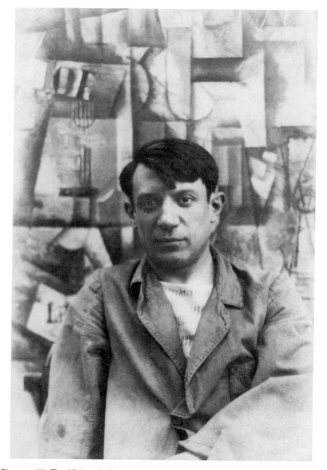

42. Pablo Picasso with *The Aficionado,* Sorgues, summer 1912. Photograph, 18 × 13 cm by Coursaget. Archives Picasso, Musée Picasso, Paris. © 2005 Estate of Pablo Picasso/Artists Rights Society (ARS), New York. Photograph Réunion des Musées Nationaux/Art Resource, NY.

Nevertheless, Picasso felt some anxiety. He turned his canvases to the wall and threw away his paintbrushes.

For many long days and just as many nights, he drew, concretizing the abstract and reducing the concrete to the essential. Never has labor been compensated with fewer joys, and it was without the youthful enthusiasm of the recent past that Picasso tackled a large canvas, which was to be the first application of his studies.

The artist had already become excited about the black Africans, whom he placed well above the Egyptians. His enthusiasm was not sustained

by a vain appetite for the picturesque. Polynesian or Dahomean images appeared "sensible" to him. Picasso, in completely changing his work, would inevitably offer us an aspect of the world not in keeping with what we had learned to see.

The regular visitors to the curious studio on rue Ravignan, who had put their trust in the young master, were generally disappointed when he allowed them to judge the first state of his new work of art.

That canvas has never been displayed before the public. It consists of six [sic] large female nudes; they are crudely drawn. For the first time in Picasso's work, the expressions on the faces are neither tragic nor impassioned. They are masks nearly devoid of all humanity. These characters are not gods, however, not Titans or heroes, not even allegorical or symbolic figures. They are nude problems, white numerals on the blackboard.

This is the posited principle of the painting-equation.

Picasso's new canvas was baptized on the spot by one of the artist's friends: "Le b[ordel] philosophique" [The Philosophical Brothel]. That was, I think, the last studio joke that the world of young innovative painters was to enjoy. Henceforth, painting was to become one of the sciences, and not the least austere.

2

The large canvas with severe figures and no lighting did not remain in its first state for long.

Soon Picasso attacked the faces, whose noses were, for the most part, set full-face, in the shape of isosceles triangles. The sorcerer's apprentice was still consulting the Oceanic and African charmers.

Shortly thereafter, these noses turned white and yellow; touches of blue and yellow threw a few of the bodies into relief. Picasso composed a limited palette for himself, and bold tones rigorously corresponding to the schematic lines.

Finally, dissatisfied with his first efforts, he attacked other nudes— heretofore spared, held in reserve by this Neronian—seeking a new statics and composing his palette of pinks, whites, and grays.

For a fairly short period of time, Picasso seemed to be satisfied with that windfall; the "philosophical brothel" was turned to the wall, and it was then that he painted the canvases, most often nudes with a beautiful

harmony of tones and supple lines, which constituted the last Picasso exhibition in 1910.

That painter, the first who had been able to return some nobility to the discredited subject, returned to the "study," and to studies in his early style (*Femme à sa toilette [Woman at Her Toilette], Femme se poignant [Woman Combing Her Hair]*); thus seeming, for an instant, to give up even the most remote benefit of the experiments that had made him sacrifice original gifts of immediate appeal.

It is necessary to follow step by step the man whose tragic curiosity was to give rise to cubism. Vacations interrupted the painful experiments. When he got back, Picasso returned to the large experimental canvas, which, as I said, existed only as a series of figures.

He created its atmosphere through a dynamic decomposition of the light, an effort that left the endeavors of neoimpressionism and divisionism far behind. Geometrical signs—a geometry both infinitesimal and cinematic—emerged as the principal element of a type of painting whose development could no longer be stopped.

Never again would Picasso be the prolific, creative, ingenuous, skillful creator of works of human poetry—he was now fatefully incapable of that.

3

Let those who were inclined to consider the cubists as daring pranksters or shrewd salesmen please pay attention to the dramatics that truly presided over the birth of that art.

Picasso too had "meditated on geometry," and, in choosing the uncivilized artists as guides, he was not unaware of their barbarism. Quite simply, he logically grasped that they had attempted the real figuration of being, and not the realization of the usually sentimental idea we make of it.

Those who see the marks of the occult, of the symbol, and of mysticism in Picasso's work run a great risk of never understanding it.

Hence he wants to give us a total representation of man and things. It is the endeavor of the barbarian image makers. But he is working with painting, a two- dimensional art, and that is why Picasso must also create by situating these balanced human figures outside the laws of academicism and the anatomical system, in a space rigorously consistent with the unexpected freedom of motion.

The desire for creation of that kind suffices to make the man it animates the foremost artist of his time, even if he were to experience only the bitter joys of experimentation without seeing it to full fruition.

The results of the early efforts were disconcerting. There was no concern with grace; taste was repudiated as a too narrow measure.

Nudes came into being, with distortions—for which we were prepared by Picasso himself, by Matisse, Derain, Braque, van Dongen, and, first of all, by Cézanne and Gauguin—that were hardly surprising. It was the hideousness of the faces that paralyzed with fright the not-quite-converted.

Deprived of the smile, we could recognize only the grimace.

The smile of the Mona Lisa was, for too long perhaps, art's shining sun.

Worship of her corresponds to some particularly depressing, supremely demoralizing, decadent Christianity. One might say, paraphrasing Arthur Rimbaud, that the Mona Lisa, the eternal Mona Lisa, was a thief of energy.

It is difficult not to engage in reflection in favor of the innovator, when we compare one of the nudes to one of the still lifes from that moment of Picassoism (cubism was not yet invented).

Whereas the human effigy appears quite inhuman to us and inspires a kind of dread, we are quicker to open our sensibility to the obvious and entirely new beauties of the representation of this bread, this violin, this goblet, painted as no one had ever done.

That is because the accepted appearance of these objects is less precious to us than the representation of ourselves, our reflection distorted in the mirror of the intelligence.

Hence we will willingly allow ourselves to be driven to look, with desperate confidence, beneath Picasso or some painter of his family.

Will it be a great deal of time wasted? Now that's a problem!

Who will demonstrate the necessity, the superior aesthetic rationale, for painting beings and things as they are, and not as our eye has recognized them—not always, granted, but ever since men have meditated on our own image?

Is that not art itself?

Is not science the only guide for these seekers, anxious to make us submit to all the edges of the prism at once, confusing touch and sight, which are the purveyors of such entirely separate joys?

No one has yet replied to that question in a peremptory way.

Conversely, the concern to make us experience an object in its total existence is not absurd in itself. The world changes its appearance, we no longer have our fathers' masks, and our sons will not resemble us. Nietzsche wrote: "We have made the earth very small, say the last men, and they flicker." A terrible prophecy! Does not the salvation of the soul on earth reside in an entirely new art?

I do not intend to reply to that today, having simply set for myself the task of proving that artists, unjustly attacked, were obeying ineluctable laws for which anonymous genius bears the responsibility.

This chapter is nothing but an anecdotal history of cubism.

There is nothing reckless in what I advance here. In 1910, Mr. Jean Metzinger confided to a reporter: "We had never had the curiosity to touch the objects we were painting."

4

But Picasso returned to the drill ground of his picture. He needed to experience the tenor of a new palette. The artist found himself in a truly tragic position. He did not yet have his disciples (several of whom were to be enemy disciples); painter friends marked their distance from him (someone other than myself could unscrupulously name names), aware of their shortcomings and fearing his example, hating the beautiful snares of the intelligence. The studio on rue Ravignan was no longer "the gathering place of poets." The new ideal separated men who were beginning to look at "all aspects at once" of one another, and were thus learning to despise one another.

Picasso, somewhat abandoned, once again found himself in the company of African augurs. He composed a rich palette for himself, with all the tones favored by the old academics—ochre, asphaltum, and sepia—and painted several formidable nudes, grimacing and perfectly deserving of execration.

But what remarkable nobility Picasso gives to everything he touches!

The monsters in his mind lead us to despair; they will never shake the most uncouth people with the democratic laughter emitted during the invasion of the Salon des Indépendants by Sunday visitors.

Already the Prince/Alchemist Picasso—the Picasso who brings to mind Goethe, Rimbaud, and Claudel—was no longer alone.

Jean Metzinger, Robert Delaunay, and Georges Braque were particularly interested in his work.

André Derain, let us acknowledge it immediately, would intersect him via his own path, only to go his own way later on, without overtaking him. At least Picasso taught him the necessity of deserting the conversation salon adjoining Henri Matisse's studio.

Vlaminck, a giant with thoughts as loyal and categorical as the straight punches of a good boxer, was losing, not without amazement, his conviction of being a typical fauve. It had never occurred to him that the fierceness of the sorrowful Vincent van Gogh could be surpassed in daring. He went back to Chatou, pensive, but not converted.

Jean Metzinger and Robert Delaunay painted landscapes strewn with little cottages, reduced to the bare aspect of parallelepipeds. These young painters, living a less inward life than Picasso, having remained more outwardly painters than their predecessor, were much more hasty to produce, albeit in a less complete way.

It was their great haste that determined the success of the undertaking.

Their works, once exhibited, went nearly unnoticed by the public and by art critics, who—whether bonnets verts or bonnets bleus, Guelfs or Ghibellines, Montagues or Capulets—recognized only the fauves, either to praise them or to curse them.

Then, with a word, Henri Matisse, king of the fauves (out of recklessness or political skill?), who had just been crowned in Berlin, ejected Jean Metzinger and Robert Delaunay from the family.

With that feminine knack for saying the right thing—the very essence of his taste—he called the cottages of the two painters "cubist." An ingenuous or ingenious art critic was with him. He ran to the newspaper, wrote from memory the article that became gospel, and, the next day, the public learned of the birth of cubism.

Schools disappear for lack of handy labels. That is troublesome for the public, since it likes schools, which make it possible to see things clearly without any effort. The public very docilely accepted cubism, even going so far as to recognize Picasso as the head of the school, and it clung to that idea.

Since then, the misunderstanding has only grown.

Georges Braque, who, a few months before, was painting brutal landscapes in the manner of Vlaminck, and who was also anxious about

Seurat's discoveries, played no little part in lending strength to the dual mistake.

He joined Jean Metzinger and Robert Delaunay. But, preoccupied with the human figure earlier than Delaunay, he borrowed directly from Picasso, even though he sometimes made a place in his works for a modest expression of his sensibility.

Later, he was to follow him respectfully, step by step, allowing an often judicious writer to say the following, which is extreme: "It is said that the inspiration of the movement is Mr. Picasso: but, since he does not exhibit, we must consider Mr. Georges Braque the true representative of the new school."

Mr. Jean Metzinger, much more intellectual, a painter and a poet, author of beautiful esoteric verses, wanted to justify this cubism created by Henri Matisse, who did not participate in the undertaking, and considered unifying the indistinct elements of the doctrine.

Hence, if cubism, baptized by Henri Matisse, really comes from Picasso, who did not practice it, Jean Metzinger is justified in calling himself its leader. Nevertheless, he very quickly conceded: "Cubism is the means, not the end." Ergo, cubism is admirable because it does not exist, even though it was invented by four people.

Today, we see cubists increasingly going their separate ways; they are gradually abandoning the little cooperative tricks; what they called a discipline was, in short, only a gymnastics, something like a training in the plastic arts.

They thought they were at the Academy, and they are graduating from the Gymnasium.

5

Whereas Jean Metzinger and Robert Delaunay, relatively united for a short time, and Georges Braque, working in isolation, were offering critics works considered to be realizations, Picasso and André Derain (who were not exhibiting) were each working on their own; one directly pursuing his studies, the other increasingly separating himself from dogma.

Picasso composed a new palette of grays, blacks, whites, and greens, which, immediately adopted by Georges Braque, became that of all the cubists.

The school then added Le Fauconnier, who was selfish, transforming everything he received, authoritarian in his affections and in that respect akin to Matisse, whom he rejected; and Albert Gleizes, who came to the speculative choir without intending altogether to renounce earthly plenitudes. Fernand Léger, within a calm academy, was awakening to art, prouder and greatly astonished.

Everything I have just summarized in the brief but rich history of cubism is totally unknown to the public, and to most of the best informed art lovers.

I have not guessed at anything. Fate has simply assigned me the role of witness, and I am now trying to give a faithful deposition.

That ignorance of the circumstances favorable to the birth of cubism explains well enough the disorder of ideas that persisted until the 1911 Salon d'Automne.

Mr. Desvallières, converted to cubism, and not practicing it at all (Mr. Charles Maurras defends the Roman church in the same way), encouraged by the attorney Mr. Granié, public prosecutor for the new school, was the first to have the idea of collecting in one room diverse works linked by a loose set of preoccupations common to MM. Jean Metzinger, Le Fauconnier, Albert Gleizes, Fernand Léger, N. de la Fresnaye [sic], Duchamp, Dunoyer de Segonzac, André Lhote, Albert Moreau, Fontenay, and so on, artists who were soon to be followed by Herbin and the sensitive Juan Gris.

A critique of that mosaic of works was given. The lack of unity can be explained by the absence of Georges Braque and Robert Delaunay, from whom characteristic submissions were expected, and who bequeathed their corner of the dado to artists from an alien family, while, at the same time, Marchand was left forgotten next to Maurice Denis.

It hardly mattered. That mistake was unimportant. The major coup had been struck. It was no longer possible to ignore cubism.

People admired or had a laugh; there was no air in Room 8. Writers spoke of renaissance, the salvation of art; others beseeched their peers not to promote a national peril. Very few chose to turn up their noses or were content to make jokes.

I confined my task to recognizing, within the cubist family, the artists truly gifted with pictorial talent.

But the people who laughed, unfamiliar with art, were to guarantee the success of that exhibition.

In the same way, neoimpressionism—pointillism in the vernacular—became notorious ten years after its revelation, when Willette, a charming artist, and one peculiarly resistant to things of the mind (he is wholly sentiment), drew a Pierrot in the guise of a painter crying: "Curses! I am doing confetti painting!"

The anger of some people left the furor of the anti-Wagnerians far behind. As in the distressing days of the Dreyfus Affair, discord devastated families; old friendships were destroyed.

Yet, at the precise moment when cubism was attracting attention, in a manner so tangible that for several people it raised a new social question, the school—entirely new—was disintegrating, with everyone pulling in a different direction.

The last to arrive, Fernand Léger, seemed to have rallied the majority of the troops behind him for the sole purpose of proclaiming a schism. The term *tubism* was invented for it. It was not long before Fernand Léger returned to more profound studies.

Everyone renounced the unity of the color scheme, everyone destroyed Picasso's palette.

Albert Gleizes was no longer bothered by the anecdotal, and Jean Metzinger, with a huge expenditure of talent, rehabilitated grace among his followers. In contrast to the grimacing idols recently worshiped, he introduced a sort of Mona Lisa of cubism.

6

Since then, everyone remains in his position and shores it up. Cubism, having been accepted, has not prevailed, since the individual effort is evolving in multiple directions. It will endure, but endlessly modified; since it has a greater capacity for development than neoimpressionism, it will fairly quickly cease to be what one now envisions.

Painters very remote from the cubists—their enemies even—will adopt some of the means of expression of Le Fauconnier and his friends, since Degas' words are still true for everyone: "They shoot us, but they go through our pockets."

Henri Matisse is alone. That famous man, made rich by art, a painter with laurels, has produced students only on the outskirts of towns: outside Paris (and, more particularly, in the Russian-American alleyways of Montparnasse), and outside Munich, Berlin, and Moscow.

As for the other intransigent fauves, I see them as divided as the cubists. Yet it is from a close and inevitable union that the great painting of tomorrow must come into being.

After many struggles, after sincere, austere, and arduous retreats, they all find themselves once more confused, in spite of themselves and without really knowing it, as they were in about 1904.

Already, some students of the fauves, without abandoning the latter, are allying themselves with the cubists for large demonstrations.

Could cubism be merely a subschool, a province of the fauve kingdom, composed of people upset by troublesome needs and failing to recognize the authority of the foreign prince that their luck has imposed on them?

Cubism has at least restored the worship of method.

Our task is now simplified. Without counting the absentees, the deserters, the absconders, we are left to examine only the work of the young painters marking a break from academicism in one manner or another.

André Salmon

1912

Commentary

André Salmon was first and foremost a poet, and in recounting his "Anecdotal History of Cubism" he structures the unfolding of the cubist movement to accord with his individual perceptions and personal involvement. As a poet Salmon, like Guillaume Apollinaire, was a neosymbolist, pushing the *vers libre* of 1890s symbolism toward modernist formal experimentation (Décaudin). Publishing his early poetry in *Le Festin d'Esope* (1903–4), a libertarian literary magazine he cofounded with Apollinaire, they attracted such avant-garde and anarchist writers to the journal as Alfred Jarry (author of Ubu roi, 1896) and Mécislas Golberg (author of *La morale des lignes,* 1908) (Leighten, 69–72). Like Apollinaire, turning to journalism and art criticism to support himself, Salmon became art critic for *L'Intransigeant* in 1908 and later wrote for *Paris-Journal* and *Gil Blas,* defending modernism—especially that of his friends—in many forms. He published poetry and art criticism throughout the cubist period and between the wars (Gersh-Nesič, "André Salmon in Perspective" and *The Early Criticism of André Salmon).*

Salmon was very close to Picasso, Apollinaire, and Max Jacob. These connections are visible in the text of "Anecdotal History of Cubism" in its privileging of Picasso over other artists, including Georges Braque, who

are cast as either talented or untalented followers. The dominance of this construction has long hampered an understanding of the real complexity of the interactions and mutual influences among the cubists (M. Antliff and Leighten), and Salmon himself has resultantly been given insufficient credit for his fluid movement among the various groupings of artists and writers (see documents 9–11, 18, 23, 27, 32, and 35). Picasso himself, however, also contributed to his reputation as an influential figure of mystery, in part by not exhibiting in the public salons but only in Daniel-Henry Kahnweiler's private gallery (Gee, 101–53; Leighten; and document 39).

This text has long been viewed as important for its rooting of the origins of cubism in Picasso's seminal work *Les Demoiselles d'Avignon,* or *The Philosophical Brothel* (1907) (see Green for the most recent literature on this key work). Unquestionably this large and ambitious painting, on the scale of major salon works, challenged Picasso's peers with its distorted and geometrized figural forms, restricted palette, and compressed space. Above all, its final layer of "Africanization," when two of the mask-like faces were repainted, overwhelmed its viewers in 1907, though a variety of responses among the fauves and other modernists soon appeared in their paintings. Picasso in his turn responded to such works, and, given the lively intellectual exchanges constantly attested to in the documents of the present text, including Salmon's, it is hard to imagine that he did not also participate in discussions with these friends about his aims in his bold picture. Certainly the influence of the *demoiselles* was striking, yet Salmon's image of Picasso as a lonely and isolated figure, single-handedly grappling with the radical reinvention of art, was myth. Salmon understandably wished to give his friend proper recognition for what was a uniquely violent form of primitivist modernism, one exceptionally influential at this stage. But the myth of Picasso's isolation is undermined when Salmon goes on to discuss the various motives and meanings of early cubism, as he necessarily conjures with ideas that were widely shared among all of the cubists, including primitivism (M. Antliff and Leighten), Henri Poincaré's notion of sight and touch combining to suggest the fourth dimension (Henderson), and Bergsonism (M. Antliff).

M. Antliff, *Inventing Bergson*
M. Antliff and Leighten, *Cubism and Culture*
Décaudin, *La crise des valeurs symbolistes*
Gee, *Dealers, Critics and Collectors of Modern Painting*

Gersh-Nesič, "André Salmon in Perspective"
Gersh-Nesič, *The Early Criticism of André Salmon*
Green, ed., *Picasso's "Les Demoiselles d'Avignon"*
Henderson, *The Fourth Dimension and Non-Euclidean Geometry in Modern Art*
Leighten, *Re-Ordering the Universe*
Salmon, *Souvenirs sans fin*

André Salmon, "La peinture féminine au XXe siècle,"
in *La jeune peinture française,* 111 and 114–18 [introduction
and section on Salmon's major figures]

Women's Painting in the Twentieth Century

Two artists command our attention; they will remain the only great
figures in women's art of the early twentieth century. One remains at-
tached to a fairly traditional art, the other is inclined to follow the daring
men of her generation, to such an extent that some have gone so far as to
name her, improperly in my view, the muse of cubism.

I shall speak of Mrs. Marval and Miss Laurencin.

One could easily imagine Mrs. Marval as the queen of a fanciful kingdom
peopled solely by young girls and girl-flowers. She would stroll, sover-
eign, down the walkways, alongside the lawns or pools of water, in the
shade of a whimsical parasol historiated with the flight of every bird and
the blossoming of every rose.

No doubt, she would distribute the flowers in the garden among her
subjects, the young girls, the friends of Adrienne and Sylvie.

Mrs. Marval is only the princess of art, and that is enough. If she has
to buy her flowers from the florist, who sells them indiscriminately to the
artist, the financier, the *grisette* [shop girl of easy virtue], and the widower,
she at least knows how to make enchanting bouquets out of them.

Do you remember the exquisite passage written by dear Gérard?

"Barely had I noticed, in the ring where we were dancing, a tall and
beautiful blonde, whom people were calling 'Adrienne.' All of a sudden,
following the rules of the dance, Adrienne found herself placed alone
with me in the middle of the circle."

Mrs. Marval painted that scene, minus the image of the poet: Adrienne after the dance, blonde, beautiful in her white dress, surrounded by her happy companions, chaste and dedicated to pleasure, and singing "one of these old-time songs, full of melancholy and love." Later, Gérard de Nerval says: "We thought we were in paradise."

We will again think so, standing before Mrs. Marval's works, just slightly spoiled by a few excesses of color. Who knows? Perhaps paradise is not perfect.

Sincerely and loyally, Mrs. Marval was able to pursue her works along the paths of fantasy, with such logic that the links now constitute a harmonious arc.

This artist, with effortless gifts, is no less a poet than a painter; but she is very obviously a painter.

Painter-poets are good workers if they are poets by choice; if, for example, Rochegrosse's style is mediocre and common, it is because his imagination is worthless.

One of the great merits of Mrs. Marval—it is from merits such as these that talent is composed—is to have known how to control her fancy without restricting it.

The human figures that take on life as a result of her verve are a people so numerous that the artist can calmly, and severely, choose her favorites.

Mrs. Marval has been criticized for being conventional, artificial, and for one perversity or another. This is not altogether accurate.

Sensuality does not need its original brutality to remain healthy; it deserves to be honored, even adorned with the deliberate graces of a premeditated artifice.

In fact, modern ideas about love, sensuality, and decency are generally absurd.

What shocks some people about the artist, who has triumphed in spite of such critics, by contrast comforts me, like an admirable spectacle of art nourished by feelings deep enough to remain perfectly artless.

The muse of the innovators in spite of herself, Miss Marie Laurencin is, by her boldness, very worthy of participating in their demonstrations.

A rigorous technique and a certain austerity of lines ally her with them.

But she is profoundly different from them by virtue of the imagination, which the cubists still repudiate—in truth, the subjects of their "pictures" are only allegories—just as the Parnassians, whom they resemble in spite of themselves, banned inspiration.

To paint her Diana the Huntress astride a hind, mischievously mounted on rollers, her tender Amazons, her Nymphs whom one imagines to be scholars, the artist had no model other than herself, and several of the young poets of our time appear in her works, without having been obliged to pose directly.

Miss Marie Laurencin is one of the very rare painters of our time capable of illustrating a poem without betraying the author's intention.

When the young artist composes following her own inspiration, not everything is always very clear in her works. But the abstruse is also part of our tradition.

Miss Laurencin is a graceful painter. Too subtle to be simple (simplicity is not a particularly admirable point), she is gifted with enough of a sense of moderation not to be mannered.

It would be wrong to believe that her inspiration comes from books; she has all the poet's emotions, but she is a painter above all. She composes diligently, but freely, because the transpositions come about naturally in her mind, even before she has picked up her paintbrushes.

Miss Marie Laurencin's fancy belongs to no one; it does not come from the Munich that welcomed the dreams of Tehran.

This young lady has looked—with her deep and ingenuous eyes—through museums the same way she observes nature. Therein lies the great charm of her talent, but not the whole secret of her art.

If the hinds that populate the gardens in which her fancy takes delight oddly resemble the bronze animals of the old artists from China, Miss Marie Laurencin manages very sincerely to forget about it. She makes everything she sees her own; conversely, up to now, no one has been able to ravish from her what truly belongs to her.

She has probably given great thought to Diderot's words: "Imagine in a pile at your feet all the personal effects of a European, the stockings, the shoes, the knee breeches, the jacket, the suit, the habit, the collar, the garters, the shirt; it's a secondhand shop. The personal effects of a woman would be a whole boutique." Nevertheless, she does not adopt the philosopher's conclusion: "Nature's habit is the skin."

Her characters are decked out in accordance with their particular male characteristics, even in spite of the role, sometimes arbitrary, that she assigns them in her compositions.

I had the distinguished honor of appearing in one of the most appealing compositions by Miss Marie Laurencin, wearing long hair and draped in a flowing blue linen dress, which I would like to have the obliging courage to sport in society.

But a scientific appetite with nothing positive about it, although it may have allowed this young lady some pleasant mistakes, has also led her, with somewhat too much direct curiosity, to latch on to the appalling works of Picasso. A few attempts justify our belief that there is nothing to be gained there for Miss Marie Laurencin.

She should have nothing to do with instructions coming from the outside. Does she remember that, when she was just getting started, she escaped the influence of Henri Matisse, whose sterile bouquets she had ingenuously copied?

Let her therefore be satisfied with visiting museums and very quickly leafing through the anthologies, blending together the Venetians and artists from the Ming dynasty, Ronsard and Omar Khayyám.

━━━━━━━

Miss Marte Galard, a graceful painter, is an artist in the French tradition, in the same way as Mrs. Marval, whose authority she does not have, and as Miss Marie Laurencin, whose sharp imagination she does not possess.

━━━━━━━

How can we not praise the plentiful decorativeness of Mrs. Galtier-Boisière? And could we take no interest in the fine efforts of Mrs. Georgette Agutte? That artist is moving toward a severe style, without consenting to the dangerous emotional restraint that does keeps us from fully enjoying Vallotton, whom she resembles, however. The sense of color, at once brilliant and limited, is not the least appealing sign of Mrs. Agutte's orderly but always picturesque talent.

We also cannot neglect Misses Albertine and Suzanne Bernouard, whose art is tiny in scale, but all the same occupies a place of importance since it strongly influenced the most recent women's fashions.

Misses Albertine and Suzanne Bernouard paint and embroider. It is not decorative art that led them to painting.

Knowing that the applied arts must reflect—and can only reflect—the recent tendencies of painting, they took up their needles without abandoning the paintbrush.

They paint flowers: roses, lilies, especially roses, pink like the faces of women in love, blue like lunar clouds; they have dreamed up fabulous and vibrant roses that quiver on cushions in parlors where the most modern poems are recited, where the boldest melodies ring out. A song by Ravel makes their petals tremble, an elegy by Henri de Régnier brings them to life, and it is on these cushions decorated with harmonious reliefs that the very young poet, leaning nonchalantly, receives the congratulations of a very old academician.

Mrs. Léone-Georges Reboux, infatuated with an art that, before the draftsmen of the Scheherazade school, was revealed by Manzana-Pissaro, has imagined and realized, for our enchantment, an Orient such that we no longer wish to know the other, the true one, no, the false one: the Orient of consuls, of reenlisted soldiers, of bazaar-keepers, and of photographers.

Let us prefer the Orient of poets, the gallant and philosophical Orient whose twists and turns were known by Diderot and of which Mrs. Léone Georges-Reboux gives an audacious and precise depiction.

It is there that French actresses become Indian dancing girls, in robes from Ispahan and hats from Paris, act out a scene for a few Harlequin Pashas. How well Mrs. Léone Georges-Reboux, too worldly to travel the world, knows the Asia she did not visit!

Mrs. Léone Georges-Reboux, with the beak of the legendary roc, paints the thousand and one sensory motifs of a ceiling welcoming marvelous dreams.

Mrs. Lisbeth Devolvé-Carrière attests to a filial diligence in perpetuating the teachings of one of the greatest artists of the past, her father, Eugène Carrière.

Each of her works is a tribute to the master's memory. Mrs. Lisbeth Devolvé-Carrière, obviously the slave of the genius that has not come down to her, is nevertheless an artist of talent who has learned to continue Carrière's legacy by supplying her palette with all the hues of flow-

ers, rare or common, and which she loves most of everything that lives, suffers, and vanishes.

—————

My task is at an end. I have acquitted myself conscientiously, if not happily.

It will be understood that, after the masters, the leaders, it was possible for me to mention only the first rank.

Of the cubists, I have deliberately defined only their common activity. As for the attempt at a particular work of art, their time has not yet come.

I have made the greatest allowances for the least well known and the most contested.

Those who excel with ease will approve without resentment.

André Salmon
MARCH–APRIL 1912

Commentary

Why Salmon singles out Jacqueline Marval, whose paintings have been associated both with the *intimisme* of Édouard Vuillard and Pierre Bonnard and with the fauvism of Henri Matisse, Kees van Dongen, et al., while leaving out the related art of such women as the prominent Émilie Charmy (Perry), is unclear. But his focus on Marie Laurencin echoes that of Apollinaire, who devoted a whole section to her art in *Les peintres cubistes* (document 62), and stems also from his longtime personal acquaintance with her (Kahn). Though, unlike Apollinaire, he does not develop a theory of "feminine art," he nonetheless insists on the flowers and animals that populate the works he describes. He emphasizes repeatedly decorativeness and imagination as fully realized values in the art of the women he chose to write about, as well as the rendering of sensory experience. "Grace" and the "picturesque" are cited as positive qualities, though Salmon does not restrict himself to a language of the "feminine": Marval's works have "authority," while he admires Georgette Agutte's works for being "severe" and "orderly," without the inhibiting "emotional restraint" of Félix Vallotton. For Salmon the poet, though, "poetry," "dream," and "enchantment" are among the highest values of art, which he finds in these women artists whom he highlights.

None achieve so high a praise in this regard as Laurencin: "she has all the poet's emotions, but she is a painter above all." Yet she is not passively led by emotion, a frequent trope for women artists; "she composes diligently, but freely." Salmon warns Laurencin, however, to resist the influence of Picasso. This "muse of the innovators in spite of herself" shares their boldness, however, and is resultantly "very worthy of participating in their demonstrations." Adding to this litany of qualities usually gendered male, Salmon also praises her "rigorous technique and a certain austerity of lines" which "ally her" with the cubists. But above all he appreciates her originality—the sine qua non of modernism—as her most outstanding quality, which undoubtedly gives her the most prominent position among women in his account: "She makes everything she sees her own; conversely, up to now, no one has been able to ravish from her what truly belongs to her."

Kahn, *Marie Laurencin*
Perry, *Women Artists and the Parisian Avant-Garde*

Louis Vauxcelles, "La 'jeune peinture française,'"
Gil Blas, 21 October 1912

The Youthful French Painting

I am too good a friend of André Salmon to devote a "friendly" article to his book. You owe the truth to those you respect, and to the others as well, in fact. My thinking is very unlike his regarding several of the artists whose stories he has just written. Yet another reason to talk frankly about it. Our different perspectives come from deep within us, from our sensibilities, the same sensibility that is so execrated by the cubists. What we called our rational arguments, in matters of aesthetics and politics, are nothing other than the systematization of our instincts. "Painting:" said Lautrec, who dressed up his definition with an energetic image, "you *smell it.*"

In the first place, I shall refrain from saying that *La jeune peinture française* is the work of a literary writer, not that of an art critic. A man of letters is not forbidden to speak the language of the plastic arts. And, although I do not enjoy the dubious theories of Apollinaire, I nevertheless appreciated *Hérésiarque et Cie.* Professional art critics are not an exclusive club, a private game preserve; I accept and even desire the criticism of poets. They have insights unsuspected by aestheticians. And then, their writing is so lovely. Too many of my colleagues in the so-called art press compose their reviews in jargon. I will not mention any names, so as not to increase the number of my cherished enemies. But the guild includes twenty-eight ignorant brokers and eleven Joseph Prudhommes who "hold their salons" in the comfortable newspapers.

Salmon is a novelist and a poet with a unique and flavorful accent, which tempers lyricism with what the English call humbug. He reminds me of Heine and Laforge. He came to the painters with an amused curiosity, and his bold intelligence immediately tackled arduous problems.

A close friend to one of the innovators, the enigmatic Pablo Picasso, who has troubled so many ingenuous minds, Salmon has witnessed the birth and rapid growth of a movement. Shall I say he held the new idol in the baptismal font?

What is the value of that cubist movement? Is it the obscure beginning of something? Is it—as I believe for my part—a failure? I have continually written that it is only an offensive return of the École des Beaux-Arts, and that the artist must not hold back the powers of his sensibility in order to blindly obey formulas out of fright.

In particular, let us not believe there are any arcana, any mysteries, or some sort of Kabbalah beneath it all, and that only "initiates" can cross over the sacred threshold. Not at all, not at all. The theory is phenomenally short and simple. Without being the late Poincaré, anybody can find a cubic root.

Nor would I wish to invoke the nationalist argument and maintain in my turn that all that agitation comes from abroad. Forget about the Milanese prestidigitators; and the futurist ravioli does not sit well with our algebraists. All right, there may be a few too many Germans and Spaniards in the fauve and cubist affair; and Matisse has become a naturalized Berliner; and Braque now swears by Sudanese art and nothing else; and the art dealer Kahnweiler is not exactly a compatriot of Père Tanguy; and that rake van Dongen is a native of Amsterdam, and Pablo of Barcelona: but none of that has any real importance in itself. Van Gogh was also Dutch. The question is not what language the cubists speak, but whether they have located a vein. Alas, I doubt it. Their doctrine is within the reach of children; and all but one of them—whom I would praise all the more willingly given that he explodes with male rage at the mention of my name—they are desperately devoid of virility. Their defenders concede this to me, in fact, and object: "They are worthless, granted! But the theory is beautiful." But the framework of cubism is a destitute scholasticism.

Let us return to André Salmon.

His work is interesting and useful. It begins with a deserved tribute to Odilon Redon, whom I do not see as a liberator. Redon, the prince of melodious recluses, has hardly been understood by the fauves. Only Verhoeven benefited from his lovely lessons.

Then comes the chapter "Fauves." These amiable barbarians did not wait for the "Salon d'Automne" of 1908 to launch their strident protests.

Henri Rousseau, whom Mr. Uhde compares to Uccello, also had no effect
on their training. Their leader was Matisse, whom we have liked since
1896. Matisse, Marquet, Dufy, and de Vlaminck exhibited at the "In-
dépendants" and in a vile shop on rue Victor-Massé, without taking any
interest in the "sweet old man from Montrouge." And, to settle a small
point of history, it was not Desvallières, but Baignières, who was the first
to bring the fauves together in a hall of the Grand Palais.

Later on, I read that "it was Charles Morice's claim to fame to have
put forward Carrière and Rodin." Devillez and Mirbeau and Roger Marx
would help me—with the help of irrefutable dates—to dispute that asser-
tion. But let's move on.

Salmon speaks of Gauguin's influence on Othon Friesz. Gauguin left
a mark on Girieud when the latter was starting out, and on Le Beau for
three or four years. And Friesz is a Cézannean.

Also, Rouault is not a realist of the "popular soul," but, I believe,
a Christian caricaturist, obsessed by the fear of the Evil One, let us say,
a Léon Bloy.

The pages on van Dongen are judicious. The "rascal" side of his over-
ripe girls, with eyes bigger than genitals, is well noted.

Salmon compares Girieud to Palma Vecchio, to Ary Renan, and to
Miss Dufau. I see Gauguin in him at the beginning, and the Sienese
tempera later on.

There's Gauguin as well, and the Japanese print, in Le Beau, who is go-
ing astray and trying to find himself outside himself. Next, André Salmon
writes "An Anecdotal History of Cubism." He renders unto Caesar that
which is Caesar's. Caesar is Picasso, a sincere seeker, stemming from
El Greco and Lautrec. "Picasso posits the principle of the painting equa-
tion." Salmon, ordinarily rather sparing with hyperbole, weaves a poly-
hedral wreath for Picasso. "Sublime, full of pathos, even Neronian. . . .
Picasso is the foremost artist of his time." And so on. I fear that the mys-
tery in which Picasso has shrouded himself serves his legend. Let him put
on an exhibit, purely and simply, and we will judge him. Salmon com-
pares him to Goethe—now that's getting serious.

Then come the aftereffects of the "Section d'Or." I feel my friend
André Salmon is "ezaggerating," as the cubists on rue Saint-Ferreol say.

I find the chapter on "Living Art" only halfway satisfying: Flandrin
(leaving out Poussin's influence), Dufrenoy (leaving out the Lyons con-
nection), Urbain, Camoin, Detrombe, Blanchet. Why forget Mainssieux,

who has talent? And what are Lemordant—whose efforts are so different from all the others—Dusouchet, Bausil, Sorolla, and Augustin Carrera, the brutal follower of Henri Martin, doing there?

There are very young artists, whom one hardly expected to see named in a book (Verdilhan, Lotiron, Marchand, Henri Doucet, and so on, could have waited for the sixth edition. Let them first learn their craft!).

A few distinguished pages on the French landscape. Among the innovators (next to Lacoste and Charlot), I am astonished to find the good de Chamaillard, whom Maufra taught impressionism; and Jean Deville. Not a word on Pierre Laprade.

A few lines, finally, on the ladies. Mrs. Marval. Perfect. Miss Laurencin. Let's wait, please. She has acquaintances in the world of the cube and the truncated cone. But that is not enough for me. Let us judge people on their own merits. Miss Laurencin draws nice images of her face, but they are still trifles, works for amusement. And why Mrs. Léone George Reboux, Gattier-Boissière, and Lisbeth Carrière? They are altogether outside a movement of which Miss Charmy, for example, is part, and Louise Hervieu.

Let us wrap things up and conclude: too much dandyish benevolence toward those who split hairs in a vacuum, very fine stu dies on various serious artists, more monographs than general ideas. And a gracefully fluent style, the style of the poet André Salmon.

Louis Vauxcelles

21 OCTOBER 1912

Commentary

This review of André Salmon's book by the influential critic Louis Vauxcelles interestingly reveals his admiration for Salmon as a man and a poet while separating this sharply from any admiration for Salmon as an art critic. Though Vauxcelles admits that Salmon has been a witness close to the source, he unwaveringly maintains that cubism is the exercise of a mere formula, whose practitioners are "desperately devoid of virility."

La Palette [pseud. of André Salmon], "Robert Delaunay," *Paris-Journal,* 1 November 1912, p. 4

Some people have regretted the fact that no canvas by Robert Delaunay adorns the unforgettable Room 8 at the Salon d'Automne. The artist will take his revenge. He began by painting goldfish blue, which everyone will agree was fairly original. But Robert Delaunay quickly tired of that game and sought something new. A great reader of Mallarmé, he announced not long ago that he was going to decorate a coffee service with figures inspired by the most mysterious images of the author of *Hérodiade;* he gave it up, or that service is not finished. You curly-headed Italians, and you, pretty girls with graceful bodies who lease classical beauty for five francs a session, do not knock on Delaunay's door. He does not need your services; he paints only the Eiffel Tower [fig. 15], and he paints it every which way. He paints it upright, lying down, leaning, soaring into space like an arrow or crashing to the ground like an airplane. The houses in the neighborhood—cubic houses—are over three hundred meters tall, and does he not have more audacity to paint them that way than to paint goldfish blue? We could not finish this "portrait" without saying that Robert Delaunay has dutifully taken care to collect a few of the most moving canvases by the innocent Rousseau: it is to Rousseau that he owes the success of the recent retrospective. No doubt Robert Delaunay is indebted to the dear Douanier for that obstinate love of the Eiffel Tower.

La Palette [pseud. of André Salmon]

1 NOVEMBER 1912

Commentary

While Salmon, like Guillaume Apollinaire, supports Robert Delaunay's role in the general modernist mission—with his audacity, originality, newness, and so-called freedom of art—unlike Apollinaire, he exhibits

little personal taste or sympathy for Delaunay's actual works. Indeed his rather wild assertions that the artist's Eiffel Towers are "upright, lying down, soaring into space like an arrow or crashing to the ground like an airplane" is fanciful and poetic rather than notably descriptive. But Salmon's role in this regard is to celebrate Delaunay's avant-gardism and to create the right sort of controversy, in which he admirably succeeds. It will be Apollinaire who undertakes a serious analysis of Delaunay's work and ideas (document 59). Yet Salmon is well informed about the artist, mentioning the immersion in Mallarmean aesthetics that he shared with Jean Metzinger (see documents 3, 8, 11, 18, 19, and Metzinger).

Salmon's mention of Henri Rousseau is also of real significance, including not only his importance for Delaunay and his art, but the impact of the Rousseau retrospective at the 1911 Salon des Indépendants (see document 18) and the 1912 exhibition at the Bernheim-Jeune Gallery (Rousseau died in 1910). The concept of the "primitive" underlying cubism was central to these artists' embrace of Rousseau's life and work (M. Antliff and Leighten, *Cubism and Culture*, 24–63; M. Antliff and Leighten, "Primitive"; *Henri Rousseau: Jungles in Paris*). Delaunay met Rousseau in 1906 and was, with Apollinaire, one of the closest to him as a friend (Rousseau et al.). Apollinaire devoted a long article to a memoir of Rousseau in 1914, which paid homage to his achievements, asserting that he "painted with the purity, the grace and the consciousness of a primitive" (Apollinaire, "Le Douanier," in Breunig, 339). Both Apollinaire and Delaunay attended Rousseau's "musical evenings" along with Max Jacob, Fernand Léger, Pablo Picasso, Maurice de Vlaminck, and Max Weber (Buckberrough, 16–17). For Delaunay, Rousseau was thus a friend, but also a mentor, one whose art he loved for its simplicity, naïveté, and honesty. In Delaunay's own words:

> This kind of art, which one finds in the suburbs, villages, and small towns—the naive, direct expression of these craftsmen, these country-fair artists, barbers, and milkmen; this entire body of painting that has sprung from the very roots of the people—Rousseau was its genius, its priceless blossom. (Ibid., 17)

Delaunay returned to the example of Rousseau throughout his career, emulating his introduction of truly modern subjects treated in a nonrealist manner. His *Cardiff Team* (1912–13), with its modern sports theme, clear outlines, and detail, pays homage to Rousseau's *Football Players* of

1908 (M. Antliff and Leighten, *Cubism and Culture*, 146; Buckberrough, 168–69). As Salmon warmly noted in his memoirs, Robert Delaunay "bien aimé et bien servi Rousseau" (loved and served Rousseau well) (Salmon, 63).

M. Antliff and Leighten, *Cubism and Culture*
M. Antliff and Leighten, "Primitive"
Apollinaire, "Le Douanier"
Breunig, ed., *Apollinaire on Art*
Buckberrough, *Robert Delaunay*
Henri Rousseau: Jungles in Paris
J. Metzinger, *Cubisme etait né*
Rousseau et al., *Robert Delaunay, 1906–1914*
Salmon, *Souvenirs sans fin, deuxième époque (1908–1920)*

Henri Le Fauconnier, "La sensibilité moderne et le tableau,"
in *Moderne Kunstkring* (Stedelijk, Amsterdam, 6 October–
7 November 1912), 17–27

The Modern Sensibility and the Picture

An error zealously fostered by the dilettantes and by all the parasites of
art would have us believe that the work of art is always an accidental
product of the human mind. Nothing is more childishly false. Like all the
important manifestations of human genius, the work of art has its laws
and appears in its time. For anyone standing at a relatively high view-
point, the conditions under which golden ages manifest themselves are
not at all surprising: only their fluctuating qualitative value may be so.

Thus, after the triumph of the fresco, the art of the picture [*tableau*]
is a perfectly logical event, absolutely in keeping with the aspirations of
the age. In Florence, at the Chiesa del Carmine, in the fresco works by
Masaccio and Lippi, that very clear tendency in the direction of the pic-
ture can be sensed; these large paintings now use very few so-called deco-
rative elements. Of course, very beautiful pictures and admirable por-
traits were painted for fifteenth-century churches and lords, but it is to be
noted that the technique and concepts of painters at that time still leaned
much more toward the old mode of expression.

It is indisputable that many of the reasons that impelled artists to
abandon the ornamental understanding of the fresco were on the social
order, but there are others, and the advent of the picture must be seen as
a complex evolution of the pictorial spirit. With the picture, other preoc-
cupations were born, and the artist glimpsed new possibilities. Plays of
shadow and light became easier for him to express than they had been on
the flat ornamental surfaces. Modeling and perspective allowed for subtle
nuances. Through chiaroscuro, which Leonardo already anticipated, the
work of art acquired an enveloping, elliptical form rich in suggestions,

and, in terms of its materials, possessed a greater wealth and joy (School of Venice) through the mysterious transparency of oil.

That conception of painting held sway for nearly four centuries and was obeyed by very great artists in accord with the nature of their talent or genius. Toward the end of the last century, painters found their sensibility cramped, poorly expressed by the old formulas. Impressionism was undeniably the first and most important innovation in a series of experiments that are currently leading to a new concept of the picture. Thanks to the pioneering role of Cézanne, the impressionists' concerns (limited to color) were supplemented by the much more important ones of order and construction. In Cézanne's own words, he dreamed of making that art akin to the art of the museums. His very French genius immediately impelled him to order and condense the modern emotionalism that was still indistinct in his contemporaries, so as to give it greater scope.

Of the various modifications to which the artist's sensibility was subjected at the end of the last century, some are located in the realm of the philosophy of art, and are primarily of interest to aestheticians; others have perfectly obvious causes. The influence of the environment, observed in every age, cannot be denied. The ease of travel, in developing cosmopolitanism in the cities, has allowed us to observe and compare specimens of the most diverse races on a daily basis. The rapid modes of transportation have made it possible for us to see very different landscapes in a short lapse of time, and have led us to a more synthetic vision of nature. Scientific inventions supply our eyes with forms unknown until now. Machines, the engine, and electricity have altered our ideas about motion and force. Industrial activity completely changed the appearance of cities, creating unexpected perspectives, audacious architecture, bizarre dissonances.

Key notions have shifted. The machine with its sharp angles has given us a violent and mathematical image of motion, which a man walking or an animal running did not allow people to glimpse in the past. The artist finds a speculative interest in the environment he experiences day to day: he is not satisfied with directly representing modern life, but seeks to provide its plastic equivalent. All the same, that representation of modern motion does not require the idée fixe of the fifteen-wheel automobile, and the dissonance of the street (the violence of billboards and posters) does not impose on the painter the exclusive use of its tonality.

That would be an overly simple concept that eludes, through a childish and mannered quaintness, all the difficulties of the problem of the picture, which every era of art attempts to solve. It is precisely here that the artist's creative and ordering role is found. His mind records forms, lines, colors, a new rhythm. From them, he draws the elements of new beauty, creating a language with which he expresses himself, often about something entirely different from the street, the factories, the machines. The artist does not have the intention of systematizing the new perceptions. He intends to offer his very mode of expression to the age in which he lives, a mode human enough and powerful enough to stand the test of time.

The laws that governed the old order of the picture have changed. The modern mind has grown weary of the expected balance. It gives more unpredictable demarcations to the primordial surfaces of the work of art, thus asserting the speed and diversity of its concepts.

The schema (whether it is still called arabesque, or the abstract line of the picture) does not seek to impose itself quite so directly, but rather to become visible as the result of a relation among volumes, forms, and strokes of color.

The artist, in his desire to become familiar with the object, is no longer satisfied with his predecessors' skillful modeling and perspective: he observes the modifications the object undergoes in space, and seeks to give a concise inscription of it that increases the force of representation by a factor of ten.

In establishing a path—as one says in optics—between the image and us, chiaroscuro separated the image from external realities through the intuitively grasped approximations of verisimilitude; it increased the plastic accidents of shadow and light. Modern complexity, having gradually grown weary of the monotony of "pleinairisme," could not neglect that mode of expression, unknown to the Orientals and the primitives of all times, but which Rembrandt ingeniously illustrated. Nevertheless, the new inscriptions of forms and volumes, in diminishing the importance of the optical path, allowed the artist freer play with shadow and light, which better serves the mobility and variety of these concepts.

A parallel modification is becoming apparent in color. In conceding that intuition played the greatest role among the ancients, we find that all their efforts led them to preserve the principles, resonance, and exactness of colors in the different accidents of shadow, halftones, or light.

The result was a harmony that our very different sensibility rejects and shatters in a desire to animate the colored surface with a more intense and multifaceted life. Hence the tones are juxtaposed with less finessing of the transitions. When the harmony is less distant, intentional holes are created and a delicate suppleness established. Through this contrast between dissonance and harmony, color gains in intensity.

One concern that is too often neglected is that of materials that, vested with a new role, might endow the work of art with a power of expression, which, if not key, is at least very important, unless one chooses to neglect the marked advantage offered by oil paint on fresco. The choice of thin, thick, fluid, transparent, or neutralized materials, with rich dyes or with a rupture, presents the artist with a multiplicity of resources for translating the vivacity of his emotion or for crystallizing its complexity. It is not solely a question of obtaining, on the colored surface, the sense of the substance of things (the preoccupation of realism) or of their fleeting appearances (impressionism), but rather of taking that astonishingly suggestive power and internal life contained within paint, in its brilliance, its mysterious transparency, and its profound radiance, and putting them in the service of intuition.

More than ever for the painter, the subject is just a "pretext to paint." An excessive preoccupation with the subject has been found only in mannered or decadent schools. Its total suppression in favor of the mere play of volumes or colored strokes would be a different kind of mannerism. If the artist suppressed that exciting duel fought between his mind and the life outside, he would be left with paintings of a state of mind with a necessarily limited plastic interest.

Of course, many of these considerations ought to be discussed at greater length—thus anticipating easy objections—than is possible here. Superficial minds have attempted, in particular, to invalidate these pursuits by calling them "theories." The true artist is not a theorist in the narrow sense of the word, and the continuing series of preoccupations, which are, in fact, of very great interest in the creation of a work of art, could not be called "theories." The vast scope of expression that emerges from a series of concepts elaborated in the unconscious and disciplined by a very sure logic slips away from the theorist, who hates intuition and whose incapacity for generalization is characterized by the maniacal preoccupation with the sole coefficient of emotionalism. Upon this coefficient, which is incapable of endowing a work of art with force and plenitude,

the theorist builds a thousand more or less ingenious—and always very mannered—little systems. That is always the case for "the theorists of the age." We see it in Mr. Armand Point with neoclassicism, in Mr. Émile Bernard with pictorial symbolism, and in Mr. Séon with the Rose-Croix. Why be surprised that there are some of more recent creation?

Theory (and not methods), with its small share of truth and its large number of often metaphysical or literary errors, is always repugnant to the painter. Methods, useful for creating a logical convention for oneself, adequate for the expression of the sensibility, could not exist by themselves without intuition, that internal fire that animates and generalizes concepts, often overturns the artist's expectations, sometimes in order to express itself bitterly and violently, to the great despair of theorists and "so-called men of taste."

That new conception of the picture, though presenting itself with an unexpectedness that may be disorienting for lazy minds, will take root in our time because it speaks the language of our age's sensibility. Sharp intellects will increasingly distinguish and appreciate qualitative differences (in force, charm, subtlety, and so on) in works that too often appear to vulgar minds to be all on the same level. That will be the best response to those who are frightened by the growing number of artists (?) who, without the slightest awareness or trace of talent, advance, in the name of modern art, along a path where their previous pursuits have not called them. Perhaps we will even see painters who, just day before yesterday, were "usefully" working the vein of the pleinairistes, leap with an ever new faith toward an ever new art.

The young painters who are pursuing a slow and reflective evolution would be wrong to worry about these unwanted nobodies.

The work of art possesses a force within itself that does not tolerate confusion, that immunizes it against the laughter of the uncomprehending, and that, sooner or later, makes it prevail.

In order to create and to judge, souls of quality always know to stand apart from petty contingencies.

Henri Le Fauconnier
OCTOBER–NOVEMBER 1912

Commentary

Henri Le Fauconnier's second aesthetic statement was written at a crucial juncture in his career. Published in Holland to accompany the Moderne

Kunstkring (Modern Art Circle) exhibition of 1912, the document stands as testimony to his rising influence among Dutch artists, even as it attests to his move away from Parisian circles. To understand this turn of events we must first consider Le Fauconnier's impact on the Moderne Kunstkring. This organization was founded in 1910 by the Dutch artist and critic Conrad Kickert (1882–1965) to promote interchange between avant-garde groups in France and Holland (for a history of the movement, see Loosjes-Terpstra; Van Adrichem). In 1910 Kickert had moved to Paris, where he quickly befriended Le Fauconnier and his Dutch follower, Lodewijk Schelfhout (1881–1943). Schelfhout, who had lived in Paris since 1903, also introduced Kickert to the circle of poets and cubist painters who attended the informal *Vers et Prose* meetings, which Paul Fort held every Tuesday at the Closerie des Lilas in Montparnasse (Décaudin, 180–83). After 1910 Kickert encountered the art dealer Wilhelm Uhde, visited Daniel-Henry Kahnweiler's gallery, and in February 1912 corresponded briefly with Picasso (Van Adrichem, 177–78). From 1910 to 1913 Kickert's home at 26, rue du Départ became a meeting place where the salon cubists Albert Gleizes, Fernand Léger, Le Fauconnier, and Metzinger interacted with Dutch artists such as Petrus Alma (1886–1969), Piet Mondrian, and Schelfhout (Van Adrichem, 167–69; Blotkamp, 57–60).

Between 1911 and 1913, the Moderne Kunstkring held three exhibitions in Amsterdam, each scheduled in the fall, on the model of the Salon d'Automne. In the first exhibition Paul Cézanne's status as the progenitor of the new art was celebrated with a display of twenty-eight of his paintings in a "hall of honor," and by the second exhibition, held from 6 October to 6 November 1912, the Kunstkring committee symbolically bestowed comparable status on Le Fauconnier. No less than thirty-three of his paintings were hung in the "hall of honor" that year (fig. 43), as compared to twelve works by Picasso and a representative selection of paintings by the salon cubists, omitting only Delaunay. The catalog accompanying the show included Le Fauconnier's newly minted manifesto, and an introduction by Kickert linking cubism to symbolist precepts (Van Adrichem, 171, 177–78). By 1913 Le Fauconnier's influence had become paramount; thus the 1913 Moderne Kunstkring exhibition was dominated by him and artists from his immediate circle, while paintings by the major salon cubists and by Georges Braque and Picasso were conspicuously absent (ibid., 182–84; see document 70).

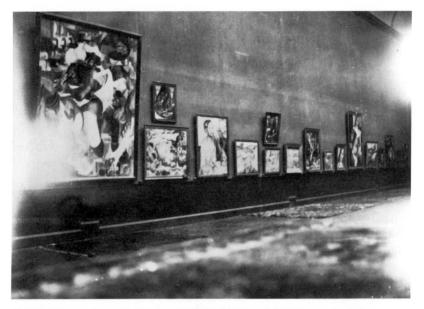

43. "Hall of Honor, Le Fauconnier," Moderne Kunstkring Exhibition, Stedelijk Museum, Amsterdam, October 1912. Photograph. Used by permission of Rijksbureau voor Kunsthistorische Documentatie, The Hague, Netherlands.

Ironically Le Fauconnier's rising fame in Holland was paralleled by a steady decline of his influence in Paris. Critics and artist colleagues had begun to express their doubts about him as early as the fall of 1911. Gleizes, in his review of the 1911 Salon d'Automne, described Le Fauconnier's contributions as "somewhat slipshod," concluding that he was an artist who "thinks more than paints" (document 29). In his review of the Salon des Indépendants of 1912, Apollinaire worried that Le Fauconnier's "manner" might become "too fixed" (Apollinaire, "New Trends and Artistic Personalities," in Breunig, 218). In his June 1912 essay "Towards a French School of Painting," Olivier Hourcade described Le Fauconnier's *Hunter* (1911) as "incoherent" and lamented the impact of Italian art on his aesthetic (document 41). By the summer of 1912, Le Fauconnier's career aspirations had begun to grate on his colleagues, which aided his sharp break with the rest of the cubist group that fall. Thus Le Fauconnier (along with Delaunay) did not participate in the vast cubist "retrospective" exhibition, La Section d'Or (October 1912). Concurrently he also refused to be included in Gleizes and Metzinger's *Du "Cubisme,"* possibly

as a result of the symbolic priority Gleizes and Metzinger planned to give to Picasso in their ordering of the book's illustrations (Robbins, 27; document 57). In his correspondence with Kickert that fall, Le Fauconnier made clear his desire that his own manifesto be published before the appearance of Gleizes and Metzinger's *Du "Cubisme"* (Robbins, 27). André Salmon's characterization of Le Fauconnier as "selfish" and "authoritarian" in his "Anecdotal History of Cubism" (October 1912) further testified to that artist's overweening ambition (document 50). Indeed in a hubristic attempt to conquer both Amsterdam and Paris, Le Fauconnier submitted a huge allegorical painting, *Mountaineers Attacked by Bears* (1910–12), to the Salon d'Automne of 1912. Having distanced himself from his former colleagues, he began to devote more energy to nurturing his growing reputation in Germany and Holland (Cottington, 105–8; Robbins; Ligthart, 28–34 and 38–55).

Due to the context in which it appeared, Le Fauconnier's essay has received scant attention, even though it is a summation of his ideas written during the most exciting phase of the cubist movement. Historians have noted that the essay heralded Le Fauconnier's turn to an "expressionist" idiom (Ligthart; Murray), but portions of it also register his interest in Henri Bergson's philosophy, which would be central to Gleizes and Metzinger's *Du "Cubisme"* (on this aspect of Le Fauconnier's text, see M. Antliff, 110–14). In addition, while scholars have acknowledged the reciprocal "dialogue"—both aesthetic and theoretical—between Wassily Kandinsky and Le Fauconnier (Murray; Ligthart), the comparable interchange between Le Fauconnier and Léger has not received the same degree of attention. Although art historians acknowledge this interchange in the realm of painterly praxis, the relation of these artists' writing to this "dialogue" has yet to be fully examined (Green, 32–33; Golding, 169). For instance, it is arguable that Le Fauconnier's theory of aesthetic dissonance anticipates Léger's well-known declarations on modern dynamism and contrasts of form published in 1913 and 1914 (see documents 65 and 75). Such interchange is not surprising, for Le Fauconnier, Gleizes, and Léger were in frequent contact throughout the prewar period, meeting regularly at such venues as the Closerie des Lilas, Le Fauconnier's studio (in 1910–11), Gleizes's studio in Courbevoie (as of 1911), Kickert's residence, and the "Dîners des Artistes de Passy" (from late 1912 to July 1913) (Golding, 6–12; Green, 12–14 and 30–37). Thus Le Fauconnier's essay

was his way of measuring himself against his peers and claiming those aspects of the salon cubists' shared vocabulary conducive to his own aesthetic aims (M. Antliff, 110).

Key to Le Fauconnier's text is the concept of "qualitative value," a term he first used in his 1910 essay "On the Work of Art" (document 10) but here extends to encompass the unique aspects of whole cultures in the history of European art. Having traveled to Italy in the summer of 1911 to study the old masters, he provides his readers with a written record of the lessons learned. In his opinion, the transition from the fresco painting of the quattrocento to the oil-on-canvas production of the High Renaissance had "qualitative value" as a sign of the changing aspirations that came with a new age. Oil painting in the Renaissance mode had then "held sway" for four hundred years, but Le Fauconnier informs us that more recently "painters found their sensibility cramped, poorly expressed by the old formulas." This restlessness resulted in the pictorial innovations of the impressionists, and then of Cézanne, whose penchant for "order and construction" gave greater scope to "the modern emotionalism." Thus the so-called Cézannism heralded yet another qualitative shift in the sensibility of an era, this one in response to new technology. "Rapid modes of transportation" and "ease of travel" had led not only to "cosmopolitanism in the cities" but also to the emergence of a "new, more synthetic vision of nature." "Machines, the engine, and electricity" had "altered our ideas about motion and force," while the industrialized urban landscape had created "unexpected perspectives" and "bizarre dissonances." The "sharp angles" of machines had given us "a violent and mathematical image of motion," qualitatively different from the organic and fluid rhythms found in nature. However, having attested to the role of modern industrialism in forging a new sensibility, Le Fauconnier quickly adds that artists should not simply represent the "violence of billboards" or of a speeding automobile, but instead should develop a "plastic equivalent" to such dissonance through the formal properties of their medium. The artist's task was to perform the "creative and ordering role" of utilizing "forms, lines, colors, a new pattern," to forge a "new beauty" fully expressive of this qualitative change. This veiled attack on the futurists for their all-too-literal portrayal of machine-age forms in motion was a theme Léger would soon take up in his own publications (documents 65 and 75).

Le Fauconnier then outlines the formal transformations needed to create an aesthetic attuned to the new sensibility. Compositional balance had to be replaced by "unpredictable demarcations," and chiaroscuro for verisimilitude by an abstract "play with shadow and light," in order to convey the "mobility and variety" of volumes and forms. In like fashion the harmony resulting from traditional uses of color had to be destroyed in order "to animate the colored surface with a more intense and multi-faceted life." Indeed a direct juxtaposition of tones, combined with the inclusion of abstract "gaps" between areas of harmony and dissonance, would enable colors to gain in intensity. This description comes very close to Léger's notion of a contrast of forms (document 65).

Le Fauconnier then brings us to the brink of abstraction, claiming that subject matter is fast becoming a mere "pretext to paint," and that it is "the internal life contained within paint" that artists are now putting "in the service of intuition." Indeed intuition—Bergson's term for an art-ist's creative power—is said to govern the artistic sensibility of each new era. However, Le Fauconnier quickly adds that the artist must strike a balance between abstraction and subject matter to capture "that excit-ing duel between his mind and life outside"; otherwise the artist's aes-thetic would result in an abstract "mannerism" or the painting of a "state of mind" (another allusion to the futurists). Le Fauconnier argues that his recourse to intuition insulates him from the accusation that he is a theorist, for all theorists hate intuition. He points to the neoclassicism of Armand Point (1861–1932), the symbolism of Émile Bernard (1868–1941), and the Rose-Croix aesthetic of Alexandre Séon (1885–1917) as exemplars of the theoretical point of view. In this manner Le Fauconnier distanced himself from an artistic triumvirate associated with neo-Catholic and ul-traconservative factions within the symbolist movement, whose agenda Bernard had been promoting through his journal *Rénovation Esthétique* (1905–13) (Marlais; Stevens).

M. Antliff, *Inventing Bergson*
Apollinaire, "New Trends and Artistic Personalities"
Blotkamp, *Mondrian*
Breunig, ed., *Apollinaire on Art*
Cottington, *Cubism in the Shadow of War*
Décaudin, *La crise des valeurs symbolistes*
Golding, *Cubism*
Green, *Léger and the Avant-Garde*

Ligthart, "Le Fauconnier en de Europese avant-garde"
Loosjes-Terpstra, *Moderne Kunst in Nederland, 1900–1914*
Marlais, *Conservative Echoes in Fin-de-Siècle Parisian Art Criticism*
Murray, "Henri Le Fauconnier's 'Village in the Mountains' "
Robbins, "Henri Le Fauconnier's *Mountaineers Attacked by Bears*"
Stevens, "Bernard as Critic"
Van Adrichem, "The Introduction of Modern Art in Holland"

"Débats parlementaires," *Journal Officiel de la Chambre des Députés* (3 December 1912): 2924–26

Parliamentary Debates
Chamber of Deputies, Session of 3 December 1912

Mr. Jules-Louis Breton. I would be reluctant, Gentlemen, in the current state of the budget discussion, to go on at length on a question that, I hasten to acknowledge, has no budgetary character. I will therefore confine myself to asking the distinguished undersecretary what measures he intends to take to avoid a repetition of the artistic scandal occasioned by the last Salon d'Automne.

For the last few years, on the pretext of reinvigorating art, modernizing its techniques, creating new forms and original formulas, certain exploiters of the public's credulity have engaged in the most insane escalation of extravagances and eccentricities.

I would not dream of contesting their pitiful right, but I cannot accept that our administration of the fine arts should lend itself to these jokes in very poor taste, and graciously hand over our national palaces to demonstrations that run the risk of compromising our marvelous artistic legacy (*Very good! Very good! from various benches*).

Particularly since it is, for the most part, foreigners who, in our national palaces, consciously or unconsciously come to discredit French art. In fact, of about seven hundred exhibitors at the last Salon d'Automne, I was able to pick out more than three hundred foreigners from the official catalog; in addition, in the jury of the Painting section, which was directly responsible for the last salon, foreigners were in the majority. If the members of the office staff are not counted, of the sixteen members, nine were foreigners.

Mr. Rognon. There were also beautiful things there.

Mr. J.-L. Breton (Cher). I do not ask the distinguished undersecretary to refuse the Grand Palais to the Salon d'Automne organization in the future, since I consider it my duty to acknowledge that, next to the so-called artistic monstrosities appearing at it, there was a delightful, a delicious exhibition of decorative art; on that point, I am in complete agreement with my colleague Paul Boncour (*Very good! Very good!*).

I also do not ask the distinguished undersecretary personally to exercise direct control over the works exhibited, which is absolutely impossible to do.

I ask him quite simply to require essential guarantees from concessionary organizations, especially regarding the constitution of the entry juries, and to advise them that, if, in the future, this year's scandal were to be repeated, he would then find himself obliged to refuse them the concession of the Grand Palais.

Gentlemen, it is, in fact, absolutely inadmissible that our national palaces should be used for demonstrations of a character so clearly antiartistic and antinational (*applause*).

Mr. Chairman. The chair recognizes Mr. Sembat [fig. 44].

Mr. Marcel Sembat. I was forewarned, first by the newspapers, and then by our colleague Mr. Breton himself, of his intention to raise the question of the Salon d'Automne "scandal" before this body. And, in fact, this year, the Salon d'Automne had the honor—always perilous and flattering—of being an object of scandal. It is indebted to the cubist painters for that.

Why this year? I don't know much about . . .

Mr. Thalamas. Exactly!

Mr. Bracke. It was already pretty bad before.

Mr. Marcel Sembat. My dear Bracke, let Thalamas say such things, since he too caused scandals in his time (*laughter*), and, as a result, has the utmost right to find it a bad thing when others cause them (*more laughter*).

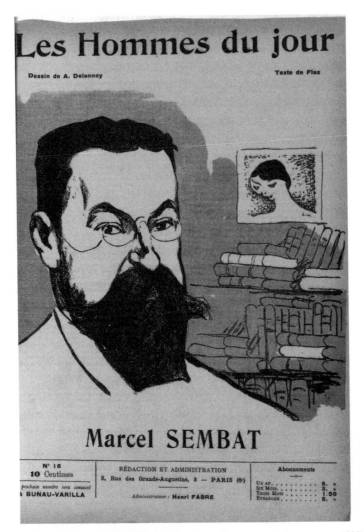

44. Aristide Delannoy, *Portrait of Marcel Sembat*. Cover of *Les Hommes du Jour* (16 November 1908). Used by permission of Bibliothèque nationale de France.

I repeat that, already last year, there were rooms where people who like to be scandalized (*smiles*) could find ample reason for it!

I am very happy that, in response to these vehement campaigns, the Salon d'Automne got support from the distinguished undersecretary and from everyone who knows him well and has an interest in art, support to which a movement that has exerted such a profound and felicitous

influence on contemporary art is entitled. I particularly note that, for decorative art, he has always been given his full due. I do not think we should limit ourselves there, and it is for his actions in general that I would like to ask your approval.

Mr. Breton does not go so far as to propose the reestablishment of censorship. I thank him for that; and it seemed at first that that had to be at issue—not from your mouth, Mr. Breton, but at the start of the campaign against what you call "the scandal." When Mr. Lampué wrote his infamous letter, that was truly the aim he was pursuing. The undersecretary was given notice to close the national palaces for us. It was a way of reestablishing censorship, the ugliest and most brutal of all, I believe! He was not told: You are going to personally choose the pictures, or have your delegates choose them! He was asked to say: The state runs this palace, it is hereby closed to you. I was particularly astonished, given that Mr. Lampué is, I am told, himself a member of the Salon des Indépendants (*laughter*).

Mr. Paul Escudier. As a photographer.

Mr. Marcel Sembat. As secretary, I believe.

Mr. Secretary of the Fine Arts. Photographers are artists.

Mr. Paul Boncour. He exhibits there.

Mr. Marcel Sembat. If my information is correct, it is bizarre that Mr. Lampué is so indignant about being in close proximity to certain people who, for a long time, he has been so willing to accept elsewhere, and, if that proximity makes him suffer a great deal, others may suffer a great deal as a result of Mr. Lampué's works! (*Laughter.*) In effect, before someone criticizes, he ought to take a good look at himself.

Here is one consideration among many that I would like to submit to the judicious mind of our friend Mr. Paul Boncour, and to our adversary Mr. Breton, and, above all, to the distinguished undersecretary, to allow them to reflect upon and evaluate at its proper worth the campaign conducted against the Salon d'Automne.

I do not wish to know either that campaign's inspiration or its shady side. People often talk about the shady side of politics, and seem to believe

that, in the loftier realms of art and thought, material considerations are always absent. Big mistake! (*Laughter.*)

While people are laughing at the canvases exhibited at the Salon des Indépendants or the Salon d'Automne, there are good men who, quite naturally, calculate that this laughter will be translated into a revival of their own influence and will be accompanied by an admiration for their own canvases! They hope that, as people find the former group's canvases ridiculous, they will find the latter group's less boring (*smiles*).

Oh, I am well aware that you have never been tempted to get involved in that artists' quarrel! If there is one thing a government ought to avoid, it is getting too closely embroiled in the quarrels of painters, literary writers, and actors! (*Very good! Very good!*) But the consideration I wish to submit to you is that good souls, artists who, for their part, have never elicited the slightest criticism from the most fastidious and strict people—from our colleague Breton in particular—have taken a very different attitude toward this movement that has unleashed so much anger.

Consider, for example, painters such as Mr. Desvallières, one of the finest heirs to Gustave Moreau's lessons and influence; consider painters of such fine and delicate talent as Mr. Baignières and Mr. Drésa, who, this year, were the installer and chairman of the jury, respectively; consider an artist you have just honored with a distinction which all artists applauded, by whom I mean Maxime Dethomas! His warm generosity and receptive understanding are such that—I apologize for revealing this intimate detail to you—in the jury we called him "Hand's Up," because he always voted for any canvas he found at all artistic.

Who, then, even in the circles most quick to be alarmed by revolutionary tendencies, will contest the worth of the people I have mentioned and the soundness of their taste? So I ask Mr. Breton how it is that people of such sound taste and such proven talent, to whom you may add Mr. Guérin and Mr. Lebasque, have opened their doors to the innovators he judges so dangerous?

Mr. Jules-Louis Breton. Probably so that their canvases will look better next to them. You're the one who suggested that explanation to me.

Mr. Marcel Sembat. No, that's not why, and you misinterpreted my words of a moment ago, because the artists who exhibit at the Salon de

la Société Nationale, and at the Salon des Artistes Français seem, on the contrary, to be afraid of that proximity! That would be an obvious contradiction.

Mr. Jules-Louis Breton. I'm not the one who came up with that explanation.

Mr. Marcel Sembat. The explanation is this: it is because the painters whose names I have just given you know perfectly well what everyone involved in art knows, that is, that one must not expect any artistic endeavor or experiment to be an immediate success in itself, and one must remember that the experiment that shocks the most and appears the most unjustifiable can have the most beneficial consequences on the subsequent evolution of art (*applause from various benches*).

An artistic endeavor must never be judged in itself, but by its subsequent repercussions. Do you remember what happened in literature at the time of the symbolist movement? I'm reminding you of the years of our youth! What cries of scandal went up against them! What accusations of obscurity, of insincerity! What ridicule and parodies were launched against them! The cubists will never unleash as much indignation as the symbolists, and, just as people stand in front of the cubists' canvases and ask the artist: "Explain to me what you wanted to do, then," they also asked Gustave Kahn and all the symbolist poets: "Explain to me what you wanted to say, then."

Mr. Gilbert Laurent. What about Mallarmé?

Mr. Marcel Sembat. I was only speaking of the symbolists, but you are right to bring up Mallarmé as well!

Mr. Charles Benoist. There are still some doing that.

Mr. Marcel Sembat. You are only reinforcing my argument, Mr. Charles Benoist.

Mr. Charles Benoist. I am well aware of that. That's why I interrupted you.

Mr. Marcel Sembat. Let me ask those who still do not understand the poems of the symbolists and of Stéphane Mallarmé, would you think of denying the profound and felicitous influence that the movement centered around Mallarmé, and the symbolist movement, exerted on the subsequent evolution of French literature? (*Very good! Very good!*)

That is why I repeat that one must take the future into account when one sees an artistic endeavor . . .

Mr. Jules-Louis Breton. You cannot call what the cubists do an artistic endeavor!

Mr. Marcel Sembat. when one sees an artistic endeavor that scandalizes you . . .

Mr. Charles Beauquier. One does not encourage garbage! There is garbage in the arts just like anywhere else.

Mr. Marcel Sembat. I am not sorry to see you hold such an opinion as well; I don't think the cubists will give you an argument. (*Smiles.*)

I don't intend in the slightest, by the way, to present a formal defense of the cubist movement! In whose name would I present that defense? I am not a painter. And before whom? I am not standing before an assembly of painters. For us politicians, let us simply remember the example of Charles X, and I congratulate the distinguished undersecretary for finding inspiration in him (*laughter*).

Might I by chance be compromising him? No, for the day Charles X's word ceases to be the rule for French statesmen in this matter, it will be because the French government has lost the wise circumspection counseled by the king's good taste and sharp mind. Charles X, when asked to intervene in the subject matter of theater plays, replied: "In such a matter, the only right I have is to my seat on the parterre." It couldn't be said better, and I congratulate you, Mr. Undersecretary, for finding inspiration in such right and proper sentiments!

If I permitted myself to recall the symbolist literary movement, it was not to present a justification of one art movement or another. My thesis is entirely different.

What I defend is the principle of the freedom of artistic experimentation. And what I do not accept is that we tell people: "So, you're poor! Well, then, we are going to take advantage of the fact that you do not have rooms of your own where you can show what you do, and close our doors to you!"

And all on the pretext that it's garbage, as Mr. Beauquier says, and a scandal!

Mr. Charles Beauquier. But the Salon des Indépendants is designed for such works.

Mr. Marcel Sembat. Not for lack of people fighting against that salon and trying to prevent us from continuing to support the exhibitions of organizations such as that of the independent artists and the Salon d'Automne!

Obviously, these exhibitions will always be cluttered with what you have the right to consider dross. But be careful! Personally, when I visit the Salon des Indépendants, I am much more shocked by the canvases of the rejected French artists, by the pictures of amateurs, than by the endeavors of youthful energies looking for their own path, sometimes losing their way, my dear Breton, that happens to everyone at the beginning of his career (*smiles*).

Conversely, I find that such spirit is leading an entire generation step by step onto extremely interesting artistic paths.

That is why, Mr. Undersecretary, I would not want there to be the shadow of a doubt about what your attitude has been. For myself, there is none, but I do not want anyone outside to try to take advantage of you and attempt to depict you as a bogeyman or a Cerberus who had to be thrown a honeycomb to be appeased. No, you have not reestablished any form of censorship: neither an overt and brutal form—"I will close the monument to you"—nor a more dissimulated form: "You can stay in our building, but there are works of art you will take down into the basement!"

No, I think that, in such a matter, neither you nor we ought to give the kind of advice solicited by Mr. Breton. We ought to tell the Salon d'Automne that it was never in danger; and that, when the committee made the somewhat unexpected resolution at issue, it may have been forgetting what ought to be discussed in the chamber if the debate were to

take on greater scope: the strange concessionaires we have seen come into our national palaces one after another.

How is it, Mr. Breton, that you now protest against painters who exhibit their pictures, even though, for many long years, we have seen the national palaces auctioned off to the highest bidder? A few years ago, upon arriving in Lauzanne, I happened to open the *Gazette de Lauzanne* and to read the sentence for fraud pronounced by the Swiss courts against people to whom we were leasing the national palaces, for having trafficked in patents.

Mr. Germain Périer. Very good!

Mr. Marcel Sembat. I know, Mr. Undersecretary, that, for a long time, before your arrival and since, great efforts have been made to clean out those Augean stables; but that needed to be done, Mr. Breton, and the protest should not have started only today.

Mr. Jules-Louis Breton. I am in complete agreement with you.

Mr. Marcel Sembat. Yes, but it's very curious: no one protests when the state hands over the national palaces to schemers, to unlicensed traders, but they do protest when it hands them over to artists to present pictures judged to be bad.

My dear friend, when a picture seems bad to you, you have one indisputable right, and that is not to look at it, to go look at others; but you don't call the police!

Gentlemen, that would be all I have to say on this subject, except that, before I leave the podium—and to avoid coming back up—since our friend Rognan spoke so eloquently about decorative art after Mr. Boncour's speech, I would like to make a point relating to the Sèvres factory.

In that regard, Mr. Boncour made the most felicitous observations; but there is also an experiment I would like to suggest to you.

It is not just money that Sèvres is lacking! One must not give it simply money, one must not give it simply financial autonomy, that right of sale to the public that you, Boncour, demanded so forcefully and with such common sense: one must, I think, tell the administrators of the factory, with the authority vested in you, Mr. Undersecretary—since that's the place where you can give advice, and something better than advice—tell

them that they would profit enormously from direct relations with certain artists.

Well before you were in power, Mr. Undersecretary, during the 1900 exhibition, there was at the time—it was in its full fervor, you remember, Paul Boncour—a very great movement in favor of fired sandstone.

It was known that, at the exhibition, individual artists and private initiatives would show admirable works, and pieces were prepared in Sèvres, making it possible to judge what our national factory was capable of, and to show that no form of art was inaccessible to it, and that there were no workers superior to its own, not in France or in Europe; emulators perhaps, rivals, so much the better, but none superior. And then, when it came to showing this evidence, these experimental pieces, they were told: "No, you will not show that because it is contrary to the general tradition of Sèvres, because it's just not Sèvres! Because that must not be seen with the Sèvres mark."

Note that this was contrary to the very broad instructions by the minister of the time, who, I know, had spurred the initiatives and encouraged daring! But those are the facts. I will have the opportunity, Mr. Undersecretary, out of simple retrospective curiosity, to place before your eyes a few of these pieces they did not want to show; you will see what honor they bring to the artists who created them.

Hence, the end of freedom in Sèvres. But, you may reply, that's all in the past. I don't know anything about that; if it's all in the past, so much the better, but there is one additional step to take and that certainly is not in the past. I would like the Sèvres factory to offer, from time to time, a studio to some ceramist worthy of encouragement, worthy of being aided, fostered, to see what the result would be.

I do not want to fall into the danger—as the distinguished chairman was criticized for doing a moment ago—of citing examples that seem to exclude those who are not named, and I declare immediately that, in addition to those I am going to name, there are many artists before whom we all bow in respect. Moreover, I will not offend anyone, I think, if I mention, by way of example, people such as Méthey, Massoul, and Lenoble!

I will stop there, but I beg you not to stop. Don't you see how reinvigorated, transformed, the production of the Sèvres factory would find itself, if, while remaining independent, such artists were authorized, for a number of years to be determined, to work in Sèvres? You would provide them with workers who would do the material work at which they exhaust

themselves and sometimes compromise their health and life. You would provide them with the potters, the unskilled workers who could only benefit from their lessons, and, thereby, Sèvres would acquire, through the production directed by these great artists, a new renown in Europe and throughout the world, and a new glory. The artists themselves might feel more directly attached to our great traditions, and everyone would win. That is an excellent piece of work to be carried out there; I certainly agree with Mr. Paul Boncour and, for his part, the distinguished under-secretary will not contradict me (*applause*).

Commentary

(Because this session of the Chamber of Deputies covered so many subjects so lengthily, in this instance we have included only those pages relevant to the debate over the cubists.)

The *Journal Officiel de la Chambre des Députés* records the exchange between parliamentarians over the merits of cubism, which took place following equally heated discussion of a resolution "to give to the police commissioner the right to prohibit any theatrical piece or any café-concert song that defends the crime of antipatriotism" (3 December 1912, p. 2918). Nationalism and patriotism are the mainsprings of the debate, in tension with the notion of freedom of art, and there is no room to doubt that indeed antipatriotic songs were being sung (Brauer; Brécy). The scandal caused by critical responses to cubism—focused as a specifically political question by Pierre Lampué (documents 45 and 49)—sparked this debate, initiated by the Socialist deputy Jules-Louis Breton. The discussion is not mere posturing. For Lampué what was at stake was a rule that only native French artists be permitted to exhibit in the national palaces (state-owned exhibition halls), which would bar foreigners from not only the Salon de la Société Nationale des Beaux-Arts and the Salon des Artistes Français, but also the Salon d'Automne (Leighten, 98–101 and 169–70). Among the cubists who could have been excluded in this manner are so many as to have forced cubism out of the public realm: Alexander Archipenko, Sonia Delaunay-Terk, Juan Gris, Alice Halicka, Jacques Lipchitz, Louis Marcoussis, Francis Picabia, Pablo Picasso, and Diego Rivera as well as allied abstractionists like František Kupka. Monsieur Breton himself counted 300 foreign names among the 700 exhibitors in the catalog list—which presumably included Jean Metzinger, whose name is of distant German origin—and he noticed 9 foreign names among the 16 members

of the jury: clear proof for him of an alien threat to France's "marvelous artistic legacy." He concludes to applause that "it is, in fact, absolutely inadmissible that our national palaces should be used for demonstrations of a character so clearly antiartistic and antinational," requesting first a warning to the jury against another scandal in the future, followed by the denial of the national palaces to the Salon d'Automne.

Breton is answered by another Socialist deputy, Marcel Sembat (fig. 44), who defends the influence the cubists have had on contemporary art and thanks M. Breton for not going "so far as to propose the reestablishment of censorship. . . . When Mr. Lampué wrote his infamous letter, that was truly the aim he was pursuing. The undersecretary was given notice to close the national palaces for us. It was a way of reestablishing censorship, the ugliest and most brutal of all, I believe!" Sembat belittles the attack on the Salon d'Automne by Lampué—who belonged to the Salon des Indépendants, where he exhibited his photography (fig. 40)—as a mere artists' quarrel, provoking laughter and amusement in the chamber. He conjures the scandals of an earlier period when symbolist poetry was emerging to prove an Apollinairean point: "one must not expect any artistic endeavor or experiment to be an immediate success in itself, and one must remember that the experiment that shocks the most and appears the most unjustifiable can have the most beneficial consequences on the subsequent evolution of art. An artistic endeavor must never be judged in itself, but by its subsequent repercussions." He sums up this argument by expressing support for all innovation in the arts: "What I defend is the principle of the freedom of artistic experimentation." Reminding the chamber that they are politicians and not critics or artists, Sembat says that they should concern themselves with fraudulent uses of the national palaces—referring to a recent scandal—rather than with bad pictures, if they are so judged by some. He then concludes the debate: "My dear friend, when a picture seems bad to you, you have one indisputable right, and that is not to look at it, to go look at others; but you don't call the police!"

Though Marcel Sembat seemed to have won the day in the Chamber of Deputies, the rhetoric here and in the press nonetheless constituted a chilly climate for relations of modernism to the French State. M. Bérard, Undersecretary of Fine Arts, took the side of Sembat on this day, calling himself "in art, partisan of a politics of least intervention . . . or even no intervention at all" (2928). Yet Bérard privately corresponded with Franz

Jourdain, president of the Salon d'Automne, suggesting that continued access to the Grand Palais would be contingent upon a revision of the rules to prevent future excesses and domination by foreigners; Jourdain in turn readily agreed both to the problem and to Bérard's conditions (Cottington, 12–13 and 197).

Marcel Étienne Sembat (1862–1922) was a well-known Parisian figure: lawyer, journalist, political writer, and longtime deputy, he was a committed parliamentary Socialist, called admiringly both "revolutionist" and "evolutionist" by the journalist Victor Méric (Méric). He actively defended workers and was involved in the major issues and debates in parliament from his first election in 1893, representing the 18th arrondissement (Montmartre). He advocated the separation of church and state, the restructuring of government on a more egalitarian model, the "civil and political emancipation of women," nationalization of mines and railways, a national savings bank, and progressive taxes (Maitron). In 1901 he helped found the Revolutionary Socialist Unity group, working hard to keep the Socialist Party from splitting, and beginning in 1906 wrote regularly for *L'Humanité,* the Socialist Party newspaper. His social aims remained revolutionary despite his willingness to serve in parliament, as is evident in a speech of 1902 to a Socialist Party assembly:

> [As] all today call themselves socialist, he declared, the true socialists . . . judged it useful to specify the bases of their doctrine in general declarations: international agreement and action of workers; political and economic organization of the proletariat, on the side of class taking over power, and the socialization of the means of production and exchange, that is to say the transformation of capitalist society into a collectivist or communist society. (Archives de l'Assemblé Nationale; cited in Raymond)

Dreyfusard during l'Affair, Sembat remained an antimilitarist throughout the prewar period, writing a polemical book in 1913 against the diplomatic crisis leading to war, which he feared would destroy the Republic: *Faites un roi, sinon, faites la paix* (a connection to the cubist movement is revealed by its publisher, Eugène Figuière, who also published *Du "Cubisme"* and *Les peintres cubistes;* see documents 57 and 62). The book argued that if one supports war, one may as well support a king, because war would inevitably lead to the death of the Republic as an institution and to the dissolution of the principles on which it is based. Ironically, this book was enthusiastically taken up by l'Action française and the

Camelots du roi as royalist (Maitron), but Sembat, given the choice he poses, of course argued in favor of peace.

Sembat also frequently defended the idea of state support for the arts, including for young and innovative artists, as we see in this debate as well as in Sembat's closing remarks about the Sèvres porcelain factory and state support for the decorative arts. His argument defending cubism as an expression of artistic freedom is at the core of the defense of the movement by many of its practitioners and apologists, including Guillaume Apollinaire (see documents 25, 47, and 62), Paul Signac (document 36), and Pierre Dumont (document 38). All these figures assert that artistic freedom is central to their concept of the Republic—whether that be construed as in a revolutionary continuum with 1789 or as a parliamentary democracy—and that this freedom should be supported within the institutional frame of the Salon des Indépendants and/or Salon d'Automne. Louis Vauxcelles—enemy of the cubists, portraying them as tricksters and worse—was also outraged by these events and declared himself firmly on the libertarian side, writing in *Gil Blas* (4 December 1912, p. 2): "Then what, you say to me? My God, do I dare avow that I think the intrusion of the State into artistic production is deleterious, and that I would wish to see art, free, expand itself in a free society, individualist doctrine of the Goncourt Brothers, of Nietzsche and of Stirner?" (documents 5 and 52; see also documents 47 and 56, and commentary for documents 36 and 56.)

Sembat's role in these politicized debates about art, revealing how his socialism and his aesthetics reinforce each other, reflects important aspects of French culture, especially leftist culture, in the cubist period. Méric in 1908 affirmed that "in literature and in art, Marcel Sembat shows himself to be a complete revolutionary and impassioned about innovators," admiring the early libertarian writings of Maurice Barrès, the symbolist free-verse poetry of Gustave Kahn, and the fauve aesthetic of Henri Matisse, whose art he collected and with whom he became close friends (Méric). That he was famous for this in his circle is demonstrated by the deft caricature of a Matisse drawing in the background of the anarchist artist Aristide Delannoy's portrait of Sembat for Méric's article in *Les Hommes du Jour* (fig. 44); Sembat also owned major Matisse paintings, including *Marguerite Reading* (1906) and *Seated Nude* (1909) (Spurling, 334–35, 366, and 458; Flam, 260). In 1905 Sembat tried unsuccessfully to get Matisse a state subsidy and/or a state purchase from the previous

Undersecretary of Fine Arts (ibid.); and in 1913 he wrote an article on his friend in *Les Cahiers d'aujourd'hui* (no. 4 [April 1913]), which he expanded in 1920 into a small book, *Henri Matisse; Trente reproductions de peintures et dessins précédées d'une étude critique* (Paris: Éditions de la "Nouvelle revue française," 1920).

Brauer, "L'Art révolutionnaire"

Brécy, *Autour de La muse rouge (groupe de poètes et chansonniers révolutionaires), 1901–1939*

Cottington, *Cubism in the Shadow of War*

Flam, *Matisse*

Leighten, *Re-Ordering the Universe*

Maitron, *Le mouvement anarchiste en France*

Méric [Flax], "Marcel Sembat"

Raymond, "Marcel Étienne Sembat"

Sembat, *Faites un roi, sinon, faites la paix*

Sembat, *Henri Matisse*

Spurling, *The Unknown Matisse*

Max Goth [pseud. of Maximilien Gauthier],
"L'Art décoratif au Salon d'Automne," *Les Hommes du Jour*
(26 December 1912): n.p.

Decorative Art at the Salon d'Automne

The section of Decorative Arts at the Salon d'Automne, let us say it immediately, can be counted among the most beautiful, the most significant manifestations of the beginning of this century.

The most felicitous observation we could hope to make, we have made: it is that of an intelligent return to the remedial tradition, in the sense that the artists seem to have understood that the revival of the art of furnishings is subordinated to the revival of architecture. The ambiguity around the efforts to acclimatize the Greco-Roman spirit to our country—a spirit that, since the fifteenth century, has been opposed to the free flowering of our own genius—was able to make us forget that only a living architecture determines the unity of style. It is obvious that an outmoded architecture would offer only a detestable framework for the innovations of our craftsmen of furniture. It is because they did not wish to admit so simple a proposition that our Greco-Latins have produced the disaster in which our decorative arts were foundering, a disaster whose depths we are beginning to measure and of which we can say, without exaggeration, that it is one of the most serious ones that aesthetics has endured.

The demonstration at the Salon d'Automne has arrived in a timely manner; it allows for a revival of all our hopes. Already, we can outline definitive classifications. This year, the efforts of the decorators are directly connected to those of two innovative architects: Charles Plumet and Duchamp-Villon. These are two tendencies that will soon stand in opposition, and style will emerge from the struggle between them.

Charles Plumet built a hall, where his desire to link modern architectonic reform to the magnificent flowering of the Gothic asserts itself, delivered, finally, from the so-called classical obsession. No more formulas applied without discernment, no more of those irritating banalities exhumed from the dusty codes perpetrated by Vitruvius, Palladio, and Vignola, but naked expression, integral to our desires, in a language that truly belongs to us: that of solids and voids, the supple harmony of archways, of flora, of the teeming, rejuvenated fauna of cathedrals. It must be said that Charles Plumet's efforts are a success in every respect. His hall is notable for its style, enriched by the sumptuous arabesques of clematis and ferns.

Duchamp-Villon's plan for a hotel is intransigently ultramodernist. Its façade draws its extremely pure originality from a very harmonious arrangement of polyhedra [fig. 27]. It is not possible, of course, to declare that Duchamp-Villon stands shoulder to shoulder with Charles Plumet on the path toward definitive works of art, but he must truly be considered an innovator deserving of credit. Less preoccupied with sumptuousness, with richness, than Charles Plumet, Duchamp-Villon verges on austerity. These same characteristics, found again in the decorative groups, these indicators, we will use as instruments of classification.

Around Charles Plumet can be grouped Maurice Dufrêne and Paul Follot.

Maurice Dufrêne is an impeccable technician. His ensembles are valuable for the qualities of elegance, meticulous care, polish. Paul Follot may be even more refined. His bedroom, decorated with twin beds set on the floor—without legs—is voluptuously and warmly intimate.

It is clear that the men of the generation now dying out will find a charm in these furnishings—whose high quality is indisputable—that, as young men, we will not find in them. Such stability, such cozy peacefulness is less befitting our youth, troubled and hungry for action, than these sometimes awkward, halting groups of audacities and timidities, rooms in which a mystery of anxious expectation seems to hover, a decor appropriate to our state of mind, and which André Groult and André Mare were able to express marvelously [fig. 26]. Of course, one could also easily find dross there, which time will shake loose, but these decorative ensembles are at present clearly enough defined for us to distinguish them easily from those that do not "hit the right note." I do not wish to

cite any of the latter. Moreover, my intention here has not been to criticize some section at the Salon d'Automne but to express in all sincerity the aesthetic considerations it suggested to me.

<div align="right">

Max Goth

LES HOMMES DU JOUR

26 DECEMBER 1912

</div>

Last Saturday, we published the letter from M. Louis Vauxcelles; our contributor, Max Goth, replies to him in these terms:

Sir and Dear Colleague,

Yes, I am sorry to see you lose—by denigrating the "cubist" movement—your fine qualities of yesteryear.

You reproach me for having dared question your good faith. But is it not you, Sir, who wrote that my friend Hourcade—whom I love for his ardent and courageous sincerity—"doesn't give a damn about the world"? I naively thought that, in making so much of the touchiness of others, you could not, without being ungracious, prove overly sensitive yourself. I was wrong.

By contrast, I persist in believing that I am not wrong to assert that you did not "discuss" the cubist theories. Reread what you wrote, I beg of you: "Discuss puerilities? You wouldn't want to. No one has taken them seriously." Is that clear?

At random, I pick out: "One of them is a practical joker; the other is a follower, seeking in scandal and bluffs the notoriety that eludes him. None of them has any character, or personality, or technique." Enough already!

Here, finally, is the conclusion of your article: "A young poet told me yesterday: 'I grant you they are idiots and have no talent . . .' 'My dear friend,' I interrupted, 'I have never said anything else.'" If you call that "courteous discussion," I very humbly admit I have lost all sense of the value of words.

Picasso and Derain, the "two launchers of that invention," as you say, have, in fact, definitively abandoned it. We have very often seen a father without audacity denying a genius child: so much for Derain. As for Picasso, he abandoned cubism only to devote himself to more lofty speculations that continue it.

"Not having a religious turn of mind," you refuse to swallow an assertion like the following, because it is without proof: "Cubism (like every innovative movement over the centuries, I will add), is the result of two opposing forces: classicism and modernism." In truth, Sir, in uttering that proposition, I feared I would pass for a fervent disciple of M. de La Palisse. In demanding proof, you fill me with joy.

Mr. Arsène Alexandre (that revolutionary!) recently said that "alone among the exhibitors at the Salon d'Automne, the cubists prove to be subjective. That is, contrary to the other painters—objective for their part—who see what they are doing only as they are doing it, the cubists attempt to create, minute by minute, a higher minute, during which they had an essential conception of their art." That unexpected testimonial authorizes me to assert further that "cubism" is a very clearly defined school, the only living school of contemporary painting.

In any case, I grant you the freedom not to "swallow" it. Moreover, I never had the intention to convert you in particular. I even admit that I do not yet understand how my assertions could have troubled you personally. But I truly want to respond to the "little quarrel" you want to pick with me.

"Why couldn't one emancipate painting from the obsessive reproduction of material forms?" Yes, why?

But, first, do you maintain that a comparison, an identification even, is possible between painting and music? If you are kind enough to concede that the only aim painting can have is to produce sensations through color and lines, exactly the way music does through sounds, we will perhaps manage to understand each other.

Shall I remind you of the famous epigraph to the pastoral symphony: "Art must be much more expressive of a feeling than imitative of things"? Having been permeated by these truths, I arrived at a comprehension of the works that Apollinaire excellently calls "Orphist." I have loved canvases that eminently justify poetic titles, such as these: [Picabia's] *Processional Music, Dances at the Spring* [Museum of Modern Art, New York], *Tarantella* [Museum of Modern Art, New York].

As for [Duchamp's] "the king and queen traversed by swift nudes" [Philadelphia Museum of Art], I grant you that the title is not felicitous. I believe, for my part, that the painting wanted to evoke in us the sensation of these strange obsessions—too well known by the intellectually overworked—obsessions that torment, with a hallucinatory chaos of absurdities, the mind fatigued by logic.

It is courageous to undertake to express that through pictorial means, to face ridicule. Ought not a critic whose "good faith is wholly won over by all the new, honest experiments worthy of interest" bring a great deal of indulgence to the judgment of the result obtained, however imperfect it may be?

Respectfully yours,

Max Goth [pseud. of Maximilien Gauthier]
LES HOMMES DU JOUR
26 DECEMBER 1912

Commentary

Max Goth, pseudonym for Maximilien Gauthier (1893–1977), was a poet and critic well known in avant-garde circles (Daix, 389–90). Before World War I he was a regular contributor to *Les Hommes du Jour*; after the war began in August 1914 Goth was drafted but then deserted, eventually finding his way to Barcelona, Spain, in 1917. While in Barcelona he joined an expatriate avant-garde community that included Robert and Sonia Delaunay, Albert Gleizes, Marie Laurencin, her German husband Otto van Watgen, and Francis Picabia (Green, 208–9; de la Fuente). In 1917 Picabia founded the Dada journal *391* (1917–24), and Goth was among the original contributors (Camfield, 92–96). Sometime after the official end of hostilities (11 November 1918), Goth returned to France and settled in Montparnasse. Having reestablished his literary and artistic contacts, he began writing under the name Gauthier, edited the journal *Chronique de l'Ours* (1921–22), and contributed to the avant-garde venue *Paris-Montparnasse* (1929–33) (Desbiolles, 77, 118–19 and 280).

This document is composed of two parts: an article on the Decorative Arts section of the Salon d'Automne of 1912, and a reply to a virulent attack on Goth and the cubist movement penned by Louis Vauxcelles (Vauxcelles's letter had been published in the 12 October edition of *Les Hommes du Jour*; see Weiss, 98 and 159). Taken together the articles attest to Goth's sympathy for the cubists: in his article on the decorative arts he singles out for special praise André Mare's collaboration with Raymond Duchamp-Villon in creating the Maison Cubiste (figs. 26 and 27); in his rebuttal of Vauxcelles he defends the cubist-related writings of his friend Olivier Hourcade, and endorses Apollinaire's doctrine of Orphism. Goth particularly admired the painting of Picabia, which indicates that

his contact with the latter likely occurred before 1917. Thus Goth (like Dumont and Elie Faure in their contributions to the journal) was at odds with his colleagues at *Les Hommes du Jour,* Henri Guilbeaux and J. C. Holl, in defending cubism (see documents 15 and 25).

In his article on the decorative arts Goth takes up the doctrine of Celtic nationalism endorsed by his friend Hourcade (document 41), but develops a unique interpretation of the theme, filtered through his interest in architecture and the decorative arts. Asserting that any renewal of the "arts of furnishing" first required a comparable revival of architecture, Goth then embarks on a diatribe against the pernicious influence of the "Greco-Roman spirit" on French culture. Like Hourcade and the Celtic League, Goth considered "Greco-Latin" culture a foreign import, which was first imposed on the French by the Latinized monarchy in the fifteenth century. This invasion had caused the native French to suppress their "own genius" and their knowledge that "only a living architecture determines a unity of style." Goth therefore calls on French artists to throw off the Greco-Latin yoke and to revivify their art by rediscovering their indigenous traditions and the fundamentals of design.

Significantly he found evidence of such thinking in the salon displays of "two innovative architects": Charles Plumet (1861–1928) and cubist Raymond Duchamp-Villon. Plumet's circular "hall" represented the traditionalist aspect of Goth's equation by linking "modern architectonic reform to the magnificent flowering of the Gothic." Contemporary photographs of the hall make plain its origins in Romanesque and Gothic architecture; moreover Plumet himself was a well-known traditionalist who counseled architects to steep themselves in the French architecture of those eras, rather than the architectural legacy of Greece and Rome (Mourey; Sedeyn). Thus Goth applauds Plumet for rejecting the "dusty codes of Vitruvius, Palladio, and Vignola," the latter a reference to the Italian architect Jacopo Vignola (1507–73), whom Francis I had commissioned to decorate his royal château at Fontainebleau. He claims that Plumet's allies in the decorative arts were Maurice Dufrène (1876–1955) and Paul Follot (1877–1941), both of whom initially associated with the art nouveau movement, but had developed a simpler style by 1912 (Duncan). These designers had exhibited interiors at the 1912 Autumn Salon: Dufrène, an austere *"cabinet de travail,"* Fallot, an elegant *"salle à manger"* (Sedeyn). Their supposed allegiance to Plumet did not stem from the im-

pact of the Gothic style on their furnishings so much as their attention to the fundamentals of design, another legacy of the Gothic tradition.

Duchamp-Villon's façade for the Maison Cubiste in turn was labeled "intransigently ultramodernist" by Goth, and therefore exemplary of Goth's desire for true innovation in design. Duchamp-Villon's allies in this quest were the designer André Mare (1885–1923), who had first envisioned the Maison Cubiste, and André Groult (1884–1967), who had collaborated with Mare in designing a study for the 1911 Salon d'Automne (Troy, 70–71). Goth then contrasts the "stability" and "peacefulness" of the designs created by the Plumet circle with the agitational impact of the Maison Cubiste, which was more befitting of the "state of mind" of "our youth." In separating Dufrène from Mare, Goth reiterates a critical division between those artists identified as "constructeurs" (Dufrène), and those labeled "coloristes" (Mare) (ibid., 67–102). Although Goth claims that Plumet and Duchamp-Villon represented two tendencies presently in "opposition," he was hopeful that a new, truly French style would emerge "from the struggle between them." In short, he argues that an eventual fusion of Plumet's Gothic orientation with the radical innovation exemplified by Duchamp-Villon's cubist façade would create a decorative art form firmly rooted in the French tradition.

In defense of cubism, the Gothic and colorist aesthetics also permeated Goth's rebuke of Vauxcelles. He ridicules Vauxcelles's condemnation of Hourcade's defense of the cubists, and proclaims cubism "the only living school of contemporary painting," precisely because of its radical attempt to "emancipate painting from the obsessive reproduction of material forms." He then asserts his own allegiance to the newest tendency in the cubist movement: Orphism (see documents 59 and 62). Having evidently heard Apollinaire's first public essay, "Orphic Cubism"—delivered at the 11 October conference held in conjunction with the Section d'Or exhibition—Goth announces that he was totally won over by the synesthetic aims of the new school. He singles out Picabia's work for special praise, referring to the "poetic" canvases *Processional Music* (1912), *Dances at the Spring* (1912), and *Tarantella* (1912). *Processional Music* and *Dances at the Spring* were then on view at the Salon de la Section d'Or, while *Tarantella* had been exhibited that summer at the June–July 1912 Société normande exhibition (see documents 42 and 47). Goth would continue to defend the synesthetic basis for abstraction in 1913, despite expressing reservations about writings on the subject by the cubists and their allies

(Goth, "Frantz Jourdain" and Goth, "Salon d'Automne," cited in Weiss, 75 and 277n124).

Camfield, *Francis Picabia*
Daix, *Dictionnaire Picasso*
Desbiolles, *Les revues d'art à Paris, 1905–1940*
Duncan, *Art Deco Furniture*
de la Fuente, *Dada à Barcelone, 1914–1918*
Goth, "Frantz Jourdain"
Goth, "Salon d'Automne"
Green, *The European Avant-Gardes*
Mourey, "Une Villa"
Sedeyn, "Au Salon d'Automne"
Troy, *Modernism and the Decorative Arts in France*
Weiss, *The Popular Culture of Modern Art*

▬▬▬▬▬▬▬▬▬▬▬▬▬▬ **DOCUMENT 57.**

Albert Gleizes and Jean Metzinger, *Du "Cubisme"* (Paris: Eugène Figuière, [27 December] 1912)

On "Cubism"

The word *cubism* is used here only to spare the reader any hesitation as to the object of this study, and we hasten to declare that the idea it evokes, that of volume, could not in and of itself define a movement leading toward the complete realization of Painting.

But we do not lay claim to definitions; we wish only to suggest that the joy of taking by surprise the art undefined within the limits of a painting is worth the effort it requires, and to induce anyone worthy of making that effort to do so.

If we do not succeed, what does it matter! . . . In reality, we are commanded by the pleasure a man takes in talking about the work to which he dedicates his daily life, and we firmly believe we have said nothing that would not strengthen true Painters in their personal spiritual love [*dilection*].

I

To evaluate the importance of cubism, we must go back to Gustave Courbet.

That master,—after David and Ingres had magnificently brought an age-old secular idealism to a conclusion,—instead of squandering himself in slavish repetition, following the example of Delaroche and Devéria, inaugurated an aspiration for realism in which all modern efforts participate. But he remained the slave of the worst visual conventions. Not knowing that, to discover a true relationship, one must sacrifice a thousand surface appearances, he accepted without any intellectual control everything his retina communicated to him. He did not suspect that the visible world becomes the real world only through the operation of

thought, and that the objects that strike us most forcefully are not always those whose existence contains the greatest wealth of plastic truths.

Reality is more profound than academic recipes, and more complex as well. Courbet was like one who contemplated the Ocean for the first time and who, diverted by the play of the waves, did not dream of the depths; we cannot blame him for that, since it is to him that we owe our present joys, so subtle and so powerful.

Édouard Manet marks a higher level. All the same, his realism was still inferior to Ingres' idealism, and his *Olympia* looks clumsy next to *L'Odalisque*. Let us love him for having transgressed the decrepit rules of composition and for having reduced the value of anecdote to the point of painting "anything at all." By that quality we recognize a precursor, we for whom a work's beauty resides expressly in the work and not in what is only its pretext. Contrary to many people, we call Manet a realist less because he represented everyday events than because he knew how to endow with a radiant reality the many possibilities enclosed within the most commonplace objects.

After him there is a division. The realist aspiration is split between superficial realism and profound realism. The former belongs to the impressionists: Monet, Sisley, etc., the latter, to Cézanne.

The art of the impressionists is inherently nonsensical: through the diversity of color it attempts to create life, and it propagates a drawing that is feeble and worthless. The dress sparkles, marvelous; the forms disappear, atrophied. Here, even more than in Courbet, the retina predominated over the mind; but the impressionists were aware of this, and, to justify themselves, they gave credit to the incompatibility of the intellectual faculties and artistic feeling!

Nevertheless, no energy can resist the general impulse [*élan*] from which it is derived. Let us refrain from seeing impressionism as a false start. The only possible error in art is imitation; it is an infraction of the law of time, which is the Law. Monet and his disciples contributed toward broadening the field, if only through the freedom with which they let technique become visible, and showed the constitutive elements of a hue. They never tried to make Painting decorative, symbolic, moral, etc. If they were not great painters, they were at least painters, and that is enough for us to venerate them.

People have wanted to make Cézanne out to be a sort of flawed genius; they have said that he knew admirable things but that he stammered rather than sang them. The truth is that he had disastrous

friends. Cézanne was one of the greatest of those who shaped history, and it is unfitting to compare him to van Gogh or to Gauguin. He is reminiscent of Rembrandt. Like the painter of *Pilgrims at Emmaus,* disregarding idle chatter, he probed reality with an obstinate eye, and, if he did not himself attain the regions where profound realism gradually changes into a luminous spiritualism, at least he dedicated a simple and prodigious method to anyone who firmly wants to attain it.

He teaches us to dominate universal dynamism. He reveals to us the modifications that objects believed to be inanimate inflict on one another. Through him we know that to alter the coloring of a body is to change its structure. He prophesies that the study of primordial volumes will open unheard-of horizons. His work, a homogeneous bloc, stirs before our eyes, contracts, stretches, dissolves, or lights up, and proves unimpeachably that painting is not—or is no longer—the art of imitating an object by means of lines and colors, but rather of giving a plastic consciousness to our instinct.

Anyone who understands Cézanne has an inkling of cubism. From now on, we are justified in saying that there is between this school and the previous manifestations only a difference in intensity; and, to convince ourselves of that, we need only attentively envision the progress of that realism, which, departing from the superficial reality of Courbet, plunges with Cézanne into profound reality, shining brightly as it forces the unknowable to retreat.

Some people claim that such a direction distorts the traditional curve. Where do they get their arguments? From the future or from the past? The future does not belong to them, as far as we know, and one must be singularly naive to want to measure what is by the yardstick of what no longer exists.

At the risk of condemning all modern painting, we must regard cubism, which continues it, as legitimate. As a result, we must see it as the only conception of pictorial art currently possible. In other words, at the present time, cubism is painting itself.

At this point, we would like to get rid of a widespread misapprehension, to which we have already alluded. Many maintain that decorative preoccupations must govern the spirit of the new painters. No doubt they are unaware of the glaring signs that make decorative work the antithesis of the picture. The decorative work of art exists only by virtue of its *destination,* takes on life only by virtue of the relationships estab-

lished between it and determined objects. Essentially dependent, necessarily partial, it must, from the outset, satisfy the mind in order not to distract it from the display that justifies it and completes it. It is an organ.

The painting bears its raison d'être within itself. It can with impunity be taken from a church to a salon, from a museum to a bedroom. Essentially independent, necessarily complete, it does not have to satisfy the mind immediately, but, on the contrary, leads it little by little toward the imaginary depths where the ordering light keeps vigil. It is not in harmony with this or that ensemble, it is in harmony with the totality of things, with the universe: it is an organism.

To be sure, we do not wish to belittle decoration in favor of painting; let us be content to argue that, if wisdom is the science of putting each thing in its place, most artists are far from possessing it. Enough with decorative plastic art and pictorial decoration, enough with confusions and ambiguities!

Let us not argue about the original goal of our art. In the past, fresco prompted artists to present distinct objects, evocative of a simple rhythm and flooded with light, for the purpose of creating a synchronic vision, made necessary by the size of the surfaces. Today, oil painting makes it possible to express notions of depth, of density, and of duration [*durée*], reputed to be inexpressible, and it incites us to present a true fusion of objects in accordance with a complex rhythm and in a limited space. Since every preoccupation in art is derived from the material used, we must consider the decorative preoccupation, if we encounter it in a painter, as an anachronistic artifice good for concealing impotence.

Does the difficulty that even a sensitive and educated public has experienced in deciphering modern art result from present conditions? We admit it; but it must result in enjoyment. Some take a liking today to what exasperated them yesterday. It is a very slow transformation, and that slowness can be explained: how could comprehension evolve as rapidly as the creative faculties? It trails behind them.

II

Separating for the sake of convenience what we know to be inseparable, let us study the integration of plastic consciousness through form and color.

To discern a form implies, in addition to the function of sight and the faculty of movement, a certain development of the mind; but the external world is amorphous to the eyes of most people.

To discern a form is to verify it in terms of a preexisting idea, an act that no one, except perhaps the man we call an artist, accomplishes without external help.

When a child stands before a spectacle of nature, to give order to his sensations and grant them a mental direction, he refers to his picture book; culture intervening, an adult relies on works of art.

The artist having discerned a form, when it presents a certain intensity of analogy to the preexisting idea, will prefer it to other forms and, consequently—we like to impose our preferences on everyone—he will make every effort to enclose the quality of that form (the unmeasurable sum of the affinities sensed between the visible manifestation and the tendency of his mind) in a sign able to touch other people. Should he succeed at this, he will oblige the crowd standing before his integrated plastic consciousness to adopt the same relationship he established with nature. But whereas the painter, anxious to create, discards the natural image as soon as he has made use of it, the crowd remains a slave to the painted image for a long time, and persists in seeing the world only through the adopted sign. That is why any new form seems monstrous and why the most slavish copies are admired.

Let the artist deepen his mission more than he broadens it. Let the forms he discerns and the signs into which he incorporates their quality be far enough from the imagination of the common people that the truth he brings does not take on a general character. Trouble arises, in fact, when the work becomes a kind of unit of measure indiscriminately applicable to several categories, both natural and artistic. We concede nothing to the past; why, then, would we favor the future by facilitating the task of the vulgarizers? Too much clarity is unseemly; let us be wary of masterpieces. Propriety requires a certain obscurity, and propriety is one of the attributes of art.

Above all, do not let the appearance of objectivity, which many imprudent artists bestow on their pictures, fool anyone. There are no direct means for evaluating the processes by virtue of which the connections between the world and a man's thought are made perceptible to us. The oft-mentioned act of finding in a painting the known features of the spectacle that gave rise to it proves nothing. Let us imagine a landscape.

The width of the river, the density of the foliage, the height of the slopes, the dimensions of every object and the relations between these dimensions, these are sure guarantees. Well! Should we find them intact on the canvas, we will have learned nothing about the painter's talent or genius. Rivers, foliage, slopes, despite being conscientiously rendered to scale, no longer have any worth in terms of measured width, thickness, or height, or in terms of the relations between these dimensions. Torn from natural space, they have entered a different kind of space that does not assimilate the proportions observed. Those proportions remain external. They have as much importance as a catalog number, or a title at the bottom of a picture frame. To dispute this is to deny the painters' space; it is to deny painting.

The painter has the power to make what we judge to be minuscule enormous, and to make what we know to be of considerable size tiny: he changes quantity into quality.

It is only when, after decades and centuries have elapsed, when thousands of consciences have corroborated with one another, when countless plagiarists have weakened the noble enigma of the picture by commenting on it, that we may perhaps be able to speak, without ridicule, of objective criticism.

To whom are we to impute the misapprehension, then? To the painters who fail to recognize their rights. When they have separated out the characteristic lines constituting a spectacle, they believe they are restricted to an accuracy that is truly superfluous. Let us remind them that we visit an exhibition to contemplate painting and to enjoy it, not to enlarge our knowledge—of geography, anatomy, and so on.

Let the picture imitate nothing and let it baldly present its raison d'être! It would be ungracious of us to lament the absence of all those things— flowers, countryside, a face—whose mere reflection it might have been. Nevertheless, let us admit that the recollection of natural forms cannot be absolutely banished, at least not at present. One does not elevate art to the level of pure effusion on the first attempt.

The cubist painters, who tirelessly study pictorial form and the space it engenders, are aware of this.

People have carelessly gotten into the habit of confusing that space either with pure visual space or with Euclidean space.

In one of his postulates, Euclid posits the undeformability of figures in motion: that spares us the trouble of insisting.

If we wanted to link the painters' space to some geometry, we would have to refer to non-Euclidean scholars, meditate lengthily on certain of Riemann's theorems.

As for visual space, we know that it results from the harmony between sensations of convergence and those of accommodation.

For the picture, a flat surface, the accommodation is negative. Convergence, which perspective teaches us to simulate, can therefore not evoke the idea of depth. In addition, we were not unaware that the most serious infractions of the rules of perspective in no way compromise the spatiality of a painting. Do not Chinese paintings evoke space in spite of the fact that they forcefully attest to a bias in favor of *divergence*?

To establish pictorial space, we must have recourse to tactile and motor sensations and to all our faculties. It is our entire personality that, in contracting or expanding, transforms the picture plane. As that plane, in reaction, reflects the personality back upon the beholder's understanding, the pictorial space is defined: a perceptible passageway between two subjective spaces.

The forms one locates there belong to a dynamism that we profess to dominate. In order that our intelligence may possess that dynamism, let us first exercise our sensitivity. There are only nuances. Form appears endowed with properties identical to those of color. It is moderated or augmented by contact with another form, it shatters or opens up, multiplies or disappears. Sometimes an ellipse may change its circumference because it is inscribed in a polygon. Sometimes a form, bolder than those surrounding it, governs the entire picture, stamps its effigy on every thing in the picture. Landscape painters, by imitating a leaf or two in minute detail so that all the leaves on the tree seem to be painted, show in a coarse manner that they have suspected this. It is an illusion, granted, but we ought to take that into account. Early on, the eye got the mind interested in its errors. These analogies, these contrasts, can act entirely for the good, or entirely for evil; the masters, who strove to compose with pyramids, crosses, circles, semicircles, and so on, sensed this.

The act of composing, constructing, designing, can be reduced to this: to regulate, through our own activity, the dynamism of form.

Some people, and not the least knowledgeable, locate the purpose of our technique solely in the study of volumes. If they added that, since surfaces are the boundaries of volumes and lines are the boundaries of surfaces, one has only to imitate a contour to represent a volume, we

might agree with them, but they are thinking only of the *sensation of relief,* which we consider insufficient. We are neither geometers nor sculptors: for us, lines, surfaces, and volumes are only nuances of the notion of plenitude. To imitate only volumes would be to deny these nuances in favor of a monotonous intensity. We would just as soon immediately renounce our vow of variety.

Amidst sculpturally bold reliefs, let us throw slender shafts that do not define but suggest. Certain forms must remain implicit, in such a way that the beholder's mind is the chosen site for their concrete birth.

In addition, let us know how to interrupt, with large, restful surfaces, any area where the activity becomes frenetic from excessive contiguities.

In short, the science of design consists in establishing relationships between curves and straight lines. A picture containing only straight lines or only curves would not express existence.

The same would be true for a painting where the curves and straight lines compensated one another exactly, since absolute equivalence equals zero.

The diversity of relationships among lines must be indefinite; on that condition, it incorporates quality, the immeasurable sum of affinities perceived between what we discern and what preexists in us; and, on that condition, a work of art moves people.

What the curve is to the straight line, the cool tone is to the warm tone in the domain of color.

III

After the impressionists had burned away the last Romantic shadows [*bitumes*],[2] people began to believe in a renaissance, or even in the advent of a new art: the art of color. They were delirious. They would have given the Louvre and all the museums of the world for a scrap of cardboard spotted with misty rose and apple green. We are not joking. It is to these excesses that we owe the experience of a bold and necessary experiment.

Seurat and Signac thought of schematizing the palette and, boldly breaking with an agelong habit of the eye, established optical mixture.

Noble works by Seurat, Signac, Cross, and a few others testify to the fertility of the neoimpressionist method; but it becomes questionable as soon as we cease to consider it on the level of superficial realism.

An effort to assimilate the colors of the palette to those of the prism, neoimpressionism is founded on the exclusive use of pure elements. But the colors of the prism are homogeneous, and those of the palette—heterogeneous—can provide pure elements only to the degree that we accept the idea of a *relative purity.*

Let us suppose this is possible. A thousand little dabs of a pure color break down the white light, the synthesis of which must come about in the beholder's eye. These dabs are arranged in such a way so as not to annihilate one another through the optical fusion of complementary colors; for, outside the prism, whether there is an optical blend or a blending on the palette, the sum of complementary colors produces a murky gray and not a luminous white. The contradiction gives us pause. On the one hand, we use a procedure capable of reconstituting light; on the other, one implicitly admits that this reconstitution is impossible.

The neoimpressionists will claim that it is not color, but rather light, that they have divided; they know too well that, in art, color is a quality of light and that one does not divide a quality. It is always light they divide. In order for their theory to be perfect, they would have to be able to produce the sensation of white with the seven fundamentals. Then, should they be satisfied with juxtaposing a red and a blue, the violet obtained ought to be the equivalent of the red plus the blue. That is not at all the case. Whether the blending occurs on the palette or on the retina, the composite is always less luminous and less intense than the components. Nevertheless, let us not hasten to condemn the optical blend; it causes a certain excitation of the visual sense, and we would not think of denying that there is a possible advantage in it. But, in the case just mentioned, one has only to juxtapose elements of the same hue and of different intensity to give the color a very appealing liveliness; one has only to *graduate* them. On this point, the neoimpressionists can easily persuade us.

The most troubling part of their theory consists in a manifest tendency to eliminate the so-called *neutral* elements that, on the canvas and everywhere else, configure the indefinite and whose presence within the spectrum itself has been revealed by Frauenhofer [*sic*] rays. Does anyone have the right to suppress in that way the countless combinations that separate a cadmium yellow from a cobalt violet? Is it similarly permissible to reduce the gradations offered by the color maker? Neither Seurat nor Signac nor Cross, painters at heart, went that far; others took it upon themselves: wanting absolute equivalence, the negation of living beauty,

they gave up all blends, disregarded shading, and entrusted the task of brightening their paintings to preselected chromatics [*précellences chromatiques*] strictly determined by industry.

The law of contrast, old as the human eye, and on which Seurat judiciously insisted, was promulgated with great fanfare, and, of those who congratulated themselves the most for being sensitive, none was sufficiently so to notice that to apply the law of complementary colors without tact is to negate it, since its only value lies in the fact that it is applied automatically, and requires only a delicate handling of values.

It was then that the cubists taught a new way of imagining light.

According to them, to illuminate is to reveal; to color is to specify the mode of revelation. They call luminous what strikes the mind and dark what the mind is obliged to penetrate.

We do not automatically link the idea of light to the sensation of white, any more than we link the idea of shadow to that of black. We acknowledge that a black jewel, a matte black jewel, is more luminous than the white or pink satin of the jewel case. Loving light, we refuse to measure it and we set aside the geometrical notions of focal point and ray, which imply the repetition—contrary to the principle of variety that guides us— of light-colored planes and dark intervals in a given direction. Loving color, we refuse to limit it and, dull or brilliant, fresh or muddy, we accept all the possibilities between the two extreme points of the spectrum, between the cool tones and the warm.

Here a thousand shades escape the prism, and rush to arrange themselves in the lucid region forbidden to those blinded by the immediate.

IV

In considering only the raw fact of painting, we gain the advantage of finding common ground.

Who would deny that this fact consists in dividing the surface of the canvas and investing each part with a quality that must not exclude the nature of the whole?

Immediately, taste dictates a rule: paint in such a way that no two parts having the same dimensions meet in the picture. Common sense approves and explains: when one part repeats another, the whole becomes measurable, and the work, which ceases to be a fixation of our personality (immeasurable, in which nothing is repeated), fails to do what we expect of it.

With the inequality of parts thus posited as a primordial condition, there are [two] ways to understand the division of the canvas. According to the first, all the parts are linked by a rhythmic artifice determined by one of them. The latter part—and it hardly matters which point it occupies on the canvas—gives the painting a center from which the gradations of color depart or toward which they converge, depending on whether the maximum or the minimum of intensity lies there.

According to the second way, in order for the beholder—free to establish the unity himself—to be able to apprehend all elements in the order assigned them by creative intuition, the properties of each part must be left independent, and the plastic continuum shattered into a thousand surprises of light and shadow.

Thus we have two methods that appear irreconcilable.

For those who know anything at all about the history of art, it is easy to find names that illustrate both methods. The interesting thing is to reconcile them.

The cubist painters attempt this, either by partly interrupting the link required by the first method, or by confining one of the forces that the second enjoins them to leave free; they attain the superior disequilibrium apart from which we cannot conceive of lyricism.

Both methods depend on the kinship of color and form.

Even though, of the hundred thousand living painters, only four or five have any inkling of it, a law is imposed at this point which is neither to be disputed nor interpreted, but followed scrupulously:

Every inflection of form is accompanied by a modification of color, every modification of color engenders a form.

There are tints that refuse to wed certain lines; there are surfaces that cannot support certain colors, that cast them away or collapse under them as under too heavy a load.

Simple forms are suited to the fundamental [hues] of the spectrum, fragmented forms to shimmering colors.

There is nothing so surprising as to hear, every day, the same voice praising the color of a picture and decrying the drawing! The impressionists do not make such nonsense forgivable. If we have lamented the poverty of their forms even as we championed the grace of their colors, it is because our eyes were fixed on their role as precursors.

On every other occasion we formally refuse to perpetrate a disjunction contrary to the vital forces of our art.

The impossibility of imagining form and color separately confers on anyone who senses it the right to imagine conventional reality in a useful manner.

There is nothing real outside us, there is nothing real but the coincidence of a sensation and of an individual mental direction. We would not dream of placing in doubt the existence of the objects that strike our senses; but we can reasonably only have certainty about the image they hatch in our minds.

Thus it comes as a surprise to us that well-intentioned critics explain the remarkable difference between the forms attributed to nature and those of present-day painting by the desire to represent things not as they appear but as they are. How are they? According to them, the object possesses an absolute, essential form, and it is in order to deliver it that we suppress traditional chiaroscuro and perspective. How simplistic! An object does not have an absolute form: it has as many as there are planes within the realm of signification. The form pointed out by these writers adapts as if miraculously to geometrical form. Geometry is a science, painting, an art. The geometer measures, the painter savors. The absolute of the one is inevitably the relative to the other; if logic is scared off by that, too bad! Will it ever prevent a wine from being perfect in a different way in the chemist's condenser and in the drinker's glass?

We laugh openly at the thought that many a novice may expiate his too literal understanding of a cubist's words, and his faith in absolute truth, by painstakingly juxtaposing the six faces of a cube or the two ears of a model represented in profile.

Does it follow that, true to the example of the impressionists, we ought to trust sensibility alone? By no means. We seek the essential, but we seek it in our personalities and not in a kind of eternity, which mathematicians and philosophers laboriously develop.

In any case, as we have said, there is, between the impressionists and us, a difference only of intensity, and we would not like for there to be more than that.

As many eyes as there are to contemplate an object, that is how many images of that object there are; as many minds to understand it, so many essential images.

But we do not know how to take delight in isolation: we want to dazzle others with what we wrest on a daily basis from the sensible world and, in return, we want others to make their trophies known to us. It is therefore

from a reciprocity of concession that these mixed images emerge, which we hasten to compare with artistic creations, in order to calculate their objective—that is, their purely conventional—content.

If the artist has conceded nothing to the common measure, his work will inevitably be unintelligible to anyone who cannot sprout wings as it were and rise to unknown planes. On the contrary, if, as a result of impotence or lack of intellectual direction, the painter remains enslaved to the forms commonly used, his work will delight the crowd—his work? rather, the work of the crowd—and will aggrieve the individual.

Among the so-called academic painters, there may be one who is very gifted; how would we know? Their paintings are so truthful that they are swallowed up by truth, by that negative truth, mother of morality and of all things insipid, which, in being right for all, is false for each individual.

Does that mean that the work of art must necessarily prove unintelligible to most people? No, that is only a consequence—temporal, in fact, and not a necessity.

We would be the first to blame those who, to conceal their weaknesses, would try their hand at fabricating puzzles. It is by virtue of its persistence that systematic obscurity can be detected. Instead of a veil that the intelligence pulls back little by little, venturing toward progressive riches, such obscurity is only a curtain over the void.

In addition, let us note that, since every plastic quality serves to guarantee a preliminary emotion, and every emotion certifies a concrete existence, a painting has only to be well painted for us to be assured of the *veracity* of its creator and of the fact that our intellective [*intellectif*] effort will have its reward.

Nothing is less surprising than the fact that people unfamiliar with painting do not spontaneously share our confidence; and nothing is more senseless than that they find it annoying. Must the painter reverse the direction of his work to satisfy them, restore to things the banal appearances which it is his mission to strip them of?

A great charm results from the fact that, when the object has been truly transsubstantiated, the most practiced eye experiences some difficulty in discovering it. The picture that opens up only slowly seems always to be waiting for someone to question it, as if it held an infinite number of responses to an infinite number of questions. On this point, we will let Leonardo da Vinci defend cubism:

We obviously know, says Leonardo, that vision, by means of rapid observations, discovers an infinite number of forms from one vantage point; nevertheless, it understands only one thing at a time. Let us posit a situation: you, the reader, will see this entire written page at a glance and will immediately determine that it is full of various letters, but you will not know simultaneously what letters they are or what they mean. You will have to move from one word to the next and from line to line if you want to have knowledge of these letters; just as, to get to the top of a building you have to take one step at a time. Otherwise, you will not reach the top.

Yes, there is a great charm in not distinguishing at first contact the individuality of the objects that make up a painting; but there is also a danger. We disapprove just as much of the easiness of fanciful occultism as we do of synchronic and primary images; if we condemn the exclusive use of conventional signs, it is not because we dream of replacing them with Kabbalistic signs. We even willingly admit that it is impossible to write without using clichés, or to paint while totally disregarding known signs. It is up to every individual to know if he ought to disseminate them throughout his entire work, or intimately combine them with his personal signs, or boldly plaster them—magical dissonances, tatters of the great collective lie—over a single point of the higher plane of reality that he takes on in his art. A true painter takes into account all the elements that experience reveals to him, even if they are neutral or vulgar. That is a matter of tact.

But objective or conventional reality, the world between other people's consciousness and our own—in spite of the fact that humanity has worked from time immemorial to hold it fast—constantly oscillates to the will of races, religions, scientific theories, and so on. From time to time, we can occasionally insert our personal discoveries into it, and introduce surprising exceptions to the norm.

We do not doubt that those who take measures with the handles of their paintbrushes will perceive in a short lapse of time that roundness helps to represent a round object more than do dimensions, which are always relative. We are sure that the least wise of them will soon recognize that the claim to configure the weight of bodies and the time taken to enumerate their various aspects is just as legitimate as the claim to imitate daylight with the clash between blue and orange. Thus, the act of moving

around an object to grasp in succession several of its appearances, which, blended into a single image, reconstitute it in time [*durée*], will no longer outrage reasonable people.

And those who confuse plastic dynamism with the din of the street will eventually appreciate the differences. People will finally realize that there never was a cubist technique, but simply the pictorial technique set out with courage and diversity by a few painters. They are criticized precisely for showing that technique overmuch; they are exhorted to conceal their craft. Is that not absurd? It is as if you were to tell a man to run and to not move his legs!

All painters display their craft, in fact, even those whose industrious refinement disturbs the barbarians across the ocean. But painters' techniques are like those of writers: in passing from hand to hand, they become colorless, insipid, abstract.

The cubists' methods are far from being that, even though they still do not emit the sharp brilliance of new coins, and even though an attentive study of Michelangelo authorizes us to say that they have earned their patents of nobility.

V

To execute a work of art, it is not enough to know the relationships between color and form and to apply laws governing them; the artist must also manage to free himself from the servitude inherent in that labor. Any painter with a healthy sensibility and suitable intelligence can give us well-painted pictures; but only the one endowed with Taste will awaken beauty. What we call taste is the faculty by means of which we become aware of Quality, and we set aside the notions of good taste and bad taste, which do not correspond to anything positive: a faculty is neither good nor bad, it is more or less developed.

To the savage dazzled by glass beads we will attribute a rudimentary taste, but we would be amply justified in considering as a savage the supposedly civilized person who appreciates only Italian painting or Louis XV furniture. Taste can be assessed in terms of the number of qualities it allows one to discern; nevertheless, when that number exceeds a certain figure, it diminishes in intensity and dissolves into eclecticism. Taste is innate; but, like the sensibility from which it stems, it is a devotee of the

will. Many deny this. But what is more obvious than the will's influence over our senses? It is proved to the point that, as soon as we wish to, we can isolate an oboe's high-pitched sound amid the metallic thunder of the orchestra. Similarly, we manage to savor some quality whose existence was affirmed only by our reason.

Is the will's influence on taste good in itself or harmful? The will can develop taste only on a plane parallel to that of consciousness.

Should a painter with a mediocre mind endeavor to savor qualities that, for him, are still only the abstract products of a line of reasoning and thus undertake to increase the little talent he owes to his sensibility alone, his paintings will undoubtedly become execrable, false, and stilted. Should a superior mind set the same goal for himself, he will draw advantages from it.

Will imposed upon taste, to initiate a qualitative possession of the world, has value through the act of subjecting each conquest to the nature of the material chosen.

Without using any literary, allegorical, or symbolic artifice, nothing but inflections of lines and colors, a painter can show, in a single picture, a city in China, a city in France, mountains, seas, fauna and flora, different peoples with their histories and desires, and everything that separates them in external reality. Distance or time, concrete thing or pure concept, nothing eludes expression in the painter's language, any more than in that of the poet, the musician, or the scientist.

The more distant the notions the painter subordinates to his art appear to be from that art, the more beauty is affirmed. The difficulty increases proportionally. A mediocre artist demonstrates wisdom in being satisfied to act on notions already long associated with painting. Is not a simple impressionist notation preferable to those compositions that drip with literature, metaphysics, or geometry all insufficiently *pictorialized*? We want plastic integration: either it is perfect, or it is not; we want style and not the parody of style.

The will's influence over taste contributes to a selection. By the manner in which the neophyte tolerates discipline, we verify his vocation.

Among the cubist painters there are some who painfully pretend to be self-willed and profound; there are others who move freely in the loftiest planes. Among the latter—it is not our task to name them—restraint, as among the great mystics, is only the outer garment of fervor.

Ever since someone declared that great painting died with the Primitives—then why not great literature with Homer?—some people, to resuscitate it, have impudently plagiarized the old Italians, the old Germans, and the old French; and, no doubt with the intention of modernizing painting, they take it upon themselves to fortify their industry through means that misinformed people are tempted to attribute to cubism. Since the language of these sly tricksters, Esperanto or Volapük, is addressed to everyone, people have quickly claimed that they are speaking, or, at least, are going to speak, of great art in the language accessible to all. Let us try to put an end to a tedious misunderstanding.

We have acknowledged that the ultimate end of painting is to touch the crowd, agreed, but it is not in the language of the crowd that painting must address the crowd; it is in its own language, in order to move, to dominate, to direct, not in order to be understood. So it is with religions and philosophies. The artist who refrains from any concession, who does not explain himself and tells nothing, accumulates an inner strength whose radiance illuminates his surroundings.

It is by completing our inner selves that we purify humanity; it is by increasing our own riches that we enrich others; it is by setting aglow the nucleus of the star for our own intimate joy that we exalt the universe.

In short, cubism, which has been accused of being a system, condemns all systems.

The technical simplifications that earned it that accusation mark a legitimate concern to eliminate everything that does not correspond exactly to the conditions of the plastic medium, a noble vow of purity. Let us concede that there is a method in it, but let us not allow a method to be confused with a system.

For the partial freedoms achieved by Courbet, Manet, Cézanne, and the impressionists, cubism substitutes an unlimited liberty.

Now that objective knowledge is finally considered chimerical, now that it is proven that everything the crowd understands to be natural form is, in fact, convention, the painter will have no other laws than those of Taste.

Then, through the study of all the manifestations of physical and mental life, he will learn to apply them. Nevertheless, if he ventures into metaphysics, cosmogony, or mathematics, may he be satisfied with extracting their savor and may he refrain from asking for certainties they do not possess. In their depths one finds only love and desire.

A realist, he will shape the real in the image of his mind, for there is only one truth, our own, when we impose it on everyone. And it is the faith in Beauty that provides him the necessary strength.

Albert Gleizes and Jean Metzinger

1912

EDITORS' NOTES

1. Émile Zola, Cézanne's closest friend growing up in Aix-en-Provence, was widely believed to have depicted Cézanne as a tragically failed genius in his novel L'Oeuvre (Masterpiece) (1886), the fourteenth novel in his twenty-volume Rougon-Macquart series. Although Zola himself claimed after its publication that the novel was a portrait of his own struggles as an artist, Cézanne never spoke to him again.

2. Bitumen is a rich brown pigment made from asphaltum, favored in the eighteenth and nineteenth centuries for the dark grounds and shadows characteristic of Romantic painting; see Dictionary of Art and Artists, 43.

Commentary

Published in October 1912, during or shortly after the Salon de la Section d'Or exhibition of the same year (10–30 October), *Du "Cubisme"* was the first book-length artists' statement on cubism. Indeed it has been argued that the publication of *Du "Cubisme"* in conjunction with the Section d'or was part of a concerted effort to legitimize cubism to a hostile public (Debray). For instance, both the exhibition and the book established a historical genealogy for cubism: the Section d'or through the display of mini "retrospectives" of each cubist (ibid., 27–28); *Du "Cubisme,"* by allying cubism with a French "realist" aesthetic that originated in the art of *enfants terribles* Gustave Courbet (1819–77) and Édouard Manet (1832–83) and whose legacy culminated in the "plastic" realism of Paul Cézanne (1839–1906) and the cubists themselves. In addition many of the works illustrated in *Du "Cubisme"* were of paintings included in the recent exhibition (ibid., 28).

The subsequent impact of Gleizes and Metzinger's summa of their artistic aims can be easily measured: *Du "Cubisme"* was reprinted seven times before December 1912, and by 1913 had been translated into English and Russian (for a cogent analysis of the Russian reception of *Du "Cubisme,"* see Henderson, 265–73 and 368–75). *Du "Cubisme"* was the first book in a projected series, Tous les arts, edited by Jacques Nayral and published by Eugène Figuière. The second book in the series was Guillaume Apollinaire's *The Cubist Painters: Aesthetic Meditations;* although it only

appeared in March 1913, that volume was originally advertised as the first in the Tous les arts series in an 18 August announcement in *Gil Blas* (for a summary of the genesis of Apollinaire's book, see Read, 18–25).

The nature of Gleizes and Metzinger's collaboration remains unclear due to the loss of any preliminary notes, revisions, and final proofs for the book. The original manuscript and related materials had been preserved by Gleizes at his parents' house in Courbevoie; in the early 1920s that house was sold and the document transferred to the library of Jules Roche, prominent politician and father of Gleizes's wife, Juliette Roche. Unfortunately the manuscript was destroyed when the Roche family home—located at Serrières—suffered severe damage during the German invasion of France early in World War II (Robbins, 9–10). Despite that loss, many scholars argue that the majority of the text registers Metzinger's theoretical concerns rather than those of Gleizes (for example, Brooke, 31–34; Cottington, 158–63). Historians have rightly noted that the lengthy commentary on neoimpressionism in *Du "Cubisme"* stemmed from Metzinger's early interest in that aesthetic, and Brooke and Cottington have both identified the Nietzschean inflection of *Du "Cubisme's"* celebration of the artist's creative superiority as more indicative of Metzinger's elitist beliefs, rather than those of the socially minded Gleizes (Brooke, 32–33; Cottington, 160–61). However, the attribution of Nietzschean individualism to Metzinger alone is contradicted by Gleizes's own endorsement of Nietzschean views in his assessment of Metzinger, published in September 1911 (see document 21). An alternative view would not only note the impact of Metzinger on Gleizes's thinking but acknowledge more fully that both artists had developed a shared vocabulary by the time *Du "Cubisme"* was published. In fact, major themes pervading *Du "Cubisme"*—Nietzschean artistic elitism, theories of space and perception derived from the writings of Henri Poincaré, and notions of temporality culled from the philosophy of Henri Bergson—were part of a general vocabulary embraced by many figures associated with the Parisian avant-garde. Thus historians who have focused on the impact of Nietzsche, Poincaré, and Bergson in *Du "Cubisme"* have identified these themes as indicative of a broader theoretical consensus that united Gleizes and Metzinger with many of the critics, artists, and literary figures who had participated in the Salon de la Section d'Or in the autumn of 1912 (Nash; M. Antliff, 40–66; Henderson, 44–103; M. Antliff and Leighten, 64–110; on the Section d'or, see Debray). Those allies included Metzinger's Montmartre friends Apollinaire and the poet

Max Jacob, as well as former members of the Abbaye de Créteil who gravitated to Henri-Martin Barzun's new journal, *Poème et Drame* (November 1912–March 1914), and the Artistes de Passy group, which began holding meetings in July 1912 and brought together Gleizes and Metzinger with artists associated with the Société normande (Robbins, 11–16). Concurrently Gleizes and Metzinger's dismissal of Kantian thought in *Du "Cubisme"* makes plain their disagreement with critics like Olivier Hourcade and Maurice Raynal, both of whom championed Kant and contributed to the Section d'or enterprise (M. Antliff and Leighten, 73, 85, and 204; Cottington, 159; see documents 33, 44, and 47).

That said, we can distinguish between the two authors on some counts. Thus the disparaging of the decorative in *Du "Cubisme"* appears to have its origins in Gleizes's earlier attack on decorative aesthetics in his December 1911 review of the Autumn Salon of that year (see document 29). By contrast Metzinger fully embraced this aesthetic, as witnessed by the decorative properties that pervaded the series of paintings he did of fashionably dressed women in late 1912 (M. Antliff and Leighten, 136–42). Scholars have also noted the absence of overtly nationalist themes in *Du "Cubisme,"* despite the fact that references to Greco-Roman culture, classicism, and the French "race" and "tradition" pervade earlier texts by both artists (see documents 11, 19, 21, and 29; M. Antliff, 125–26; Cottington, 160–62). Historians have conjectured that such absence indicates a disagreement between Gleizes and Metzinger over the cultural politics of cubism, a fact borne out by Gleizes's unilateral championing of an indigenous French "Gothic" tradition in texts published shortly after *Du "Cubisme's"* appearance (see documents 58 and 60; M. Antliff, 125–32; Cottington, 161–62; and Briend). Thus the publication of *Du "Cubisme"* was the product of a theoretical consensus in cubist circles that proved to be very brief, even for its authors.

M. Antliff, *Inventing Bergson*
M. Antliff and Leighten, *Cubism and Culture*
Briend, "Albert Gleizes au Salon de la Section d'Or"
Brooke, *Albert Gleizes, For and Against the Twentieth Century*
Cottington, *Cubism in the Shadow of War*
Debray, "La Section d'or"
Henderson, *The Fourth Dimension and Non-Euclidean Geometry in Modern Art*
Nash, "The Nature of Cubism"
Read, *Apollinaire and Cubism*
Robbins, "Préface"

Henriquez-Phillipe, "Le cubisme devant les artistes," *Les Annales Politiques et Litteraires* (July–December 1912): 473–75

The Artists Look at Cubism

Is that new school, which has caused so much talk in recent times, really the result of a guiding idea or, on the contrary, is it the work of a few "very Parisian" practical jokers? More than one visitor will have asked himself that question, standing in front of the outlandish creations that were exhibited at the Salon d'Automne and elsewhere [fig. 39]. What do the artists think of these efforts, which want to turn every tradition on its head? That is what we asked a few of them. Here are their responses, in the order they were received by us.

Mr. de Saint-Marceaux

For fear of becoming incensed, I avoid, as far as possible, submitting to the spectacle of the stupid horrors with which perpetrators of nasty hoaxes have for so many years captured the public's attention.

Of the latest arrivals, the cubists, I have seen nothing but a few reproductions in the newspapers. I do not know how to check the invasion of systematic ugliness in art. The press might simply seek to repair the damage it has done. But let us rather count on eternal beauty, the cult of which is not dead, and which, one day, will certainly draw back to its magnificent law those who now claim to escape it.

R. de Saint-Marceaux, of the Institut

Mr. Denys Puech

In reply to the questions you were kind enough to ask me, it is my opinion that the cubist technique, applied to the human figure or to any other art

of truth, is unacceptable: the interpretation to which it subjects the model is all too distortional.

To try to check that movement is pointless: it cannot go far on its own power.

The only use that these new apostles might make of their ingenuity would be to apply it to decorative art. That avenue allows the artist the most varied fantasies—the most outlandish even—provided that the combinations of lines and the harmony of colors are agreeable to the eye.

But to wish to express life with geometrical forms is to defy common sense.

Denys Puech, of the Institut

Mr. Léandre

As you have guessed, I am not someone who is moved and astonished by the fantasies of the cubist genre.

The naive claim of these so-called innovators makes even the most impervious and indifferent people laugh and cry at the same time . . . If they simply confined themselves to absurdity, it would be nothing; but the grave matter is that they add a sort of pretension to it, a kind of solemn and haughty vanity, which, from one day to the next, makes them the pontiffs and heads of school, more hackneyed and more sectarian than any of the ones who, not long ago, hardheartedly closed their doors to Delacroix, Millet, Rousseau, Puvis, and so on.

Cubism! Well, it did not require a great deal of effort on their part to find the system! I ask you, what modest teacher of drawing, what ordinary student at a school of fine arts, does not know that the planes forming the surfaces of a body can be inscribed within all the geometrical figures! Those are the ABCs of drawing. But isn't that childish?

A new formula was needed, it was lacking! In fact, there can be no *new* art without a formula: we no longer face nature in the studio, we have gone to the laboratory! And it's all very modern! Except that it is distressing as well as ridiculous to see serious men, wearing haloes like saints, solemn as statues, more or less patrons of the arts and of artists, sponsoring these worthless and pointless flights of fancy.

How to check the invasion of that artistic barbarism, you ask?

Don't be concerned, leave it alone, let it go. . . .

Jokes in bad taste never last long. In our country, happily, imagination never proceeds without reason!

Such, dear sir, is my opinion on cubism; I entrust it to you, it is sincere.

C. Léandre

Mr. Léopold Bernstamm

I hasten to reply to your interesting question: what I think of cubism and of the cubists is what I believe any person who is the least bit sensible and has some notion of taste and art must think of it, that is, that it is troubling, in a country such as France, where art is so beautiful and so great, that the negation of all art, namely, cubism, could come into being.

As a passionate advocate of sincerity, of the truth of life, and as the pious admirer of the old masters, I deplore that bad joke more than anyone.

What would be needed is the most complete silence surrounding the cubists' flights of fancy; perhaps they will be forgiven once they are forgotten.

Léopold Bernstamm

Mr. Abel Truchet

The cubists! The newspapers are the only ones to talk about them, and, as for the danger they pose to French art, rest assured that it runs a much greater risk every year in the spring . . . Go to the salon on Sunday, and see which pictures are drawing a crowd: that's the danger. And it is not very great.

Abel Truchet

Mr. Lévy-Dhurmer

What do I think of the cubists? They are impotent, they've run off the track for the moment, they are causing an awful fuss. But they are looking for something different. In that respect, they are very interesting.

L. Lévy-Dhurmer

Mr. Antonin Carlès

First and foremost, I must confess I am not very familiar with that new method adopted by a few, and, that being the case, you will understand why I cannot formulate any criticism.

Nevertheless, I am glad to be afforded the opportunity to say that, in general, any truly strong work of art conceals what we might call the technique, without the artist having intended anything by it.

But cubism is much closer to an interpretation of forms, an intentional and too prominent interpretation. Now, the interpretation constituting the work of art must not be intentional, it is purely intuitive; hence, though I am not familiar with cubism, I am bold enough to believe that those who are involved in it are wasting their time.

How to check that invasion of bad taste? I really don't know: but I think that, if true writers, all of whom like and respect true artistic endeavors, truly wanted to exalt these endeavors, even while remaining dead silent about these manifestations of spirits more ambitious than courageous, frightened off in advance from the long and patient studies art requires, that entire invasion of cubists and others would be crushed.

Antonin Carlès

Mr. Brispot

You ask me to tell you what I think of cubism? Well, I don't think anything of it, I admit it.

As for the cubists, they are, in my opinion, practical jokers or sickos who want at all cost for people to say things about them, even while they make fun of the public.

They are succeeding marvelously; people do say things about them—bad things, to be sure, but at least they are talking about them. This year, however, they may be vexed that the press has openly condemned their annoying tendencies.

The way to check that invasion of bad taste would be: (1) to convince the state to no longer lend out its palace to these sorts of exhibitions; (2) to plead with the press to maintain absolute silence, while beseeching the public from now on to abstain from visiting anywhere these gentlemen might exhibit.

If everyone has the wisdom to do that next year, the cubists will be done for.

<div align="right">

M. Brispot

</div>

Mr. Ernest Dubois

It seems to me that the cubists make the mistake of taking for a result what might be a working method.

It may be reasonable for artists to confine reliefs and outlines within geometrical figures so as to determine more easily the different planes of construction, light, and shadow, but it is only a means of execution and not a result, and to remain at that point is to stop before the end of the journey. Sometimes, the simplicity of planes and lines is found to be a requirement of the material: granite, for example, by virtue of its hardness, may oblige you to appear an adherent of cubism and to produce a fairly felicitous effect in a work that has to face harsh climates and brave the weather.

But that is very different from what I saw at the Salon d'Automne, which I visited for the first time this year. What I saw reminded me of the articulated wood mannequins that are sold by frame dealers.

As for the way to check that invasion of bad taste, I believe the best thing is not to be concerned with it. Cubism will do no more damage to the good taste and clarity of the French genius than did futurism. In fact, most of the efforts are coming to us from foreigners, and one must make the best of these tendencies; snobbery and the spirit of opposition will always supply them with admirers and the favor of certain critics, who consider it a game and an amusement to exalt anything that might be at variance with their colleagues.

I also believe that time, which puts everyone in his place, will be disastrous enough for the cubists and futurists: one has only to let it happen.

<div align="right">

Ernest Dubois

</div>

Mr. A. Robida

What do I think of cubism? Why, exactly what the cubists think of it— within themselves and without telling us so.

Cubism, futurism, jokerism, or lunaticism, it all amounts to the same thing as far as I'm concerned. And let us rest assured: that *delirium* of the palette is a *delirium* for laughs; it's just that the farce is a bit clumsy and the joke tedious.

The briefest jokes are the best: witness the masterpiece of the great Bo-ronali, who gleefully avenged us two years ago for the canvases inflicted on our afflicted eyes.

The cubists and futurists are malingerers; they want to make us believe they belong to the Charenton Lunatic Academy: they are proud of it. That might be an excuse. But if they don't snap out of it, they'll be going there. It's a dangerous game: people have been seen taking notes in front of their canvases—not art critics but doctors specializing in mental illness. Brrr!

In short, there's no reason to build barricades at the end of the Pont des Arts: the Institut is not in danger.

A. Robida

Mr. Aubé

I know the paintings you mention only by the reproductions in the news-papers. I did not go to see them, and I wonder whether the public's indif-ference might not be the best remedy for similar follies.

In any case, I see no other.

J. Aubé

Mr. Le Gout-Gérard

What do I think of cubism? Quite simply that that so-called new school is only a huge farce that the French public has been made to swallow for too long, and every year, as an hors-d'oeuvre in the spring and a dessert in the fall; and, instead of laughing at it, that public would do better to get angry.

It is truly disheartening to see these flights of fancy from abroad come to be displayed in France, placed side by side in the window with the mas-terpieces of French art—the great galaxy of 1830, for example—without anybody protesting!

Will the cry of alarm from a municipal councillor in the city of Paris be heard to echo in high places?

Let us hope so, and let us be patient. That would be the only remedy to this invasion of bad taste.

And, in conclusion, I quote this sentence, found in the manifesto of futurist literature, which applies well to this case:

"Man, completely spoiled by the library and the museum, enslaved to a horrifying logic and wisdom, holds absolutely no interest anymore."

No comment required, don't you think?

F. Le Gout-Gérard

Mr. Luc-Olivier Merson

To better reply to your questionnaire, I purchased the illustrated manual by the cubist painters MM. Albert Gleizes and Jean Metzinger. It is pointless to add that I understood absolutely nothing of the treatise *Du "Cubisme."* I retained only this delicious sentence: "At the risk of condemning all modern painting, we must consider Cubism (with a capital C) legitimate, and, as a result, must see it as the only conception of pictorial art currently possible. In other words, at present, Cubism (again with a capital C) is quite simply the art of painting."

As for the text's illustrations, it is in vain that they aim for originality. Quéniaux's [*sic*] *Le manuel de dessin* and M. Reja's [*sic*] *L'Art chez les fous* long ago accustomed us to the sight of insanities of the same order. Is it necessary to attempt to check that movement? I don't think so. That would be making martyrs of these unfortunate souls, who are only children or sickos. Only the Australian savages would have the right to complain about the unfair competition, which could in no way overtake our French art.

Luc-Olivier Merson, of the Institut

Mr. F. Cormon

The cubists are gleeful practical jokers who make fun of human stupidity. They have no importance and must truly be amused by that which has been granted them.

What does have importance are the antiartistic and anti-French campaigns that, for the last thirty years, have gradually depraved the taste, the artistic sense of our race, and which condemn our young people to depressing worries and discouragement.

F. Cormon, of the Institut

After such a harsh indictment, our impartiality obliged us to ask one of the protagonists of the new and boisterous school to present us with the defense

of "cubism." Mr. Albert Gleizes, a young artist whose canvases attracted a great deal of notice at the Salon d'Automne, at the exhibition of the Section d'Or, and so on, was kind enough to initiate us, in a few lines, to the mysteries of "cubist art."

Albert Gleizes

In collaboration with Jean Metzinger, in *Du Cubisme,* published by Eugène Figuière, I wanted to show the absolute logic of the current pictorial movement. For the partial freedoms acquired by Courbet, Manet, the impressionists, Cézanne, and even Matisse, cubism substitutes an indefinite freedom: it is the natural continuation of the work of these liberators, which leads us back to the true sense of the French tradition and is violently opposed to the detestable Italian influence, the sad legacy of the sixteenth-century Renaissance, an attack on our national genius. In fact, it is by looking at and questioning our primitives and our cathedrals— and they are certainly of our race—not as picturesque and amusing curiosities, but as masterpieces in time, that we will be able to understand the significance of the cubist pictures. It is from these past works that we must ask for lessons and advice, and not from the Italian masters, who are not part of our heritage and whose creative genius is inferior to it. A painter ought not to be ignorant of those Italians, just as he cannot be ignorant of artists of other races, but he ought to know, above all, how to extract from his culture the elements that are part of its essence, and develop them in that spirit: a matter of intuition, of tact, and of will.

A more subtle understanding of the object and its development in the universe is what may currently be found surprising in the pictures of the new painters. The object, participating in a totality, cannot impose itself as an episode in the first instance—hence the error of the beholder who struggles, first and foremost, to find again the clichés to which he has become accustomed, instead of appreciating the picture as an altogether independent organism that finds its reason within itself. Moreover, the role of the painter is not to restore to things their ordinary appearance; rather, his mission is to strip them of it. And the inscription of form, limited by vision up to now, at present expands to include everything the intelligence allows us to know of it.

In these canvases, do not look for literature, states of mind, or useless chatter; in them, you will not find emotion through the ripples of the

hour, of the season, plays of sunlight, or through displays of geographical, anatomical, or other such knowledge. Drawing (which does not mean reproduction), the study of the form alone, the space to which it gives rise, the weight of the bodies, architecture, invention, and the color appropriate to each shift of plane: these are essentially plastic qualities, which ought to be disturbing and which must be tirelessly elaborated. In a word, we want plastic integration.

Finally, a day will come when we recognize that there never was a *cubist technique,* but simply the pictorial technique, exhibited with courage and diversity by a few painters.

These painters are currently being attacked, just as all the schools of art now called classical once were, with the same insults used to address them, the same epithets, the same bad faith. How could they be surprised? They know that understanding proceeds much more slowly than creative abilities, because it follows in their wake, and the first to have exhibited so-called cubist pictures a few years ago at the Salon des Indépendants (Room 41), who were not spared sarcasm, are already surprised to see that many who repudiate recent productions already accept the works of that time.

And later, when the extremists, the unskilled followers of the new generations have fallen by the wayside, the painters who remain will suffice to justify the discoveries of today.

Albert Gleizes

The public will draw whatever conclusion it likes from this inquiry. We will not add any commentary, since our role, given the circumstances, has been limited to having artists say out loud what they have until now been content to think.

Our only goal was to serve the fine cause of French art.

—*Henriquez-Philippe*
July–December 1912

Commentary

The journalist Henriquez-Philippe's "The Artists Look at Cubism" was one of two such *enquêtes* (surveys) published in late 1912, in which a single cubist painter was pitted against the predominantly hostile assessments of his artist-peers. In October 1912 the newspaper *Eclair* had published an article, "Le mystère cubiste," in which a team of artists were canvassed for

their assessment of Fernand Léger's *Woman in Blue* (1912), then on view at the Salon d'Automne. Over the course of October and early November *Eclair*'s "Echoes" column published artists' derogatory interpretations of *Woman in Blue,* which culminated in Léger's own explication in a letter published on 3 November (see Weiss, 75). Henriquez-Philippe took on the even more ambitious task of surveying artists' responses to the cubist movement as a whole, and his choice of Albert Gleizes as interlocutor indicates the artist's newfound prominence in the fall of 1912. Shortly before *Du "Cubisme"*'s publication, Gleizes had been asked by the critic André Tudesq to respond to public criticism of the paintings on view at the Salon d'Automne and Salon de la Section d'Or (*Paris-Midi,* 4 October 1912). In November 1912 the first issue of Henri-Martin Barzun's journal *Poème et Drame* published chapter 5 of *Du "Cubisme"* to signal Barzun's own allegiance to the cubism of his former Abbaye de Créteil colleague, Gleizes. In both the Tudesq text and Henriquez-Philippe's December *enquête,* Gleizes draws freely from his coauthored book in defending the movement, but he also allies cubism to a particular definition of the French tradition in anticipation of his February 1913 manifesto "Tradition and Cubism" (see document 60 and related commentary).

Like Olivier Hourcade's earlier survey (document 36), Henriquez-Philippe's text gives us crucial insight into the evolving critique of cubism both in the press and among members of the art establishment under the Third Republic (on the latter, see Genet-Delacroix; Green; Levin; Mainardi; and Vaisse). Many of the artists cited in the December 1912 survey were prominent members of the Société des artistes français who had a rivalrous relation to avant-garde artists affiliated with the Salon des Indépendants and Salon d'Automne.

In 1881 the state-sanctioned salon had been privatized and renamed the Société des artistes français. Funded and run by its members, the Société became the commercial vehicle for artists affiliated with the École nationale des Beaux-Arts and the École's teaching ateliers. The juries for painting and sculpture at the Société's annual exhibitions were dominated by artists from this small circle. As Fay Brauer and Christopher Green note, the Société des artistes français was tacitly recognized to be the official arbiter of French taste, a status that was challenged with the founding of an even more restrictive salon by the self-proclaimed Société nationale des Beaux-Arts in 1890. The hegemony of these organizations was countered in 1884 with the creation of the jury-free

Salon des Indépendants as a venue for artists excluded from the mainstream salons.

The Independents Salon was the vehicle of the newly formed Société des artistes indépendantes, a group spearheaded by Paul Signac and the neoimpressionists. As we have seen, Signac and his colleagues envisioned their salon as a venue free of the partisan politics that crippled the jury system; as such it was a threat to the status quo exemplified by the Société des artistes français and Société nationale (see document 36). In 1903 a middle ground was struck between the juried salons and jury-free Independents with the founding of the Salon d'Automne. This salon was juried by a group of artists elected annually by their peers, thus guaranteeing a regular rotation of the jury committee among the organization's membership.

The Société des artistes français and Société nationale were both officially sanctioned by the state, and were allowed to hold their exhibitions in the state-owned Grand Palais; in 1904 the Autumn Salon also gained entrance into this exhibition space by virtue of the support of the City of Paris (as opposed to the national government). By contrast the Salon des Indépendants remained outside this governmental and institutional frame until 1918, even though the Autumn Salon specialized in profiling new "movements" that arose out of this avant-garde venue (for concise analyses of these institutional issues, see Brauer, chap. 2; Green, 39–42). As a result the annual Salon des Indépendants was regularly held in temporary quarters, such as the Grande Serre de l'Alma, Cours-la Reine, or the Baraquement du Quai d'Orsay, Pont de l'Alma.

Although the fourteen artists surveyed in Henriquez-Philippe's text are little known today, a brief biography of each contributor in order of appearance testifies to their importance at the time. Most exhibited at the annual salons of the Société des artistes français, and some had achieved the high honor of being elected to the Académie des Beaux-Arts, a section of the Institut de France. René de Saint-Marceaux (1845–1915) was a sculptor who first exhibited in 1868, obtained the Légion d'honneur in 1880, became a Sociétaire of the Salon des artistes français in 1885, and was named a member of the Institut de France in 1905. Denys Puech (Pierre Denis) (1854–1942) was another prominent academic sculptor who was a member of the sculpture jury for the Salon des artistes français. Like Saint-Marceaux, Puech was appointed a member of the Institut de France in 1905. Charles-Lucien Léandre (1862–1930), by contrast, was a student

of the academic artist Alexandre Cabanel. Before 1914 Léandre had established a dual career as a painter and caricaturist well known among the bohemians of Montmartre. Beginning in 1887 he exhibited regularly at the Salon des artistes français, and with Louis Morin, he founded the Société des humoristes. Named a Chevalier de la Légion d'honneur in 1900, Léandre was an habitué of Montmartre who is primarily remembered for his acidic drawings for *Le Chat Noir* (1882–95) and *L'Assiette au Beurre* (1901–12) and for his murals at the Taverne de Paris in Montmartre. Léopold Bernstamm (1859–1935) was a Russian-born sculptor, trained at the St. Petersburg Academy, who became a regular contributor to the salons of the Société des artistes français after he emigrated to France in 1885.

The painters Louis Abel Truchet (1857–1918) and Lucien Lévy-Dhurmer (1865–1953) on the other hand shared Léandre's rather unorthodox profile, when compared to the more academically oriented respondents. A student of Jules Lefebvre and Benjamin Constant at the Académie Julian, Abel Truchet later worked in the impressionist mode, but was also a founding member of the Société des humoristes. Beginning in 1891, he exhibited at a full cross-section of salons, including the Salon d'Automne, the salon of the Société nationale des Beaux-Arts (which made him a member in 1910), and the Salon des artistes français, which had designated him *hors-concours* (an honor conferring the right to submit nonjuried works). The painter Lucien Lévy-Dhurmer began his career as a lithographer and decorator, taking up the position of artistic director of the decorative stoneware factory at Golfe-Juan between 1887 and 1895. In 1896 he had a one-person exhibition at the Galerie Georges Petit in Paris, and afterward exhibited regularly at the Salon des artistes français. Lévy-Dhurmer was firmly allied with the symbolist movement, and of all of Henriquez-Philippe's respondents, he was the most unorthodox from the standpoint of his artistic training and painterly style.

Henriquez-Philippe's other correspondents had more traditional profiles. Jean Antonin Carlès (1851–1919) was a sculptor who studied at the École des Beaux-Arts in Paris: he obtained a Grand Prix at the Exposition universelle of 1889. Henri Brispot (1846–1928) in turn studied under the academician Léon Bonnat: he exhibited genre paintings at the Salon des artistes français throughout his career. Ernest Henri Dubois (1863–1931) was a sculptor who became a Sociétaire des artistes français in 1893, and an Officier de la Légion d'honneur in 1900. Albert Robida (1848–1926),

like Léandre, was an illustrator-caricaturist as well as a painter who exhibited at the Salon des artistes français. His caricatures appeared under the pseudonym Roby in standard humorist magazines such as *Paris Comique* and *Paris-Caprice* and under his own name in *L'Assiette au Beurre*. In 1893 he was made Sociétaire of the Salon des artistes français. Jean Paul Aubé (1837–1916) was a sculptor trained at the École des Beaux-Arts who also studied decorative sculpture in Italy; he made his debut at the Salon in 1861. The recipient of numerous awards, Aubé became a Sociétaire of the Société nationale in 1891. The painter Fernand Le Gout-Gérard (1856–1924), who specialized in marine views, exhibited at the Salon des artistes français from 1889 to 1894, before switching allegiances to the Société nationale des Beaux-Arts. The painter Luc Olivier Merson (1846–1920) was perhaps the most well known of Henriquez-Philippe's respondents: named a professor at the École des Beaux-Arts in 1894, he painted mural-size works for the Palais de Justice, the Sorbonne, and the Opéra Comique (on Merson see Vaisse). The final respondent, the painter Fernand Cormon (1854–1924), was a former student of Cabanel and Eugène Fromentin, who was a professor at the École des Beaux-Arts and member of the Institut de France.

These critics were almost universally hostile to cubism, but the basis of their criticism varied, sometimes dramatically. Most common was the accusation that cubism was little more than a hoax, launched by insincere and incompetent artists to generate publicity (Saint-Marceaux, Bernstamm, Carlès, Brispot, Robida, Le Gout-Gérard, Cormon). At least one artist, Brispot, thought that the writers who supported cubism were themselves hoaxers who were duping a gullible public. Both these accusations had been voiced previously in Olivier Hourcade's *enquête* by Maurice Robin and Camille Mauclair (document 36); moreover art historian Jeffrey Weiss has charted the pervasiveness of such criticism in the French press before 1914 (Weiss). To counter the cubist threat, some artists called for a boycott of cubist exhibitions, by both the critics and the exhibition-going public (Bernstamm, Carlès, Brispot, Dubois, Aubé). In at least one case (Abel Truchet), the existence of the jury-free Salon des Indépendants was considered part of the problem, since it allowed the cubists to exhibit their paintings free of all constraints. The institutional thrust of Truchet's argument complements those of Brispot and Le Gout-Gérard, both of whom supported the Paris city councillor Pierre Lampué in his call for state exclusion of the cubists—on the presumption that they

were all foreigners—from all public buildings, a clear condemnation of the Salon d'Automne (see documents 45, 49, and 55). These complaints are supplemented by generous doses of xenophobia. Fernand Cormon subsumes cubism into a thirty-year-old assault on French taste by practitioners of what he calls "antiartistic and anti-French" campaigns. Presumably Cormon had in mind all avant-garde art from the 1880s onward. Robida and Le Gout-Gérard air the same complaint by lumping the cubists together with the Italian futurists, to underscore the so-called foreignness of the former. Le Gout-Gérard goes so far as to describe cubism as an "invasion of bad taste" and cubist paintings as "flights of fancy from abroad." Robida and Merson go further by pathologizing the cubists, Robida with a touch of irony, Merson without. Robida claims that the cubists had embarked on a "dangerous game" in indulging in a "delirium of the palette" for "laughs"; their art, we are told, had not attracted art critics, "but doctors specializing in mental illness." Merson in turn claims that the images published in Du "Cubisme" were comparable to the art of the mentally ill in Marcel Réja's L'Art chez les fous (1907), or to the schematic drawings in Gaston Quénioux's instruction manual for primary school-children, Manuel de dessin à l'usage de l'enseignement primaire (1910). Merson not only compares cubist paintings to the art of "children or sickos," he includes those of "Australian savages" in the mix, thus constituting a trilogy commonly associated with the "primitive" (see M. Antliff and Leighten, "Primitive," 217–33). These artists' correlation between cubism and "primitive" degeneracy also encompass notions of the grotesque (in contradistinction to the beautiful): thus Saint-Marceaux declares cubism an "invasion of systematic ugliness in art" (on cubism and the grotesque, see M. Antliff and Leighten, Cubism and Culture, 24–63; Connelly, 79–110; Leighten).

Merson's allusion to Quénioux's instruction manual echoes another accusation: that the cubists had substituted preliminary drawing exercises taught in primary schools and at the École des Beaux-Arts for finished works of art (see Weiss, 78). Thus Léandre states that cubist technique amounted to nothing more than "the ABCs of drawing": "I ask you, what modest teacher of drawing, what ordinary student at a school of fine arts, does not know that the planes forming the surfaces of a body can be inscribed within all the geometrical figures!" The sculptor Dubois claims that the cubist geometrization of figures was a common means for determining "planes of construction, light, and shadow," but that the

cubists erred in mistaking "a means of execution" for "a result," namely, a finished work of art. Such accusations updated a critical paradigm previously applied to the impressionists, who were accused of wrongly applying preliminary academic techniques of the *esquisse* and *ébauche* to finished works. In response the impressionists asserted that their method allowed for a greater degree of expressive originality and spontaneity when compared to the ossifying technique of their academic rivals (on the impressionists' "technique of originality," see Shiff). Gleizes and Metzinger's *Du "Cubisme"*—the text vilified by Merson—also made a claim for originality and self-expression, but within the metaphysical frame of Bergsonian "intuition" and Nietzschean "will to power." Not surprisingly, Gleizes draws extensively on *Du "Cubisme"* in his closing remarks to Henriquez-Phillipe's survey, describing the cubist method as "a matter of intuition, of tact, and of will."

M. Antliff and Leighten, *Cubism and Culture*
M. Antliff and Leighten, "Primitive"
Brauer, "L'Art révolutionnaire"
Connelly, *The Sleep of Reason*
Genet-Delacroix, *Art et état sous la IIIe République*
Green, *Art in France, 1900–1940*
Leighten, "The White Peril and *l'Art nègre*"
Levin, *Republican Art and Ideology in Late Nineteenth-Century France*
Mainardi, *The End of the Salon*
Shiff, *Cézanne and the End of Impressionism*
Vaisse, *La Troisième République et les peintres*
Weiss, *The Popular Culture of Modern Art*

Guillaume Apollinaire, "Realité, peinture pure," *Der Sturm* ([Berlin,] December 1912) [pub. 1910–32]

Reality, Pure Painting

At the height of the struggle that is being conducted against those young artists who as proof of the depth of their art proudly bear the name of cubists—a name that was given to them in order to render them ridiculous—I felt obliged to take up their defense in the great French newspapers *Le Temps* and *L'Intransigeant* and in my book *Méditations esthétiques* (Figuière, 1912) [document 62]. I provided definitions of cubism and clarified the difference between the old imitative form of painting and that in which an artist as well known as Picasso has distinguished himself.

The diversity of opinion among these artists reassured me as to the future of an art that is not merely a matter of technique but rather the ascent of an entire generation toward a sublime aesthetic that excludes perspective and other conventions.

During this period I frequently saw a young artist who has been much discussed in recent years both in France and abroad: Robert Delaunay, one of the most daring and gifted artists of his generation [fig. 45].

His construction of colored volumes, his abrupt break with perspective, and his treatment of surfaces influenced a large number of his friends. I also learned about his researches into pure painting, which I reported in *Le Temps*.

However, at this time he did not fully explain his ideas to me, so I was pleased when just a short time ago he showed me his latest work—in which reality is as full of movement as living light—and decided that for my greater edification he would explain the fundamental principles of his discovery, a discovery that will exert an even greater influence on

Translated from the German by Jason Gaiger.

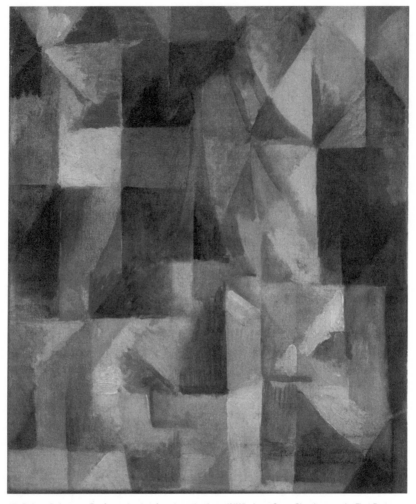

45. Robert Delaunay, *Fenêtres simultanées, 1 partie, 3 motif* (*Windows Open Simultaneously, First Part, Third Motif*), 1912. 45.7 × 37.5 cm. Tate Gallery, London. © L&M Services B.V. Amsterdam 20050801. Used by permission of L&M Services.

art than the sudden transformations brought about by his most famous painting, *Ville de Paris* [*City of Paris*]. I believe that it will be to the benefit of everyone if I record here his aesthetic statement "on the construction of reality in pure painting."

"Realism is what is permanent in art: without it there can be no enduring beauty, for the two share the same essence.

"Let us seek for purity of means in painting, for the most pure expression of beauty.

"In impressionism—and here I include all those manifestations that reacted to it: neoimpressionism, precubism, cubism, neocubism, that is, everything that is concerned with technique and with scientific procedures—we find ourselves before the immediacy of nature, far from the purity of 'styles': including Italian, Gothic, African style, and so forth.

"From this point of view, impressionism can still be regarded as a splendid victory—but an incomplete one. It is the first stammering of souls who overflow before nature, souls who are still intimidated by this great reality. Their enthusiasm has removed all the old false ideas, the archaic procedures of the old painting (draftsmanship, geometry, perspective) and everything to do with the intellectualized, moribund, neoclassical academy.

"This emancipatory movement began with impressionism. There were precursors: El Greco, certain English artists, and our own revolutionary Delacroix. It was a great period of preparation in the search for the sole reality: for 'light,' which allowed all of these experiments and reactions to be brought together in impressionism.

"The effect of light, the indispensable prerequisite for any vital expression of beauty, still remains the problem of modern painting. It was from light that Seurat first set free the 'contrast of complementaries.'

"Seurat was the first theoretician of light. Contrast itself became his means of expression. Seurat's early death broke off his researches. He can be seen as the artist who, within impressionism, achieved the greatest possible with the means of expression that were then available.

"His creation remains the contrast of complementary colors. (The optical blending through dots that he and his contemporaries practiced was only technical and did not yet possess the significance that contrasts possess as a means of pure expression.)

"He used this first means to achieve a specific representation of nature. His paintings are a sort of fleeting image.

"The most daring of the impressionists had not yet discovered or achieved simultaneous contrast, and yet this alone is the foundation of all pure expression in painting today.

"'Simultaneous contrast' ensures the dynamism of colors and their construction in the painting: it is the most powerful means of expressing reality.

"The means of expression should not be personal; on the contrary, they should be ready to serve every intuition of beauty, and the artist's craft [*métier*] should be identical with the creative idea.

"The sole reality that can be constructed in a painting consists in the 'simultaneity of colors' through the 'simultaneity of contrasts' and all the (uneven) quantities that emanate from color in accordance with the expression of its representative movement.

"It is no longer a matter of effect (neoimpressionism within impressionism), nor of the object (cubism within impressionism), nor of the image (the physics of cubism within impressionism).

"We thus arrive at a purely expressive painting that excludes every past style (archaic, geometric), an art that is becoming plastic and that serves only a single purpose: to inspire human nature toward beauty. Light is not a method: it floods over us and is communicated to us by our senses. Without the perception of light—without the eye—there can be no movement. For it is our eyes that transmit the sensations that we perceive in nature to our soul.—It is in our eyes that the present moment, and thus our sensations, are mirrored. Without this sensibility, that is to say, without light, we could do nothing: our soul discovers its most complete feeling of life in harmony, and harmony in turn arises only out of the simultaneity with which the quantities and relations of light reach the soul (the highest of the senses) through the intermediary of the eyes.

"The soul judges the forms of the image of nature by comparing them with nature itself—pure criticism—and thereby commands the creator. The creator takes into account everything that is present in the universe through being, succession, imagination, and simultaneity.

"It is nature therefore that brings forth the science of painting.

"The first painting was simply a line that described the contour of a man as a shadow thrown on the floor by the sun.

"And yet with the means that we employ today, how far removed we are from this simple image, we who posses light (bright and dark colors, their complementaries, their intervals, and their simultaneity) and all the quantities of colors that the mind can use to create harmony.

"Harmony is the faculty of sensation ordered by the artist, who must exert himself to achieve the maximum degree of realistic expression, or what we might term the subject: the 'subject' is harmonic proportion and this proportion is composed from different simultaneous elements

brought together in a single action. The 'subject' is eternal in a work of art and must appear to the initiated in all its order and all its science.

"Without the 'subject' there are no possibilities: however, this does not mean that there is any literary or anecdotal subject: the painterly subject is completely plastic and derives from vision; it must be the pure expression of human nature.

"The eternal subject is found in nature itself; it is the inspiration and the clear vision that belong to the wise person who has discovered the most beautiful and powerful limits."

Such words have no need of commentary. They wish to be understood directly and to give rise to that "simultaneity" which, alone, constitutes creation. What remains is mere note taking, observation, study. Simultaneity is life itself and whatever the actual succession of elements, the artwork leads to an ineluctable conclusion, to death, while the creator knows only eternity. For too long the artist has preoccupied himself with unifying the sterile elements of art; it is time that he arrives at fecundity, at the trinity, and at simultaneity.

And Delaunay has not only achieved this in his words but also in his works—pure painting, reality.

Commentary

Robert Delaunay wrote two essays in the last half of 1912: "La lumière" (Light), which was translated by Paul Klee and published in *Der Sturm* (vol. 3, nos. 144–45) in January 1913, and the above essay, "Réalité, peinture pure," which Delaunay gave to Guillaume Apollinaire in the form of notes and which the poet quoted, with minor changes. "Reality, Pure Painting" was written while Delaunay was developing his *Windows* series of paintings from April to December 1912 (Buckberrough, 99–132; Rousseau et al., 166–83). Three major influences played mingled roles in the development of Delaunay's ideas at this time: Maurice Princet, Wassily Kandinsky, and Leonardo da Vinci. Princet, the insurance actuary who befriended the cubists and introduced them to the advanced mathematical theories of Henri Poincaré (Henderson, 64–72; see document 35), shared with Delaunay an interest in searching for scientific laws underlying and unifying art and life. Kandinsky's own search for an abstract art, with its basis in the spiritual, came forcibly to his attention at the Salon des Indépendants in spring 1912 when Kandinsky exhibited three of his *Improvisations*

(#24, *Troika;* #25, *Garden of Love;* and #26, *Rowing*). Also by this date Delaunay had read a translation of *On the Spiritual in Art,* by Elisabeth Epstein and Sonia Delaunay-Terk (Rousseau et al., 166); Kandinsky himself encouraged Delaunay to write down his theories as they developed. Finally, Joséphin (Sâr) Péladan had recently translated Leonardo's treatises into French (Société du Mercure de France, 1907). Delaunay read them closely, making notes whose reflection is discernible in this essay, especially the role of the eye in perception and understanding and the superiority of vision to the other senses, hence the superiority of the visual over the other arts. As with nearly all the cubists, Delaunay was also steeped in symbolism, especially Mallarmean poetics, as well as Bergsonism; but he made his own direction clear at this juncture with his so-called discovery of "simultaneous contrasts" and "color construction." This moved him more quickly into abstraction than any other Parisian modernist, with the single exception of František Kupka (Hicken, 181–86, persuasively argues that Kupka only later became associated with Apollinaire's Orphism by Alexandre Mercereau and others, though never by Apollinaire himself; his argument, though, is weakened by his misunderstanding of Kupka's mystical art as "decorative formalism").

For Delaunay, the window is a metaphor for the eye (fig. 45), which is both an object and the transparent medium through which the soul perceives the outer world and through which nature makes its impact on the soul (as Leonardo wrote, in "instinctive communion" [Rousseau et al., 167]; he also revisited "the eye as the window of the soul," a quote included in Delaunay's notes which Apollinaire somewhat laboriously changed to "it is our eyes that transmit the sensations that we perceive in nature to our soul"). That these operations go both ways underlies the concept of "simultaneity" as Delaunay used it. Color plays for Delaunay the role that light played for Apollinaire: the vehicle of consciousness and communication, of sensory and spiritual enlightenment, with mystical overtones for the poet (see commentary, document 62). In the *Windows* series, the physical realities of the outer world blend through the window with the artist's consciousness of those realities, producing dynamic "simultaneous contrasts" in a "primitive language of colors" (Rousseau et al., 167).

Delaunay (and Henri Le Fauconnier) refused either to participate in the Section d'Or exhibition or to be included in Metzinger and Gleizes's *Du "Cubisme"* (document 57), signaling his departure from these group

efforts in an attempt to establish an independent reputation. He even published a letter in *Gil Blas* on 25 October 1912, "Les origines du cubisme," disassociating his work from theirs during the course of the exhibition. Apollinaire, having coined the all-important term *Orphic cubism* for Delaunay's painting, joined him in distinguishing Delaunay's work from that of the salon cubists, discussing only his earlier work in *Les peintres cubistes* (document 62) and reserving its elaboration for his even more widely ambitious concept of Orphism (see commentary, documents 61 and 62) in his reviews of the Salon des Indépendants in March 1913 (Hicken, 181). Delaunay was by no means unhappy to play a role in this expanded concept, redefined as "peinture pure." "Reality, Pure Painting" furthers that project, predicting "the ascent of an entire generation toward a sublime aesthetic that excludes perspective and other conventions." It is important to grasp the intersection of Delaunay's concept of simultaneity with the more broadly shared poetic concept, which Apollinaire elaborated in "Simultanism-Librettism" (see document 76) (Décaudin; Bohn, 64–68). For further evidence of Delaunay's theory in the period from 1912 to 1914, see his correspondence with Franz Marc in *Écrits et correspondances, Franz Marc,* edited by Maria Stavrinaki (Paris: École nationale supérieure des beaux-arts, 2006), 457–98.

Bohn, *The Aesthetics of Visual Poetry, 1914–1928*
Buckberrough, *Robert Delaunay*
Décaudin, *La crise des valeurs symbolistes*
Henderson, *The Fourth Dimension and Non-Euclidean Geometry in Modern Art*
Hicken, *Apollinaire, Cubism and Orphism*
Leonardo da Vinci, *Textes choisis*
Rousseau et al., *Robert Delaunay, 1906–1914*

Albert Gleizes, "La tradition et le cubisme," *Montjoie!* (1 and 2 February 1913)

Tradition and Cubism

If we are to believe most critics, a manifest anarchy is emerging from the different currents toward which, they believe, French painting is headed. The same critics who are irritated by the most audacious endeavors are hardly less peevish about painters who have been officially consecrated. Routine and daring are equally subjects for concern, and their anger is appeased, giving way to smug satisfaction, only in the face of creations by skillful and astute conciliators. One critic assures us, with ingenuousness and acknowledged authority, that it is not possible to admire both Claude Lorrain and the impressionists; another, that the proximity to Cézanne would be ignominious for the masterpieces housed in the Louvre, repeating today all that was said about Manet in the past. These are entirely gratuitous assertions, remaining within the limited realm of personal opinion, but which nevertheless attest to the absolute lack of perspicacity in the historical record of our painting; and their disorderly admiration explains their powerlessness to coordinate what was with what is. Contrary to them, we consider the works of the most willful artists of the present to stem from the sources of our national tradition. Thus, it is important to know which painters were attached to that tradition in centuries past, which ones were most profoundly capable of expressing the generalities of the race and of their time, most capable of breaking free from the petty contingencies of fashion.

In the history of our art, the most disastrous pressure to be exerted, because of the unfortunate direction it imposed, was indisputably the official invasion called the Renaissance of the sixteenth century.

Instead of weighing the colossal and original artistic heritage we possessed at the time against this Italian art, so remote from our primordial

aspirations and so permeated by Greek antiquity and gaiety of heart, we accepted, on the robust rosebush where the roses of our cathedrals had bloomed, the graft of the Latin branch, already withered, whose invasive leaves would, for centuries, delay the blooming of the main branch.

Had we not already had our Renaissance, more beneficial and more in keeping with the hopes of the race, better and more beautiful in its time, nearly two centuries earlier? And who would contest the influence of that renewal of vitality, of luxury, of pomp, of the love of truth—so visible in the arts of the time in Paris, in Bourges, and in Dijon—on the artistic directions of both the Flemish and the Italians? Since the early thirteenth century, France has been the nucleus for all the manifestations of the human spirit, and, if the Hundred Years' War arrested that admirable expansion for a time, there was a new flowering as soon as the squall died down. In Burgundy, Jean Malouel, in Bourbonnais, Master of Moulins, and, in Avignon, Nicolas Froment, were the foremost illustrations, and, along with our most glorious ancestor Jehan Fouquet, they constituted the triumph of our national genius, so sober and so moving, in its natural relation to humanity.

But the irreparable was about to occur. The man who had done so much for the hegemony of French art was also to be the instrument of its ruin. The death of René of Anjou was, in fact, the unexpected signal for the Renaissance, since the wars in Italy were the profound reasons for it: the official arrival in Paris of Il Rosso and Primaticcio, with their sparkling verve, consummate virtuosity, and conventional showiness, clearly signified the direction that the man who was master of the hour wanted to impose on our destiny. And there was the most intransigent infatuation with everything coming from the other side of the Alps; an intoxication with pedantry and artificiality penetrated the aristocracy, turned people's brains upside down, and became official taste [*raison d'état*]. Many painters would remain unknown because of that mad drunkenness for Italian taste, which our knights brought back on horseback from the ultramontane expeditions. Many painters, too in love with their homeland, too sincere to deny their faith, too respectful of the legacy of their ancestors, would be misunderstood for not accepting the yoke of that art. Triumphal marches marked its apotheosis, and, to the brilliant sound of the trumpets, among the flapping streamers, it entered France as condottiere.

Even if the cycle had been perfect from Cimabue to Raphael, that was no reason to put all the hopes of our race on it, especially at the precise moment

when the imitators were affirming its decadence. The influence of Raphael, Michelangelo, and Leonardo would yield as negative a result on sixteenth-century France as the influence of our "stone carvers" did on twelfth-century Italy. This is so true that, a century later, in one of the greatest painters not to escape that formidable influence, namely, Nicolas Poussin, we will have to deplore, throughout his oeuvre, the continuation of Raphael and da Vinci via Fra Angelico: it is that boundless admiration for the showy past that made him campaign throughout his life for the title of Italian painter, and we have to concede that, in reality, he belongs more to that period of confusion than to the true lineage we now claim as our own.

The damage was done. It would be a long and heated struggle before the intruders the court had made fashionable were completely cast out: but the destiny of a people cannot be stopped, and the robust and true descendants of the old image makers would finally prevail over the cosmopolitan, stilted, and false favorites, whom events had attempted to place in their path. The courtiers immediately bowed to the king's will, but, at the same time, we saw, with the Clouets, the ancestral truth reappearing, pointing the way for those with enough faith and courage.

François Clouet was able to remain French in spirit throughout his work; he expressed himself solely with his painter's means. He did not concern himself with chiaroscuro, he painted faithfully what his eye revealed to him, because his prudence defended him against the bad taste of the moment, and he had no interest in falling into clumsy imitation of the Italians. He knew how to interest us through the plastic values he discovered in his models, and through the profound and faithful study of faces and objects. He avoided a puerile psychology that was very much in favor. Joséphin [Sâr] Péladan, whose great talent as a writer I admire, will forgive me for smiling when I think of him criticizing Clouet's portrait of Francis II for not revealing to us that king's love for Mary Stuart. Such criticisms, when applied to the plastic arts, require no commentary; nevertheless, such is the vice of almost all writers on art who discourse on painting, that they see it in the same light as a literary work, and measure one by the quantities they are accustomed to require of the other. It would not occur to us painters to crush Jehan Clouet's Francis I under the weight of literature, which the Sâr discovers in Titian's Francis I. Jehan and François Clouet had the wisdom not to let themselves be affected by transalpine declamation, and, in those equivocal times, they preserved the freshness and naturalness of our origins.

A century after Clouet, Philippe de Champaigne also reacted with all his might against the Renaissance. Clouet's art ripened; it was not afflicted by redundancy, reminiscences hardly open to doubt, affectation, and prettiness. The austerity, truth, and unity of that painting became very pronounced, which means that Champaigne must be considered the artist who cultivated the reconquered field and, in spite of the times, reconnected the slender thread of pure tradition.

Even though the appearance of his compositions and a certain neo-Greek tendency in the architecture may elicit some doubts, Claude Gellée, known as Claude Lorrain, is, deep down, one of us. He can rightly be regarded as the first to have a sense for the play of light, the fluidity of the atmosphere in landscapes; and his progeny, *pace* Mr. Péladan once again, the masters of Barbizon and the great impressionists, would, during the nineteenth century, singularly develop what his genius allowed him to glimpse and what his century prevented him from pursuing further. His *Fête villageoise* [*Village Fête*] anticipates Corot, his *Gué* [*Ford*], Théodore Rousseau, his *Ports,* Monet. Lorrain bears few outward signs of the time he spent in Italy, and, though his eye may have sometimes retained certain visions of it, his brain defended him well enough that the work no longer contains anything of them. With him, the era of the landscape began for French painting.

Jean Boulogne laboriously followed in Carrvaggio's [*sic*] footsteps; at the same time, we must also loudly proclaim the importance of painters who have been forsaken, if not misunderstood, rather too much for my liking, namely, the Le Nain brothers, who bravely inaugurated a popular art from which all realist audacity would emerge. With them, one got the sense that the beauty of a painting does not in any way reside in the choice of subject, and that the most humble representations of even vulgar motifs could be the pretext for beautiful pictures. That boom, arrested for a moment by mannerism, pedantry, and preciousness, which became even more acute with eighteenth-century painters, found an admirable defender in J.-B.-S. Chardin. Chardin also declared himself disdainful of the subject, in contrast to his contemporaries in whom the banter, smartness, and grace of the piquant anecdote, and the elegance of expression, tended—even in Watteau—to seduce the beholder much more than simply touch him by the quality of the painting itself. This was the swan song for all sixteenth-century influences, both in France, the country of choice for Boucher and Fragonard, and in Italy, Tiepolo's country of origin.

Only Chardin's canvases offered many rich starting points for those who would succeed him. Then, in the face of the collapse of so many aborted illusions, two men with considerable talent stood up, and tried to erect anew the millennial edifice of idealism. David and Ingres' aim was nothing less than to come as close as possible to the cornerstone, Raphael. That supreme effort did not last long; the descendants of the two masters were Cabanel's students, whereas the glory of Chardin, who incarnated an entire race full of vital sap [sève], shone with the most brilliant light in Géricault and Delacroix. The rigid poses were replaced by a still-latent, but spirited and lyrical dynamism in line and color, and the *Chasseur de la garde* [*Charging Hussar*] certainly anticipated *Entrée des croisés à Constantinople* [*Entry of the Crusaders into Constantinople*].

From that point on, the movement gathered speed, and two parallel paths opened. On the one hand, the lesson of Lorrain was understood, and there was a great exodus toward nature. The Ile de France provided painters with nearly all their pretexts. Although a special place must be granted to Georges Michel for his role as precursor, Théodore Rousseau, Millet, Decamps, J. Dupré, and Corot took the art of the landscape to new heights, soon followed by the impressionists, who definitively rid themselves of Romantic ungainliness. On the other hand, after Delacroix, it was Courbet and Manet who, in large compositions, gave greater focus to Le Nain's realism; and finally, Renoir spiritualized it, using the trophies of impressionist color for his figures.

French art had definitively recovered its rights, after struggles three centuries old. Thanks to the isolated sharpshooters who stood up to the invaders, the inauspicious influence of the Renaissance was now defeated; only a few, who poorly understood the lesson of Ingres, persisted in showing us more or less Romanized Junos, Marses, and Minervas, emerging fully armed from the theater warehouse. But the danger no longer lay in that corner. Impressionism, on the contrary, with its considerable and selective contributions to the palette, presented a few dangers. Blinded by the discoveries of light, artists forgot architecture; but, as they raved on about the relationships among tones, one very great painter understood the weakness of the recent finds, and struggled to link and to balance the two inseparable elements of any painted work: line and color. Paul Cézanne introduced new concepts into the still-superficial realism of Courbet, and saw that the study of primordial volumes would open unprecedented horizons. He sensed that plastic dynamism had nothing to

do with the motion animating our streets, our machines, and our factories; he broke the future wide open, and the rising generation of painters found a new field to cultivate. Painting, heretofore considered objective, discovered it was destined for a different fate, and an undreamed-of plastic development became available for its investigations.

Since my friend Jean Metzinger and I have studied at length the different rationales for contemporary painting in Du "Cubisme" (E. Figuière, 1912 [document 57]), I will not insist on that point here. Let me simply say quickly that painters today consider the object only in relation to the set of things, and that set itself only in relation to the set of aspects it entails. Since they are not unaware that a more prominent form governs forms that are less so, plastic dynamism comes into being through the pattern of relationships among objects, or even among the different aspects of a single object, *juxtaposed*—and not superimposed as some delight in making people believe—with all the sensibility and taste of the painter, who now has no other rule. Finally, cubism—an imperfect epithet—does not consist in inscribing the volume of bodies geometrically, that is (I insist upon this because, here again, there are many who want to make that claim), by enclosing the form in a *geometrical figure* as beginners are taught to do in the academies, but rather in establishing new plastic connections among the purely objective elements that compose a picture. If the painter's art consists in investing with a radiant reality many virtualities included in the objects surrounding us, the cubists do not think they have fallen short of their role in fervently taking on the task of discovering these qualities.

Now that our old Celtic origins are better understood, we must salute those who have safeguarded and transmitted the legacy of our fathers, "the master painters," and the "image makers" of the Middle Ages, a legacy more precious to each succeeding age. We know how stifled their genius was under the importations of the Renaissance; we know how much they had to struggle to defend it; and we know what our task is, now that we judge their victory decisive. But we would not be worthy of their memory if we supposed we were being faithful to them by imitating or plagiarizing any of them, whether Jehan Fouquet or Claude Monet.

Painting, emanating from human thought, cannot be rigidly fixed in a form. It evolves constantly, and constantly offers its tribute money to the discoveries in the field that has fallen to it. Unable to remain apart from the great problems of the age, it will necessarily reflect them. Yet, how

puerile it would be to want contemporary painting to have the same look as that of the twelfth century! It does not escape the inspirations, the aspirations of the present; it receives all the active seeds of the environment where it blossoms; and our century, which has seen such miraculous accomplishments in all realms of human activity, cannot have an art that is not in contact with all the energies our century creates. But, above all, painting must not in itself live off foreign elements, it must know how to avoid any compromise, whether literary, musical, philosophical, or scientific: it would be a grave error to believe it could express its age solely by depicting everyday episodes, anecdotes, picturesqueness, any more than that, by painting flywheels, tie rods, and pistons, it could evoke the lyricism of the machine. The full dynamism, the full might, the full beauty of the times will rise up, even from the most nondescript object, only if the painter succeeds in investing it with an equivalent degree of plasticity.

Albert Gleizes

1 FEBRUARY 1913

Commentary

In this important essay Albert Gleizes summarizes those aspects of his own cultural politics that were excluded from *Du "Cubisme,"* coauthored with Jean Metzinger in late 1912 (see document 57). To counter critics who claimed that modern art from Paul Cézanne forward rejected the French tradition, Gleizes mounts an argument for cubism's integral relation to France's cultural legacy. Cubism, we are told, had its roots in the Gothic era, and beyond that, in a concept of the French "race" defined in terms of "our old Celtic origins." Gleizes then contrasts this indigenous Gothic and Celtic heritage with that born of Greco-Latin culture, as exemplified by Italian art. In doing so he writes a history of French art that charts the suppression of a native Gothic tradition by an Italianized French monarchy. In Gleizes's estimation this process began with Francis I's construction of the royal place of Fontainbleau in 1528, and the importation of the Italian mannerists Rosso Fiorentino (1494–1540) and Francesco Primaticcio (1504–70) to oversee the palace decoration. As a result the whole court experienced a "drunkenness for Italian taste." This situation was further exacerbated by the return to France of knights from "ultramontane expeditions," for they too were enamored of Italian art and culture.

From the sixteenth century forward France was locked in the cultural equivalent of a civil war that pitted the nativist defenders of the Gothic

against the "Italianate" artists who were promoted through monarchical and aristocratic patronage. Gleizes employs militarist metaphors to describe the pernicious influence of Italian art on French society: Italian culture entered the country as "condottiere," its dissemination under the monarchy amounted to "an official invasion," and the upholders of the Gothic tradition were "isolated sharpshooters who stood up to the invaders." Implicit in Gleizes's formulation is a concept of class war, in which the aristocracy had become alienated from the common people who remained true to France's Celtic roots. Greco-Latin culture became synonymous with elite culture, because it was propagated by the Académie des Beaux-Arts (founded in 1648) and later through the teachings of the École des Beaux-Arts. Both these institutions embraced an Italianate concept of classicism. Artists affiliated with this orientation included the doyen of classicism, Nicolas Poussin (1594–1665), the "Caravaggesque" Moïse Jean Valentin de Boulogne (1591–1632), rococo artists François Boucher (1703–1867) and Jean-Honoré Fragonard (1732–1825), and Raphael's followers Jacques-Louis David (1748–1825) and Jean-August-Dominique Ingres (1780–1867). By the midnineteenth century the Italian invasion had run out of steam, with the academic Alexandre Cabanel as its last significant representative.

Italian culture, propped up by state and aristocratic patronage, did not succeed in totally suppressing the Gothic. Its first defenders were Jean Clouet (1485–1540/41) and his son François (1510–72), both of whom served as court painters for Francis I. Gleizes signals his high regard for these artists by illustrating his article with an engraving by Jacques Villon, after Francois Clouet's *Portrait of Francis I* (1541). In his text he also admonishes the neo-Catholic symbolist Joséphin (Sâr) Péladan (1858–19) for disparaging Jean Clouet's accomplishments (on Péladan, see Marlais, 139–51). Gleizes's attack on the symbolist Péladan is significant, for Péladan's annotated addition of Leonardo da Vinci's *Trattato della pittura* (1910) had been circulated among the cubists in 1912 at the instigation of Villon. The Sâr's mystical reading of Leonardo's pronouncements on the golden section is thought to have inspired the naming of the Salon de la Section d'Or: thus Gleizes's attack may have been a coded rebuttal of this aspect of cubist discourse (see documents 46 and 47).

Other French "primitives" singled out by Gleizes for praise were Jean Malouel (1365–1415), the Master of Moulin (1483–1500), Nicholas Froment (1460–84), and Jean Fouquet (1450–81). These artists were the "robust and

true descendants of the old image makers," and the Clouets, together with Philippe de Champaigne (1602–74), managed to keep this tradition alive in the face of the Italianate onslaught. In later years the Gothic impulse resulted in the rise of French landscape painting in the seventeenth century—Gleizes cites Claude Lorrain—and the birth of realism, exemplified by the Le Nain brothers and Jean-Baptiste-Siméon Chardin (1699–1779). By the nineteenth century these two genres merged in the Romanticism of Théodore Géricault (1791–1824) and Eugène Delacroix (1798–1863), the art of the Barbizon school, that of Gustave Courbet and the impressionists, and finally the painting of Cézanne. Significantly Gleizes utilizes terminology from his earlier cubist criticism to praise the Gothic tradition: François Clouet is admired for having discovered "plastic values" in his models; the Le Nain brothers and Chardin had chosen ordinary subjects in order to focus attention on "the quality of the painting itself"; the Romantics revealed "lyrical dynamism in line and color"; while Cézanne had corrected the impressionists' overemphasis on color by employing "primordial volumes" to create "plastic dynamism." Gleizes uses this formulation to refute those critics who identified cubist aesthetics with simple academic exercises in drawing (see document 58). These formal properties also served to distinguish cubism from an art that equated plastic dynamism with the anecdotal depiction of "flywheels, tie rods, and pistons." Here Gleizes was alluding to futurist aesthetics, which subsequently provoked Umberto Boccioni to define "plastic dynamism" from a futurist perspective in a manifesto published in the 15 December 1913 issue of *Lacerba* (Boccioni in Apollonio, 92–95). Gleizes closes his article by asserting that the dynamism of modern life could only be captured through the plastic qualities of the painting itself, a claim that anticipated Fernand Léger's essays of 1913–14 (see documents 65 and 75).

There is some debate over the relation of Gleizes's text to the cultural politics of the period. His claim that a native Celtic-Gothic tradition was suppressed by monarchical fiat is seen by Antliff to reiterate views promoted by an organization known as the French Celtic League (M. Antliff, 106–32). From its founding in 1911 the league had recruited many figures associated with the salon cubists, including Gleizes's close friend Alexandre Mercereau, *Du "Cubisme's"* publisher Eugène Figuière, cubist critic Olivier Hourcade, and the symbolists Paul Fort and Tancrède de Visan. When an excerpt from *Du "Cubisme"* appeared in the November 1912

issue of Henri-Martin Barzun's *Poème et Drame*, it was preceded by a diatribe against Italian culture written by league member Charles Callet. In the same issue Barzun published a major aesthetic statement attacking "Greco-Latin" culture, and identifying the Gothic tradition as truly expressive of "our audacious Gallo-Celtic race" (Barzun, cited in M. Antliff, 117). The league's founder, Robert Pelletier, had posited an absolute divide between Greco-Latin culture and France's Gothic tradition, claiming that the monarchy from Francis I forward had betrayed France by importing Italian culture and inculcating a taste for such art among the aristocracy. In the artistic sphere, Pelletier praised the French primitives of the fourteenth century and drew comparisons between medieval artisanal corporations and modern-day syndicates. This sharp contrast between a Gothic art of "le peuple" and that of an oppressive monarchy would have appealed to Gleizes's own populist leanings, which further suggests a close correlation between Gleizes's essay and the league's agenda (for a general history of populist critiques of the French monarchy from the standpoint of Celtic nationalism, see E. Weber, 21–39).

David Cottington, while endorsing Antliff's interpretation, has located an alternative source for Gleizes's cultural politics in the writings of Adrien Mithouard, citing Gleizes's "appeals to race as the basis of tradition," his emphasis on "the temporal character of French classicism," and his eulogy "to the Cathedrals of Ile-de-France" as "reminiscent" of the "Barrèsian nationalism" found in Mithouard's *Traité de l'occident* (1904) and his journal *L'Occident* (Cottington, *Cubism in the Shadow of War,* 162; Cottington, *Cubism and Its Histories,* 146–47). However, there were profound differences between Gleizes's views and those of Mithouard. Mithouard thought that the cathedral represented the supreme synthesis of the Greco-Roman and Celtic streams in occidental culture, whereas Gleizes, like Pelletier, posited a rigid distinction between the Greco-Latin and "Celtic" medievalism (on Mithouard, see Décaudin, 146–49; McWilliam, "Action française"; McWilliam, *Monumental Intolerance,* 167). Mithouard was an ardent Catholic whose closest ally among the artists was the Catholic symbolist Maurice Denis; during the same period Gleizes was decidedly anti-Catholic, as witnessed by his earlier affiliation with the secular Association Ernest Renan and his derogatory comments on ultramontanism in "Tradition and Cubism."

However, *L'Occident* was receptive to alternative opinions, as witnessed by Mithouard's publication of the anti-Latin diatribes of the sculptor and

Celtic League member Jean Baffier (McWilliam, *Monumental Intoler-ance*, 167). Theoretically Mithouard could have subsumed Gleizes within his cultural project (as he did Baffier), but the absence of Gleizes's writ-ings in *L'Occident* suggests that any such overtures were not reciprocated. Peter Brooke in his monograph on Gleizes disagrees with both M. Antliff and Cottington, asserting that Gleizes was a leftist who rejected "right-wing, nationalist and traditionist, attitudes." In Brooke's opinion the true measure of Gleizes's prewar cultural politics was the unpublished war-time text *L'Art dans l'évolution générale* (1917), which identified France as "the meeting point of the Mediterranean and Nordic cultures" (Brooke, 28 and 42–43). However, the outbreak of World War I in August 1914 completely altered avant-garde cultural politics in France, and led to the ubiquitous celebration of the "Latin" culture of France's military ally, Italy (Green; Silver). Thus we should be extremely cautious about read-ing Gleizes's wartime text as an undistorted window onto the cultural landscape of the prewar era. In addition Pelletier's defense of modern syndicalism, combined with the antimonarchism of his Celtic national-ism, suggests that the French Celtic League's agenda was anything but right wing. While we can agree with Brooke's view that Gleizes's cul-tural politics were still embryonic before 1914, it is nevertheless evident that "Tradition and Cubism" made a strong case for a leftist nationalism that then proved untenable after the start of World War I (Brooke, 42; M. Antliff and Leighten, 197–214).

M. Antliff, *Inventing Bergson*
M. Antliff and Leighten, *Cubism and Culture*
Apollonio, ed., *Futurist Manifestos*
Brooke, *Albert Gleizes, For and Against the Twentieth Century*
Cottington, *Cubism and Its Histories*
Cottington, *Cubism in the Shadow of War*
Décaudin, *La crise des valeurs symbolistes*
Green, *Cubism and Its Enemies*
Marlais, *Conservative Echoes in Fin-de-Siècle Parisian Art Criticism*
McWilliam, "Action française"
McWilliam, *Monumental Intolerance*
Silver, *L'Esprit de Corps*
E. Weber, *My France*

Guillaume Apollinaire, "Die moderne Malerei," *Der Sturm* ([Berlin,] February 1913): 272

Modern Painting

France in the nineteenth century produced the newest and the most varied artistic movements, all of which together constitute impressionism. This tendency stands at the opposite pole to the old Italian perspectival painting. If this movement, whose beginnings can already be identified in the eighteenth century, appears to be restricted to France, this is because Paris in the nineteenth century was *the* city of art. In reality, this movement is not only French but European—English artists such as Constable and Turner, a German such as [Hans von] Marées, a Dutchman such as van Gogh, and a Spaniard such as Picasso, played an important role in the movement, which is not so much a manifestation of French genius as of a universal culture.

Nonetheless, this new art first gained a foothold in France, and the French expressed themselves in this form of art in greater numbers and with more success than the artists of other nations. The greatest names in modern painting, from Courbet to Cézanne, from Delacroix to Matisse, are French.

From an artistic standpoint, it is possible to claim that France plays the role that Italy played for the old form of painting. Later, this tendency in painting was studied in Germany with just as much enthusiasm as it was in France, at least until the time of the "fauves." From this point on, impressionism started to fragment into personal tendencies, each of which, after some hesitation, has embarked on its own personal path toward the living expression of the sublime.

Translated from the German by Jason Gaiger.

The same thing has taken place in French literature: each new movement draws together the most diverse tendencies. The name *dramatism* does not express the antidescriptive element that dominates the work of certain poets and writers. Here I would include Barzun, Mercereau, Georges Polti, and myself.

In just the same way, there are also new tendencies in modern painting; the most important seem to me to be, on the one hand, Picasso's cubism, and on the other, Delaunay's Orphism. Orphism derived from Matisse and the "fauve" movement, in particular, from its anti-academic and luminous tendency.

Picasso's cubism derived from a movement that began with André Derain. André Derain, a restless personality who was in love with form and color, issued more than mere promises once he had awakened to art, for he awakened the true character of the people that he met: in Matisse he awoke a sense for the symbolism of colors, and in Picasso he awoke a sense for sublime new forms. Thereafter Derain withdrew and for a time he neglected to participate in the art of his time. The most important of his works are the calm, profound paintings (up to 1910), whose influence has been so considerable, and the woodcuts that he made for my book *L'Enchanteur pourrissant* [1909]. These woodcuts, whose technique was suppler and more adaptable than, for example, that of Gauguin, signaled a renaissance of the woodcut—a revival that took place across the whole of Europe.

Let us now consider the principal tendencies of modern painting. Authentic cubism to use an absolute expression—would be the art of painting new compositions with formal elements that are derived not from visual reality but from the reality of concepts.

This tendency leads to a form of poetic painting that goes beyond visual perception; for even in the case of simple cubism, opening out the necessary geometric surfaces means that in order to provide a complete representation of an object—above all, an object whose form is not absolutely simple—the artist must produce an image that, even if one made the effort to understand it, would completely distance itself from the ob-

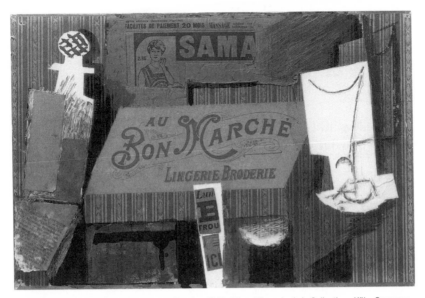

46. Pablo Picasso, *Still Life 'Au Bon Marché,'* spring 1913. 24 × 36 cm. Ludwig Collection, Köln, Germany.
© 2005 Estate of Pablo Picasso/Artists Rights Society (ARS), New York. Photograph Rheinisches
Bildarchiv Köln. Used by permission of Ludwig Museum, Köln, and Rheinisches Bildarchiv, Köln, Germany.

ject whose representation—that is to say, whose objective reality—one
had sought to give.

The legitimacy of this form of painting is beyond question. Everyone
must admit that a chair, no matter from what side it is looked at, still
possesses four legs, a seat, and a back, and that if any of these elements are
taken away something essential has been removed. Moreover, the primi-
tives did not paint a town as it would have looked to someone standing
in the foreground, but as it was in reality, that is to say, complete, with
gates, streets, and towers. A large number of the innovations introduced
into this form of painting confirm on a daily basis its human and poetic
character.

Picasso and Braque incorporated into their work letters from signs and
other inscriptions because in modern cities inscriptions, signs, and ad-
vertisements play an important artistic role and are suited to be incorpo-
rated into art. Sometimes Picasso renounced the use of ordinary colors
and made works in relief out of paper, formed from torn pieces of paper

stuck together; he was led by a plastic form of inspiration, and these un-usual, crude, and disparate materials were rendered noble because the artist conferred on them his own sensitive and powerful personality [figs. 46, 47, and 51].

To this movement belong Georges Braque, Jean Metzinger, Albert Gleizes, Juan Gris, and certain works by Marie Laurencin.

A subsidiary current has formed within this main current: physical cub-ism, which consists in the creation of new combinations out of elements that are borrowed from visual reality. It is not a pure art, and this move-ment only belongs to cubism because of its constructive appearance.

Another tendency within impressionism ascends toward the sublime, to-ward light. The efforts of the impressionists have brought them so far that they paint the very appearance [*simulacre*] of light. Then Seurat came along; he discovered the contrast of complementary colors, but he was unable to liberate himself from the image because a contrast can only exist through itself; nonetheless, these efforts were of considerable im-portance, at least insofar as they paved the way for a large number of new seekers.

Delaunay believed that if it is true that a simple color conditions its com-plementary, it does so not by breaking up the light but by setting free all the colors of the prism. This tendency can be termed Orphism [fig. 45]. I believe that this movement is closer than the others to the sensibility of several modern German painters.

This dramatic movement in art and poetry is growing ever stronger in France; it is represented above all by the works of Fernand Léger, whose investigations receive considerable attention among young artists; also by certain paintings by Mlle. Laurencin, by Picabia's recent work, whose raw violence outraged the public at the "Salon d'Automne" and the "Sec-

tion d'Or," and finally by the strange paintings of Marcel Duchamp, who attempts to symbolize the movement of life, etc., etc.

The most interesting German painters, such as Kandinsky, Marc, Meidner, Macke, Jan Censky, Münter, Otto Freundlich, etc., belong—instinctively—to this movement. The Italian futurists, who developed out of the fauves and cubism but who did not think it was right to abolish all perspectival and psychological conventions, also belong to Orphism.

These two movements constitute a form of pure art because they determine only the pleasure of our faculty of sight. They are movements of pure painting because they ascend to the sublime without relying on any artistic, literary, or scientific conventions. We are drunk with enthusiasm. Here we ascend to plastic lyricism.

In the same way, the most recent movement in poetry, which in France is known under the name of *dramatism,* ascends to this concrete, direct lyricism, which the descriptive poets cannot attain.

This creative tendency now extends throughout the universe. Painting is not an imitative, but a creative art. With the movements of Orphism and cubism we arrive at complete poetry in bright light.

I love the art of the modern painters, because I love light more than anything else.

And because all human beings love light more than anything else, they invented fire.

Commentary

Though this essay was written after Guillaume Apollinaire's *Les peintres cubistes*—from which much of it is drawn—"Modern Painting" preceded his book into print by one month. Whereas in the book, however, Apollinaire developed his theory of four types of cubism (see commentary, document 62), here he lays out two forms of modernism in art,

developing his new distinction between cubism and Orphism, crediting Robert Delaunay with the latter's clearest manifestation and rooting it in Georges Seurat as well as in the luminosity of fauvism (that is, giving it a distinct genealogy as well). Yet both achieve "pure painting," and both, along with the new poetry, are "lyrical." Given that this essay was intended for a German audience, it is interesting that Apollinaire's French nationalism is even more sharply articulated than in *Les peintres cubistes,* going so far as to claim that, in the development of modernist painting, "France plays the role that Italy played for the old form of painting." Literature too is being transformed in Paris, "*the* city of art." Yet he also parades his internationalism in crediting German and other European nations—including England, Holland, Italy, and Spain—with important contributions, and emphasizes his strong interest in and good relations with Wassily Kandinsky, Franz Marc, August Macke, and other German modernists, whom he relates most closely to Orphism (see commentary, document 62).

The term *pure* had been introduced by Apollinaire in "Du sujet dans la peinture moderne," published in his journal *Les Soirées de Paris* in February 1912 (1–4), and developed in this essay as well as in *Les peintres cubistes.* Maurice Raynal used the term *pure painting* in a different way in his essay "L'Exposition de 'La Section d'Or,'" in the single issue of *La Section d'Or* of 9 October 1912 (document 47).

Guillaume Apollinaire, *Les peintres cubistes: Méditations esthétiques* (Paris: Eugène Figuère [17 March], 1913)

The Cubist Painters: Aesthetic Meditations

On Painting

I

The plastic virtues—purity, unity, and truth—keep nature subdued beneath their feet.

In vain: someone strings the rainbow, the seasons tremble, mobs hurl themselves toward death, science takes apart and reassembles what exists, worlds forever remove themselves from our conception, our shifting images repeat themselves or resuscitate their unconscious, and the colors, odors, and noises ushered in astonish us, then disappear from nature.

That monster of beauty is not eternal.

We know that our breath had no beginning and will have no end, but, before anything else, we conceive of the creation and the end of the world.

Nevertheless, too many painters still worship plants, stones, waves, or humans.

One quickly becomes accustomed to the enslavement of mystery. And, in the end, servitude creates sweet leisure.

The workers are allowed to control the universe and gardeners have less respect for nature than do artists.

It is time to be the masters. Goodwill does not assure victory.

This side of eternity, the mortal forms of love are dancing and the word *nature* encapsulates their accursed discipline.

The flame is the symbol of painting and the three plastic virtues blaze and glow.

The flame has purity, which tolerates nothing foreign and cruelly transforms within itself what it catches.

It has that magical unity whereby, if one divides it, every spark is similar to the single flame.

It has, finally, the sublime truth of its light, which no one can deny.

The virtuous painters of this Western age consider their purity in spite of the natural forces.

It is the forgetting that comes after study. And, for a pure artist to die, all those of bygone centuries must have never existed. Painting is purifying itself in the West, with the ideal logic that the old painters transmitted to the new, as if they were giving birth to them.

And that is all.

One person lives in pleasure, another in pain, some squander their inheritance, others become rich, still others have only life.

And that is all.

One cannot carry one's father's corpse everywhere. One abandons it to the company of the other dead. And one remembers it, one misses it, one speaks of it with admiration. And, if one becomes a father, one must not expect one of our children to want to go through life accompanied by our corpse.

But in vain do our feet leave the ground that contains the dead.

To consider purity is to baptize instinct, it is to humanize art and deify the personality.

The root, the stem, and the flower of the lily show purity's progression toward its symbolic flowering.

All bodies are equal before the light and their modifications result from the luminous power that constructs at its whim.

We do not know all the colors and every man invents new ones.

But the painter must above all make a spectacle of his own divinity, and the pictures he offers for human admiration will confer on them the glory of exercising for a moment their own divinity as well.

To do that, one must embrace in a glance the past, the present, and the future.

The canvas must present the essential unity that alone produces ecstasy.

Then, nothing fleeting will lead astray by chance. We will not return abruptly to the past. Free spectators, we will not abandon our life because of our curiosity. The traffickers in appearances will not smuggle our salt statues past the tollhouse of reason.

We will not wander into the unknown future, which, separated from eternity, is only a word bound to tempt man.

We will not exhaust ourselves grasping the too-fleeting present, which, for the artist, can be nothing but the death mask: fashion.

The picture will exist inescapably. The vision will be full, complete, and its infiniteness, rather than marking an imperfection, will simply bring out the relation between a new creature and a new creator, nothing more. Otherwise, there will be no unity, and the relationships that the various points of the canvas will have with different geniuses, with different objects, with different lights, will show only a multiplicity of ill-assorted parts without harmony.

For although there can be an infinite number of creatures each bearing witness to its creator, without any one creation crowding the area of those that coexist, it is impossible to conceive of them at the same time, and death results from their juxtaposition, their tussles, their love.

Every deity creates in its own image; so it is of painters. And only photographers manufacture the reproduction of nature.

Purity and unity do not count without truth, which cannot be compared to reality since it is the same, apart from all natures that strive to hold us within the fatal order where we are only animals.

Before all else, artists are people who want to become inhuman. They laboriously seek the traces of inhumanity, which are found nowhere in nature.

These traces are truth, and outside of them we have no knowledge of reality.

But no one will ever discover reality once and for all. Truth will always be new.

Otherwise, it is only a system more wretched than nature.

In that case, the deplorable truth, more distant, less distinct, and less real every day, would reduce painting to the state of plastic writing, destined merely to facilitate the relations between people of the same race.

In our time, someone would quickly find the machine to reproduce such signs, without understanding.

II

Many new painters paint only pictures where there is no real subject. And the denominations found in catalogs thus play the role of names, which designate people without characterizing them.

Just as there are Mr. Littles who are very big, and Mr. Whites who are very dark, I have seen canvases called *Solitude* on which there were several human figures.

In such cases, one sometimes still condescends to use vaguely explanatory words such as *portrait, landscape,* or *still life;* but many young painters use only the general word *painting.*

These painters, though they still observe nature, no longer imitate it, and they carefully avoid the representation of natural scenes observed and reconstituted through study.

Verisimilitude no longer has any importance, since the artist sacrifices everything in favor of truths, of necessities of a superior nature, a nature he assumes to exist but without discovering it. The subject no longer counts, or, if it counts, it does so just barely.

Modern art generally rejects most of the methods for pleasing set in place by the great artists of former times.

If the aim of painting is still what it was in the past—pleasure for the eyes—the art lover is now asked to find in it a different pleasure than that which the spectacle of natural things can procure for him just as well.

We are thus heading toward an entirely new art, which will be to painting as it has been conceived until now what music is to literature.

It will be pure painting, just as music is pure literature.

The music lover, in hearing a concert, experiences a joy of a different order than the joy he experiences while listening to natural noises like the babbling of a brook, the crash of a torrent, the whistling of the wind through a forest, or the harmonies of human language, founded on reason and not on aesthetics.

Similarly, the new painters will procure from their admirers artistic sensations due solely to the harmony of asymmetrical lights.

The anecdote of Apelles and Protogenes, found in Pliny, is well known. It illustrates well the aesthetic pleasure resulting solely from that asymmetrical construction I mentioned.

One day, Apelles landed on the island of Rhodes to see the works of Protogenes, who was living there. Protogenes was absent from his studio when Apelles arrived. An old woman was there keeping an eye on a large board ready to be painted. Apelles, instead of leaving his name, made a stroke on the board so slender that nothing so fine had ever been seen.

Upon his return, Protogenes, perceiving the line, recognized Apelles's hand, and made on that stroke a stroke of another color, even more subtle than the first, and, as a result, it appeared there were three strokes.

Apelles came back again the next day, and again did not run into the one he was seeking; and the subtlety of the stroke he made that day drove Protogenes to despair. For a long time, that picture inspired the admiration of connoisseurs, who looked at it with as much pleasure as if, instead of representing three almost invisible strokes, it had been a depiction of gods and goddesses.

The secret aim of the young artists of the extremist schools is to make pure painting. This is an entirely new plastic art. It is only at its beginnings and is not yet as abstract as it would like to be. Most of the new painters are practicing mathematics without knowing it, but they have not yet abandoned nature, which they patiently question so that it may teach them the path of life.

Picasso studies an object the way a surgeon dissects a cadaver.

That art of pure painting, if it manages to free itself completely from the old painting, will not necessarily cause the disappearance of the latter, any more than the development of music has caused the disappearance of the various literary genres, or the pungency of tobacco has replaced the flavorfulness of food.

III

The new painters have been sharply criticized for their geometrical preoccupations. Nevertheless, geometrical figures are essential to drawing.

Geometry, a science whose object is area, its measurement, and its relationships, has always been the very rule of painting.

Until now, the three dimensions of Euclidean geometry were enough to quiet the sensation that the infinite produced in the souls of great artists.

The new painters have not proposed to be geometers any more than their elders did. But one can say that geometry is to the plastic arts what grammar is to the writer's art. Today, however, scientists no longer confine themselves to the three dimensions of Euclidean geometry. Painters have been led quite naturally and, so to speak, intuitively, to preoccupy themselves with the new ways of measuring area now possible, which, in the language of the modern studios, are briefly and globally designated by the term *fourth dimension.*

From the plastic point of view, the fourth dimension, as it presents itself to the mind, is supposedly produced by the three known measurements: it represents the enormity of space expanding toward eternity in all directions at a determined moment. It is space itself, the dimension of the infinite. It is the fourth dimension that endows objects with plasticity. In the work, it gives them the proportions they merit, whereas, in Greek art, for example, a pattern, mechanical in some sense, constantly destroys proportions.

Greek art had a purely human conception of beauty. It took man as the measure of perfection. The art of the new painters takes the infinite universe as the ideal, and it is to that ideal that we are indebted for a new measure of perfection, which allows the painter to give the object proportions consistent with the degree of plasticity to which he wishes to bring it.

Nietzsche divined the possibility of such an art: "O divine Dionysius, why are you pulling on my ears?" Ariadne asked her philosopher lover in one of those famous dialogues on the island of Naxos.

"I find something agreeable, something pleasant, about your ears, Ariadne: why are they not even longer?"

Nietzsche, in reporting that anecdote, gives an indictment of Greek art through Dionysius's words.

Let us add that this imagination, *the fourth dimension,* was only the manifestation of the aspirations, the restlessness, of a large number of young artists looking at Egyptian, African, and Oceanic sculptures, meditating on the works of science, awaiting a sublime art, and that only a historic interest, so to speak, should now be attached to that utopian expression, which needed to be noted and explained.

IV

The young painters, wishing to attain the proportions of the ideal and not limiting themselves to humanity, offer us works more cerebral than sensual. They increasingly distance themselves from the old art of optical illusions and local proportions in order to express the magnitude of metaphysical forms. That is why present-day art, though not the direct emanation of definite religious beliefs, nevertheless displays several characteristics of great art, that is, of religious art.

V

The social function of great poets and great artists is to constantly transform the appearances that nature assumes in human eyes.

Without poets, without artists, people would quickly grow bored with the natural monotony. The sublime idea they have of the universe would drop away with dizzying speed. The order that appears in nature, and which is only an effect of art, would immediately vanish. Everything would come apart in the chaos. No more seasons, no more civilization, no more thought, no more humanity, no more life even, and an impotent obscurity reigning forever.

The poets and artists determine in concert the figure of their age, and the future docilely rearranges itself to fit their vision.

The general structure of an Egyptian mummy is consistent with the figures drawn by Egyptian artists; nevertheless, ancient Egyptians were very different one from another. They conformed to the art of their time.

The property of art, its social role, is to create the illusion of the *type*. God knows people made fun of Manet's and Renoir's pictures! Well, one has only to take a look at photographs of the time to perceive that the people and things conform to the pictures these great painters made of them.

That illusion appears entirely natural to me, since, from the plastic point of view, the work of art is the most energetic thing an age produces. That energy takes root in people and for them becomes the plastic measure of an age. Hence, those who make fun of the new painters are making fun of the figure they themselves cut, since the notion that the humanity of the future will form of the humanity of today will be based on the representations of them that the artists of the most vivid, that is, the newest, art, have left behind. Do not tell me there are other painters

today painting in such a way that humanity can recognize its own image in their pictures. In the end, all the artworks of an age resemble the most energetic, the most expressive, the most typical works of art. Dolls stem from a popular art; they always seem inspired by the works of the great art of the same era. That is a truth that is easily verifiable. And yet, who would dare say that the dolls sold in general stores around 1880 were produced with a feeling similar to that of Renoir when he painted his portraits? No one noticed it at the time. This means, however, that Renoir's art was energetic enough, vivid enough, to take root in our senses, whereas, for the general public at the time he made his debut, his conceptions appeared as so many absurdities and follies.

VI

It has sometimes been imagined, especially regarding the most recent painters, that they may be pulling a collective prank or committing an error.

And yet, in the entire history of the arts, not a single collective prank is known to have existed, or any collective artistic errors. There are isolated cases of pranks and errors, but the conventional elements that for the most part constitute works of art guarantee us that there could not be any collective instances of them.

If the new school of painting were to present us with such a case, it would be an event so extraordinary that it could be termed a miracle. To imagine a case of that sort would be to imagine that, in a nation, all the children were suddenly born without heads or without a leg or an arm, obviously an absurd notion. There are no collective errors or pranks in art; there are only various ages and schools of art. If the aim pursued by each of them is not equally elevated or equally pure, all are equally respectable and, depending on the ideas people have of beauty, every artistic school is admired, then scorned, then admired again.

VII

The new school of painting bears the name *cubism*, which was coined derisively in autumn 1908 by Henri Matisse, who had just seen a picture representing houses, the cubic appearance of which made a strong impression on him.

That new aesthetic was first elaborated in the mind of André Derain, but the most important and most audacious works it immediately produced were those of a great artist, who must also be considered a founder, namely, Pablo Picasso. His discoveries, corroborated by the good sense of

Georges Braque who, in 1908, exhibited a cubist picture at the Salon des Indépendants [*Woman,* illustrated in Burgess, 405 (document 3)], were formulated in the studies of Jean Metzinger, who exhibited the first cubist portrait (of myself) at the Salon des Indépendants in 1910 [fig. 10], and, the same year, had cubist works accepted by the jury at the Salon d'Automne. It was also in 1910 that pictures by Robert Delaunay, Marie Laurencin, and Le Fauconnier, who belonged to the same school, appeared at the Indépendants.

The first general exhibition of cubism, whose followers were becoming more numerous, took place in 1911 at the Indépendants, where Room 41, reserved for the cubists, caused quite a sensation. Skillful and appealing works by Jean Metzinger appeared there, as did Albert Gleizes's landscapes and *Homme nu* [*Nude*] and *Femme aux phlox* [*Woman with Phlox,* Museum of Fine Arts, Houston], Miss Marie Laurencin's *Portrait de Mme Fernande X* and *Jeunes filles* [fig. 17], Robert Delaunay's *Tour* [fig. 15], Le Fauconnier's *Abondance* [fig. 9], and Fernand Léger's *Nus dans un paysage* [*Nudes in a Forest;* see document 18].

The first manifestation of the cubists abroad took place in Brussels the same year and, in the preface to that exhibit, I agreed, in the names of the exhibitors, to the designations *cubism* and *cubists*.

In late 1911, the exhibition of cubists at the Salon d'Automne caused a considerable stir, and neither Gleizes (*La chasse* [*The Hunt*], *Portrait de Jacques Nayral* [fig. 33]) nor Metzinger (*La femme à la cuiller*) nor Fernand Léger was spared mockery. These artists were joined by a new painter, Marcel Duchamp, and by a sculptor-architect, Duchamp-Villon.

Other collective exhibits took place in November 1911, at the Galerie d'Art Contemporain on rue Tronchet in Paris; in 1912, at the Salon des Indépendants, now joined, notably, by Juan Gris; in May, when Barcelona, Spain, enthusiastically welcomed the young French artists; and finally, in June, in Rouen, at an exhibition held by the Société des Artistes Normandes, at which time Francis Picabia joined the new school. (*Note written in September 1912.*)

What differentiates cubism from the old painting is that it is not an art of imitation, but an art of conception that tends to rise toward creation.

The painter, in representing conceived or created reality, can produce the appearance of three dimensions, can in some sense *cubicize*. He could not do so by simply rendering seen reality, unless he produced trompe-

l'oeil through foreshortening or perspective, which would distort the quality of the conceived or created form.

Four tendencies have now manifested themselves in cubism as I have subdivided it, including two parallel and pure tendencies.

Scientific cubism is one of the pure tendencies. It is the art of painting new pieces with elements borrowed, not from the reality of vision, but from the reality of knowledge.

Every man has a sense of that internal reality. There is no need to be an educated man to conceive of a found form, for example.

The geometrical aspect that so stunned those who saw the first scientific canvases resulted from the fact that essential reality had been rendered with a great purity and visual and anecdotal accidents eliminated from it.

The painters who fall within the province of that art are: Picasso, whose luminous art also belongs to the other pure tendency of cubism; Georges Braque; Metzinger; Albert Gleizes; Miss Laurencin; and Juan Gris.

Physical cubism, which is the art of painting new pieces with elements borrowed for the most part from the reality of vision. That art nevertheless falls within the province of cubism by virtue of its constructive discipline. It has a great future as history painting. Its social role is well marked, but it is not a pure art. In it, the subject and the images are blended together.

The physicist-painter who created that current is Le Fauconnier.

Orphic cubism is the other great tendency of modern painting. It is the art of painting new pieces with elements borrowed not from visual reality, but created whole by the artist and endowed with a powerful reality by him. The works of the Orphic artists must offer simultaneously a pure aesthetic pleasure, a construction obvious to the senses, and a sublime significance, namely, the subject. It is pure art. The light in Picasso's works contains that art, discovered, for its part, by Robert Delaunay, and toward which Fernand Léger, Francis Picabia, and Marcel Duchamp are also striving.

Instinctive cubism, the art of painting new pieces borrowed not from visual reality but from the reality suggested to the artist by instinct and intuition, has for a long time tended toward Orphism. The instinctive artists are lacking in lucidity and in an artistic belief; instinctive cubism includes a very large number of artists. That movement, stemming from French impressionism, has now spread throughout Europe.

The last paintings of Cézanne and his watercolors belong to cubism, but Courbet is the father of the new painters, and André Derain, to whom I shall return one day, was the eldest of his beloved sons, since he is to be found at the origin of the fauve movement, which was a sort of preamble to cubism, and also at the origin of this great subjective movement. But it would be too difficult to write properly at this time about a man who deliberately stands apart from everything and everyone.

It seems to me that the modern school of painting is the most audacious that has ever existed. It has posed the question of the beautiful in itself.

It wants to imagine the beautiful freed from the delight that man produces in man, and no European artist has dared do that since the beginning of historical time. The new artists need an ideal beauty that is no longer simply the proud expression of the species, but the expression of the universe, insofar as it has been humanized in light.

The art of today decks its creations in a grandiose, monumental appearance that surpasses in that regard everything that had been previously conceived by the artists of our time. Passionate in the search for beauty, it is noble and energetic, and the reality it brings to us is marvelously clear.

I love the art of today because I love light above all, and all humans love light above all: they invented fire.

New Painters

Picasso

If we were to know, all the gods would awaken. The adored pantheistic gods, which resembled humanity, having arisen from the profound knowledge humanity retained of itself, have dozed off. But, in spite of their eternal sleep, there are eyes in which human entities, similar to divine and joyous ghosts, are reflected.

These eyes are attentive as flowers, which always want to contemplate the sun. O fertile joy, there are people who see with such eyes.

In those times, Picasso had looked at human images floating in the blue yonder of our memories, and which partake of divinity to damn the metaphysicians. How pious his skies are, stirred up by the flight of birds, how pious his light, low and heavy like the light of caves.

There are children who have wandered about without learning their catechism. They stop and the rain stops falling: "Look! People in those big buildings and their clothes are poor." These children, whom no one kisses, understand so much! Mama, love me, please! They know how to leap and the turns they make are mental evolutions.

These women, whom no one loves any longer, remember. They have gone over their brittle ideas too much today. They do not pray; their devotion is to memories. They nestle in the twilight like an old church. These women are giving up and their fingers would move to weave straw wreaths. When daylight comes, they disappear, they have consoled themselves in silence. They have passed through many doorways: the mothers protected the cradles, so that the newborns would not be given evil gifts; when they bent over, the infants smiled to know their mothers were so good.

They have often given thanks and, as they gestured, their forearms trembled like their eyelids.

Enveloped in an icy mist, old men wait without contemplating, since only children contemplate. These old men, prompted by distant lands, by the quarrels of beasts, by heads of hair grown hard, these old men can beg without humility.

Other beggars have been worn down by life. They are infirm, on crutches, and good for nothing. They are astonished to have reached the goal, which has remained blue and is no longer the horizon. Growing old, they have gone mad as kings with too many herds of elephants bearing little citadels. There are travelers who confuse flowers with stars.

Grown old as oxen who die around twenty-five, the young have led nurslings suckled by the moon.

On a pure day, women fall silent, their bodies are angelic, and their gazes tremble.

When it comes to danger, their smiles are internal. They wait for terror before confessing innocent sins.

In the space of a year, Picasso got through that moist painting, blue like the wet bottom of the abyss and pitiable.

Pity made Picasso more bitter. The town squares bore a hanged man stretched out against the houses above oblique passersby. These tortured souls were awaiting a redeemer. The rope overhung the mansard roofs, miraculous; the panes blazed with the window flowers.

In bedrooms by lamplight, poor painters drew nudes thick with body hair. The abandoned women's shoes near the bed signified a tender haste.

Calm came after that frenzy.

The Harlequins live under gaudy clothes, when the painting gathers together, warms up, or bleaches out its colors to express the force and duration of the passions, when the lines bound by the suit bend, break off, or soar.

Paternity transfigures the Harlequin in a square room, while his wife moistens herself with cold water and admires herself, slim and slender, as well as her husband the puppet. A nearby grate warms the caravan. Beautiful songs interlace and soldiers move along, cursing the day.

Love is good when one adorns it and the habit of living in one's own place increases paternal feeling twofold. The child becomes closer to the father, the woman Picasso wanted glorious and immaculate.

The first-time mothers were no longer expecting the child, perhaps because of certain chattering crows of ill omen.

Christmas! They gave birth to future acrobats among the familiar apes, the white horses, and the bearlike dogs.

The adolescent sisters, balancing on the acrobats' big balls beneath their feet, commanded the radiant motions of worlds from these spheres. These adolescent, prepubescent girls have the worries of innocence, the animals teach them religious mystery. Harlequins accompany the glory of women, they resemble them, neither male nor female.

The color has some of the dullness of frescoes, the lines are solid. But the animals, placed on the borderline of life, are human and the sex organs ambiguous.

Hybrid beasts have an awareness of the half gods of Egypt; taciturn Harlequins have cheeks and foreheads shriveled by morbid sensibilities.

The acrobats cannot be confused with clowns. Their spectator must be pious, since they celebrate mute rites with a difficult agility. It is that which distinguished this painter from the Greek potters his drawings sometimes brought to mind. On the painted clay, the bearded and babbling priests made sacrificial offerings of animals resigned and with no destiny. Here, virility is beardless but manifests itself in the sinews of the thin arms, the planes of the face, and the animals are mysterious.

Picasso's taste for the fleeting, shifting, penetrating stroke has produced nearly unique examples of linear drypoints, in which he has not altered the general features of the world.

That malaguena bruised us like a brief chill.

His meditations were stripped bare in the silence. He came from afar, from the richness of composition and the brutal decoration of the seventeenth-century Spaniards.

And those who had known him remembered a quick colorfulness that was already no longer experimental.

His persistence in the pursuit of beauty, then, has changed everything in Art.

So, severely, he questioned the universe. He accustomed himself to the vast light of the depths. And sometimes, he was not above committing authentic objects to clarity: a two-bit song, a real postage stamp, a piece of oilcloth on which the caning of a chair was printed. The painter's art would add no picturesque element to the truth of these objects.

Surprise laughs wildly in the purity of the light, and it is legitimate that numbers and hand printing should appear as new, picturesque elements in art, already long steeped in humanity.

It is not possible to discern the possibilities, or all the tendencies, of an art so profound and so meticulous. The object, real or in trompe-l'oeil, is undoubtedly destined to play an increasingly important role. It is the internal frame of the picture and marks its depth boundaries, just as the frame marks its outer boundaries.

Imitating the planes to represent volumes, Picasso gives an enumeration of the various elements composing objects; it is so complete and so sharp that these elements do not take the shape of objects by virtue of the work of the beholders, who are forced to perceive their simultaneity, but by virtue of their arrangement.

Is that art more profound than it is lofty? It does not bypass the observation of nature and acts on us as familiarly as nature itself.

There are poets to whom a muse dictates their works; there are artists whose hand is guided by an unknown being, who uses them as an instrument. They feel no fatigue, since they are not working, and can produce a great deal, at any hour, every day, in every land and in every season. They are not people, but poetic or artistic instruments.

Their reason has no power against them; they do not struggle and their works do not bear traces of struggle. They are not divine and can do without themselves. They are like an extension of nature, and their works do not pass through the intelligence. They can be moving without the harmonies they produce becoming humanized. Other poets, other artists, on the contrary, are those who strive; they go toward nature and have no immediate proximity with it. They must extract everything from themselves, and no demon, no muse inspires them. They live in solitude and nothing is expressed except what they have themselves stammered, stammered so often that they sometimes manage to formulate what they wish to formulate by dint of repeated efforts, repeated attempts. These people, created in the image of God, will rest one day to admire their work. But how much exhaustion, how much imperfection, how much vulgarity!

Picasso used to be an artist of the first kind. There was never a spectacle so fantastic as the metamorphosis he underwent in becoming an artist of the second kind.

For Picasso, the plan to die was formed by looking at the eyebrows forming inverted Vs on the face of his best friend, eyebrows stampeding in agitation. Another of his friends took him one day to the border of a mystic land, where the inhabitants were at once so simple and so grotesque that they could easily be refashioned.

And then, really, anatomy, for example, no longer existed in art; it had to be reinvented. One had to carry out one's own murder with the expertise and method of a great surgeon.

The great revolution in the arts, which he accomplished almost by himself, is that the world is his new representation.
An enormous flame.
A new man, the world is his new representation.
He enumerates its elements, its details, with a brutality that can also be graceful. He is a newborn who orders the universe for his personal use, and also to facilitate relations with his own kind. That enumeration has the magnitude of an epic, and the drama will burst forth with order.

One can dispute a system, an idea, a date, a likeness, but I do not see how one could dispute the simple act of the numerator. From the plastic point of view, we may find that we might have done without so much truth, but once that truth has appeared, it becomes necessary. And then, there are countries. A cave in a forest where people capered about, a journey on the back of a mule along the edge of a precipice, and the arrival in a village where everything smells of hot oil and rancid wine. It is also the stroll to a cemetery and the purchase of an earthenware crown (crown of everlastings) and the notation *Mille regrets* [A thousand regrets], which is inimitable. I have also heard of clay candelabras that had to be applied to a canvas so that they would look like they were coming out of it. Crystal pendants, and the infamous return from Le Havre.

As for me, I have no fear of art and no prejudice regarding a painter's medium.

Mosaic workers paint with marble or colored wood. Someone mentioned an Italian painter who painted with feces; during the French Revolution, someone painted with blood. You can paint with anything you like, with pipes, postage stamps, postcards or playing cards, candelabras, bits of oilcloth, detachable collars, wallpaper, newspaper [figs. 46 and 47].

For myself, I need only to see the labor, one has to see the labor, it is by the quantity of labor supplied by the artist that one measures the value of a work of art. Delicate contrasts, parallel lines, a workman's craft, sometimes the object itself, sometimes an indication, sometimes an enumeration that takes on a personality of its own, less gentleness than coarseness. One does not choose in the modern, just as one accepts fashion without question.

Painting . . . An astonishing art whose light is limitless.

Georges Braque

Peaceful appearances in plastic generalization: that is what, in a temperate region, has held together the art of Georges Braque.

Georges Braque is the first of the new painters to have made contact with the public after his aesthetic metamorphosis.

That key event took place at the Salon des Indépendants in 1908.

The historic role of the Salon des Indépendants is now beginning to be well defined.

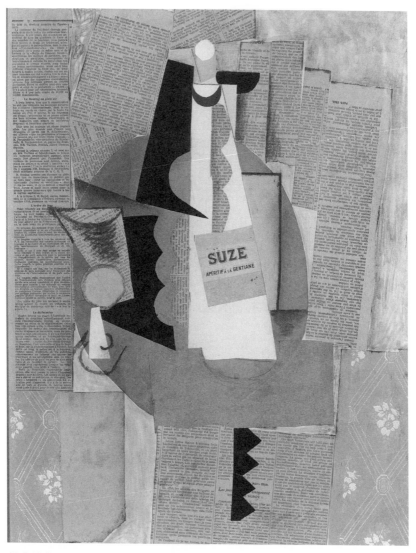

47. Pablo Picasso, *La bouteille de Suze* (*Still Life with Bottle of Suze*), November 1912. Pasted papers, gouache, and charcoal, 25¾ × 19¾ ". Mildred Lane Kemper Art Museum, Washington University, St. Louis. University purchase, Kende Sale Fund, 1946. © 2005 Estate of Pablo Picasso / Artists Rights Society (ARS), New York. Used by permission of Mildred Lane Kemper Art Museum.

The art of the nineteenth century—an art through which the French genius as a whole again manifested itself—was only a long revolt against academic routine, which the rebels contrasted with the authentic traditions that escaped the masters of the degenerate art defended by the citadel on rue Bonaparte.

Since its foundation, the Salon des Indépendants has played a preponderant role in the evolution of modern art and bit by bit reveals to us the tendencies and personalities that, for twenty-five years, have been joined body and soul to the history of French painting, the only one that counts today, which, in the very face of the universe, pursues the logic of the great traditions and always manifests a great intensity of life.

It is fitting to add that grotesques do not appear at the Salon des Indépendants in a higher proportion than they show up in the official salons, with so-called legitimate art.

Moreover, the artistic culture of our time no longer stems from a social discipline. And it was not the least of the merits of that art, which manifested itself in 1908 in a work by Georges Braque, to have been in harmony with the society where it evolved.

That fact, which had not been the case since the fine period of Netherlandish painting, constitutes, in short, the social element of the revolution for which Georges Braque served as orator.

That revolution would have advanced by two or three years if Picasso had exhibited, but he needed silence, and who knows whether the mockery to which Georges Braque was subjected at that time did not turn Picasso away from the difficult path where he had first walked all alone.

But, in 1909, the revolution that transformed the plastic arts was complete. The public's and the critics' jokes could no longer stop it.

People were astonished—perhaps more so than by the innovations that appeared in Braque's pictures—that one of the young painters, without indulging in the affectations of illustrators, restored to their place of honor order and craft, without which there is no art.

Consider Georges Braque therefore. His role was heroic. His peaceful art is admirable. He strives with all seriousness. He expresses a beauty full of tenderness and the mother-of-pearl in his pictures turns our understanding iridescent. This painter is angelic.

He taught men and other painters the aesthetic use of forms so unknown that only a few poets had had an inkling of them. Luminous signs

shine around us, but only a few painters have drawn out their plastic sig-
nificance. The work, especially in his roughest creations, contains a mul-
titude of aesthetic elements, the novelty of which is always in harmony
with the sense of the sublime, which allows man to give order to chaos.
We must not look down on what seems new, or what is soiled, or what
is of service to us, the false wood or false marble of housepainters. Even
though their appearance seems trivial, when a man is called to action, he
must begin from such trivialities.

I hate artists who do not belong to their own era, and just as, for Mal-
herbe, the language of the common people was the right language for his
time, for the artist the craft of the artisan, the housepainter, ought to be
the most vigorous material expression of painting.

Some will say: Georges Braque the verifier. He has verified all the in-
novations of modern art and will verify more of them.

Jean Metzinger

No contemporary young painter has endured as much injustice as Jean
Metzinger, or shown more determination than that refined artist, one of
the purest living today. He never refused to accept the lesson of events.
In the painful journey he made in search of a discipline, Jean Metzinger
stopped at all the civilized cities he encountered along the way.

We ran into him first in that elegant and modern city of neoimpres-
sionism, whose founder and architect was Georges Seurat.

That great painter has not yet been recognized at his true worth.
In their lines, composition, and even in the discretion of their contrast-
ing luminosity, his works have a style that sets them apart and perhaps even
above most of the works of the painters who are his contemporaries.

No painter makes me think of Molière more than Seurat does, the
Molière of *Le bourgeois gentilhomme,* which is a ballet full of grace, lyri-
cism, and good sense. And canvases such as *Cirque* [*Circus*] or *Chahut*
are also ballets full of grace, lyricism, and good sense.

The neoimpressionist painters are those who, to quote Paul Signac,
"have, since 1886, set in place and developed the so-called technique
of *division,* using the optical blend of shades and tones as a mode of
expression." That technique could be linked to the art of Byzantine
mosaic artists, and I remember that one day, in a letter addressed to
Mr. Charles Morice, Signac also laid claim to the Libreria of Siena.

That luminous technique, which gave order to the impressionist innovations, was intuited, even applied, by Delacroix, to whom it had been revealed through his examination of Constable's pictures.

It was Seurat who, in 1886, exhibited the first divisionist picture: *Un dimanche à la Grande-Jatte* [*A Sunday at La Grande Jatte*]. It was he who carried the furthest the contrast of complementaries in the construction of pictures. Today, Seurat's influence can be felt even at the École des Beaux-Arts and will continue to spawn innovations in painting.

Jean Metzinger played a role among the refined and hardworking divisionists. Nevertheless, the colored minutiae of neoimpressionism still served only to indicate which elements formed the style of an age that, in almost all its artistic and industrial manifestations, appeared devoid of style in the eyes of contemporaries. Seurat, with a precision that can be called genius, drew a few portraits of his age, in which the firmness of style was equal to the almost scientific sharpness of conception (*Chahut* and *Cirque,* which almost belong to *scientific cubism*). He corrected everything about the art of his time, in order to capture the gestures characterizing that fin de siècle, that end of the nineteenth century, where everything was angular, nerve-wracking, childishly insolent, and sentimentally comic.

Such a beautiful intellectual spectacle could hardly be continued, and once the picturesque style, which broke free from nineteenth-century art, had been laid out, neoimpressionism ceased to play an interesting role. It did not offer any innovations other than the contrast of complementaries, and pointed to the aesthetic value of the innovations discovered by earlier schools since the end of the eighteenth century. Too many new elements were appealing to the young artists. They could not be immobilized in an art that, as the last and strictest expression of an artistic period, had to show what it was capable of from the first.

That discipline was becoming a tedious set of rules. The great colored screams of the fauves rang out in the distance. They attracted Jean Metzinger and without a doubt taught him the symbolic significance of colors, the forms they represent; and when, from that barbarous and not primitive city, given over to luxury and violent orgies, the barbarians had gone away and the fauves had ceased to roar, no one remained but a few quiet bureaucrats, who resembled down to the last detail the officials on rue Bonaparte in Paris. And the kingdom of the fauves, whose civilization

had seemed so new, so powerful, so startling, suddenly assumed the aspect of an abandoned village.

It was then that Jean Metzinger, going off to meet Picasso and Braque, founded the city of the cubists. Discipline is strict there, but does not yet run the risk of becoming a system, and freedom is greater there than anywhere else.

From his association with the neoimpressionists, Jean Metzinger retained a taste for minute detail, and not a mediocre taste.

There is nothing incomplete in his works, and nothing that is not the fruit of a rigorous logic; and if he has ever made a mistake, which I do not know and which it is not important for me to know, it was not made by chance. His works will be among the most reliable documents for those wishing to explain the art of our time. It is thanks to Metzinger's pictures that we will be able to distinguish straight off between what in our art has an aesthetic value and what does not.

A painting by Metzinger always contains its own explanation. That may be a noble weakness, but it is certainly highly conscious and, I believe, a unique case in the history of the arts.

As soon as one comes upon a picture by Metzinger, one feels that the artist had the firm desire to take seriously only what is serious, and that the events, in accordance with what seems like an excellent method to me, provide him with the plastic elements of his art. But, though he may accept all of them, he does not use them at random. His works are sound, more sound without a doubt than those of most artists who are his contemporaries. He will delight those who like to know the reasons for things, and these reasons have the capacity to satisfy the mind.

The works of Jean Metzinger have purity. His meditations assume beautiful forms, the pleasure of which tends to approach the sublime. The new pieces he is composing are entirely devoid of everything known before him.

His art, increasingly abstract but still pleasant, tackles and attempts to solve the most difficult and unexpected problems of aesthetics.

Each of his works contains a judgment of the universe, and his entire work resembles the night sky when it is pure, cloudless, and when a delightful glow shimmers in it.

And nothing is incomplete in his work; poetry ennobles its smallest details.

Albert Gleizes

The works of Albert Gleizes are powerful harmonies, which must be distinguished from theoretical cubism as the scientific painters established it. I remember his first efforts. One already sensed in them the desire to return his art to its simplest elements. At his beginnings, Albert Gleizes found himself face to face with the schools that were flourishing: the late impressionists, the symbolists, some of whom had become intimists, the divisionist neoimpressionists, and the fauves, nearly the same situation in which Le Douanier Rousseau found himself in relation to academicism and the intellectualism of the official salons.

It was then he understood the work of Cézanne, who had influenced the artworks of the first cubists.

Then he developed those harmonies that are among the most serious things, and those most worthy of attention, that the plastic arts have produced in close to a decade.

Albert Gleizes's portraits show well enough that in his art, as in the art of most new painters, the individuation of objects is not only the work of the beholders.

Albert Gleizes's pictures and those of many young painters are often seen as timid generalizations.

Nevertheless, in most of the new pictures, the individual characteristics are still marked with a solidity, even a meticulousness, that could not escape those who have seen the new painters at work, who have looked at their paintings with a little attention.

On the contrary, lifeless generalization is characteristic of the intellectual painters of decadence. What individual characteristics are there in the paintings of Henri de Groux, who generalizes the decadent feeling of Baudelaire's imitators, or in the pictures of Zuloaga, who generalizes the conventional Spain of the late Romantics?

True generalization entails a deeper individualization, which lives in both the light and in the pictures themselves of impressionists like Claude Monet, Seurat (and even Picasso), who generalize their sincerity and have given up detailing the superficial characteristics. There is not a tree, not a house, not a human figure of which the impressionists have kept an individual characteristic.

It was an impressionist painter who, before making a portrait, began by saying he would not make it a likeness.

But there is a generalization that is vaster and more precise at the same time. So it is that the portrait is one of the important branches of the new painters' art.

They could always guarantee the likeness, and I have never seen any of their portraits that was not a likeness.

What concern for reality, for individual characteristics, have painters such as Bouguereau or Henner ever had?

Among many new painters, every plastic conception is also individualized within generalization, with a patience that must truly be acknowledged.

Because they are concerned neither with chronology nor with history nor with geography, because they connect what no one else had connected, because Gleizes is attempting to dramatize the objects he depicts by drawing out from them the elements of artistic emotion, it can be said that the purpose of their art is sublimely precise.

All the figures in Albert Gleizes's pictures are not the same figure, all the trees are not a tree, all the rivers are not a river, but the beholder, if he can rise toward the general ideas, will certainly be able to generalize that figure, that tree, or that river, because the painter's labor has elevated these objects to a higher degree of plasticity, to such a degree of plasticity that all the elements constituting the individual characteristics are represented with the same dramatic majesty.

Majesty: that, above all, is what characterizes Albert Gleizes's art. He has thus brought a stirring innovation into contemporary art. Before him, it was found in only a few modern painters.

That majesty awakens the imagination, stirs the imagination, and, considered from the plastic point of view, is the immensity of things.

That art is vigorous. Albert Gleizes's pictures are created with a force of the same kind as the forces that created the pyramids and the cathedrals, that create metal constructions, bridges and tunnels.

These works sometimes have the somewhat unskilled look of great works, those humanity places on the highest plane, because, in effect,

the intention of the person who made them was always to do the best he could. And the purest feeling an artist can have about his art is to do his best, and it is a base feeling to be satisfied with completing his works without effort, without labor, without having done the best he could.

Miss Marie Laurencin

Our era has allowed female talents to blossom in letters and in the arts.

Women bring something like a new vision to art, full of joy in the universe.

There have always been women painters, and that marvelous art offers the attention, the imagination, pleasures so delicate that it would not have been surprising if there had been a larger number of paintresses.

Sixteenth-century Italy produced Sophonisba Angussola [sic], celebrated by Lanzi and Vasari. Paul IV and the king of Spain fought over her works. There are some in Madrid, Florence, Genoa, and London. The Louvre does not possess any. Born in Cremona in about 1530, she quickly surpassed her master, Bernardino, and took the art of the portrait a long way. The moderns have sometimes attributed certain of these works to Titian himself. Having had her greatest success in the court of Philip II, she finally retired to Genoa, where she went blind. Lanzi said that she passed for the person who reasoned best about the arts of her century, and Van Dyck, who came to listen to her, claimed he had learned more from that blind old woman than from *the most clear-sighted* painter.

Sophonisba Angussola is, up to the present, the loftiest example of feminine glory achieved by virtue of the plastic arts.

In the major art of painting, Miss Marie Laurencin has been able to express an entirely feminine aesthetic.

With her first paintings, her first drawings, and her first etchings, even though these efforts were remarkable only for a certain natural simplicity, it was clear that the artist who was about to reveal herself would one day express the grace and charm of the world.

She then produced pictures where arabesques turn into delicate figures.

Since that time, throughout her research, one always finds that feminine arabesque, the knowledge of which she has been able to keep intact.

Whereas Picasso, while extolling the still unknown picturesque element of an object, was preoccupied with making it render everything it could offer in the way of aesthetic emotion, Miss Laurencin, whose art stems from that of Henri Matisse and Picasso, devotes herself above all to expressing the picturesque novelty of objects and figures. Thus her art is less severe than Picasso's, an art to which her own nevertheless displays some similarities. That is because her art is the numeration of the elements that compose her picture. Thus she attaches herself to nature, studying it tenaciously, but carefully setting aside what is neither young nor graceful, and welcomes the unknown elements of things only if they appear in a youthful form.

I think she has oriented her art deliberately toward the young and the new, whether grave or cheerful.

The task of the feminine aesthetic, which has rarely shown itself before now, except in the applied arts such as lace and embroidery, was above all to express in painting the very novelty of that femininity. Later, women will come along who will explore other feminine aspects of the universe.

As an artist, Miss Laurencin can be situated between Picasso and Le Douanier Rousseau. That is not a hierarchical designation but a simple statement of kinship. Her art dances like Salome between that of Picasso, the new John the Baptist, who washes the arts in the baptism of light, and that of Rousseau, a sentimental Herod, a magnificent and childish old man led to the limits of intellectualism by love. It is there the angels came to distract him from his sorrow; they prevented him from entering the ghastly kingdom whose *douanier,* tax collector, he had become; and that old man, finally, is admired among the host, and he came to them with heavy wings.

The young artists have already given proof of the honor they have bestowed on the works of that poor old angel Henri Rousseau *Le Douanier,* who died in late summer 1910. He could also be called the master of Plaisance, both because he lived in an area by that name and because of what makes his pictures so agreeable to look at.

Few artists have been more mocked during their lifetime than Le Douanier, and few men responded with a calmer head to the mockery and crude insults that were heaped upon him. That courteous old man al-

ways kept the same even mood and, by a fortuitous twist in his character, he chose to consider the mockery itself as interest in his work, to which even those most malevolent toward him were in some sense obliged to bear witness. That serenity was only pride, of course. Le Douanier was aware of his power. One or two times, he let it slip that he believed himself the strongest painter of his time. And it is possible that on many points he was not very wrong. That is because, though he lacked an art education in his youth (and it shows), it seems that, late in life, when he wanted to paint, he looked to the masters with passion and that he was almost the only one of the moderns to have caught a glimpse of their secrets.

His only shortcomings are, at times, an excess of sentiment, and, almost always, a popular good-naturedness which he could not rise above, and which contrasted rather sharply with his artistic enterprises and with the attitude he was able to take toward contemporary art.

But, aside from that, what fine qualities! And it is very significant that the young artists have discerned them! They can be congratulated for that, especially if the intention is not only to honor these qualities but also to gather them up. Le Douanier took his pictures as far as possible, a very rare thing today. There is no mannerism in them, no artifice, no system. Hence the variety of his work. He no more distrusted his imagination than he did his hand. Hence the grace and richness of his decorative compositions. Since he had been part of the Mexican campaign, he kept a very precise plastic and poetic memory of the tropical vegetation and fauna.

As a result, Rousseau, a Breton and longtime resident of the Parisian outskirts, was without a doubt the strangest, the most audacious, and the most charming painter of exoticism. His *Charmeuse de serpents* [*The Snake Charmer*] shows this well enough. But Rousseau was not only a decorator, and he was also not a maker of images: he was a painter. And that is what makes understanding his works so difficult for some people. There was order to his work, and that can be seen in his drawings, as orderly as Persian miniatures. His art had purity; in the female figures, the construction of the trees, the harmonious song of different tones of a single color, it had a style that belongs solely to French painters, and which, wherever they are found, distinguishes French pictures. I am speaking, of course, of the pictures of masters.

That painter's will was extremely strong. How can we doubt it in the face of the minute detail, which is not a weakness; how can we doubt it

when the melody of the whites, the chant of the blues, rise up in *Noce* [*The Wedding*], in which a figure of an old peasant woman brings to mind certain Dutch painters.

As a portrait painter, Rousseau is incomparable.

A half-length portrait of a woman with delicate blacks and grays is pushed farther than a portrait by Cézanne. Twice, I had the honor of being painted by Rousseau, in his little bright studio on rue Perrel. I often saw him working and I know how much care he took in all the details, the capacity he had for holding on to the original and definitive conception of his picture until he had completed it, and I also know that he left nothing to chance, and especially, nothing essential.

Of Rousseau's beautiful sketches, there is none so astonishing as the little canvas entitled *La Carmognole* (it is the sketch of the Independence Centennial, under which Rousseau wrote: "Auprès de ma blonde, / Qu'il fait bon, fait bon, fait bon" [a popular French song]).

It is a terse drawing: the variety, pleasantness, and delicacy of tones make this sketch an excellent little piece. His pictures of flowers show the resources of charm and accent that were in the old Douanier's soul and hand.

All the same, it can be noted here that these three painters, among which I shall establish no hierarchy but whose degree of kinship I quite simply seek to make out, are portraitists of the highest caliber.

In Picasso's inspired works, portraits hold an important place, and some of them (*Portrait de M. Vollard* [Pushkin Museum, Moscow], *Portrait de M. Kahnweiler* [Art Institute of Chicago]) will rank among the masterpieces. I find Le Douanier Rousseau's portraits extraordinary works, whose full beauty it is still impossible to measure. Portraits also form an important part of Miss Laurencin's oeuvre.

The prophetic element of Picasso's oeuvre and the intellectual element that, in spite of everything, made its way into Rousseau's paintings, an old man's paintings, are all found again here, transformed into an entirely new picturesque element. That element is similar to dance, and, in painting, it is an infinitely graceful, rhythmic counting.

Everything that, until now, has made for the originality and delicacy of the feminine arts of lace, embroidery, Bayeux tapestries, and so on, we find again here, transfigured and purified. Feminine art has become a major art and will no longer be mistaken for masculine art. Feminine art is composed of gallantry, courtesy, and joy.

It dances in the light and it flags in the memory.

It has never been imitative, it has never descended to the baseness of perspective. It is a happy art.

Regarding one of Miss Laurencin's tenderest pictures, *La toilette*, Mr. Mario Meunier, secretary to Mr. Rodin at the time and an excellent translator of Sappho, Sophocles, and Plato, reported an amusing anecdote.

He was showing the sculptor a few photographs depicting pictures from the fauve school; by chance, there was a reproduction of Miss Laurencin's picture. "At least," said the illustrious old man, "here is one that is not a *fauvette* [a little sparrow]; it knows what grace is, it is serpentine."

That's it exactly: feminine painting is serpentine, and it may have been Loïe Fuller, the great artist of motion and color, who was the precursor of today's feminine art, when she invented the ever-shifting effects of lighting in which painting, dance, and grace blend together in what is rightly called serpentine dance.

And it was in reference to another work by a woman that the shrewd temperament of Rodin used the same word!

Feminine art, the art of Miss Laurencin, tends to become a pure arabesque, humanized by the attentive observation of nature and which, because it is expressive, takes its distance from simple decoration even while remaining just as agreeable.

Juan Gris

This is the man who meditated on everything that is modern, this is the painter who wants to conceive solely of new pieces, who would like to draw or paint only materially pure forms.

His antics were sentimental. He cried as one does in sad love songs rather than laughing as in drinking songs. He still does not know that color is a form of reality. And now he is discovering the minutiae of thought. He discovers them one by one, and his first canvases look like preparations for masterpieces. Gradually, the little genies of painting come together. The pale hills become populated. The bluish flames of gas stoves, skies with the hanging shapes of weeping willows, damp leaves.

In his pictures, he maintains the wet look of freshly repainted façades. The wallpaper in a bedroom, a top hat, the disorder of posters on a large wall, can all serve well to bring a canvas to light, to give the painter a limit in what he proposes to paint. In that way, the large forms acquire

a sensibility. They are no longer tiresome. That art of ornament is set on collecting piously and bringing back to life the last remnants of classical art, such as Ingres' drawings and David's portraits. It achieves style as Seurat did, but without having any of his theoretical novelty.

That is certainly the direction Juan Gris is looking for. His painting marks its distance from music, that is, it strives above all for scientific reality.

Juan Gris has extracted from the studies that link him to Picasso, his only master, a kind of drawing that at first appeared geometrical, and which is unmistakable even in its style.

That art, if it continues in the direction it has taken, cannot culminate in scientific abstraction but in aesthetic arrangement, which can definitively be considered the highest aim of scientific art.

No more forms suggested by the painter's skill, no more colors even, which are also suggested forms.

Objects would be used, and their capricious arrangement would have an aesthetic meaning that would be undeniable.

Nevertheless, the impossibility of placing on a canvas a man in the flesh, a mirrored armoire, or the Eiffel Tower will force the painter to return to the methods of true painting, or rather to confine his talent to developing the minor art of display—there are at present admirably designed store windows—or even that of the interior decorator, if not of the landscape gardener.

These last two minor arts have not been without influence on painters, and that of display will have a similar influence. It will do no harm to painting, because it cannot take its place in the representation of perishable objects. Juan Gris is too much the painter to give up painting.

We may perhaps see him attempt that great art of the surprise; his intellectualism and the attentive study of nature could provide him with the unexpected elements from which style would emerge, as it now emerges from the metal constructions of engineers: department stores, parking garages, railroad lines, airplanes. Since today, Art has only a very limited social role to fill, it is right to set itself the disinterested task of studying scientifically—without even any aesthetic intention—the enormous expanse of its domain.

Juan Gris's art is too rigorous and too poor an expression of the scientific cubism stemming from Picasso, a profoundly intellectualist art where color has only a symbolic meaning. But, whereas Picasso's art is conceived in light (impressionism), Juan Gris's is satisfied with purity conceived scientifically.

Juan Gris's conceptions always assume a pure appearance, and, from that purity, parallels will undoubtedly spring forth one day.

Fernand Léger

Fernand Léger is one of the very gifted artists of his generation. He did not linger long at postimpressionist painting, which dates from barely yesterday and already seems so distant to us. I saw a few of Léger's efforts when he was just starting out.

Evening swims, the sea horizontal, heads already scattered about, as in the difficult compositions tackled only by Henri Matisse.

Then, after entirely new drawings, Léger wanted to devote himself to pure painting.

The woodcutters bore traces on their bodies of the blows their axes had left on the trees, and the general color participated in the deep, greenish light that descends from the foliage.

At the time, Léger's works were a land of enchantment, with smiling human figures swimming in fragrance, indolent figures, who voluptuously transformed the light of the city into multiple and delicate shady colors, memories of Norman orchards. All the colors churn. Then steam rises from them and, when it has dissipated, you can behold selected colors. A sort of masterpiece came into being from that fire and was called *Le fumeur* [Guggenheim Museum, New York].

In Léger, then, there is a desire to extract from a composition all the aesthetic emotion it can give. Now he's taking a landscape to the highest degree of plasticity.

He sets aside everything in it that does not help to give his conception the agreeable aspect of happy simplicity.

He is one of the first who, resisting the ancient instinct of the species, of the race, has happily abandoned himself to the instinct of the civilization in which he lives.

It is an instinct resisted by many more people than is generally believed. In other people, it becomes a grotesque frenzy, the frenzy of ignorance. In

still others, it consists in taking advantage of everything that comes to us through the five senses.

When I see a picture by Léger, I am very content. It is not a stupid transposition where a few forger's skills have been applied. Nor is it a work whose author did what everyone else has wanted to do today. There are so many who want to rebuild a soul, a craft for themselves, as in the fifteenth or fourteenth century; there are others, more skillful, who forge a soul from the century of Augustus or of Pericles, in less time than it takes a child to learn to read. No, Léger is not at all one of those people who believes that the humanity of one century is different from that of another, and who confuses God with a costume designer, while at the same time confusing his costume with his soul. He is an artist similar to those of the fourteenth and fifteenth centuries, or to those of the time of Augustus or Pericles, no more, no less; and, for glory and masterpieces, let the painter help himself, since heaven helps those who do.

Once, when the sculptor Manolo was going through some hard times, he went to an art dealer who had a reputation for being willing to foster unknown talents.

Manolo intended to sell him a few drawings, and asked to see the dealer.

The dealer sent word back to Manolo that he did not know him.

"Go tell Mr. Expert that I am Phidias," replied Manolo.

But the dealer again sent the reply that he did not know that name.

"Then tell him that it is Praxiteles whom he would not receive." And the sculptor went away.

Of course, Phidias or Praxiteles or Manolo might very well be there, but you cannot remake your soul to be like Phidias's. And most people disguise themselves. It is easy to understand why there are always so few modern artists. Most are disguised. The salons contain hardly anything but carnival props. I love authentic works of art, those that were conceived by souls that have not been refashioned.

Look at you beautiful hues, light colors, and you, churning forms; pleasant wafts of steam are the emblem of civilizations.

That lopsided sky is the sky of our streets, it has been cut out and set upright. The infinite sweetness of roofs the color of raspberry. And what if a hand has six fingers, if that man has three feet.

Do not believe there is any mysticism here. Oh, I have no contempt for mysticism. I am terrified with admiration for it. May that great mystical artist come along some day; may God command him, force him, order him. He will be there, perhaps he is there, close at hand, I know his name, but must not say it, it will certainly be known one day, it is better not to tell him. What luck for him if he could be unaware of his mission, not know that he is suffering and also that he is always in danger here on earth!

But Fernand Léger is not a mystic; he is a painter, a simple painter, and I take as much delight in his simplicity as in the solidity of his judgment.

I love his art because it is not contemptuous, because it also does not do anything base and it is not argumentative. I love your *light* colors, Fernand Léger. Fantasy will not elevate you to the land of enchantment, but it procures your every joy.

Here, the joy is in the intention as well as in the execution. He will find more churning. The same orchards will give off lighter colors. Other families will scatter like the droplets of a waterfall and the rainbow will come along to sumptuously bedeck the minuscule ballerinas in the corps de ballet. The people in the wedding party hide behind one another.

Just a bit more effort to get rid of perspective, the wretched trick of perspective, that backward fourth dimension, perspective, that method of inevitably making everything look smaller.

But these paintings are liquid: the sea, blood, rivers, rain, a glass of water—and also our tears, with the sweat of great effort and the long exhaustion, the wetness of kisses.

Francis Picabia

Having started out from impressionism like most contemporary painters, Francis Picabia, with the fauves, transposed light into colors. It is from that point that he came to the altogether new art where color is no longer merely coloring, no longer even a transposition of light; and finally, it no longer has any symbolic meaning, since it is itself the form and light of what is represented. He thus took on an art where, as in Robert Delaunay's art, the ideal dimension is color. As a result, it contains the

other dimensions. Nevertheless, for Picabia, form is still symbolic, when it is color that ought to be formal, a perfectly legitimate art, which can be considered extremely lofty. In that art, color is saturated with energy and its edges continue out into space. Here, reality is matter. Color no longer depends on the three known dimensions; rather, it creates them.

This art is as close to music as an art which is its opposite could be. It might be said of Picabia's art that it would like to be to the old painting what music is to literature, but it cannot be said that it is music. In fact, music proceeds by suggestion; here, conversely, the colors presented should no longer impress us as symbols, but as concrete forms. Nevertheless, without tackling new methods, an artist like Picabia denies himself one of the principal elements of universal painting: conception. For the artist to be able to deny himself in appearance, color ought to be formal (matter and dimension: measure).

Let us add that, for Picabia, the act of giving the work a name is not an intellectual element apart from the art to which he has devoted himself. That act must play the role of an internal frame, just as real objects and inscriptions copied verbatim do in Picasso's pictures. It must separate intellectualism from decadence and ward off the danger painters always face of becoming writers of literature. The picturesque equivalent of the titles written by Picabia and the real objects and printed numbers and letters in Picasso's and Braque's pictures can also be found: in Miss Laurencin's pictures, in the form of arabesques rendered in depth; in Albert Gleizes's pictures, in the form of right angles that retain the light; in Fernand Léger's pictures, in the form of bubbles; in Metzinger's pictures, in the form of vertical lines parallel to the edges of the frame and interrupted by occasional ladder rungs. Their equivalent could be found in all great painters. It is designed to give a picturesque intensity to a work of painting, and this role alone indicates it is legitimate.

It is in that way that one refrains from becoming a literary painter, in that way that Picabia attempted to abandon himself entirely to colors, yet without daring, upon tackling the subject, to give them a personal existence. (Let us note that the act of giving a title does not mean that the artist is taking on a subject.)

Pictures such as *Le paysage* [*The Landscape*], *La source* [*The Spring*, Museum of Modern Art, New York] and *Les danses à la source* [*Dances at the Spring*, Museum of Modern Art, New York] are thus truly paint-

ings: colors that join together and contrast with one another, that take on a spatial direction, diminish or increase in intensity to produce aesthetic emotion.

Abstraction is not at issue, then, since the pleasure these works take it upon themselves to give the beholder is direct.

Surprise plays an important role in them. Will anybody say that the flavor of a peach is only an abstraction? Every one of Picabia's pictures has its own existence, limited by the title he has given it. These pictures scarcely represent a priori abstractions, so little, in fact, that the painter could tell you the story of each of them, and the picture *Les danses à la source* is merely the realization of a natural plastic emotion felt somewhere near Naples.

The possibilities of aesthetic emotion contained in that art, if that art were pure, would be enormous. Poussin's words could be applied to it: "Painting has no other aim than the delight and joy of the eyes."

Picabia, who seems to want an art of mobility, might abandon static painting and now take on new media (as Loïe Fuller did).

But, as a painter of pictures, I advise him to openly take on the subject (poetry) that is the essence of the plastic arts.

Marcel Duchamp

Marcel Duchamp's pictures are not yet numerous enough and differ too much from one another for anyone to be able to find evidence that they provide a judgment on the real talent of the artist. Like most of the new painters, Marcel Duchamp no longer worships appearance. (It seems Gauguin was the first to renounce what had so long been the religion of painters.)

When he was starting out, Marcel Duchamp was influenced by Braque (the pictures exhibited at the Salon d'Automne in 1911 and at the gallery on rue Tronchet, also in 1911), and by Delaunay's *Tour* [Guggenheim Museum, New York] (see *Jeune homme mélancolique dans un train* [Sad Young Man on a Train,* Peggy Guggenheim Collection, Venice]).

To remove from his art all perceptions that might become notions, Duchamp writes the title he confers on his picture on the picture itself. Hence literature, which so few painters have done without, disappears

from his art, but poetry does not. He then uses forms and colors, not to render appearances, but to penetrate into the very nature of these forms and formal colors, which drive painters to despair, to the point that they would like to do without them, and which they will try to do without whenever possible.

In contrast to the concrete composition of his pictures, Marcel Duchamp gives them titles that are intellectual in the extreme. He goes as far as possible in that direction and is not afraid to incur the criticism of producing esoteric, if not abstruse, paintings.

All humans, all beings, who have passed close by us have left traces in our memory, and these traces of life have a reality whose details can be scrutinized and copied. These traces, taken together, thus acquire a personality whose individual characteristics can be indicated plastically through a purely intellectual operation.

There are such traces of beings in Marcel Duchamp's pictures.

Allow me an observation that has its importance. Duchamp is the only painter of the modern school who is presently concerned (in autumn 1912) with the nude (*Le roi et la reine entourés de nus vites; Le roi et la reine traversés par des nus vites; Nu descendant un escalier* [*King and Queen Surrounded by Swift Nudes; King and Queen Traversed by Swift Nudes; Nude Descending a Staircase*, all Philadelphia Museum of Art]).

This art, which strives to aestheticize the musical perceptions of nature, does not allow itself caprice or the inexpressive arabesque of music.

An art whose aim would be to extract from nature not intellectual generalizations but collective forms and colors, the perception of which has not yet become a notion, is quite conceivable, and it seems that a painter like Marcel Duchamp is in the process of bringing it into being.

It is possible that these unknown, profound, and suddenly grandiose aspects of nature do not need to be aestheticized in order to move people, and that would explain the flame shape of the colors, the N-shaped compositions, the sometimes delicate, sometimes solidly pronounced swarming. These conceptions are determined not by an aesthetic but by the energy of a small number of lines (forms or colors).

This art may produce works of an unimaginable power. It may even play a social role.

Just as one of Cimabue's works was taken out for a stroll, our century has taken Blériot's airplane—full of humanity and millennial efforts and necessary art—out for a stroll, triumphantly leading it to Arts et Métiers. It may be up to an artist as disengaged from aesthetic preoccupations, and as preoccupied with energy, as Marcel Duchamp, to reconcile art and the common people.

Appendix

Duchamp-Villon

As soon as sculpture takes its distance from nature, it becomes architecture. The study of nature is more necessary to sculptors than it is to painters, since it is perfectly possible to imagine a painting that would distance itself altogether from nature. In fact, the new painters, though they relentlessly study nature and even copy it, have entirely broken free from the cult of natural appearances. Moreover, it is only through conventions voluntarily accepted by the beholder that it has been possible to establish a relationship between a particular painting and a particular real object. The new painters have rejected these conventions, and some of them, rather than return to observing these conventions, have deliberately introduced into their pictures elements that are alien to painting and perfectly authentic. For them as for writers, nature is a pure spring one can drink from without fear of being poisoned. It is their safeguard against the intellectualism of decadence, which is art's greatest enemy.

Sculptors, on the contrary, can reproduce the appearances of nature (and many have done so). Through coloring, they can even give us the appearance of life. Nevertheless, they can ask more of nature than these immediate appearances and can even invent, enlarge, or reduce forms endowed with a powerful aesthetic life, but whose justification must always be found in nature, as the Assyrian, Egyptian, African, and Oceanic sculptors did. It is the observation of that essential condition of sculpture that justifies the works of Duchamp-Villon, and, when he wanted to set it aside, he did so in order to take on architecture directly.

As soon as the elements that compose a sculpture no longer find their justification in nature, that art becomes architecture. Whereas pure

sculpture is subject to a peculiar necessity—it must have a practical aim—it is perfectly possible to conceive of an architecture as disinterested as music, the art it most resembles. The Tower of Babel, the colossus of Rhodes, the statue of Memnon, the sphinx, the pyramids, mausoleums, labyrinths, the sculpted blocks of Mexico, obelisks, menhirs, and so on, triumphal or commemorative columns, triumphal arches, the Eiffel Tower—the whole world is covered with useless or almost useless monuments or, at the very least, monuments whose proportions are greater than the aim desired. In fact, mausoleums and pyramids are too large to be tombs and, as a result, they are useless; columns, even those like the Trajan or the Vendôme column, which are designed to commemorate events, are equally useless, since it is hardly possible to follow the details of the historic scenes depicted on them all the way to the top. Is there anything more useless than a triumphal arch? And the utility of the Eiffel Tower arose only after its disinterested construction.

Nevertheless, we have lost the sense of architecture to such a point that the uselessness of a monument now appears to be a strange thing and almost a monstrosity.

Conversely, it is well accepted that a sculptor may make a useless work of art; nevertheless, when the sculpture is disinterested, it is ridiculous.

Whether the statue of a hero, a sacred animal, or a deity, sculpture has the practical aim of presenting simulacra, and that artistic necessity has always been understood. It is the reason for the anthropomorphism of gods, since the human form is that which most easily finds its natural justification and also allows for the most imagination on the artist's part.

As soon as sculpture moves away from the portrait, it is no longer anything but a decorative technique designed to give intensity to architecture (street lamps, allegorical statues of gardens, balustrades, and so on.).

The utilitarian aim that most contemporary architects have set out is the reason architecture has fallen considerably behind the other arts. The architect or engineer must construct with sublime intentions: raise the highest tower, make ready a ruin more beautiful than any other for ivy to grow on and for time to corrupt, build an arch more daring than the rainbow over a harbor or a river, compose definitively a persistent harmony, the most powerful ever imagined by man.

Duchamp-Villon has that titanic conception of architecture. For him, a sculptor and an architect, only light counts, and for all the other arts as well, only light counts, incorruptible light.

Note

In addition to the artists I mentioned in the previous chapters, there are other living artists who, in the schools prior to cubism, in the schools contemporary to it, or among independent personalities, are linked, whether we like it or not, to the cubist school.

The scientific school defended by Mr. Canudo, Jacques Nayral, André Salmon, Mr. Granié, Mr. Maurice Raynal, Mr. Marc Brésil, Mr. Alexandre Mercereau, Mr. Reverdy, Mr. Tudesq, Mr. André Warnod, and the author of this book has, as new members, Mr. Georges Deniker, Mr. Jacques Villon, and Mr. Louis Marcoussis.

The physical cubism defended in the press by the above-mentioned writers, and by Mr. Roger Allard and Mr. Olivier Hourcade, can lay claim to the talents of Mr. Marchand, Mr. Herbin, and Mr. Véra.

The Orphic cubism that was defended by Mr. Max Goth and the author of this book seems to be the pure tendency that Mr. Dumont and Mr. Valensi will follow.

Instinctive cubism constitutes an important movement begun long ago, and which is already spreading abroad. Mr. Louis Vauxcelles, Mr. René Blum, Mr. Adolphe Basler, Mr. Gustave Kahn, Mr. Marinetti, and Mr. Michel Puy have defended certain personalities belonging to that art; it encompasses numerous artists, such as Henri Matisse, Rouault, André Derain, Raoul Dufy, Chabaud, Jean Puy, van Dongen, Severini, Boccioni, and so on and so on.

Of the sculptors who want to attach themselves to the cubist school, let us mention, in addition to Mr. Duchamp-Villon, Mr. August Agéro, Mr. Archipenko, and Mr. Brancusi.

Guillaume Apollinaire

1913

Commentary

This book is, with Albert Gleizes and Jean Metzinger's *Du "Cubisme"* (document 57), one of the two most important texts defending the art-

ists associated with the cubist movement that were published during its development. Yet, unlike the artists' more explanatory (though challenging) text, Apollinaire's book has long left readers seeking enlightenment about the cubists' motives—and their specific engagement with issues and ideas—somewhat confused. This is because his *Méditations esthétiques,* which remain somewhat obscure as art criticism, follow primarily from his poetic theories rather than from a disinterested engagement with the painters' concerns. Yet given Apollinaire's importance as a leading poet of his generation (Décaudin, Le dossier d'"Alcool"), and arguably the most influential, what he has to say is of real interest for its reflection of his own thinking as well as his perception of and engagement with the cubist movement and individual artists.

Apollinaire put *The Cubist Painters* together by drawing on and updating numerous earlier published pieces from 1905 to 1912 (see Apollinaire, "La genèse," in *Les peintres cubistes,* 141–59; and Read *Apollinaire and Cubism* (Book Two), 18–25; Read's translation and commentary (Book Two) includes all of the original illustrations). Working on the book throughout 1912, he instituted major changes to his text in response to the Salon d'Automne of that year (with its group presentation in Room 11 as well as la Maison Cubiste [see document 56]) and to the larger Salon de la Section d'Or exhibition in the rue La Boétie (see documents 46 and 47). Concurrently Apollinaire's cultural politics were also in flux. In his response to xenophobic attacks on cubism in 1912 (documents 45, 49, and 55), his criticism intermingled an ongoing interest in anarchism, as manifest in his defense of artistic freedom (Leighten, 53–63; document 25), with the emergence of nationalist themes (Décaudin, *La crise des valeurs symbolistes;* Read, 38). He opens with a section meditating generally on creativity, the arts, and the importance of the new painting, introducing the four categories with which he attempted to understand differences among the artists within the movement: scientific cubism, physical cubism, Orphic cubism, and instinctive cubism. This section is followed by short sections on individual artists in the order of his view of their importance to the movement and in relation to the four categories: Pablo Picasso, Georges Braque, Metzinger, Gleizes, Marie Laurencin, Juan Gris, Fernand Léger, Francis Picabia, Marcel Duchamp, and Raymond Duchamp-Villon.

Adrian Hicken has most thoroughly explored the fabric of Apollinaire's poetics, based both in a profound engagement with notions of classicism

going back to ancient Greece and also Renaissance France and in equally deep conviction of the importance of classicism's relevance in responding to the modern world. Apollinaire's central poetic construct of Orphism is discussed by Hicken (p. 37) as

> the celebration of the imagination: the creation of new forms and concepts. "J'émerveille" ["I astonish"] was the motto the poet had devised for himself in 1910 and the engendering of surprise was the acknowledgement of the creative faculty in action. In painting it was possible to represent the activity of making art itself. Apollinaire's hermetic and classical tendencies were not a nostalgic, historicist and bigoted *evocation* of a lost heritage, they were screened through the veil of modern images and experience: a simultaneous projection.

This aesthetic deeply informs *Les peintres cubistes,* depending on the otherwise obscure metaphor of light—"the luminous power that constructs at its whim"—which peppers the text (see also Spate, 65–77). Like Roger Allard, Alexandre Mercereau, André Salmon, and Maurice Raynal, Apollinaire embraced cubism as rooted in new science and mathematics, including the fourth dimension, though his grasp of this is even more metaphorical. For many contemporary writers, artists, and scientists, the new science—for example, Wilhelm Roentgen's discovery of X-rays, which confirmed an invisible energy underlying the material universe—was laced with the occult. Apollinaire, like Mercereau, was a full participant in the culture of theosophy, occultism, mediumism, and the "paranormal" at this time (Henderson, "Modern Art and the Invisible"; and Hicken, 8–15).

Apollinaire shares with Allard and Mercereau, as well as with Gleizes and Metzinger, a fundamentally subjectivist and antirational philosophy of individualism, beholden to both Henri Bergson and Friedrich Nietzsche. Artists are viewed as in a position to convey altogether novel perceptions and conceptions of reality: "the painter must above all make a spectacle of his own divinity, and the pictures he offers for human admiration will confer on them the glory of exercising for a moment their own divinity as well." At the same time, reality itself no longer holds still:

> someone strings the rainbow, the seasons tremble, mobs hurl themselves toward death, science takes apart and reassembles what exists, worlds forever remove themselves from our conception, our shifting images repeat

themselves or resuscitate their unconscious, and the colors, odors, and noises ushered in astonish us, then disappear from nature.

Indeed, artists (and, even more, poets) are necessary to society, since they will be the first to detect the importance of changes modernity ushers in: "artists are people who want to become inhuman. They laboriously seek the traces of inhumanity, which are found nowhere in nature. These traces are truth, and outside of them we have no knowledge of reality." Because of this crucial role of the modern artist, "verisimilitude no longer has any importance." Grasping these underlying ideas in Apollinaire's thought helps greatly in understanding some of the more famous extracts from *Les peintres cubistes*. For example, in this light we can distinguish between Apollinaire's preoccupations and those of Whistler or Kandinsky, who likewise compared music to painting. Whereas James Whistler and Wassily Kandinsky wished to evoke the idea of synesthesia (equivalence between various senses, such as vision and sound), Apollinaire identified artistic perception as a form of sensory and spiritual enlightenment. Such was the function of the avant-garde:

> We are thus heading toward an entirely new art, which will be to painting as it has been conceived until now what music is to literature. It will be pure painting, just as music is pure literature. The music lover, in hearing a concert, experiences a joy of a different order than the joy he experiences while listening to natural noises like the babbling of a brook, the crash of a torrent, the whistling of the wind through a forest, or the harmonies of human language, founded on reason and not on aesthetics. Similarly, the new painters will procure from their admirers artistic sensations due solely to the harmony of asymmetrical lights.

Apollinaire dutifully brings in some of the issues embraced by the artists themselves, such as Bergsonism, with his reference to intuition, and the fourth dimension, defending their au courant relations to new science and mathematics:

> The new painters have not proposed to be geometers any more than their elders did. But one can say that geometry is to the plastic arts what grammar is to the writer's art. Today, however, scientists no longer confine themselves to the three dimensions of Euclidean geometry. Painters have been led quite naturally and, so to speak, intuitively, to preoccupy themselves with the new ways of measuring area now possible, which, in the

language of the modern studios, are briefly and globally designated by the term *fourth dimension.*

Quickly departing from the painters' grasp of the new geometries—Gleizes and Metzinger better explain Henri Poincaré's concepts and their operations in their cubist paintings (document 57)—he vaguely identifies the fourth dimension as "the dimension of the infinite," giving objects "the proportions they merit." He somewhat dismissively concludes that the fourth dimension is a "utopian expression" already of mere "historic interest," as it was "only the manifestation of the aspirations, the restlessness, of a large number of young artists looking at Egyptian, African, and Oceanic sculptures, meditating on the works of science, awaiting a sublime art."

Clearly Apollinaire more greatly valued the primitivist roots of cubism—he was a longtime promoter and collector of African art—than the more rigorously studied interests of many of the salon cubists who gathered in Puteaux (see commentary for document 30). There may be more to this association, however. As Willard Bohn has demonstrated, Apollinaire's discussion of the fourth dimension draws heavily on the writing of American modernist Max Weber, whose article "The Fourth Dimension from a Plastic Point of View" had appeared in the July 1910 issue of *Camera Work* (M. Weber; Bohn). Weber, who befriended Apollinaire, Henri Matisse, and Picasso while living in Paris from 1905 to 1908, had likewise associated sensations of immensity with African sculpture, that—despite its diminutive scale—reportedly conveyed a sensation of the fourth dimension. His article was the first published discussion of the fourth dimension and modern art; as it summarized ideas Weber had developed while in Paris, it proved particularly attractive to Apollinaire as a record of early discussions of the issue among members of the Picasso circle (for an overview of Weber's activities before 1914, see North; and Henderson, *The Fourth Dimension and Non-Euclidean Geometry in Modern Art*).

But Apollinaire returns to the theme that matters most to him: what he calls the "social function of great poets and great artists," which is "to constantly transform the appearances that nature assumes in human eyes." This leads, in section V, to one of his most well-known statements:

> Without poets, without artists, people would quickly grow bored with the natural monotony. The sublime idea they have of the universe would drop

away with dizzying speed. The order that appears in nature, and which is only an effect of art, would immediately vanish. Everything would come apart in the chaos. No more seasons, no more civilization, no more thought, no more humanity, no more life even, and an impotent obscurity reigning forever.

The poets and artists determine in concert the figure of their age, and the future docilely rearranges itself to fit their vision.

He argues from this that the cubists are the artists not of the future, but of the present, and that all future viewers of their works will recognize the age in which they lived from their paintings: this amounts to an endorsement of Allard's and Metzinger's earlier association of cubist aesthetics with a so-called future classicism (documents 11 and 12). Apollinaire's defense of cubism is at its strongest where it is most unspecific, where he most eloquently defends the unique social role of the artist as a visionary, where, in short, he defends "the modern school of painting" as "the most audacious that has ever existed." Thus in his meditations "On Painting," he comes full circle in folding cubism into his own modernist poetics of surprise and astonishment.

In the "New Painters," Apollinaire privileges Picasso as the artist who occupies the top rank: "The great revolution in the arts, which he accomplished almost by himself, is that the world is his new representation." In "On Painting" he credits André Derain with having preceded the other cubists, promising to write on the subject, although he never did return to it: "This new aesthetic first took shape in the mind of André Derain, but its most important and daring works were immediately produced by a great artist who must also be considered as a founder of the movement, namely Pablo Picasso." Apollinaire met Picasso in 1904 and spent many hours in his company over the next decade. His evocation of Picasso's paintings goes back to his first publication on Picasso in 1905, and much of this section of his text is taken up with appreciative comments on identifiable Blue and Rose Period works.

As Apollinaire approaches Picasso's cubist period, though, he becomes increasingly vague in his discussion, threading his themes into his defense of Picasso's new paintings: "His persistence in the pursuit of beauty, then, has changed everything in Art. So, severely, he questioned the universe. He accustomed himself to the vast light of the depths."

Recognizing the importance of Picasso's incorporation of "authentic objects" into his collages—"a two-bit song, a real postage stamp, a piece of oilcloth on which the caning of a chair was printed"—Apollinaire concludes that "surprise laughs wildly in the purity of light, and it is legitimate that numbers and hand printing should appear as new, picturesque elements in art, already long steeped in humanity." Though Apollinaire's Orphic themes of purity and light may not seem the most useful concepts with which to approach our own understanding of Picasso's cubism, their Nietzschean exaltation of the artist's role in society, the pursuit of surprise and novel form, and the embrace of modernity, with all its quotidian populism, were fully shared by the poet and the artist (Leighten, 53–63. Apollinaire also interviewed Picasso—possibly changing the artist's words—about 1910–11; ms. in Bibliothèque Doucet [ms. 7540]; see Richardson, 488n24).

Apollinaire's treatment of other artists admiringly repeats these themes in various ways, creating a hierarchy of artists despite his generally evenhanded approach to their individual variations on cubism. Braque and Metzinger he clearly sees as of primary importance after Picasso, placing them with Gleizes, Laurencin and Gris in the category of scientific cubism, one of the "pure tendencies . . . with elements borrowed, not from the reality of vision, but from the reality of knowledge." For instance, Braque

> taught men and other painters the aesthetic use of forms so unknown that only a few poets had had an inkling of them. Luminous signs shine around us, but only a few painters have drawn out their plastic significance. The work, especially in his roughest creations, contains a multitude of aesthetic elements, the novelty of which is always in harmony with the sense of the sublime, which allows men to give order to chaos.

Metzinger's works have "purity," his "meditations assume beautiful forms, the pleasure of which tends to approach the sublime." Gleizes's art brings a "stirring innovation into contemporary art" whose "majesty awakens the imagination, stirs the imagination, and, considered from the plastic point of view, is the immensity of things."

Henri Le Fauconnier, in whose works "the subject and the images are blended together," stands alone in the category of physical cubism, which "has a great future as history painting" and "its social role is well marked." Picasso reappears in the important category of Orphic cubism

along with Robert Delaunay, and Léger, Picabia, and Duchamp: all are acknowledged as striving in this exalted direction (see also commentary, documents 56 and 66). (His category of instinctive cubism seems to cover all forms of Cézannism, though no artists are specifically named.)

Though for the most part Apollinaire seeks and finds his poetic ideas in the paintings by these artists, he is also perceptive about some of their differences; thus some eyewitness observations come through his poetic evocations of their works. For example, he recognizes the rather programmatic quality of Metzinger's paintings, saying that "his works will be among the most reliable documents for those wishing to explain the art of our time" and that "a painting by Metzinger always contains its own explanation. That may be a noble weakness, but it is certainly highly conscious." And the first sections of the essay on Juan Gris valuably suggest a *saltimbanque* (street entertainer or mountbank) theme in those early works that Gris destroyed around 1911. Since Delaunay was busy distancing himself from cubism at this time, Apollinaire only considers his earlier work, when he did exhibit with the salon cubists (see documents 59 and 61).

The greatest departure from the general tone of *Les peintres cubistes* comes in the essay on the other artist he knew best: Marie Laurencin, his lover. Here Apollinaire mounts a unique argument about the feminine in art and life as well as making a relatively lengthy and thoroughly grounded comparison of her work to that of Le Douanier Rousseau (M. Antliff and Leighten). Proud that "our era has allowed female talents to blossom in letters and in the arts," he asserts that "women bring something like a new vision to art, full of joy in the universe," discussing Sofonisba Anguissola at some length to prove his point. He praises Laurencin, who "in the major art of painting . . . has been able to express an entirely feminine aesthetic." She is indebted to Matisse and Picasso, attaching "herself to nature, studying it tenaciously, but carefully setting aside what is neither young nor graceful." For Apollinaire, this is not faint praise but reflects an important aspect of the arts and their relation to new realities: "The task of the feminine aesthetic, which has rarely shown itself before now, except in the applied arts such as lace and embroidery, was above all to express in painting the very novelty of that femininity. Later, women will come along who will explore other feminine aspects of the universe." He clearly shares with many others in this period a gendered concept of experience and even of the "universe." Apollinaire concludes by placing Laurencin's painting between that of Picasso and Rousseau; he

then launches into a lengthy discussion of the importance of Rousseau's art for modernist painting, valuing Rousseau's primitivism very highly in his pantheon of moderns (Shattuck has treated Apollinaire's relationship to Rousseau most substantively; see also *Henri Rousseau: Jungles in Paris*).

Laurencin's own approach to her art was a self-primitivization of the feminine, a variation on other forms of the modernist primitive she also embraced, including African and "Oriental" (Elliott; Otto; Perry). According to Bridget Elliott, Laurencin's art practiced a "tactical indeterminacy," allowing her to problematize this discourse of the feminine. Nonetheless, the ambivalence of Laurencin's position has distorted our understanding of her contribution to cubist aesthetics (M. Antliff and Leighten; Elliott; Otto; Perry).

In conclusion, Apollinaire views cubism as having a supreme importance and affirming his own poetic mission. The metaphor of light, which he sees throughout the paintings of these artists, equals thought and spirit for him, which are constitutive of both poetry and painting. And though his discussions of cubism are rarely specific enough to recognize particular works, reflecting instead his larger mystical vision, students of this movement can read Apollinaire for more than an interest in the poet himself. There is unquestionably a shared grandiose aim with the cubists: art should respond to new perceptions and understandings of the changing universe and, in turn, should play a social role in offering to others this vanguard vision, whether poetic or pictorial. This obligation, which for Apollinaire is also mystical, he discusses most eloquently in the section on Léger, in which he warns against seeing that artist as a mystic. He continues, however, to say,

> Oh, I have no contempt for mysticism. I am terrified with admiration for it. May that great mystical artist come along some day; may God command him, force him, order him. He will be there, perhaps he is there, close at hand, I know his name, but must not say it, it will certainly be known one day, it is better not to tell him. What luck for him if he could be unaware of his mission, not know that he is suffering and also that he is always in danger here on earth!

M. Antliff and Leighten, *Cubism and Culture*
Apollinaire, *Les peintres cubistes*

Bohn, "In Pursuit of the Fourth Dimension"

Décaudin, *La crise des valeurs symbolistes*

Décaudin, *Le dossier d' "Alcool"*

Elliott, "The 'Strength of the Weak' as Portrayed by Marie Laurencin"

Elliott and Wallace, *Women Artists and Writers*

Henderson, *The Fourth Dimension and Non-Euclidean Geometry in Modern Art*

Henderson, "Modern Art and the Invisible"

Henderson, "X-Rays and the Quest for Invisible Reality"

Henri Rousseau: Jungles in Paris

Hicken, *Apollinaire, Cubism and Orphism*

Leighten, *Re-Ordering the Universe*

North, *Max Weber*

Otto, "Marie Laurencin and the Gendering of Cubism, 1904–1914"

Perry, *Women Artists and the Parisian Avant-Garde*

Read, *Apollinaire and Cubism*

Richardson, *A Life of Picasso,* vol. 1

Shattuck, *The Banquet Years*

Spate, *Orphism*

M. Weber, "The Fourth Dimension from a Plastic Point of View"

Les Compagnons de l'action d'art, "Monument du poète Oscar Wilde par EPSTEIN, broadside distributed with *L'Action d'Art* (15 April 1913)

Monument for the poet Oscar Wilde by [Jacob] EPSTEIN

Erected since last October, in the Père Lachaise Cemetery (89th section, near the crematorium)

This low-relief [sculpture reproduced in the broadside] was exhibited in London to the view of the most puritanical and raised no protest; then, since its arrival in the territory of the [French] Republic, it has, it seems, become an object of scandal.

In September 1912, the Prefect of Police forbade the inauguration of this monument, considered by him as offending public morals.

Lastly, on the 10th of February, in the judgment of the Aesthetic Committee of the Prefecture of the Seine,—composed of Misters Delanney, Prefect of the Seine, President; Aubanel, general secretary, Vice-President; Lorieux and Alexandre, Inspectors General of bridges and roads; Pascal and Nénot, Members of the Institute [Institut de France], Inspectors of civic buildings; Jean-Paul Laurens and Gabriel Ferrier, painters, Members of the Institute; Charles Girault, architect, Member of the Institute; Denys Puech, Injalbert and Antonin Mercié, sculptors, Members of the Institute; Selmersheim, Inspector General of Historic Monuments; Bordais, Denfer, Dumont, engineers of arts and industry; Boileau, architect; Alasseur, former contractor of public works; Bouvard, Honorary Director of the Police; Galli, President of the Municipal Council; Dausset, President of the Budget Committee; Chérioux, President of the Third Commission of the Municipal Council, contractor of public works; Mithouard, Vice-President of the Commission for Old-Paris; d'Andigné, Municipal Councillor; and Georges Cain, Conservator of the Musée Carnavalet,—the police informed the London representative of the Oscar Wilde Committee that

they must mutilate the work of the sculptor Epstein (currently in South Africa) or be liable for all costs, risks and perils.

With the Oscar Wilde Monument, it is the principle itself of the freedom of art that is threatened. For this freedom, Charles Baudelaire, Gustave Flaubert, Catulle Mendès, Jean Richepin, Paul Adam, Lucien Descaves, Charles-Henry Hirsch, Steinlen, Forain, Louis Legrand, Willette, Poulbot, Grandjouan, Delannoy, etc., were not afraid to confront the harshness of the laws.

The summons of the prefecture are a danger for art, and an attack on the dignity of healthy men.

We have elsewhere demonstrated (see the *Action d'Art* of March 1, 1913) that the museums, public squares and churches swarm with otherwise realist works of art.

Thinkers, artists and writers must defend their rights, and beyond their rights their ideal of freedom. We assume then that all will be intent on signing our petition to ensure that the Oscar Wilde Monument be respected.

<div align="right">THE COMRADES OF ART ACTION</div>

L'Action d'Art is directed in collaboration by the founding members of the Comrades of Art Action: Atl, Banville d'Hostel, André Colomer, Paul Dermée, René Dessambre, Manuel Devaldès, Tewfik Fahmy, Gérard de Lacaze-Duthiers, Paul Maubel.

Commentary

This public petition, distributed in March and April 1913 to protest the government censorship of Jacob Epstein's *Tomb of Oscar Wilde* (1912), was the initiative of a collective of self-proclaimed anarchists who had significant ties with the cubists and their literary allies. The Comrades of Art Action were advocates of the anarchist doctrine of "Artistocratie," which called for the founding of anticapitalist, communitarian societies and upheld unrestricted creative freedom as an aesthetic and life-affirming ideal. From 1906 onward the "Artistocrats" established a series of journals and artists' collectives, but it was with the founding of *L'Action d'Art* (February–December 1913) that they forged serious links with the cubist milieu (for a history of the movement, see M. Antliff, *Inventing Bergson*, 135–56; and M. Antliff, "Cubism, Futurism, Anarchism"). The journal's chief theorist, André Colomer (1886–1931), was instrumental in

this regard. An enthusiast of Nietzsche and Bergson, Colomer adapted Bergson's theory of intuition to his own espousal of anarchism. Throughout the life of *L'Action d'Art* he argued that intuition gave artists access to the creative essence of their inner beings, which liberated both themselves and their art from the mediating influence of societal structures and proscriptions, whether ethical, moral, sexual, or institutional. An art that broke with established conventions, therefore, amounted to a Nietzschean act of destruction, a revolutionary gesture synonymous with creation. As the "comrades" put it in the journal's opening "Declaration": "What we mean by 'art action' is not only an action in art, with reference to such or such work of 'fine arts' or 'literature'; it is still more and especially our attitude in life, the individual acts of someone eager for the integral and harmonious birth of their being" ("Déclaration," *L'Action d'Art* [15 February 1913]: 1). The self was to become a work of art, and this aestheticist merger of art and life was premised on resolute opposition to any external force that would inhibit or actively suppress an individual's freedom of expression.

In this context the collective developed its links with the cubists and their literary supporters. Colomer, who was undoubtedly aware of the salon cubists' confrontation with Pierre Lampué and the French government in the fall of 1912 (documents 45, 49, and 55), admired the politicized import of their avant-gardism; moreover he interpreted the cubists' allegiance to Bergsonism, Nietzsche, and symbolist aesthetics as fully compatible with his own. He celebrated Stéphane Mallarmé's "free verse" poetry as a literary and individualist revolt against academic adherence to the Alexandrine; in like fashion the "art action" collective endorsed the Salon des Indépendants as the only jury-free venue where artists could exhibit their work without fear of state interference. In the realm of philosophy, Colomer synthesized the anarcho-individualism of Max Stirner with Nietzsche's doctrine of will to power and Bergson's theory of creative intuition (M. Antliff, *Inventing Bergson*, 141–54).

The Nietzschean and Bergsonian assumptions informing the art criticism of Apollinaire, Gleizes, and Metzinger proved especially appealing to the Artistocrats: thus Gleizes and Metzinger's *Du "Cubisme"* and Apollinaire's *Les peintres cubistes* were the only texts on art sold in the Action d'art bookstore, located at 25, rue Tournefort in the Latin quarter (see documents 57 and 62). Gleizes and Metzinger's aspiration, outlined in *Du "Cubisme,"* to transform their audience by imposing their taste on a public still mired in academic conventions, resonated with Colomer's

vision of the revolutionary potential of avant-garde art. Apollinaire, long steeped in anarchist thought, affirmed Picasso's status as the quintessential Nietzschean in *Les peintres cubistes,* describing him as a protean creator who "orders the universe for his personal use" (on Apollinaire's early anarchism and related art criticism, see Leighten, chaps. 3 and 4). Indeed Colomer declared these books in keeping with the Artistocrats' "individualist and anarchically idealist tendencies," and filed them among writings by Bergson and Nietzsche—along with anarchist polemics by Max Stirner, Pierre-Joseph Proudhon, and Peter Kropotkin—in a subsection titled "Philosophy-Aesthetics-Combat." Other books for sale included Mallarmé's poetry, a text on "vers libre" by the symbolist and anarchist Gustave Kahn, treatises on modern poetry by the Abbaye de Créteil associates Charles Vildrac, Georges Duhamel, and René Ghil, and poems by Paul Fort, editor of the neosymbolist journal *Vers et Prose* (1905–14) ("Librarie de l'Action d'art,' *L'Action d'Art* [10 August 1913]: 4). These overtures were warmly reciprocated by the cubists and others in their milieu. Over the course of 1913 Roger Allard, Fort, and the Paris-based futurists Gino Severini and Ugo Giannatasio participated in Action d'art fundraising events. In addition members of this anarchist collective regularly mingled with the cubists, futurists, and neosymbolists who attended Fort's weekly gatherings at the Closerie des Lilas (Severini; M. Antliff, *Inventing Bergson,* 137–140).

This sense of solidarity and common purpose was brought into even sharper focus by the controversy surrounding the censorship of Epstein's *Tomb of Oscar Wilde.* Shortly after the tomb's transport to the Père Lachaise Cemetery in the summer of 1912, the cemetery authorities declared the sculpture indecent and covered it with a tarpaulin. A gendarme was placed next to the statue to prevent clandestine attempts to unveil the monument (Epstein, 51–55; Silber, 130–32). The dissention over the Wilde memorial picked up steam over the fall of 1912—simultaneous with Lampué's tenacious campaign against the cubists and the debate over cubism in the French Chamber of Deputies (documents 45, 49, and 55). Finally in February 1913 the Prefect of Police—at the behest of an official "Comité d'esthétique"—declared Epstein's sculpture an affront to public morality by virtue of the winged figure's highly legible genitals and called for the monument's "alteration."

In March, Colomer and the Action d'art collective launched a campaign in favor of the monument and in defense of Wilde himself, whom they identified as an anarchist Aristocrat in the full sense of the term.

Their support of artistic freedom from government censorship, their active merger of anarchism and avant-gardism, and their stated allegiance to cubist and neosymbolist aesthetics guaranteed that their petition drive received widespread support among the Parisian avant-garde. By 1 April, a virtual cross-section of the cubists and their literary allies had signed the petition, including the writers Apollinaire, André Billy, Fort, Max Goth, Max Jacob, Olivier Hourcade, and Alexandre Mercereau, and the artists Alexander Archipenko, Pierre Dumont, Gleizes, Francis Picabia, and Félix Tobeen (the futurist Severini also signed the petition) ("Notre Pétition," *L'Action d'Art* [1 April 1913]: 1). Picabia in particular would have been sympathetic to the Artistocrats' cause, since he and Marcel Duchamp had immersed themselves in the anarcho-individualist writings of Stirner the previous year (A. Antliff, "Egoist Cyborgs"). Unfortunately the Action d'art campaign failed to sway the authorities, and when the sculpture was finally unveiled in August 1914, the angel's genitals had been covered by a bronze fig leaf (Silber, 132).

The interchange between the Action d'art collective and cubist circles indicates that aesthetic innovation was still regarded as a form of revolutionary activity in leftist circles as late as 1913. The Artistocrats' stated aim to revolutionize art and life amounted to a form of aestheticized politics that negated any bifurcation between the aesthetic and the political. Many cubists and their literary associates clearly welcomed this ideological reading of their avant-gardism, as evidenced by their involvement in the movement's activities. The emergence of anarcho-individualism on the cultural and political scene after 1906 breathed new life into the association of vanguard art with revolution developed by an older generation of anarcho-communists and their neoimpressionist allies (on the history of anarcho-individualism in France, see Maitron and Parry; for analyses of anarcho-individualism's cultural impact, see Leighten, Clarke, and A. Antliff, *Anarchist Modernism;* on the anarcho-communism of the neoimpressionists, see Herbert, Hutton, Roslak, and Ward). Such realities contradict more recent assertions that anarchism had disappeared from the literary and artistic landscape after 1906, and that the cubists and their neosymbolist allies resultantly endorsed a depoliticized form of aestheticism as a sign of their withdrawal from political activism (Cottington, 26–28).

A. Antliff, *Anarchist Modernism*
A. Antliff, "Egoist Cyborgs"

M. Antliff, "Cubism, Futurism, Anarchism"
M. Antliff, *Inventing Bergson*
Clarke, *Dora Marsden and Early Modernism*
Cottington, *Cubism and Its Histories*
Epstein, *Epstein*
Herbert, "Artists and Anarchism"
Hutton, *Neo-Impressionism and the Search for Solid Ground*
Leighten, *Re-Ordering the Universe*
Maitron, *Le mouvement anarchiste en France*
Parry, *The Bonnot Gang*
Roslak, "The Politics of Aesthetic Harmony"
Severini, *The Life of a Painter*
Silber, *The Sculpture of Epstein*
Ward, *Pissarro, Neo-Impressionism, and the Spaces of the Avant-Garde*

[Anonymous,] "Evolution de l'art: Vers l'amorphisme,"
Les Hommes du Jour (3 May 1913): 10

The Evolution of Art: Toward Amorphism

These are difficult times, very difficult. We are at a turning point in the history of art. The patient research, the passionate experiments, the daring attempts of bold innovators, on whom a rhetoric as ferocious as it is stupidly easy has too long exerted itself, are finally going to reach the long-coveted formula, the single and multiple formula that will enclose within itself the entire visible and sentimental universe, the free and tyrannical formula what will take hold in minds, will lead hands, will inspire hearts, the definitive but transitory formula having, on the whole, only the value of a recommendation, subtle and precise at the same time. Let us explain ourselves.

For years, we have been fighting and marching toward a bright goal. The precursors—the Claude Monets, the Renoirs, the Cézannes—quickly surpassed by the little neoimpressionist troop and the valiant pointillist phalange, where Signac and Seurat shine with a pure brilliance, have broadly pointed out the road to follow. On their heels, the fauves rushed in, with Gauguin in the lead. Then came Matisse. Let us say this right away: *Those painters still knew how to paint; a few could even draw.* By that, one can judge the unheard-of backwardness in their conceptions of an outdated aesthetics. All the same, they made praiseworthy efforts to achieve true art, which consists in purely and simply neglecting form, in order to concern oneself solely with the thing in itself, and in not seeing the universal in its inevitably temporary guise. Quite obviously, once we had paid a just tribute to these pure artists, we had to abandon them halfway along, and to soar to dizzying heights on the open road to amorphism.

It is then that cubism made its appearance, soon followed by conism. Why were these painters reproached for their geometrical preoccupations? It was difficult for them to conceive of objects in a less rudimentary form, and they remained, to a certain degree, the victims of the preoccupations and prejudices of their time. At first glance, the object must be returned to the state of a simple notion of dimensions. Its only value lies in its dimensions and its relationships with the ambient light, relationships that vary with the position of the object and the intensity of the light washing over it. Let us note that, in that already reckless conception, and in that strangely lucid vision of the interpretation of beauty, disseminated and scattered in the universal tide, no place was set aside for the soul of things. But let us move on. The cubists carried their stone, one might say. They made their effort. We have no more to demand from them.

Cubism, in fact, like all the great arts, has folded in on itself and subdivided into several currents. First scientific, then physical, it has become instinctive, and finally—and this is the highest form—Orphic. To this day, Orphism—if we neglect futurism, an impetuous endeavor but one lacking in true science—is the last word in contemporary art. It is the logical outcome of all the efforts of the past. It is the first step toward the inevitable formula, toward amorphism.

Already, Rouault, Matisse, Derain, Picasso, van Dongen, Jean Puy, Picabia, Georges Braque, Metzinger, Gleizes, and Duchamp (whose irresistible *Nu descendant un escalier* [*Nude Descending a Staircase*, 1912] and *Jeune homme* [*Young Man*, 1912] cannot be forgotten), seem to have understood and accepted the necessity of absolutely eliminating form and of confining themselves solely to color. There is more to be done, however. One has to decompose the color, which, to a certain point, can evoke form, one has to disassociate it and leave it to the eye to synthesize and reconstruct.

Hence, little by little, amorphism is taking root. To be sure, people will squeal like pigs in the presence of the imminent works by the young pioneers of art. But we are a small group of independent critics, enemies of the bluff, and with no relation to the art dealers, and we have come to defend the new art, the art of tomorrow, the art of eternity. For today, let us confine ourselves to publishing the manifesto—too short but all too suggestive—of the amorphist school. Unbiased minds and true intellects will judge.

Manifesto of the Amorphist School

We declare war on Form!

Form is the enemy!

Such is our program.

It has been said of Picasso that he studied an object the way a surgeon dissects a cadaver.

We want nothing more to do with those bothersome cadavers, that is, with objects.

Light is enough for us. Light absorbs objects. Objects have value only for the light in which they are bathed. Matter is only a reflection and an aspect of universal energy. From the relations between that reflection and its cause, which is light energy, what are wrongly called objects are born, and the following piece of nonsense is established: form.

It is up to us to indicate these relations. It is up to the observer, the looker, to reconstitute the form, at once absent and necessarily alive.

Example: Take the inspired work of Popaul Picador, *Femme au bain* [*Woman Bathing*]:

Popaul PICADOR.

Cherchez la femme, look for the woman, some will say. What a mistake!

Through the opposition of hues and the diffusion of light, is not the woman visible to the naked eye, and what barbarians could seriously demand that the painter exert himself needlessly to sketch a face, breasts, and legs?

Now let us take *La mer* [*The Sea*], by the same artist:

Popaul PICADOR.

You see nothing at first glance. Press on. Once you've gotten used to it, you'll see that the water is forming in your mouth.

Such is amorphism.

We rebel against Form, the Form with which our eyes and ears have

been beaten down, the Form before which the Bridoisons [cognoscenti] of painting kneel down.

3 MAY 1913

Commentary

One important feature of modernism—and of its reception—played itself out in parody, hoax, and mystification, "Vers l'amorphisme" (roughly, "shapelessness") being one of the best examples relating to cubism. Its most well-known precursor was the submission of a work by "Joachim-Raphael Boronali" to the 1910 Salon des Indépendants (which by philosophy had no jury system) narratively entitled *And the Sun Set over the Adriatic*. This work was a hoax organized by the writer Roland Dorgelès (Roland Lecavelé, pseud., 1886–1973) and had actually been painted by the twitching tail of an ass who lived at the Lapin Agile, an evening gathering place for the Montmartre cubists (Severini). Dorgelès even had a photograph taken so that he could *prove* the hoax, which was published on 28 March in *Le Matin* (Weiss, 75–76, 85–89, and 149–51). The main objects of Dorgelès's ridicule, according to his memoirs, included futurists (known at this date more by their manifestos than by their art) and cubists generally, and Henri Matisse, Henri Rousseau, and Henri Le Fauconnier specifically (Dorgelès, 232–40). He also ridiculed the gap between cubist painting and photographic appearance when he published "What the Cubes Say . . ." in *Fantasio*, a humorous biweekly, on 15 October 1911, illustrated with reproductions of two cubist paintings—Jean Metzinger's *Le Goûter* and Albert Gleizes's *Portrait of Jacques Nayral* (fig. 33)—juxtaposed with images, "after nature," of their subjects (Green, 115–16).

"Evolution de l'art: Vers l'amorphisme" purports to be an artists' manifesto of "the amorphist school," reproduced by "a small group of independent critics, enemies of the bluff" who "have come to defend the new art, the art of tomorrow, the art of eternity." Much of the text parodies Apollinaire's writing style as an art critic—Apollinaire wrote in 1914, "The critic must be as accurate as posterity; he must speak in the present the words of the future" (Breunig, xxix)—and echoes his division of cubism into four currents, coining the term *Orphism*. The description of "amorphism" most closely evokes Apollinaire's essay on Delaunay published in December 1912 in *Der Sturm*, "Reality, Pure Painting" (document 59), which he incorporated several months later into his *The Cubist Painters: Esthetic Meditations* (appeared March 1913), and echoes the recent *suc-*

cès de scandal of František Kupka, one of the abstractionists Apollinaire defended as "Orphist," whose *Amorpha: Fugue in Two Colors* drew animated attention at the Salon d'Automne in 1912 (fig. 39).

Weiss discusses the possible attribution to Picabia of this parody, possibly based on its reprinting without commentary in Alfred Stieglitz's June 1913 special issue of *Camera Work* on Picabia (fig. 41). Weiss, though remaining doubtful, suggests that if Picabia was author or coauthor of the piece, it is "an exercise in self-send-up, anticipating a characteristic strategy of Dada as it would be practiced by Picabia and his circle after the war" (Weiss, 87). Alternatively, if by Picabia or indeed others sympathetic with the cubist movement, it could be a parody of a parody, ridiculing the uncomprehending critics of cubism and related hoaxers. Most likely, however, an anonymous and clever critic in tune with the general hostility toward cubism in the pages of *Les Hommes du Jour* attempts here to expose the absurdity of the cubist painters and their chief defender Apollinaire.

Breunig, ed., *Apollinaire on Art*
Dorgelès, *Bouquet de Bohème*
Green, *Juan Gris*
Severini, *The Life of a Painter*
Weiss, *The Popular Culture of Modern Art*

Fernand Léger, "Les origines de la peinture et sa valeur représentative," *Montjoie!* (29 May 1913): 7 and 14–29; (June 1913): 9–10

The Origins of Painting and Its Representative Value

Part 1

Notes collected for a lecture given to the Académie Wassilieff Saturday, 5 May 1913

Without making any claim to explain the goal and methods of an art already at a fairly advanced stage of development, I am going to attempt to respond, as far as that is possible, to one of the questions most often asked by those looking at modern pictures. I transcribe that question in all its simplicity: "What does it represent?" I therefore set that simple inquiry as my goal, and I shall endeavor, in a very short talk, to prove how perfectly inane it is.

If, in the realm of painting, imitation of the object had a value in itself, any painting by anyone at all that had an imitative quality would, in addition, have a pictorial value. Since I do not believe that it is necessary to insist on and discuss such a case, let me assert something that has already been said, but which needs saying again here: "The *realist* value of a work is perfectly independent of any imitative quality."

That truth must be accepted as dogma, must be axiomatic for the general comprehension of painting.

I purposely use the word *realist* in its strictest sense, *because the quality of a pictorial work is in direct proportion to its quantity of realism.*

What does "realism" in painting consist of?

Definitions are always dangerous, since, to confine an entire concept to a few words requires a conciseness that is often lacking in clarity or overly simplistic.

In spite of everything, I will risk one, and will say that, in my view, "pictorial realism is the simultaneous arrangement of the three great plastic quantities: lines, forms, and colors."

No work can lay claim to pure classicism, that is, it cannot claim to endure beyond the era when it was created, if one of these quantities is simply sacrificed in favor of the two others.

I am well aware of the somewhat dogmatic side of such a definition, but I believe it necessary to differentiate clearly the pictures with classical tendencies from those that do not possess them.

Every age has been witness to facile creations whose success was as immediate as it was short-lived, some of which completely sacrificed depth for the charm of a colored surface, others of which were content with a calligraphy and an external form that was even christened "painting of character."

I repeat, every period has had such creations, and such works, even with all the talent they entail, remain only period manifestations. They are memorable, they can be astonishing or intriguing to the present generations, but, since they do not possess the quantities required to achieve pure realism, they must finally disappear. For most painters prior to the impressionists, the three indispensable quantities mentioned above have been closely linked to the imitation of a subject that carried an absolute value in itself. Apart from the portraits, all compositions, decorative or otherwise, have always been subjugated to the description of great human manifestations, illustrating either religious and mythological dogmas or contemporary historical acts.

The impressionists were the first to have rejected the *absolute value of the subject and to have considered only its relative value.*

That is what holds together and explains the entire modern evolution. The impressionists are the great innovators of the current movement. They are its primitives in the sense that, wishing to free themselves from the imitative aspect, they considered painting only for its color, almost neglecting all form and all line in their efforts.

The admirable works that came out of that conception required the understanding of a new kind of color. Their search for real atmosphere was already relative to the subject; the trees and houses blend together and are closely associated, enveloped in a dynamism of color that their methods did not yet allow them to develop.

The imitation of the subject still at issue in their works is thus no longer anything but a pretext for variety, a theme and nothing more. For the

impressionists, a green apple on a red carpet is no longer a relationship between two objects but a relationship between two tones, a green and a red.

When that truth was formulated in living works, the current movement inevitably had to come into being. I will insist on this era of French painting in particular because I think it was at that moment that the two great pictorial concepts, *visual realism* and *realism of conception* met, the former finishing its arc, which encompassed all previous painting up to the impressionists, and the latter, the realism of conception, beginning with them.

The former, as I said, includes the requirements of the object, of the subject, and of the method of perspective, which are currently considered negative and antirealist.

The latter, neglecting all that cumbersome baggage, has already been realized in numerous present-day pictures.

One of the impressionist painters—Cézanne—understood everything that was incomplete in the aforementioned requirements. He sensed the need for a new form and a new kind of drawing that would be closely adapted to a new color. His whole life and his whole body of work were devoted to that search.

I will borrow from Mr. Émile Bernard's well-documented book a few observations made by him regarding the master of Aix, and also a few reflections drawn from Cézanne's own conceptions. Bernard writes:

> His optics, says Bernard, were much more in his brain than in his eye; he interpreted what he saw too much; in short, what he did came absolutely from his genius, and if he had had a creative imagination, he could have dispensed with the effort of going "to the motif," in his own expression, or of placing still lifes in front of him. In Cézanne's letters, I find ideas such as this: "Objects must turn, move away, be alive. I wanted to make of impressionism something lasting, like the art of museums." And, later on, he writes something that supports what I said above: "For an impressionist, to paint after nature is not to paint the objective, but to realize sensations." He wept in despair at the sight of Signorelli's designs, and exclaimed: "I could not bring it to fruition, I remain only the primitive on the path I have discovered."

In his moments of doubt and depression, Cézanne momentarily believed in the need for the old formulas. He frequented museums, studied the means of expression of the painters who had preceded him; he made copies, hoped to find thereby what his restless sensibility was seeking.

His body of work, beautiful and admirable as it was, frequently bore the mark of that restlessness. He saw the danger of that erudition; he understood that it is perilous to look back, and that the traditional value of a work is personal and subjective. He writes, in fact, and I quote a fragment from one of his letters verbatim: "Once one has seen the great masters, one must hasten to leave and to verify in one's self the instincts, the sensations, that dwell within us."

This notation by the great painter deserves to be carefully considered.

Every painter facing works of ancient conception must hold on to his own full personality: he can look at them, study them, but only in the most objective sense.

He must have control over them, analyze them, not be absorbed by them; it is the amateur art lover who abandons his own personality for one imposed by the work before him.

The artist must always monitor his era and balance against it the perennial, natural need for varied impressions.

In the history of modern painting, Cézanne came to occupy the same place as Manet a few years earlier. They were two transitional painters.

Manet, through his research and his sensibility, gradually abandoned the methods of his predecessors and arrived at impressionism, of which he is unquestionably the chief inventor.

The more we examine the works of these two painters, the more we are struck by their historical similarities.

Manet was inspired by the Spaniards—Velázquez, Goya, the most brilliant ones—to arrive at new formulas.

Cézanne found a color and, going against Manet, strove toward a design [*dessin*] and form, which Manet *destroyed* and which Cézanne felt absolutely necessary to express the great reality [*la grande réalité*].

Part 2

All the great pictorial movements of various currents have always proceeded by revolution, by reactivity, and not by evolution.

Manet destroyed in order to arrive at his creation. Let us go farther back. The eighteenth-century painters, too sensual and too mannered, were followed by David and Ingres and their school, reactive in their misuse of the opposite formulas.

That school ended in the equivalent misuse of those formulas and necessitated Delacroix, who, violently breaking free from the previous concept, returned to sensualism in color and to a great dynamism in form and drawing.

I need only these examples to show clearly that the modern concept is not a reaction against impressionist ideas, but, on the contrary, its development and the expansion of its aim through the use of methods neglected by them.

The divisionism of color, however timid it might have been, but which existed among the impressionists, was followed not by a static contrast, but by similar research into the divisionism of form and design [*dessin*].

The impressionists' works are therefore not the end of a movement but rather the beginning of another, to which the modern painters are the successors.

The relationships among volumes, lines, and colors will be at the origin of everything produced in recent years and of everything that has influenced artistic circles, both French and foreign.

Henceforth, everything must converge toward an intensity of realism obtained by purely dynamic means.

Pictorial contrasts in the narrowest sense—complementary colors, lines, and forms—are henceforth the armature of the modern picture [fig. 48].

As in the history of painters before the impressionists, the Nordic artists will tend to seek their dynamic means by developing color, whereas the southern painters will probably give more importance to forms and lines.

This understanding of modern-day painting, born in France, is a universal concept that allows all sensibilities to develop; the Italian futurist movement is evidence of that. Logically, the picture is going to get larger and production must be more limited.

Every dynamic tendency must necessarily be oriented toward an expansion of the means, so that it can manifest itself to its full extent.

Many people are patiently waiting for what they call a *moment* in the history of art to have passed; they are waiting for *something else* and think that modern painting is going through a stage, perhaps necessary, but that it will return to what is commonly called "painting like everybody else."

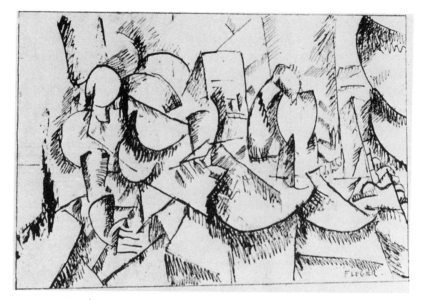

48. Fernand Léger, *Étude de dynamisme linéaire* (*Study of Linear Dynamism*), 1913. Illustration in *Montjoie!* no. 8 (28 May 1913). © Artists Rights Society (ARS), New York / ADAGP, Paris.

This is a very great error. When an art like this one is in possession of all its means, which allow it to produce absolutely complete works, it must take root for a very long time.

I am persuaded that we are arriving at a conception of art as vast as the greatest of the previous eras, the same large-scale tendency, the same collective endeavor. This last remark deserves further consideration. It has its importance.

Most French literary and artistic movements have, in general, manifested themselves in the same manner. It is one proof of great vitality and of the power of influence. Whereas one can doubt an isolated creation, vital proof of its validity is provided when it is expressed collectively with very distinct means of personal expression.

The sentimental conception of the plastic arts is certainly the one that the vast majority holds most dear. The older painters, in addition to displaying plastic qualities, had to satisfy that need with their pictures and to carry out a complex social task; they had to assist architecture in its role as popular expression. They needed literary values of their own to instruct, educate, and amuse the people. With that aim in mind, they illustrated the churches, monuments, and palaces with decorative frescoes and with

pictures representing the great deeds of humanity. The quantity of description was a necessity of the age.

Painters, living like everyone else in an age neither more nor less intellectual than the preceding ages but merely different, needed something besides their audacity and their individual concepts to impose such a way of seeing, and to destroy everything that perspective and sentimentalism had helped to build.

If the age had not lent itself to this, or rather, if their art had not found itself in a relationship with the age and in evolution with respect to the previous eras, it would not have been viable.

Present-day life, more fragmented, more rapid than previous eras, had to pass through an art of dynamic divisionism as a means of expression; and the sentimental side, the expression of the subject in the popular sense of the term, has reached a critical moment which we must make very clear.

To find a comparable era, I will return to the fifteenth century, the apogee of the Gothic style and of its decadence: during that entire period, architecture was the major means of popular expression; the armature of the cathedrals was adorned with everything the French imagination could find and invent in the way of vivid ornamentation.

But the invention of the printing press was to revolutionize and altogether change the means of expression.

I will quote the famous passage from Victor Hugo's *Notre-Dame de Paris*, in the chapter "This Will Kill That":

> In the fifteenth century, human thought discovered a means of perpetuating itself that was not only more durable and more resistant than architecture, but that was even simpler and easier; the stone letters of Orpheus were replaced by the lead letters of Gutenberg. The book is going to kill the edifice.

Without wanting to compare the current evolution and its scientific inventions to the revolution—in the area of humanity's means of expression—that came about in the late Middle Ages with Gutenberg's invention, I would like to note that modern mechanical creations such as the color photograph, the movie projector, the profusion of more or less popular novels, and the popularization of theater, are effectively replacing the development of the visual, sentimental, representative, and popular subject in pictorial art and are now rendering it perfectly useless.

I really wonder what competitive claims all those more or less histori-cal or dramatic pictures in the French salons can make when compared to the movie screen of any cinema whatever.

Never has visual realism been rendered so intensively.

A few years ago, it could still be argued that, at the very least, these new inventions lacked color: but then the color photograph was invented. Paintings with subjects no longer even have that resource. The popular side of their work, the only one that gave them a reason for existence, is disappearing, and the few working men who could be seen in the muse-ums standing dumbfounded before a cavalry charge by Mr. Detaille or a historical event evoked by Mr. J.-P. Laurens can no longer be seen: they are at the movies.

Then too, the average bourgeois, the small tradesman who, fifty years ago, provided a living for all the minor neighborhood and provincial masters, now get along perfectly well without their services.

The photograph requires less posing time than the portrait, renders the likeness more faithfully, and costs less. The portrait painter is dying off; the genre and history painters will not die a natural death, but will be killed off by their times.

This will have killed that.

Since the means of expression have multiplied, plastic art logically has to restrict itself to its goal: *realism of conception* (it came into being with Manet, developed with the impressionists and Cézanne, and has man-aged to spread widely with the present-day painters).

Architecture itself, stripped of all these representative embellishments, has reached a modern and utilitarian concept after several centuries of false traditionalism.

Architectural art is confining itself to its own methods, the relation-ships between lines and the equilibrium of large volumes: the decorative part is itself becoming plastic and architectural.

Every art is isolating itself and restricting itself to its own realm.

Specialization is a modern thing, and pictorial art, like all the other manifestations of human genius, must submit to its law; it is logical, since, in restricting everyone to his own aim, it makes possible the inten-sification of creative works.

Pictorial art thereby gains in realism. The modern concept is therefore not a transitory abstraction good for a few initiates only; it is the total

expression of a new generation to whose needs it submits and to whose aspirations it responds.

Fernand Léger

29 MAY 1913

Commentary

Fernand Léger (1881–1955) was one of the most important of the salon cubists but unlike his colleagues Delaunay, Gleizes, Le Fauconnier, and Metzinger he produced no major aesthetic statement before this essay in the 29 May 1913 issue of *Montjoie!* Born the son of a cattle breeder in Argentan, Normandy, Léger first received training in architecture, apprenticing in this field in Argentan (1897) and then in Caen, Normandy (1897–98). In 1900 he moved to Paris where he began work as an architectural draftsman. Following his military service in 1902–3, Léger was admitted into the École des arts décoratifs. Since he hoped to gain entrance into the École des Beaux-Arts, he decided to become a nonenrolled student of the academician Léon Gérôme and supplemented that training by attending the Académie Julian. In 1903–4 he shared Paris studios with his childhood friend, the future designer André Mare (on Mare see document 34).

Léger first exhibited at the 1907 Salon d'Automne, the same salon that held a major retrospective of Paul Cézanne. Cézanne, in tandem with the "primitive" Henri Rousseau, had a lasting impact on Léger who, in 1908, embarked on a new aesthetic indebted to his two mentors (Green, 6–12). In late 1908 or early 1909 Léger took a studio in the vast artists' complex known as La Ruche (The Beehive), located on the Passage de Danzig in Montparnasse (on La Ruche, see Warnod). While there (1908–10) he established close relationships with Russian and eastern European artists, including Alexander Archipenko (1887–1964), Marc Chagall (1889–1985), Jacques Lipchitz (1891–1973), Chana Orloff (1888–1968), and Chaim Soutine (1894–1943). Concurrently Léger befriended the poets Guillaume Apollinaire, Max Jacob, and Pierre Reverdy, and the art critic Maurice Raynal. In 1910 Léger's avant-garde contacts expanded to include former members of the Abbaye de Créteil, and in spring 1911 he made his public debut as a cubist by exhibiting his *Nus dans un fôret* (*Nudes in a Forest*) in the infamous Salle 41, the "Cubist Room" at the 1911 Salon des Indépendants (document 18 and 19), alongside paintings by Delaunay, Gleizes, Marie

Laurencin, Le Fauconnier, and Metzinger (for biographical notes on Léger, see Erickson, 262–85).

Léger's invitation to speak at the Académie Wassilief is testimony to his strong ties with members of the Russian and eastern European community in Paris. Founded by the artist Marie Wassilieff (1884–1957) in November 1911 and located at 21, avenue de Maine in Montparnasse, the Académie was funded from donations given by the Union des artistes russes (founded in 1905) (Klüver and Martin, 69–79). Around the time of the Wassilief lecture, Léger was invited by the Ukranian sculptor Chana Orloff to serve as resident "critic" at her own newly opened Free School, held in her Montparnasse studio; Léger charged students 5 francs for his advice (Ferenczy). The appearance of his essay in *Montjoie!* not only solidified his status as a theorist, it followed on the heels of Gleizes's own manifesto, "Tradition and Cubism," published in the February edition of the same journal. The importance of the term *realism* in both texts, combined with the crucial role that concept played in Gleizes and Metzinger's *Du "Cubisme"* (document 57), indicates that the cubists' shared vocabulary was now contested terrain.

Léger's lecture begins with a simple question: what does a painting represent? To answer it he separates a painting's representative value from its "pictorial value," claiming that the capacity for imitation had nothing to do with the true value of art. Like Gleizes and Metzinger he uses the term *realism* as the master signifier for abstraction, asserting that "the *realist* value of a work is perfectly independent of any imitative quality." Léger then constructs a formula for determining the realist value of a painting: "the quality of a pictorial work is in direct proportion to its quantity of realism." Such quantity is made up of three plastic elements, "lines, forms, and colors." In realizing a work of art, no single quantity should be allowed to dominate the other two; if such harmony is achieved, then a painting could "endure beyond the era when it was created" and thus lay claim to "pure classicism."

Léger then charts the vicissitudes of "pure realism" (abstraction) in past eras when "imitation of a subject" was thought to possess "absolute value in itself." He identifies the impressionists—from Édouard Manet to Cézanne—as the first to dissociate "visual realism" (imitation) from "realism of conception" (abstraction); however, he chides the group for privileging color above all other plastic quantities. Of the impressionists, Cézanne alone "sensed the need for a new form and a new kind of drawing that would be closely adapted to a new color." As proof of Cézanne's

conceptual orientation, Léger refers to Émile Bernard's assessment of the artist along with quotations from Cézanne's correspondence with Bernard: both had recently appeared in Bernard's *Souvenirs sur Paul Cézanne et lettres* (1912). Léger's usage of Bernard to support his "conceptual" reading of both Cézanne and classicism effectively updated the symbolist notion of classicism advanced by Bernard himself, but Léger did not embrace the reactionary agenda undergirding Bernard's criticism (on Bernard's classicism, see Shiff, 125–32; on his politics, see Stevens, 68–91).

Léger cites Cézanne's response to the art of Luca Signorelli (1441–1532) and other old masters in the Louvre as proof that artists should give free rein to their "own full personality" rather than to slavishly imitate past achievements. However, he does not call for a violent break from the past; instead he argues that modern art should build on the conceptual orientation pioneered by the impressionists. This enabled Léger to distance himself from the wholesale critique of impressionism endorsed by Roger Allard and later by Gleizes and Metzinger (see documents 11, 12, 18, 19, 21, 29, and 57). In contrast to Gleizes, whose text "Tradition and Cubism" drew an absolute divide between the French Gothic tradition and Italian art, Léger preferred to reconcile the two cultures. Thus modern French painting synthesized the "Nordic" artists' penchant for color and dynamism and the "southern" painters' preference for "forms and lines." As a result "modern-day painting, born in France, is a universal concept," and to validate his thesis Léger points to the Italian futurist movement. He subsumes the cultural politics of Gleizes and the futurists under the umbrella of a cosmopolitan modernism whose geographical home was Paris. However, Léger's assertion that pictorial dynamism was part of a northern tradition with roots in the French Gothic was clearly indebted to Gleizes. After World War I Léger adopted a position very close to that of Gleizes by championing the Gothic and the "primitive" to the detriment of the Italian Renaissance (Herbert, 143–51).

Having sketched his history of modernism Léger then analyzes the role of modern technology in the triumph of conceptual realism over imitation in the plastic arts. He claims that the invention of color photography and the cinema had made academic illusionism redundant, and robbed the official salons of their proletarian audience and bourgeois patrons. Citing Victor Hugo's famous dictum that the invention of the printing press had killed off the pedagogical role of Gothic cathedral sculpture, Léger argues that industrial techniques of image making had released the plastic arts from

the chains of mimetic imitation. Thus each branch of the arts, whether architecture, the decorative arts, painting, or sculpture, would henceforth focus on the conceptual properties of its own medium. Conceptual realism therefore culminated in increased specialization in the arts. To point the way Léger included two illustrations in his article: a pen drawing, "Study of linear dynamism," and a painting, "Dynamism obtained by black and white contrasts and linear complementaries." As Christopher Green points out, these illustrations mark Léger's transition from figural works like his Cézanne-inspired *Woman in Blue* of 1912 to the full-blown abstraction of his *Contrast of Forms* series of 1913 (Green, 46–95; and Schmitt).

Léger's thesis, while novel in some respects, was also heavily indebted to the art criticism of his peers. As we have seen, his notion of "realism" was informed by that of Gleizes and Metzinger; moreover Hélène Lassalle has noted that Léger's theory of abstraction owes much to Apollinaire's definition of "Orphic cubism" in his *Cubist Painters,* published in March 1913 (document 62), as well as to Allard's earlier pronouncements (Lassalle). Léger's concept of "pure classicism" had a precedent in both Allard's and Metzinger's definitions of cubist classicism (documents 11 and 12), and his meditation on technological modernism and the plastic arts bears comparison to Le Fauconnier's thoughts on plastic dynamism developed in his manifesto of 1912 (document 54). Scholars have also argued that Léger's lecture was his opening salvo in the ongoing polemical exchange with the Italian futurists over who had precedence in conceptualizing pictorial abstraction (Buckberrough; Lista, 37–38; Del Puppo, 115–85). After the war Léger would continue to promote his definition of realism, which played a key role in the aesthetic and political debates over abstraction in the interwar period (Lassalle; Affron).

Affron, "Léger's Modernism"
Buckberrough, *Robert Delaunay*
Del Puppo, *"Lacerba" 1913–15*
Erickson, "Chronology"
Ferenczy, "Days in Paris"
Green, *Léger and the Avant-Garde*
Herbert, "Léger, the Renaissance, and 'Primitivism'"
Klüver and Martin, "Carrefour Vavin"
Lassalle, "Art Criticism as Strategy"
Lista, "La poétique du cubo-futurisme chez Fernand Léger"
Schmitt, "La femme en Bleu"
Shiff, *Cézanne and the End of Impressionism*
Stevens, "Bernard as Critic"
Warnod, *La Ruche et Montparnasse*

Yvonne Lemaitre, "An Interview with Jean Metzinger on
Cubists and What They Are Doing in the Art World,"
Courier-Citizen, [Lowell, MA,] 12 May 1913, p. 7

In the Rue du Val-de-Grace at the front of a quiet modern house which
looks like all quiet modern houses, is a sober, discreet, unextravagant
little sign: La Palette. You enter; the concierge ushers you into a drawing
room, pleasant, cool, clear, furbished to the shining point, and unmistak-
ably possessed, for an "atmosphere," of the maiden-aunt chasteness of an
English tea-room. You would not think it: it is the Cubist academy.

In the large hall beyond, a score or two of earnest youths are busy giv-
ing the model's altogether on canvas, a few anatomical details which, did
the poor thing really possess them, would force her out of the profession.
Who shall describe the emotions of a cubist model, and the things she sees
in the night when she has had a lobster-fest? For seeing one's self pictured
with a square stomach, two elbows coming out of one's right knee, a tri-
angular bosom, an eye in one's chin or no eye at all, and a thigh which
is a parallelogram, must give a woman views of life somewhat different
from yours or mine. Conscientious students of the "influence of environ-
ment" cannot logically ignore her. It is true that one must remember that a
model very seldom deigns to cast a glance on the vain images called forth
by her anatomy. She is not much given to writing Art with a capital A, the
model.

I said "earnest youths." Like the rest of the world, I had gazed agape at
the Salon des Indépendants, at the incomprehensible new art. All Paris,
and now, like Paris, Boston, New York, London and Amsterdam, where
exhibitions of it are being held, has been defiled by the unaccustomed vi-
sions and laughed. I won't now go to the length of saying that the cubists
will laugh last. No prophecy would be more shaky. But it is ridiculous to
say that they are only "posing," that the thing is but a get-famous-quick

game, that cubism is the only way—though George Bernard Shaw asserts martyrdom is—to get famous without ability, judiciously trod by young men unable to "pierce" otherwise. Undoubtedly there are among the new artists sheep of that wool. But after talking with some leaders of the movement, and seeing them teaching their doctrine at La Palette, I am convinced that no madness ever had in it more method. Earnest masters, earnest pupils. There is certainly there an earnest effort at creation, a sincere desire for a renovation of art by methods not yet employed. And Paris is getting, little by little, to recognize that. There is a distinct shade in the laughter which met last year's Salon des Indépendants, and this year's. For if there is no more terrible judge than herself, with her universal raillery, there is also none more equitable before that high thing: sincerity of effort.

"We are seeking to enrich art by means not yet applied, feeling that the old principles, exploited for more than 2000 years, have furnished the beauty they had to furnish and said their last word," said Jean Metzinger to me the other morning at La Palette. Metzinger is today one of the recognized leaders of the movement. His "Blue-bird" is one of the sensations of the Independents, and a canvas of undeniable charm even to the uninitiated unable to grasp its full subtility [*sic*]. I need not tell you that I am of that clan. I don't know how the thing is done or what it is all about. But it is deep and strong with suggestion, with avocation. And this is, as you know, the subtle secret of great works: making the spectator see a lot of things which are not there.

Metzinger has that sort of personality also. You don't know just what he is going to do, but you are sure he will do something. Embraced by such a man, the new theories must achieve something worth while. We shall know in 10 or 20 years. But meanwhile, the earnest young master in the midst of his earnest pupils is anything and everything except what the world fondly imagines of a cubist: a futile, laughable and sterile decadent.

He resents the term "New Academism," recently applied to the new art. "Academic," he says, "is precisely the word which cannot apply to us. We are seeking. We think we have discovered a fruitful principle which will immeasurably enrich art when we have mastered its application, but we are seeking. This is our secret, our difference, and our chief claim to praise, if any. And the secret of academies, their raison d'être, their pride, is the exact contrary. Art with them is a full-revealed religion of which

the cult is fixed. They possess the truth—the Truth, rather. They have their little affair and are well content.

"The truth of the academies has been fecund. But we think it has served. The Greeks have done beautiful things. But the man who does a Greek thing today, a thing sought, conceived, achieved, brought to its culmination 2000 years ago, is no more an artist in my esteem than the artisan turning out plaster casts by the machine and by the dozen. What else is he doing? What is he creating? What soul guides his hand?

"What the new school claims to have discovered, what it hopes to apply, is 'mobility in space,' to define our foremost principle in most succinct form. Art to this day has represented only the immobile, given only one aspect of form, as if substance had only one aspect, or the human eye were able to grasp only one, and were itself a fixed, immovable organ. The new school seeks to achieve a greater reality by portraying things in their entirety, that is, by giving them on the same canvas, as many of the aspects under which they may be seen, as the artist may choose to give. Take a portrait. It has been the custom to paint a man either full face or profile, as the traditional artist decided, and 'only' in that particular form decided upon, once decided upon. But a human face does not consist solely of profile, or of full front view. Its most salient characteristic, that by which you 'know' it, may reside in the one aspect and be lacking in the other. Therefore, you will find the new artist drawing, in order to achieve an integral resemblance, a nose in profile in the middle of a full face portrait.

"Take any object. A chair, if you will. The chair presents a certain aspect if seen at a certain angle, by an eye immovably fixed on a certain spot. But a chair may be seen at various angles, and a human eye is the most inveterate traveler in space. Art has applied itself for 3000 years to fixing images as if substance had only one aspect, and as if the eye did not travel. I do not say that the principle was false, but it was incomplete.

"In order to achieve a fuller integral presentation of a chair, the new artist has the right, then, to present it on the same canvas as many times and under as many angles as his eye may seize it, the eye traveling, moving, encompassing the 'real' human eye, in brief, the eye in movement, as it really exists. The principle appears to me immeasurably fecund. It gives untold promise. We are testing it. We are seeking. The old principles, on the other hand, have given their measure. If art is to live, it must rejuvenate itself by new blood. As it stands in the old academies, it is bound to

perish if it does not invent new formulas. Nothing, no matter how perfect of its kind, can eternize itself and deny the possibility of fuller life for what may come later."

Listening to Metzinger, I recalled the words I had heard in the mouth of a white-haired master of the old school, pensive at the Salon des Indépendants before the canvases of the young iconoclast and his colleagues. The old artist, former Prix de Rome, nourished of the divine milk of Athens and Florence, is nearing the end of a career full of good work and recompense; for 30 years his shaggy head has been a feature, as were the works it conceived, at that other Salon, which is "the" Salon, and where the new art would no more be admitted than it would care to be admitted. For this business of scorn, you know, was ever as mutual as love. An officious friend by his side, thinking the better to pay his court, was voluble in his scoffing of the Futurist and Cubist canvases on the walls. But the shaggy old hand shook. "Qui sait? Qui sait?" [Who knows? Who knows?] said the old voice with one knew not what melancholy retrospect of a youth which had broken nothing. "Ils ont peut-être raison" [They may be right]. It was Bonnat.

They may be right! They may be wrong! But whichever way it is, whichever way the wind will turn and the coming years prove, one feels of [sic] know not what sympathy, what liking for them already, ridiculed, out in the cold, "not in society," shabbily installed in a skimpy shed of the Quai de l'Alma. There is such a difference between the mere housing of them and that official gorgeousness of the great Salon in its setting of palace, triumphant avenues, and chestnut trees all a-bloom! Whoever has seen Paris pouring into the Vernissage, on a sunny April day, from all the walks and avenues leading through the Champs-Elysées to the Grand Palais must remember the scene as probably the most complete, in the way of luxurious elegance, that the world offers. I do not mean the women's toilette. Invariably, when one speaks of Parisian elegance, outsiders think of dress. It is a great mistake. Women go to the Vernissage dressed as they please. But it is the setting, the richness, the completeness coupled with measure, of the whole scheme, of that incomparable stretch of city which reaches across the great park and the Pont Alexandre III to the very dome of the Invalides. That setting is as much—perhaps more—a manifestation of French art than the Salon itself. It has taken millions

and millions to create that setting. But it has taken more, the thousand years of civilization which Paris has in the blood.

But crystallized elegancies have their bad points. "The" Salon holds this 1913 spring its 131st official triumph. Poor little brother Independent is being laughed at only for the 29th time. There is a margin. And for all the splendors of the great official art realm you would find in it that element of ridicule, wholly absent at least from the vagaries of the other: the conventional, the hopeless, painful, disastrous conventional, what French artists in their jargon call the "pompier"—is it from the delight taken by the average fireman in a style of art virgin of originality?—and which is the malady peculiar to dowagers too long secure in their social position. The Salon des Indépendants is certainly guilty of the seven deadlies, but its sins make you laugh. You can only weep before certain exhibits of the only true church. Before such a figure as an Apollo singing to the sound of a much too immortal lyre, a weight overwhelms your spirit. That in this 1913 a man should have the courage!—that a man should have the courage!

YVONNE LEMAITRE.

Commentary

In this interview with Jean Metzinger we are given a glimpse into an understudied dimension of the cubist movement, namely the role of the salon cubists as art instructors and pedagogues before 1914. In an act that provoked a good deal of controversy at the time, Henri Le Fauconnier was appointed to succeed painter Jacques Émile Blanche (1862–1952) as director of the Académie de la Palette in February 1912 (Golding, 169). Simultaneously Metzinger and André Dunoyer de Segonzac were hired as full-time instructors for the morning sessions, while Eugène Lak and Francis Auburtin took over in the afternoon (see the announcement in Olivier Hourcade's *Revue de France* [March–April 1912]). Segonzac had long been associated with la Palette, having studied there and been hired, along with the Scottish fauve J. D. Fergusson (1874–1961), as a part-time instructor as early as 1907 (Cumming, 12). Like the Académie Colorossi and Académie Julian, la Palette served as an alternative venue where artists could receive training outside the pedagogical framework of the École des Beaux-Arts. Located at 18, rue du Val de Grâce in the Montparnasse district, the school was ideally placed to attract a local artists' community dominated by foreigners (see Klüver and Martin, 69–79). La Palette's

owner—a Swiss woman named Ms. Stettler—had capitalized on this by hiring the bilingual Blanche, who supervised students from 1902 to 1911 (Blanche, 167–77). Because instruction was offered in both French and English under Blanche's tutelage, la Palette became a popular venue for English and North American artists seeking exposure to the latest avant-garde tendencies. As a result an older generation of avant-gardists was able to build a following among the burgeoning international avant-garde: such was the case with the Scot Fergusson, whose students included the American modernists Marguerite Thompson (later Zorach; 1887–1968) and William Zorach (1889–1966), the British avant-gardist Jessie Dismorr (1885–1939), and the Canadian Emily Carr (1871–1945) (M. Antliff, 67–105; Greutzner-Robins, 108–115; Nathanson; Tarbell, Thom).

Following the appointment of Le Fauconnier and Metzinger in February 1912, they too developed a following, but in this case among French, Danish, and Russian artists newly arrived in Paris. Their students included such canonical figures as the French artist Marcel Gromaire (1892–1971), the Danish painter Albert Naur (1889–1973), and the Russians Marc Chagall (1887–1985), Lyubov Popova (1889–1924) (fig. 49), and Nadezhda Udal'tsova (1886–1961). In her memoirs (written 1933), Udal'tsova confirmed the dominance of foreigners among those studying with the cubists: "Americans, Swedes and Russians studied in our studio: it was kept by an Englishman but the French didn't come for some reason—they considered it a madhouse" (Udal'tsvova, quoted in Pardon and Yablonskaya, 171).

Yvonne Lemaitre, in her account of la Palette, gives us a sense of how outrageous the idea of a "cubist school" must have seemed at the time. She does so by contrasting the ordinary appearance of the École building and the mundane interior with the art being produced by "earnest students" in the studio space itself. Whereas the building façade looked like "a quiet modern house" and the interior "drawing room" resembled "an English tea-room," the youths in the studio were "busy giving the model's altogether on canvas, a few anatomical details which, did the poor thing really possess them, would force her out of the profession." Lemaitre gives us a quick survey of the details: "a square stomach, two elbows coming out of one's right knee, a triangular bosom, . . . a thigh which is a parallelogram." A cubist study of a model drawn by Udal'tsova while she studied at la Palette (reproduced in Pardon and Yablonskaya, 164) gives us a clear idea of what disturbed Lemaitre. Having gasped at

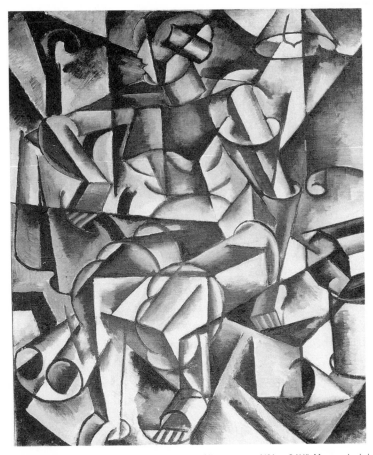

49. Lyubov Popova, *Seated Female Nude,* ca. 1913–14. Oil on canvas, 41¾ × 34¼". Museum Ludwig, Cologne. Photograph Rheinisches Bildarchiv.

the students' work, she then turned to Metzinger in hopes of gaining an understanding of his pedagogical aims. When asked whether the cubists, in their capacity as teachers, were creating a "New Academism," Metzinger rejected the term, claiming that, while the official academies were "fixed" in their methods, and merely taught techniques already mastered by the ancient Greeks, the cubists were still "seeking" to explore new methods: "What the new school claims to have discovered, what it hopes to apply, is 'mobility in space.'" Mobility, we are told, is fundamental to our visual experience, for "a human eye is the most inveterate traveler in space"; moreover, in acknowledging that mobility—by combining multiple views of a given subject on a single canvas—the artist could now

capture all the physical characteristics that best conveyed an "integral resemblance." Convinced "that no madness ever had in it more method," Lemaitre is sure that the cohort at la Palette are not lacking in sincerity, and that, in 1913, one could no longer dismiss the cubists but must let posterity pass judgment on their accomplishments (she quotes the venerable academic artist Léon Bonnat to that effect).

In her memoirs Udal'tsova recounted the routine at la Palette in the winter of 1912–13: "Le Fauconnier, Metzinger, and Segonzac used to visit the studio once a week. Le Fauconnier offered pictorial solutions for the canvas, while Metzinger spoke of Picasso's latest accomplishments. . . . Le Fauconnier was a ferocious expert, and many students trembled before the canvas. Both Le Fauconnier and Metzinger responded positively to my works, and I was so happy when Metzinger told me two weeks later 'You have made extraordinary progress.'" Metzinger also encouraged Udal'tsova and Popova to keep abreast of Picasso's work: thus in a letter to Udal'tsova written on 3 March 1913, Popova excitedly recounted a recent excursion "to see the new Picassos at Uhde's and Kahnweiler's" (Udal'tsova and Popova, quoted in Bowlt and Drutt, 343–44). Evidently Metzinger regarded cubist experimentation as a collective endeavor, with no separation made between salon and gallery cubists; and, in a magnanimous spirit, he encouraged his students at la Palette to think likewise.

M. Antliff, *Inventing Bergson*
Blanche, *Portraits of a Lifetime*
Bowlt and Drutt, eds., *Amazons of the Avant-Garde*
Cumming, "Colour, Rhythm, and Dance"
Golding, *Cubism*
Gruetzner-Robins, *Modern Art in Britain, 1910–14*
Klüver and Martin, "Carrefour Vavin"
Nathanson, *The Expressive Fauvism of Anne Estelle Rice*
Pardon and Yablonskaya, eds., *Women Artists of Russia's New Age, 1900–1935*
Tarbell, *Marguerite Zorach*
Thom, *Emily Carr in France*

Gabrielle Buffet [Picabia], "Modern Art and the Public," *Camera Work,* special issue ([New York,] June 1913): 10–14

The difficulty experienced by the public in understanding modern art is the result of a misunderstanding.

This misunderstanding exists not only towards modern art but towards every manifestation of ancient or modern art. The number of people who really understand the interest and beauty of the Primitives and of El Greco and Rembrandt is as limited as the number of those who genuinely appreciate modern painting.

This misunderstanding arises because the public looks upon art merely as a pastime, a form of entertainment that is due to it, and balks at making the slightest effort to understand the significance of the work of art or the art itself. It seeks in the work of art merely its own personal vision of life—its own conventions—and it declares it to be absolutely without interest if it does not find in it the egotistical and superficial pleasure that it had hoped to find there. It is because of this that the whole misconception has arisen.

For art is *not* just a pastime, not a striving for pleasure; nor is it the expression of a mere conventional beauty. It is simply a means by which men may communicate with each other and express the profound needs of their being, of their race and of their epoch to go beyond the exact meaning of words and to reach the mysterious source of nature.

And so it is not from our own egotistical point of view alone that we ought to regard a work of art in order to form an opinion of it. The question, even, of whether one has or has not a merely sensuous pleasure ought not to impose itself at all. On the contrary one should try to suppress one's own personality in order to understand that of the artist. One should try to reconstitute his thought, his need and the need of the epoch in which he lived and the form of the language in which he tried to

express himself. For example the ideal of the primitive painters has little or no relation to the ideal of our time. If we judge their work from the point of view to which we have arrived today it will seem to us unskillful and absolutely illogical. In order to feel the purity of these paintings one has to remember the simple religious temperament of the artists of the Middle Ages and the mystical tendency of their minds, and then we can understand that the grotesque deformities which offend our conventional modern standard of proportion is [sic] intentional with them for a more intense expression.

We have to realize, for a further comprehension of them, that they did not want to represent merely external nature but that they availed themselves of natural forms to embody their religious and sentimental ideals; and the beauty of their achievement lies rather in the expression of feeling than in the representation of objects.

In looking, then, at the work of the Primitives and seeing it from the point of view of expression which was their only intention, the deformities and disproportions of their figures will cease to trouble us. We will notice them no longer, but will only perceive, beyond the external representation, the intensity of what they express.

It is in the same attitude of mind and with the same good will that we should approach the modern artists, Cubists, or Post-Impressionists (as they are called in New York) if we want to find out what they mean; and before judging them it is but fair to try and see their work form [sic] the angle from which it was done. To do this it is necessary to recall and go over briefly the evolution of modern thought which is now, as it has always been, the profound reason for the evolution in art.

The development of science has given us a new conception of life. It has given life a new meaning.

We have gone past the first sensorial contact of our senses with the universe. We know now that the forms among which we move are the conventions of our senses. We no longer content ourselves with differentiating between these forms, by the means of our sensorial perceptions.

We plumb to their depths, we pierce below the surface to grasp their quality, their essence, and in doing so an infinite world of new forms is opened up to us—thanks to the continual analyses of chemistry and physics.

Out of the ever deepening consciousness of life which we derive from every new scientific discovery there arises a new and complex state of

mind to which the external world appears *more clearly* in the abstract form of the qualities and properties of its elements than under the concrete form of our sense perceptions. Or more broadly speaking, we can say that at the same time that we have our perception of the external, we have the consciousness of all that exists above and beyond it.

In order that art should express the complexity of this new state of mind, it has to create new elements. The old language of the artist is no longer appropriate for the last new needs of our being.

The condition of art today is not, then, one of sudden and unexpected upheaval but the result of a necessary evolution. Each mode of expression naturally tends to break through the limitations of the old artistic conventions in its endeavor to find a new formula which will relate to the trend of events of modern consciousness.

It is in painting that this evolution shows itself most definitely and most clearly. Its essential characteristic is the partial or complete abandoning of the representation of the object in nature.

There is practically no objective representation in these recent works, or if we do find certain traces they are there to corroborate some preestablished theory (varying according to the different temperaments or different qualities of the imagination of the artists who are all working along the same line) but *not* from the point of view of the purely representative.

These theories—the first tentative to form a *convention* for pictorial composition that will be purely intellectual—are the necessary stages for arriving at a formula that will be absolutely free from any trace of objectivity—that will be expressive by the force of its rhythms, and the relations of line and color—a convention, abstract and free and pure—expressive of the artist's imagination and desire.

The most advanced works of this movement seem to us a combination of different volumes of form and color, one balanced by another, in which it is impossible to find any vestige of representation either concrete or symbolic. These works do not form any part of Decorative Art (as has been alleged) for they form a unity, wholeness, in themselves, and awaken an emotion of the same kind as that which music evokes.

The mistake on the part of the public is in desiring to find that a particular subject has aroused this emotion (as was the case in old-fashioned painting) and in frantically trying to find some objective point of contact between the title of a picture and the picture itself. This point of contact

doesn't exist; and the title represents only the state of mind, the emotion, which influenced the artist to desire and express a certain artistic equilibrium.

This is particularly true of the paintings of Picabia [fig. 41]. If he calls some of his recent water-colors "New York" [Centre Georges Pompidou] or "Negro Songs" [Metropolitan Museum of Art, New York] it is only because he did them when stimulated by his impression of the city or by the bizarre rhythms of ragtime.

To try and explain how, from an external impression that he has received, is born in the artist the desire to desire to [sic] express it in either rhythmical sound or in rhythmical line would necessitate entering into the domain of the psychology of aesthetics and would take us to the great problem of the reason itself for the existence of art. But here we want merely to give a definition as precise and concrete as possible of these works that have been dubbed incomprehensible by the public, and try and make this definition of them confirm their logic and simplicity.

And so to go back to *the title,* which has no more importance as far as understanding the picture is concerned than have the names of musical compositions such as the "Heroic Symphony," and of "Spring," etc., we should not look for anything more in it than the abstract suggestion of the impression that has impelled the artist to express himself by this *special balance* of form and color, without trying to give some objective or literary interpretation to the meaning or sensation expressed by this equilibrium. To be sure, this sensation, reacting upon different imaginations, may suggest to each according to his temperament or aptitude some special concrete form, as certain music suggests to us the idea of repose or inquietude, etc. But this reaction is a secondary consideration only. The real meaning of the work of art can only have an indefinite influence on this reaction, and it is for the onlooker to limit and define it according to his own fancy. It is unimportant whether the "African Song" of Picabia indicates an altogether different subject, or doesn't evoke any subject at all to the spectator. The essential is that he should have an impression of the volumes of color which form the equilibrium in the picture and take an abstract and impersonal pleasure in this equilibrium.

The obstacle which lies in the way of our comprehending is the need which has become a routine part of us, to give some conventional literary interpretation to the balance of form and color in a work of art and which is its only reason for being, instead of giving ourselves up to

the emotional impression which we feel when we listen to music. For the expressive value of line and color is as logical as that of sound; to deny one is to deny the other. Indeed, we believe that the abstract idea in pure line and pure color is conveyed to our understanding more directly than in the musical form, for in the latter we cannot completely appreciate it without an initiation into the arbitrary laws of composition and harmony. The entire objectivity of sound had to be created, a convention of the musical language to be organized. The deepest meaning of a musical composition will escape, in part, the comprehension of those listeners who are not educated in music, or who have not, at least, the heredity of a long education. On the other hand, pure line and color have a definite and particular meaning in themselves which the normal development of our sense perceptions permits us to appreciate without effort. Everyone has in himself the comprehension of the straight line and the curve, of the colors blue and red. Everyone can seize the relations that exist between two lines and two colors and the different impression that ensues from different relations of these same lines and colors. We can realize the geometrical objectivity in the work of "peinture pure," free as it is from all representation, as clearly as we can realize the materialistic objectivity of the representative work of art and we experience the emotion in this abstract balance in the work since we realize the value of its elements.

The objection has been raised against this form of painting that it deprives this art of its richest source of emotion in relinquishing its representative mission, the role of representation. To this we reply that if representation had been an essential element in painting this old form would have now no reason for existing because no work of art made by a human hand will ever have the accurate value of the mechanical reproduction by photography, and so the evolution of photography, far from retarding the development of painting, has, on the contrary, contributed to its progress in showing the uselessness of a method of painting whose sole interest was the facility to reproduce by the deceit of perspective and "trompe l'oeil"—some model—either person, place or anecdote. Thanks to photography and to the cinematograph this kind of painting has ceased to live. Furthermore, if one looks a little deeply into the history of art it is only too apparent that the methods that the artist has employed in the past to express himself have never been of more than secondary importance. The symbol or the representation of a subject has never been the main reason why the work of art was a living expressive thing. They may

have been the psychological reason but not the aesthetic one. They were the point of contact between the materialization of the desire of the artist and the comprehension of the public. It is this materialization that transforms itself in the passing of time and which has been successively, according to the development and the new needs of each epoch, the symbolism of Gothic art, the cleverness and the individualism of the Renaissance, the realism of the Impressionists, and which is the Intellectualism and the spirit of analysis of our time. But in spite of all its different forms of materialization the real "raison d'être artistique" remains the same, as mysterious and incapable of analysis in the art of antiquity as it is in the art of today. In the presence of a work of art of any time we can only define and analyze its mode of materializing; but what it is that makes it "beautiful" (to use a very indefinite word, but the only one which is given us by our vocabulary) will always escape all analysis; and we can only rest content to feel the special pleasure that we do, in the artist's expression, without seeking to or knowing how to explain it.

It does seem evident that instead of belittling itself in suppressing all mechanical reproduction modern painting has enlarged and added to its resources. It has freed from all shackles the imagination of the artist and has found the formula for expressing itself that is the most adequate for the development towards the abstract which is the tendency of our modern thought.

GABRIELLE BUFFET.

Commentary

Gabrielle Buffet, a musicologist, met Francis Picabia (1879–1953) in 1908; they married the following year. Buffet was a serious student of music, and the two shared a dialogue about the importance of "liberating" art and the equivalence of art and music (see commentary for document 47). Picabia, of mixed Cuban and French parentage, had attended the École des arts décoratifs in Paris between 1895 and 1897, when he inherited an independent income. From this date, he listed himself as a student of Ferdinand Humbert, Albert Charles Wallet, and Fernand Cormon and exhibited in the conservative Salon des Artistes Français until his conversion in 1903 to impressionism. Switching to the Salon des Indépendants and the Salon d'Automne, as well as exhibiting in the fashionable Galerie Haussmann, Picabia subsequently enjoyed success both critically and financially (Camfield, 8–9). After meeting Buffet, Picabia briefly switched

to an exploration of neoimpressionist and fauve styles, and had an exhibition at the Galeries Georges Petit in March 1909 (ibid., 13). The following four years he experimented with forms of abstraction, responding to cubism and futurism, and no later than early 1911 met Marcel Duchamp, who became a lifelong friend (ibid., 17–21) and, later, fellow Dadaist.

Throughout this period, Picabia sought a form for his art that could reflect symbolist theories of *correspondance* and synesthesia (equivalence between various senses, such as vision and sound) and directly evoke his inner experiences. He felt he had finally achieved this by spring 1912 with two works, *Tarantelle* and *Port de Naples*, both exhibited in June at the third Salon de la Société Normande (Camfield, 28–29; see also documents 42 and 43). Though these works were heralded by his friend Guillaume Apollinaire as cubist, William Camfield rightly points to the differences in Picabia's aims from either the Picasso circle or the Puteaux cubists (ibid., 29–32). Nonetheless, Picabia was an organizer of the Salon de la Section d'Or (October 1912; see documents 46 and 47) and was doubtless pleased to be included in Apollinaire's *Les peintres cubistes* (document 62) as one of the "New Painters." Indeed, he was probably influential in a number of ways on Apollinaire's development and defense of *peinture pure* ("pure painting"); in turn the poet had a substantial impact on his friend, with particular reference to his development of the titles for his abstract works (Hicken, 124–26). According to Apollinaire in *Les peintres cubistes*, titles in Picabia's new works perform the structural role that painterly elements play for other artists:

> For Picabia, the act of giving the work a name is not an intellectual element apart from the art to which he has devoted himself. That act must play the role of an internal frame, just as real objects and inscriptions copied verbatim do in Picasso's pictures. It must separate intellectualism from decadence and ward off the danger painters always face of becoming writers of literature. The picturesque equivalent of the titles written by Picabia and the real objects and printed numbers and letters in Picasso's and Braque's pictures can also be found: in Miss Laurencin's pictures, in the form of arabesques rendered in depth; in Albert Gleizes's pictures, in the form of right angles that retain the light; in Fernand Léger's pictures, in the form of bubbles; in Metzinger's pictures, in the form of vertical lines parallel to the edges of the frame and interrupted by occasional ladder rungs. Their equivalent could be found in all great painters. It is designed

to give a picturesque intensity to a work of painting, and this role alone indicates it is legitimate. (Document 62)

Together Buffet and Picabia came to New York during the Armory Show in 1913, followed by a one-person show at Alfred Stieglitz's "291" Gallery, which was the occasion for Buffet's article as well as Picabia's published statement (see document 68). She begins her piece by calling for greater understanding of the variations in artistic expression of different eras, comparing the "primitives" (Italian quattrocento artists such as Fra Angelico) to the new art. The role of the spectator is to defer to the artist's vision: "one should try to suppress one's own personality in order to understand that of the artist. One should try to reconstitute his thought, his need and the need of the epoch in which he lived and the form of the language in which he tried to express himself." This is a more elitist position than that of Albert Gleizes and Jean Metzinger, who in *Du "Cubisme"* invited the spectator to participate fully in the achievement of a work of art: "It is our entire personality that, in contracting or expanding, transforms the picture plane. As that plane, in reaction, reflects the personality onto the beholder's understanding, the pictorial space is defined: a sensory passageway between two subjective spaces" (document 57). While Buffet may thus privilege the artist over the spectator more than other supporters of cubism, it is in order to serve art. The role of art, we are told, "is simply a means by which men may communicate with each other and express the profound needs of their being, of their race and of their epoch to go beyond the exact meaning of words and to reach the mysterious source of nature." In understanding this, she asserts, "the deformities and disproportions" of the primitives and their modernist counterparts "will cease to trouble us."

One of Buffet's key ideas is that art must express the epoch in which any artist lives. In the modern period, "The development of science has given us a new conception of life. It has given life a new meaning." Alluding to various new scientific ideas popular among the cubists, such as wave theory and non-Euclidean geometry (Henderson; documents 57 and 62), Buffet writes that

We have gone past the first sensorial contact of our senses with the universe. We know now that the forms among which we move are the conventions of our senses. We no longer content ourselves with differentiating between these forms, by the means of our sensorial perceptions.

We plumb to their depths, we pierce below the surface to grasp their quality, their essence, and in doing so an infinite world of new forms is opened up to us—thanks to the continual analyses of chemistry and physics.

Like the cubists, Buffet embraced the idea of an invisible underlying structure to the universe indiscernible to our senses. The implications for art are resultantly imperative for any artist in touch with the new era: "Out of the ever deepening consciousness of life which we derive from every new scientific discovery there arises a new and complex state of mind to which the external world appears *more clearly* in the abstract form of the qualities and properties of its elements than under the concrete form of our sense perceptions." And, since the sense of vision is now inadequate for both life and art, "in order that art should express the complexity of this new state of mind, it has to create new elements. The old language of the artist is no longer appropriate for the last new needs of our being." Abstraction therefore is inevitable and only awaits an understanding public.

Buffet conveys less interest than Picabia (see document 68) in the philosophical and psychological theories of Henri Bergson, as evidenced by her claim that the new art must be "purely intellectual." Bergson, whose influence on the Puteaux cubists was profound, clearly rejected the purely intellectual for the intuitive when he described forms of creative thought or activity (M. Antliff, *Inventing Bergson*). But Buffet boldly describes this "intellectual" art as "absolutely free from any trace of objectivity" and as expressive "of the artist's imagination and desires" through "the force of its rhythms, and the relations of line and color—a [new] convention, abstract and free and pure." Indeed, it will be "impossible to find any vestige of representation either concrete or symbolic," for there is no "objective point of contact between the title of a picture and the picture itself."

These last comments of Buffet's do not address cubism at all, but reflect the move Picabia himself made in his recent art, and here she turns to him. In doing so, she introduces a musical analogy, drawing on her knowledge as a musicologist. First making a comparison between the titles of Picabia's paintings and those of musical compositions, she reminds the viewer to "not look for anything more in it than the abstract suggestion of the impression that has impelled the artist to express himself"; we should surrender to "the emotional impression which we feel when we listen to music. For the expressive value of line and color is as

logical as that of sound." She even claims a certain superiority for paint-
ing over music, since painting comprises basic elements such as line and
color that, "unlike the arbitrary laws of composition and harmony," do
not require an education in the arts to be understood. As she indicated
earlier in her article, the hard part for the public will be to jettison its ex-
pectation of finding the "old artistic conventions" in the realm of "pein-
ture pure."

M. Antliff, *Inventing Bergson*
Camfield, *Francis Picabia*
Henderson, *The Fourth Dimension and Non-Euclidean Geometry in Modern Art*

"Exhibition of New York Studies by Francis Picabia," *Camera Work* ([New York,] April–July 1913): 19–20

In presenting the Studies of New York by Francis Picabia [fig. 41], "291" introduced to the New York public examples of the latest stage of abstract expression by one of the most sincere workers of the present day. A clear and logical thinker, Picabia set forth his attitude in a short statement for the benefit of the public that came to see his work. We reprint this statement in full. The article by Gabrièle [sic] Buffet (Mrs. Picabia) in June Special Number of CAMERA WORK is a further clear exposition of the attitude of those who work along the lines of abstract expression. Naturally, in view of the Marin and Stieglitz New York pictures, the interest in Picabia's abstract expression of New York was greatly intensified.

Picabia's "Preface" written for his exhibition:

Art is one of the means by which men communicate with each other and objectivize the deepest contact of their personality with nature. This expression is necessarily related to the needs of the civilization of the time. It has its conventions as has any means of expression. Its conventions are the limitation of the personality of the artist, a limitation which man tends to extend, as he tends to remove all limitations to his perception. Just as the simple and direct perception of the outside world does not satisfy us any longer, and we try to go deeper into the essence and quality of this simple perception, so have our feelings towards nature become more complicated, and similarly the expression of these feelings.

The objective representation of nature through which the painter used to express the mysterious feelings of his ego in front of his subject 'motive' no longer suffice [sic] for the fullness of his new consciousness of nature. This representation bears no longer a relationship to his new conception of life, and has become not only a limitation but a deformation.

'The objective representation of nature is a deformation of our present conception of nature.'

Reality imposes itself upon us not only under a special form but even more under a qualitative form.

For example: When we look at a tree we are conscious not only of its outside appearance but also of some of its properties, its qualities, and its evolution. Our feelings before this tree are the result of this knowledge acquired by experience through analysis; hence, the complexity of this feeling cannot be expressed simply by objective and mechanical representation.

The qualitative conception of reality can no longer be expressed in a purely visual or optical manner: and in consequence pictorial expression has had to eliminate more and more objective formulae from its convention in order to relate itself to the qualitative conception.

The resulting manifestations of this state of mind which is more and more approaching abstraction, can themselves not be anything but abstraction. They separate themselves from the sensorial pleasure which man may derive from man or nature (impressionism) to enter the domain of the pure joy of the idea and consciousness.

But expression means objectivity otherwise contact between beings would become impossible, language would lose all meaning. This new expression in painting is 'the objectivity of a subjectivity.' We can make ourselves better understood by comparing it to music.

If we grasp without difficulty the meaning and the logic of a musical work it is because this work is based on the laws of harmony and composition of which we have either the acquired knowledge or the inherited knowledge. These laws are the objectivity of painting up to the present time. The new form of painting puzzles the public only because it does not find in it the old objectivity and does not yet grasp the new objectivity. The laws of this new convention have as yet been hardly formulated but they will become gradually more defined just as musical laws have become more defined and they will very rapidly become as understandable as were [sic] the objective representation of nature. Therefore, in my paintings the public is not to look for a 'photographic' recollection of a visual impression or a sensation, but to look at them as but an attempt to express the purest part of the abstract reality of form and color in itself.

PHOTO-SECESSION GALLERY, MARCH, 1913. FRANCIS PICABIA.

Commentary

Picabia's statement, distributed at "291" during his exhibition, is in most ways a condensed version of Buffet's article (document 67). Clearly they shared a good understanding of both music and painting, and both passionately supported this radical new direction for the arts. Picabia, like Buffet, first defines art—"one of the means by which men communicate with each other and objectivize the deepest contact of their personality with nature"—then emphasizes that art is "necessarily related to the needs of the civilization of the time." Not naming the new science, he nevertheless conveys that the artist responds to "the fullness of his new consciousness of nature." The "objective representation of nature . . . bears no longer a relationship to his new conception of life, and has become not only a limitation but a deformation." Unlike Buffet, however, he then emphasizes concepts drawn from Henri Bergson and Henri Poincaré (M. Antliff; Henderson) as central to his art, stating that "reality imposes itself upon us . . . under a qualitative form." This Bergsonian term places us firmly inside the subjective, "qualitative," experience of the artist, mingling with it Poincaré's notion—shared by Bergson—of consciousness as a reflection of not just vision but all our senses, combined with memory. Picabia gives an example:

> When we look at a tree we are conscious not only of its outside appearance but also of some of its properties, its qualities, and its evolution. Our feelings before this tree are the result of this knowledge acquired by experience through analysis; hence, the complexity of this feeling cannot be expressed simply by objective and mechanical representation.

The implications for art follow directly from such consciousness: "The qualitative conception of reality can no longer be expressed in a purely visual or optical manner: and in consequence pictorial expression has had to eliminate more and more objective formulae from its convention in order to relate itself to the qualitative conception." Indeed, as in Buffet's argument, only abstraction can follow:

> The resulting manifestations of this state of mind which is more and more approaching abstraction, can themselves not be anything but abstraction. They separate themselves from the sensorial pleasure which man may derive from man or nature (impressionism) to enter the domain of the pure joy of the idea and consciousness.

Picabia succinctly concludes that "this new expression in painting is 'the objectivity of a subjectivity,'" reconciling what may have remained obscure in Buffet's use of the term *objectivity*. From this point, Picabia ends with a final paragraph that echoes Buffet's article quite directly, introducing the comparison of the new painting with music and concluding that "the laws of this new convention have as yet been hardly formulated but they will become gradually more defined just as musical laws have become more defined and they will very rapidly become as understandable as were [*sic*] the objective representation of nature." He then invites the public to look at his canvases as "an attempt to express the purest part of the abstract reality of form and color in itself."

M. Antliff, *Inventing Bergson*
Henderson, *The Fourth Dimension and Non-Euclidean Geometry in Modern Art*

Roger de la Fresnaye, "De l'imitation dans la peinture et la sculpture," *La Grande Revue* (10 July 1913): 316–25

On Imitation in Painting and Sculpture

When painting and sculpture are called arts of imitation, this ordinarily means that the imitation in question is that of Nature, and refers to the fact that these two arts have in general endeavored to imitate realities by simulating them. Just as dramatic art proceeds by placing in the mouths of fictive characters themselves the words the author wants the public to hear, it seems that the plastic arts, to express themselves, have always had to resort to the representation of human figures or objects. The fidelity with which artists of every age have gone out of their way to reproduce, with a host of details, the appearance of natural things—from a stone-age man making cave carvings to a painter with an admirably developed genius, Raphael, for example—led to the idea that the most accurate imitation of Nature not only was an indispensable means for touching people, but, up to a certain point, even constituted an aim. Nevertheless, in the evolution that painting in particular has undergone in recent years, that imitation of Nature has seemingly tended to play an altogether secondary role. Several of us can even envision the moment when that role will disappear altogether, just as the antique chorus—the origin of tragedy—gradually disappeared from theater. It is very easy today to imagine that painting and sculpture, definitively breaking off from their former means of expression, might restrict themselves to the realm of abstract thought, measure, and a kind of rhythm.

In the plastic arts, in fact, the imitation of Nature is not the essential element: a careful analysis always discovers another sort of imitation in them, this one indispensable, namely, the imitation of what has already been done in these arts. In every time, artificial images, already attributable to human thought and human hands, have had infinitely more

influence on artists than the shifting and fleeting images that Nature and Life have offered them.

The primordial instinct that pushes men to create a work of art, an instinct that drove very primitive peoples and dwells deep within each of us, does not tend solely toward the representation of things or living beings. If very young children, or adults who have not yet received specialized instruction, are asked to draw or paint something in common under certain conditions of independence and freedom, upon studying and comparing the works thus obtained, we will be struck by certain resemblances that crop up after a short time among the creations of different individuals, and which can only come about through an instinctive imitation of something other than nature.* For example, when one of these primitive artists has the idea of adding two long leaves to the bouquet of flowers he is drawing, framing it on either side, others immediately add the same leaves to their own bouquets, as if they could now no longer conceive of a bouquet deprived of these ornaments. That conception of the bouquet will be respected until another modification is adopted in turn, or until another subject comes to interest the little group even more.

That is a very simple image of what is happening from the highest level of art to the lowest: whether ingenious finds or insignificant fancies, the momentary success they meet with resides in a profound need that reigns over the artistic instinct and forces it to use elements already tested by others, which have thereby become conventional. The child who draws a sketch of a dog or pig as he has been taught, with a few skillfully combined strokes, even though he has never seen one, is more similar than is generally believed to the artist of every age who uses the ready-made forms left by his predecessors without questioning them.

Modern philosophy has shown the role the concepts of our intelligence play in our perception of the outside world; it is likely that we would be unable to distinguish a wagon wheel from its square chassis if we did not project onto the wheel our abstract notion of a circle; and animals,

* A conscientious artist, Mlle Gabriel-Claude, had the happy idea of no longer making her young municipal school pupils go on copying open parasols, or the traditional watering can, but of appealing to their natural tastes by telling them simply to paint beautiful pictures, and a young painter, G. de Miré, while in the services, obtained by the same method some very interesting rudimentary works, often beautiful in composition and refined in color, from soldiers who had never held a paintbrush.

though often endowed with a keener sense of sight than our own, probably have a vision of the outside world that is, so to speak, continuous, which does not in any way resemble the expertly divided, classified, and distinct vision we owe to our intelligence. We must get used to the idea that we do not see anything in the world around us except what falls within the framework of our understanding and what education, which has permeated us through and through, forces us to see; that we are, so to speak, blind to everything we have not been taught to distinguish. A child needs the language taught him by his parents to become clearly aware of thoughts that had only to be formed in his mind. The artist needed the mute language of images, carved or painted, which he saw at random in his early years, in order to perceive, in the vast chaos of his visual sensations, those images that his mind is going to choose, analyze, and delimit in precise forms.

It is not adequately recognized that painting and sculpture are languages with multiple dialects, the most diverse patois; just as we have all a mother tongue, a certain vision was imposed on us by virtue of our birth and education.

Just as the child I mentioned a moment ago, who has been shown a sketch of a pig, should he happen to run into one of those animals, will immediately recognize the large triangle of the ears and the corkscrew tail from the sketch that struck him, the artist always rediscovers in the different objects presented to his vision the images of them he already knows. There is no doubt that, in the eyes of an Egyptian sculptor from the age of the pyramids, a living man appeared in the simple and majestic posture of statues from that period; and there is not a young Englishwoman painting with watercolors who does not see for a fact the color blue in the shadows cast on a beautiful summer day, ever since the impressionists painted shadows blue. Not only do conventional images appear before our eyes at the slightest notice, but they even mask the appearance that nature would have otherwise offered us; they impose their form and their character on the images mechanically projected onto our retina from the outside; they completely replace them.

These conventional images are the only models who really sit for us, and any immediate access to nature is only a vain illusion. The realist school of the nineteenth century, which claimed to draw the nourishment for its art exclusively from nature, did not, in so doing, enter into more direct communication with that inaccessible reality.

But, for that school, the traditional influence of manmade images was supplemented by that of artificial images of a new kind, obtained mechanically, without the aid of the human mind. It was photography that, in becoming infinitely popular, imposed its special vision as an absolute dictator on an entire generation; it is to photography alone, and not to a more accurate perception of things, that we owe the countless Breton religious festivals, the thousands of old beggars who seem about to ask for money, and the cavalry charges with galloping horses in postures that our eye inevitably struggles in vain to find among real horses; it is to photography, finally, that we owe a large share of Manet's works, and the fragmentary picture as the impressionists conceived it.

As a matter of fact, photography is not the only mediation external to the human brain and hand that has placed new images within the reach of our imitation. Without going back to the invention of painting as the Greeks told it, to the young shepherd drawing on a rock the outline of his sleeping companion's shadow, we may note that painters of the past already used procedures, such as a pane of glass or the camera lucida, which were truly the precursors of photography. These methods, which gave our perception both a crispness and an accuracy they would not have had otherwise, had a clear effect on the direction in which European art developed. Perspective itself, which has been taught for five centuries, is basically nothing but the set of laws according to which light rays emanating from objects come to be projected onto the photographic plate of a camera; originally, for the first people who applied it, it was only a curiosity for the mind, a way of displaying the genius of science, and in no wise an innate and instinctive need.

Therefore, the tendency people would be tempted to find in our Western art, that of approaching nature to an ever greater degree, is only a vain appearance. That movement is something completely different; it is easily explained by certain outside influences; it is only the result, in sum, of a fortuitous disruption in the development of the forms of that art. Here again, the influence of Nature plays absolutely no role, and our art is no more the result of an impartial observation of the outside world than is Chinese or Hindu art.

In relation to immutable truth, the multiple artistic creations bursting forth across time would remain inexplicable: but, considered in relation to one another, that is, to the previous forms they have assumed, they always seem to have resulted from a gradual development.

Over the course of centuries, they form an uninterrupted series; they evoke the idea of a vast living organism, an immense tree always growing new branches; that chain makes us think of the chain connecting creation as a whole. Just as the naturalist, with the help of the many intermediaries science discovers every day, manages to classify all living things of the most varied species and to locate them logically in a gradual evolution, all art forms, all of humanity's major ways of seeing, manage to come together step by step. Our museums are abundantly supplied with transitional works, which are so many convenient stages to move, for example, from Egyptian art to Greek art of the classical age.

Along with secondary influences from time to time—returns to the past as it were—all forms created by art seem to derive in that way from those that have preceded them.

By virtue of that kinship among all artistic productions, we can, with a little practice, confidently and with no fear of error find the place of any work whatever from any era, any country, any school: whatever genius may have distinguished an artist's works, they nevertheless belong to a nation and to a precise time. If it so happened that someone discovered Michelangelo today, his body of work would immediately be classified among the sixteenth-century Italians. It seems that an obligatory force of habit constrains the artist, whatever his value, to never do anything but to continue to construct a building begun by his predecessors, modifying the plans as his capacities allow. Those who have wanted to escape that law inevitably find themselves subjected to it once more by a force superior to their will and talent.

For a very long time now, a revolt of sorts has been at the foundation of all great works, and, in our time, there is barely a truly noble genius who has not, as a matter of principle, turned away from the generally admired art of his time. David was driven by the same feelings toward eighteenth-century art that the Jacobins felt toward the ancien régime. The Jacobins banned the words *king* and *saint* from the language and imposed the use of the republican calendar; David turned away in horror from the pastoral paintings and the *fêtes galantes* done by painters in lace with mother-of-pearl swords, and invoked antiquity as the liberator of all inspiration. Delacroix sought to forget the academicism honored in his time, when faced with the works of Rubens and the Venetian masters. Finally, many artists since then have dreamed of breaking free from every convention and every influence; they have presumed to demolish, to re-

move stratum by stratum, the foundations they judged defective. But, having soon grown weary, they too began to build, and their work simply found its base a little lower down in the works of the past. Gauguin fled far from Paris, only to be influenced by Breton Calvaries, then by the art of the savages among whom he ended his life. He was happy to say he was an Aztec; but he was, above all, a Frenchman of his time, steeped in the impressionism of the times and in the most solid aspects of what was already beginning to break free from it.

There is no art in the world that does not cling to the past like a tree to the soil; at times, a root seems to wander off, but it only becomes embedded more deeply somewhere else.

The continuity of art across time is the indispensable element without which it could not remain alive and evolve. The role of convention transmitted from one generation to the next serves as our bridge between one art form and the next, allowing us to become accustomed to innovations that are disconcerting all alone.

A totally unprecedented art would be accessible to no one, and a new beauty cannot touch us unless it is attached by some point, however tenuous it might be, to a former beauty already experienced. The continuing incomprehension of the vast majority of the public toward the new works inconsiderately set before its eyes every year lies in great part in the fact that the public has not had the time to gradually become accustomed to the intermediary forms that painting has recently taken on one by one. In the realm of art, as in other realms, growing specialization has in effect created a smaller and smaller elite, which, in a very brief time, passes through a complete evolution of taste, which the masses need many years to accomplish in peace. The general public is still at the stage of being initiated, at the salons of the Société des artistes français, to bad reworkings and pale, diluted versions of the impressionism of forty years ago.

That persistent element, maintained through imitation of the past, is also the framework on which art has continued to be erected and developed over the centuries. It is by virtue of a real, unconscious plagiarism that it has emerged from the most rudimentary primitivism, since, if all progress—in any sense whatever of that word—presupposes a share of innovation, it also presupposes that the one who achieves that progress has himself assimilated the previous innovations beforehand.

In recent years, it has been believed that art education could be based on something other than conventions; sixty students have been shut in a room around a naked man and told to copy the model with great accuracy. They measured him crosswise and up and down; they spread their color with paintbrushes or palette knives; but what everyone saw on the table, in place of the amorphous creature standing before them, was the academies of their predecessors, all the art we have seen, composed for the most part of old photographs. Folding easels were invented, kits perfected, and landscape painters were sent out to conquer the world, their box of paints on their backs. But some took with them, from deep inside their heads, some memory of Corot, others a few impressionist blotches, and look what they brought back in the way of feeble and clumsy replicas, bearing the name *studies after nature*.

In the past, conversely, the only art education in existence consisted of the passive imitation of a master's technique.

The young artist, the student, began by learning one by one, from the older artist he had chosen as his master, all the procedures, all the secrets of execution, until he knew all "the ins and outs," as one still says when speaking of an apprenticeship in a manual craft. He docilely copied the master's works, until he managed to make reproductions so faithful that they did not need the slightest retouching to be mistaken by everyone for the master's. He finally adopted so much of the master's personality that the latter very often foisted a part of his own labor onto the student. The old schools have thus left us a good number of works that are very difficult to attribute with any certainty to the master or the student.

The works of one of the most innovative human geniuses, those of Leonardo da Vinci, were utterly indistinguishable at the beginning from those of his master, Verrocchio. The early works of Raphael resemble those of Perugino to the point of being easily mistaken for them. Finally, Michelangelo himself walked in the footsteps of Luca Signorelli; centuries later, knowing the works of the two masters equally well, we discover an obvious kinship between the emaciated, tortured figures in the cathedral in Orvieto and those that Michelangelo set spinning in an improbable burst of forces on display.

For us, then, the geniuses who, at first glance, seem the greatest and the most isolated, cease to be the fireballs fallen from the sky that many people thought they admired; but there is nothing about their place on

the timeline that can serve to diminish our notion of their attainments, their essentially creative role. Anyone who had known Napoleon I's parents would have been perfectly justified in observing that the emperor had his father's voice or his mother's forehead, but that would not have brought him down to the level of the common man.

After the fact, when considering completed deeds, our intelligence easily perceives relationships, manages to reconstitute step by step the great march of life across time, based on the results it leaves behind. But, when considering the future, or even the present, the creation that is continually perpetuated before our eyes remains absolutely mysterious and inaccessible to us as to its effects.

As for manifestations of the human mind, then, we witness their development as spectators, never knowing what will follow. Who could not be struck by the way modern industries are developing around us? For example, anyone who has observed the different machines and succession of forms assumed by "horseless carriages"—as they used to be called—since the origin of the automobile, present-day vehicles, with their multiple improvements and their long, sleek look, perfectly adapted to speed per their function, seem to be the inevitable culminating point toward which all previous metamorphoses were converging. Nevertheless, who could have foreseen with certainty, when looking at some of the race cars built ten years ago, which themselves seemed to be a culminating point, which of the different characteristics of these cars would be developed to meet the new demands?

In the realm of art, who could have predicted during Cézanne's lifetime in what new directions that master's works were going to steer painting? His pictures, objects of both admiration and of the harshest criticism, left the very vague impression that they were destined to have a major influence on the following generation. But some people did not hesitate to see them as a return to classicism, and the only lesson they drew from them was the subsequent need to produce pastiches devoid of any artistic content, with the help of the ancient works that fill museums. Others saw Cézanne as simply a painter more skillful in harmonizing beautiful colors and obtaining sumptuous results on his canvas. It is only now, thanks to the light projected on that work by subsequent efforts and creations, that everyone can easily find the elements in them that are destined to survive and to appear again, further developed and expanded in the school alive today.

As for the relationship among different manifestations of art, it is only intelligible to us through the recorded traces left behind in the past, as it were, by the share of imitation contained within these works.

A new element always catches by surprise the expectations of our reasoning mind. Just as, in the doctrine of evolution, one must explain the ingenuity and miracles of Nature by referring to a creative power, whether it is called God or simply Life, one must at this point introduce the notions of genius or talent. Imitation coordinates the succession of artistic forms and connects them from beginning to end: at its origin, each of these forms is only the springboard from which the artist propels himself toward the goal to which his personality draws him in a more or less vague, more or less obscure, manner.

Artistic inspiration, the offshoot of the most mysterious tendencies of our instinct, remains entirely free: no one, in the name of the past, could assign a direction to it or impose limits on it. It will always escape the rules and theories by a route no one had thought of. But, just as the most unexpected dreams we have while sleeping always turn out, upon reflection, to stem from some event or from some thought we had in our waking lives, the works produced by inspiration can always be explained after the fact by what has preceded them.

We must confine ourselves to the retrospective interest that the abstract study of the evolution of previous manifestations of art can offer. That study shows us that, taken together, the parts form a whole independent of the reality of things, and surviving on its own, so to speak, not beholden for any of its different forms to the direct imitation of nature. It shows us that, conversely, art is entirely supported by the imitation of tradition, just as even the smallest branches of a tree are sustained by the trunk sprouting from the soil. Let us study the branches and the way the branches are attached, but let us refrain from drawing pointless conclusions about the young shoots, conclusions that might be contradicted come spring.

Roger de la Fresnaye
10 JULY 1913

Commentary

The French painter and decorative artist Roger de la Fresnaye (1885–1925) was an important figure in cubist circles whose interactions with right-wing advocates of neo-Catholicism gave his version of cubism a con-

servative inflection (Seligman; Silver, "The Heroism of Understatement"; Silver, *Esprit de Corps*). De la Fresnaye was the son of a military officer and scion of an aristocratic family with an ancestral chateau in Falaise, Normandy. His artistic training began with his enrollment in the Académie Julian (1903–4) and subsequent entrance into the École des Beaux-Arts, where he studied from 1904 to 1908 (with an interruption in 1905–6 to fulfill his military service). While at the Académie Julian, de la Fresnaye befriended Jean-Luc Moreau, André Dunoyer de Segonzac, and André Vera. It was Vera who, in the spring of 1908, introduced de la Fresnaye to the Salon des Indépendants and, most significantly, to the art of the neo-Catholic symbolist artist Maurice Denis. That October Vera encouraged de la Fresnaye to abandon the École and join him in enrolling in Denis' Académie Ranson, where de la Fresnaye met his future lover and companion Jean-Louis Gampert.

De la Fresnaye's painting during this period was indebted to the symbolist painters Paul Gauguin and Denis; in addition, he began studying neo-Catholic writers, as evidenced by his planned illustrations for the ardent Catholic Francis Jammes' (1868–1938) *Le roman du lièvre* (1903) (Griffiths; Seligman, 15–22). In 1910 he nurtured his interest in sculpture and the decorative arts by studying at the Grande Chaumière Atelier, where he worked under Aristide Maillol (1861–1944) and befriended the cubist and fellow Norman Raymond Duchamp-Villon. From the spring of 1910 to the outbreak of World War I in August 1914, de la Fresnaye exhibited regularly at the Salon des Indépendants and Salon d'Automne. He also joined the avant-garde Société normande de la peinture moderne and exhibited at the group's second exhibition, held in the spring of 1911. Another contributor to the Société normande was the decorative artist André Mare, who would later collaborate with de la Fresnaye in constructing a number of decorative ensembles, the most famous being the Maison Cubiste at the 1912 Salon d'Automne (Troy, 63–99). De la Fresnaye also contributed four works, each entitled *Paysage* (*Landscape*), to the cubist Section d'Or exhibition in the fall of 1912 (Lucbert, 194–96).

His own explorations of the art of Paul Cézanne and a cubist idiom began in earnest in late 1910. De la Fresnaye's initial contacts with cubist circles came through his friendship with Duchamp-Villon, and in the spring of 1911 he was among those included in a gallery of cubist "fellow travelers," adjacent to the infamous Room 41 at the Salon des Indépendants (André Lhote, another conservative, showed alongside de la Fresnaye). Following that exhibition, de la Fresnaye regularly attended

the weekly meetings organized by the salon cubists at Courbevoie. In the fall of that year he and Duchamp-Villon were members of the committee for the Salon d'Automne that convinced a hostile jury to allow the cubist painters to exhibit (Golding, 12). Concurrently de la Fresnaye joined his companion Gampert, and fellow artists Marie Laurencin, Duchamp-Villon, Fernand Léger, Vera, and Jacques Villon, in contributing to Mare's "Colourist" ensembles in the Decorative Arts section of that year's Salon d'Automne. De la Fresnaye's contributions included a white fireplace (fig. 23)—set against a blue wall—which incorporated a decorative panel by Laurencin. He also exhibited a sculpture titled *Eve* (1910) in Mare's "Study." Mare in his memoirs recounted that Vera, Gampert, and de la Fresnaye's previous training at the Académie Ranson meant that he could call on their expertise when planning his own initial foray into the decorative arts (Malone). In 1912 Mare joined de la Fresnaye, Gampert, Vera, and the cubists in constructing the Maison Cubiste at that year's Salon d'Automne, and at the following year's, de la Fresnaye contributed a series of decorative panels to Mare's "boudoir" ensemble on display (Troy, 126–27).

De la Fresnaye's political conservatism can be measured in his choice of subject matter while a practicing cubist (Seligman, 15–38 and 147–50). In the 1911 Salon des Indépendants he exhibited his *Cuirassier* (1910–11), a painting whose militarist theme derived from neo-Catholic Paul Claudel's religious play *Tête d'or* (1889); at the Independents Salon of 1912 he exhibited another *Tête d'or*–inspired painting, *Artillery* (1911; fig. 28); and the same year he painted a cubist *Joan of Arc* (1912), thus underscoring his enthusiasm for that symbol of militant Catholicism revered by French nationalists like Maurice Barrès and Charles Maurras. Thus de la Fresnaye, like Lhote, was partially inspired by the reactionary Catholicism of Claudel (see commentary for document 13). This nationalist orientation also informs his most famous cubist painting, *Conquest of the Air* of 1913 (Museum of Modern Art, New York). As Kenneth Silver has demonstrated, de la Fresnaye's inclusion in the painting of an ochre-colored hot-air balloon in close proximity to an enormous French flag was meant to celebrate France's pioneering role in the development of aeronautics despite American claims to superiority following the successful flight of the Wright brothers at Kitty Hawk (Silver, 2001).

Like many of his colleagues de la Fresnaye defined his own interpretation of cubism in 1913: first in an essay on Paul Cézanne published in the January 1913 edition of Henri-Martin Barzun's *Poème et Drame*

(reproduced in Seligman, 276–77), and then in his major aesthetic statement before World War I, "On Imitation in Painting and Sculpture." This later essay appeared in the 10 July 1913 edition of *La Grande Revue*, the same journal which published Henri Matisse's "Notes of a Painter" in December 1908. In both of his essays de la Fresnaye proclaims his allegiance to the art of Cézanne, but he does so at the expense of the former symbolist Émile Bernard, whose *Souvenirs sur Paul Cézanne et lettres inédites* had appeared in article form in 1907, but gained a wider audience when published as a book in 1912 (Bernard, *Souvenirs sur Paul Cézanne*; Dorn, 50–83).

Bernard's conversion to hard-line neo-Catholicism in the late 1890s had made him increasingly hostile toward modern art, including that of his supposed maître, Cézanne (Stevens). From May 1906 to June 1910 he edited the journal *La Rénovation Esthétique* to defend his new credo: "I believe in God, in Titian and in Raphael." As Mary Anne Stevens notes, Bernard's writings for *La Rénovation Esthétique* diminished Cézanne's accomplishment by identifying his art and technique as too individualistic and therefore not the proper basis for any new school of painting. Writing in March 1906, Bernard claimed that Cézanne's achievement paled in comparison to that of Michelangelo before concluding that Cézanne's art "will inspire nothing more than incompetent and clumsy imitations" (Bernard, "De Michelange à Cézanne"; cited in Stevens, 83). Although he continued to identify Cézanne as a classicist, he now did so in a qualified manner by counseling artists to follow Cézanne's example only through studying the old masters, rather than imitating Cézanne himself.

As a self-proclaimed follower of Cézanne who sought to reconcile neo-Catholic subject matter with a cubist idiom, de la Fresnaye was evidently challenged by Bernard's assertions. Thus in claiming the mantle of Cézanne for cubism, he went out of his way to criticize Bernard, writing in January 1913 that Bernard's memories of Cézanne were clouded "by his own ideas on painting" (de la Fresnaye). In the essay reproduced here, "On Imitation in Painting and Sculpture" of July 1913, de la Fresnaye was more circumspect in his criticism of Bernard, simply noting that those artists who advocated "a return to classicism" had only succeeded in producing "pastiches devoid of any artistic content, with the help of the ancient works that fill museums."

De la Fresnaye's later essay justifies the cubist debt to Cézanne by sub-

suming that movement into an overarching theory of human perception and artistic evolution. Like his cubist colleagues, he held that all artistic innovation is premised on socially relative conventions, both perceptual and aesthetic. Thus art in no way can be identified with a naive and unmediated imitation of nature. To bolster his case de la Fresnaye counters the so-called realists' claim to have derived their art "exclusively from nature" by noting that painters of Breton religious festivals like Pascal-Adolphe-Jean Dagnan-Bouveret (1852–1929) were inspired by another manmade invention: photography. However, despite the ongoing debt of all art to past conventions, both perceptual and artistic, de la Fresnaye argues that art is still endlessly novel and its future evolution profoundly unpredictable. In this respect art resembles nature itself or other arenas of human endeavor, as witnessed by ongoing developments in machine technology (here he comes close to Henri Le Fauconnier and Léger). One could find no better example of this than in the legacy of Cézanne, whose art had inspired myriad versions of what could be termed Cézannism—some successful, like cubism, others not, as manifest by the so-called return to classicism.

Despite his sympathy for the Catholic revival and his previous training under Denis at the Académie Ranson, de la Fresnaye was evidently opposed to the version of Cézanne promoted by the neo-Catholic Bernard. Like Jean Metzinger he was prepared to align cubism with tradition, but only under the sign of creative innovation, rather than any restrictive return to the art of the past.

Bernard, "De Michelange à Cézanne"
Bernard, *Souvenirs sur Paul Cézanne*
Dorn, ed., *Conversations with Cézanne*
de la Fresnaye, "Paul Cézanne"
Golding, *Cubism*
Griffiths, *The Reactionary Revolution*
Lucbert, "Roger de la Fresnaye"
Malone, "André Mare and the 1912 maison Cubiste"
Seligman, *Roger de la Fresnaye*
Silver, "The Heroism of Understatement"
Silver, *Esprit de Corps*
Stevens, "Bernard as Critic"
Troy, *Modernism and the Decorative Arts in France*

"Moderne Kunstkring, Stedelijk Museum, Amsterdam.
Exposition internationale du Cercle de l'art moderne
à Amsterdam," *De Kunst: Een Algemeen Geïllustreerd
En Artistiek Weekblad* ([Amsterdam,] 8 November 1913)

International Exhibition of the Circle of Modern Art in Amsterdam
*On the occasion of the opening of the third International Exhibition of the
Circle of Modern Art in Amsterdam, we have the advantage of presenting
our readers with this issue of our journal, specially devoted to that artistic
event. One of the most accomplished Parisian critics has written an article
on modern art for us, and a few of the modern French poets of the school
allied with those painter stylists have let us have their poems. We are con-
vinced that our readers will be very interested to read these drafts of mod-
ern French literature, and we give our thanks to the artists who have been
kind enough to let us enjoy their art.—The Editors*

René Arcos

Dedication

Here is my poem, o my friends, . . . and night is falling
I am peaceful and refreshed
Like the earth after the rage of the waters.
I am no longer the voice who cast the word
I am no longer the voice who cast the word
into an enormous lake to make waves;
I am a circle—tired—which dilates—to die.

Oh, I know very well: tomorrow perhaps, right away,
feverish with expectation,
I'll know the regency before the reign

of the minute when a first star comes out,
that regency . . . and then that constellated reign . . .

But since that instant stretches out with hands slow
as a peace, over the spent chimes
I choose it to speak to you again, o my friends . . . and my voice trembles.
We are large and strong, each of us, for being together.
We breathe the same air without disturbing each other.
Not one of us is a bad man.
As it is written, we forgive the trespass
and strive not to commit it.
If we do not give to those over there,
is it not because—we give here
every bit of us—without even tallying it up?
Since we have been walking the earth for a long time,
we have loved one another a long time.
The years go by, a little of us—each day comes in
backwards—into the silence.
We have reached the age when a man speaks less;
he begins to draw
a heavy booty, toward his house, for winters;
he walks in life with a pair of scales;
but we will not yet know of calculation
and the harsh law of merchants.

You are there, my sweet friends, and I see you.
I feel, trembling,
your gazes blossoming
around my forehead
like a crown;
I feel hot from your hearts
burning together
around me
and my devotion contains them all
like a church

You are there and I see you, your eyes are good
Everything is calm and I rest;
I stretch out my peacefulness,

like a large black dog
at the feet of your vigilance.
Invincible climb, I feel myself lifted up
by such a need for trust
that I would like to die this evening, telling myself
that I would like to go away all
in an inexhaustible phrase . . .

My proud, my dear friends!
My life is meditative and you know it.
I possess nothing but this power of tears.
No presence in my house
that could, when a dream full of darkness builds up,
hold back with a smile a weight ready to fall.

I am standing in a long dream, and lonely.
Oh! I know where the gold is that can be woven into leaves,
I know where the fire must be carried
so that the thick fragrance and the spirals of incense

shoot up all around:
the man I imagine
is proud and nude, without a crown,
he is the rich one and the one who gives,
he asks nothing from the multitude,
he walks ahead of it,
he walks ahead of it and he trails it behind
like the miraculous mantle of a pilgrim to the sound of the sea!

Here is my poem, o my friends, the moon is high.
I dilate slowly, I dilate to die,
toward the interminable conciliabule of the stars.

René Arcos

International Exhibition of the Circle of Modern Art: Municipal Museum [Stedelijk], Amsterdam, November–December 1913

The end of the nineteenth century offered us the curious situation of a troubled age of art, uncertain of its way—hungry for discipline and tradition—but still too much the dilettante to dare make a few assertions.

During the charming impressionist decadence, it was up to Cézanne, van Gogh, and Gauguin to reestablish, through the power of their synthetic minds, the chain connecting them to the past masters. With them, preoccupations about order and style rose up in the new generations. The artists reflected on the profound laws of their art by listening to the spontaneity of their instinct. They probed the problem of forms and colors and put all the variety and richness of the pictorial means of expression in the service of their art.

Pleinairism, "the window open on nature," and luminism were relegated to the arsenal of painting, giving way to more universal and more synthetic preoccupations.

A greater ambition has just come into being. A curious accident—an inevitability perhaps—brought together in Amsterdam, the city of Rembrandt, the most prominent elements of those currently representing the hope of a whole new generation.

Since the golden age of the seventeenth century, so glorious for Flanders and Holland, French art has asserted its predominance in Europe.

It would be bad form to compare the painters of The Hague to the Barbizon painters: is the very personal van Gogh the equal of the universal Cézanne? Van Dongen steps aside for Matisse, and we must also acknowledge how far Le Fauconnier still outdistances his Dutch friends in the new school.

The limelight offered to Le Fauconnier last year by the Circle of Modern Art [fig. 43] gave us a complete idea of the development of this very fine French painter, whose art is so directly connected to that of Clouet, Poussin, David, Ingres, Courbet, Corot, and Cézanne.

Frenchmen are born architects, just as Englishmen are born writers, Germans, born musicians, and Dutchmen, painters. French painters are still architects.

With his own style, Poussin seems to have defined their style, which the masters of the eighteenth and nineteenth centuries continued, nuancing it with new attributes.

Originally from a northern province where the Gothic originated, Le Fauconnier is essentially French. His architectural art—composed, reflective, intellectual, full of charm—is at once measured and daringly rich. As varied as the carved portal of a cathedral, as measured as the forest of its columns, it possesses the audacious imagination of towers blasting toward the sky.

Like all French art, Le Fauconnier's art borrows from foreigners—the Dutch, the Flemish, the Italian—but, like all French art, it assimilates the elements it has acquired. And I see this painter as one of the most original of our time.

Some might have believed that Le Fauconnier, having fallen under Cézanne's rich influence, would lag behind with the cubist movement, of which he was one of the promoters. His artistic erudition and intellectual independence rapidly distanced him from a group of narrow and impotent theoreticians, making him understand the need for a productive isolation, from which the ever-so-personal works he is now showing in Holland have emerged.

The period of his first research (1908) was marked by relentless work toward great simplification, from which somber, harsh, and ferocious Breton landscapes originated [fig. 13], as well as two very significant canvases: *Femme à l'éventail* [*Woman with Fan*] and *Femme au miroir* [*Woman before a Mirror*; both in the Gemeentemuseum, The Hague].

Later (1910), we find him preoccupied with subtleties of color and form, a time of gray pictures, sensitive to the point of excess, but profoundly plastic all the same, as attested by *Abondance* [fig. 9].

With *Chasseur* [*Hunter*, Gemeentemuseum, The Hague] and *Réplique du chasseur* [*Retort of the Hunter*], Le Fauconnier's art was enriched by warm color schemes, a complexity of forms—there are arabesques now, the material grows richer and deeper, and acquires new resonances. The need for a sharp determination of the surfaces is less in evidence, and a restless composition audaciously builds on pictorial distributions.

Le chasseur and *Les montagnards* [*The Hunter* and *The Mountaineers*, Museum of Art, Rhode Island School of Design], the *Paysage* [*Landscape*] at the museum in Hagen, were the most notable results of that period, complemented by other landscapes and still lifes; but already in these works, other aspirations show through, encapsulated in *La toilette* (Salon d'Automne, 1913) [Gemeentemuseum, The Hague], which is one of Le Fauconnier's key works.

In violent contrast to that abstract Frenchman stands the art of the modern Dutch painters, whose tradition of realism instinctively leads them to disregard abstraction.

Let us cite, before the young artists, the precursor of the new tendencies in Holland: Jan Toorop. The important place he occupies in our modern history of art, by virtue of his very fine qualities as an artist, is well known,

as are his continual struggles against the apathetic traditionalism of the official circles.

Lodewijk Schelfhout was the one most directly influenced by the modern French painters. Infatuated by turns with Cézanne, van Gogh, Matisse, and Le Fauconnier, Schelfhout has an art characterized by a very keen, assimilative intelligence with a rare quality of elegance and imagination.

The most original part of his work is undoubtedly his drypoints, where the distributions of black and white are masterfully sustained by a profoundly personal sharpness of line.

If Schelfhout is all intellect, Mondrian is all feeling. His art does not reason nor does it compose; it dreams in abstraction. With abandon and negligence, he distributes the charming kindness of his vague feelings in harmonies of gray and yellow. His art seeks nothing representative; rather, it seeks to provide equivalences for sensations of art similar to music, too similar, some might object, and on which the influence of the Spaniard Picasso has recently been strongly in evidence.

Alma is a fine painter of Dutch blood. To be sure, he is one of the painters whose art reaches our hearts by passing through our minds. Such painters, masters of their feelings, which they guide and direct, impress us as innovators and seekers.

Others are excellent for their naive feeling, their passion, or their calm. Rational argument is not their domain, and their greatest error is to trouble themselves with questions they cannot solve.

A similar criticism could be lodged against Alma. We might wish him to have a sharper will, which would protect him from continual hesitations and allow him to extract a personal, profound art, of which he already shows the reliable signs.

Conrad Kickert's art seeks to establish a proper balance between feeling and intellect. A preoccupation with reconnecting to the old tradition very clearly asserts itself, combined with a very modern sense of art.

Instinctively, he feels drawn toward warm and rich color schemes, toward large compositions with harmoniously swaying lines. Refinements of technique are enriching his works with a great variety of expression.

With a vivid, generous, somewhat romantic, but at the same time profoundly plastic art, Conrad Kickert will one day master his high spirits, will discipline his exuberance, to give us the full measure of his talent in works soon to come.

Even though he is too much in love with luminist preoccupations, Jan Sluyters [*sic*] displays a vigorous temperament, a brimming sensuality; and his art is oriented toward new tendencies.

Along with Derain, the French painter de Segonzac gives us a sensation of beautiful, robust, exuberant painting, whose generosity contrasts very audaciously with the theoretical tendencies of certain Parisian painters.

Gromaire, a young Frenchman from the north, occupies the first rank of the recent artists revealed to us by this exhibition. Visibly inspired by the Flemish masters, Gromaire shows evidence of fine painterly qualities.

The Circle of Modern Art had the very fortunate idea of inviting a few of the best painters from Russia: Konchalovsky, Mashkov, Kandinsky.

Konchalovsky and Mashkov offer us a violent and bizarre exoticism, which can astonish us and often charms us.

Kandinsky's art—more cerebral, sometimes mystical—shows evidence of a great intellectual refinement.

The resounding success that the research of the Circle of Modern Art has experienced in the last few years is well known. Such a profoundly interesting collective effort cannot leave public opinion indifferent in a country that, in the finest hours of its history, saw the greatest glories of art.

Today we must thank the Circle of Modern Art of Amsterdam for audaciously attempting to shake our intellectual elite out of the apathy of the official salons, and invite it to artistic emotions of a rarer quality.

Wilmon Vervaerdt

Poèmes.

Paul Castiaux.

Far Away, Someone Is Singing on the Road

And what was it, our life,
If not unquiet sadness,
Deep and frantic sobs,
False laughter and grimacing masks?

After the scintillating joy,
What remains in our mouths,
If not the ashes of an autumn,
which our fever, eternally pale, chews up?

As for the thoughts of mortal life,
We would like to forget them;
The best thoughts of the sparkling hours
Are now only pain to the memory in flight . . .

And how many times has our heart,
Like a child wreathed in springtime,
On the bright avenues of time,
Betrothed its fingers to the blossoms of trembling joy?

I see you again and find you again with my tears,
Childish emotions of finished hours
When I gave my hand to the most youthful caresses.

The brightest day of my adolescence,
Where, then, does it die?—Deep in a provincial garden
Like a weary gown left behind
By the flesh of another ancient time.

O my thoughts, awaken,
Pull back, as you kneel, the fresh curtains of the dream.

Listen: a bird is passing.
Time flies, the gate creaks
With the cry of a smothered beast who is dying.

In the fog of the unquiet evening,
Heavy, adventurous clouds
Pass like an army of captive flags.

It is raining and the forest of flowers bends and breaks.

Now he has come back to you, this evening past,
Trembling under a mantle of cold.

Look: Does he not seem like a freezing beggar?
The mere sparkle of his eye
Seems to love you, to recognize and call to you . . .
Listen to the murmuring of his lips:

You guessed with your religious hands
The infinite and chaste modesty of his breasts.

That clarity, which your desire has mourned,
Passed in front of your eyes like a daybreak confession,

It said: . . .

But the words fell away,
And were no longer anything but silence,
From its mouth tasting ashes with death.

The beggar went away . . .

O my thoughts, do not cry any longer!
Is this not your finest hour?
Deep in the great garden, provincial and tender,
Now they are reborn, exquisite and fragrant!

Why remember,
And why reawaken with feverish steps
The sad shivering of the past,
To the truest sobbing of these extinguished hours,
To the deepest part of this life?

Paul Castiaux

Roger Allard.

Adelaide

The season is dying and you are leaving,
while I remain on the shore
And I knock in vain at the massive
Door of our summer gardens . . .

Farewell, light tennis racket,
The English cries, the white gestures!
The only game now, in late October,
Is to kiss one another on the benches.

Alas! It is no longer the happy time
Of waltzes with naive oaths,
which led you to the bocages,
Melodious sister of the yew.

With a frail girl cousin,
Destined for some cold dormitory,

A somber lover of crinolines
Came to sit here perhaps.

Is that a gunshot on the plain,
Or the pistol of young Werther?
My heart is drunken on its pain,
My mouth has the taste of winter.

Roger Allard
(*LES BANDEAUX D'OR*)

Théo Varlet

Holland Twilight

The canals are frozen. It's snowing. Nothing offends
The intimacy of the meditative tavern:
The curaçao, preserved torpors of Antilles,
Instills in me a philosophic somnolence.

I am alone, at the perfect depths of a tepid silence;
Where I can see practically nothing: through the misty windowpanes
I see the streetlamps come on,
And beneath the dusk contingencies go astray;

Rendered idle in the Dutch quietude,
I dream of like evenings where the good Spinoza
Patiently shaped a lemma from Ethics.

—And the clock, attentive to a peaceable ascesis.
Following the expert rhythm of my Gouda pipe,
I slowly savor the metaphysical hour.

Théo Varlet
NOTES ET POÈMES, 1905

P. J. Jouve.

Word

I open up, I weep, o companion of shadow.
The afternoon, too dark, has given up without a cry.
A true word rises to my eyes.

I am the bed of a churning
That is already covering the noise of two streets:
It happened to me like a child out playing.

But time, whose tears form in beads on the flesh
And drop their sorrow down to the ground,
The world lets go in a great hiss.

Shadow has blended the breath of three horizons.
And it is here, nonetheless, that evening wants to weep
Altogether, in its promise of death.

May the damp city laden with fires,
May the earthy bodies coated in sleep,
And the woman destined for every crossroads
Feel redeemed in the starless wind!

A man is crying for no reason but his heart,
And for each of his bygone glances.

And if my flesh never left again
That outstretched peak of sorrow—my life,
Would I venture something against you?

P. J. Jouve
PARLER, 1913

Jules Romains.

The City

"There is a joyful streaming of bodies."

My smoke arches their blue chests,
Shakes their heads, twists their torsos,
Stamps on the chimneys, rears up
In a brutal desire to gallop.
It rained just now. The trees,
The roofs, the sidewalks hold a little water
Where the sun melts like honey.
The uneven lightning rods
Suddenly discharge against the dawn
My most youthful urban will.
It seems to me that down in my streets
The passersby run in the same direction,
And, unraveling the neutral crossroads,
Straighten out the twisted boulevards

So that, diverging less and less,
In spite of the walls, in spite of the buildings' frames,
The countless forces flow together
And, abruptly, the total momentum
Sets all the houses in motion.
The city is going to move, this morning
It is going to wrest itself from the earth,
Uproot its foundations,
Extricate them from the thick clay
Carry away the stones in the flesh;
Swarm like beasts; cover
The space with its heavy creeping;
Brandishing towers, swelling crowds
Under the multicolor clouds;
And then leave for the Ocean or for the Dawn.

Jules Romains
(*LA VIE UNANIME*)

Charles Vildrac.

Song

Hoping for nothing, to go through the streets,
That is a better fate than people may think
Because of the comings and goings
Of all the sweet girls who are . . .
Hoping for nothing, to sail through life,
It's worth the trouble just the same
Because of the sun-filled instants
Which are truly good to feel passing by.

Did you notice that you are happy
If your happiness lasted more than an hour,
And isn't it better
To be able to love with your eyes alone,
And for a poor moment, the neck, the eyes,
The mystery slipping away with pretty steps
Of all the sweet girls who are . . .

Let's go, then, life agrees to be borne.
The earth is not so cold yet,

And the rare minutes are not so rare
When you admit to yourself that it feels good to live;
When, quite simply, you take to living,
Cool in the grass, warm in the sand
Or along the streets, everything for the joy
Of plucking with the eyes the lovely passing
Of all the sweet girls who are . . .

Charles Vildrac
(*LE LIVRE D'AMOUR*)

Georges Duhamel.

Elegy

The wind came from above the sparkling sea;
A wind without soul and memory, but so pure,
But so full of steady virtues that its breath
Passed like eternity over our faces.

The coast, with its countryside, its roads,
And the houses of its familiar villages,
Offered us now that foreign face
That memory lends to things and men.
Young sailors were making the oars bend back
And the boat made a vibrant and empty sound.
I can see again, near your bare feet, sleeping,
Captive crustaceans with mutilated claws.

The beautiful silence was faithfully haunted
By the distant detonation on the shore;
We were approaching a solitary reef where, on watch,
Stood a glistening cormorant contemplating the sea.

Did I think of the peril clutching at our chests?
Did I think of the black bird bleeding on my knees,
Or of the gunshot that pierced the world
When the heron fell from the crest of the rocks?

What does it know about it today, that divided soul,
Which, in the universal green sputtering,

Bitterly calculated, from second to second,
What that hour would be worth far in the future?

Georges Duhamel
(*LES BANDEAUX D'OR*, PART 28)

Commentary

This special issue of the Dutch magazine *De Kunst,* devoted to the third and final exhibition of the Moderne Kunstkring before World War I, gives us insight into the lasting impact of Le Fauconnier on Dutch avant-garde circles. After Le Fauconnier broke with Albert Gleizes and Jean Metzinger in the fall of 1912, he joined Conrad Kickert in enhancing his profile in Holland. To augment Le Fauconnier's importance, Kickert cast him as a leading avant-gardist whose reputation in Parisian circles rivaled that of Pablo Picasso. Indeed Le Fauconnier had played a significant role in Dutch circles, having influenced such major modernists as Piet Mondrian, Lodewijk Schelfhout, Petrus Alma (1886–1969), Leo Gestel (1881–1941), and Jan Sluijters (1881–1957). To help consolidate that reputation, Kickert organized a "Dutch Room" at the 1913 Salon des Indépendants, where cubist-inspired paintings by Mondrian, Schelfhout and Alma were exhibited, along with work by Le Fauconnier's French student at la Palette, the youthful Marcel Gromaire (Apollinaire in Breunig, 284 and 289).

In the summer of 1913 Kickert and Le Fauconnier went on a painting trip to Ploumanach in Brittany, where they also made preparations for the upcoming Moderne Kunstkring exhibition, to be held at the Stedelijk Museum from 7 November to 8 December (Schipper, 9–10). The biggest challenge facing them was how best to address Le Fauconnier's split with the salon cubists while asserting his continued relevance within the avant-garde community. Their strategy unfolded in two related spheres: the exhibition itself and the arena of art criticism. The 1913 exhibition was once again dominated by Le Fauconnier, who showed twenty-seven works; but in contrast to the 1912 Moderne Kunstkring, Georges Braque, Picasso, Gleizes, Léger, and Metzinger were now totally absent. In their stead were those artists most closely associated with Le Fauconnier's aesthetic aims: Kickert, who exhibited work from the Ploumanach campaign; Alma; Sluijters; Schelfhout, represented by drypoints as well as paintings; Gestel; and Gromaire. Mondrian's cubist work was also on display, although by

now he clearly gravitated in the direction of Picasso's cubism rather than that of Le Fauconnier and Schelfhout (Blotkamp, 59–81). The exhibition also included three Russian painters: Wassily Kandinsky, Ilya Mashkov, and Pyotr Konchalovsky (1876–1956). All these artists were known to Le Fauconnier through his contacts with Kandinsky and the "Golden Fleece" group in Moscow (see document 10 and commentary). Finally works by Dunoyer de Segonzac and André Derain were included, no doubt to affirm the Moderne Kunstkring's continued ties with major figures among the Parisian avant-garde.

Kickert provided a critical explanation for this new configuration in an article published in N. H. Wolf's *De Kunst* in conjunction with the Moderne Kunstkring opening. Kickert informed the Dutch public that the cubist movement was now divided between two factions, one headed by Picasso, the other by Le Fauconnier. Le Fauconnier's turn away from his former friends among the salon cubists was justified because they had reportedly rejected him to join Picasso's coterie (Kickert, cited in Van Adrichem, 184). Thus the 1913 Moderne Kunstkring exhibition heralded a new phase in the development of European modernism, with Le Fauconnier leading the way in forging a new aesthetic orientation.

The special issue of *De Kunst,* published in French, furthered Kickert and Le Fauconnier's agenda by means of poetry as well as art criticism. Le Fauconnier's longstanding friendship with many of the "unanimist" and Abbaye de Créteil poets associated with the journal *Les Bandeaux d'Or* meant that he was able to marshal their support in launching this new phase of his career (see document 2 and commentaries of documents 1 and 10; on the poets, see Robbins, 33–34; Cornell). Thus in an editorial note—illustrated by a recent painting by Le Fauconnier—N. H. Wolf announces that "a few of the modern French poets of the school allied with those painter stylists [the Moderne Kunstkring] have let us have their poems." René Arcos provided a poetic "Dedication" written especially for *De Kunst,* while Paul Castiaux, Roger Allard, Théo Varlet, Pierre-Jean Jouve, Jules Romains, Charles Vildrac, and Georges Duhamel all submitted poems culled from recent French publications. Interspersed among the poems were reproductions of Le Fauconnier's *Portrait of Paul Castiaux* (1910), a full-size image of *L'Abondance* (1910–11; fig. 9), and a painting by his former student Gromaire.

Wolf also published an essay on the exhibition written by "one of the most accomplished Parisian critics," the now-obscure writer Wilmon

Vervaerdt. In his text, Vervaerdt lionizes Le Fauconnier as one who "outdistances his Dutch friends in the new school" and thus serves as a beacon for those artists engaged in modernist experimentation. To those who would criticize Le Fauconnier's postcubist work as retrograde, Vervaerdt had the following response: "His artistic erudition and intellectual independence rapidly distanced him from a group of narrow and impotent theoreticians, making him understand the need for a productive isolation, from which the ever-so-personal works he is now showing in Holland have emerged." In his earlier essay for the October 1912 Moderne Kunstkring, Le Fauconnier had condemned the symbolist painters as overly theoretical, but by 1913 Le Fauconnier, Kickert, and Vervaerdt were casting the salon cubists in the same mold, no doubt in reaction to the flood of artists' statements published by Gleizes, Metzinger, and Léger (Van Adrichem, 182–83).

Le Fauconnier cemented his Dutch ties by moving to Holland at the outbreak of World War I; there he had a significant influence on the so-called Bergen school of Dutch modernists (Robbins, 44; Ligthart, 43–53). Despite his break with the salon cubists, his friendship with the unanimist poets continued unabated, possibly as a result of their shared opposition to the war (M. Antliff and Leighten, 197–203; Goldberg; Ligthart, 53, 56–59).

M. Antliff and Patricia Leighten, *Cubism and Culture*
Blotkamp, *Mondrian*
Breunig, ed., *Apollinaire on Art*
Cornell, *The Post-Symbolist Period*
Goldberg, *En l'honneur de la juste parole*
Ligthart, "Le Fauconnier en de Europese avant-garde"
Robbins, "Henri Le Fauconnier's *Mountaineers Attacked by Bears*"
Schipper, "Biografie"
Van Adrichem, "The Introduction of Modern Art in Holland"

Roger Allard, "Le Salon d'Automne," *Les Ecrits Français* (14 November 1913): 3–4

The Autumn Salon

The 1913 Salon d'Automne boasts at least one masterpiece: the catalog preface. Mr. Marcel Sembat signed it. It is, I repeat, in its genre, a kind of masterpiece of logic, wit, subtlety, and verve, worthy in every respect of the author of *Faites un roi, ou bien faites la paix*, who, in the Chamber and at political meetings, remains, above all, a perfect writer and a man of taste. If the Salon d'Automne needed to be defended, and if the best guarantor of its success, namely, the foolishness of its detractors, should come to be lacking, Mr. Marcel Sembat would be up to the task. He possesses a quiver well stocked with sharp ironies.

Unless you are mired in the most conceited incomprehension, that is, in the most contemptible snobbery, you cannot deny the life and variety of this year's salon. You would probably search in vain for the unknown and suddenly revealed genius, but how many prominent talents, clarified intentions, and better defined personalities there are.

A very great number of painters appear to have made notable progress. Several have turned out better than they seemed to promise, and some have evolved in a manner that, however unexpected, is no less felicitous.

It is easy to note a few other particularities. Group painting, program painting, subject to a discipline tacitly agreed upon, has almost completely disappeared. That did not occur without a few snags. The dismemberment of the cubist empire is a fait accompli. All things considered, the victorious generals have shown genuine discretion in distributing the spoils. An exchange of influences and of procedures has come about and everyone has definitively enriched his own temperament with a share of the overall achievements. All that is perfectly legitimate and natural.

What is no longer disputable is the phenomenal influence of what has been called cubism on artistic production as a whole; I mean vibrant production, that which is not frozen in academic and pseudofashionable industrialism. That influence has, as we know, nearly penetrated to the heart of the École des Beaux-Arts and the Salon des artistes français, those bastions of the Institut. There is now a new curiosity, a restlessness reaching the least attentive minds. Moreover, we have transitional painters, who are accustoming the public to the novelties that disconcerted it at first.

The most relentless adversaries of the new schools of painting are beginning to admit the sincerity and loyalty of the efforts they only recently singled out for ridicule. The practical jokers will find much more reason for amusement: but, when they have had a good laugh, they will realize that it is much more difficult to appreciate what one believes one likes than to laugh at what one does not like. Because they are unable smugly to admire canvases underwritten and stamped by the official experts, many will resign themselves to impartial curiosity, nuanced with an indulgent irony. That is still the best attitude and the only one suitable for the well-bred. Soon, only the incorrigibly vain will be left to believe that the artists are adopting one manner or another for the purposes of making fun of them. In the long run, the belief that one is the object of a concerted hoax amounts to a persecution complex, and the sign of an intolerable self-importance.

A glance around the salon allows us to observe, at the very least, this fact, key in my opinion: the painters who appeared to impose new constraints on themselves, far from being the architects of some ill-defined reaction, have been the initiators and propagators of new freedoms, even as they have returned honor to unfairly neglected forms.

Roger Allard

14 NOVEMBER 1913

Commentary

In the wake of the 1912 Section d'Or exhibition, Roger Allard began expressing doubts about cubism, although he launches a spirited defense of the movement in this review of the Autumn Salon of 1913. The review, however, focuses less on cubism per se and more on general support of avant-garde art as both sincere and worthy of emulation. Allard's retreat from the éngagé tone of his early criticism reflects his diminished status

as a critic in cubist circles. Although he was listed as one of the nineteen "collaborateurs" associated with the short-lived journal *La Section d'Or* (1 October 1912), his prominence declined as the artists he had supported as a coherent group went their separate ways (Lucbert, 43–48). Allard tacitly acknowledges this in his 1913 review, noting that "group painting, program painting" had "almost completely disappeared," so that "the dismemberment of the cubist empire" was now a "fait accompli." Another factor in Allard's eclipse was the ascendancy, in late 1912, of critics Guillaume Apollinaire and Maurice Raynal, which led to Allard's plaintive claim to critical priority in his review of the 1912 Salon d'Automne (Cottington, 164–65). His earlier concern about "Mallarmism" (document 18) was compounded after 1912 by his complaints about the increasingly arcane, pseudoscientific criticism developed by the cubist painters (Allard, *Les Ecrits Français*, 5 April 1914; cited in Gamwell, 61; Weiss, 80–81). By 1914 Allard had shifted his critical support from his former allies to Roger de la Fresnaye, a fact signaled by his preface for de la Fresnaye's first solo exhibition at the Galerie Lesvesque (20 April–3 May 1914) and by his laudatory essay on the artist published in the 5 May 1914 issue of *Les Ecrits Français* (Gamwell, 227–28; Seligman, 92).

Allard opens this review by praising Montmartre's Socialist Deputy Marcel Sembat's spirited defense of avant-garde art in his preface to the 1913 Salon d'Automne, his earlier support of cubism in the Chamber of Deputies debate of 1912, and the politician's critique of the bellicose nationalism of the Action française, published in *Faites un roi, ou bien faites la paix* (1913) (see document 55 and commentary). Sembat's 1913 preface made explicit his correlation between freedom in the arts and the fundamental principle of *liberté* undergirding the Republic (Weiss, 93); Allard evidently concurred, closing his own article by describing the avant-garde as "the initiators and propagators of new freedoms." Allard then notes the "phenomenal influence" of cubism on artistic production, adding that even cubism's most vocal adversaries "are beginning to admit the sincerity and loyalty of the efforts they only recently singled out for ridicule." As Jeffrey Weiss notes, the sheer persistence of the avant-gardists had begun to cause critics to regard cubism as something more than a publicity stunt with a limited shelf life. The result was an emerging discourse in what Weiss terms "tolerance": a newfound acknowledgment of the sincerity of these artists, coupled with a healthy skepticism regard-

ing the products of their "research" (Weiss, 100-105). It was in this arena that Allard's criticism continued to remain relevant.

Cottington, *Cubism in the Shadow of War*
Gamwell, *Cubist Criticism*
Lucbert, "Du succès de scandale au désenchantement"
Seligman, *Roger de la Fresnaye*
Weiss, *The Popular Culture of Modern Art*

Jean Metzinger, "Kubistická Technika," *Volné Směry*
12 ([Prague,] 1913): 279–92

Cubist Technique

(Original article for *Volné Směry*)

The ability to suggest volume and depth on a flat surface by relying on various two-dimensional and spatial qualities is the most essential aspect of a painterly composition. The study of perspective should, therefore, always be the basis of all fine-art education. It was this aspect of art making that preoccupied the cubists, especially when they began to feel discontented with the mysterious requirement to discover a new law.

Classical perspective merely satisfies our visual faculty: our intellectual abilities must nearly always fill in what is missing, correct its flaws, or even reject it entirely.

The horizon line gives direction to all the other perspectival lines within a painting. This line is strictly defined by the position of the artist. Within classical perspective the emphasis was on immobility, since the picture itself was immobilized by the artist and could not be put into motion by the eyes of the person looking at it. Classical perspective was favored by the old masters, whose aesthetic was based on stasis. They tried to express their emotions through anecdotal organization rather than the inherent value of the work of art. For us today this is not the case. Today we strive for dynamic art where emotion is expressed directly, through harmony of form. Classical perspective is reminiscent of a lifeless world; a world seen through eyes that were able to see, but could not move.

Perspective is additionally an element that deforms and distorts. What I am trying to say is that perspective destroys the integrity of a form and its peculiar characteristics. It forces us, for example, to imagine a circle as

Translated from the Czech by Ivana Horacek.

an ellipse or a straight line, depending on whether the circle is placed on the ground a few steps away from us, or if we lift it up parallel to our line of sight. Perspective forces us to depict a square façade of a building (one that we see from an angle) as a trapezoid. It forces us to ignore thousands of experiences that we have gained through our intelligence and tactile and kinesthetic senses.

These distortions and nonsensical tendencies, however, did not prevent artistic souls from expressing themselves. This we cannot deny. Despite this fact, it is necessary to determine whether something that did not wholly obstruct good intentions can actually be good. The old masters frequently treated perspective liberally, at times even disobeying its rules. We can therefore deduce that perspective is not always negative. But it is futile. We will therefore be patient, knowing that perspective redeems itself only when it ceases to exist.

Cubist perspective attempts to satisfy not only the eye but also the spirit. It gives the artist the right to mentally grasp all the salient features of an object, from any angle. It also teaches the artist to keep changing the position of objects in such a way as to draw attention to certain features that would otherwise get overlooked by a spectator trained in the traditional manner. It goes without saying that these changes are governed by objective laws, and not by accidental moments of "inspiration." If we are rejecting classical perspective because it is repulsive to the artistic imagination, it is not because we are replacing it with another ideal that is repulsive in another manner. We do not want to substitute a new inanity for an old one.

For cubist perspective, the most important feature is motion. In other words, it facilitates the existence of an abundance of relations between the artist and reality. However, it demands that the artist succumb to the natural laws of motion so that he may pass from one relationship into another. If he were to yield merely to his emotion alone, his painting would lack unity. Indeed, the relationship between an artist and reality develops gradually and becomes simultaneous when reality is transformed into a painting. In other words, the specific duration* of those successive relationships determines the simultaneity in the work of art. If the artist fails

*The author employs the word *valeur* in the context of time, and continuity, as it is understood in music. The fascination with an abstract way of writing, which the cubist theorists were usually unable to avoid, often leads not only to bizarre expressions, but also conceptual ambiguities which can disrupt the entire thought process. [(Original) translator's (Fr. Sedláček) note]

to execute these changes in circumstance with common sense, sincerity, and in good conscience, he may create only an artistic composition of haphazardly organized parts—the total opposite of what he intended to accomplish in the first place.

It is possible that a work painted in this manner may be analyzed and that it would be easy to pick out thousands of partial images that help create the greater whole. This may manifest itself more or less distinctly. It is important, however, that this method allows us to return with ease to the original emotion behind a painting so that, through successive steps, we may finally understand the work of art.

A painting executed using this approach to perspective will have as many "horizons" as the artist deems necessary. Space in such a picture will not be divided following the *cone of sight*—the perspectival lines that converge at the vanishing point—but rather it will be divided by perpendicular or transverse cross-sections, which preserve the qualities and characteristics of a form. Circles remain circles and squares remain squares.

In order to explain the strengths of the new perspective let us consider the example of an open box resting on a table. One must portray it, not reproduce it. A photographer reproduces, whereas an artist portrays. Therefore I will not attempt to copy the visual mage of an object; I will try to convey the ideas and feelings an object awakened within me through the use of line and color and render them in the order in which they arose in my imagination.

The first idea is stability. I will render it by suggesting actual contact between the contours of the box with the surface of the table. The second idea is space, which is conveyed by drawing a rectangular surface that encompasses shapes and outlines of the tops of objects contained within the box.

One does not have to grasp the reproach implicit in the third idea in order to become aware of the visual incompatibility of the first two and the impossibility of expressing them simultaneously following the rules dictated by the old perspective. One may suggest physical contact between the walls of the box and the surface of the table through the use of perpendicular lines. To phrase it differently, the stability of the box seems certain only when the side walls of the object in question are perpendicular to the horizontal surface upon which it rests.

However, at this juncture the interior of the box does not exist. In order to take account of it, I must stand in such a manner that my field of vision runs parallel with the side walls and perpendicular to the horizon-

tal surface of the table. From this point of view the horizontal surface has now become perpendicular, the vertical surfaces blend with the horizon, and the walls of the box cease to exist visually.

When the idea of spaciousness is awakened, both visually and in harmony with traditional perspective, the idea of stability disappears. The opposite would occur if we were to reverse the progression of ideas.

With the birth of cubist perspective, reason reigns.

My verdict is as follows: the goal of art is to express ideas and never to modify actual physical objects. Therefore, the coherence of ideas carries greater weight than the legibility of objects. I can perceive the box in two ways, both equally coherent and visually complete. However, their relation to each other is such that the idea, which results in one image, negates the idea behind the alternative image. I will merge these two images into a single visually multifaceted image that will suggest both ideas. Whether applying brutal cuts or gentle gradations, I will suggest the passage of objects from horizontality to perpendicularity. I will not be afraid to show parallel portions of side surfaces, the rectangular opening of the box, and stability together with spaciousness.

It takes more talent to present the basic elements of a painting in such a way that the observer may easily understand changes in position. This means that one must recognize the natural laws of motion, so that the successive flow of ideas can intelligibly reveal itself. I should add that this incongruous depiction must be three dimensional. If it is not, it would be similar to a specific type of technical drawing. This would miss our objective.

It is an odd prejudice that certain people have no problem with visual incongruity as long as inanimate objects are being used. They protest if this method is applied to the human face. They call for adherence to anatomical principles. It would be utter foolishness for an anatomist to dissect a body based on an artist's interpretation of anatomy. The artist should only worry about the coherence of ideas. Proof of this: when painting a likeness of a face, the artist may completely invert the sequence of facial characteristics without disturbing the physiognomic likeness of the individual whom he is portraying.

I would even assert that he who wishes to respect the unfolding succession of ideas that enter the mind may disassemble and redistribute all the parts of the face, and in so doing attain a greater likeness than the fool who wastes his efforts in trying to capture a sense of the living by depicting one single moment in time, an unattainable goal.

A portrait painted by Titian or a cubist will forever remain just a portrait. A portrait is a combination of lines, colors, and signs, which, taken as a whole, signify a face.

The freedom the new perspective allows in the treatment of anatomy never contradicts common sense and will always coincide with the possibilities of motion manifest through our bodily action. Changes in position, which we impose on the various parts of this structure, will disturb only its visual organization and never the underlying truth that makes things visually and mentally comprehensible. The same logic holds true in other fields with regard to charts or tables.

We have seen that classical perspective has damaged our ability to express coherent ideas because it changes the very nature of forms. Without referring to the thousands of examples that come to mind I will only draw attention to the fact that classical perspective favors logic over our sense of beauty because it reduces all proportion to a function of distance. Most people are aware that what is represented in a painting as being large or small does not correspond to its actual size in a metric system. Cubist perspective teaches us to qualitatively estimate distances and to consider the ancient idea of geometrical precision a ludicrous concept, if we mean by that the calibration of size according to distance.

I acknowledge, nonetheless, that cubist perspective does encompass certain geometric forms that official science at present claims to be utopian. I am not far from believing in the possibility of an artistic geometry, which at this point in time is still in its infancy. However, this geometry has no bearing on cubist technique as it is conceived at present.

I hope I have adequately described the relationship between cubist technique and the logical understanding of space, so that I may move forward and describe other resources that will soon be available to artists. In the future, artists will be able to represent all ideas inspired by reality and to impart to that reality the highest degree of expression. Such ideas, however, will encompass all those that pertain to the realm of graphic art, and not literary, philosophical, or musical ideas. It is quite difficult to choose among these ideas; indeed it is not easy to be a painter.

As long as we are being objective, a circle must not cease to be a circle, and a square must remain a square; forms must preserve their essence and all

of their related attributes. However, exceptions can be made if a loftier, wholly extraordinary and subjective criterion should happen to come into play. At least in appearance. There are cases in which the idea of a circle must be expressed through the use of an ellipse and a square by means of a rectangle or a trapezoid. In such cases, we will not consider the forms as signs of an idea, but as living portions of the universe. The form emerges and submits to the physical laws of action and reaction, and is capable of being enlarged or reduced through processes of assimilation or contrast.

In order for cubists to more easily study the intimate life of forms, they have simplified and reduced them to their original interplay of curves and lines. They have learned to interrupt certain lines in order to enhance the expressive power of those that have been left intact. They have learned how to make short lines vibrate by surrounding them with large curves and maintaining rhythm through the use of parallel lines, etc.

This type of perspective is based on expression and quality. One should not oppose it, on the model of the old masters who struggled with classical perspective but were nevertheless limited by it at every turn. That said, it is undeniable that this new type of perspective should sometimes be put aside if one wishes to convey a sense of rhythm. However, I am tempted to assert that such a choice is indicative of an artist's own weakness in attempting to reconcile emotion with rationality rather than as evidence of any real conflict between the extrinsic and intrinsic values of form.

A new conception of light and color should exist as a complement to our new approach to space and form.

Artists who preceded us worked hard to reproduce light, but not to express it. Their failure was not without benefit. There were young artists who finally grasped the truth that all those who came after the Primitives failed to recognize: namely, that in painting the reality of light is weakened by the reality of color and vice versa.

Indeed, to make light conform to color means to destroy all but one of the elements that make up that light. To make color conform to light means to destroy the quality of that hue for the benefit of denseness of tone. It is through quality that we individualize color.

Light and color contribute equally and in different ways to educating us about the nature of objects. To sacrifice one to the other diminishes a painting. It is therefore necessary to express both, but separately.

In order to prove what I am suggesting, let us take an object of a specific color, such as an orange. I know that the color suggests this type of fruit, and that it is the identical color from all sides. I know this because when the orange is turned in all possible directions, the color remains orange. However, I also observe that the orange color gets brighter or darker on one side depending on whether it is getting closer or farther away from a light source. So if, in accordance with traditional technique, I will imitate this change in tone based on what I see, and if following this same technique I try to capture the tone and color simultaneously, it becomes clear that it is utterly impossible to express the uniformity of the coloration, which corresponds to what I know about the orange. If on the other hand I blatantly ignore what I see in order to concentrate singularly on what I know, and consequently sacrifice differences in tone for uniformity of coloration, it will be equally impossible to express the volumetric roundness of the orange, as well as the varying distances that we can observe between the different points on the fruit's surface and the light source as it reflects off that surface (which corresponds to what I see).

Some might object that these issues are of little importance, and that traditional techniques suffice to paint the orange without representing it as a volumetric sphere of an indefinite color or as a plain orange disk, that the artist only requires his feelings, etc.

To this I will answer that, in the first instance, two myths no matter how willfully connected or associated will never equal the truth. Second, artistic emotion does not give one the right to replace reality with myth: if we take away the quality of the orange's color, or if its shape is completely changed, the orange ceases to exist, at least as an orange.

Thanks to the influence of cubist technique, we can overcome the hurdle described above. This technique dictates that we should represent an orange in a way that is visually incongruent, but wholly comprehensible. When painting the orange, I will paint certain aspects of it according to my imagination and others based on my perception. I will place a uniform color in between shades devoid of color, thereby expressing my notion of chromatic unity while separately capturing the idea of roundness. It is important to indicate the relationship of these two ideas in such a way that an educated viewer can synthesize them in his mind and evoke the object in its entirety.

Just as an educated viewer does not take offence when the impressionists employ a patchwork of bright colors to enhance the beauty of

a uniformly colored object, so too the viewer should not attack me for mutilating the objects that I am including in my painting. Does not the viewer realize that physical properties, such as form, color, or sound, and spiritual reality do not exist as absolutes in our relative world?

If I am looking at a group of objects as opposed to a single object the differences between the various artistic elements are thrown into sharp relief. Not only is the color's quality threatened at every moment by quantitative differences in light, but the action and reaction with which the objects influence each other further complicate the situation. If we treat a group of objects in the same way that we treat one object, then we will subject this whole to fragmentation and bestow a special function on each element. We will not trouble ourselves with what most artists call harmony, which is all too often an easy way to dilute the overall effect of the painting. Instead we will attempt—by combining our changes to the horizon line with the remedies we have proposed for the integration of elements—to subordinate everything to those natural principles that assure that the painting possesses rhythmic unity. In particular, we will reconcile a particular series of tones with a particular series of forms, a particular category of colors with this or that category of surfaces. The color will change depending on whether the surface is horizontal or vertical. Instead of ruining the hue under the pretense of harmony, it is far better to decrease its volume. We should also note that the shades of color in a painting that serve to indicate a light source can produce an unbearable clash. This is usually the result of a lack of proportion in the drawing, rather than a bad choice of color. When composing a work of art it is important to bear in mind the quality of shades of color that the painting requires. When I say "composition" I am referring to the analysis of space in all directions, which should be carried out in an organic and spontaneous manner.

It is not enough to express ideas which relate to the form, color, shade, and position that objects take up in a specific space; it is also crucial that we find a way to express the idea of their mass and materiality. Very few artists have dared venture to this point. They have no clue about the art of disassembling artistic elements. They worry that they will commit the crime of banal realism or that they will waste their efforts on useless endeavors.

One does not depict in detail the wood of a table, the threads of a cloth or the veins in marble. One should only seek to suggest their qualities or to imitate them.

Imitation in art is repulsive if it dominates all other artistic procedures and becomes an end in itself, rather than one painterly technique among others. However, if we are successful in delimiting this technique, it can become very useful. Such imitation will allow us to liven up the highest concepts by adding a note of intentional vulgarity to the finished product.

If we are successful at incorporating imitative elements in a representative context, and we do so in such a way that the generalization of these elements does not compromise the greater whole but enriches it through contrasts, then we achieve the most complete realization possible.

We must assure that the imitative depiction is perfect; this is the first requirement if we are to realize our goal. To achieve this, young artists have rehabilitated the idea of "visual delusion." They were not afraid to faithfully and "stupidly" copy the wood of a table, the marble of a fireplace, and even the arabesques of a Persian carpet. Moreover any confusion about this is simply impossible. The most ignorant viewer will have no doubt that he is confronting an intentional opposition and not a simple stylistic shortcoming.

The second requirement is that imitative techniques should never serve to describe the whole surface of an object. Because the cubist technique of imitation is fragmentary, it has a well-defined meaning, like an author's note, or like something that shines light onto a world that, though of lesser importance, should not be forgotten entirely.

I will also remark that certain things can not be treated in an artistic way because they lack volume. If they are deemed important enough to be placed in the painting, one can still not render them in painterly manner. We must respect their nature and tertiary status. A label on a bottle, a piece of colored paper, or a playing card all lack volumetric qualities, but these objects can bring an element of surprise and unforeseen animation into a painting. They connect the painting to everyday life. Let us not suppress them, and to avoid ambiguity, let us attempt to depict them as faithfully as possible, for the analysis of objects with little volume requires the minutest attention to detail.

Certain artists are satisfied, to the amazement of people who declared themselves to be reasonable, with gluing onto their canvases cutouts of signs, stamps, newspaper clippings, etc. What could be more logical? I

repeat: these things have no intrinsic artistic value of their own, they are incidental and of little importance.

═══════════

From this we can deduce that cubism, from a technical perspective, does not react against impressionism; it continues it and gives it greater depth. Like impressionism, cubism is based on a modern conception of the incongruity of the world as experienced through our senses.

Although impressionism failed as an aesthetic project it did prove to us that color gains in expressive power if—instead of simply applying paint to a canvas—we place the basic elements of each tone separately on the canvas in small dots or patches.

We are guided by the same analytical spirit as the impressionists, but our circumstances have changed. We no longer form the world out of the vibrations of the sun's rays, but rather out of the vibrations of the mind.

People speak superficially about analysis and synthesis with reference to art. This is why certain aestheticians find fault with younger artists for promoting analytical art, because for them a painting should be synthetic. They confuse ends with means. The cubists create analytical signs that are fully capable of expressing synthetic concepts. I believe that artists have always behaved in this fashion, for one cannot paint without searching for relationships, and does not the search for relationships entail some form of analysis?

What I dare not deny, however, is that a certain level of effort is required of the viewer, who will be unable to rise to the occasion without a high level of education. In order to understand a cubist painting, it is necessary to be familiar with all the subtleties of modern art and to examine in detail its development. Despite this, I know people who are not well educated, and yet they easily interpret what experts proclaim to be incomprehensible. This is because they do not bring any preconceived notions and prejudices to the act of looking.

Impressionism was likewise not easily accessible at first. Everyone is aware of documents that attest to this. Its widespread acceptance only occurred gradually and required a mental effort on the part of many individuals before such effort finally ceased and the ability to perceive an impressionist painting became a matter of habit.

Since then, impressionism has served to define the way we perceive a substantial portion of our world. This is why I do not doubt that those

cubist paintings, which are today labeled incomprehensible, will in a few years become completely understandable. Nothing that a person writes or paints remains incomprehensible forever. Those who accuse young artists of arrogantly stumbling around in the dark are in actual fact quite naive. Is it not foolish to proclaim something illegible if we do not know or understand its alphabet?

My explanation is rudimentary, and I am not suggesting that cubism is the type of language that requires a key to be understood. I will not even say that the study of cubist technique alone would suffice if one wanted to create a successful cubist painting.

To gain insight or understanding in the field of art as well as life, one requires grace.

For a cubist, an impressionist, or anyone else, a method will never be a substitute for talent. Method only serves to strengthen talent and helps the artist to avoid wasting it.

I do not advocate the use of cubist technique because I consider it closer to some absolute truth, but because I think it is the method best suited to our era. I am constantly discovering all around me new principles that serve to guide my technique: the relativity of space, the flow of ideas that can only be expressed through incongruities, and the gradual reconstitution of temporal duration [*la durée*] through the succession of simultaneous values [*valeur(s) simultanées*]. Consider the other arts, philosophy, and the sciences. Is it not the duty of every artist to create for posterity the sign of his own times?

Czech translation by Fr. Sedláček

Commentary

Jean Metzinger's little-known essay "Cubist Technique" not only gives us fresh insight into his evolving art theory following the publication of *Du "Cubisme"* and his appointment as instructor at the Académie de la Palette; its publication in Czech in the journal *Volné Směry* (*Free Directions*) attests to the complex reception of cubism abroad and the influence of factional debates in Paris on unfolding rivalries among the avant-garde in other parts of Europe (on the Czech context, see Hume, and Lahoda, *Českyý Kubismus*).

Volné Směry (1896–1949) was the official publication of the Mánes Society of Fine Artists (Spolek vývarných umělců Mánes), an association founded in 1887. The Mánes Society was the most progressive organiza-

tion representing modern artists in Prague until a younger faction led by the modernist Emil Filla (1882–1953) broke away from it in May 1911 to form a procubist circle known as the Group of Plastic Artists (Skupina výtvarných umělců). Skupina founded the avant-garde journal *Umělecký měsíčník* (*Art Monthly*; October 1911–June 1914), which the artist and art critic Josef Čapek (1887–1945) edited until April 1912. Over these same years Filla, Čapek, and the influential art critic and collector Vincenc Kramář (1877–1960) all made trips to Paris to keep abreast of developments in the art world: as a result they were well aware of the rising factionalism within the cubist movement and of Daniel-Henry Kahnweiler's campaign to distance Georges Braque and Pablo Picasso from those cubists exhibiting at the annual Parisian salons (for a detailed analysis of this aspect of Czech modernism, see Hume, chap. 4). These Paris-based debates soon impacted on the Prague school: sometime in November or December 1912, Čapek and a group of close allies split from Filla's circle and rejoined the Mánes Society, claiming that Skupina was not sufficiently open to all tendencies within the cubist movement. To publicize his views, Čapek gained editorial sway over *Free Directions* in 1913, reoriented the journal toward contemporary art, and initiated a polemical debate over the status of cubism with Filla's *Art Monthly*.

It is in this context that *Free Directions* published a translation of Metzinger's essay "Cubist Technique," written specifically for the journal, as well as a Czech version of Henri Le Fauconnier's "La sensibilité moderne et le tableau" (document 54). Concurrently *Art Monthly* propagated a Kahnweiler-inspired history of cubism in articles such as Kramář's wilting review of Le Fauconnier's January–February 1913 Munich retrospective (*Umělecký měsíčník* 2, nos. 4–5 [February 1913]: 115–30). Titled "Chapter on -isms: On the Exhibition of Le Fauconnier in Munich," Kramář's article asserted that the style of Braque and Picasso had been clumsily appropriated by Le Fauconnier, Albert Gleizes, and Metzinger, who then purportedly founded the movement known as cubism to publicize their mediocre painting. This one-sided narrative would be more fully developed in Kramář's highly influential postwar publication *Kubismus* (*Cubism*; 1921), which drew inspiration from Kahnweiler's *Der Weg zum Kubismus* (*The Way of Cubism*) (on Kramář's art criticism see Hume, chap. 1; on *Kubismus*, see Bois, and Lahoda, "Avant-propos").

In 1914 the confrontation between these Czech factions took symbolic form in rival exhibitions held in Prague in February–March 1914:

the Group of Plastic Artists' last exhibition (which included paintings by Braque, André Derain, and Picasso) and Modern Art, the huge salon cubist retrospective organized by Josef Čapek and Alexandre Mercereau under the auspices of the Mánes Society (Mercereau wrote the catalog preface; excerpt translated in Fry, 133–35). The Mánes exhibition included seventeen paintings by Gleizes, ten by Metzinger, six by Robert Delaunay, and representative paintings by Roger de la Fresnaye, André Lhote, and Jacques Villon as well as five sculptures by Alexander Archipenko and six by Raymond Duchamp-Villon. Although Čapek tried to persuade Kahnweiler in April 1913 to lend works by Braque, Derain, and Picasso for inclusion in the forthcoming Mánes exhibition, he failed, possibly due to Filla's interventions with the dealer (see Hume, 304–16). Thus the appearance of Metzinger's essay under the auspices of *Free Directions* implicated the French artist in a highly contentious debate not unlike that already under way in Paris.

Metzinger's "Cubist Technique" is remarkable, not only for the insight it gives us into his artistic praxis, but as evidence of his assimilation of collage, faux-bois (artificial wood-graining), and other artisanal practices employed by Braque, Juan Gris, Picasso, and Metzinger himself into his own theory of cubism. In seeking to justify cubism as a style, in the essay's conclusion Metzinger claims that it is an expression of new discoveries in philosophy and the sciences. Thus the guiding principles behind his art are "relativity of space" and "the gradual reconstitution of temporal duration [*la durée*] through the succession of simultaneous values [*valeur(s) simultanées*]." Accordingly the essay defines his technique in terms of space, the durational consciousness of the artist, the expressive properties created through pictorial rhythm, and an extended discussion of the role of color and imitation in the work of art. Many of these themes had been broached in *Du "Cubisme"* and Metzinger's interview with Yvonne Lemaitre (see documents 57 and 66)—for instance, his discussion of space highlights the distinction between pure visual space and cubist space first developed in *Du "Cubisme"*—but this text is much more explicit about the actual artistic processes by which Metzinger constructed his paintings.

Thus in his analysis of color Metzinger distinguishes between the sense of an object's volume, produced by the play of natural light across an object's surface, and the object's local color, whose intrinsic quality he wishes to retain, despite variations in shadow and light. Using the example of

an orange, Metzinger sets out to reconcile these two elements by placing "a uniform color [orange] in between shades devoid of color, thereby expressing my notion of chromatic unity while separately capturing the idea of roundness." Metzinger instructs artists to take account of how tones, colors, and volumetric forms interact with each other, thereby giving a painting its own unique "rhythmic unity."

In addition to his unique discussion of color in this text, there are significant shifts in emphasis from his earlier writings. Metzinger wishes to emphasize that cubism is an *expressionist* aesthetic whose plastic elements (space, line, rhythm, color) are conventional signs. The artist, therefore, is under no obligation to utilize these elements to create the illusion of verisimilitude. Metzinger, however, is then faced with a challenge: how to take account of the introduction of trompe l'oeil, collage, and other artisanal techniques into cubist painting. Such methods, he asserts, are utilized by the cubists in order to enrich their abstraction through contrast without compromising the painting's overall expressive and volumetric properties. Thus the choice of *which* objects to render in trompe l'oeil is dictated by their "lack of volume," which robs them of any "painterly" qualities. Metzinger puts it this way:

> I will also remark that there are certain things that cannot be treated in an artistic way because they lack volume. If they are deemed important enough to be placed in the painting, one can still not render them in a painterly manner. We must respect their nature and tertiary status. A label on a bottle, a piece of colored paper, or a playing card all lack volumetric qualities, but these objects can bring an element of surprise and unforeseen animation into a painting. They connect the painting to everyday life.... let us attempt to depict them as faithfully as possible, for the analysis of objects with little volume requires the minutest attention to detail.

Objects to be rendered in trompe l'oeil, then, are restricted to depiction of their two-dimensional surfaces: Metzinger cites "the wood of a table, the marble of a fireplace, and even the arabesques of a Persian carpet." The latter two instances of trompe l'oeil objects appear in a number of Metzinger's paintings of 1913; however he also notes that some painters go further by merely "gluing onto their canvases cutouts of signs, stamps, newspaper clippings, etc." In Metzinger's estimation such collage elements are mere formal devices; there is no suggestion here that the medium of collage could have political import or that the newsprint is to be read. Instead

these forms of illusionism are minor elements possessing "no intrinsic artistic value" and are therefore "of little importance." Such comments give us new insight into Metzinger's own use of collage in works like his *Cyclist* of 1911–12 (Peggy Guggenheim Collection, Venice).

In sum, Metzinger's "Cubist Technique" stands as testimony to his distance not only from the politicized version of cubism developed by his friend Gleizes, but also from the antimilitarist import of Picasso's use of collage. And once again, he attempts to speak on behalf of the whole movement, in defiance of the factional schisms that now divided his former friends and colleagues.

Yve-Alain Bois, "Préface"
Fry, *Cubism*
Hume, "Contested Cubisms"
Lahoda, "Avant-propos"
Lahoda, *Českyý Kubismus*

Raymond Duchamp-Villon, "L'Architecture et le fer,"
Poème et Drame (January–March 1914): 22–29

Architecture and Iron

The Eiffel Tower

Word is they are going to put the image of the Eiffel Tower on new post-age stamps.

Does not that act, in its desire to make reparations, assume all the significance of an admission of injustice?

Had it come into existence in America, the tower would have been crushed under advertising and hyperbole. In France, it was ridiculed: different manners, identical result.

Time, very fortunately, erases human foolishness, and ridicule never kills any but the false and weak, whatever one might say. The tower has thus continued to trace its gray silhouette with golden head in the shifting sky, and to raise high its lacy ironwork, its lace of numbers, like a desire, like a sign, motionless.

As for the scholars and critics responsible for that unjustly bad reputation, they will continue no doubt to reinflate a new bladder every day, to deceive themselves that they are spreading light.

It is nevertheless distressing that public opinion, as a result of their incompetence, was contemptuous of the art of iron for such a long time, and saw in its use only crude utility resulting from a clever and solid calculation.

So it was that no one could, no one dared, defend against speculation a work full of power and audacity, screaming out the glory of steel in a fantastic building: the Galerie des Machines.

The memory of that gallery, built for the 1889 exposition, dominates our first impressions of collective life, and I can still see very sharply, in

the brightness of the enormous hall, the hallucinated journey of the traveling crane above the whirlwind flywheels, the reptile belts, amidst the creaking, the whistles, the sirens, rising up from the black hole of disks, pyramids, and cubes.

I must confess to my shame that I feel gratitude and respect for Dutert, the creator of that work, which the sight of the École Militaire cannot make me forget.

The destruction of the gallery, masked by arguments of municipal aesthetics, is proof of the indifferent attitude toward iron architecture. And yet, is there not a surprising similarity between the conceptions of engineers working in steel and medieval builders?

Is it not the same desire to design spaces in which the crowd will move about at ease, the same need to elaborate simplicity, lightness, even to the point of paradox?

Do we not rediscover in medieval builders the same boundless ambition to build ever larger, ever taller, ever more daringly? Across from the Gothic Notre-Dame, the true steeple of modern Paris rises on the Champ-de-Mars. The two works, the tower and the nave of the church, arose from the same constructive desire, and both bring to life a similar dream of superhuman exaltation.

It is undoubtedly true that construction exclusively out of iron belongs solely to an age of transition. One ought nevertheless to preserve the monuments that marked the pinnacle of that age, and pay tribute to the precursors who were daring at a time when there was some peril in being so. I mention, for the record, the Pont des Arts, built in 1811.

Among the leading architects, let us mention the Labrouste brothers, to whom we are indebted for the halls of the Bibliothèque Nationale and of the Bibliothèque Sainte-Geneviève.

They were erected in about 1850, and, since then, their elegance and simplicity, impossible to produce in other materials, have only too rarely been praised.

In these temples of the book, the straight columns—splitting their fluted outer skin under the vault and effortlessly bearing the clean arches—demand to be seen.

Around them forms an atmosphere of calm and grandeur, the mark of style.

It is truly painful to go along the streets and see the errors of those who have not understood that lesson.

We must also mention Baltard, who was able to give the Halles, merely through the logical elaboration of their utility and requirements, the appearance of a mysterious organism, always alert, concentrating the city's agitation at night, only to give it back, newly honed for the next day.

Wide avenues, stalls, the absence of obstacles: it's a temporary camp that must constantly be replaced, an empty space that must never remain empty.

That monument is one of the most remarkable for its adaptation to its function, the first condition of an architecture worthy of the name.

It is in the works of these men that the undeniable origin of our modern architecture lies, an architecture that complements the particulars of iron by adding those of concrete.

But this is not the time or the place to elaborate on that claim; we all know the few examples of that liberated construction, which is Paris's pride and joy, and we need only dream a little to glimpse the future of reinforced concrete, either bare or wearing a decoration of stone, marble, or even wood.

Let me recall in passing, to drive home that point, the famous theater built by our friends the Perret brothers, whose suggestions aided me in this study.

If, however, the steel shell is now only a skeleton, it currently authorizes every sort of audacity, the most robust and the most mannered. We must do justice to it as it once lived, and recognize it, when the case merits it, as a work of art.

Everyone remembers, at least through images, the nearly intact ruins left nearly everywhere by the Romans, those masons of genius; and no one denies the most pompous titles, in the almanac of our national treasures, to the remains of the Pont du Gard, for example. And yet, its raison d'être was pure utility, like the Garabit viaduct today, which was sent flying across two mountains, spanning in a single stroke a space that would hold the Arc de Triomphe standing on the towers of Notre-Dame.

You cannot really reduce such a creation to the value of a work of art like the Argenteuil Bridge.

To adapt a convention to nature and to the proportions of the surrounding landscape is to solve problems of architecture; and Eiffel, without suspecting it perhaps, on this occasion and later on as well, obeyed necessities of the plastic order, controlled and shored up by the logic of the material.

Is not this one of the best conditions, the ignorance of the cataloged artistic laws, which allows a free man to pursue the joy of creating in accordance with an intuited idea, in order to plan and complete a masterpiece? Eiffel and his collaborators, architects unbeknownst to themselves, had genius.

At the end of the last century, they alone extolled French architecture and were able to translate its audacity, its power, and its grace into a language of simple lines.*

At first, the magnificent tower, which owes its salvation to the fact of being put to a false use, looked like the wager of a fanatical believer.

People sang about it on street corners, in verses whose hyperbolic grace can be judged by this quotation:

Et l'on dit que tout en haut
On verra, jusqu'au Congo
Brazza chasser la gazelle,
de la Tour Eiffel(le).

[In the Congo far away,
Brazza's chasing the gazelle,
You can see him, so they say,
From the Tour Eiffel.]

Then, like every new thing, it received by way of baptism its certificate of undesirable ineptitude, duly initialed by the greatest pontificators of the age: witty artists even circulated a protest by people of taste, which was called the protest of the three hundred masters, while, at the same time, François Coppée expressed his contempt by exclaiming: "People will pay admission to go to the top of it!" Only Édouard Lockroy, state minister at the time, responded to these insults with a very courageous defense.

*Certainly Eiffel had his role among the group of engineers [du génie collectif] that gave birth to the Eiffel Tower. For if we accept his name as the patronymic for the baptism, we cannot forget Sauvestre, first author, around 1880, of an initial project—and his true inspiration, perhaps—nor [can we forget] Nouguier, engineer collaborator, nor Koeklin, calculator of the tower project, nor all the others: architects, managers, artisans, humble laborers, who were the anonymous ironworkers—brothers of the constructors of Chartres Cathedral—that is, representatives of a race and of a people in this grandiose manifestation of national genius that would lead to the erection, fourteen centuries after Cheops, of the Pyramid of Iron which symbolizes the West (*Poème et Drame*).

During the same period, skeptics in the provinces responded with irony: on a triumphal arch erected for the occasion of the festival of wine-growers, at the Tower of Peilz, the following words appeared:

En ces lieux calmes et champêtres
On reconnaît la main du temps
La Tour Eiffel a trois cent mètres
La nôtre a plus de six cents ans.

On this spot so calm and rustic
One recognizes the hand of time
The Eiffel Tower stands three hundred meters
Our own has stood six hundred years.

But no voices rose up at that moment to express how much beauty such an effort entailed: the comparisons and examples used to amuse the public were not designed to erase from their minds the idea of a slightly mad, though successful, experiment.

Some of these demonstrations are rather curious and deserve to be reported.

I borrow the details, and the above quotations, from the altogether affectionate booklet published by Mr. Charles-Édouard Guillaume, on the occasion of the festival of the sun in June 1912, under the title, *Le premier quart de siècle de la Tour Eiffel* [The First Quarter Century of the Eiffel Tower].

Seven thousand metric tons of iron were used, that is, seven million kilograms.

To demonstrate its judicious economy, let us suppose that the tower were reduced to a height of thirty centimeters while maintaining the same ratio between its weight and its dimensions. It would then have to weigh seven grams, the weight of a sheet of paper.

A cylinder whose base circled the four pedestals of the tower and enclosed it from top to bottom would encase a volume of air whose weight would be greater than that of the steel used.

Finally, the mass of iron, melted down to a solid sheet covering the square formed by the base, 125 meters on each side, would be only six centimeters thick.

These observations, which are diversions of a sort, nevertheless demonstrate a virtuosity of construction, an expertise in the use of the material, which it would otherwise be difficult to imagine.

Now, what can we say about the most preposterous prophecies that accompanied the execution of Eiffel's plan?

For the two years during which it was being built, it was rarely spared: the tower would never be finished.

The wind would bend it, lightning would shatter or melt it; variations in temperature would break it apart; it was a certain, predicted, desired catastrophe.

The labor went on for not quite two years, and proceeded smoothly, without any surprises, solely on the strength of its methodicalness.

The tower was assaulted by winds, and confined itself to describing small ellipses, between ten and twelve centimeters in diameter, at its summit.

It was struck by lightning and rang like a tuning fork. On extremely hot days, the unilateral heat made it bend down a few centimeters, in the suggestion of a bow, but as for catastrophes, there were none.

The tower, living its strange life, swaying imperceptibly, stretching to its full height in the sun, shrinking under the gray sky, glorious and resonant, resisted both men and the elements.

Today, we find it imposing, necessary, and we no longer need its record-breaking statistics to admire it.

After all, this masterpiece of mathematical energy, beyond its rational conception, drew its source from the subconscious realm of beauty.

It is more than a statistic, a number, since it contains an element of profound life to which our minds are required to submit, if they seek emotion in the arts of statuary and architecture.

I would like to give the most striking, as well as the most simple, example of this:

"A plumbline, motionless, suspended in the center of a free space."

That is the purest element of sculptural language, of which man has a clear, indisputable, and inexplicable notion. That harmony, absolute and definitive, makes a point of infinity tangible for man.

And it is because he used that primordial truth without overwhelming it with flashiness that Eiffel made a vivid and lasting work.

For us, the iron cycle is now complete, but the chain of human effort has, through it, been enriched by another link.

After fifty years, we are proud to offer it the tribute of our young generation, in gratitude for a lesson in energy and power, in which our present-day dreams of art are steeped.

To the masters who opened the way to the future, those of us who are not afraid that the sky is falling will know how to demonstrate that a new hour is truly sounding, loud and clear.

I believe it has been helpful to say to whom we are indebted for it.

Raymond Duchamp-Villon

JANUARY–MARCH 1914

Commentary

Raymond Duchamp-Villon (1876–1918) was arguably the preeminent cubist sculptor before World War I (see Agee and Hamilton; Ajac and Pessiot, 28–33; and Zilczer, "Raymond Duchamp-Villon" and "Raymond Duchamp-Villon and the American Avant-Garde"). The son of a Norman notary, he and his brothers Marcel Duchamp (1887–1968) and Jacques (Gaston) Villon (1875–1963) played prominent roles in the development of modernism in the regional capital of Rouen and in Paris (fig. 50). Duchamp-Villon moved to Paris to study medicine in 1894, and the following year he shared an apartment on the rue des Écoles with his brother Jacques, who was studying art at the Atelier Cormon on the boulevard de Clichy. In 1898 an attack of rheumatic fever forced him to abandon his medical studies. During his long convalescence (1899–1901) Duchamp-Villon took up sculpture, and in 1901 he sculpted his first significant works in an art nouveau style while living in an atelier at 9, rue Campagne-Première. In 1902 he exhibited at the Salon de la Société nationale des Beaux-Arts, and in 1905 he submitted work to the Salon d'Automne, where he showed regularly until 1913. In 1906 he and Jacques Villon held a joint exhibition at the Galerie Legrip in Rouen, and the same year saw the establishment of the Société des artistes rouenais, which included Pierre Dumont, Duchamp-Villon, and his brother Marcel Duchamp among its members (Lespinasse). In 1907 Duchamp-Villon moved in with his brother Jacques at 7, rue Lemaître in Puteaux, where he befriended another local resident, artist František Kupka.

Duchamp-Villon's artistic success led to his being chosen as vice-president of the jury for the Salon d'Automne in 1910. At that salon he exhibited his *Pastorale: Adam and Eve* (1910), which signaled his rejection of Auguste Rodin and the impact of the classicizing aesthetic of Aristide Maillol on his developing mode of abstraction (Agee and Hamilton, 45–51; Pessiot). In December 1910 the newly founded Société normande de peinture moderne had its first exhibition, which included Dumont, Duchamp, Villon,

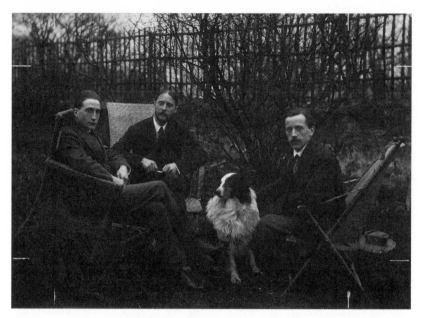

50. Marcel Duchamp, Jacques Villon, Raymond Duchamp-Villon, and their dog Pipp, 7, rue Lemaître, Puteaux, winter 1913. Photograph in "Brothers Who Paint Those Queer Pictures," *New York Times,* 13 April 1913, picture section, p. 4. Fonds Raymond Duchamp-Villon, Documentation du Musée national d'art moderne (Centre Georges Pompidou, Paris). Photograph courtesy of the Walt Kuhn, Kuhn Family Papers, and Armory Show records, 1882–1966, Archives of American Art, Smithsonian Institution, Washington, DC.

and Francis Picabia among the exhibitors. Throughout 1911 Duchamp-Villon participated in the weekly meetings of artists, poets, and critics held on Sunday afternoons at 7, rue Lemaître: regulars included the salon cubists as well as literary luminaries such as Roger Allard, Guillaume Apollinaire, and Henri-Martin Barzun. The interaction between the Société normande and the salon cubists led to greater participation of the latter in the Normandy group's exhibitions, as witnessed by the cubist roster included in the society's November 1911 and June 1912 exhibitions (documents 30 and 43). As we have seen, Duchamp-Villon played a major role in assuring the cubists' inclusion in the 1911 Salon d'Automne at the Grand Palais. From that salon onward he joined fellow Norman André Mare and his cubist colleagues in creating a series of decorative ensembles, the most famous being his architectural façade for the Maison Cubiste (Autumn Salon, 1912). Duchamp-Villon also ventured into art criticism with the appearance, in the 17 September 1912 edition of *Gil Blas,* of his response to a survey on the deteriorating condition of the famous sculpture *La dance*

(1869) by Jean-Baptiste Carpeaux (1827–75) (trans. in Agee and Hamilton, 113–14).

In September 1912 a new group known as "The Artists of Passy" was launched with its first monthly dinner in a café at the Place de l'Alma. Regular participants included the three Duchamp brothers, Allard, Apollinaire, Barzun, Gleizes, Marie Laurencin, Le Fauconnier, Fernand Léger, Mare, Metzinger, Olivier Hourcade, Picabia, and Tancrède de Visan. It was under the auspices of the Passy dinners that Duchamp-Villon met the architect Auguste Perret (1874–1954), who had made a reputation championing the use of concrete as a building material (Laurent, 265). In November 1912 Barzun published the inaugural issue of *Poème et Drame* (November 1912–March 1914), which served as the principal literary vehicle for the Passy group. In late 1912 and over the course of 1913 contributors to the journal (Barzun and Gleizes) actively aligned cubism with the doctrine of Celtic nationalism promoted by the Ligue celtique française, founded by the literary theorist Robert Pelletier in spring 1911 (M. Antliff, "Cubism, Celtism, and the Body Politic"; M. Antliff, *Inventing Bergson*, 106–10). Pelletier, who also attended the "Artistes de Passy" dinners, praised the Gothic churches built by medieval guilds as evidence of a national tradition rooted in the Celtic *sensibilité* of the common people. He also claimed that the corporative guilds and the communitarian values they promoted had a modern-day counterpart in proletarian syndicalism, republican ideology, and opposition to royalism and Greco-Latin culture. This leftist discourse was later endorsed by Gleizes in his *Poème et Drame* essay "Tradition and Cubism" (document 60 and commentary) and resuscitated by Léger after World War I (Herbert).

Duchamp-Villon's enthusiasm for the Gothic in "Architecture and Iron" may indicate his sympathy for the cultural politics promoted in Barzun's journal, and more broadly for the architectural theory of Eugène-Emmanuel Viollet-le-Duc (M. Antliff, "Cubism, Celtism, and the Body Politic"; Murphy). Duchamp-Villon's essay was based on a talk he gave at an "Artists of Passy" dinner in November 1913. Published in the January–March 1914 edition of *Poème et Drame*, his article amounted to a spirited defense of the Eiffel Tower as the latest manifestation of a French tradition with roots in the Gothic. He claims that Notre Dame Cathedral and the Eiffel Tower were the product of "the same constructive desire," arguing that "medieval builders" possessed "the same boundless ambition to build ever larger, ever taller, ever more daringly." Gothic masons and

modern engineers shared an urge to work with experimental materials; thus one can detect "a surprising similarity between the conceptions of engineers working in steel and medieval builders." Reactionaries such as the poet François Coppée were blind to this tradition; indeed, Duchamp-Villon's mention of Coppée serves as a reminder of the poet's involvement in the infamous "Pétition des artistes" protesting the tower's construction and signed by a cross-section of academic artists (published in *Le Temps* on 14 February 1887) (Mathieu).

Like the Gothic cathedral, the glass and iron structures built by engineers were adapted to "collective life": as an example Duchamp-Villon cites Ferdinand Durtert's Galerie des Machines, constructed for the 1889 Paris World's Fair but demolished in 1910. He then embarks on a thoroughly nationalist history of "the art of iron" to underscore the modern-day legacy of this Gothic spirit. Highlights include the Pont des Arts, the first iron bridge constructed in Paris in the early nineteenth century; Victor Baltard and F.-E. Callet's les Halles Centrale, completed in the mid-1850s; and Henri Labrouste's Bibliothèque Saint-Geneviève (1844–50) and his Bibliothèque Nationale (completed 1869).

Gustave Eiffel is singled out for special praise: Duchamp-Villon not only chides the public for valuing the Roman Pont du Gard over Eiffel's viaduct Garabit (1884), he draws on the scientist Charles-Édouard Guillaume's "affectionate booklet" on the Eiffel Tower—*Le premier quart de siècle de la Tour Eiffel* (Paris: Maretheux, 1913)—to underscore its status as a marvel of engineering. Guillaume (1861–1936) was a specialist in thermometry and then the associate director of the Bureau of Weights and Measures who would later win the Nobel Prize in Physics (1920). Duchamp-Villon proclaims, "It is in the works of these men that the undeniable origin of our modern architecture lies, an architecture that complements the particulars of iron by adding those of concrete." On this note he draws our attention to the innovative use of iron and concrete in the architecture of his "Artists of Passy" colleague Perret, citing the recently completed Théâtre des Champs Elysées (1913).

As Kevin Murphy has demonstrated, Duchamp-Villon shared architectural theorists Viollet-Le Duc's and Auguste Choisy's contention that modern engineers, like medieval masons, lacked any academic architectural training. For this reason figures like Eiffel were unencumbered by the now-exhausted legacy of classicism, still taught at the École des Beaux-Arts and exemplified in Duchamp-Villon's text by Jacques-Ange

Gabriel's École Militaire (1751–72). Duchamp-Villon's circumspect defense of the Gothic was augmented by a footnote appended to his article by the editor of *Poème et Drame*. There Barzun let it be known that Duchamp-Villon's text proved that the architects, engineers, artisans, and metalworkers who had assisted Eiffel were "the brothers of the builders of Chartres—that is, representatives of a race" whose new "iron pyramid" was the product of "national genius" (see Mathieu on the collaborators listed by Barzun). In this manner Barzun gave Duchamp-Villon's essay an even more nationalist and racial inflection, more in keeping with the Celtic nationalism professed by Barzun himself and his principal ally among the cubists, Albert Gleizes.

Agee and Hamilton, *Raymond Duchamp-Villon 1876–1918*
Ajac, "Repères biographiques"
Ajac and Pessiot, eds., *Duchamp-Villon*
M. Antliff, "Cubism, Celtism, and the Body Politic"
M. Antliff, *Inventing Bergson*
Herbert, "Léger, the Renaissance, and 'Primitivism'"
Laurent, "Artistes de Passy"
Lespinasse, "Les événments de la vie artistique de 1878 à 1914"
Mathieu, "Exposition Universelle 1889"
Murphy, "Cubism and the Gothic Tradition"
Pessiot, "Quand l'obsession de la dynamique, bouleverse les thèmes classiques. . . ."
Zilzcer," Raymond Duchamp-Villon"
Zilczer, "Raymond Duchamp-Villon and the American Avant-Garde"

Adolphe Tabarant, "Le Salon des Indépendants," *L'Action*
(1 March 1914): 2

The Independents' Salon

Room 10. This set of rooms, except for the left side, which is given over
to the cubists, are the best composed of the salon. Pierre Bonnard brings
them the meticulously nuanced charm of *Soleil couchant* [*Setting Sun*];
Lucie Cousturier, her opulent flowers; Jean Peské, the stunning *Pointe de
Gouron*, and two powerful drawings of landscapes, the kind that open
vast horizons through the stylized branches of trees from Provence. Paul
Signac, who was kept in the Midi by an indisposition, and away from
the Indépendants, which he chairs, offered *Pont-Neuf*, where all the light
fairies have deposited their jewels. Hans Ekegardh has one of the nudes,
which he captured in thick, translucent paste, and flowers opening like
the flicker of flames, which are an enchantment to the eye.

Maximilien Luce has a landscape of incomparable serenity, *Peupliers
au bord de la Chalouette* [*Poplars on the Banks of the Chalouette*] and
Baignade au Pertuis [*Bathing at Pertuis*], where all his gifts for bringing
things to life can be found. Mrs. Georgette Agutte offers the banks of the
Seine and figures of children in a garden.

Then there is Paul Deltombe, very much improved: first, in a large panel
showing a young woman in a straw hat, arms and bosom bare, receiving
a basket of fruit, which an uncouth and strapping young man—some-
what reminiscent of the Marseilles "thugs"—is holding out to her from
his perch on a ladder. The construction is strong, the color beautifully
orchestrated. It represents a tremendous effort. A radiant landscape and
Femme se coiffant [*Woman Combing Her Hair*] are the other submissions
of that hardworking artist, who is so passionately trying to find himself.

Finally, I could not say enough about the dark and bright-colored
drawings of Miss Louise Hervieu, who is quite simply one of the most

personal artists of our time. It is not possible to do pencil sketches of landscapes with more nervous emotion, to sustain them with such simple strokes and to keep them in balance, or to express with more acuity the character of the human face. It is great art.

Daniel Dourouze's landscapes, especially *Le Moulin de la Galette*; Jeanne Baudot's flowers; still lifes by Jacques Pick, Germaine Magnus, Georges Willaume, André Verger, and Sigrist; landscapes by Lepreux, Seligmann, Miss Helena Dunlop, Hippolyte Petitjean, Grollon, Van Coppenolle, André Sivade, and Fernand Morin; Charles Guilloux's delicate *Bords de Seine* [*Banks of the Seine*]; René Martin's beautiful *Intérieur*; and the series of pencil portraits by Séverin Rappa.

Room 12. I am sorry that Miss Émilie Charmy is not represented by human figures or by flowers. But the landscapes she sent to the salon are nevertheless very expressive of her talent, whose passion for decoration never leaves out a concern for the balance of forms. Landscapes as well by Coussedière, especially his pleasantly nuanced *Environs de Clermont-Ferrand*; Gabriel Fournier, Billette, Jeanne Baraduc, Gaulet, Georges Séveau; Louis Soullard's *La Seine à Mirecourt* [*The Seine at Mirecourt*].

Ramon Pichot's Spanish scenes are always unusually picturesque, well served by remarkable painterly gifts. Maurice Robin, with an amusing studio interior furnished with exotic objects drawn in great detail, has two curious still lifes in sanguine and blue cameo.

Finally, Miss Kleinmann's human figures, Maurice Rétif's *Mousse*, Max Friedland's flowers, E. Bernard-Toublac's *Jardin ensoleillé* [*Sunny Garden*]; Elisabeth Boyd's and René de Saint-Délis's seascapes; Mrs. Marguerite Hérold's interiors.

The Odd-Numbered Rooms

Room 1. Very little, apart from the lively *Promenoir à l'Olympia* [*Walkway at Olympia*] by Claudio Castelucho, landscapes by André Jolly and Jean Spellani; Gabriel Sue's *En Dordogne* [*In the Dordogne*]; Hippolyte Tavernier's *Fruits*.

Room 3. Joseph Lépine's landscapes, and, for example, his *Moulin sur la mer* [*Mill on the Sea*], which is conscientious and delicate. From Léon Bauche, *Jardins de Versailles*, a fresh and delicate vision, and then *Quai de Seine, à Paris* [*Seine Quai, in Paris*], in a wrapping whose harmony is very appealing.

The other landscape artists worthy of attention are relatively numerous here: Gabriel Belot, Lucien Breton, Henri Bourly, André Hermain, Rose Dujardin-Beaumetz, François Gueiu, Charles Wittmann, Luc Charron. Then there are a few good painters of still lifes: F. Batigne, Miss von Spreckelsen, Jean Bertrand, J. Mathey.

Hubert Meuwissen, much improved, presents, along with flowers in thick strokes, *Cirque*, a circus scene, superbly captured, and a delicious decorative landscape representing two nudes: *Au bord de l'eau* [*On the Banks of the Water*]. The human figures of Maria de Pstrokuska; Fernand Bruguière's *Yvonne le Goff*; Marcel Bach's decorative sketches.

Room 5. This suite of three rooms is well composed. The harmonious colorist Altmann, who stylizes with such lyricism and who makes the trembling branches of the trees stretch out so felicitously, exhibits two Pyrenees landscapes in their opulent fall clothes, and a view of Nemours, pleasingly nuanced. Paul Renaudot, with two female figures tenderly drawn, comes forward as the incomparable interpreter of feminine intimacy. Eugène Delestre, working as always in thick paste, creates appealing backlit effects in his *Fenêtre ouverte* [*Open Window*] and *Fenêtre aux dahlias* [*Window with Dahlias*]. Conscientious still lifes by Ludovic Vallée, who also catches the eye with a sure, firm figure in *Au jardin*. Additional still lifes from A. Caillaud, Pierre Rougeot, and Alice Shaw; landscapes by Charles Thorndike, William Gore, Igounet de Villers, Camille Mohler, and Georges Schreiber (especially *Bois des forges*); Madonnas by Alfred Coeuret; a sober portrait of an aged lady by Benoni-Auran; and, by the same honest artist, twinkling *Ports de Marseille*. A glistening nude by Fernand Lantoine; sketches of cats by Marcel Falter.

Room 7. Gustave Cariot's ardent, passionate palette is well suited to express the warm sight of ripe wheat. Hence his harsh landscape *Messidet* is enjoyable. A decorative subject by Pierre Chapuis. The landscapes of Marshall, André Barbier, Frédéric Fiebig, and Allard-L'Olivier; the Algerian scenes by Anselmo Bucci.

Room 9. Pierre Dumont clearly marks his place here with *Cathédrale de Rouen*, one in a series that makes you look intently at his vigorous and willful talent, then with two portraits with sharply expressed volumes, *René Fauchois* and *M. Franz de l'opéra*, depicting the Franz from *Parsifal*. André Lhote, lively with charming grace and effortless power, even when he returns to his research of cubist dimension, is wholly present in *Petit-Déjeuner* [*Breakfast*], representing a young woman in

a curiously depicted interior. Van Dongen regales us with disturbing creatures, which he envelops in his infinite discoveries of color, sometimes intense, always agreeable. Then there are the submissions of Tobeen (*Le repos* [*The Rest*]), Mainssieux, Sterenberg, Georgio de Chicico, Chabaud, Raoul Dufy, Hayden, Marchand, landscapes by Maurice Utrillo, a still life by Sonia Lewitska, and Erna Hope's *Danseuses* [*Dancers*]. A portrait and nudes of an austere but real beauty by Luc-Albert Moreau. I don't like everything about Mérodack-Jeaneau's *Jongleuse australienne* [*Australian Juggler*], which alarms me a little. Nevertheless, I acknowledge it has a very curious liveliness of motion. Mrs. Suzanne Valadon, who is exceptionally gifted and endowed with a reflective manner of drawing, exhibits a very large work, too large perhaps, *Le lancement du filet* [*The Casting of the Net*]. A considerable effort, to be sure.

Room 11. Cubists, eccentrics, practical jokers. Let us refrain from giving them publicity. Silence is what they fear most.

But I would like to go through the various rooms a second time to note in passing a few that it would be unfortunate to overlook. So let me recommend the still life by Marie Laurencin; Alexandrovich's portrait *Jean Grave*; Miss Olga Bing's *Soir d'été* [*Summer Evening*]; the sensitive Henri Coulon's landscapes of Creuse; Robert Diaz de Sorin's flowers with delicate harmonies; François Fischbach's landscapes, beautifully ascending toward color and light, especially *Étang de Ville-d'Avray (effet du soir)*; the submissions of Miss Marthe Garlard, Lucien Laurent-Gsell, Paul-Louis Mestrallet, Mrs. Quentin-Mille's *Jardin d'hiver* [*Winter Garden*] and *Rochers d'Erquy* [*Rocks of Erquy*]; and Jean-Baptise Follin's *Environs de Fécamp*.

Sculpture is not well represented at the Indépendants. But it is masterfully so by Jean Baffier, nicely by Marius Cladel, Emile Baudot, and Léonce Dohin. Finally, let me mention Henri Laurens's ceramic bas-reliefs and Legras de Léger's decorated pottery.

In short, a very fine salon. Cubism? Pooh! It is everywhere and it is nowhere. In fact, the gods must be praised who have made it survive so long. Cubism? Orphism? I-don't-know-who-ism? The committee of the Indépendants would have to create it if it did not exist! It is true to say that its existence is fleeting in the extreme, like the flickering image on a movie screen, which passes and vanishes in the same instant. Of course, I would like to state my reservations once more. I persist in enjoying Metzinger, Gleizes, de la Fresnaye, and a few others as well, even in their

worst aberrations, because I know their value, and my presumptuousness does not go so far as to impose my aesthetic, my point of view, my mind, on them. But as for the others, so many others! Because Picasso, that huge and extremely uneven creator, has at present taken it upon himself to no longer paint, but simply to paste pieces of paper, colored or not, which he cuts out at random from store catalogs, advertisements, or calendars, because that inspired madman amuses himself with that—the distraction of a giant—now the poor followers cut and paste in turn! Paint? What's the use, since Picasso no longer paints? And the games of old retirees who have got it into their heads to make landscapes with ingeniously cut-out postage stamps, that childish game is on its way to replacing the obsolete painter's craft. Moreover, we shall surely see worse to come. Madness has limits, but who could assign any to practical jokes? I await the works of Hégésippe Simon, the great patron of precursors.

Adolphe Tabarant

1 MARCH 1914

Commentary

Adolphe Henri Philippe Tabarant (1863–1950) was a self-described "socialist libertarian" journalist (Maitron, 193), novelist, and writer on art who sympathized with both the aesthetics and the anarchism of Camille Pissarro and Maximilian Luce. He was involved in the late 1880s in several Socialist projects, including the journals *La Revue Socialiste* and *Le Combat*; in the '90s, he wrote for *La Revue Moderne* and the anarchist *L'En Dehors* (Ward, 151 and 230). Before 1914 Tabarant was best known as an ardent supporter of the neoimpressionists who founded "le Club de l'art social" (1889–94) as a forum in which artists and writers could discuss the revolutionary potential of art (Hutton, 2–3 and 99–102; Ward, 151). The club attracted Socialists and anarchists, including Pissarro, anarchist editor and activist Jean Grave, the sculptor Auguste Rodin, and the anarcho-syndicalists Émile Pouget and Fernand Pelloutier (Varias, 125–26). After World War I, Tabarant consolidated his reputation as an art critic by contributing to the journal sponsored by the Bernheim-Jeune gallery, *Le Bulletin de la Vie Artistique* (1919–26), edited by Félix Fénéon (Desbiolles, 275) and through his publications on Édouard Manet (1931; 1947), Pissarro (1924), and Luce (1928).

Like Urbain Gohier and Henri Guilbeaux (documents 14, 24, and 25), Tabarant's libertarian politics and his tastes coincided to ensure his

support of the modernists of his generation—impressionists, symbolists, Nabis, neoimpressionists, and fauvists—as is visible in his warmly appreciative comments here on works of Pierre Bonnard, Paul Signac, and Luce. But the cubists exceeded his understanding. Unlike Gohier or Guilbeaux, however, he tempers his accusation of practical jokesterism with kind words to say about Pierre Dumont, André Lhote, Jean Metzinger, Albert Gleizes, and Roger de la Fresnaye. His harshest words were reserved for Pablo Picasso and are of importance as one of the very few published references to the practice of papier collé in the prewar period. Tabarant characterizes collage with irony as a "childish game . . . on its way to replacing the obsolete painter's craft" and the papers themselves, rather incorrectly, as cut "at random from store catalogs, advertisements, or calendars," emphasizing the commercial aspect of the materials.

Desbiolles, *Les revues d'art à Paris, 1905–1940*
Hutton, *Neo-Impressionism and the Search for Solid Ground*
Maitron, *Dictionnaire biographique du mouvement ouvrier français*
Varias, *Paris and the Anarchists*
Ward, *Pissarro, Neo-Impressionism and the Spaces of the Avant-Garde*

Fernand Léger, "Les réalisations picturales actuelles,"
Les Soirées de Paris (15 June 1914): 349–56

The New Achievements in Painting
Lecture Given at the Académie Wassilieff

In a previous lecture given last year at this same academy, I developed the theme of "The Origins of Painting and Its Representative Value." I ended that lecture by asserting that the new achievements in painting were the result of the modern mentality, and were closely linked to the visual aspect of external things, which, for the painter, are creative and necessary.

I am therefore going to try, before taking on purely technical questions, to explain why the paintings of today are representative, in the modern sense of the word, of the new visual state imposed by the evolution of the new means of production.

A work of art must be indicative of its time, like any other intellectual manifestation. Painting, because it is visual, is necessarily the reflection of external, rather than psychological, conditions. Every pictorial work must capture the momentary and eternal value that makes it endure beyond the era when it was created.

If pictorial expression has changed, it is because modern life made that change necessary. The lives of modern creative men are much more condensed and complicated than those of people in previous centuries. The image of the thing is less fixed, and the object in itself exposes itself less than it once did. A landscape traversed and broken up by an automobile or an express train loses in descriptive value but gains in synthetic value; the doors of the train car, or the windows of the automobile, combined with the speed achieved, have changed the usual look of things. Modern man registers a hundred times more impressions than the eighteenth-century artist, for example, to such a point that our language is full of

diminutives and abbreviations. The condensation of the modern picture, its variety, its breaking of forms, are the result of all that. It is clear that the evolution in the means of locomotion and their speed play a role in the new visuality. A number of superficial people cry anarchy upon seeing these pictures, because they cannot follow, in the pictorial domain, the entire evolution of everyday life that is captured in them. They believe these pictures represent a sharp break in continuity when, on the contrary, they have never been so realistic or clung so closely to their times as they do today. A realist mode of painting in the loftiest sense is beginning to come into being and will not soon end.

This mode of painting is a new measurement that has come into existence to respond to a new state of affairs. There are countless examples of rupture and change occurring in this act of registering our visual awareness. I shall take the most striking of these. The billboard advertisement, imposed by modern commercial necessities, and which brutally interrupts a landscape, is one of the things that has most enraged people of so-called good taste. It has even spawned the stupefying and ridiculous organization pompously calling itself Society for the Protection of Landscapes. Is there anything more comical than the hot air spewed by good people charged with solemnly decreeing that one thing is beneficial to the landscape and another is not? In that case, it would be preferable to immediately eliminate the telegraph poles and the houses, and leave only the trees, sweet harmonies of trees! People of so-called good taste, cultured people, have never been able to digest contrasts; there is nothing more terrible than habit, and the same people who protest with conviction against the billboard can be found at the Salon des Indépendants, convulsed in laughter in front of modern pictures, which they are incapable of tolerating like the rest.

And yet, that yellow or red billboard screaming in the timid landscape is the most beautiful of the new pictorial arguments in existence; it beats hands down the whole sentimental and literary concept and announces the advent of plastic contrast.

Naturally, to find, in that rupture from everything habit has consecrated, an argument for a new pictorial harmony and a plastic means of life and movement, it took an artistic sensibility, which always outstrips the crowd's normal way of seeing.

Similarly, the modern means of locomotion have completely overturned relationships familiar since time immemorial. Before them,

a landscape was a value in itself, which a white and dead road traversed without changing anything around it.

Now railroads and automobiles, with their plumes of smoke or dust, appropriate the entire dynamic for themselves, and the landscape becomes secondary and decorative.

Wall posters and illuminated signs are on the same order of ideas; they have spawned this formula, as ridiculous as the organization mentioned previously: *Post No Notices*.

It is an incomprehension of everything new and alive that has led to that policing of walls. Hence the interminable surfaces of administrative and other sorts of walls are the saddest and most sinister things I know. The poster is a modern piece of furniture, which painters have immediately known how to use. This is again bourgeois taste that one finds in these rules, the taste for the monotonous, which they drag everywhere with them. The peasant, for his part, resists such mollifications; he has retained his taste for violent contrasts in his costumes, and a sign in his field does not frighten him.

In spite of all that resistance, the ancient costume of the cities had to evolve with the rest; the black evening attire, which stands out sharply from the light-colored gowns of the women at society gatherings, is a clear manifestation of an evolution in taste. The black and the white sing out and clash, and the visual effect of modern-day society gatherings is the exact opposite of the effects produced by similar gatherings in the eighteenth century, for example. The costumes of those times were all in the same tone; the overall effect was more decorative with fewer contrasts, more monotonous.

In spite of that, the average bourgeois has retained his concept of combining one tone with another, that is, the decorative concept. For a long time yet, the red parlor and the yellow bedroom, especially in the provinces, will be the last manifestation of the proper tone. Contrasts have always provoked fear in peaceful and satisfied people; such people eliminate them from their lives as far as possible, and, just as they are disagreeably shocked by the dissonance of a sign or of something else, their life is also organized to avoid any unpleasant contact. These are the last circles artists ought to frequent; the truth is shrouded and everyone is afraid of it; the only thing left is politeness, from which an artist seeks in vain to elicit information.

In previous eras, the application of contrasts was never used in a complete manner, and for several reasons: (1) the need to submit to the rigors of a subject (I elaborated this idea in a previous lecture), which had to have a sentimental value.

Before the impressionists, the painter was never able to break the spell of literature; as a result, the application of plastic contrasts was necessarily diluted within a story that had to be told, which the modern painters have recognized as perfectly pointless.

The day the impressionists liberated painting, the modern picture immediately began to build on contrasts; instead of submitting to a subject, the painter intervenes and uses a subject for purely plastic ends. All artists who have offended public opinion in recent years have always sacrificed the subject for the pictorial effect. If we go back further, even Delacroix was very controversial for that reason, when, in spite of the weight of his literary Romanticism, he produced pictures such as *Entrée des Croisés à Jérusalem* [*Entrance of the Crusaders in Jerusalem*], where the subject was clearly dominated by the plastic expression; he was never accepted by the qualified and official people.

That liberation leaves the modern-day painter free to use any of these means as he considers the new visual state I have just described; he will have to organize himself to give a maximum plastic effect to means that have not yet served in that capacity; he must not become an imitator of the new objective visuality, but an entirely subjective sensibility for this new state of affairs.

He will not be novel because he has broken up an object or placed a red or yellow square in the middle of his canvas; he will be novel by virtue of the fact that he has grasped the creative spirit of that external manifestation.

As soon as one accepts that only the realism of conception is able to "realize," in the most plastic sense of that term, these new contrasting effects, one must leave visual realism aside and concentrate all one's plastic means in a qualitative aim.

Composition takes precedence over all the rest; the lines, forms, and colors, to assume their maximum expressiveness, will have to be used with the greatest logic possible. It is the logical mind that will obtain the greatest result, and what I mean by logic in art is the person capable of imposing order on his sensibility, someone who knows how to obtain the maximum effect from the concentration of means.

It is very clear that, if I look at objects in their surroundings, in the real atmosphere, I do not perceive any lines delimiting the zones of colors. That is understood, but it lies within the realm of visual realism and not that of the very modern realism of conception. It is childish and backward to try to eliminate, out of prejudice, a means of expression, such as the outline or form apart from the significance of its color. The modern picture can have a lasting value and avoid death not by favoring one means of expression over others, but, on the contrary, by concentrating all the means of plastic expression possible toward a qualitative aim. It is an achievement on the part of modern painters to have understood that. Before them, a drawing had a value in itself, a painting in itself; now, everything is brought together, in order to arrive at a necessary variety and a maximum realist power. A painter who calls himself modern and who rightly considers perspective and sentimental value negative means must know how to replace them in his pictures with something other than a continual relationship of pure tones, for example.

That is absolutely insufficient for justifying a picture of even average dimensions, and, even less, the pictures measuring several square meters in area, as a few of them did at the last Salon des Indépendants—this is the increase in scale of the neoimpressionist formula.

That concept, which consists of using the immediate contrast of two tones to avoid lifeless areas, is negative in the construction of the large picture. Construction through pure color has also long been judged in terms of its perfect neutrality and equality: that is what I shall call "addition painting," in contrast to "multiplication painting," which I shall try to develop later on.

The impressionists, who are sensible people, have felt that their rather impoverished means did not allow for large compositions; they remained within justifiable dimensions. The large picture requires variety and, as a result, the addition of other means than those of the neoimpressionists.

Tonal contrast can be understood as the ratio between 1 and 2, 1 and 2, repeated ad infinitum. The ideal formula would be to apply it through and through, which would lead us to a canvas divided into a quantity of equal planes, where tones of equal and complementary value stand opposed; one picture composed in that way may be astonishing for a time, but ten are certain to cause monotony.

To arrive at construction through color, the two tones must balance each other out from the point of view of value (since, fundamentally, that is the

only thing that counts), or, in other words, must neutralize each other; if the green-colored plane, for example, is larger than the red-colored plane, there is no longer construction. You see where that leads. The neoimpressionists experimented with that long ago, and it is outdated to return to it.

In addition to a greater experience of realism, composition by multiplicative contrasts, by using all pictorial means, allows for the certainty of variety. In fact, instead of contrasting two means of expression in an immediate relationship of addition, you compose a picture in such a way that groupings of similar forms stand opposed to other, contrasting groups. If you distribute your color in the same spirit, that is, as an addition of similar tones, coloring one of these groupings of forms in contrast to another, contrary addition, you obtain thereby collective sources of tones, lines, and colors acting against other contrary and dissonant sources. Contrast = dissonance, and, as a result, the maximum expressive effect. I shall choose an example from any subject at random. Let me take the visual effect of curving, circular plumes of smoke rising between houses, whose plastic value you wish to express. You have there the best example on which to apply this research on the multiplicative intensities. Concentrate your curves with the greatest variety possible, but without disconnecting them; frame them by the hard and dry relationships with the surfaces of the houses, lifeless surfaces that will begin to move as a result of the fact that this color will contrast with that of the central mass, and because they stand in contrast to living forms. And you obtain a maximum effect.

That theory is not an abstraction, but was formulated after noting natural effects that can be observed on a daily basis. I deliberately did not choose a so-called modern subject, since I do not know what an ancient or modern subject is. I only know a new interpretation, that is all. But locomotives, automobiles, if you like, billboards, anything can be used in the application of a form of motion; all that research comes, as I have already said, from the modern ambience. But you can replace to advantage the locomotives and other modern machines, which it is difficult to get to come pose for you at home, with the most commonplace, the most worn-out subject, a nude woman in a studio or a thousand other things. They are all means; what is interesting about them is only the way they are utilized.

In many pictures by Cézanne, one can see, roughly suggested, that restless sensitivity to plastic contrasts. Unfortunately, and this corroborates

what I was saying a moment ago, his very impressionist circle and his era, less condensed and less fragmented than our own, could not guide him to the concept of multiplication. He sensed it but did not understand it. All his canvases were made in front of a subject, and, in his landscapes, where houses are awkwardly crashing into trees, he sensed that the truth was there. He was unable to formulate it and create the concept for it. I say that it is an error to abandon that discovery, which is a clear development and a beginning in the creative process, in order to return to neoimpressionism, which is a conclusion and an end, and an error that ought to be denounced. The neoimpressionist has said everything, his arc was infinitely short, it was merely a very small circle offering nothing to hold on to.

Seurat was one of the great casualties of that mediocre formula in many of his pictures, and he wasted a great deal of time and talent at it, by confining himself to that little spot of pure color, which, in fact, does not color at all, since the question of power in the color effect also has to be clarified. Because you use contrasting tones as a means of dynamic movement, in order to eliminate the local tone, you theoretically lose coloring power. A yellow and a violet contrasted in equal volumes, are constructive—that is understood—but at the expense of coloring power, which, for its part, has an intrinsic value that is no longer respected in the optical blend, which is gray. Only the local tone has its maximum coloration. Only the system of multiplicative contrasts allows us to use it; as a result, the neoimpressionist formula arrives at the relatively paradoxical but clear goal of using pure tones to arrive at an overall gray effect.

Cézanne, I repeat, was the only one of all the impressionists to have put his finger on the profound sense of plastic life, through his sensitivity to contrasts of forms.

I will end the technical explanations at this point, but I do not want to end this talk without responding to a few objections that have been made regarding the Salon des Indépendants.

I do not want to defend that salon, which would be trite, but I would like to respond to the objections made by people who have certainly forgotten what the purpose of that salon was.

The Salon des Indépendants, which, as it does every year, has occupied a preponderant place in the worldwide manifestation of painting, is above all a salon of painters and for painters. As a result, all the people who come

to look for completely realized works have no reason to be there. They are totally wrong about the aim of the exhibitors. Other people have criticized the fact that yesterday's avant-garde painters are now abandoning that salon and no longer exhibit their pictures there. They believe this is a more or less interested calculation, which is perfectly false. Those who make that judgment have forgotten that this salon is above all a salon of artistic manifestation. It is the largest in the world (and I am not exaggerating in saying this).

Its raison d'être lies precisely in its perpetual transformation, in contrast to other salons, where you see the same paintings forever and ever.

Here, there must always be room for the seekers and their preoccupations, thanks to the artists who, definitively in possession of their means of expression, give up their places for the younger ones, who need to see their works hanging among other, related works. If all the painters who led the battle at the Indépendants continued to occupy rooms—which would certainly attract people—at the expense of younger painters, they would prevent the new manifestations from occurring.

The Salon des Indépendants is a salon of amateurs. When these painters master their means of expression, when they become professionals, they no longer have any reason to be there. That salon would become like all the others, a sales salon directed at buyers.

It is the perpetual element of novelty that makes for the worldwide interest it elicits; it is the only one that can allow itself to be the eternal wanderer, whose itinerant existence, far from diminishing it, gives it a new spark of life every year. No matter where it goes, it will always have its public of curiosity-seekers and painters. Everything that counts in modern art has passed that way, all who seek and labor aspire to exhibit there. Paris ought to be very proud to be the chosen site for that great pictorial manifestation. These shabby rooms of cloth and wood have seen more talent blossom there than all the official salons combined. It is the Salon of Inventors, and side by side with follies that may never come to fruition, there are a few painters who will be the honor of their age. It is the only salon where bourgeois good taste has been unable to penetrate, it is the big, ugly salon, and that is very beautiful. Nobody tramples the carpets, you catch a head cold along with a glimpse of the pictures. But never have so much emotion, life, anxiety, and pure joy been amassed in such a modest place.

You have to have exhibited there in your youth, brought your first sketches there at the age of twenty, trembling, to know what it is: the

hanging of the pictures, the lighting, opening night, the brutal light that shocks you and leaves nothing in shadow, all these unknown things that, in a single blow, overwhelm your senses and your shyness. You remember it your whole life. What you bring there is everything you hold dearest. The bourgeois who come to laugh at these palpitations will never suspect that a whole drama is being played out there, with all its joys and sadness. If they were aware of it, since on the whole they are good people, they would enter the salon with respect, as if it were a church.

I take great pleasure in saying these things this evening, especially since I am saying them before an audience of Europeans who will understand me, since you are the ones who are the Salon des Indépendants.

Fernand Léger

15 JUNE 1914

Commentary

In this, his second essay delivered at the Académie Wassilieff, Fernand Léger outlines the tenets for a new art that anticipated his "machine aesthetic" of the 1920s (Green; Silver). His article appeared in *Les Soirées de Paris* (February 1912–August 1914), which differed dramatically from his last venue, *Montjoie!*, the self-proclaimed "Organ of French Artistic Imperialism." Under the early editorship of André Billy, *Les Soirées de Paris* cultivated a satirical response to cultural nationalism, but the journal abandoned this stance when Guillaume Apollinaire took over the editorship in November 1913. The change in staff occurred after Billy sold the journal to an *haute bourgeois* couple who collected modern art, Hélène d'Oettingen and Serge Jastrebzoff. Under Apollinaire *Les Soirées de Paris* was meant to cater to an upscale readership willing to purchase the art illustrated in the journal. The strategy failed miserably when the publication of Picasso's constructions in the November 1913 issue caused a precipitous drop in subscribers (Paragoris). Moreover, Léger's disparaging comments on bourgeois taste in his essay in the June 1914 edition likely increased the sense of alienation among Apollinaire's hoped-for audience.

Léger opens his essay by summarizing the thesis of his previous lecture, namely that modern painting expresses a new sensibility created "by the evolution of the new means of production." He then defines those pictorial methods conducive to his notion of "conceptual realism." The readers are informed that their sensory experience of speed had resulted in

a sensitivity to dissonance and fragmentation—what Léger terms "synthetic value." This newfound interest in "rupture and change" created an aesthetic appreciation for the modern landscape, with its billboards, posters, smoke plumes, railroads, and automobiles. The result was "the advent of plastic contrast," and Léger called on artists to embrace this new aesthetic. Returning to an argument first broached in his previous article, he claims that this new art was only possible because impressionism had "liberated painting" to pursue "purely plastic ends" attuned to "a modern realism of conception." However, he next defines the pitfalls of impressionism, and of its offspring neoimpressionism. Although the impressionists and neoimpressionists grasped the concept of plastic contrasts, they limited themselves to the study of complementary colors. Neoimpressionists such as Georges Seurat took this principle to its extreme, but their color complements only served to neutralize each other and produced a dull gray effect. Léger's critique attests to his familiarity with neoimpressionism, a technique he had adopted before his conversion in 1909 to an aesthetic inspired by Paul Cézanne (on neoimpressionism, see Herbert, 15–26; on Léger, see Green, 7–10, 74–76).

Léger wanted to replace this "addition painting" with "multiplication painting"—his term for an aesthetic able to maximize and concentrate the plastic impact of contrasts. Cézanne was a pioneer in this regard, for he had "sensed" the need for greater plastic contrasts despite the fact that his era was "less condensed and less fragmented than our own." As an example of contemporary research on "multiplicative intensities," Léger cites his own creation of dissonant contrasts through the study of curving smoke plumes in an urban landscape: "Concentrate your curves with the greatest variety possible, but without disconnecting them; frame them by the hard and dry relationships with the surfaces of the houses, lifeless surfaces that begin to move as a result of the fact that this color will contrast with that of the central mass. . . . And you obtain maximum effect." Léger's choice of imagery was indebted to the unanimist poetry of Jules Romains, as well as to Henri-Martin Barzun's doctrine of "Dramatisme" (Green, 22–24, 81–82; Sund). Léger's appeal to dissonance, fragmentation, and plastic contrast also bears relation to the broader literary and artistic debate over "simultaneity." Poets Barzun, Nicolas Beauduin, Apollinaire, and Blaise Cendrars; artist Robert Delaunay; and the Italian futurists all contested the concept over the course of 1913 (Bergman). The exact relation of Léger's aesthetic to this myriad constellation of poetic and

painterly doctrines remains open to discussion (Buckberrough; Cornell, 124–34; Décaudin, 449–91; Green, 72–95).

Léger also developed the class-based implications of his theory of plastic contrasts. He argues in the essay that the bourgeois arbiters of "so-called good taste" were hostile to modernity, retained an outmoded conception of art, and thus were out of step with modern dissonance and its progeny: the art on display at the Salon des Indépendants. By contrast Léger lauds "the peasant" for retaining "his taste for violent contrasts in his costumes," adding that the presence of a modern billboard in his field "does not frighten him." This seemingly anachronous conflation of a rural peasant sensibility with the dissonance of modernity allowed Léger to ally himself with *le peuple*; it may also register the impact of André Mare's Normand-inspired colorist aesthetic on Léger's modernism (on Mare, see Cottington and document 34). Léger closes his article with a moving defense of the Salon des Indépendants as the only arena where aspiring artists shunned by the bourgeoisie could have a chance to exhibit their innovative art. "You have to have exhibited there in your youth, brought your first sketches there at age twenty, trembling, to know what it is," he states. Surveying the expatriates gathered to hear his talk, Léger closes his lecture by declaring his "great pleasure" to have shared his ideas with "an audience of Europeans who will understand me, since you are the ones who are the Salon des Indépendants." His essay was published in June 1914; two months later that salon community was shattered by the advent of World War I.

Bergman, *"Modernolatria" et "Simultaneità"*
Buckberrough, *Robert Delaunay*
Cornell, *The Post-Symbolist Period*
Cottington, "The Maison Cubiste and the Meaning of Modernism in Pre-1914 France"
Décaudin, *La crise des valeurs symbolistes*
Green, *Léger and the Avant-Garde*
Herbert, *Neo-Impressionism*
Parigoris, "Les constructions cubistes dans 'Les Soirées de Paris'"
Silver, *Esprit de Corps*
Sund, "Fernand Léger and Unanimism"

Guillaume Apollinaire, "Simultanéisme-Librettisme," *Les Soirées de Paris* (15 June 1914): 322–25

Simultanism-Librettism

It's intolerable, really: in the Dutch navy, they spend their time changing uniforms.
—*Fântomas* 36:168

The number of schools of poetry is increasing daily. There is hardly one into which I have not been put willy-nilly. Nevertheless, I come from a time when my comrades and I did not like to fall in behind somebody or with social-climbing groups.

We have not changed and all of us, as we are—no less cultured than others, no less poets than anyone else, no less modern than all poets around the world—do not remain long in those schools, those coteries, still called *petites chapelles,* "little chapels." So it was pointless for Mr. Barzun, on the pretext that there can be no salvation outside his chapel, to take the trouble to excommunicate me from his simultanism, to which I never belonged.

Certainly, he is a bilious character. His obsession about having invented everything is equal only to the haunting presumptuousness with which he boasts about it.

Now he is full of resentment toward me because I wrote about the phonograph in this very forum. In an express letter addressed to André Billy, I admitted that Mr. Barzun published his *Manifeste sur le simultanéisme poétique* [Manifesto on Poetic Simultanism], a manifesto for which he can claim paternity. What more does he want? I clearly showed my intentions in that way. They were to let Mr. Barzun develop his theories fully. He replied with very unfriendly words. I will respond to him, overlooking his reply and examining his theories.

Mr. Barzun's poetic simultanism can express itself only through several voices combined. It is theater. In a book, these voices can only be

successive for a reader; hence, if Mr. Barzun wants a truly simultaneous poetry, he must call on several reciters or use the phonograph, but as long as he makes use of accolades (or braces—a printer's mark combining two or more lines) and the usual typographical lines, his poetry will remain successive. As for polyphony, I said that Jules Romains had tried an experiment at my home in 1909; that does not make Mr. Barzun any less worthy, since he codified that important theatrical reform.

Well before then, Villiers de l'Isle-Adam published a play in which a large number of voices spoke at the same time, saying different things.

And Mr. Barzun can look at it, he will see the brace there, the notorious brace, which is only a direction for the performance and not simultaneity in a book, where voices, as in Mr. Barzun's theories, remain successive.

There are also simultaneous voices in Jules Romains' "L'Armée dans la ville." One would seek in vain such simultaneous voices in Mr. Barzun's works before the end of 1913, and, if one finds examples after that date, it is still simultaneity that can only be realized theatrically or phonographically, and in no other way.

As for the recitation of the poem "Église," let Mr. Barzun make no mistake, the declamation Jules Romains attempted to have performed in 1909 in no way constituted "the expression of a single poetic *phrase* in four, six, or eight voices." The voices of the four reciters mingled, rose up, sometimes alone, sometimes together, and, with each voice saying different stanzas, intertwined in a true polyphony.

But can Mr. Barzun further believe that this theatrical transformation of lyricism is the only form through which lyrical simultaneity will be expressed? He knows very well it is not, since that form retains the book's clearly successive character.

Poems have been offered in this forum where that simultaneity existed in the mind and even in the letter, since it is impossible to read them without immediately conceiving of the simultaneity of what they express, poem-conversations where the poet, at the center of life, in some sense records the ambient lyricism.

And even the printed version of these poems is more simultaneous than Mr. Barzun's successive notation.

So it is that if some poems ("L'Enchanteur pourrissant," "Vendémiaire," "Les fenêtres," and so on) have attempted to accustom the mind to conceiving of a poem simultaneously as a scene from life, Blaise Cendrars and Mrs. Delaunay Terck [*sic*] have made a first attempt at written simultaneity, where contrasting colors accustomed the eye to read the whole

of the poem in a single glance, just as an orchestra conductor reads the superposed notes in the score all at once, and just as people see both the illustrated and printed elements of a sign at the same time.

In Mr. Barzun's entourage, Mr. Sébastien Voirol has himself taken a step toward that figural simultanism, which can exist in a book as well as on the phonograph.

(I wonder why Mr. Barzun says of that instrument: "But the original poem will nevertheless remain requisite, in the same way as the painter's canvas and the composer's score," as if the poet could not directly record a poem on the phonograph and, at the same time, natural sounds or other voices in a crowd or from his friends?)

Mr. Voirol, then, writing his "Sacre du Printemps" [Rites of Spring] in different-colored inks, was closer to figural simultaneity than Mr. Barzun, whose aesthetic remains solely a theater aesthetic. In fact, if the stage directions are taken away, Mr. Barzun's simultaneity would, after all, be merely something like *Paroles en liberté* [*Words in Freedom*] by Marinetti, who in fact, in one of his manifestoes, indicated, prior to Mr. Barzun in any case, the possibility of a printed simultaneity.

In this very forum, someone, having striven to synchronize the mind and letter of the poems, to give them, if I dare say so, the gift of ubiquity, will also strive to take a step toward that question of a new kind of printing, which must in no way be confused with Mr. Barzun's stage poetry, of which he will also find good examples in the old rounds, such as "Are You Sleeping, Brother John?"

In fact, if the paternity of the *Manifesto on Poetic Simultanism* belongs to Mr. Barzun, that simultanism does not belong to him at all.

The idea of simultaneity has long preoccupied artists; already in 1907, it preoccupied Picasso and Braque, who made every effort to represent several facets of figures and objects at once. It then preoccupied all the cubists, and you can ask Léger about the pleasure he felt in capturing a face seen both frontally and in profile. Nevertheless, the futurists extended the realm of simultaneity and spoke clearly of it, even including the word in the preface to their catalog.

For a time, Duchamp and Picabia explored the borders of simultaneity; then, Delaunay* declared himself its champion, and made it the basis

*At his suggestion, I published, in the course of 1912, some notes on simultaneity in *Der Sturm*, in *Les Soirées de Paris* (December 1912) and, finally, in January 1913, I gave a talk in Berlin on the same subject, and the Berlin journals published some accounts. It was later that M. Barzun, having met Delaunay, adopted the habit of believing himself

of his aesthetics. He contrasted the simultaneous with the successive and saw the former as the new element in all the modern arts: the plastic arts, literature, music, and so on. For him, it was a technical term, because, if he had not been alluding to a new technique, he might just as well have chosen one of the many words ending in -ism that, up to the dynamism of Guilbeaux, express the current generations' desire to be modern.

It is pointless to ask Mr. Barzun where he got the name simultanism; did he find it himself, or does it come to him through Delaunay?

Barzun himself remarked that his method had to do with theater, opera, and did not represent anything simultaneous in the printing, and he acted as was his habit, going with the tide. In an echo of Poème et Drame, Du Descriptif à l'Impressif, he tells us of poems providing a visual, plastic impression.

He is free to make painted poems, to try his hand, not at dramatic simultanism any longer, but at printed simultanism; but then, don't let him say he invented it, since he was preceded by the typographical novelties of Marinetti and the futurists, who, even without colors, took a step toward color and inaugurated the typographical simultaneity glimpsed by Villiers and Mallarmé, and not yet entirely explored; by the poem in simultaneously contrasting colors, "La Prose du Transsibérien et de la petite Jehanne de France," by Blaise Cendrars and Mrs. Delaunay Terck [sic]; by Voirol's "Le Sacre du Printemps"; by my poems, different in their expression and in their printing from those that preceded them, and which my friends saw and read at my home; by Picabia's painted poems, again different from all that preceded them.

All these things are available from their authors; a few can be purchased. Mr. Barzun is now free to declare himself their inventor.

Abbey, unanimism, simultanism, everything belongs to him.

For my part, I declare I am delighted that he has borrowed the term Orphic from me, in the sense I have used it.

I very willingly abandon its paternity to Mr. Barzun, who reclaimed it from me one day, on the pretext that, in 1907, he intended to write an Orphéide, and the announcement of that intention, it appears, gave him an indisputable right to the meaning of all words similar to that one.

Guillaume Apollinaire

15 JUNE 1914

the inventor of this simultaneity of which he is not certain that he yet has a clear idea even today.

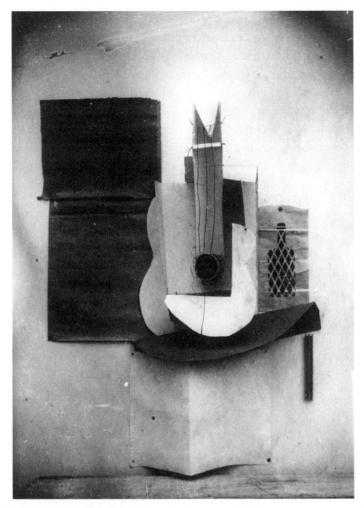

51. Pablo Picasso, *Guitare et bouteille* (*Guitar and Bottle*), autumn 1913. Cardboard and paper. Illustration in *Les Soirées de Paris,* 18 (15 November 1913): 13. Original photograph in the Archives Picasso, Musée Picasso, Paris. Location unknown; presumed destroyed. © 2005 Estate of Pablo Picasso / Artists Rights Society (ARS), New York. © Photo RMN.

Commentary

Apollinaire took over the editorship of *Les Soirées de Paris* in November 1913 (see commentary, document 75) and undertook to promote his radical aesthetics in both literature and the visual arts. He boldly published photographs of Picasso's innovative assemblages (fig. 51), which would be the first chance viewers had to see this work by the artist, unless they succeeded in getting an appointment at Kahnweiler's gallery or knew Picasso personally.

In addressing the issue of poetic simultanism, Apollinaire reveals the finely tuned array of modernist experiments with poetic form relating to this concept among a variety of writers, artists, and media. He had signed the manifesto *L'Ère du drame* of Henri-Martin Barzun (editor of *Poème et Drame*) in July 1912, "in which the fully formulated concept of simultaneity had been first published" (Hicken, 136; Décaudin, 477–80). Apollinaire, Robert Delaunay, and Herwarth Walden (publisher of *Der Sturm*, where his "Reality, Pure Painting" [document 59] appeared the same year) pledged allegiance to "L'Ère pure" (pun on *Aer,* or cosmic harmony, related to simultaneity for the poet) in a card to Barzun in January 1913 [Hicken, 136]).

Though he was competitive with Barzun and anxious for recognition for his own "simultaneous" achievements in his "Calligrams," Apollinaire begins his essay by acknowledging Barzun's precedence in his claim of originality. But he goes on to question all the poetic territory Barzun had wanted to occupy, referring as he does so to a variety of aspects of modernism in poetic form, both on the page and in the theater: Jules Romains, polyphony; Villiers de l'Isle-Adam, simultaneous voices; Sébastien Voirol, figural simultanism. He also points to Blaise Cendrars and Sonia Delaunay-Terk, who "have made a first attempt at written simultaneity, where contrasting colors accustomed the eye to read the whole of the poem in a single glance." And he asserts that his own poems, including "L'Enchanteur pourrissant," "Vendémiaire," and "Les fenêtres," "have attempted to accustom the mind to conceiving of a poem simultaneously as a scene from life." Apollinaire even wiltingly concludes that an Italian actually preceded Barzun, whose "aesthetic remains solely a theater aesthetic. In fact, if the stage directions are taken away, Mr. Barzun's simultaneity would, after all, be merely something like *Paroles en liberté* by Marinetti, who in fact, in one of his manifestoes, indicated, prior to Mr. Barzun in any case, the possibility of a printed simultaneity." Above all, he asserts that it was the cubist painters Pablo Picasso and Georges Braque who initiated simultaneity in their works of 1907, which was followed up by Fernand Léger, Francis Picabia, and Marcel Duchamp, and more substantially extended by the futurists. And it was Delaunay, from whom he suggests Barzun borrowed the term *simultanism,* who "declared himself its champion, and made it the basis of his aesthetics. He contrasted the simultaneous with the successive and saw the former as the new element in all the modern arts: the plastic

arts, literature, music, and so on." Having ceded Barzun's precedence at the beginning of his somewhat bitter essay—the notes of combined hurt and humor are not untypical of Apollinaire—he ends by taking it away completely.

Apollinaire pursued his battle with Barzun, who had also accused him of stealing "Dramatism" and "Orphism" as well as "Simultanism," into the arena of the poem "Lettre-Océan" (fig. 52). According to Bohn, here he includes, among myriad other references, "Zut pour M. Zun" (Phooey on Mr. Zun) and "ta gueule mon vieux pad" (shut your trap, pal), where he not only articulates his response to Barzun's accusations, but also demonstrates his own achievement of "real" simultaneity through the use of slang, which offers "immediate clues that this is spoken language" (Bohn, 22).

Bohn, *The Aesthetics of Visual Poetry, 1914–1928*
Décaudin, *La crise des valeurs symbolistes*
Hicken, *Apollinaire, Cubism and Orphism*

Gabriel Arbouin, "Devant l'idéogramme d'Apollinaire," *Les Soirées de Paris* (July–August 1914): 383–85

Regarding Apollinaire's Ideogram

I say "ideogram" [fig. 52] because, after this production, there is no further doubt that certain modern scripts tend to participate in ideography. The event is curious.

Already, in *Lacerba*, efforts of this kind could be seen from Soffici, Marinetti, Cangiullo, Iannelli, and also by Carrà, Boccioni, Bètuda, and Binazzi, less definitively in the latter group. Standing before such works, we could still remain undecided. After *Lettre-Océan*, doubt is no longer possible.

Someone will raise the objection that a pure ideogram is a pure design and cannot include written language. I will reply that, in *Lettre-Océan*, what stands out and prevails is the typographical aspect, precisely the image, that is, the design. That this image is composed of fragments of spoken language does not matter *psychologically*, since the connection between these fragments is no longer that of grammatical logic, but that of an ideographical logic culminating in an order of spatial arrangement diametrically opposed to that of discursive juxtaposition.

It is a revolution in the strongest sense of the word. But that revolution is only at its beginning. In fact, with *Lettre-Océan*, we already possess a poem-design, a poem precisely in dial-form. Who does not perceive that this can only be a beginning, and that, by the effect of a determinist logic that drives the evolution of all mechanisms, such poems must finally present a pictorial whole in harmony with the subject treated? Thus will one achieve with difficulty a somewhat more perfect ideogram.

I call *Ocean-Letter* a poem, but it is a little random. Obviously, it is not a narrative. It is the opposite of a narrative, since narrative is, of all literary

genres, that which demands the most discursive logic. But up to what point may one call a poem a production where nearly all the rhythmic element has disappeared? Certainly, one can provoke emotion by the cunning or felicitous disposition of two or three ideas. Yet, it has always seemed to people that rhythm was even more emotionally communicative than the naked idea. And these are naked ideas that we present in *Lettre-Océan*, in a *visual order*.

Then, assuredly not narrative, hardly a poem. If you like: an ideographic poem.

Revolution: because our intelligence must habituate itself to understand synthetico-ideographically rather than analytico-discursively.

But, is it really a revolution? Has not this nature of human intelligence preexisted? Yes. It even seems to have constituted the first phase that put an end to the invention of alphabetic writing, permitting intellectual development to be based on spoken language, more numerous, more supple than ideographic language, and above all more clear, more accessible, more lively and more moving.

It would appear that the endeavors like those of Apollinaire in the *Soirées de Paris* represent not precisely a revolution, but rather a regression, that in reverting to the ideogram one tends to create a language of initiates, an art of initiates, that finally such efforts are, from the social perspective, anticollective, which perhaps is not at all the goal of the protagonists of the movement.

All this is presented not as biased criticism, from a member of one school of poetry, but as the disinterested speculations of a psychologist and linguist curious about all human activities and the enemy only of those who attempt nothing.

Gabriel Arbouin

LES SOIRÉES DE PARIS

JULY–AUGUST 1914

Commentary

Sometimes assumed to have been a pseudonym for Apollinaire, Gabriel Arbouin was a writer who frequented the avant-garde and was killed at the front during World War I (Bohn, *Modern Visual Poetry*). Here he comments "as a psychologist and linguist" on the radical new form of Apollinaire's poetic "calligrammes," which had been unveiled in the June

Lettre-Océan

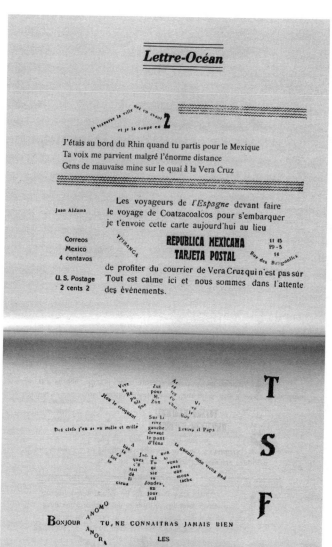

Je traverse la ville *nez en avant* et je la coupe en **2**

J'étais au bord du Rhin quand tu partis pour le Mexique
Ta voix me parvient malgré l'énorme distance
Gens de mauvaise mine sur le quai à la Vera Cruz

Les voyageurs de *l'Espagne* devant faire
le voyage de Coatzacoalcos pour s'embarquer
je t'envoie cette carte aujourd'hui au lieu

Juan Aldama

Correos
Mexico
4 centavos

YPIRANGA

REPUBLICA MEXICANA
TARJETA POSTAL

11 45
29 - 5
14
Rue des Batignolles

U. S. Postage
2 cents 2

de profiter du courrier de Vera Cruz qui n'est pas sûr
Tout est calme ici et nous sommes dans l'attente
des évènements.

T
S
F

Vive
la
Ré
pu
bli
que

Zut
pour
M.
Zun

Az
te
tec
co
co
zhec

Vi
ve
le
Roy

Hou le croquant

Sur la
rive
gauche
devant
le pont
d'Iéna

Reviva il Papa

Des clefs j'en ai vu mille et mille

bas A
ca
la
lot
te
Jac
ques
c'é
tait
si
bien
La
Tu
ni
sie
Journe-
en
jour
nai

qua
si
vous
avec
une
mous
tache

tu n'écris mon vieux pad

BONJOUR *TAMOMO* TU NE CONNAITRAS JAMAIS BIEN
ANORA LES

Mayas

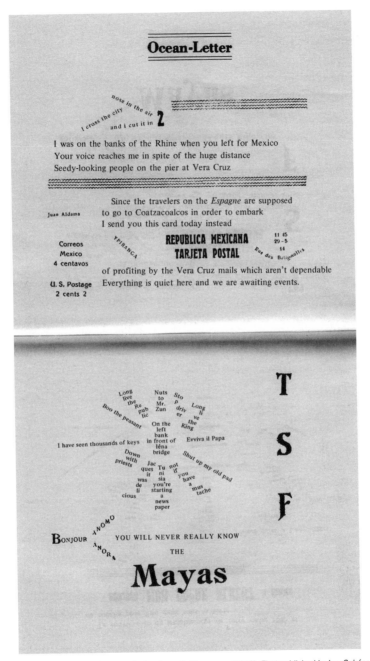

52A, B. Guillaume Apollinaire, *Lettre-Océan,* from *Calligrammes* (1918). First published in *Les Soirées de Paris* (June 1914); trans. in Guillaume Apollinaire, *Calligrammes: Poems of Peace and War* (1913–1916) (University of California Press, 1980). Used by permission of The University of California Press.

issue of *Les Soirées de Paris* with *Lettre-Océan* (fig. 52). Before the war, Apollinaire had planned to publish his shaped poems under the title *"Et moi aussi je suis peintre"* ("And I too am a painter") (Breunig, 77).

The collagelike character of these picture-poems has often been noted by art and literary historians (Bohn, Leighten, Perloff, Shattuck), and here Apollinaire specifically echoes collages of Picasso, Braque, and Gris with his parallel introduction of two postage stamps and a postcard and, more profoundly, his "radical dislocation of poetic structure" (Lockerbie, 3). His earlier poetry was also "cubist" in the sense of introducing "simultaneous" images responding to the texture of the contemporary world, and here he juxtaposes radically disparate objects, images, and lines to form a psychovisual collage constituting a faithful impression of contemporary reality. The distortions of the traditional space-time nexus wrought by recent advances in communication (telephones, telegraphy) and transportation (airplanes, automobiles) are reflected by comparable fragmentation and distortion in the poem (Bohn, *The Aesthetics of Visual Poetry, 1914–1928*, 17).

Arbouin also rightly mentions the parallel production of visual poetry—and verbal painting—among the Italian futurists, including Ardengo Soffici (who also wrote "Picasso e Braque," *La Voce*, 24 August 1911 [document 20]), F. T. Marinetti, Umberto Boccioni, and Carlo Carrà (Carrà even lodged in the offices of *Les Soirées de Paris* during his visit to Paris in 1914 [Carrà, *La mia vita* (1945); cited in Bohn, *The Aesthetics of Visual Poetry, 1914–1928*, 9]).

Rather than focusing on the poem's relation to other artistic movements, however, Arbouin explores the calligram's relation to the concept of the "ideogram." Numerous modernists embraced the notion of visual poetry and interested themselves in the Chinese ideogram—Ezra Pound, Ernest Fenellosa, and Sergei Eisenstein among others (Bohn, *Modern Visual Poetry*)—but Apollinaire took its element of visuality further. Evoking often nearly realist images, including for example the Eiffel Tower's plan (*Lettre-Océan*), falling rain, a heart, a crown, a fountain, and a prancing horse, Apollinaire is urged here by Arbouin to go even further in this direction, so as to develop an art accessible to more than close initiates. Arbouin himself is clearly one of those initiates, which makes his witness of Apollinaire's "ideographic" aims of special interest. Just as clearly, he performs as an advocate of "revolutionary" modernism, a term he labors over several times in this short text. Like the journal's editor—Apollinaire

himself—he is "curious about all human activities and the enemy only of those who attempt nothing."

Bohn, *The Aesthetics of Visual Poetry, 1914–1928*
Bohn, *Modern Visual Poetry*
Breunig, *The Cubist Poets in Paris*
Leighten, *Re-Ordering the Universe*
Lockerbie, "Introduction," *Calligrammes, Poems of Peace and War (1913–1916)*
Perloff, *The Futurist Moment*
Shattuck, "Apollinaire's Great Wheel"

BIBLIOGRAPHY

Adams, Bruce. *Rustic Cubism: Anne Dangar and the Art Colony at Moly-Sabata.* Chicago: University of Chicago Press, 2004.

Adamson, Walter. "Ardengo Soffici and the Religion of Art." In *Fascist Visions: Art and Ideology in France and Italy,* edited by Matthew Affron and Mark Antliff, 46–72. Princeton, NJ: Princeton University Press, 1997.

———. *Avant-Garde Florence: From Modernism to Fascism.* Cambridge, MA: Harvard University Press, 1993.

Adriani, Götz. *Henri Rousseau.* New Haven, CT: Yale University Press, 2001.

Affron, Matthew. "Léger's Modernism: Subjects and Objects." In Lanchner, *Fernand Léger,* 121–48.

Agee, William, and George H. Hamilton, *Raymond Duchamp-Villon 1876–1918.* New York: Walker and Co., 1967.

Ajac, Bénédicte. "Repères biographiques." In Ajac and Pessiot, *Duchamp-Villon,* 130–41.

Ajac, Bénédicte, and Marie Pessiot, eds. *Duchamp-Villon: Collections du Centre Georges Pompidou, Musée national d'art moderne et du Musée des Beaux-Arts de Rouen.* Paris: Centre Georges Pompidou et Réunion des Musées nationaux, 1998.

Albert Gleizes and the Section d'Or. New York: Leonard Hutton Galleries, 1964.

Amano, Chika. "Cubisme, décor et tradition vers 1912." *Histoire de l'Art* (December 1991): 81–95.

André Derain: Le peintre du "trouble moderne." Paris: Musée d'art moderne de la Ville de Paris, 1994.

Antliff, Allan. *Anarchist Modernism: Art, Politics and the First American Avant-Garde.* Chicago: University of Chicago Press, 2001.

———. "Egoist Cyborgs." In *The Uncanny: Experiments in Cyborg Culture,* edited by Bruce Grenville, 101–13. Vancouver, BC: Arsenal Pulp Press, 2001.

Antliff, Mark. "Bergson and Cubism: A Reassessment." *Art Journal* (Winter 1988): 341–49.

———. "Cubism, Celtism, and the Body Politic." *Art Bulletin* (December 1992): 655–68.

———. "Cubism, Futurism, Anarchism: The 'Aestheticism' of the Action d'art Group, 1906–1920." *Oxford Art Journal* 21, no. 1 (1998): 99–120.

——. "The Fourth Dimension and Futurism: A Politicized Space." *Art Bulletin* (December 2000): 720–33.

——. "Georges Sorel and the Anti-Enlightenment: Art, Ideology, Politics." In Hargrove and McWilliam, *Nationalism and French Visual Culture,* 307–22.

——. *Inventing Bergson: Cultural Politics and the Parisian Avant-Garde.* Princeton, NJ: Princeton University Press, 1993.

——. "Organicism against Itself: Cubism, Duchamp-Villon, and the Contradictions of Modernism." *Word & Image* (October–December 1996): 366–88.

——. "Their Country: Henri Gaudier's Anarchist Antimilitarism, 1910–1914." In *We the Moderns: Gaudier-Brzeska and the Birth of Modern Sculpture,* edited by Sebastiano Barassi, 75–87. Cambridge, UK: Kettles Yard Gallery, 2007.

Antliff, Mark, and Patricia Leighten. *Cubism and Culture.* New York: Thames & Hudson, 2001.

——. "Primitive." In *Critical Terms for Art History,* 217–33. Chicago: University of Chicago Press, 2003.

Apollinaire, Guillaume. *Chroniques d'art, 1902–1918.* Edited by L. Breunig. Paris: Gallimard, 1960.

——. "Le Douanier." *Les Soirées de Paris* (15 January 1914). Translated in Breunig, *Apollinaire on Art,* 339–54.

——. "Du sujet dans la peinture moderne." *Les Soirées de Paris* (1 February 1912): 1–4. Translated in Breunig, *Apollinaire on Art,* 197–98.

——. "New Trends and Artistic Personalities." *Le Petit Bleu,* 20 March 1912. Translated in Breunig, *Apollinaire on Art,* 217–20.

——. *Les Peintres cubistes: Méditations esthétiques.* Edited by L. C. Breunig and J.-Cl. Chevalier. Paris: Collection Savoir, Hermann, 1965, 1980.

Apollonio, Umbro, ed. *Futurist Manifestos.* London: Thames & Hudson, 1973.

Auslander, Leora. *Taste and Power: Furnishing Modern France.* Berkeley and Los Angeles: University of California Press, 1996.

Bascou, Mark, et al. *Paris in the Late Nineteenth Century.* London: Thames & Hudson, 1997.

Benjamin, Roger. "The Decorative Landscape, Fauvism, and the Arabesque of Observation." *Art Bulletin* (June 1993): 295–316.

——. *Matisse's "Notes of a Painter": Criticism, Theory, and Context, 1891–1908.* Ann Arbor: UMI Research Press, 1987.

Berghaus, Günter. *The Genesis of Futurism: Marinetti's Early Career and Writings, 1899–1909.* Bristol, UK: W. S. Manley & Son, Ltd., 1995.

Bergman, Pär. *"Modernolatria" et "Simultaneità": Recherches sur les deux tendances dans l'avant-garde littéraire en Italie et en France à la veille de la première guerre mondiale.* Stockholm: Scandinavian University Books, 1962.

Bergson, Henri. *Creative Evolution.* 1907. Authorized translation by Arthur Mitchell, New York: Modern Library, 1944.

Bernard, Émile. "De Michelange à Cézanne." *La Rénovation esthétique* (March 1906).

——. *Souvenirs sur Paul Cézanne et lettres inédites.* Paris: Société des trente, 1912.

Bidal, Marie-Louise. *Les ecrivains de l'Abbaye.* Paris: Bovin, 1939.

Bilski, Emily D., and Emily Braun. *Jewish Women and Their Salons: The Power of Conversation.* New Haven, CT: Yale University Press, 2005.

Birnbaum, Pierre. *Anti-Semitism in France: A Political History from Léon Blum to the Present.* Oxford: Blackwell, 1992. Translation of *Un mythe politique: La "République" juive* (1988).

Blanche, Jacques-Émile. *Portraits of a Lifetime: The Late Victorian Era; The Edwardian Pageant, 1870–1914.* New York: Coward-MacCann, 1938.

Blau, Eve, and Nancy Troy, eds. *Architecture and Cubism.* Cambridge, MA: MIT Press, 1997.

Blotkamp, Carl. *Mondrian: The Art of Destruction.* New York: Harry N. Abrams, 1994.

Bohn, Willard. "The Abstract Vision of Marius de Zayas." *Art Bulletin* 63, no. 3 (September 1980): 434–52.

———. *The Aesthetics of Visual Poetry, 1914–1928.* Cambridge: Cambridge University Press, 1986.

———. *Modern Visual Poetry.* Newark, DE: University of Delaware Press; London: Associated University Presses, 2001.

———. "In Pursuit of the Fourth Dimension: Guillaume Apollinaire and Max Weber." *Arts Magazine* (June 1980): 166–69.

Bois, Yve-Alain. "Kahnweiler's Lesson." *Representations* (Spring 1987): 33–68. Reprinted in *Painting As Model,* 65–97. Cambridge, MA: MIT Press, 1990.

———. Préface. In Kramář, *Le Cubisme,* ix–xxi.

———. "The Semiology of Cubism." In Zelevansky and Rubin, *Picasso and Braque,* 169–208.

Bowlt, John, and Matthew Drutt, eds. *Amazons of the Avant-Garde.* New York: The Solomon R. Guggenheim Museum, 2000.

Bozo, Dominique, et al. *Daniel-Henry Kahnweiler.* Paris: Centre Georges Pompidou, 1984.

Brauer, Fay. "L'Art révolutionnaire—The Artist as Alien: The Discourses of Cubism, Modern Painting, and Academicism in the Radical Republic." Ph.D. diss., University of London (Courtauld Institute of Art), 1997.

———. "Commercial Spies and Cultural Invaders: The French Press, *Pénétration Pacifique* and Xenophobic Nationalism in the Shadow of War." In Gee and Kirk, *Printed Matters,* 105–31.

Braun, Emily. "Vulgarians at the Gate." In Mattioli and Greene, *Boccioni's Materia,* 1–21.

Brécy, Robert. *Autour de La Muse rouge (groupe de poètes et chansonniers révolutionaires), 1901–1939.* Saint-Cyr-sur-Loire: Éditions Christian Pirot, 1991.

Breunig, Leroy C., ed. *Apollinaire on Art: Essays and Reviews, 1902–1918.* New York: Viking Press, 1972.

———. *The Cubist Poets in Paris: An Anthology.* Lincoln: University of Nebraska Press, 1995.

Briend, Christian. "Albert Gleizes au Salon de la Section d'or." In Debray and Lucbert, *La Section d'or,* 71–75.

———. "Lhote, l' 'imagier' du cubisme." In Moulin and Fossier, *André Lhote 1885–1962,* 18–25.

Brooke, Peter. *Albert Gleizes, For and Against the Twentieth Century.* New Haven, CT: Yale University Press, 2001.

Buckberrough, Sherry. *Robert Delaunay: The Discovery of Simultaneity*. Ann Arbor: UMI Research Press, 1982.

Burgess, Gelett. "Essays in Subjective Symbolism." New York: Little Galleries of the Photo-Secession, 27 November–8 December 1911.

Caizergues, Pierre. "Apollinaire journaliste." *Cahiers du Musée Nationale d'Art Moderne*, 6, 19–39. Paris: Centre Georges Pompidou, 1981.

Camfield, William. *Francis Picabia: His Art, Life and Times*. Princeton, NJ: Princeton University Press, 1979.

———. "Juan Gris and the Golden Section." *Art Bulletin* 47 (March 1962): 128–34.

———. "La Section d'Or." In *Albert Gleizes and the Section d'Or*, n.p.

Carco, Francis. *De Montmartre au quartier Latin*. Paris: Albin Michel Éditeur, 1927.

Carr, Reg. *Anarchism in France: The Case of Octave Mirbeau*. Montreal: McGill-Queen's University Press, 1977.

Cavallo, Luigi, ed. *Ardengo Soffici*. Milan: Mazzotta, 1992.

Cheetham, Mark. *Kant, Art, and Art History: Moments of Discipline*. Cambridge: Cambridge University Press, 2001.

Clark, Timothy J. *Farewell to an Idea: Episodes in the History of Modernism*. New Haven, CT: Yale University Press, 1999.

Clarke, John. *Dora Marsden and Early Modernism: Gender, Individualism, Science*. Ann Arbor: University of Michigan Press, 1996.

Clifford, James. *The Predicament of Culture: Twentieth-Century Ethnography, Literature, and Art*. Cambridge, MA: Harvard University Press, 1988.

Connelly, Frances S. *The Sleep of Reason: Primitivism in European Art and Aesthetics, 1725–1907*. University Park: Pennsylvania State University Press, 1995.

Cornell, Kenneth. *The Post-Symbolist Period: French Poetic Currents, 1900–1920*. New York: Archon Books, 1970.

Cottington, David. *Cubism and Its Histories*. Manchester: Manchester University Press, 2004.

———. *Cubism in the Shadow of War: The Avant-Garde and Politics in Paris, 1905–1914*. New Haven, CT: Yale University Press, 1999.

———. "Cubism, Law and Order: The criticism of Jacques Rivière." *Burlington Magazine* 126 (December 1984): 744–50.

———. "The Maison Cubiste and the Meaning of Modernism in Pre-1914 France." In Blau and Troy, *Architecture and Cubism*, 17–40.

Coudert, Marie-Claude. "Pierre Dumont." In Pétry, *L'École de Rouen*, 194.

Courtois, Martine, and Jean-Paul Morel. *Élie Faure: Biographie*. Paris: Librarie Séguier, 1989.

Cousins, Judith. "Documentary Chronology." In Rubin, *Picasso and Braque*, 335–452.

Cowling, Elizabeth, and Jennifer Mundy, eds. *On Classic Ground: Picasso, Léger, de Chirico and the New Classicism, 1910–1930*. London: Tate Gallery Publications, 1990.

Cox, Neil. *Cubism*. London: Phaidon, 2000.

Crowther, Paul. "Cubism, Kant, and Ideology." *Word & Image* (April–June 1987): 195–201.

Cumming, Elizabeth. "Colour, Rhythm, and Dance: The Paintings and Drawings of J. D. Fergusson and His Circle." In *Colour, Rhythm & Dance: Paintings & Drawings of J. D. Fergusson and His Circle in Paris*, 6–12. Edinburgh: Scottish Arts Council, 1985.

Daix, Pierre. *Dictionnaire Picasso.* Paris: Éditions Robert Laffont, 1995.

Daix, Pierre, and Joan Rosselet. *Le Cubisme de Picasso: Catalogue raisonné de l'oeuvre peint 1907–1916.* Neuchâtel, Switzerland: Éditions Ides et Calendes, 1979.

Datta, Venita. *Birth of a National Icon: The Literary Avant-Garde and the Origins of the Intellectual in France.* Albany: State University of New York Press, 1999.

Debray, Cécile. "La Section d'or: 1912-1920-1925." In Debray and Lucbert, *La Section d'or*, 19–41.

Debray, Cécile, and Françoise Lucbert, "Dictionnaire de la Section d'or." In Debray and Lucbert, *La Section d'or*, 121–75.

———, eds. *La Section d'or: 1912, 1920, 1925.* Paris: Éditions Cercle d'Art, 2000.

Décaudin, Michel. *La crise des valeurs symbolistes: Vingt ans de poésie française, 1895–1914.* Toulouse: Éditions Privat, 1960.

———. *Le dossier d' "Alcools": Édition annotée des préoriginales avec une introduction et des documents.* Paris: Droz, 1965.

DeLeonibus, Gaetano. *Charles Maurras's Classicizing Aesthetics: An Aestheticization of Politics.* New York: Peter Lang Publishing, 2000.

———. "The Quarrel over Classicism: A Quest for Uniqueness." In Hargrove and McWilliam, *Nationalism and French Visual Culture*, 293–305.

Del Puppo, Alessandro. *"Lacerba" 1913-15: Arte e critica d'arte.* Bergamo, Italy: Lubrina Editore, 2000.

Desbiolles, Yves Chevrefils. *Les revues d'art à Paris, 1905–1940.* Paris: Ent'revues, 1993.

Dictionary of Art and Artists. Rev. ed. by Nikos Stangos, London: Thames & Hudson, 1984.

Distel, Anne. "Portrait of Paul Signac: Yachtsman, Writer, Indépendant, and Revolutionary." In Ferretti-Bocquillon et al., *Signac*, 51–66.

Dorgelès, Roland. *Bouquet de Bohème.* Paris: A. Michel, 1947.

Dorn, Michael, ed. *Conversations with Cézanne.* Berkeley and Los Angeles: University of California Press, 2000.

Duncan, Alastair. *Art Deco Furniture: The French Designers.* New York: Holt, Reinhart, and Winston, 1984.

Elliott, Bridget. "The 'Strength of the Weak' as Portrayed by Marie Laurencin." *Genders* 24 (1996): 69–109.

Elliott, Bridget, and Jo-Anne Wallace. *Women Artists and Writers: Modernist (Im) positionings.* London: Routledge, 1994.

Encyclopédie Perret. Edited by Joseph Abram, Jean-Louis Cohen, and Guy Lambert. Paris: Éditions Miniteur, 2000.

Epstein, Jacob. *Epstein: An Autobiography.* London: Vista Books, 1963.

Erickson, Kristen. "Chronology." In Lanchner, *Fernand Léger*, 262–88.

Fabre, Gladys. "Albert Gleizes et l'Abbaye de Créteil." In *Albert Gleizes: Le cubisme en majesté*, 130–43. Paris: Réunion des Musées nationaux, 2001.

———. "Alexandre Mercereau." In *L'École de Paris, 1904–1929, le part de l'autre*, 386–87. Paris: Musée d'art moderne de la Ville de Paris, 2001.

Faure, Elie. "Sur une guerre." *Les Hommes du Jour*, 7 and 21 October 1911.

Ferenczy, Béni. "Days in Paris." *New Hungarian Quarterly* 8, no. 28 (1967): 113–24.

Ferretti-Bocquillon, Marina, et al. *Paul Signac, 1863–1935.* New York: Metropolitan Museum of Art; New Haven CT: Yale University Press, 2001.

Fineberg, Jonathan. *Kandinsky in Paris 1906–07.* Ann Arbor: UMI Press, 1984.

FitzGerald, Michael C. *Making Modernism: Picasso and the Creation of the Market for Twentieth-Century Art.* Berkeley and Los Angeles: University of California Press, 1996.

———. "Skin Games." *Art in America* (February 1992): 71–82.

Flam, Jack. *Matisse: The Man and His Art, 1869–1918.* Ithaca, NY: Cornell University Press, 1986.

Four Americans in Paris: The Collections of Gertrude Stein and Her Family. New York: Metropolitan Museum of Art, 1970.

Fry, Edward F. *Cubism.* London: Thames & Hudson, 1966.

———. "Cubism 1907–1908: An Early Eyewitness Account." *Art Bulletin* (March 1966): 70–73.

———. "Picasso, Cubism, and Reflexivity." *Art Journal* (Winter 1988): 296–307.

Fuente, Véronique de la. *Dada à Barcelone, 1914–1918: Chronique de l'avant-garde artistique parisienne en exil en Catalogne pendant la Grande Guerre.* Céret: Éditions des Albères, 2001.

Galitz, Katherine Calley. "Chronology." In Ferretti-Bocquillon et al., *Paul Signac,* 299–323.

Gamwell, Lynn. *Cubist Criticism.* Ann Arbor: UMI Research Press, 1980.

Gee, Malcolm. *Dealers, Critics and Collectors of Modern Painting: Aspects of the Parisian Art Market, 1910–1930.* New York: Garland, 1981.

———. "The Nature of Twentieth-Century Art Criticism." In Gee, *Art Criticism since 1900,* 3–21.

———. "Raynal, Maurice," In *The Grove Dictionary of Art Online,* edited by L. Macy, <http://www.groveart.com>. Accessed 7 July 2003.

———, ed. *Art Criticism since 1900.* Manchester: Manchester University Press, 1993.

Gee, Malcolm, and Tim Kirk, eds. *Printed Matters: Printing, Publishing and Urban Culture in Europe in the Modern Period.* Aldershot, UK: Hants; Burlington, VT: Ashgate Publishing, 2002.

Genet-Delacroix, Marie-Claude. *Art et etat sous la IIIe République: Le système des Beaux-Arts, 1870–1940.* Paris: Publications de la Sorbonne, 1992.

Gersh-Nesič, Beth. "André Salmon in Perspective." *Rutgers Art Review* 9–10 (1988–89): 151–58.

———. *The Early Criticism of André Salmon: A Study of His Thoughts on Cubism.* New York: Garland, 1991.

Gleizes, Albert. "The Abbaye of Créteil: A Communistic Experiment." *Modern School* (October 1918): 300–315.

———. *Cahiers Albert Gleizes: Souvenirs, le cubisme, 1908–1914.* Lyon: Association des amis d'Albert Gleizes, 1957.

———. "Les débuts du cubisme." In *Albert Gleizes et le cubisme,* by Jean Chevalier, 53–99. Basel: Basilius Press, 1962.

———. *Tradition et cubisme, vers une conscience plastique: Articles et conférences, 1912–1924.* Paris: J. Povolozky, 1927.

"Gohier." In *Dictionnaire de biographie française,* edited by M. Prévost, R. d'Amat, and H. Tribout de Morembert, 500–501. Paris: Librairie Letouzey et Ané, 1985.

Golan, Romy. "From Fin-de-Siècle to Vichy: The Cultural Hygienics of Camille (Faust) Mauclair." In *The Jew in the Text: Modernity and the Construction of*

Identity, edited by Linda Nochlin and Tamar Garb, 156–73. London: Thames & Hudson, 1995.

Goldberg, Nancy Sloan. *En l'honneur de la juste parole: Le poésie française contre la Grande Guerre.* New York: Peter Lang, 1993.

————. "From Whitman to Mussolini: Modernism in the Life and Work of a French Intellectual." *Journal of European Studies* (June 1996): 153–73.

Golding, John. *Cubism: A History and an Analysis, 1907–1914.* 3rd ed. London: Faber and Faber, 1988.

Goth, Max. "Frantz Jourdain." *Les Hommes du Jour* (12 October 1912): 2–3.

————. "Salon d'Automne—La peinture pure." *Les Hommes du Jour* (13 December 1913): 13.

Green, Christopher. *Art in France, 1900–1940.* New Haven, CT: Yale University Press, 2000.

————. *Cubism and Its Enemies: Modern Movements and Reaction in French Art, 1916–1928.* New Haven, CT: Yale University Press, 1987.

————. *The European Avant-Gardes: Art in France and Western Europe, 1904–1945.* London: Zemmer, 1995.

————. *Juan Gris.* New Haven, CT: Yale University Press, 1992.

————. *Léger and the Avant-Garde.* New Haven, CT: Yale University Press, 1976.

————, ed. *Picasso's "Les Demoiselles d'Avignon."* Cambridge: Cambridge University Press, 2001.

Greutzner-Robins, Anna. *Modern Art in Britain, 1910–14.* London: Merrel Holberton, 1997.

Griffiths, Richard. *The Reactionary Revolution: The Catholic Revival in French Literature, 1870–1914.* New York: Frederick Ungar Publishing, 1965.

Guilbeaux, Henri. "Paul Signac et les Indépendants." *Les Hommes du Jour* 4, no. 170 (22 April 1911): n.p.

Hargrove, June, and Neil McWilliam, eds. *Nationalism and French Visual Culture, 1870–1914.* New Haven, CT: Yale University Press, 2005.

Henderson, Linda D. *Duchamp in Context: Science and Technology in the Large Glass and Related Works.* Princeton, NJ: Princeton University Press, 1998.

————. "Editor's Introduction: II. Cubism, Futurism, and Ether Physics in the Early Twentieth Century." *Science in Context* 17, no. 4 (December 2004): 423–66.

————. *The Fourth Dimension and Non-Euclidean Geometry in Modern Art.* Princeton, NJ: Princeton University Press, 1983.

————. "Modern Art and the Invisible: The Unseen Waves and Dimensions of Occultism and Science." In *Okkultismus und Avant-garde: Vom Munch bis Mondrian, 1900–1915,* 13–31. Frankfurt: Schirn Kunsthalle, 1995.

————. "Mysticism, Romanticism, and the Fourth Dimension." In *The Spiritual in Art: Abstract Painting, 1890–1985,* 219–37. New York: Abbeville Press, 1986.

————. "A New Facet of Cubism: 'The Fourth Dimension' and 'Non-Euclidean Geometry' Reinterpreted." *Art Quarterly* (Winter 1971): 410–33.

————. "X Rays and the Quest for Invisible Reality in the Art of Kupka, Duchamp, and the Cubists." In "Revising Cubism," special issue, *Art Journal* (Winter 1988): 323–40.

Henri Le Fauconnier: Kubisme en Expressionisme in Europa. Haarlem: Frans Halsmuseum, 1993.

Herbert, Robert. "Artists and Anarchism: Unpublished Letters of Pissarro, Signac, and Others." In *From Millet to Léger: Essays in Social Art History*, 99–114.

———. *From Millet to Léger: Essays in Social Art History*. New Haven, CT: Yale University Press, 2002.

———. "Léger, the Renaissance, and 'Primitivism.' " In *From Millet to Léger: Essays in Social Art History*, 143–51.

———. *Neo-Impressionism*. New York: The Solomon R. Guggenheim Museum, 1968.

Herbert, Robert, and Eugenia Herbert. "Artists and Anarchism: Unpublished Letters of Pissarro, Signac, and Others." *Burlington Magazine* 102 (November 1960): 473–82, (December 1960): 517–22.

Hicken, Adrian. *Apollinaire, Cubism and Orphism*. Aldershot, UK: Hants; Burlington, VT: Ashgate, 2003.

Hourcade, Olivier [Olivier Bag, pseud.]. "Beaux-Arts: Les Futuristes." *La Revue de France* (March–April 1912).

Hugill, Andrew. "Imaginary Music Technologies: A Survey." Paper presented at "Technologies imaginaires: L'Approche pataphysique de la musique," Université de Paris—IV, Sorbonne, 30 March 2005 (http://www.mti.dmu.ac.uk/~ahugill/pataphysics/Techimagin/index.html).

Hume, Naomi. "Contested Cubisms: Transformations of the Czech Avant-Garde, 1910–1914." Ph.D. diss., University of Chicago, 2004.

Hutton, John G. *Neo-Impressionism and the Search for Solid Ground: Art, Science, and Anarchism in Fin-de-Siècle France*. Baton Rouge: Louisiana State University Press, 1994.

Jammes, Francis. "Un peintre girondin: Charles Lacoste." *La Revue de France et des Pays Français* (June 1912): 216–18.

Jensen, Robert. *Marketing Modernism in Fin-de-Siècle Europe*. Princeton, NJ: Princeton University Press, 1994.

Kahn, Elizabeth Louise. *Marie Laurencin: Une femme inadaptée in Feminist Histories of Art*. Burlington, VT: Ashgate, 2003.

Kahnweiler, Daniel-Henry. *Der Weg zum Kubismus*. Munich, 1920. Translated by Henry Aronson, *The Way of Cubism* (New York: Wittenborn, 1949).

Kahnweiler, Daniel-Henry, with Francis Crémieux. *My Galleries and Painters*. Translated by Helen Weaver. New York: Thames & Hudson, 1971.

Karmel, Pepe. *Picasso and the Invention of Cubism*. New Haven, CT: Yale University Press, 2003.

Klüver, Billy, and Julie Martin. "Carrefour Vavin." In Silver and Golan, *The Circle of Montparnasse*, 69–79.

Kosinski, Dorothy, ed. *Fernand Léger: The Rhythm of Modern Life, 1911–1924*. New York: Prestel, 1994.

Kramář, Vincenc. *Le Cubisme*. Edited by Erika Abrams and Hélène Klein. Paris: École nationale supérieure des Beaux-Arts, 2002.

Krauss, Rosalind E. "In the Name of Picasso." *October* (Spring 1981): 5–22. Reprinted in *The Originality of the Avant-Garde and Other Modernist Myths* (Cambridge, MA: MIT Press, 1985), 23–40.

———. "The Motivation of the Sign." In Zelevansky and Rubin, *Picasso and Braque*, 261–86.

———. *The Picasso Papers*. New York: Farrar, Straus and Giroux, 1998.

——. "Re-Presenting Picasso." *Art in America* (December 1980): 91–96.

Krukowski, Lucian. "Formalism." In *Encyclopedia of Aesthetics,* edited by Michael Kelly, 213–16. Oxford: Oxford University Press, 1998.

La Fresnaye, Roger de. "Paul Cézanne." *Poème et Drame* (January 1913): 53–59. Translated in Seligman, *Roger de La Fresnaye,* 276.

Lahoda, Vojtěch. "Avant-propos." In Kramář, *Le cubisme,* xxiii–xxxiii.

——. *Českyỳ Kubismus.* Prague: Brána, 1996.

Lanchner, Carolyn, ed. *Fernand Léger.* New York: Museum of Modern Art, 1998.

Lassalle, Hélène. "Art Criticism as Strategy: The Idiom of 'New Realism' from Fernand Léger to Pierre Restany." In Gee, *Art Criticism since 1900,* 199–218.

Laurent, Christophe. "Artistes de Passy." In *Encyclopédie Perret,* edited by Joseph Abram, Jean-Louis Cohen, and Guy Lambert. Paris: Éditions Miniteur, 2000.

Lee, Jane. *Derain.* Oxford: Phaidon, 1990.

——. "Les écrits inédits de Derain." In Pagé et al., *André Derain,* 389–97.

Le Fauconnier, Henri. "L'Oeuvre d'art." In *Henri Le Fauconnier,* 61–62.

Leighten, Patricia. "Cubist Anachronisms: Ahistoricity, Cryptoformalism and Business-As-Usual in New York." *Oxford Art Journal* 17, no. 2 (1994): 91–102.

——. "The Dreams and Lies of Picasso." *Arts Magazine* 62 (October 1987): 50–55.

——. "Picasso's Collages and the Threat of War, 1912–14." *Art Bulletin* 67, no. 4 (December 1985): 653–72. Reprinted in Katherine Hoffman, ed., *Collage: Critical Views* (Ann Arbor: UMI Research Press, 1989).

——. *Re-Ordering the Universe: Picasso and Anarchism, 1897–1914.* Princeton, NJ: Princeton University Press, 1989.

——. "*Réveil anarchiste:* Salon Painting, Political Satire, Modernist Art." *Modernism/modernity* 2 (April 1995): 17–47.

——. "The White Peril and *l'Art nègre:* Picasso, Primitivism and Anticolonialism." *Art Bulletin* (December 1990): 609–30.

Leonardo da Vinci. *Textes choisis.* Translated by J. Péladan. Paris: Société du Mercure de France, 1907.

Le Pelly Fonteny, Monique. *Adolphe et Georges Giraudon.* Paris: Musée Rodin; Bourges: Somogy, 2005.

Lespinasse, François. "Les événments de la vie artistique de 1878 à 1914." In Pétry, *L'École de Rouen,* 33–35.

Levin, Miriam R. *Republican Art and Ideology in Late Nineteenth-Century France.* Ann Arbor: UMI Research Press, 1986.

Lhote, André. *André Lhote: 48 Reproductions commentées par le peintre.* Paris: Librarie Floury, 1947.

Ligthart, Arnold. "Le Fauconnier en de Europese avant-garde." In *Henri Le Fauconnier,* 12–59.

Lista, Giovanni. "La poétique du cubo-futurisme chez Fernand Léger." In *Fernand Léger,* edited by Hélène Lassalle, 29–44. Nord Pas-de-Calais: Musée d'art moderne, 1990.

Lockerbie, S. I. Introduction. In *Calligrammes, Poems of Peace and War (1913–1916): Guillaume Apollinaire.* Berkeley and Los Angeles: University of California Press, 1980.

Logue, William. *Léon Blum: The Formative Years, 1872–1914.* De Kalb: Northern Illinois University Press, 1973.

Loosjes-Terpstra, Aleida B. *Moderne Kunst in Nederland, 1900–1914*. Utrecht: Dekker & Gumbert, 1958.

Lubar, Robert. "Cubism, Classicism, and Ideology: The 1912 Exposició d'Art Cubista in Barcelona and French Cubist Criticism." In Cowling and Mundy, *On Classic Ground*, 309–23.

———. "Unmasking Pablo's Gertrude: Queer Desire and the Subject of Portraiture." *Art Bulletin* (March 1997): 57–84.

Lucbert, Françoise. "Du succès de scandale au désenchantement: La réception contrastée de la Section d'or." In Debray and Lucbert, *La Section d'or*, 43–61.

———. "Lhote aux expositions de la Section d'or (1912–1925)." In Moulin and Fossier, *André Lhote 1885–1962*, 26–37.

———. "Roger de la Fresnaye." In Debray and Lucbert, *La Section d'or*, 192–95.

———. *Roger de La Fresnaye, 1885–1925: Cubisme et tradition*. Paris: Somogy Éditions d'art, 2005.

Mainardi, Patricia. *The End of the Salon: Art and the State in the Early Third Republic*. Cambridge: Cambridge University Press, 1993.

Maitron, Jean. *Dictionnaire biographique du mouvement ouvrier français*. 44 vols. Paris: Éditions ouvrières, 1964–97.

———. *Le mouvement anarchiste en France*. 2 vols. Paris: Gallimard, 1975.

Malone, Margaret M. "André Mare and the 1912 Maison Cubiste." Master's thesis, University of Texas at Austin, December 1980.

Malraux, André. *La tête d'obsidienne*. Paris: Gallimard, 1974.

Marlais, Michael. *Conservative Echoes in Fin-de-Siècle Parisian Art Criticism*. University Park: Pennsylvania State University Press, 1992.

Marquardt, Virginia H., ed. *Art and Journals on the Political Front, 1910–1914*. Gainesville: University Press of Florida, 1997.

Martin, Alvin. "Georges Braque and the Origins of the Language of Synthetic Cubism." In *Braque: The Papiers Collés*, edited by Isabelle Monod-Fontaine and E. A. Carmean, 61–75. Washington, DC: National Gallery of Art, 1982.

Martin, Marianne. "Futurism, Unanimism, and Apollinaire." *Art Journal* (Winter 1968–69): 258–68.

Mathieu, Caroline. "Exposition universelle 1889." In Bascou et al., *Paris in the Late Nineteenth Century*, 58–64.

Mattioli, Laura, and Vivien Greene, eds. *Boccioni's Materia: A Futurist Masterpiece and the Avant-Garde in Milan and Paris*. London: Thames & Hudson, 2004.

McCoy, Garnett. "The Post Impressionist Bomb." *Archives of American Art Journal* 20 (1980): 12–17.

McGuinness, Patrick, ed. *Symbolism, Decadence and the Fin-de-Siècle: French and European Perspectives*. Exeter: University of Exeter Press, 2000.

McWilliam, Neil. "Action française, Classicism, and the Dilemmas of Traditionalism in France, 1900–1914." In Hargrove and McWilliam, *Nationalism and French Visual Culture, 1870–1914*, 269–91.

———. *Monumental Intolerance: Jean Baffier, A Nationalist Sculptor in Fin-de-Siècle France*. University Park: Pennsylvania State University Press, 2000.

Mercereau, Alexandre. *L'Abbaye et le bolshévisme*. Paris: Figuière, 1922.

———. *La littérature et les idées nouvelles*. Paris: Figuière, 1912.

Méric, Victor [Flax, pseud.]. "Marcel Sembat." *Les Hommes du Jour* 16 (2 April 1908): 1–4.

———. "Urbain Gohier." *Les Hommes du Jour* 2, no. 59 (6 March 1909): n.p. [2–5].

Metzinger, Fritz. *A Forgotten Painter in the Rijksmuseum Kröller-Müller.* Frankfurt: R. G. Fischer, 1991.

———. *Before Cubism.* Frankfurt: R. G. Fischer, 1994.

Metzinger, Jean. *Cubisme etait né: Souvenirs.* Paris: Éditions Presence, 1972.

———. *Écluses: 27 Poèmes de Jean Metzinger.* Preface by Henry Charpentier of the Académie Mallarmé. Paris: G. L. Arlaud, 1947.

Meyer, Steven. "Writing Psychology Over: Gertrude Stein and William James." *Yale Journal of Criticism* 8 (1995): 133–63.

Miller, Sandy. *Constantin Brancusi: A Survey of His Work.* Oxford: Clarendon Press, 1995.

Morin, Isabelle. *Analyse raisonnée des catalogues d'exposition des peintres cubistes (1907–1914).* Paris: Institut d'art et d'archéologie, 1972.

Morris, Frances, and Christopher Green, eds. *Henri Rousseau: Jungles in Paris.* London: Tate Publishing, 2005.

Moser, Joann. *Jean Metzinger in Retrospect.* Iowa City: University of Iowa Museum of Art, 1985.

Moulin, Hélène, and François Fossier, eds. *André Lhote, 1885–1962: Rétrospective présentée au Musée de Valence du 15 juin au 28 septembre 2003.* Paris: Réunion des Musées nationaux, 2003.

Mourey, Gabriel. "Au Salon d'Automne." *Le Journal,* 30 September 1912, p. 2.

———. "Une Villa: Charles Plumet." *Art et Décoration* 30 (September 1911): 277–88.

Munck, Jacqueline, and Miriam Simon. "1911–1914, les années singulières: Période dite gothique ou byzantine." In Pagé et al., *André Derain,* 180–229.

Murphy, Kevin. "Cubism and the Gothic Tradition." In Blau and Troy, *Architecture and Cubism,* 59–76.

Murray, Anne. "Henri Le Fauconnier's 'Das Kunstwerk': An Early Statement of Cubist Aesthetic Theory and Its Understanding in Germany." *Arts Magazine* (December 1981): 125–33.

———. "Henri Le Fauconnier's 'Village in the Mountains.'" *Bulletin of Rhode Island School of Design* (January 1973): 21–39.

Nash, John. "The Nature of Cubism: A Study of Conflicting Interpretations." *Art History* (December 1980): 436–47.

Nathanson, Carol A. *The Expressive Fauvism of Anne Estelle Rice.* New York: Hollis Taggart Galleries, 1997.

North, Percy. *Max Weber: The Cubist Decade, 1910–1920.* Atlanta: High Museum, 1992.

Otto, Elizabeth. "Marie Laurencin and the Gendering of Cubism, 1904–1914." Master's thesis, Queen's University, 1997.

Pagé, Suzanne, et al. *André Derain: Le peintre du "trouble moderne."* Paris: Musée d'art moderne de la Ville de Paris, 1995.

Papanikolas, Theresa. "The Cultural Politics of Paris Dada, 1916–22." Ph.D. diss., University of Delaware, 1999.

Pardon, Anthony, and M. N. Yablonskaya, eds. *Women Artists of Russia's New Age, 1900–1935.* New York: Rizzoli, 1990.

Parigoris, Alexandra. "Les constructions cubistes dans 'Les Soirées de Paris': Apollinaire, Picasso et les clichés Kahnweiler." *Revue de l'Art*, no. 82 (1988): 61–74.

Parry, Richard. *The Bonnot Gang: The Story of the French Illegalists*. London: Rebel Press, 1987.

Perloff, Marjorie. *The Futurist Moment: Avant-Garde, Avant Guerre, and the Language of Rupture*. Chicago: University of Chicago Press, 1986.

Perry, Gill. *Women Artists and the Parisian Avant-Garde*. Manchester: Manchester University Press, 1995.

Pessiot, Marie. "Quand l'obsession de la dynamique, bouleverse les thèmes classiques...." In Ajac and Pessiot, *Duchamp-Villon*, 28–33.

Pétry, Claude. "L'École de Rouen, de l'impressionisme à Marcel Duchamp." In Pétry, *L'École de Rouen*, 11–15.

———, ed. *L'École de Rouen, de l'impressionisme à Marcel Duchamp, 1878–1914*. Rouen: Musée des Beaux-Arts de Rouen, 1996.

Poggi, Christine. *In Defiance of Painting: Cubism, Futurism, and the Invention of Collage*. New Haven, CT: Yale University Press, 1992.

———. "*Lacerba:* Interventionist Art and Politics in Pre–World War I Italy." In Marquardt, *Art and Journals on the Political Front, 1910–1914*, 17–62.

Pradel, Marie-Noëlle. "La Maison Cubiste en 1912." *Art de France*, no. 1 (1961): 176–86.

Raymond, J. "Marcel Étienne Sembat." In Maitron, *Dictionnaire Biographique du Mouvement ouvrier Français*, 17:152–55.

Read, Peter. *Apollinaire and Cubism*. In Guillaume Apollinaire, *The Cubist Painters*, translated by Peter Read, 5–152. Forest Row, East Sussex: Artists Bookworks, 2002.

Reboux, Paul. "Revue des revues—La doctrine des 'fauves.'" *Le Journal*, 28 November 1910, p. 4.

Richardson, John. *A Life of Picasso*. Vols. 1, *1886–1906*, and 2, *1907–1917*. New York: Random House, 1991, 1996.

Richter, Mario. *La formazione francese di Ardengo Soffici, 1900–1914*. Milan: Vita e pensiero, 1987.

Robbins, Daniel. "The Formation and Maturity of Albert Gleizes: A Biographical and Critical Study, 1881 through 1920." Ph.D. diss., New York University, 1975.

———. "From Symbolism to Cubism: The Abbey of Créteil." *Art Journal* (Winter 1963–64): 111–16.

———. "The Genealogy of the Section d'Or." In *Albert Gleizes and the Section d'Or*, n.p.

———. "Henri Le Fauconnier's *Mountaineers Attacked by Bears*." *Rhode Island School of Design: Museum Notes* (1996): 24–53.

———. "Jean Metzinger: At the Center of Cubism." In Moser, *Jean Metzinger in Retrospect*, 9–23.

———. "Préface." In *Du "Cubisme,"* by Albert Gleizes and Jean Metzinger [1912], 9–16. Sisteron: Éditions Présence, 1980.

———. "Sources of Cubism and Futurism." *Art Journal* (Winter 1981): 324–27.

———, ed. *Jacques Villon*. Cambridge, MA: Fogg Art Museum, Harvard University, 1976.

Roslak, Robyn, *Neo-Impressionism and Anarchism in Fin-de-Siècle France: Painting, Politics and Landscape*. Aldershot, Hants. and Burlington, VT: Ashgate, 2007.

———. "The Politics of Aesthetic Harmony: Neo-Impressionism, Science, and Anarchism." *Art Bulletin* (September 1991): 381–90.

Rothman, Roger I. "Between Music and the Machine: Francis Picabia and the End of Abstraction." *Tout-Fait: The Marcel Duchamp Studies Online Journal* 2, no. 4 (2002), http://www.toutfait.com/duchamp.jsp?postid=1235&keyword=rothman.

Rousseau, Pascal. "'L'âge des synthèses': L'Oeuvre d'Albert Gleizes à Barcelone (1912–1916)." In *Albert Gleizes: Le cubisme en majesté*. Paris: Réunion des Musées nationaux, 2001.

Rousseau, Pascal, et al. *Robert Delaunay, 1906–1914: De l'impressionisme à l'abstraction*. Paris: Centre Georges Pompidou, 1999.

Rubin, William. "Picasso." In *"Primitivism" and Twentieth-Century Art*, edited by William Rubin, 241–343. New York: Museum of Modern Art, 1984.

———, ed. *Picasso and Braque: Pioneering Cubism*. New York: Museum of Modern Art, 1989.

———, ed. *"Primitivism" and Twentieth-Century Art*. New York: Museum of Modern Art, 1984.

Ruddick, Lisa. "'Melanctha' and the Psychology of William James." *Modern Fiction Studies* 28, no. 4 (Winter 1982–83): 545–56.

———. "William James and the Modernism of Gertrude Stein." In *Modernism Reconsidered*, edited by R. Kiely and J. Hildebidle, 47–63. Cambridge, MA: Harvard University Press, 1983.

Salmon, André. "Courrier des artistes." *Paris-Journal*, 10 May 1910.

———. *La jeune peinture française*. Paris: Société des trente, 1912.

———. *Souvenirs sans fin*. 3 vols. Paris: Gallimard, 1955–61.

Schipper, Wendela. "Biografie." In *Henri Le Fauconnier*, 8–11.

Schmitt, Katherina. "La femme en bleu." In Kosinski, ed., *Fernand Léger*, 37–43.

Sedeyn, Emile. "Au Salon d'Automne." *Art et Décoration* 32 (July–December 1912): 141–60.

Seligman, Germain. *Roger de La Fresnaye: With a Catalogue raisonné*. Greenwich, CT: New York Graphic Society, 1969.

Sembat, Marcel. *Faites un roi, sinon, faites la paix*. Paris: Eugène Figuière, 1913.

———. *Henri Matisse; Trente reproductions de peintures et dessins précédées d'une étude critique*. Paris: Éditions de la "Nouvelle revue française," 1920.

Sénéchal, Christian. *L'Abbaye de Créteil*. Paris: Libraire André Delpeuch, 1930.

Severini, Gino. *The Life of a Painter: The Autobiography of Gino Severini*. Translated by Jennifer Franchina. Princeton, NJ: Princeton University Press, 1995.

Shattuck, Roger. "Apollinaire's Great Wheel." In Shattuck, *The Innocent Eye: On Modern Literature and the Arts*, 240–62. New York: Farrar Straus Giroux, 1984.

———. *The Banquet Years: The Origins of the Avant-Garde in France, 1885 to World War I*. Rev. ed. New York: Vintage Books, 1968.

Sheon, Aaron. "1913: Forgotten Cubist Exhibitions in America." *Arts Magazine* (March 1983): 93–107.

Shiff, Richard. *Cézanne and the End of Impressionism: A Study of the Theory, Technique, and Critical Evaluation of Modern Art*. Chicago: University of Chicago Press, 1984.

Silber, Evelyn. *The Sculpture of Epstein*. London: Phaidon, 1996.

Silver, Kenneth. *Esprit de Corps: The Art of the Parisian Avant-Garde and the First World War, 1914–1925*. Princeton, NJ: Princeton University Press, 1989.

———. "The Heroism of Understatement: The Ideological Machinery of La Fresnaye's 'Conquest of the Air.'" In *Self and History: A Tribute to Linda Nochlin*, 177–26. London: Thames & Hudson, 2001.

Silver, Kenneth, and Romy Golan. *The Circle of Montparnasse: Jewish Artists in Paris, 1905–1945*. New York: Universe, 1985.

Smith, Paul. *Seurat and the Avant-Garde*. New Haven, CT: Yale University Press, 1997.

Sonn, Richard. *Anarchism and Cultural Politics in Fin-de-Siècle France*. Lincoln: University of Nebraska Press, 1989.

Spate, Virginia. *Orphism: The Evolution of Non-Figurative Painting in Paris, 1910–1914*. Oxford: Oxford University Press, 1979.

Spurling, Hilary. *The Unknown Matisse: A Life of Henri Matisse; The Early Years, 1869–1908*. New York: Knopf, 1998.

Stein, Leo. *Appreciation: Painting, Poetry and Prose*. New York: Crown Publishers, 1947.

Steiner, Wendy. *Exact Resemblance to Exact Resemblance: The Literary Portraiture of Gertrude Stein*. New Haven, CT: Yale University Press, 1978.

Stevens, Mary Anne. "Bernard as Critic." In *Émile Bernard, 1861–1941: A Pioneer of Modern Art*, edited by Mary Anne Stevens, 68–91. Amsterdam: Van Gogh Museum, 1990.

Stone-Richards, Michael. "Nominalism and Emotion in Reverdy's Account of Cubism, 1917–27." In Gee, *Art Criticism since 1900*, 97–115.

Sund, Judy. "Fernand Léger and Unanimism." *Oxford Art Journal* 7, no. 1 (1984): 49–56.

Tarbell, Roberta K. *Marguerite Zorach: The Early Years, 1908–1920*. Washington, DC: Smithsonian Institution Press, 1973.

Thom, Ian M. *Emily Carr in France*. Vancouver, BC: Vancouver Art Gallery, 1991.

Thomson, Richard. *Monet to Matisse: Landscape Painting in France, 1874–1914*. Edinburgh: National Gallery of Scotland, 1994.

Tinterow, Gary, ed. *Juan Gris (1887–1927)*. Madrid: Salas Pablo Ruiz Picasso, 1985.

Troy, Nancy. *Couture Culture: A Study of Modern Art and Fashion*. Cambridge, MA: MIT Press, 2003.

———. "Domesticity, Decoration, and Consumer Culture: Selling Art and Design in Pre–World War I France." In *Not at Home: The Suppression of Domesticity in Modern Art and Architecture*, edited by Christopher Reed, 133–29. London: Thames & Hudson, 1996.

———. *Modernism and the Decorative Arts in France: Art Nouveau to Le Corbusier*. New Haven, CT: Yale University Press, 1991.

Vaisse, Pierre. *La Troisième République et les peintres*. Paris: Flammarion, 1995.

Van Adrichem, Jan. "The Introduction of Modern Art in Holland: Picasso as pars pro toto, 1910–1930." *Simiolus* 21, no. 3 (1992): 162–211.

Varias, Alexander. *Paris and the Anarchists: Aesthetes and Subversives during the Fin-de-Siècle*. New York: St. Martin's Press, 1996.

Varichon, Anne. *Albert Gleizes: Catalogue raisonné, Volume I*. Paris: Somogy Éditions d'art, 1998.

Vaughan, Gerard. "Maurice Denis and the Sense of Music." *Oxford Art Journal* 7, no. 1 (1984): 38–48.

Vauxcelles, Louis. "Au Salon d'Automne (II): L'art décoratif." *L'Art Décoratif*, no. 26 (November 1912): 253, 256.

———. "Le Salon d'Automne." *Gil Blas*, 30 September, 1909, p. 5.

Vera, André. "Le nouveau style." *L'Art Décoratif*, no. 27 (January 1912): 21–32.

"Victor Méric." *Les Hommes du Jour*, no. 37 (3 October 1908): 6.

Vinall, Shirley W. "French Symbolism and Italian Poetry, 1880–1920." In McGuinness, *Symbolism, Decadence and the Fin-de-Siècle*, 244–63.

Voignier, Jean-Marie. *Répertoire des photographes de France au dix-neuvième siècle français*. Chevilly-Larue: Le pont de pierre, 1993.

Walker, Kathrine Sorley. *De Basil's Ballets Russes*. New York: Atheneum, 1983.

Ward, Martha. *Pissarro, Neo-Impressionism, and the Spaces of the Avant-Garde*. Chicago: University of Chicago Press, 1996.

Warnod, Jeanine. *La ruche et Montparnasse*. Geneva: Weber, 1978.

Weber, Eugen. *My France: Politics, Culture, Myth*. Cambridge, MA: Harvard University Press, 1991.

———. *Peasants into Frenchmen: The Modernization of Rural France, 1870–1914*. Stanford, CA: Stanford University Press, 1976.

Weber, Max. "The Fourth Dimension from a Plastic Point of View." *Camera Work* (July 1910): 25.

Weiss, Jeffrey. *The Popular Culture of Modern Art: Picasso, Duchamp, and Avant-Gardism*. New Haven, CT: Yale University Press, 1994.

Zelevansky, Lynn, and William Rubin. *Picasso and Braque: A Symposium*. New York: Museum of Modern Art, 1992.

Zilzcer, Judith. "Raymond Duchamp-Villon." Special issue, *Philadelphia Museum of Art Bulletin* (Fall 1980).

———. "Raymond Duchamp-Villon and the American Avant-Garde." *Archives of American Art* 38, nos. 1–2 (1998): 14–27.

INDEX